D1597106

The Medieval Salento

THE MIDDLE AGES SERIES

Ruth Mazo Karras, Series Editor

Edward Peters, Founding Editor

A complete list of books in the series is available from the publisher.

The Medieval Salento

Art and Identity in Southern Italy

Linda Safran

PENN

University of Pennsylvania Press

Philadelphia

Publication of this book has been aided by a grant from the
Millard Meiss Publication Fund of the College Art Association.

Published by
University of Pennsylvania Press
Philadelphia, Pennsylvania 19104-4112
www.upenn.edu/pennpress

Printed in the United States of America on acid-free paper
10 9 8 7 6 5 4 3 2 1

Library of Congress Cataloging-in-Publication Data

Safran, Linda.
 The medieval Salento : art and identity in Southern Italy / Linda Safran. — 1st ed.
 p. cm. — (Middle Ages series)
 Includes bibliographical references and index.
 ISBN 978-0-8122-4554-7 (hardcover : alk. paper)
 1. Visual communication—Italy—Salentina Peninsula—History—To 1500. 2. Material
culture—Italy—Salentina Peninsula—History—To 1500. 3. Arts and society—Italy—
Salentina Peninsula—History—To 1500. 4. Ethnicity—Italy—Salentina Peninsula—
History—To 1500. 5. Salentina Peninsula (Italy)—Social life and customs. 6. Visual
communication in art. 7. Material culture in art. 8. Group identity in art. 9. Ethnicity
in art. I. Title. II. Series: Middle Ages series.

 P93.5.S235 2014
 306.4'60945753—dc23
 2013031247

Contents

Color plates follow page 336

Note

Numbers in boldface brackets indicate images and texts in the Database. Greek in the Database reproduces the accentuation and orthography of the original text, whereas in the rest of the book the Greek is corrected. Conventions for inscriptions in the text are the same as in the Database; see page 242.

Introduction

In this book I explore the visual and material culture of people who lived and died in a particular region of Italy in the Middle Ages. I investigate their names, the languages they used in public, how they were represented (and how they actually may have looked), and what components of status seem to have been important to them. I then reconstruct some of the rituals that accompanied local residents throughout their life cycles and during their worship, their daily lives, and their calendar year, focusing on those practices that can be extrapolated from visual evidence. By combining analytical methods drawn from art history, archaeology, anthropology, ethnography, and sociolinguistics,[1] I add texture to the stylistic and iconographic analyses that have dominated art-historical study of the region and shed new light on nonelite people who are often overlooked because they have left few traces in documentary texts.

The Medieval Salento: Art and Identity in Southern Italy is not one of those clever book titles that obscure the contents; it is, at first glance, an unambiguous and perhaps even uninspiring title. Yet not one of its principal words—"Medieval," "Salento," "Art," "Identity"—is at all straightforward. These words turn out to be challenging intellectual and historical constructs that require both careful definition and a series of authorial choices. It is important to explore each of these terms to understand how they interrelate and why it is necessary, and even urgent, to consider them together in this book. I begin with the subtitle.

Art

"What is art?" is hardly a new question, but it seems to have become more exigent in the past century as novel forms of creativity, spurred by emerging technologies and social change, constantly appear and are frequently contested. I am concerned in this book with visual arts, not with literature or music or other creative spheres of human activity, but that restriction scarcely narrows the possible answers. Found art, environmental art, performance art, digital art are all "new" types of

art that are valid to some viewers, and presumably to all of their creators, yet neither serious nor even "art" to others. It is crucial to acknowledge that definitions of art are culturally and temporally specific and, in particular, that Renaissance notions of art are not relevant to the millennium that preceded it. Despite its widespread impact over the past five centuries, the Renaissance idea of art as something finely crafted, a product of unusual skill or inspiration to be appreciated principally for its aesthetic value, is much too limiting.[2] Before the European Renaissance (and also in non-European contexts), visual art had a much broader scope.

Objects that qualify as art share three features: they are made to be seen; they are indexes of, and products of, social agency; and they fascinate, compel, or otherwise command attention, whether because they are difficult to execute or because they require a spectator to think as well as to see.[3] These essential features of art accommodate a wide range of visual production: from objects (clothing, jewelry, painted ceramics) to decoration and embellishment (inscriptions, wall paintings, churches) to spectacles (liturgies, civic processions, funerals). Such an expansive definition of art is much closer to that used by archaeologists and anthropologists than to the one typically employed by historians of postmedieval art.[4] It deliberately unites the categories of visual culture, material culture, and traditional fine art.[5] All of these visual and artificial intrusions into the natural landscape had an effect on their viewers. Indeed, pre-Renaissance art was always intended to *do* something; it was never commissioned, produced, collected, or exhibited for its own sake.[6] Exploring the motives for and the effects of visual communication, broadly defined, are among the objectives of this book.

Visual communication before the Renaissance was not limited to pictorial means; it also involved texts. All texts are symbolic means of communication, but they also have visual and material qualities that make them more (or less) effective. They fully satisfy the three criteria for "art" outlined above, and at least some are meant to be seen by more than just their authors. These latter texts are those in the public domain, created to be read or viewed by multiple audiences over time and usually in perpetuity. Like many other forms of visual and material culture, public texts may be costly (e.g., professionally carved marble inscriptions) or humble (e.g., incised graffiti); what they share is the attention of readers/viewers whose experience of the visual is dictated by the text's fixed location in a public space with multiple viewers. This is very different from the visual experience afforded by portable and private objects, which have limited viewership and, because they may be seen in varied settings, can change their messages according to context. Words that appear in a public context are just as important as those found in documents and should be accorded the same respect.

The subjects of this study, then, are visual products—architectural, performative, pictorial, and textual—that are associated with specific places and intended

from the outset to be viewed by multiple persons. These are the visual and material objects most likely to have a social impact because they were always meant to be seen and talked about. I include in this visual-cultural corpus buildings and their furnishings; wall paintings and mosaic pavements; relief (not portable) sculpture; painted and carved inscriptions; incised and painted graffiti (both verbal and pictorial); graves, their markers, and their contents (visible at the time of interment and again when the grave was reused); and any evidence for the built environment and groups acting within it (rituals, regular practices). All of these features of the visual landscape were produced or enacted for public consumption, crafted with the express intent of communicating information and initiating or shaping human (re)action. They were not, or at least not principally, objects of aesthetic pleasure. Books are excluded because of their intentionally limited accessibility, although they do figure here in the background, and panel paintings (icons) are omitted because no locally produced examples survive from the centuries under consideration.[7] Because they were mainly, if not exclusively, part of a limited viewing experience, books and portable paintings provide scant information about the agency of public art.

It is my contention throughout this book that pictures and words mattered because they had a critical social role and that art in the public domain had the ability to influence social realities. Art is a form of representation: the images and texts "present" or stand in for their patrons, authors/artists, and viewers. Even ostensibly mimetic art is not the same as reality; it re-presents selected realities, inevitably distorting them in the process. Buildings, images, and inscriptions all need to be "read"—that is, to be analyzed and interpreted in culturally specific ways—and every interpreter naturally brings something different to the task. In this book, I apply selected theoretical perspectives about visual representation to a region and historical period whose visual culture typically has been approached according to more traditional methods of stylistic, iconographic, and textual analysis.

Identity

The theoretical construct "identity" has been for some decades a topic of scholarly and popular interest, but, like "art," it remains difficult to define.[8] A working definition is "that bundle of verbal and corporal [and visual] statements persons and groups use to recognize one another."[9] Identity involves "individuals' identification with broader groups on the basis of differences socially sanctioned as significant."[10] People acquire identities through social interaction, but these identities are multiple and unstable because all individuals simultaneously occupy more than one

position in society and because identity "is a 'production' which is never complete, always in process."[11] Identities become more and less relevant "depending on the context of specific social situations" (I am, at various and overlapping times, primarily a scholar, an editor, a mother, a wife, and countless other things).[12] Social-identity groups may be based on interpersonal interactions (such as family or village groups), or they can be looser categories based on impersonal symbolic links (the elites, the Byzantines, Christians).[13] The sum of overlapping personal and social identities composes the self; and representations of the self, and of groups of selves, through visual means is a principal subject of this book.

One of the significant finds of identity theorists of the past half century is that identity is often an etic perception, imposed from outside, and not just by modern interpreters.[14] But it is also emic, internal; identities are situational; they "harden" when challenged.[15] Thus a local Orthodox response to increasing papal pressure—usually called, erroneously, "Latinization"—was to increase cultural production in Greek in the late thirteenth–early fourteenth centuries, as witnessed by a wealth of new manuscripts.[16] However, calling the scribes or their patrons "Greek" or "Byzantine" is a misleading etic categorization. Prior to the fifteenth century, notions of religion, ancestry, and culture were fluid; only in the early modern era, or even later with the rise of nationalism, did these taxonomies become more rigid.[17] Because identity is not unilateral, labels inevitably elide important distinctions and risk essentializing their subjects. While this has been rightly criticized by poststructuralist theorists, the "affirmative action" necessary to counteract totalizing discourse about "Greeks," "Latins," and "Jews" relies on those very labels.[18] In fact, we need labels, and I use them in this book, but I try to be precise in my definitions and therefore use "Greek" and "Latin" to refer to languages rather than cultural groups.

While postpositivists do not claim to "know" historical selves, we can study their representations and the material culture they produced. Indeed, as cultural theorist Stuart Hall argued, identity is constructed within representation.[19] The visual information permits some proximity to historical social-identity groups and even to their individual members. This emic, "insider" view is inevitably filtered through the perceptions and interpretations of our own time and vantage point, but I would still claim that examining texts, images, and artifacts produced for local consumption can yield insights into social realities and changes not represented in contemporary documents created for a textual elite.

Over the course of this book, and culminating in the final chapter, I argue that an evolving identification with local and regional neighbors trumped older and more geographically remote identities—in other words, that there was such a thing as "Salentine identity," and that it differed from the social and cultural realities in other places because of the particular juxtaposition of languages, religions, and

cultural features found there. By recovering the people of the medieval Salento from what survives of their visual and material culture, using both emic and etic perspectives, I reunite them as neighbors who shared similar (or at least comparable) habits of visuality and analogous strategies of representation, donation, and commemoration regardless of confession or language or social class. In so doing, I open fresh perspectives on social and cultural interactions in daily life that complement recent work in other areas, although most of those other works, by historians, give short shrift to the visual.[20] Knowing how identities were promoted and reinforced in the medieval Salento helps us learn more about medieval people in general and, ultimately, more about identity formation and cultural interaction today.

The Medieval Salento

This study focuses on a particular region of southern Italy in the period between the ninth and the early fifteenth centuries. Both the geographical extent and the limited time frame require explanation, given the unfamiliarity of the term "Salento," at least outside of Italy, and the absence of obvious temporal ruptures. A historical précis helps to clarify the geographical and chronological choices made here.

Geography and Chronology

At the tip of the heel of the Italian boot, the indigenous Messapian people resisted the founding of what would become flourishing Greek colonies in Magna Graecia between the eighth and fourth centuries BCE.[21] By the third century BCE, all of them, even mighty Taranto, bowed to the superior might of the expanding Roman republic. Under Augustus in the first century BCE, the southern part of the new Second Region of Apulia, equivalent to ancient Messapia, began to be called Calabria; it sheltered tribes of Sallentines in the north and Calabrians in the south.[22] Already in the third century BCE the Via Appia had been extended across the peninsula from Taranto to Oria and Brindisi (see map at beginning of the Database); directly across the Adriatic Sea, the Via Egnatia continued across the Balkans to Constantinople. Under the Romans in the second century CE, the Via Traiana was extended south from Brindisi and then farther south around the coast. The principal regional roads, and the Roman cadastral grids, were in place.[23] So were the Jewish communities at Taranto, Brindisi, and Otranto, populated by prisoners from Palaestina Secunda brought west, first by Pompey the Great (mid-first century BCE) and then by Titus after the destruction of the Jerusalem Temple in 70 CE.[24]

Ancient Calabria, then, was essentially the area south of Taranto and Brindisi. The region has extensive limestone and calcareous sandstone outcrops in a slightly undulating terrain that never rises more than 195 meters above sea level.[25] Nevertheless, it is not easy to generalize about agriculture, climate, or topography because of significant small-scale variations. There is abundant evidence for a much greater degree of forestation than exists now, with extensive *boschi* near Taranto, Oria, Lecce, and Supersano.[26] In general, the settlement pattern appears to have been influenced mostly by the kind of soil available and the consequent ease, or difficulty, of obtaining water. Geological conditions likely underlie the presence of a majority of rural centers and may explain the surprisingly high number of settlements that still characterize the area.[27] In the Middle Ages the region produced wheat and winter barley, legumes, and grapes. Olive production increased slowly in importance, only dominating local agriculture beginning in the fifteenth century.[28] Other important economic activities included fishing, salt production, and textile dyeing and weaving.[29]

In the fifth and sixth century, some of the earliest monasteries on Italian soil (indeed, in the entire central Mediterranean) were founded in the hinterland of Otranto, including the "Centoporte" (Saints Cosmas and Damian) and perhaps San Nicola at Casole.[30] Following the Byzantine-Gothic wars of the sixth century and the Lombard conquests of the seventh, the name "Calabria" migrated across the Ionian Sea to the toe of the Italian boot, and the former Calabria became known as the Salento.[31] "Sallentum," the ancient Bruttium, originally had referred to the southernmost tip of ancient Calabria. Only Gallipoli and Otranto remained in imperial hands after the early medieval destructions;[32] all the rest was integrated into the Lombard duchy of Beneventum. The wars had severe consequences for the urban infrastructure, which would be further weakened by Arab invasions in the ninth century. Half of the ancient cities and many smaller late-Roman sites disappeared, and rural fairs replaced urban markets.[33] In the early Middle Ages, the tall, freestanding menhirs once thought to be prehistoric monuments likely served as the most visible points of reference in the Christian religious landscape.[34]

Jean-Marie Martin has renewed earlier opinions that the Muslim invasions of Sicily spurred a new wave of Greek speakers immigrating into the toe and then the heel of the Italian boot.[35] These adherents of Orthodox Christianity sought, not always successfully, to establish and promote a new ecclesiastical organization, especially in the later ninth century with the Byzantine reconquest of Lombard territories in the former Calabria. Despite the successful reconquest, Byzantine sources continued to call the whole area—all of Apulia plus adjacent parts of Lucania/Basilicata—"Longobardia," implicitly recognizing the dominance of Lombard law, Latin language, and Roman rite.[36] The entire province remained mostly Latin-speaking and faithful to Lombard law except for the southernmost

extreme. South of the Via Appia, and especially south of Lecce, Greek speakers subject to Byzantine law and following Orthodox rites constituted a majority.

The medieval Orthodox liturgy in southern Italy remained close to that of Constantinople but with several variations, some of them culled from the old Palestinian (Jerusalem) Liturgy of Saint James.[37] The Roman liturgy was translated into Greek in the tenth century, with the resulting Liturgy of Saint Peter intended for use in mixed-language areas.[38] In the Jewish communities, Palestinian liturgy, exegesis, and customs were gradually replaced, beginning in the ninth century, with the Babylonian practices that would eventually become normative throughout medieval Europe.[39] The Salento Jews practiced the Romaniote (Byzantine) rite, only later coming under the influence of thinkers trained in the Rhineland and Spain.

Two centuries of Byzantine rule brought important demographic changes and renewed relations with the Byzantine provinces to the east. Numerous "Greeks" were forcibly resettled in the Salento from their homes in Herakleia (Pontos) and the Peloponnese.[40] In the 960s, the former Longobardia became the Katepanate of Italy with its capital at Bari. A new network of regional habitats was established, probably a continuation of trends already occurring under Lombard rule. This network consisted of a few cities,[41] fortified καστέλλια (*kastellia*; Latin, *castra*), and small hamlets or villages (χωρία, *choria, casalia*), the latter almost always unwalled and often with an originally isolated church serving as a nucleus. A *chorion* might also be an agglomeration of rural habitats and the surrounding hinterland.[42] An ongoing survey by the University of Salento has identified approximately 360 medieval villages, with the greatest concentration in the southeastern part of the province of Lecce.[43] Most of the population was scattered in these very small habitats, which began to nucleate into *choria* around cult sites often erected on the ruins of earlier Roman villas.[44] The Byzantines promoted a network of bishoprics to serve the dispersed habitats.[45]

The Norman conquest of the eleventh century (Bari fell in 1071) instituted a feudal system of compact fiefdoms as well as larger counties and principalities.[46] By 1168, the Terra d'Otranto is cited as one of three discrete administrative units in Apulia (with Capitanata and the Terra di Bari), probably with its own judges and tax collectors (cf. a later Latin inscription in the Database, [**28.W**]), although the primary motive for its formation was surely defensive.[47] While the Norman kings ruled from Palermo, in Sicily, their relatives held important territory in the Terra d'Otranto. Tancred, the Count of Lecce—which became the Norman regional capital—became king of Sicily in the late twelfth century. The Normans founded numerous monasteries, both Orthodox and Roman rite, and promoted a kind of ecclesiastical feudalism by donating many *casalia* and other properties to the new foundations.[48] At the same time, sizable Jewish communities continued

to flourish, particularly in the coastal cities; their numbers and leaders were recorded by the traveling merchant Benjamin of Tudela circa 1165. When the Holy Roman Emperor Henry VI invaded in 1194, with the excuse that he was married to the last of the Norman princesses, Tancred's family fled to France. His daughter married Walter III, Count of Brienne, who assumed the title of Count of Lecce and returned to southern Italy with papal encouragement.

The Normans were succeeded by the Swabian dynasty, including the *puer Apuliae* Frederick II, who built extensively, mostly north of the Terra d'Otranto, and promoted the region's economic vitality.[49] After the fall of Frederick's grandson Conradin to Charles I of Anjou, in 1268, the capital was moved from Palermo to Naples and large principalities were carved out for the Angevin family and its favorites. Following the loss of Sicily during the Vespers of 1282,[50] the Angevins were constantly at war with the Aragonese, which caused sustained economic crisis in the Salento. Bubonic plague and Hungarian invasions in the mid-fourteenth century exacerbated the crisis, and over the next century and a half many of the area's rural habitats were abandoned.[51]

The Angevins were major supporters of the Franciscans, counting one of the latter—Saint Louis of Toulouse—as family. The spread of the mendicant orders had important repercussions for religious and social life in southern Italy, particularly for the Jews, against whom they preached aggressively. In 1276 the largest Jewish communities were in Brindisi, Nardò, and Taranto, cities that saw occasional outbursts of violence by the Christian citizens against their Jewish neighbors.[52] The Jews of the kingdom of Naples were *servi camerae regiae*, important contributors to the royal treasury under the direct control of the ruler. Charles I generally supported the Jewish minorities in his realm against local abuses, but his son and successor, Charles II, was the first ruler to expel them, in the 1290s. He was under pressure from the Dominicans, who used the Inquisition meant to uncover Christian heretics as a means of encouraging conversion of the Jews.[53] New Jewish converts received fiscal exemptions in return for professing Christianity, but many fled to northern Italy rather than convert. Others remained, and the Angevin king Robert the Wise (r. 1309–43) invited more Jews into the kingdom, asserting that nowhere else in the world could they find treatment as favorable as in the kingdom of Naples.[54] Privileges were extended by Robert's successors to most of the Jewish communities until these were all rescinded in 1427.[55]

By the late fourteenth century, the different branches of Angevins in Provence and Durazzo were at war with each other and the only beneficiaries were Venetian traders and Florentine bankers; the Salentine population was in dire straits. Local control was exercised by the descendants of the Brienne family who had married into the powerful Enghien clan and controlled a vast feudal state that included the principate of Taranto, county of Lecce, and county of Soleto.[56] In 1384 Maria

d'Enghien became Countess of Lecce; the next year she married Raimondello del Balzo Orsini, prince of Taranto and Count of Soleto and Nola. Thus, at the end of the fourteenth century, most of the Terra d'Otranto—with the exception of Nardò in the south and with the addition of Matera in the northwest—was in the hands of one powerful feudal leader, and the minor nobility was kept in check.[57] There were major changes in settlement patterns: about a third of the existing villages were abandoned, many transformed into *masserie* (large farms), suggesting different modes of agricultural organization.[58] It was at this time, too, that Italian definitively began to replace Greek and Latin, as Maria d'Enghien, sole ruler after the death of her husband in 1406, authorized the use of *volgare* for letters and local statutes.[59]

The Angevins also were responsible for striking changes in the region's architecture and art. "Gothic" features were introduced by the early fourteenth century, especially via extensive patronage of the basilica of Santa Maria del Casale, outside Brindisi [**28**]. Royal patronage of the Franciscan order later stimulated such imposing structures as Santa Caterina at Galatina, and a wave of church and monastery building in the fourteenth and fifteenth centuries, not necessarily connected with the rulers, fundamentally altered the urban fabric of many cities.[60] Tuscan-style paintings were introduced in the second half of the fourteenth century, a half century behind their initial appearance in the Angevins' Neapolitan court milieu. With the Torre di Belloluogo [**59**] and Santi Niccolò e Cataldo in Lecce [**58**], Santo Stefano in Soleto [**113**], and Santa Caterina in Galatina [**47**] all painted in the late fourteenth to early fifteenth century, the late Gothic courtly style—substantial figures in increasingly convincing pictorial space, discursive narrative cycles—began to take hold and significantly altered the generally "Byzantine" flavor of the region's painting. These are the principal artistic reasons for ending the current study soon after 1400.

We can now summarize the chronological and geographical parameters of this study. Byzantine hegemony, a probable influx of Greek speakers, and new ecclesiastical organization point to the ninth century as a time of major change in southern Apulia. An agrarian crisis after the Black Death and the resulting abandonment of many settlements; an explosion of mendicant preaching bringing new animosity toward local Jews; a shift toward Italian as a written language; changing artistic preferences around the turn of the fifteenth century; and, eventually, the establishment of the new Aragonese dynasty in Naples (1442) mark the end of this study—and the gradual change from late medieval to early modern.[61]

While the definition and contours of the Salento were mutable, and even now the term is used inconsistently, it was certainly an administrative entity in the Middle Ages when the Normans called it the "Terra d'Otranto," a synonym still in use today. The region extends some two hundred kilometers north from Leuca along

both the Ionian and Adriatic coasts.[62] It incorporates the whole of the modern province of Lecce in the south and, in the north, most of the provinces of Brindisi and Taranto, including the southern part of the diocese of Ostuni, all of the dioceses of Oria and Taranto, and most of the diocese of Castellaneta (see map, pp. 240–41). I do not include in this study data from the microregions northwest of Taranto (Laterza, Castellaneta, and Ginosa) or north of San Vito dei Normanni and Ceglie Messapica, which are not traditionally considered part of the Salento.[63]

Demographics

In the Byzantine era (ca. 870–1071) and later, the Salento was very densely settled, with villages averaging only eight kilometers apart.[64] It remains today the Italian province with the greatest number of settlements although it lacks, and always lacked, correspondingly high population numbers. While reliable demographic figures are not available for the early periods, the Terra d'Otranto appears in several Angevin and Aragonese tax registers. In 1278 the province contained 212 *terre* (habitats), more than any other region in the kingdom of Naples; in 1378 there were 225 *terre*, but in 1447 the number had declined to between 155 and 162, a loss of some 70 habitats (31 percent) in only seventy years.[65]

For the period 1284–1343, the population was approximately 270,000 persons. This estimate is based on the number of *fuochi* (hearths), equivalent to households, and assumes six persons per household.[66] In 1378 there were approximately 72,000 inhabitants (using the coefficient of five persons per household), while an Aragonese census of the "Terra Idronti" in 1447 counted between 51,000 and 60,000 persons.[67] By that time there were only four important cities (Nardò, Lecce, Taranto, and Brindisi), of which only two had more than five hundred *fuochi*, Nardò (540) and Lecce (1,323),[68] compared with 114 habitats of between one and fifty households.[69] While the Terra d'Otranto had over 10 percent of the settlements in the kingdom of Naples, the population comprised only 6 percent of the kingdom's households.[70] Thus, in contrast with other regions of Italy, the population was still dispersed in many small centers and over 70 percent of its inhabitants were villagers.

Documentation for most Salentine dioceses has been lost, but we do have population figures for the diocese of Nardò in 1412. This list, reported to the Holy See by the incoming archbishop in the year that Nardò was elevated to a bishopric, contains the approximate number of inhabitants—one village having as few as one hundred—and their religious affiliation. The towns and villages are called either "Greek" (Orthodox) or "Latin" (Roman-rite Christians); only Nardò itself, with a population of 15,000, is listed as hosting adherents of both rites with an archpriest for each.[71]

Around 1165, Benjamin of Tudela counted five hundred Jewish *fuochi* at Otranto, three hundred at Taranto, and just ten at Brindisi. Few other firm figures are available. In 1294, some 1,300 Jews allegedly converted to Christianity, including 172 at Taranto and 310 at Trani.[72] By the later fifteenth century there were some 50,000 Jews in the kingdom of Naples responsible for paying taxes; many Ashkenazim had come from northern Italy and Provence, others from Catalonia. Nevertheless, at the beginning of the fifteenth century the Jews of the Salento were predominantly Romaniote, their numbers swelled by Balkan immigrants escaping the Ottoman conquests to the east.[73] Only at the end of the century did the composition of the community change appreciably due to Sephardic immigration from Spain, Sicily, and Sardinia after Ferdinand II of Aragon expelled the Jews from his Iberian kingdom in 1492. Around 1500, the number of Jews in southern Italy perhaps totaled about 150,000.[74] In 1541, the 1,500-year-old Jewish communities in the Salento and elsewhere in the kingdom were completely eradicated when their expulsion was ordered by Charles V, the Holy Roman Emperor (and grandson of Ferdinand II), who had become the king of Naples and Sicily.

The depleted Jewish population was partly offset by an influx of Albanians and other Slavic groups in the fifteenth century. Fleeing westward before the Ottomans, these refugees repopulated some abandoned villages and also settled in existing towns, including Lecce by 1452. Their numbers included potters who stimulated new kinds of ceramic production in Lecce, Cutrofiano, Manduria, and possibly Grottaglie.[75] The increased presence of Slavs, coupled with diminishing numbers of Jews, dramatically altered some of the bases of local identity. In this way, the demographic evidence for population change helps support an end point for this book in the early fifteenth century.

Salentine Identity Today

The issue of Salentine identity is very much alive today. Beginning in the 1970s, local folk music—especially that of the Grecìa salentina, the group of villages in which Greek was still spoken—began to be performed outside the region.[76] By the 1990s, many local groups began to play the music of the *pizzica*, a form of tarantella, as an expression of local culture that had its roots in the region in the late Middle Ages. Originally this lively form of musical therapy had helped its victims recover from putative tarantula bites. The musicians played for several days almost without stopping, while the afflicted person—often female, and perhaps suffering less from a tarantula bite than from individualized psychosocial trauma—danced literally until she dropped.[77] Isolated cases of tarantism were documented through the twentieth century and studied in detail beginning in 1959.[78]

Now the *pizzica* has been revived, popularized at concerts and festivals by so-called *neo-* (or *nuovi*) *tarantati*. These performers use the dialect of Lecce and centuries-old *pizzica* rhythms to publicly, and in a sense ritually, foster a communal identity among the participants through music and dance.

Cultural anthropologists have suggested that tarantism's contemporary manifestations constitute a key to Salentine culture.[79] At least one of the motives for the revival of this medieval Salentine practice is "to emphasize the distinctiveness of Salento, its territory and its people"; additional objectives, not unrelated to group identity, are to inspire other artistic forms and increase tourist revenues.[80] The self-representation of the *neo-tarantati*—those who play the "traditional" tunes and those who dance along—now attracts up to half a million tourists annually to the two-week-long "Notte della Taranta" (Night of the Tarantula) cultural festival.[81] Culminating in a grand concert in the Grecìa salentina, the preceding nights feature smaller shows in over a dozen communities. In this way, folk music ostensibly rooted in a medieval medical ritual participates in a local revival that goes beyond music, as there has been a simultaneous promotion and resurgence of the local *griko* dialect.[82] The "exoticism" of the region's culture is being advertised both within Italy and to the rest of Europe, bringing in much-needed euros that also come with a cost.[83]

Jewish identity in the Salento also has a modern history. Numerous Jews passed through displaced-persons camps in the region in the 1940s; some stayed, and one produced evocative murals that recently have been restored.[84] North of the Salento, one of the four medieval synagogues in Trani has been returned to the Jewish community [**148**] and a number of local Christians are rediscovering their Jewish roots. Monthly Sabbath services are held there, and major festivals are celebrated with the accompaniment of kosher foods that have not been seen in Apulia for half a millennium.[85]

Finally, a specifically Salentine identity has been reinforced on the administrative and fiscal level by a project called "Grande Salento," initiated in January 2006 by the presidents of the three provinces that compose the region. The aim is to promote regional infrastructure, agriculture, tourism, and culture and to streamline financial coordination among the constituents. Under this initiative, the University of Lecce was rechristened University of Salento and the former Papola-Casale airport of Brindisi became the brand-new Aeroporto del Salento.[86]

I like to think that these new manifestations of a corporate Salentine identity are a result of a long-standing local sensibility, one that became an increasing reality in the course of the Middle Ages. At the same time, however, it is important to underscore that even a region with a relatively uniform material and visual culture was never isolated from its neighbors; there were no fixed cultural boundaries in a place that witnessed as much conquest and commerce as the Salento. The emic

evidence for names, languages, appearance, and status clearly shows the effects of intercultural contacts, and these become even clearer when additional evidence is introduced to assess local ritual practices. On the whole, however, the evidence for medieval individuals is roughly consistent across the Salento. This is due mainly to the infusion of Greek language and Byzantine culture in the ninth century, which produced a distinctive and enduring cultural substratum for everything that followed. In uncovering the lives of "regular" individuals alongside the elites, we can hope to acquire a better sense not only of this region, but also of others like it—communities in which people recognized the social, cultural, and spiritual value of leaving their marks on the built and natural environment and were, in turn, changed by those visual markers.

Art and Identity: Some Methodological Considerations and Consequences

I believe that it is just as important to know about Donna, represented in word and image in a rock-cut (also called a "crypt") church at Vaste [**Plate 18**], or a Jewish teen named Leah, movingly commemorated on a tombstone in Brindisi [**16**], as it is to learn about Bishop Donadeus, textually present in both a Latin inscription on the exterior of the Castro cathedral [**35**] and a Greek hospital dedication at Andrano [**4**]. These otherwise anonymous people are not "just names." The names themselves have a larger context in a history of naming that is informative about kinship, innovation, and tradition. Moreover, the names rarely exist in isolation; they are usually embedded in shorter or longer devotional, dedicatory, funerary, didactic, or hortatory texts.[87] The choice of language in which to present information to contemporaries and for posterity is meaningful, not least when two languages are combined in a single statement or monument. The combination of images and texts in all three of these examples—Donna dressed with a certain elegance, the menorah and shofars on Leah's rubricated epitaph, the blessing Christ and coat of arms alongside Donadeus's dedication at Castro—tells us even more about these individuals' perceived place in their world and in the world to come. When these data are supplemented by material remains, such as excavated belt fittings, and when analogous instances of display and additional evidence for local rituals of life, death, and commemoration are also considered, a richly textured picture of local medieval life can emerge. A "real-life" regional microhistory extrapolated from visual and material sources is the subject and the object of this book.[88] The analogies between this approach and those of the New Historicists and anthropologists' "thick description" should be clear.[89]

To underscore the local and regional qualities of the people in my study, I have limited my inquiry to monuments and objects that are more or less fixed in time and space. I say "more or less" because Donadeus's inscription was moved from inside the cathedral to the outside, but it is still in the same relative location; Leah's tombstone is now in a museum, not in a cemetery, but there is no doubt that it was produced and displayed in Brindisi; and Donna's tiny image and short accompanying text are still exactly where they were painted in a crypt church in the hinterlands of Vaste over six hundred years ago. Castro, Brindisi, and Vaste were in the Middle Ages a town, city, and village that had more in common with each other than with places of similar size located farther away.

The changes in context, function, and usage that have affected virtually all medieval monuments mean that historians have to work that much harder to gain insight into the past. Interdisciplinarity is essential. Within the Salento, it seems to me a mistake to consider Leah's Hebrew tombstone in isolation from Stratigoules's long epitaph in Greek produced a century later [**32.J**]. And yet scholars have divided these fragments of historical information according to a rigid taxonomy of religion or language, or a conflation of the two. One might argue that Jewish hopes for the afterlife are so different from those of Christians that such a separation is legitimate—an argument that bears examination, given that both tombstones promote the deceased's resurrection albeit in different terms—but even scholars who examine Christian texts in Latin have been unwilling or unable to juxtapose them to Christian examples in Greek.

I argue that looking at Donna's dress, pose, and language of supplication yields greater insights if compared not only to other representations of female supplicants produced between the ninth and fifteenth centuries, but also if supplication patterns are analyzed across the lines of gender, language, or even confession. Early feminists promoted the study of women as a kind of "affirmative action" to redress previous inattention, but many scholars now prefer to consider both genders in tandem.[90] Similarly, I maintain that our understanding of the Orthodox Christians of the medieval Salento can only be enhanced by looking also at the Roman-rite Christians and the Jews.[91] If the Muslims had left any visual traces of their frequent early medieval raids, I would have included them, too.[92]

I practice a certain amount of affirmative action on behalf of the Jewish residents of the Salento because they have been routinely ignored, except by Jewish-studies specialists, whose publications are in turn ignored by art historians. For the Jews I have availed myself of a wider chronological range of visual testimony, from the seventh to the later fifteenth century, and expanded the geographical limits to include central Apulia and a bit of Basilicata; I also introduce relevant texts from Trani, Rome, and Ashkenaz. Perhaps in the future this will not be necessary, but at present it is important to underscore firmly the coexistence of mul-

tiple faiths in the Salento even at the risk of overemphasizing one of them. For the Christians, by contrast, I do not mine documentary sources,[93] and I have included local manuscript texts only sporadically, focusing instead on public texts.[94]

Visual and material evidence indicates that people of different faiths and different languages lived and died in close proximity in the Salento. The proximity of neighbors who were not entirely like oneself must have heightened awareness of similarities as well as differences. Public art therefore could be an agent of separation or unification, mediating onomastic, linguistic, cultural, and social friction and effecting different desired outcomes.[95] Even such a humble visual display as a short graffito could be an effective means of publicly communicating what was important to its author/inciser, and viewing it and adding one's own text alongside created a new social community.

While nearly all of the local Hebrew texts are available in good editions, the Latin ones are insufficiently studied (and untranslated), and only the more impressive of the Greek texts have been published; shorter texts, including graffiti, and their accompanying images have received very limited attention. Moreover, local texts and images often have been published in isolation: witness the many volumes devoted exclusively to rock-cut churches even though the visual and textual culture of the so-called *civiltà rupestre* is no different from that above ground.[96] Jewish tombstones are compared only with one another and not with epitaphs for the dead of other faiths even when they bear a non-Hebrew text. It is critical to move beyond these restrictive taxonomies to a regional perspective, one that incorporates all of the visual material and thereby gives a voice, however faint or distorted, to more members of medieval society. While church doctrine and courtly literature and political intrigue are undeniably of cultural importance, they had less impact on most people's lives, and on the formation of their identities, than did daily exposure to the visual environment and regular encounters in worship spaces, cemeteries, and village streets. While I focus here on a single region in medieval Italy, a multidisciplinary approach to historical visual culture and to questions of individual and group identity has implications well beyond that time and place.

The Database

The basis for this book is the Database (pages 239–336). Readers have already seen references to the Database in the form of boldface numbers and letters within square brackets. Sites are arranged alphabetically, with each city, town, or village followed by its modern Italian province in parentheses and by the name of the specific structure or kind of work within each site; if the work has a specific date, it appears in boldface type. This is followed by measurements or other details.

Capital letters (A, B, C, and so on) identify every relevant inscription or image within that site; each inscription is given in the original language, followed by an English translation (unless otherwise indicated, translations are mine). If both inscriptions and images exist, the former precede the latter. Works of unknown provenance are alphabetized according to their current location. Pictorial graffiti (pg) are listed separately from textual graffiti, which are considered inscriptions. These data are followed by a list of narrative scenes (sc) and identifiable saints (st). With very few exceptions, representations of Christ and the Virgin are not included because they are ubiquitous and uninformative about matters of personal or regional identity. Each entry concludes with a short bibliography that emphasizes recent literature. Notes to the text do not duplicate this bibliography.

The Database is not a compendium of all texts and images in the medieval Salento; it is a collection of published and unpublished art, as defined above, that serves as a starting point for all of my observations about local identity. Some well-known and art-historically significant monuments (such as San Mauro and San Salvatore, outside Gallipoli) are not included because they contain no pictorial or textual representations of contemporary people. And while the Database does include every image (or partial image) known to me of a nonsacred individual datable with reasonable certainty between the ninth and early fifteenth centuries, it does not include every inscription from that period.[97] In addition to texts unavailable to me, I have omitted texts whose published transcriptions seem unreliable and whose original has been lost. The images and texts that *are* included all yield insight into individual or corporate identity in the medieval Salento. Taken together, these disparate data provide a picture of local life that complements and expands upon previous studies based exclusively on documentary sources, archaeological finds, or a single artistic medium.

Names

Ever since Adam named the animals in Genesis 2:20, humans have given things—and people—names. Names, and the kinship relationships expressed through them, are among the most essential and universal components of identity. Personal names and surnames connect people with ancestors, places of origin, social and religious communities, and larger cultural groups, and thus contribute to the formation of both individual and communal identity. They have a taxonomic function, suggesting things—rightly or wrongly—about their bearer's religious, social, or cultural affiliation. Some names confer power by linking an individual, even superficially, with an important family (e.g., the Kennedys, the Rothschilds). An infamous name can compel shame or fear: how many boys now are named Adolf?[1] While few people believe that *nomen est omen*, we still draw conclusions from people's names.[2]

Naming is a fundamental way of imposing control over one's surroundings. In the past two decades, many evangelical Christians have followed a "prosperity theology" of "name it and claim it."[3] Some medieval Jews and Christians could harness divine power by invoking supernatural names known to only a few. In traditional families, assigning someone a theophoric or festal or saint's name is still thought to afford special access to a powerful intercessor: the patron saint or guardian angel surely will protect his or her namesake. By extension, communities named after a saint had a privileged relationship with heavenly intercessors beyond what the great majority of places could claim.

The study of names has become fashionable in recent decades, resulting in prosopographical catalogs, anthroponymic colloquiums, and onomastic or prosopographic journals in several countries. Few of these, however, look beyond documentary sources at names made visible inside churches or on humble tombstones, and even fewer consider a regional name stock across different language groups. These public visual sources have been ignored or underutilized in anthroponymic studies. In this chapter, I look at people, places, and power—Jewish and

Christian personal names, hagiotoponyms and other place names, divine and demonic names—in the medieval Salento.

Personal Names

Soon after birth, children are given a personal first name that, in most cases, stays with them throughout their lives. By the Middle Ages, when infant baptism was the rule, Christian children received their names at a baptismal ceremony; his or her very existence, theologically and culturally, was linked with having a name.[4] Jewish boys got their names at circumcision, Jewish girls on the first Sabbath after their birth or at their benediction a month later.[5] Personal names are perpetuated after death by being given to a member of a new generation, and the practice in southern Italy, Greece, and many other places today is to give the paternal grandfather's or grandmother's name to the firstborn son or daughter and the maternal grandfather's or grandmother's name to the next child.[6] Baptismal names might be altered during one's lifetime by entering a monastery and acquiring a new name; in the Byzantine sphere this name commonly began with the same initial as the former name.[7] In addition, given names might be amended or effaced by the use of nicknames, and in the later Middle Ages these nicknames often became, or were supplemented by, a surname. Our sources often reveal the personal and sometimes the family names of craftsmen and patrons, of clerics and laypeople who indicated their presence and some important elements of their identity in painted or incised texts. Names of the deceased are recorded by family or associates whose identity was somehow connected to theirs, and who therefore might indicate kinship, religion, age, or other components of identity as part of their commemoration. The most important part of being a recognized individual was, and remains, having a name, and ethnographic studies reveal that even in modern times, a Salentine baby is in a sense not really born until his or her name has been officially recorded.[8]

Jewish Names

Jews, and others, believed that there was an intimate connection between one's name and one's essence. The Hebrew word for soul, *neshama*, has as its stem the word *shem*, which means name.[9] Midrashic literature contains many references to the power of names, and urges discretion in selecting a good name for a child inasmuch as the name itself might be an influence for good or for evil.[10] According to the Talmud, it was meritorious to keep one's Jewish name,[11] and several midrashim noted that one of the reasons the Hebrews merited liberation from

Egypt—and thus communal identity as Jews—was that they kept their Jewish names.[12] Hebrew names were integral to their identity as Jews; at the same time, the Talmud recognized that many postexilic Jews had adopted the non-Jewish names found in their new environments.[13] Acts 18:24 describes a learned Jew named Apollo who confessed Christ, undisturbed by any pagan religious connotations, and numerous epitaphs reveal that theophoric pagan names were common in antiquity.[14] Apparently this continued into the Middle Ages; a thirteenth-century Ashkenazic treatise argues that Jews should not be taking the names of heathen idols or saints.[15] Yet this was possible because male Jews had two names: a sacred name, the *shem ha-kodesh*, used in religious contexts and for such important life-cycle events as marriage and death, and a secular name, the *kinnui*, which could be anything at all but was often a vernacular translation of, or a name similar in sound to, the sacred name.[16] A Hebrew name was required for males because it was the language of the celestial court; the angels, messengers of God, were monolingual, and the angel of death demanded one's proper (Hebrew) name.[17]

The whole range of Jewish onomastic possibilities can be observed in the medieval Salento. Material evidence for local Jewish names comes exclusively from funerary inscriptions, which always record the sacred name but, unfortunately, do not postdate the tenth century, and a small number of carved synagogue texts. In order to expand this paltry data set, I also consider documentary and literary evidence from liturgical poetry, a family chronicle, letters, and a twelfth-century travel account.[18] In addition, I include evidence from Bari and Trani, north of the Salento (but do not venture farther north to Siponto or inland to Venosa), and move back into the seventh/eighth century and forward into the fifteenth. Nevertheless, the sample of Jewish names remains so small that nothing can be said statistically about onomastic preferences; for this reason I have not noted how many individuals have a particular given name.

From the early period, seventh/eighth to twelfth century, special mention must be made of a Jewish "dynasty" from Oria, famous—if only legendarily—for successfully exempting their community from the conversion orders issued by the Byzantine emperors Basil I and Romanos I Lekapenos. In 1054, a genealogical chronicle (*Megillat Yuhasin*, "Scroll of Genealogy," better known as *Megillat Ahima'az* or the *Chronicle of Ahima'az*) was completed by a family member who had settled in Capua, outside the Salento.[19] Among the names associated with early medieval Oria are Ahima'az, author of the work, and his forebears Amittai, Baruch [cf. **18, 50**], Eleazar, Hassadiah, Papoleon, Shephatiah (who allegedly debated with Basil I in Constantinople),[20] Abdiel, Hananel, Shemu'el (Samuel) [cf. **13, 123**], and Paltiel. Theophoric names ending in –*el*, referring to God, were especially popular in Italy.[21] Other names from Oria include Ahima'az's distant relative Shabbetai Donnolo [cf. **125, 131**], a tenth-century philosopher, astrologer, physician, and

acquaintance of Saint Neilos of Rossano,[22] as well as Abraham, Yehoshaphat, and Hodijah. The flourishing Oria Jewish community disappears from the historical record in the tenth century, probably due to the city's destruction during Arab raids in 925, after which the ancestors of Ahima'az scattered to Amalfi, Benevento, and Capua.[23]

Additional Hebrew male names from the early period include Aaron, Amnon,[24] Azariah, Benjamin, Caleb,[25] Chiyya, David [**11, 121**], Elijah [**10, 12**], Ephraim, Evyatar, Ezekiel [**123**], Ezra, Isaiah, Israel, Jacob [**126**], Jeremiah, Joel, Jonah [**18**], Joseph [**13, 136**], Judah, Levi, Machir, Madai [**14**], Mali (probably Emanuel),[26] Meir, Meiuchas, Menachem, Menashe [**11**], Mordechai, Moses [**9, 10, 12, 14**], Natan, Nuriel, Ribai [**17**], Shemaria, Sheshna, Solomon, Uriel, Yafeh Mazal [**16**], Zadok, and the poets Zebadiah and Menachem Corizzi.[27] Greek and Latin names held by male Jews include Anatolius [**124**], Basil [**134**], Justus [**124**], Daudatus, Domnolus [**125**], Julius [**81**], Leon [**121, 131**], Silanus [**123**], Tophilo (Theophilos), Theophylact, and Ulsherago.[28] Many of the Hebrew names have Greek equivalents: Jehoshaphat (or Shephatiah) corresponds to Theokritos and Shemaria to Theophylact.[29]

For the late Middle Ages, from the thirteenth to the first half of the fifteenth century, documents, diatribes, poetic acrostics, and epitaphs (only from Trani) show that many of the earlier Hebrew names were still popular. Additional ones include Adoniyah [**149**] (meaning "Lord"), Isaac, Menashe, Snya (?), Moses de Meli (a surname), and Tanhum [**150**].[30] These are supplemented by such new assimilated names as Astruc, Gaudinus, James, Rubi(n), Sabatino Russo (the first name comes from "shabbat"), Sabinus, Sanban, Ubene, and even one Cristio Maumet, documented in Lecce in 1447.[31] It is interesting to note that it was a lapsed Jew with the secular name Manoforte (or Manuforte), derived from a nickname, who persuaded King Charles I of Anjou to confiscate the Talmud and Jewish liturgical books in 1270.[32]

In sum, Italy had a stock of Hebrew names that were not common elsewhere: the aforementioned –*el* names, plus Ahima'az, Amnon, Yehoshaphat, Natan, Shephatiah, Zadok. The latter are all names of early prophets or men associated with the Davidic line.[33] Amnon, for instance, was David's oldest son and apparent heir—until he raped his half sister Tamar and was killed by her brother Absalom. Unlike the Ashkenazim, who originated in Italy, southern Italian Jews did not hesitate to use names that had negative connotations elsewhere.

Because Jewish women did not require a *shem ha-kodesh* they had unlimited onomastic possibilities. Early female names in the region are Hebrew or Greek in origin: Cassia, Erpidia [**132**], Esther [**133**], Hannah [**81**], Leah [**16**], Naomi (?), Susanna, Yocheved [**17**], and Zipporah [**17**]; later female names include Stella and Lisia.[34] The paucity of later names is due in part to the fact that Jewish epitaphs

disappear after the tenth century and women are poorly represented in official documents. Even in the lengthy and ostensibly genealogical *Chronicle of Ahima'az*, only three female names appear: Cassia (the name of two different women, one of whom was known for her beauty, disposition, and piety), Esther, and Albavera of Capua, the latter well outside our geographical range. All three are recorded as the wives of more important males. Besides Cassia, only once does a Jewish woman—or any woman—in the Salento receive a title, *domina*, that supplements the simplest assertion of filial or spousal kinship [**81**]. The lone dated Jewish epitaph in the region, that of Leah at Brindisi, was erected by her grieving father, Yafeh Mazal, who himself boasts an augurial name meaning "good fortune" equivalent to the Greek Eutychios [**16**].[35]

Jewish sacred names supplement the personal name with that of the father or mother (the patronymic A son of B or matronymic C daughter of D), although this is not always attested epigraphically or in documentary sources. At least in some families, there was a tendency to reuse particular Hebrew names over time. In the ninth-to-eleventh-century "family tree" of Ahima'az, most male names, including the author's, appear more than once. In some cases the same names repeat in alternate generations, with the oldest son named after his paternal grandfather,[36] but this is not consistent. On at least one tombstone, a son has the same Latin name as his father [**125**]. This also occurs with Hebrew names: a ninth-century or later Aramaic epitaph from Taranto identifies the tomb of Joseph son of Joseph [**136**], and in the 1490s an Elijah son of Elijah is attested at Alessano and Gallipoli.[37] Yet there are also many cases of relatives having names of different linguistic origin. One Latin-named father (Justus) gave his son a Greek name (Anatolius) [**124**]; another, Silanus—whose own brother had the Hebrew name Ezekiel—named his son Samuel [**123**]. The family relationships attested in the sources are wife (*ayshet*), son (*filius, ben, bar*), daughter (*filia, bat*), and uncle/father's brother (*barbanus, ahi avi*).[38]

There is some evidence for Jewish surnames that are not simple patronymics. An early epitaph from Taranto recalls the unnamed wife of Leon son of David *min Meli*, probably a toponymic surname indicating his or her origin on the island of Melos [**121**].[39] Moses de Meli, of Copertino, was perhaps of the same origin as David; he had an exchange of letters in 1392 with Sabatino Russo, a fellow Jewish merchant in Lecce with a more generic surname that is now the third most common family name in Italy.[40] An unusual case of a profession used as a surname is the tenth-century[41] Otrantine poet "Menachem named Corizzi," identified more fully in another of his acrostics as "Menachem the humble, son of rabbi Mordechai, the administrator, who is strong, Amen, Corizzi, of the community of Otranto, *mohel*." In addition to being one of the earliest Italian authors of Hebrew liturgical poetry, Menachem was apparently a (the?) *mohel* in Otranto,

charged with circumcisions;[42] one of his professional identities became a surname. Shabbetai Donnolo's surname, the Greek Δόμνουλος, is a diminutive of Latin *dominus*; "little master" would be an appropriate nickname for a physician.[43] Yet unlike the case with Christian names, where "Rossi," from "red," is today the most common Italian surname,[44] nicknames rarely became surnames in Jewish communities.

Jewish surnames followed the tendency of personal names in having a vernacular equivalent. Santoro de Iosep Sacerdote[45] was surely the son of the erstwhile Joseph ha-Cohen or ha-Levi, whose distant ancestors were of the priestly class. Those with old-fashioned Hebrew first names, like Elya Nicolai of Lecce,[46] sometimes added a more Christian-sounding one. From the beginning, the Jewish civic name had a Greek, Latin, or (later) Italian equivalent: either a simple translation (Baruch, "blessing," became Benedict; Hayyim, "life," became Vito); a vague phonetic similarity (Pinchas–Felice); or a logical or homiletic connection (Judah, whose tribal sign in Gen. 49:9 was the lion, became Leon). These equivalents became more or less fixed by the early fourteenth century,[47] and Christians in the late medieval Salento probably knew their Jewish neighbors only by their familiar-sounding civic names.

Christian Names, Ninth to Eleventh Centuries

When we turn to medieval Christians, a much larger stock of names can be recovered from visual sources, making it unnecessary (and impractical) to consider the kinds of texts upon which we relied to enrich the corpus of Jewish names. My findings differ somewhat from those of André Jacob, who examined Salentine onomastics by drawing upon a broader range of material—inscriptions, manuscript colophons, diptychs of the dead, acts, family annals, charters, and the like—but focused exclusively on Greek names in the southern part of the Salento.[48] Jean-Marie Martin and Joanna Drell addressed more of southern Italy, not just the Terra d'Otranto, but their sources were limited to notarial documents.[49] My Database is at once larger and smaller than these earlier noteworthy efforts: it spans the whole Salento but is limited to names that were publicly visible in the form of painted or carved inscriptions and graffiti, regardless of length or content. I have divided the evidence into two broad periods: ninth to eleventh century and twelfth to fourteenth century. In most cases a specific year is not provided by the primary source and I rely on stylistic or paleographic evidence, whether of the names themselves or of the monuments with which they are associated, to assign a general date. It can be assumed that all of these names belonged to Christians even though not all are "typical" Christian names (for example, Aprilios).[50] My lists omit the names of rulers who were not based in the Salento (e.g., Charles,

king of Jerusalem and Sicily [**1**]), but they do include clergy whose presence in the region may have been limited. Only names that can be restored with a high probability of accuracy are included.

Male names in the earlier period include Akindynos [**33.D**], Andrew [**80.A**], Aprilios [**32.D, F**], Arsakes (of Armenian origin) [**159**], Blasios [**32.K**], Constantine [**32.I, 101**], Demetrios [**33.B**], Eustathios [**32.D**], George [**33.A**], John [**25, 33.F, 33.I,** possibly **115**], John Pankitzes [**32.I**], Leo [**5, 32.A, 32.E**], Leon(?) Kephalas [**33.E**], Magelpotus [**84**], Michael [**33.G**], Michael the African [**154.A**], Michael Korkouas [**154.A**], Nikodemos [**114.A**], Porphyrios [**72.A**], Stratigoules [**32.J**], Theodosius [**83**], Theophylact [**32.A**], and Vincent [**32.G, 115**]. The few female names recorded between the ninth and eleventh centuries are Anastasia [**32.H**], Anna [**32.B**], Chrysolea [**32.A**], Maria [**33.J**], T(h)ecla [**25**], and possibly Veneria [**146.A**].[51]

Among Christians who left a visible record of piety, presence, or death there are names that are Greek, Latin, Armenian, and Germanic in origin, but also many universal Christian names. John is the most commonly attested name in inscriptions, epitaphs, and graffiti between the ninth and eleventh centuries, and this accords with the "supremacy of John" noted by scholars who rely primarily on written texts.[52] However, the other popular male names—Leo, Michael, and Constantine—differ slightly from those other results, in which Nicholas was second to John in popularity, followed by Leo and Constantine.[53] What factors might explain the local preference for Michael rather than Nicholas? While the cult of Nicholas was diffused in southern Italy under Byzantine domination long before the Norman translation of his remains to Bari in 1087,[54] it appears that the personal name followed more slowly, at least among the social classes documented in epitaphs and wall paintings.[55] Michael had been enormously popular among the Lombards (or Longobards) as their regional patron saint, with his cult site at Montesantangelo in northern Apulia, although his name was not especially common.[56] However, Michael had a much longer history than Nicholas of being depicted in Byzantine wall paintings, and he was included in prayers as a miracle worker and intercessor at the Last Judgment.[57] It is probably his long-standing association with healing and battling demonic forces that accounts for Michael's earlier popularity as an augurial name.[58] Nevertheless, in the succeeding centuries Nicholas would become one of the two most common South Italian male names and one of its most important iconographic subjects.[59]

A few surnames are used in the Byzantine and early Norman era, for men only:[60] Leo Kephalas [**33.E**], John Pankitzes [**32.I**], Michael Korkouas [**154.A**]. These early surnames belong to residents of the southernmost part of the region who enjoyed an elevated social level as bishop,[61] priest, and church builder. The Kephalas family produced the emperor Basil I and were benefactors of Mount

Athos.[62] The Korkouas were notaries in Taranto whose relatives held high office in Constantinople.[63] The mere fact of having a surname in the eleventh century underscores the individual's high social status, as such names begin to appear in significant numbers only in the thirteenth century.[64]

Two of the early named individuals reveal information about their geographic origins, albeit not in the form of a surname. Michael "the African" must have traced his roots to North Africa [**154.A**];[65] Michael Korkouas "of Corone" hailed from Messenia in the Peloponnese. Additional inhabitants of the Peloponnese were transferred to Byzantine Longobardia under Leo VI,[66] and connections between southern Greece and southern Italy are also evidenced by imported ceramics.[67]

Christian Names, Twelfth to Fourteenth Centuries

A great increase in the variety of men's first names and the quantity of surnames occurs in the twelfth to fourteenth centuries. Not only does the name stock more than triple, but the number of attestations of many popular names multiplies noticeably: Agnus [**58.B**], Antony [**143.E, 157.A**], Asotes (of Armenian origin) [**111**], Azzolinus de Nestore [**78.A**], Bailardus [**21.A, 78.C**], Bartholomew [**22.F**], Basil [**104, 153.A**], Bastianus (Sebastian) [**94.C**], Benedict [**109.A, 143.B**], Bisardus [**78.C**], Blasius [**94.E**], Bosos [**44.A**], Calogerius [**92.A**], Ceccarius [**66.C**], Constantine [**158**], Cosmas [**144**], Cyriakus [**4**], Cyril [**61.A**], Daniel [**54, 109.A**], Demetrios [**43.A**], Dionysos [**143.E**], Dominic [**51**], Dominic de Juliano [**39**], Donadeus [**4, 35**], Dymenos [**107**], Espeditos [**94.M**], Formosus [**57**], Gaycierius [**28.T**], George [**4, 24.B, 37, 55, 110, 157.G**], George Longo [**4**], Giraldus [**140.D, 144**], Godfredus [**57**], Gosfridus [**78.C**], Grisius [**69.A**], Guarino Montefusco [**48**], Guidonis [**21.C**], Hugh [**2**], Iacobinus [**27.A**], Iaquintus [**94.B, 116.A–B**], Ioannikios [**144**], James [**110**], James Pipinos [**80.B**], John [**1, 4** (x2)**, 36, 38, 65.A, 66.I, 76.A, 87.A, 93.B, 94.K, 96, 114.B, 141, 143.A, 143.E**], John de Andrea [**26.A**], John Crispulus [**76.A**], Jonathan [**86.C–D, F–G**], Laurence [**157.G**], Laurence Vetanus [**79.A**], Leo [**66.F, 73.B, 88.A, 94.J**], Leonard [**91.A**], Luke [**144**], Magerius [**93.A**], Magi—os [**49**], Maraldus [**142.A**], Mari [**31**], Mark [**66.A**], Matthew [**22.F, 79.C**], Ma(tthias?) [**95**], Michael [**94.K**], N— Melitinos [**1**], Nicholas [**1, 43.A, 45.A, 73.B, 79.C, 87.A, 94.A, 108.A, 161**], Nicholas Castaldo [**26.C**], Nicholas de Marra [**28.W**], Nicholas Ferriaci [**156.A**], Nicholas Markiantos [**36**], Nicholas Palia [**23.B**], Pantoleon/Pantaleon [**49, 86.C–D, 105**], Paul [**30**], Peregrinus/Pellegrinus [**36, 114.F**],[68] Peter [**21.C, 66.H, 94.I, 117.A**], Peter Stea [**94.F**], Petroius [**140.C**], Pigonatios [**45.A**], Raimondo del Balzo [**48**], Radelchis [**66.D**], Richard [**144**], Rinaldus [**28.A**], Roger [**21.B** (a ruler)**, 38**], Roger Moraville [**82**], Rosemannus [**140.B**], Sarulus [**75.A, 76.C**], Senatoros

[**64.A**], Souré [**43.A**], Stephen [**143.D, 155.A**], Symeon [**114.C–D**], Tancred [**58.A–B**], Taphouros [**114.C**], Theodore [**22.E, 46**], Ursus [**66.H**], and Vitalius Ferriaci [**156.A**].

Compared to the earlier (Byzantine) period, almost three times as many women's names from the twelfth to fourteenth centuries are preserved: Donna [**Plate 18**], Doulitzia [**157.A**], Eulalia [**138.A**], Gemma [**4**], Ioanna (or Jeanne) [**157.A**], Isabella [**48**], Kalia [**157.C**], Marciana [**74.A**], Margaret [**157.I**], Maria [**137, 157.A**], Rogaie [**82**], and Theokari [**107**]. There are Christian (and also Jewish) examples of men providing a tombstone for a dead wife and omitting her name while including their own [**26.C, 121**]; as in the earlier period, elision of the wife's name is very frequent in family supplications.

There are about six times more Christian names, both male and female, for the later medieval period than for the earlier centuries because of the larger number of later monuments and their greater likelihood of preservation. The average number of inscriptions per monument is slightly larger in the early period; there are four sites with a large number of texts that signal multiple patrons, multiple identities inscribed within a single cult space.[69] All of these inscriptions are in Greek, a fact that merits discussion in the following chapter. In the later period, more sites attracted multiple patrons or visitors.[70] A record of multiple individuals at a single site in the ninth to eleventh centuries gives way in the twelfth to fourteenth centuries to fewer individuals, or just one, attested by name in a given monument or site. Even if the specific numbers should prove to be skewed, it seems fair to say that in all periods the percentage of inscriptions that contain a personal name is very high. In at least three cases out of four in my data set, including a name or names was a motive—perhaps the most important one—for composing an inscription or graffito.

The most popular given names for men in the twelfth- to fourteenth-century inscriptions and graffiti are John (attested 18 times), Nicholas (14 or 15), George (7), Peter (5), Leo (4), and Pantaleon (3). John remains the most popular name, catching up in the visual sources to the "supremacy" he enjoyed earlier in all sources. Nicholas has also risen in the standings, as prefigured in the documentary sources, while Leo has declined, and Michael and Constantine have dropped out of onomastic competition. George has a sudden surge, as does Peter, and Stephen and Pantaleon to a lesser degree.[71] Using a larger range of written sources for a smaller geographical area, Jacob found that John and Nicholas were the most popular names in the twelfth and thirteenth centuries,[72] followed by George, Leo, and Peter.[73] He identified many more names in fourteenth- and early fifteenth-century sources; these continue to show a strong regional preference for John and Nicholas, followed now by Peter, Stephen, and George, with Leo far behind. Ecclesiastical tax records indicate that Nicholas was the name most commonly held by clerics

in Apulia, Lucania (Basilicata), and Calabria in the early fourteenth century, followed by John and Peter,[74] but the visual sources identify only one priest named Nicholas [**108.A**].

The later medieval period witnessed the introduction of many names not found in the earlier visual sources. Some of these are Germanic, Norman, or Breton names previously unknown in the region (Bailardus, Bosus, Formosus, Giraldus, Godfredus, Gosfridus, Guidonis, Hugh, Leonard, Magerius, Maraldus, Pellegrinus, Radelchis, Richard, Rinaldus, Roger, Sarulus, Ursus).[75] Petrus (Peter) also arrives, probably with the Normans, but his popularity is attested more in written sources and hagiotoponyms than in dedications and epitaphs.[76] In the fourteenth century, a new stock of personal names was introduced throughout Europe in conjunction with the spread of the mendicant orders. These new names permeate the written sources before they appear in the visual record; Francis, for example, is not found in public inscriptions in the Salento before 1432 [**47.D**].[77] Antony is inscribed in a graffito at Taranto [**143.E**] and in the 1379/80 apse inscription at Vaste [**157.A**], but there is disagreement about whether the new popularity of this name is connected with Antony of Padua, canonized in 1232, or the much older Antony Abbot.[78] In 1372/73 we find a bishop named Cyriakus [**4**], the Greek equivalent of Dominic, whose name began to penetrate the Salento along with its representatives in the Dominican order.[79] The female equivalents of these new names, Kyriake and Domenica, are lacking in the local visual sources but well attested in textual documentation.

In the few female names known from the visual record, Maria was in use by the eleventh century, as it was in other Byzantine areas, although it would not become widespread in Europe until the thirteenth century.[80] For the twelfth century, Jacob found that Maria was matched by Anna as a common female name, but Anna does not survive at all in our late evidentiary corpus. Diminutives are popular among the Greek names (Doulitzia, Kalia, Eulalia).[81] As with male names, Latinate female names are introduced by the twelfth century (Rogaie) and begin to dominate in the fourteenth (Margaret, Isabella, Donna). In the family dedication at Vaste, the father, Antony, and one of the daughters, Ioanna (or Jeanne), have names that could not predate the fourteenth century [**157.A**]. At the beginning of the fifteenth century there is still a great variety of personal names in the Salento for both men and women; the different strata of names (Lombard, Greek, Latin) were not amalgamated into a smaller, more uniform stock as was the case elsewhere in Europe by the thirteenth century.[82]

Even families that were open to innovative personal names did not necessarily adopt a surname.[83] Jacob found that approximately one-third of the twelfth- and early thirteenth-century names in his textual sources were supplemented by a last name, but the proportion is lower in the visual sources, under 25 percent for the

whole period of the twelfth through fourteenth centuries. Three-quarters of these surnames are found in inscriptions or graffiti written in Latin; only a handful are in Greek. This significant disparity suggests that the authors of Greek public texts were less inclined to adopt last names even when their Latin-speaking neighbors did so and even though some upper-class Greek speakers had done so in preceding centuries.

There are four distinct types of surnames: anthroponymic, in which a first name is used as a last name; nicknames, often a given name in origin; geographical; and names related to professions or crafts. Of some 1,800 surnames culled from thirteenth- and fourteenth-century documentary sources, Jean-Marie Martin found that over 50 percent were anthroponymic, 30 percent were nicknames, 15 percent were geographical, and only a small percentage were related to profession.[84] Of our nineteen male surnames, the geographical type is better represented than in Martin's sample, with toponymic and anthroponymic surnames about equally present, but there are far fewer nicknames and professional attributes. Anthroponymic surnames include De Nestore [**78.A**], De Juliano [**39**], and probably Crispulus [**76.A**]. Local toponyms in our list include Leo of Nucilia (Nociglia) [**66.F**], Paul of Sogliano [**30**], and the archpriest of Latiano, George "de Horia," presumably the nearby city of Oria [**55**]. More exotic in origin are Del Balzo (des Baux) [**48**], Moraville [**82**], De Marra [**28.W**],[85] and Melitinos [**1**]. The toponym "de Morciano" accompanies a supplicant at Santa Maria di Cerrate [**114.F**], possibly from northern Italy rather than the southern Salento.[86] Nicholas Palia identifies himself as coming from Giovinazzo, north of Bari [**23.B**], but his surname is unrelated to it. Longo seems to be the only local surname derived from a nickname [**4**], while Castaldo (from the Lombard *gastaldus*, representative of the king) [**26.C**] and Ferriaci (from the Latin for iron, a smith) [**156.A**] appear to be professional names. Markiantos [**36**] and Palia are both of unknown derivation.

In the most recent study of contemporary Italian surnames, roughly the same categories appear: augurial names culled from medieval personal names in Italian; names based on historical and literary tradition that became popular in the fifteenth century; nicknames ultimately derived from Latin personal names but used in medieval Italian (*volgare*) as ironic comments on an individual's character or physiognomy; anthroponymic surnames culled from the Latin, German, Greek, and Hebrew substrata; and epithetic surnames, including patronymics or matronymics, ethnic and toponymic names, and professional names.[87] In the medieval Terra d'Otranto the epithetic name was the most common; many of the names that we might consider anthroponyms are patronymic in origin, using a first name as a second name. In southern Italy in general, the epithetic surname is still the most common, especially the patronymic plural.[88] For example, De

Giorgi or Giorgio, D'Andria, and De Luca are among the top ten surnames in the modern provinces of Lecce and Taranto, and Iacobini is still attested in Lecce and Taranto.[89] Among the twenty most common surnames in all of Italy, with particular frequency in the cities of Lecce, Brindisi, and Taranto, is the toponym "Greco,"[90] reflecting the Byzantine demographics of a millennium ago. Longo, the surname of a fourteenth-century hospital builder in Andrano [4], is still popular in both Lecce and Brindisi,[91] and even the decreasingly popular personal name Leo is still present as a common surname, especially in Taranto.[92] Even today, in comparison with the rest of Italy the province of Apulia is characterized by exceptional diversity and local specificity in its surnames.[93]

We have already noted a few disparities in onomastic preference based on the types of sources consulted, so it is worth considering whether different social levels appear in the epigraphic record versus the documentary records. If, as has been argued, the intellectual milieu—represented by commissioners and signers of books, acts, and charters—is not inclined toward innovation in the domain of names,[94] the same seems true for nonelites: with few opportunities to "make a name" for themselves and their relatives, they preferred to maintain tradition, perpetuating family identification by repeating names from previous generations. In his work on late thirteenth- to mid-fourteenth-century surnames in Bari, Martin identified laymen as most likely to adopt a surname, followed by clergy and then women[95] (female surnames are nonexistent in the Salento). I discuss in other chapters the ways in which women were present in the visual culture of the Salento, but names were not the primary vehicle.

Kinship

Kinship information is preserved in about half of the early visual sources (ninth to eleventh century) that contain fully or partly preserved names of Christians. Most common are references to a named man's wife and child(ren), but in only three of those cases is the wife's name given [**32.A, 32.H, 146.A**]. In an inscription from Brindisi, John and Thecla share equal billing as parents of their children [**25**]. In addition to children mentioned in connection with a wife, there are two references to children alone [**32.I, 33.A**], one "very dear child" [**32.J**], and a single child [**159**]; unlike contemporary Jewish epitaphs, no early medieval Christian text singles out a daughter. In one exceptional case, a named mother is associated with her unnamed child without any reference to a husband or father [**32.B**]. In this small sampling of ninth- to eleventh-century sources, which come from only a handful of sites, wives are recalled less often than children; twice as many wives

as children are noted in the twelfth- to fourteenth-century texts. These numbers are probably too small to extrapolate larger social patterns.

In a long eleventh-century epitaph at Carpignano, the father of the deceased gives the name of his "very dear" child, Stratigoules (a diminutive of profession), but omits the name of his wife while drawing attention to his own now-illegible name [**32.J**]. This is the only case in the Christian Salento in which an emotional relationship is made explicit: repeated expressions of love and grief supplement a list of all the relatives, friends, and slaves who will miss the dead boy. In other texts, relatively unemotional exhortations to God or the Virgin or a saint to remember the speaker or his or her loved one are supplemented by pleas to passersby to pray for the "speaker" or for the commemorated deceased [**156.A**].[96] All the attempts to solicit participation in the named individuals' salvation come from the twelfth- to fourteenth-century visual evidence.

A greater range of family relationships is documented in the later visual material. There are references to parents [**1.A, 35**], a father and mother [**153.A**], and a brother [**94.A**]. Men are often identified as the son of a named father, and one identifies himself in relation to his grandfather [**94.K**]. The male line is by far the best-documented kinship category. One named man shares a tomb with a widow, but their relationship to each other and to the author of the inscription is not specified [**107**]. A wife is often cited but not usually named (in [**1.A**], her name is now lost). In connection with a husband/father, one unnamed wife and son merit collective mention [**24.B**], a wife and unspecified child(ren) three [**43.A, 44, 143.B**], and motherless children once [**33.A**]. The only time a wife and children are fully identified by relationship and name is in the 1379/80 apse at Vaste, where the figures' proportions also reinforce the family relationships [**157.A**].[97] The depiction of family groups is very rare, but the Greek-language patrons or the artist at Vaste may have been inspired to depict the whole family based on precedents in large Roman-rite churches, such as Santa Maria del Casale outside Brindisi, where numerous couples and family groups are shown adoring the Virgin and Child [**28.D, G, I, Q, R, U; Plates 4, 5**]. Another man and woman, presumably a married couple, kneel and stand to the left of an unusual scene, in Massafra, of Christ being led to school by his mother[98] [**63.A; Plate 12**]. At the crypt church of the archangel Michael at Li Monaci, an embracing couple depicted on the ceiling [**43.C; Plate 9**] has been identified as the "soldier Souré and his wife" named in the apse dedicatory inscription [**43.A**], but this is very unlikely: the couple is far from the dedicatory text and cannot be seen by someone reading it; there are no precedents for depicting patrons in anything but a devotional or supplicating posture; and patronal images are seldom found on church ceilings.[99] The paucity of visual examples underscores that it was mainly

through words, not images, that familial and emotional relationships could best be expressed.

Visualizing Names

Names often have a visual aspect that draws the reader's attention. Names in all kinds of texts are often divided so that they occupy more visual space, usually two lines; examples include Leon/tos (Leo) and his wife Chryso/lea in the 959 inscription at Carpignano [**32.A**], Domin/icus de Juliano at Ceglie [**39**], and Ni/cholas son of Vitalius Fe/rriaci at Vaste [**156**]. In Hebrew texts, the "son of" or "daughter of" that is almost always part of the name marks the line division. In all three local languages, a name may also be emphasized by its placement at the beginning or end of a line of text (Souré [**43.A**], Nicholas de Marra [**28.W**]). In Leah's epitaph, her father's name is emphasized this way while hers is centered, a visually less prominent position [**16.A**]. Nicholas of Sternatia's name occupies both the end and the beginning of lines in his dedicatory inscription [**108.A**]. Multiple ligatures also draw the eye to those words in a block of text: in the dedicatory inscription at San Vito dei Normanni, the principal patron's and painters' names are condensed with triple ligatures—double ligatures are far more common—and thus seem darker and more prominent against the white background than do the other names [**109.A**]. John of Ugento, who built a church at Acquarica del Capo, has his name perfectly centered, both vertically and horizontally, in the dedicatory inscription at the center of the west wall [**1**]; Antony in the Vaste apse is centered horizontally [**157.A**], and the surname Moraville appears on Roger's column in the exact center, the fourth line of a seven-line text [**82**]. Anna is centralized in the Latin epitaph at Oria but Hannah is not in the Hebrew one [**81**].

Finally, it is very common to inscribe a name so that it abuts a sacred figure. This is the case for both Leon/tos and Chryso/lea at Carpignano, where half of each name nearly touches the throne of Christ [**32.A**]. At the other end of the same crypt, the dead Stratigoules's name comes close to the right arm of Saint Christine, a proximity not vouchsafed his father's name in a different quadrant of the inscription [**32.J**]; perhaps the proximity of names and saints was understood to benefit of the deceased. This text also emphasizes certain lines by means of a change in color of both background and script. Spotlighted in white letters are "with Nicholas the wise," plus six more lines on the viewer's left; to the right of the standing Saint Christine is "saints seen here, the all-" ("-immaculate Lady Theotokos and Nicholas of Myra" are on the next line). The striking color change draws the viewer's attention to Nicholas and the Virgin, who are also painted in

the soffit of the arcosolium and therefore present both visually and verbally at the tomb of Stratigoules. While such coloristic emphasis is atypical, it is clear that naming was not exclusively a verbal phenomenon; identities also could be announced and reinforced by visual means.[100]

Place Names

Jewish names have left no traces in local toponymics apart from references to streets or neighborhoods in which Jews formerly lived.[101] These often date to the fifteenth century or later, when Jews were required to live in special enclaves at the edges of towns rather than throughout the habitat, as was generally the case in the Middle Ages.[102] Therefore, the vast majority of information about medieval Jewish onomastics concerns personal names. For Christians, however, personal names and place names overlapped because both toponyms and given names were often the names of saints. Given the importance of names in general, the tenacity of toponyms, and the potential for places to forge communal identity, it is worth considering the entire region and not only sites in the Database.

The Italic inhabitants of what would become the Salento—Messapians, Bruttians, Sallentines—gave descriptive or evocative names to such specific sites as Brindisi (from the Indo-European for "horn," the shape of the city's harbor), Diso ("fort"), Rudiae ("red earth"), Manduria ("horse"), Vaste, and possibly Lecce, Ugento, Taranto, Oria, and Otranto.[103] From the ancient Greek colonies in Magna Graecia come such geonyms as Gallipoli ("beautiful city") and Leuca ("white soil"), and more sites were named after the Byzantine reconquest (Calimera, "good day"; Alliste, "the beautiful"). Others took their names from individual ancestors (Alessano, from Alexios) or families, including the Zurlo of Zollino and the Galati who settled Galátone and San Pietro in Galatina.[104] Many Greek toponyms are identifiable by their oxytonic accent, including Castrì (from κάστρο), Seclì ("pile of stones"), and Strudà (uncertain origin).

By the third century BCE the Latins had conquered all of southern Italy, and a large number of Salentine toponyms derive from the personal names or surnames of early Roman landholders. Most of these end today in *-ano*, from the original Latin *-anum*: Carpignano (from Carpinius, Calpinius, or Calpurnius), Corigliano (Corelius), Martano (Martus). Crispiano derives from Crispius, Miggiano probably from a landowner named Aemilius or Midius.[105] Further Latinisms include Grottaglie ("grotto"), Ortelle ("garden"), and Mottola ("elevation"). Others are phytotoponyms, such as Faggiano (from "beech") and Nociglia ("walnut").[106] Specchia della Mendolea, the possible home of a priest [**79.C**] and the place where a Hebrew medical manuscript was copied and illuminated in 1415, was an elevation notable

for its almonds.[107] Casole, south of Otranto, site of the great Orthodox monastery of San Nicola founded by the Normans in 1099, derives from the ancient Latin "hut." Quattro Macine, excavated in recent years by the University of Salento [98–103], appears to have been named for its industrial specialization ("four mills").[108]

Despite a sustained Lombard presence, the region has few Germanic toponyms. A possible reminiscence of Muslim raids is Racale (Arabic "village"),[109] but it was more likely named for Herakleia, in Pontos (Asia Minor), from which colonists were brought to settle the area near Gallipoli after the Arabs deported the population of nearby Ugento to Africa in 876.[110] A memory of a Slavic presence is preserved in San Vito degli Schiavoni,[111] known since the nineteenth century as San Vito (or Santovitu) dei Normanni.

Hagiotoponyms

In addition to these largely anthroponymic and nature-based toponyms, many places in the Salento are named for the saint around whose church or monastic complex the settlement grew. Such hagiotoponyms are evidence of the dispersed nature of the medieval habitation, where a cult site might serve a number of isolated rural dwellers before becoming the nucleus of a new village.[112] Of some 360 medieval villages identified in the province of Lecce alone, at least 43 are hagiotoponyms named for saints, the Virgin, or Christ.[113] Yet it is difficult to compile a comprehensive list of regional hagiotoponyms because it is rarely clear whether a textual source refers to a village, a neighborhood, a beach, a tower, or a cult site around which villages might develop. In the following list, I attempt to include only towns and villages (*casalia*). From the fourteenth century onward, the successively smaller administrative subdivisions (*pictagia*, neighborhoods, contained *vicinia*) of cities like Lecce and Nardò were uniformly hagiotoponyms named after neighborhood churches.[114] Including such cult sites yields a much higher percentage of saints' names than in earlier periods. Nevertheless, at the end of the Middle Ages communal identity was connected inextricably with the name of a saint (or other holy person) regardless of whether one had the same personal name.

Extant hagiotoponyms cannot communicate the rich array of earlier village dedications because so many sites were abandoned in the late medieval period or agglomerated into modern towns and cities.[115] I have compiled a list of over forty medieval Salentine hagiotoponyms,[116] which are Anglicized or Latinized as follows (number of sites follows if greater than one): Andrew, Anne, Barbara, Bartholomew, Benedict, Blasius, Cassian, Cataldus, Caesarius, Cosmas, Costantina (?), Danactus, Demetrius, Donatus, Elijah (2), Elizabeth, Emilianus, Euphemia, George (4), Helena, James (3), John (5), Laurence, Lucy, Mark (2), Martin, Marzanus, Michael, including Angelus (4), Nicholas (5), Pancratius, Paul, Peter (6?), Phocas, Potitus, Praexedonia

(?), Simon, Stephen, Susanna, Theodore, Three Hebrews ("Trium Puerorum"), Victor, and Vitus (2).

Throughout Italy, hagiotoponyms recall saints of the early church; rarely are places named for Saint Francis or Saint Dominic, even as those personal names grew in popularity.[117] Mario Villani asserted that southern Italian place names replicated toponomastic preferences elsewhere in Italy but in a different order of frequency. The ten most common hagiotoponyms in Italy are Peter (643), Martin (160), John (128), Michael (or Angelus, 120), Laurence (79), George (68), Andrew (65), Stephen (61), Nicholas (50), and Vito (49),[118] but only Peter, John, Nicholas, George, Michael, James, Mark, Vitus, and Elijah (Elias) are used more than once as place names in the Salento. Nicholas and to a lesser degree Elijah are thus over-represented locally, while Martin is scarcely present as a toponym even though there were many churches dedicated to him.[119] This toponymic disparity parallels the one between the local name stock and that in Italy more generally.

Salento hagiotoponyms evidence a special devotion to Saint Peter: San Pietro in Lama and San Pietro Vernotico, both thriving small towns today; San Pietro in Galatina, now simply Galatina; and the extinct *casalia* of San Pietro de Hispanis,[120] San Pietro de lacu Iohannis,[121] and probably San Pietro in Bevagna, whose homonymous church still stands. The popularity of Petrine place names is due in part to local legends about the apostle's sojourn in Apulia en route to Rome,[122] even though most of the sites with his name date only to the Middle Ages. In any case, Peter is, after the Virgin, the most widely diffused hagiotoponym throughout Italy,[123] so his prominence cannot be attributed merely to local factors.

Most hagiotoponyms commemorate universal saints, but a number of less familiar and even unknown saints' names are also attested locally. A rare Old Testament hagiotoponym (in addition to Elijah) is Casale Trium Puerorum, now San Crispieri, a reference to the Three Hebrew Children placed into the fiery furnace in the book of Daniel.[124] Caesarius probably is not the sixth-century bishop of Arles, but a deacon from Terracina (Sicily) who was sewn into a sack and cast into the sea;[125] Danactus (Dana) was a martyr from Illyricum who met the same fate after first being chopped into pieces.[126] Emilianus—unknown in modern Italy, but attested near Otranto—could be one of a number of saints with that name; Potitus was an early martyr executed in northwestern Apulia.[127] There is no record of a saint named Praexedonia, a hagiotoponym attested near Aurio, although Santa Praxedis exists as a Roman cult, and Rome may also be behind a Santa Co(n)stantina. It is unlikely that these uncommon toponyms represent the collective choice of a community. More likely they reflect individual preferences as the titular saints of privately owned churches around which hamlets or villages later developed.

Popular personal names and hagiotoponyms in the Salento generally coincide, with one interesting exception. Leo, a name used by all three faiths in the medieval

Salento and that remained popular throughout the Middle Ages, never appears as a hagiotoponym, possibly because the earliest sainted Leo dates only to the fifth century. The universally renowned John and Nicholas outpace all rivals as both personal names and toponyms. Yet while a male resident of the Salento had a very good chance of being named some variant of Nicholas (Nicola, Niccolò), an inhabitant of Trium Puerorum was highly unlikely to bear the name Shadrach, Meshach, or Abednego, just as residents of Naples were never named for their patron saint, Januarius.[128] Local cults had little influence on naming patterns except when the local titular saint was also a prominent universal saint.[129]

To a certain degree, medieval onomastics are indexical of piety. Every place named for a saint signifies devotion to that sacred figure at some past date; nevertheless, hagiotoponyms were and are only a small percentage of all Apulian place names.[130] Particular devotion might also inspire a parent to name a child after a saint, and while we might think this was desirable—an extra layer of infant protection—it was not done consistently. Chrysolea [**32.A**] and Aprilios [**32.D, F**] at Carpignano are two of the earliest medieval Greek names that demonstrate how parental preferences and other traditions might favor other types of names. Similarly, Jewish anthroponymy demonstrates a willingness by some to invent novel monikers even if most parents adhered to familiar scriptural names.

Supernatural Names

Among the distinctive features of male Jewish names in the Salento was their frequent ending in *-el*, a reference to God; local Christian equivalents included Theodosius, Theophylact, and Theodore. According to *Sefer Yetzirah*, on which Oria's Shabbetai Donnolo wrote an important commentary, God created the world by manipulating the letters in his own divine name.[131] In fact, the Lord was believed to have many names, including the Tetragrammaton—so awesome that it was never to be pronounced explicitly—and others composed of seventy-two or forty-two letters or syllables.[132] All of these names were enormously powerful, capable of effecting miracles if properly invoked by knowledgeable practitioners.[133] Moses, Jesus, and Simon Magus knew the names, and they were available to later epigones in the corpora of esoteric texts that included the Jewish Hekhalot and Merkavah literature and the (probably) Christian *Testament of Solomon*.[134] The *Chronicle of Ahima'az* identifies the *Book of Righteousness* (*Sefer ha-Yashar*), parts of which survive in the Cairo Genizah, as containing magical instructions for employing the divine name.[135]

Ahima'az's ancestor Hananel temporarily restored his brother Papoleon to life by inserting a parchment with the name of God under his tongue; "the Name resurrected him" until the parchment was removed.[136] God's name also was required for successful exorcisms. When Shephatiah, another ancestor, cured the daughter of the Byzantine emperor Basil I in Constantinople, he adjured the demon who afflicted her "in the Name of 'He who dwells high aloft,' and in the Name of 'He who created the earth with His wisdom,' in the name of 'He who created the mountains and the sea,' and in the Name of 'He who suspends earth upon emptiness' . . . come out in the Name of God."[137] The repetition of biblical phrases underscores how frequently the concept of the holy name appears in Scripture: the name of God *is* God.

Christians used the name of God in countless liturgies, hymns, and rituals, and in the sixth century Pseudo-Dionysius the Areopagite produced an influential treatise on divine names.[138] Two local exorcisms that guard against devastating hail begin with "the great name of (all-powerful) God), "Τὸ μέγα ὄνομα τοῦ Θεοῦ" and "Τὸ μέγα ὄνομα τοῦ παντοδυνάμου Θεοῦ."[139]

In the late antique *Testament of Solomon,* well known in the Middle Ages, a demon refuses to give its name to the king because that knowledge will permit Solomon to bind not only that malefactor but others as well; nevertheless, wise Solomon prevails and becomes a model for later practitioners. An exorcist needed to know all of a demon's names in order to counter them with powerful angelic names.[140] The omission of the demons' names from the Last Judgment scene at Santo Stefano in Soleto renders them unavailable for control by their nameless victims, identified by their sins, as well as by their viewers [113.B].[141] The dangerously powerful names of God and of demons are not found in public art.

Names and Identity

Let us conclude with the late fourteenth-century apse inscription from Santi Stefani in Vaste [157.A]. The personal names recorded there—Antony, Doulitzia, Maria, and Ioanna (Jeanne)—reveal both continuity in onomastic fashion (Maria) and novelty (Antony, Ioanna). Long after the end of Byzantine domination, only one name in this Greek inscription is unambiguously Greek (Doulitzia). No surname is indicated despite the late date, which suggests the family's nonelite social status. The fact that names of all members of the family are included makes this text unique among medieval Salentine visual sources. The toponym Nuci (Nociglia) and the location of the church speak to the agricultural roots of many

local place names and the ancient Messapian origins of a few. The supplication situates the apse figures in a family and community context at a specific moment in time, the Byzantine year 6888. It underscores that names and kinship are among the core elements of medieval identity, which involved both persons and places. What, then, should we make of Kalia, Margaret, Stephen, and Donna, who are identified by name but not by kinship [**157.C, I, K, M; Plate 18**]? Perhaps they are related to George, son of Lawrence [**157.G**], and to Antony and his family in the apse [**157.A**], and this is a single-family cult site. The single women may all be independent widows, although this seems unlikely. In subsequent chapters I shall have more to say about these figures' appearance, their status, and their painted expressions of piety.

Perhaps the most important aspect of names was the belief, shared by Jews and Christians alike, that names held power. Receiving an individual name at baptism afforded protection, and only named, baptized children could hope to enter heaven.[142] Names could affect one's future, and changing a name might fool demons or the angel of death, who summoned a person by name.[143] Orthodox individuals entering a new life in a monastery or convent often received a new name. Foremost among the powerful names were the divine ones, only some of which were accessible to regular Christians and Jews.

Anthroponymy is informative, but it has its limits. What does it mean to say someone has a "Greek" or "Latin" or, for that matter, a "Jewish" name? Someone named [M]araldus is remembered in a Greek supplication in a poorly preserved apse at Taranto [**142.A**], but was Maraldus a Lombard, a Norman, a Swabian, or an Angevin? In fact, he was not necessarily a "Latin" at all; people could change their names in order to fit better into society, and ambitious men adopted Latin-sounding names in the late eleventh century in order to rise in the new Norman political hierarchy.[144] A name alone reveals little about the origin or cultural background of its bearer: after all, who would have supposed that Cristio Maumet of Lecce was a Jew? His name had to be supplemented by *ebreo*, an ethnic signifier, as well as by his place of habitation, Lecce.[145] Some onomastic patterns are socially or culturally circumscribed, but names are only distorting mirrors of the cultural background of their possessors. Similarly, place names tell us about the foundation of a site but not about subsequent changes. Quattro Macine may not always have had four mills, and a hagiotoponym like San Pietro in Galatina does not indicate that in the later Middle Ages the town came to be associated with a different saint, Paul.

When toponyms are used as a shorthand for a place's inhabitants, it is easy for outsiders to believe that all of them share certain characteristics. Names, in such cases, are not specific to individuals, but elide unique qualities and become gen-

eralized but potentially powerful labels. The early modern inhabitants of Alessano and Carpignano were called by outsiders *Sciuteì* or *Sçiudèu*, Jews, with all the pejorative implications this term had in sixteenth-century southern Italy.[146] In many ways, names were (and are) the essence of group identity: they are usually assigned by others; they assume greater and lesser importance in different situations; and they can be altered if necessary. Giving someone a name, a nickname, or another label signifies power over that individual's place in a family or community,[147] or even an attempt to create certain outcomes beyond the terrestrial world. Even if onomastics cannot provide all the reliable information we would like, their study tells us more than we would otherwise know about the medieval Salento. We can now look beyond names to their contexts, beginning with the languages in which names and much other information are communicated.

Languages

One of the most important lessons to be learned from examining linguistic choices is that language, like names, is not a secure indicator of cultural or ethnic background. Speaking, reading, writing, and commissioning texts are learned behaviors whose use is socially determined. As numerous sociolinguistic studies have shown, different languages might be appropriate in different situations, and a person might have many reasons to commission or execute a text that was not in his or her ancestral tongue. In the medieval Salento, the relevant languages of inscription were Greek, Latin, and Hebrew; Aramaic, Old French, and pseudo-Kufic script also make an appearance. *Griko*, the local dialect of Greek, and *Romanzo*, the Romance vernacular that became modern Italian, were spoken languages that, before the end of the fourteenth century, very rarely intrude into written texts. The contemporaneous use, juxtaposition, and combination of these languages are among the features that gave (and continue to give) the Salento a unique regional character. While Jews and Christians could look back to a golden age of linguistic unity before the Tower of Babel was built (Gen. 11:1), postbiblical languages had long since become an index of diversity, a criterion for belonging to or being excluded from certain groups. In what follows, I argue that texts in the public domain were visible social statements that contributed in meaningful ways to the construction and communication of individual and communal identity.

Information about languages comes from a variety of public texts, some carefully planned and formally carved or painted, others informally incised or painted ad hoc. For Hebrew, this material evidence is supplemented by manuscript data. I discuss each language group in turn and consider linguistic patterns found in different types of texts. By "types of text" I refer not to medium but to the primary function of the inscription or graffito: hortatory, dedicatory, didactic, devotional, or funerary. Certainly there is overlap between these categories, but if a devotional text also asks readers to pray for the author, I consider it hortatory. Dedicatory and devotional texts can be very similar; in assigning an inscription to the former

group, I look for verbs that stake a personal claim to such notable action as build-ing or rebuilding a church or paving an entire floor. I include *fieri fecit* texts (so-and-so "had made") in this group only if they demonstrate extensive patronage and include additional information. Simpler claims of patronage, artist's signa-tures, deictic texts that designate or identify something, labels or captions that instruct, inform, or merely indicate the writer's presence are all considered under the rubric of didactic texts. Devotional texts, or supplications, either request divine help or ask that the person named be remembered by God or, less commonly, by the Virgin or a saint. These are usually termed "votive" texts, but I want to remove the implication that a vow has been promised or fulfilled because of a complete lack of evidence that this was the case: "vow" is nowhere used in public texts in the Salento in any language.[1]

Language Distribution

Although the types of medieval public texts are more or less the same everywhere, the linguistic map of the Salento is very different from that of the rest of Italy (it most closely resembles Calabria). The majority of the peninsula did not have ancient Greek colonies, two centuries of Byzantine rule, and an influx of medieval Greek speakers. Other regions of Italy do not contain a microregion of towns in which a Greek dialect is still spoken.[2] No other Italian province can claim so many medieval public texts in Greek.

The Salento also has a significant number of texts in Hebrew, and this does have parallels elsewhere in Italy. Nevertheless, even expanding the geographical and temporal parameters to offset the paucity of Jewish remains yields less than a handful of synagogue dedications and epitaphs from only five sites. From other sources we know of many more Jewish communities in the Terra d'Otranto, espe-cially in the late medieval and early modern periods.[3] There is no doubt that these communities maintained Hebrew as their sacred tongue and continued to produce religious and scientific manuscripts until the sixteenth century, but they are both geographically and materially underrepresented here.

The southern Salento (the province of Lecce) preserves more than twice as many Greek texts as Latin ones, whereas in the northern Salento (most of the provinces of Brindisi and Taranto) Latin inscriptions outnumber Greek ones by a ratio of approximately three to one. (The south also had two-thirds of the sites known to have a Jewish presence.) If my inscriptional and graffiti evidence is an accurate indication of a larger truth about spoken Greek and Latin, we would con-clude that there were relatively more Greek speakers in the southern part of the Salento and relatively more Latin in the north. Indeed, some scholars have made

more sweeping claims about the precise borders of a Greek-speaking south and a Latin-speaking north.[4] But inscriptional language is not the same as speech and the surviving material evidence may not be representative of larger communities of speakers. Even a modest painted inscription or a poorly carved tombstone denotes a certain level of social or financial means and depends on the availability of skilled craftsmen and other factors. When language is a product of sociolinguistic choice, a patron might choose a less common tongue to reach a particular subset of his potential audience.[5]

Dominant and alloglot (minority) languages probably could be found in most sizable communities in the Salento, even if it is not possible to document this archaeologically. Considering only the precisely dated material evidence, we see an increase in the use of Latin for formal texts beginning in the twelfth century, particularly after midcentury, and Latin texts continue to outnumber Greek ones in the thirteenth century; in the fourteenth and early fifteenth centuries, however, the two languages are evenly distributed over the extant dated texts. In other words, while we might have expected the proportion of Latin texts to rise on pace with its increasing value as a language of power and administration—an increase that is apparent from documentary sources—dated Greek texts remained just as abundant. By contrast, the limited evidence for Jewish sites indicates that these were razed or reused by the tenth century (when Hebrew epitaphs disappear) or the thirteenth century (when synagogues are converted to churches at Trani) or later (late fifteenth century, when the synagogue of Lecce is destroyed). Such actions resulted in the loss of most Hebrew inscriptions even though manuscript and documentary evidence for continuous Jewish cultural activity survives.[6]

The proportions in which the various types of texts are preserved in Greek and Latin reveal some surprising differences. There are more Latin dedicatory inscriptions, perhaps because the latter tend to be epigraphs carved in stone and often still in situ in Roman-rite churches. On the other hand, there are three times as many devotional texts in Greek as in Latin, which may reveal something about differing expressions of piety—not that users of Greek were more pious, but perhaps that their public piety was more likely to be recorded in written form while Latin (actually Romance) speakers may have offered objects or images to their churches instead. Perhaps later Greek speech communities, such as that at Vaste in 1379/80 [**157**], had a greater need for visible public prayers than their neighbors because of the ever-declining numbers of Orthodox clergy and the infiltration of non-Orthodox church practices (see Chapter 6). If the early bilingual Hebrew-Latin epitaphs are excluded, there are eight times as many funerary texts in Greek as in Latin. Such a great disparity surely is due to multiple factors that probably include Orthodox funerary customs and local habits of display and imitation. Given the size of the sampling and absence of corroborating evidence, it is not

possible to make claims about greater Greek literacy or financial clout. In the end, we cannot even be sure that differences in linguistic proportion are meaningful, as both absolute and relative numbers of texts are products of what has survived and what has been published or made accessible.

In addition to the texts in Hebrew, Latin, and Greek that figure in the Database and are discussed below, other languages were occasionally used for public texts. The former pavement of the Norman cathedral at Brindisi illustrated the story of Roland and labeled those scenes in French (*Rollant, l'arcevesque Torpin*) [**21.sc**].[7] Kufic or pseudo-Kufic script is used to evoke Arabic at San Pietro at Otranto, Santa Maria di Cerrate near Squinzano, and elsewhere, but the comprehensibility of these texts was probably nil and their meanings nonverbal and abstract.[8] There was an Armenian community at Ceglie, near Bari, beginning in 990,[9] and two funerary stelae in the Salento record Armenian names, but the language of both is Greek [**111, 159**]. The use of these other tongues was very restricted, and we can seriously discuss the local population's languages and literacy only in terms of Hebrew, Latin, Greek, and their associated vernaculars, alone and in combination.

The official imposition of a Tuscan variety of Italian since the nineteenth century has not erased traces of earlier languages and dialects in the Salento. The region's linguistic picture seems always to have been complicated by the interaction of alloglot tongues with one or more majority languages. In general, the dialects called "Salentine" by linguists have many analogies with those in Sicily and southern Calabria, although they display greater lexical archaism and a significant admixture of Greek is apparent in semantics, phonology, and syntax. In the north, such sites as Taranto and Massafra have an Apulian dialect, with pronunciations different from those farther south and a linguistic system more akin to that of Naples.[10] Except for this northern fringe, the linguistic map corresponds well to the entity I defined in the Introduction as "the Salento."

Hebrew

Medieval Jews, or at least the Jewish intellectuals who led them, believed that the twenty-two letters of the Hebrew alphabet were identical with the Torah and with the name of God himself: God had used these letters, rotated and in combination, to create the entire world.[11] For Jewish mystics, the Hebrew language "was not regarded as a means or a tool, but as the subject and ultimate purpose of speculation."[12] As noted in Chapter 1, Hebrew names were mandatory for Jews because Hebrew was the language spoken by God and his angels; even some Christian sources agreed.[13] As was the case with keeping their names, maintaining the

Hebrew language was one of the criteria for the Jews' liberation from Egypt and its identity as a chosen people.[14]

Jewish prayers were almost all in the holy tongue, the *lashon ha-kodesh*, although a few prayers persisted in Greek for many centuries.[15] A medieval Italian source permitted certain intercessory prayers to be recited in Aramaic, particularly those directed to the angels "appointed [as supervisors] over the gates of prayer," although not to those who serve as one's "guardian angels" or constant spiritual companions.[16] The same text indicates that it is a mitzvah—a positive commandment—to translate Torah readings into the vernacular, although whether this translation is to be done ad hoc or from a prepared translation is not clear. Although this vernacular proviso was already noted in the Talmud, its relevance to thirteenth-century Italy is evident from the author's personal statement: "My opinion is that of my brother, Rabbi Judah, who says the principle behind the translation is to comment on the words of Torah for women and the ignorant who do not understand the holy language."[17] This halakhic (legal) text, *Shibolei ha-Leqet* ("Gleaned Ears"), was written in Rome in the mid-thirteenth century by Zidkiyahu ben Abraham ha-Rofe ("the doctor"), a member of the learned Anav family, which traced its origins in Italy to forced exile from Israel under the Roman rulers Pompey and Titus. The work is an invaluable source of information on many aspects of medieval Italian Jewish life and is cited often in this book.[18]

While Jews lived, worshipped, and died in southern Italy until the sixteenth century, material evidence for their presence consists mainly of funerary inscriptions that do not postdate the tenth century. Late antique epitaphs in the region consistently combined a Hebrew text with one in Greek,[19] but in the seventh and eighth centuries Latin became a more frequent adjunct [**81, 122–127, 131–133, 135**]. All but one of these bilingual examples come from Taranto, where the overall epigraphic record is dominated by Latin even though Greek-speaking Jews and Christians also are attested there.[20] The latest funerary texts, which are usually assigned to the ninth or perhaps tenth century, use only Hebrew [**10–14, 16–18, 121, 128–130, 134, 149–150**],[21] and in one case Aramaic [**136**]. It is risky to draw broad conclusions from such a small set of data, but I agree with Cesare Colafemmina that communication solely in Hebrew reflects an emerging sense of Jewish identity vested in language and manifested simultaneously in a flourishing of Hebrew literature that included the first historiographic work (*Sefer Josippon*), the first family chronicle (*Megillat Ahima'az*), and astrological, philosophical, mystical, and medical treatises in addition to liturgical poetry (*piyyutim*).[22] Perhaps this literary production had a trickle-down effect, resulting in a wider Jewish (male) literacy and more Hebrew epitaphs. The religious texts and poetry produced in Apulia were known outside the region: several *piyyutim* became part of the Ashkenazic prayer book, and a scholar in twelfth-century France remarked that "from

Bari comes forth the Law, and the word of God from Otranto."[23] The preponderance of Hebrew-only tombstones may also indicate that Jewish graves became less visible to non-Hebrew readers as the centuries progressed. The Christian and Jewish cemeteries at Taranto were contiguous,[24] but later Jewish burials may simply have been farther from the neighboring Christian ones and so had a more limited and homogeneous audience. It seems likely that the bulk of Jewish tombstones at Taranto were used to rebuild the city walls after the tenth-century Arab raids [**139**],[25] but the fate of later Jewish epitaphs there and elsewhere is unknown.[26] Were Salentine Jews not permitted such public displays? Did they lose the epigraphic habit for other reasons? Or were all of their tombstones after the ninth or tenth century simply repurposed by Christians for either practical or ideological reasons? Unfortunately, we lack answers to all these questions.

Among the formulas used to commemorate the Jewish dead are the Hebrew *po schichvat* (here lies), *po yanuach* (here rests), and *mishkav* (tomb of). In the Latin parts of the Jewish epitaphs, *Hic requiescit* (here rests) predominates.[27] The deceased is sometimes remembered positively as *bene memorius*, in Hebrew *b'zikaron tov*.[28] An invocation for *shalom al minuchato*, "peace upon the resting place," echoing Isaiah 57:2, is very common; it is equivalent to the Latin *Sit pax in requie eius* or, in one case, *Sit pax super dormitorium eorum* [**123.B**]. "Amen" often concludes a short Hebrew funerary text. Often the deceased is noted as a righteous man whose memory merits a blessing, *zecher tzaddik livrachah*, from Proverbs 10:7 [**12.D, 14, 124.B, 126.B, 128.B**]. This is the most common biblical citation or paraphrase, although a few epitaphs quote from Psalms, Job, or Isaiah [**18, 124.B**].[29] Overreliance on phrases drawn from the ancient funerary ritual of the land of Israel led the composer or the carver of Leah's epitaph in Brindisi [**16**] to conclude that text with a line from Song of Songs in which the male gender of the original has not been amended for a female commemoration.[30] Similar errors of gender are not uncommon, as in a funerary inscription at Taranto [**121**], where the verb "rests" is masculine even though the commemoration is for an unnamed wife.[31]

All-Hebrew epitaphs tend to multiply scriptural and liturgical references, and two examples in Trani abbreviate the common prayer "May his soul be bound in the bond of life" (1 Sam. 25:29) [**149, 150**], echoing the earlier abbreviation in Brindisi of "The holy one, blessed be he" [**16**]. Such complex textual referencing and abbreviations are indications of Hebrew literacy that serve to advertise and solidify Jewish identity through language. Some epitaphs are notable for their relationship to contemporary Hebrew liturgical poetry [**18.A**], and there are rhyming lines as well as acrostics that yield the name of the text's author.[32] This is the case at Oria [**81**], where "Samuel" may have composed the commemoration for his mother, Hannah, if indeed this eighth-century pair deliberately echoes the well-

known biblical mother and son of 1 Samuel 1–2.[33] Not only was the Oria inscription composed by and for a Jewish patron, but it seems to have been carved by a native Hebrew speaker as well. He mistakenly began the Latin text at the right rather than the left and had to correct himself; the letter *N* is consistently rendered with a backward diagonal;[34] and *ES* at the beginning of line 3 is a meaningless repetition of the letters immediately above [**81.B**].[35] In most of the Hebrew inscriptions the quality of carving is quite good, and in the bilingual epitaphs the Hebrew text tends to be better than the Latin, carefully incised and with more regular letters. Were two different carvers employed, or does a Jewish craftsman betray here his greater familiarity with Hebrew? In a seventh–eighth-century stela from Taranto, the Latin epitaph omits a syllable and reads *benemorius* rather than *benememorius*, although the correction is inserted above the line [**133.C**]; in another, *requiescit* is misspelled.[36] Yet the only Latin error in a four-line seventh- or eighth-century epitaph from Taranto [**123.B**] is *suum* for *suo*; the unusual preceding word, *barbane* (uncle), is a third-declension ablative from *barbas*, here rendered properly.[37] When both languages are executed well, it is impossible to link the carver's competency to his religious affiliation.

Another important body of information about the use of Hebrew in medieval southern Apulia comes from inscriptions originally placed inside synagogues. The texts from Gravina [**50**] and Bari [**9**] were introduced previously because they provide onomastic data. Two other synagogue inscriptions, devoid of names, survive in Trani [**147**] and Lecce [**56**]. Despite its brevity, the latter is especially valuable as the only physical testimony for a synagogue building in the Salento proper. A Jewish community in Lecce is attested by 524, and because this particular edifice was not transformed into a church (dedicated to Santa Maria Annunziata) until 1495,[38] it testifies to the endurance of Salentine Jewry.

These synagogue inscriptions differ from the majority of Jewish epigraphs because three of them bear specific dates (1184/85, 1246/47, 1313/14), given in years since the creation of the world. The epitaphs communicate the age of the deceased and not the date of death. Unlike Christian inscriptions, Jewish ones pay no attention to such specifics of dating as day, month, ruler, or indiction. The three dated synagogue dedications specify the extent of the construction or renovation for which the donor was responsible. Trani's synagogue may have been built entirely by one unnamed individual, but the patron commemorated at Bari gave only a window and his counterpart at Gravina provided the pavement and seats. Such parceling out of donations implies communal effort and has its roots in the Jewish synagogues of late antiquity, where the mosaic decoration was often credited to many individuals.

The synagogue texts occasionally include both non-Hebrew loan words and nonstandard orthography. For instance, the word for benches or seats, *iztabaot*,

used at Gravina [**50**] and Trani [**147**] comes from the Greek *stibadion*, here spelled two different ways (איצטבאות, אצטבאות).[39] In the Bari inscription [**9**] the date is communicated by a *gematria*: adding the numerical values of the Hebrew letters in the word "Hadasah" gives the year. That this word should be read numerically and not literally is indicated graphically by small "v" signs over each letter (the symbolic implication of Hadasah/Esther, who saved the Jews of Persia, was doubtless present as well). This use of letters for numbers is common in Hebrew manuscripts and is found on a tombstone from Trani, where it is used to indicate the year of death [**150**]. This is the reverse of the Greek practice of isopsephy, in which numbers are used to indicate letters: in the Salento, three or four eleventh-century Greek devotional texts conclude with the number 99, whose isopsephic value is "Amen" [**32.E, 32.F, 33.A, 80.A**].[40]

Even formal texts seem to betray the influence of spoken language. Two such elements are present in the Latin on the Oria epitaph [**81.B**], where the Italianate *G* replaces the Latin *I* at the beginning of the deceased woman's father's name, Julius, which ends in the genitive -*u*.[41] In one Taranto inscription [**123.A**], Silanus ends with a *vav* (hence Silano or Silanu), probably reflecting that the final -*s* was disappearing in pronunciation at this time, a feature typical of southern Italian dialects.[42] Iotacisms that reflect current speech are common in all of the languages used for Jewish as well as Christian texts.

In a manuscript of the Mishnah produced in Otranto circa 1072 and now in Parma, glosses written in the vernacular language but with Hebrew characters clarify which plants cited in Mishnaic Hebrew could not be grown alongside others.[43] This vernacular would not reappear in local texts until the late fourteenth century. Shabbetai Donnolo's pharmaceutical terms provide tenth-century evidence for a distinctive Salento dialect, but because Donnolo's scientific terms are very similar in Greek, Latin, and proto-Italian it is difficult to know which language they represent (the absence of many final consonants supports the vernacular).[44] A sampling from the Otranto Mishnah reveals the unambiguous Greek sources of many terms, including *klivanidt*, from Greek κλιβανίτης, a kind of bread, and *savani*, from Greek σάβανον, a linen cloth.[45] Robert Bonfil's investigation of two South Italian Hebrew chronicles, *Megillat Ahimaʿaz* and *Sefer Josippon* (written outside the Salento), concluded that their authors were actually thinking in Latin or the Romance vernacular even when writing in Hebrew; because they were used to speaking those other tongues, it infiltrated their texts.[46]

By the medieval period, the use of Greek in Jewish liturgy had largely been replaced by Hebrew.[47] That Hebrew was used for praying and writing facilitated interaction with faraway Jewish communities and was an important marker of Jewish difference from Christianity. Yet as a sacred language, and one known only to men, it could not be used generally for speaking. Romaniote (Byzantine) Jews,

including those in the Salento, spoke a hybridized Greek, not Hebrew.[48] In the ninth century, the Jews of Venosa (in Basilicata) needed a translator when a scholar visiting from Baghdad delivered a Sabbath sermon in an unfamiliar language that was probably Hebrew.[49] However, in the public disputation circa 1220 between the Jews of Otranto and Nicholas-Nektarios, abbot of the Orthodox monastery at Casole, the abbot records that the Jews conferred among themselves in Hebrew.[50] Nicholas-Nektarios knew the language—on occasion he even wrote Hebrew in Greek characters[51]—so he probably was correct about what he heard. Perhaps the simplest explanation is that the most learned local Jews could converse in Hebrew, or at least quote from written sources, but this was not a widespread phenomenon; medieval Hebrew was for writing and worship, not for speech. In later chapters I suggest that the most learned Jews also dressed differently from their coreligionists and engaged in certain ritual practices that "regular" Jews did not. They were, in effect, equivalent to such Christian role models as abbots and bishops, whose standards of behavior and learning were different from those of most Christians.

Latin

Latin was used in the Salento for a large number of dedicatory inscriptions, a few epitaphs, and two kinds of public expression unattested in Hebrew: painted or incised devotional inscriptions and hortatory texts.[52] Except for the Latin faces of ten bilingual Hebrew epitaphs from Taranto and early dedicatory or didactic inscriptions from Oria [**83, 84**] and Brindisi [**20, 25**], the Latin texts can be dated between the twelfth and fourteenth centuries. As with Hebrew, Latin public texts are far outnumbered by surviving examples in Greek.

The dedicatory inscriptions vary widely in scale and include commemoration of whole churches or monasteries [**1, 21.A–B, 57, 58, 144**], roof beams [**78.B**], an altar [**38**], pavements [**86.A–G, 140.C–E**], and individual wall paintings [**78.C**], in addition to partial renovations of or additions to existing buildings [**35**]. A Byzantine claim to have rebuilt the entire city of Brindisi from its foundations stands out for its hubris [**20**]. Over 60 percent of these inscriptions give the year of the dedication with *Anno Domini* or *Anno Dominice,* year of the Lord, or *Anno ab Incarnatione,* year since the Incarnation. The date is usually supplemented by additional elements and highlighted by its placement in the first or last line. In two-thirds of the dated inscriptions there is a reference to the current king and/or the local lord, complete with titles; in several cases the month or day is noted, and even more often the indiction [**1, 28.W, 38, 79.A, 86.E, 117.A, 144**]. This impre-

cise but widespread system of dating according to fifteen-year cycles was much more common in Greek public texts. Its use in Latin probably indicates awareness of the Byzantine indiction, which began on September 1, but may also indicate familiarity with other kinds of cyclical reckoning, with different starting dates, used irregularly by the papacy, notaries, and others. This method of dating was falling rapidly out of fashion in Europe by the fourteenth century, but it endured much later in the Salento with its strong Byzantine ties [**79.A**].[53]

Patrons inscribed dedications in Latin for many reasons. They rarely cite as motives the remission of their sins [**1.A**] or eternal life [**58.A**]; more often the dedication is simply to honor Christ, the Virgin, and various saints [**1, 38, 57, 67.B, 78.C, 144**]. The phrase *ad* (or *in*) *honore Dei* [**144**] is an echo of the liturgy.[54] Sometimes no reason is given; perhaps generic piety was motive enough. On the column base at Brindisi, the dedication seems to be in honor of the "magnificent and benign emperors"; unfortunately, the text is incomplete [**20**]. Pious donations of goods (*bonorum, donis*) and serfs (*colonis*) were publicly recorded at Castro [**35**] and Lecce [**58.A**]. Of the Latin dedicatory texts that preserve information about their patrons, a clear majority were high-ranking ecclesiastics or priests, alone or in combination with lay donors, followed by feudal lords, then architects or artists.[55] Two of these texts were in Leonine hexameters, the metrical form underscoring the episcopal patronage [**57, 78.C**].

In contrast with the dedications, devotional and hortatory texts in Latin rarely preserve a date of any kind. An exception is at Statte in 1416, where Nicholas Bertini, a traveler from northern Italy, left his name and the date of his visit to nearby Taranto [**117.B**].[56] This kind of specificity fits the late date of this graffito, incised at a time when ideas about individualism were taking hold in northern Italy. In the Salento, too, dates are included in many postmedieval graffiti not included in my Database. Medieval visitors, by contrast, wanted to transcend the specifics of their recorded presence and solicit eternal favor or remembrance.

With the notable exception of incised graffiti, devotional invocations almost invariably begin with an abbreviation of the vocative *Memento Domine*, "Remember, Lord." This is followed by "your servant," either *famuli tui*, the correct genitive case, or the dative *famulo tuo*, which by the Middle Ages is a much rarer form. The dative is used disproportionately in Salentine Latin texts, however, either because of a contamination from the Greek or an attraction to the case of the patron's name in the vernacular. In any case, the meaning of the inscription would have been, and remains, clear. The priest Sarulus who dedicated images of Saint Nicholas and Saint Margaret in two different crypt churches at Mottola must have been unperturbed when artists wrote *famulo* in one and *famuli* in the other [**75.A, 76.C**].

Latin devotional graffiti occur in large numbers at only two sites, San Marco in Massafra and Santa Lucia in Palagianello [**66, 94**]. These differ from more formal texts in several ways: they are incised irregularly, rather than painted or carefully carved; they are often much shorter and may be superimposed; some are in minuscule, or in a combination of capital, uncial, and minuscule letters; and they very rarely use the formal *Memento Domine* formula. Instead, most Latin graffiti begin with *Ego*, "I am," followed by a name or names. These two sites, along with a third [**116.A**] that is also in the province of Taranto, contain the only Latin hortatory injunctions in the Salento. The overt request that readers of these texts pray for the person named therein was directed to Latin readers such as the monks, priests, and other clergy who identify themselves by profession in didactic Latin graffiti at the same sites.

In Santa Lucia (the former Trinità) at Brindisi, a painted text combines a devotional introduction, *Memento Domine*, with "rest in peace," ending with "Amen" [**27.A**]. Given its location low on the left wall of the church, there is little doubt that the inscription marked a family burial place. At San Paolo, in the same city, a painted "Here lies" (*hic iacet*) records the tomb of an elite named man originally from Florence [**26.A**], while a carved marble plaque marks the burial of an elite unnamed woman [**26.C**]. The metrical inscription of the latter adds that an altar and a joint tomb have been prepared nearby by her devoted husband, Nicholas Castaldo. A now-lost sarcophagus lid for a *magister* states "Here lies the body" (*hic jacet corpus*) and warns of excommunication by the archbishop for anyone disturbing the tomb [**31**]. Like the Brindisi epitaph the lid gave a specific date, and this seems typical of elite commissions.

If we consider not only epitaphs and dedicatory and devotional inscriptions but also the didactic explanatory labels that accompany wall paintings, we find some evidence for the Latin literacy of a few painters. At Acquarica del Capo [**1.A**], where a long dedicatory inscription in Latin is signed by two artists in Greek, the caption for Saint Hippolytus on horseback is labeled both in Greek, "Ο ΑΓ(ΙΟС) ΙΠΠΟΛΥΤ(ΟС)," and in Latin, "S(AN)C(TV)S VPOLIT[VS]." The initial *U* (as *V*) in the Latin legend betrays the hand of the Greek painters.[57] In the Saint Catherine cycle in the vault at Casaranello, which is entirely Latin in its captioning, the evil emperor is mislabeled once "MANSENCIUS" (for Maxentius), and "AGVSSTA" (Augusta) is also misspelled.[58] This is sloppy Latin and hardly indicative of the artist's better Greek if he was trained in France, as scholarly consensus has it.[59] Vernacular pronunciation probably influenced the spellings of "CATERINA" (*T* for *TH*), "MASENCIUS" (*S* for *X*), "PORFILIUS" (*L* for *R*), and "IMPERATRICS" (*CS* for *X*).[60] Similarly, at the Candelora crypt in Massafra, Saint Stephen is identified as "STEFANUS" (*F* for *PH*) and Nicholas the Pilgrim as "PELLEGRINUS" (*LL* for *R*) [**63.B**].[61]

Greek

The impressive quantity of Greek texts produced in the medieval Salento gives the lie to Nikephoros Gregoras's lament that by his time, the first half of the fourteenth century, nothing remained of Greek poetry or spoken language in the ancient Magna Graecia: καὶ οὐδὲν ἔτι ἴχνος ἐλλέλειπται μὴ ὅτι γε μούσης Ἑλληνικῆς ἀλλ᾽ οὐδὲ διαλέκτου κοινῆς.[62] Greek public texts of a funerary and devotional nature greatly outnumber Latin and Hebrew ones, but there are fewer dedicatory and didactic inscriptions in Greek than in Latin and only four hortatory texts, [**43.A, 48, 114.B, 156.A**], which are both dedicatory and funerary. The Greek dedicatory inscriptions commemorate a village [**48**], walls [**139**], a tower [**30**], hospitals [**4, 46**], a ciborium [**114.C**], and several churches [**36, 43.A, 108.A, 109.A, 113.A, 146.A, 154.A**]. A church (ναός) is invariably all-holy (πάνσεπτος), except for one humble δόμος (house) [**154.A**].[63] The usual Greek term for constructing, ἀνοικοδομέω, is preferred, albeit often misspelled, but κατασκευάζω and ἀνηγέρθη are other options. Decorating church walls with frescoes is communicated by ἐζωγραφήθη or ἀνιστορήθη, which might be done at the "efforts and expense" (κόπου καὶ ἐξόδου), "cooperation and effort" (συνδρομῆς καὶ κόπου), "labor and travail" (πόνου καὶ μόχθου), or simply the "expense" (δαπάνης) of the patron. Only three of the dedicatory inscriptions in Greek include the name and titles of the secular ruler, far fewer than in the Latin texts and good evidence that most patrons who chose to be remembered in Greek were disinclined to use a method of dating that highlighted a European ruler after the Byzantines were evicted circa 1071. The date is regularly included at the beginning or end; the month is noted three times, the day and hour once each.[64] Few of the Greek dedications share the concern with precise details of dating seen in Latin dedicatory texts; most are content with the year since the creation of Adam (like the Hebrew, and unlike the Latin post-Incarnation dates) and the indiction. Reference to the indiction was much more widespread in Greek and used by a larger group of patrons from different social classes.

As was also the case in Latin, almost all of the Greek devotional texts begin with the injunction "Remember," Μνήσθητι, directed to the Lord (Κύριε). Only in a single late monument is the addressee Christ [**157.G**], the Virgin (δέσποινα) [**157.A**], or an unspecified saint, presumably the one depicted adjacent to the relevant text [**157.I, K**].[65] With very few exceptions, the supplicants identify themselves as "servants" (δοῦλοι) of the Lord, just as they did in Latin. The only other devotional formula is "Lord, help your servant" (Κύριε βοήθει) [**53.C, 64.A, 66.G, 71.A(?), 94.D, 143.C–E, 154.A, 155.B** (only **154.A** is a dedicatory text)].[66] The overwhelming popularity of Μνήσθητι Κύριε is not paralleled in other regions where abundant Greek inscriptions are found, including Cappadocia, Greece, and

the Balkans.[67] There the usual invocation is either Κύριε βοήθει or δέησις τοῦ δούλου τοῦ Θεοῦ, "petition of the servant of God," and the latter is nonexistent in the Salento. The verb μιμνήσκωμαι rarely appears in public texts outside of Italy, where its popularity probably derives from its use in the liturgy. Salentine diptychs of the dead endlessly repeat the formula "Remember, Lord, your servant(s)," and from the mid-fourteenth century onward the local euchologia (service books) were supplemented by an amplification of the anaphora unknown in other regions that also begins with Μνήσθητι Κύριε.[68] There may also be a connection with the identical Latin phrase "Memento Domine," used in the Roman-rite canon of the mass.

The majority of funerary texts in Greek also use a repetitive formulation, Ἐκοιμήθη ὁ δοῦλος (ἡ δούλη) τοῦ θεοῦ, literally, "The servant of God has fallen asleep," but usually translated as "The servant of God died." In the devotional texts variety was introduced only in the fourteenth century, but in the epitaphs variety preceded standardization: in the tenth through early twelfth centuries there were still such phrases as Ὑπὲρ κοιμήσεως καὶ ἀναπαύσεως ("for the sleep and repose") [159], ἀπόθανε ("died") [33.K],[69] Ἐνθάδε κεῖται ("here lies") [111], and Ἔνθα τέθαπται ("here is buried") [32.J]; μακαριώτατος (deceased) is also used once [33.E].[70] These recall the semantic range found in contemporary and earlier Hebrew epitaphs.

Unlike the liturgical diptychs, which often commend the deceased to the bosom of Abraham, Isaac, and Jacob,[71] very few epitaphs in Greek add such injunctions as "help your servant" or "pray for him." They do, however, supplement the declarative statement of death with multiple details about the date. In this they resemble Greek and Latin dedicatory inscriptions more than devotional texts.[72] The year of death is always given according to the Orthodox calculation from the beginning of the world. Only a few epitaphs cite the indiction, but more give the month and date and some even the day of the week or the precise hour of death [37, 99.A, 114.A, 137.A, 156.A].

The Greek used in all types of inscriptions and graffiti ranges from excellent to crude. Every possible iotacism is found: η–ι, η–ε, η–ει, ει–ι, ι–οι, and others (for example, μη for μοι [143.D]), and much exchanging of other vowels (ω–ο, ω–ου) and consonants (θ–τ) as well. The large number of undeclined names in public texts—Βενεδίτους at San Vito dei Normanni in the late twelfth century [109.A], Μαργαρίτα at Vaste in the fourteenth [157.I]—suggests vernacular influence.[73] Some of the damned in the Last Judgment at Santo Stefano in Soleto are identified in Greek (Ο ΠΛΟΥΣΙΟ, ΝΕΣΤΟΡΗΟ) but consistently omit the final S [113.B].[74] In the late fourteenth-century hospital dedication from Andrano, where ξενόνας ίτη σπητάλη is a vulgarization of the classical ξενών (hostel), it was necessary to signal its equivalence (ἤτοι, "that is" or "in other words") to the

Italian *spitali* (from Latin *hospitale*) [**4.A**], which must have been the more familiar term.[75] At the same time, the Greek epigraph over the right door at Santa Caterina in Galatina identifies the church, or part of it, as a *kappella*, Italian for "chapel" but with the more Greek-looking orthography of *k* instead of *c* [**47.A**].

In a devotional text from Vaste, the priest George is identified as son of Lawrence, and either he or his father is an ὀβφέρτος, probably an oblate,[76] of Saint Stephen, to whom the rock-cut church was dedicated [**157.G**]. In the elegant inscription by George of Gallipoli for a liturgical candelabrum [**49**], the Latin "patron" (πάτρωνος) is used, probably for metrical reasons, in lieu of available Greek terms.[77] Perhaps the best example of vernacular impact in a Greek linguistic context is the sundial outside Santa Maria della Strada at Taurisano [**145**]. It has a Greek caption, Αἱ ὧραι τῆς ἡμέρας, but these "hours" are the Latin liturgical ones—Prime, Terce, and so on—identified here by their first letter rendered in Greek.[78] The language of this sundial is bilingual, both literally and metaphorically.

Bilingualism

When Hebrew and Latin texts are juxtaposed in a single Jewish tombstone, the information in each text may differ minimally or substantially. In one stela at Taranto [**123.A–B**] the two epitaphs are very similar; they share the desire to highlight the important names, ensuring that they appear at the beginning or end of a line. Yet in another example from the same city, only the Latin side communicates the dead man's age and his father's name, while the Hebrew side combines excerpts from a psalm and a proverb [**124**]. The stela from Oria is similar [**81**]: the Hebrew face quotes from the ancient funeral liturgy, praises Hannah as a wise woman, and affects literary pretensions with its rhyming lines and initial acrostic that reveals the author's name, Samuel. Only in the Latin text on top is the deceased woman given a title ("Lady") and her father named with an abbreviated honorific ("R," for "Rabbi"). It seems clear that this information was directed toward different audiences, not only in terms of literacy but also in content: titles in Latin, liturgy and poetry in Hebrew.

Hebrew bilingualism seems to end before the ninth century, but different types of Greek-Latin bilingualism are much more numerous and of longer duration. The absence of visual bilingualism except by Jews before the twelfth century indicates a high degree of language exclusivity by the people involved in commissioning and executing wall paintings and inscriptions. I have identified three major types of bilingualism in the public monuments of the later medieval Salento: intrasentential language mixing, which occurs within a single sentence or text; intramonumental mixing, in which a minority of texts are rendered in a language

different from the one used extensively in a single monument; and fully bilingual monuments.[79] Linguists have shown that such "code switching"—embedding a syntactic unit (a letter, morpheme, word, or sentence) in one language in a different matrix language—was a socially meaningful act.[80]

A handful of monuments exhibit intrasentential language mixing, in which an inscription, or *titulus*, begins in one language and ends in, or is interrupted by, another.[81] An example is the *titulus* that identifies John Chrysostom in the apse of Santo Stefano in Soleto in the fourteenth century [**113.sc.2**]. It reads "S," the Latin abbreviation for "Sanctus," and "IⲰ," the beginning of John in Greek.[82] A longer intrasentential text is the dedicatory inscription at Acquarica del Capo [**1.A**]: the eight-line paragraph begins in Latin but concludes with the painters' names in Greek. The artists shifted to their native tongue to record their statement of authorship once the text assigned to them by the patron was complete. Code switching of the modest intrasentential sort may be unplanned, but it is not uninformative: it indicates that artists had some familiarity with a second language.

Monuments that manifest intramonumental mixing are the largest group. In these, one or two discrete texts are written in a language different from the one that dominates in that site. This group can be divided into three subtypes according to the kind of texts involved: didactic *tituli*; devotional and dedicatory inscriptions; and sacred speech acts. In the first subset, one or two short *tituli* interrupt an otherwise monolingual pattern of figural identification. Nicholas, who scarcely needed identification, received a double *titulus* more often than any other saint, although in the crypt church dedicated to Michael at Li Monaci it is the archangel and John the Evangelist who received the double label, done by the same hand [**43.st.1**]. As in this case, only rarely is the saint with the extra *titulus* the titular saint,[83] so the double name is not warranted by communal significance; nor is the doubly labeled figure the name saint of any patrons or supplicants or artists whose inscriptions survive (there is a low correspondence in the Salento between supplicants and homonymous saints).[84] Most likely the special *tituli* were connected with an individual's desire to advertise personal devotion by visual means: more text attracted more attention because of the power of script itself. Sacred figures were made more powerful and more insistently present by graphic and epigraphic means.

A second type of intramonumental language mixing occurs when the less-used language is employed for a devotional or dedicatory text. Hence a layman and a Latin text are inserted into the otherwise entirely Greek program at the Orthodox monastery of Santa Maria di Cerrate [**114.E–G; Plate 15**]. Clearly, the Lord accepted prayers in both Greek and Latin, and language did not preclude someone from patronizing a church of a different Christian confession. The third type occurs when code switching indicates a speech act by a holy person. In the

thirteenth-century Annunciation scene in San Pietro at Otranto, the *titulus* for the archangel Gabriel is in the church's dominant language, Greek, but his salutation to the Virgin is rendered in Latin.[85] The open Gospel book held by Christ at several sites displays text in a language different from the majority inscriptional language in the church. It serves to distance him from the local speech community, and a few individuals likely reaped social benefits from this change of code: the local priest may have been seen as bridging the gap between sacred and secular because of his (relative) scriptural literacy, and the patron's status would only increase if the language of the sacred citations were also his own public language. This was certainly the case with John of Ugento at Acquarica [**1.A**].

Only a few sites in the medieval Salento can be termed "bilingual monuments." In these cases there is no dominant language; both Greek and Latin are used extensively and contemporaneously. Perhaps the best example is the dated crypt at Li Monaci, where the long dedicatory inscription is in Greek [**43.A**], two saints are identified in both Greek and Latin [**43.st.1**], the protagonists in the Annunciation and the Crucifixion are labeled only in Latin, and the Crucifixion scene in the apse has the *titulus* "VICT[OR] MORTIS" [**43**]. The date in the dedicatory text (1314/15) applies to all of the extant images on stylistic and paleographic grounds. The French-surnamed patron employed a father-and-son team of painters, one of whom used artistic models intended for Roman-rite places of worship even though this site was intended for Orthodox use: it contains an exclusively Orthodox saint, Onouphrios, in the left corner. In the left apse niche, an elderly John the Evangelist—the Byzantine type, not the youthful evangelist favored in European art—holds a Gospel book that has around its edge Ἐν ἀρχῇ ἦν ὁ λόγος ("In the beginning was the Word," John 1:1) [**43.st.1**]. Above him, a partly preserved fragment of a fish is the one that swallowed Jonah, identified by the letters *omicron* plus a superimposed *pi* and *rho*, the beginning of *ho prophetos*, "the prophet," in Greek. The connection between Jonah and John is both liturgical and textual. In the Orthodox liturgy the book of Jonah was read at Vespers on Holy Saturday while John 1:1 was read the next morning, Easter Sunday. The text of Jonah begins "The Word of the Lord came to Jonah" and John's Gospel begins "In the beginning was the Word."[86]

Adjacent to Jonah and John at Li Monaci is the Annunciation, done by a different hand and labeled in Latin [**43**]. Several Byzantine hymnographers linked Jonah with the Virgin, including an eighth-century ode by Cosmas the Melodist that also references the Logos, as on the Gospel book held by John.[87] Farther to the right is the apse Crucifixion with its exceptional *titulus* referring explicitly to Christ's victory over death rather than to the usual "Jesus of Nazareth King of the Jews" [**43.A**]. Such an explicitly salvific title reinforces the message of the Jonah image and strongly suggests a funerary function for the church. The presence of

the Virgin and John flanking the cross brings the image in line with the deesis imagery more typical of apses in the Salento. At Li Monaci, then, the languages serve to introduce the complexity of the cultural space.

Literacy

The preceding discussion of bilingualism raises the question of literacy, a term that is notoriously difficult to define. Does it imply reading complex texts, or only recognizing one's name? Does it require the ability to write or only to read? How many spelling or grammatical errors are permitted before one's supplication is considered illiterate? However it is defined, there are no studies of medieval literacy that focus on public texts in the Terra d'Otranto. Among private texts, historians who have studied notarial documents identify as illiterates those parties or witnesses who cannot sign their names and instead make the sign of the cross.[88] In Taranto, the notarial acts in Greek from the tenth to thirteenth centuries reveal approximately 70 percent literacy, 27 percent semiliteracy, and only 3 percent illiteracy.[89] At the same time, some of the monks at the important Orthodox monastery of Saint Nicholas at Casole could not read Greek.[90] A study of Latin usage in medieval Bari found a high level of literacy among upper- and middle-class laymen and a lower level among ecclesiastics, two-thirds of whom did not surpass the elementary level.[91] While functional literacy seems to have been more prized in Byzantium than in Europe, this was no longer true, at least in Italy, by the thirteenth century.[92]

Jack Goody wrote, "Where writing is, class cannot be far away."[93] Literacy was a source of social power, and the very fact of an inscription connoted status; this was true in antiquity and it remained true in the Middle Ages and beyond.[94] The literate, or those who could afford to fabricate evidence of it by commissioning texts, dominated the illiterate majority through the power of the word. "Monumental texts may exercise power through their location in space and the way they look,"[95] and many of the local dedicatory inscriptions—solid, framed blocks of words—were inscribed permanently, or at least durably, in prominent interior and exterior spaces. Most are in a church apse or over a doorway, obvious focuses of viewer attention. In this way messages and status were broadcast widely. The multiplication of monumental texts, such as the repeated strips of information in the Otranto mosaic pavement [**86.C–G**], make grand statements that attract the eye, as do texts supplemented by figural imagery. Devotional and funerary texts are rarely as long, as prominent, or as sizable as dedicatory inscriptions, but when they are disproportionately large or noticeable they command proportionally greater attention. Anyone entering the Carpignano crypt would be drawn to

Stratigoules's burial site, which has the longest funerary text in the Salento in any language and a unique arcosolium setting [**32.J**]. With its composition underscored by color, its intimate physical connection with sacred figures on the intrados who shelter the tomb, and its literary pretensions (regardless of its dodecasyllabic defects),[96] this text for a dead boy mostly helped his father stake his place in the local community, despite his modest title of σπαθάριος.

Linguistic Identities

La'az (לעז) is the generic term in Hebrew for a non-Hebrew language, including one that a Jew might speak.[97] In the *Arukh*, a Hebrew dictionary compiled in Rome circa 1100, *la'az* is glossed with the vernacular *barbaro*—stranger, non-Jew, from the Greek term for "barbarian." It is a cultural term as well as a linguistic one. Three centuries later, in an extensive glossary compiled by Judah Romano in Rome to clarify difficult terms in Maimonides's *Mishneh Torah*, the meaning of *la'az* is again limited to "foreign" language, probably synonymous with "vernacular." Other terms are introduced here as well: *Latino* refers to someone who does not speak Hebrew, but likely refers to Romance rather than Latin.[98] In the *Arukh* and elsewhere, the expression *lashon romi* does not mean "speech/language of Rome," which would be a literal translation referring to some form of Latin, but rather "a hybrid language, strongly graecicizing, perhaps that spoken in the central-southern regions of Italy under Byzantine influence."[99] *Rom* in medieval Hebrew sources is Byzantium, the medieval Roman empire and not the ancient imperial city; Byzantine (and South Italian) Jews were Romaniotes. In general, the non-Hebrew *lo'azim*, including Italian *volgare*, were derided by learned Jews as *notzrì*, Christian (from "Nazarene"), and this attitude meant that it was not used as a creative literary language by Jews before the sixteenth century. Nevertheless, short glosses in medieval texts indicate that the Italian Jews were developing their own written and spoken vernacular, which we now call "Judeo-Italian," based on vulgar Latin.[100] Jewish women, and not a few men, would have profited from translations of the Scriptures and the prayer book written specifically for them in the thirteenth and fourteenth centuries.[101]

Greek speakers are found in today's Salento only in nine communities south of Lecce, but the medieval Hellenophonic zone was much larger.[102] The language spoken in the Grecìa salentina is a particular dialect called by its users *griko* or *grika*: "milume grika" means "we speak *grika*." This word is not Greek; it corresponds neither to Latin *graecus* nor ancient Greek γραικός. Gerhard Rohlfs suggested that it was the term that the ancient South Italians, speaking an Italic language related to Latin, called their Greek-speaking neighbors in Magna

Graecia.[103] It remains unclear whether the dialect represents a survival of ancient Greek or a medieval phenomenon.[104] Regardless of its antiquity, the term and the dialect survived through and beyond the Byzantine period.[105] After unification in 1861, when Italian was imposed as the country's official language, *griko* speakers in the Salento continued to use their traditional dialect among family and friends, while the Romance vernacular was used for everyday business and Italian only for official matters and largely unavailable higher education.[106]

Griko is illuminated by considering its use among Jews. After being expelled from Spain in 1492 and from the Salento by the Spanish rulers in 1541, the affected Jews went mostly to Thessalonike, part of the Ottoman Empire, or to Corfu, under Venetian rule. In both places they found Romaniote (formerly Byzantine) Jews, Italian Jews from Rome, Ashkenazim, and Sephardim practicing their distinctive liturgical rites. Visitors to early modern Corfu record that there were communities of Jews of diverse origin that included both *gregi*—Jews from the Salento who spoke *griko*—and others from Apulia who used *pugghisu*, "Puglian," the Salentine Romance vernacular.[107] These communities had names derived from their languages: *qehillah apulyanit* (the Apulian community, using Romance) and *qehillah griqa*, or *griga*, using Salentine Greek.[108] The linguistic term was thus a cultural signifier for both Jews and Christians.

The ancient Greeks labeled those who did not speak their language *barbaroi*, "barbarians," and this term is also used to describe the Libyan heathens in the Byzantine dedication of the rebuilt walls of Taranto [**139**].[109] Today, *ppoppiti*, with the same kind of staccato syllables as *barbaroi*, is used to describe the inhabitants of the southern Salento by those who live along and beyond its northern limit and speak an Apulian rather than a Salentine dialect.[110] *Ppoppiti* has also come to connote boorish, unlettered peasants, just as speaking a non-Greek tongue once implied other kinds of cultural and behavioral barbarisms. As usual, when the term is adopted by those who have been identified pejoratively—when it becomes an emic rather than an etic label—it loses much of its negative force.[111]

This chapter has demonstrated ways in which language is a linchpin of identity. Hebrew users were at least bilingual because they were always part of a larger community that did not share their language. Greek and Latin speakers, especially those who lived in a monolingual village, lacked such linguistic pressures, but their verbal interaction is apparent in their public texts nonetheless. Despite the erasure of the Jewish communities of the Salento by the sixteenth century, both the Jews and their sacred language have left traces in the local record. In addition to the toponyms that refer to Jewish streets or neighborhoods, we noted in the previous chapter the derogatory labels *Sciutei* and *Sçiudèu* applied to the inhabitants of two southern towns. In Taranto, during the procession of the "Perdoni" characteristic of Holy Week, those seeking pardon from sin walk in pairs to venerate tombs in

the city's churches and are greeted in the street with *u salamelecche*, a respectful inclination that surely derives either from the Arabic *salaam aleikum* or the Hebrew *shalom aleichem*, peace be with you.[112] Few today understand the origin or meaning of the phrase.[113] While I cannot prove that Hebrew words penetrated the local dialects, they did in Rome and may have done so here.[114] In any event, the Salento vernaculars mix linguistic elements from Greek and Latin, and this is one of the features that conferred a unique regional identity. Even now, the inhabitants of one town in the Salento can identify those of another by their dialect. As was the case in the Middle Ages and earlier, language continues to be used as a method of inclusion and exclusion.

CHAPTER 3

Appearance

It is often said that "clothes make the man," and appearance is indeed the most obvious signal of identity.[1] Before names are exchanged and languages employed in spoken discourse, impressions have already been formed on the basis of appearance.[2] Instinctively, and not always correctly, we interpret such cues as physiognomy, dress, and jewelry in order to categorize and judge others according to gender, status, and even religious or cultural or ethnic affiliation. The elements of appearance thus communicate social identities in a nonverbal manner.[3] Yet because the meanings and relative importance of the components of appearance vary according to context, messages sent by the wearer of a certain costume may not be perceived, or even received, by his or her viewers. The people we meet have likely conferred upon us a social identity based entirely on appearance without our even being aware of it.

How can we apprehend the appearance of medieval Salentine men, women, and children who belonged to a range of social, religious, and cultural groups? First, we can examine both skeletal remains and artifacts retrieved from tombs. Physical remains tell us something about the size and health of these people, and grave goods provide evidence for contemporary dress and ornament. Second, painted representations of individuals, often called "donor portraits,"[4] are especially valuable; even if they do not report what the supplicant really looked like or what he or she actually wore, the depictions are at least related to patrons' and viewers' aspirations and expectations about appearance. Third, certain realistic details in the religious imagery so prominent in South Italian medieval art may also reveal contemporary practices in clothing, hairstyle, and adornment; convincing work has been done on the interpretation of such "realia" in Byzantine religious art.[5] Finally, textual sources sometimes convey information about the ways in which the various elements of appearance communicated meaning in their own time. In this chapter, I analyze archaeological, artistic, and textual sources to uncover the most significant components of appearance: physiognomy, dress, jewelry, and hairstyle.

Physiognomy

Skeletal material from medieval southern Italy is limited but still informative about stature and diseases that might affect appearance. Tenth- and eleventh-century skeletal remains from the medieval village of Quattro Macine provided a male adult specimen approximately 1.672 meters (5.48 feet) tall and a female 1.515 meters (4.97 feet) tall (from tomb XI, [**102**]).[6] Here and at the nearby excavated medieval village of Apigliano, the deceased are aptly described as "smallish" in stature.[7] Many individuals suffered from joint ailments, particularly osteoarthritis,[8] and even children were susceptible to the dental decay that caused adults to lose most of their teeth before death.[9] Three infant burials at Quattro Macine show a malformation of the growing ends of the long bones, a visible genetic defect.[10] The curved femurs of an early medieval male buried at San Pietro Mandurino may indicate an equestrian profession,[11] though they would seldom be visible under his clothing.

 To a limited degree, biological characteristics helped constitute individual and group identities.[12] This is particularly clear in the case of slaves. Even though the most detailed information about slavery in medieval Italy comes from northern cities, there is no doubt that slavery was a part of southern Italian urban life as well. There are records of purchases and manumissions in twelfth-century Bari and thirteenth-century Lucera;[13] in the Salento, a slave in Gallipoli was donated, along with his sons and property, to the Benedictine monastery of Santa Maria at Nardò in 1115.[14] However, prior to the early thirteenth century skin color is rarely used as a descriptive adjective for slaves.[15] A female slave purchased by a Jewish resident of Taranto in 1482 is identified as having black skin, but also, and equally, she is said to be unbaptized, of good health, and named Catherine.[16] Assigning color was, in any case, a highly subjective process: "Tartar" slaves brought to Florence from the north shore of the Black Sea might be described as black, brown, olive, fair, reddish, or white.[17] Faces were far more important than color, as they were believed to communicate aspects of character and elements of distinctive individuality that would be most useful in identifying a slave who ran away.[18] Hence eye shapes and colors were often noted in slave transactions, as were body piercings (mostly ears, though one Greek female had a pierced nose), whereas such mutable traits as hair color and hairstyle were omitted. Unlike skin color, nose shape could serve as a proxy for ethnic labeling: Tartars all had flat, snub noses even though they came in six colors.[19] An ancient Jewish midrashic compilation says there can be no legal identification of a man without identification of his nose, the most important feature of his face.[20] It is worth noting that all the religious groups in the Salento believed that things seen by a woman during her pregnancy would affect the appearance of her child.[21]

If we turn to images of human suppliants to assess the physiological and immutable features of appearance—stature, skin color, facial features—we find some correspondence with the archaeological record. When the painted figures are paired, presumably husband and wife, the male is shown noticeably taller, which accords with the skeletal evidence. Two examples are the parents, Antony and Doulitzia, in the apse at Vaste [**157.A**], and the anonymous embracing couple on the ceiling at Li Monaci [**Plate 9**]. The size disparity is even greater at the Candelora crypt in Massafra, where a kneeling male figure adjacent to Mary in the scene of Jesus going to school is the same height as the standing female behind him [**63.A; Plate 12**]. Almost all depicted suppliants are very small compared to the holy figures they venerate—Santa Maria del Casale near Brindisi [**Plate 5**] contains notable exceptions—but this is clearly symbolic.

Depictions of nonwhite skin are limited to nonhumans: the devilish personifications of the Jordan River in scenes of Christ's baptism at Otranto and San Mauro near Gallipoli are black, as is the enormous stucco-relief Satan in the Last Judgment at Soleto [**113.B**] and the tiny demons there and in the same scene at Santa Maria del Casale [**28.A**]. The angels who guard the access to Paradise in Soleto are red. No depicted suppliant or servant is black or brown, but what I am calling "white" might well have been termed "olive" or "reddish" or "fair" by medieval viewers (and slave owners). Different kinds of noses are shown, sometimes in the same monument, but it seems very unlikely that a snub nose, like that found on many of the painted figures at San Vito dei Normanni [**109**], is anything other than an artist's unconscious stylistic fingerprint.

Clothing

More than stature, skin color, and even facial features, clothing was critical to the construction and perception of individual and group identities in the Middle Ages. Yet the homogeneity of depicted fashions at any given date—regardless of the language of accompanying inscriptions or material evidence for local worship or textual information about the local community—indicates that clothing alone is not an adequate indicator of cultural identity. It could reveal or conceal the wearer's gender, age, profession, wealth, and other aspects of status through the selection of colors, fabrics, specific garments, and trims. Only at the very end of our period did clothing reliably reveal the wearer's faith: even though badges were imposed on Jews after the Fourth Lateran Council of 1215, we do not see them in local artwork until more than two centuries later. While no aspect of dress is remote from the issue of status, in this section I examine clothing from the perspectives of fabrics, colors, garments, and styles, showing how depictions of dress can serve, in

conjunction with other features, as indicators of date. Only after compiling these "factual" data about medieval garments can we discuss what they reveal about social class.

Fabrics and Colors

The information gleaned from a close look at painted clothing has been almost entirely ignored in the local literature; the sole exception is that archaeologists regularly compare excavated metal belt fittings and earrings with the same objects worn by a well-preserved painted Saint Lucy at the Buona Nuova crypt at Massafra [62].[22] A recent study of the nomenclature of material culture in Apulia relies almost exclusively on notarial acts and rarely ventures into the artistic evidence for the terms being defined; the same limitation applies to a classic older study of Byzantine clothing in Greece.[23] Yet it is worth combining the textual, archaeological, and artistic data in a more nuanced manner to assess which features in the painted corpus are observed, contemporary realia and which are the products of model books or the artist's imagination.

No cloth has survived in Salentine tombs, where even leather has decomposed in the damp climate, but archaeologists have identified spindle hooks and whorls at the medieval village of Quattro Macine.[24] The presence of more sheep bones than goat remains at Otranto suggests that the former were preferred, doubtless for their wool,[25] though rough goatskin garments are not unknown in the Byzantine world.[26] Sheep remains have been found at every medieval excavation, even prior to the tenth century.[27] Wool and linen were the most common fabrics and both were manufactured locally. In damp areas along the coast flax was cultivated for linen,[28] and linen fibers have been identified inside a belt buckle from Quattro Macine.[29] Very fine byssus cloth was made from the silky filaments of bivalve mollusks at Taranto and recorded in documents as ταραντίνον.[30] Cotton does not seem to have been produced in the Salento until late in the period covered here.[31]

Locally worked leather was used for belts, shoes, and the soles of stockings. Belts and shoes could be trimmed with bronze or iron, and at the village of Apigliano iron was worked on-site.[32] Fur, highly prized in medieval Italy, may have been available locally in the form of wolf or cat as well as rabbit and lamb.[33] However, the opulent furs worn in wall paintings by a few painted supplicants and a much larger number of religious figures could not have been manufactured locally, so if they were actually worn and not merely represented they must have been imported.[34]

Unlike neighboring Calabria, Sicily, and Greece, Apulia probably did not practice sericulture in the Middle Ages, though silk may have been dyed or otherwise treated there.[35] In the twelfth century all ten of the Jewish households in Brindisi

were associated with the dye industry,[36] but the sources do not tell us what fabrics they dyed and wool likely predominated. A part of Grottaglie known as the Lama del Fullonese apparently took its name from the community of Jewish dyers who worked and probably lived there.[37] The Jews of Taranto had a monopoly on textile preparation and dyeing in that city, granted initially by William II; from the mid-thirteenth century on they paid the archbishop of Taranto a handsome sum for the privilege.[38] However, there is no indication that Jews were restricted to this particular livelihood or that non-Jews could not participate in textile production outside the city of Taranto. The fulling mills at Racale and Ostuni were not associated with Jews.[39] It is likely that Jews were active in the dyeing industries at Otranto, Oria, and other cities in southern Italy, as was the case around the Mediterranean.[40]

We possess written sources that have not been used previously to confirm the archaeological and historical evidence for cloth manufacturing in medieval southern Italy. Glosses in the Salentine dialect found in the margins of the eleventh-century Mishnah manuscript now in Parma clarify many of the terms found in the Hebrew text related to the production and sale of cloth. In these marginalia are such terms as *kui karmena*, he who dyes wool its most common color, red; *raiiu*, from Latin *radius*, the weaver's spindle; *savani*, from the Greek σάβανον, *sabanon*, a thick linen cloth.[41] The uniquely Jewish prohibition against mixing together fabrics obtained from animals and plants, specifically wool and linen (*sha'atnez*), is reiterated in these glosses with the injunction to weave each fabric on its own loom to avoid any accidental mixing[42] and the warning that one who weaves or wears "impure" fabrics will bring upon himself the wrath of God.[43] The local Christians' tendency to combine different fibers may lie behind the Salentine Jews' concerns in this regard.[44] The medieval glossator cites the Palestinian rather than the Babylonian Talmud, which is important evidence for the continued use of that source in southern Italy in the eleventh century.

Judah Romano's glossary, another heretofore unused source, also sheds light on fourteenth-century Italian textiles and practices. For the entry *cuffia, coife*, referring to a hair covering, Judah notes that one is permitted on the Sabbath to transport a quantity of nuts or pomegranate peels or skins, or indigo or madder or other colors, sufficient to color a small garment such as a girl's bonnet.[45] These materials for dyeing were thus known and available in fourteenth-century Italy.

The most common dyestuffs in medieval Europe were vegetal: woad, from which indigo was derived and which did not require a mordant to make the color adhere, and madder, which yielded red.[46] According to a Jewish midrash, the madder plant is called פוה (*pu'ah*), which was also the name of Issachar's second son about whom it was said, "as this plant colors all things, so the tribe of Issachar colors the whole world with its teachings."[47] *Pu'ah* could also refer to the blue or red

obtained from woad.[48] A blue cloth dyed in the wool could be redyed by the piece with red or yellow (from weld or rose seeds, or saffron) to produce a wide range of other colors, including black,[49] but each successive dyeing added to the cost of the cloth. Even when such costly dyestuffs as kermes, brazilwood, and shellfish were not used, dyeing was the highest single component of cloth price.[50] A wide range of colors was available; the ones most prized were lustrous, luminous, and resistant to fading.[51] Many colors—black, red, white, blue—were difficult to obtain, but could be purchased by the wealthy and are recorded in documents. A strong green was a problematic color rarely recorded in notarial acts.[52]

In the fifteenth century, some Jews were distinguished by color appliqués: the red *rotella* is visible in two narrative scenes at Soleto [**113.sc.1; Plate 14**],[53] and it may have been the clothing of Jews in late medieval Gallipoli that inspired the local name of a fish, the *sciudeo* (literally, "Jew-fish"), distinguished by its red and yellow stripes.[54] Red and yellow stripes are worn by servants—horse grooms—at Santa Maria del Casale near Brindisi [**28.H, V; Plate 7**]. The two colors are juxtaposed but not striped on the ceiling at Li Monaci [**Plate 9**] and on the walls and ceiling at Ugento [**151.B, C, st.1**], all datable to the early fourteenth century.[55]

The poor wore undyed fabrics, and we see two of them, dressed in grayish tones, holding candles in the crypt church of San Nicola at Mottola [**76.E; Plate 13**]. Yet these are not the individuals who are most often shown in small village churches. Modest as they or their contributions may have been, these supplicant figures usually wear dyed garments that would have communicated a more elevated social identity to contemporary viewers. I do not suggest that this identity was real, or that people actually wore the specific garments shown; more likely these garments are stylistic syntheses, idealizations effected by artists eager to please and open to inspiration from varied sources. I agree with those historians of dress who argue that in commemorative images of people, unlike narrative religious images, artists did not simply work from a prototype, but there is a high degree of sameness among the humble Salentine supplicants.[56] While blue, greenish gray, white, and yellow are occasionally worn, red (or reddish brown) is by far the color most commonly worn by a painted human figure in the Salento across the Middle Ages. This is the case in Santi Stefani at Vaste [**157; Plate 18**] and Santa Maria del Casale [**28; Plates 5–7**], two otherwise very different fourteenth-century monuments. At Vaste, nine different figures are shown in virtually identical red garments. Only the wealthiest patrons could afford richer, more costly dyestuffs like kermes and fine cloths like imported "scarlets," printed silks, and furs. A few supplicants, mostly in fourteenth-century Roman-rite churches, are shown wearing such obvious luxuries; otherwise, only painted saints and ancillary figures in Christian narrative scenes are depicted in luxurious garments.

Certain special days were occasions for wearing garments of a particular color, which at times distinguished Christians and Jews. The *Shibolei ha-Leqet* treatise of practical halakha (Jewish law) illuminates this in its discussion of Rosh Hashanah, the Jewish New Year:

> The custom in the world [*ba'olam*] is that when a man knows he will be judged he wears black and covers himself in black and grows his beard and does not cut his nails because he does not know what the judgment will be. Jews [*Yisrael*] do not do this: they wear white and cover themselves in white and shave their beards and cut their nails and eat and drink and are happy during Rosh Hashanah because they know that God is making miracles for them and is judging them favorably. These are the reasons why it is not allowed to fast on Rosh Hashanah.[57]

The supposed black clothing of Christians on Judgment Day is not supported by extant wall paintings, where the damned and the saved in those scenes at Santa Maria del Casale [**28.sc.1**] and Soleto [**113.B**] wear many colors, with the same preference for red that characterizes the depictions of supplicants. Perhaps real people did wear dark hues on penitential occasions, however. There are a few more differences in clothing and hairstyles with a religious rationale, but the vast majority of distinctions in clothing depend on gender, age, and social status rather than on faith.

Infants' and Children's Clothing

Infants are seldom depicted in extant Salentine wall paintings, except for the Christ child in the Nativity scene and the infant Virgin held by her mother or, in the form of a swaddled soul, by Christ at her dormition [**Plate 15**]. An infant is recognizable by its tight herringbone swaddling;[58] regardless of season, strips of white linen were wrapped tightly around the body, mummylike, with only the face left free. Such swaddling was still done in the Salento a century ago[59] and is an example of medieval realia when found in religious scenes. In nonnarrative images this realistic swaddling is uniformly suppressed, as when Anne holds the infant Mary [**32.B**] or in countless scenes of Christ in the lap of his mother; this indicates that Mary and Jesus were understood not as infants but as children. Corroboration that swaddling of newborns was also done in Jewish families is found in the fourteenth-century Maimonidean glossary from Rome, where *anfasciatu*, "bound in strips" (*fascie*), glosses the Hebrew equivalent.[60] The same source gives the motive for such wrapping: "one wraps and ties so that the legs and arms are long and straight and not curved and distorted"; moreover, it is permitted to do so on the

Sabbath because not doing so endangers the infant's health. Infantile *sabanon*, referring to the linen cloth (Greek, ρινάρικος, σάκκινος), is not mentioned in earlier medieval sources.[61]

Depictions of children as supplicants are limited to the two daughters at Vaste [**157.A**] and roughly contemporary mother-daughter pairs at Santa Maria del Casale [**28.C, U**]; in both cases the girls are dressed just like their mothers in long red garments. In narrative scenes, holy children—Christ, the Virgin, Nicholas at Muro Leccese—are almost always classically dressed in a long robe over a full-length tunic (χιτών). Only occasionally does this costume vary in a way that suggests youthful attire. In the Flight into Egypt at San Vito dei Normanni, Christ's tunic is short enough to reveal his knee and lower leg, and in the Candelora crypt at Massafra, Christ, being taken to school by his mother, wears a knee-length tunic, a short-sleeved vest or doublet (*dubblectus*),[62] and a short blue cape over one shoulder; on his feet are patterned socks or soft boots [**63.A**]. The children in the Entry to Jerusalem scene at San Vito dei Normanni wear a white knee-length undergarment, the *camisia*, or καμίσιον, beneath patterned tunics that have been removed for easy tree climbing.[63] In general, juvenile clothing did not differ appreciably from that of adults of the same gender.[64]

Male Dress

While all of the male supplicants wore underclothes, none are visible. These would have included breeches (*guttela*, βρακιά) and a short linen chemise (*camisia*).[65] Both are visible in the early fifteenth century at Soleto and Galatina, in narrative scenes that depict condemned persons, torturers, and lowly workers [**113.sc.1; Plate 14**].[66] The chemise alone was worn by adult male laborers, including shepherds in Nativity scenes, Nicodemus in the Deposition at San Simeone in Famosa [**70.sc**], and agricultural workers and builders in the mosaic pavement at Otranto [**86.A**]. Until a half-century ago this was the typical dress of the Mediterranean peasant,[67] and no supplicant in the Salento is shown in such penurious and practical attire.

If we review the surviving representations of laymen shown in the pose of a supplicant, we find a variety of costumes, not all of which correspond with terms recorded in documentary sources; perhaps their value was too low to figure in wills or donations. The majority of these depictions date to the end of the Middle Ages and are in contexts where Latin inscriptions predominate. Because the earliest dates to 1196, it is worth considering local examples of male lay dress in the preceding centuries in narrative contexts.

Whether they are intended to be real individuals or historical or imaginary ones, the eleventh-century males on a capital now in Brindisi from the Norman-

era Benedictine monastery of Sant'Andrea all'Isola seem to wear good Norman-era garb [**19**]. They sport belted knee-length tunics (*tunica*) over high socks (*calza*) and ankle-high shoes (*calces*); some also wear a thick scapular-like garment, perhaps of fur, that falls almost to the hem in front.[68] At least some of the garments resemble caftans, closed vertically rather than pulled over the head, a fashion derived from the Islamic world that was just emerging in Europe in the eleventh century.[69] All are belted with a long, often elaborately knotted cord (*cingulum*).

In the twelfth century styles changed, for those who could afford to follow fashion, to a longer tunic with sleeves called the *tunica, cotta*, or *gonnella*.[70] At San Vito dei Normanni one of the supplicant figures wears a calf-length green tunic, belted at the waist, over contrasting red hose and pointed black ankle-strap shoes trimmed with white dots [**109.B**]. In this he imitates not so much the adjacent saint whom he venerates, dressed in a green himation over a red tunic and with sandaled feet, as a shepherd in the Nativity scene on the opposite wall, who is even better dressed than he is with pearl trim on his hose, shoes, and the skirt of his short tunic. Moderately pointed shoes became fashionable early in the twelfth century.[71] A second supplicant at San Vito is clad in a knee-length tunic, like the shepherds, this time yellow with a red fringed belt and red socks or stockings [**109.C**]. A surprising feature of both figures' garments is how tightly they fit through the torso even though no lacing is visible. This style is documented elsewhere in Europe earlier in the century, generally in conjunction with a floor-length tunic.[72]

Later male figures in monuments with Greek inscriptions include the affectionate partner at Li Monaci (1314/15) [**Plate 9**] and figures at Vaste in 1379/80. The latter kneel in long red garments that are cinched at the waist even though the belts themselves are not visible; Antony, in the apse, has a white loop suspended from his, presumably a stylized handkerchief [**157.A**]. (Handkerchiefs are represented in late Byzantine art but not earlier.)[73] Stephen has an identical red robe but with a row of white dots from neck to waist and from the wrists to the elbow [**157.K–L**]. The dots represent buttons (*pumettus*, ἀνάστολες), which began to appear in Byzantium by the eleventh century but were then used only to fasten the front of elite men's garments.[74] Flat and spherical buttons are known from excavations at Otranto and elsewhere.[75]

Very similar figures are associated with monuments containing Latin inscriptions. At least four of the fourteenth-century supplicants at Santa Maria del Casale are shown kneeling in plain, tight-sleeved red tunics [**28; Plate 5**], as is a single figure at Grottaglie's Cripta delle Nicchie who also has something suspended from his belt [**53.D**]. Others at Santa Maria del Casale wear more elaborate clothing, with tight buttoned sleeves emerging from a red hooded mantle with elbow-length sleeves; both the sleeves and the hood are lined with fur, either white or the distinctive black-and-white vair [**28.I, N, O; Plates 5–6**].[76] (A very similar figure, in

red trimmed with vair, is poorly preserved at San Paolo in Brindisi [**26.F**].) Below a devotional text dated 1335, Nicholas de Marra adores the Virgin and Child in a red tight-sleeved tunic topped by a short cape trimmed with fur [**Plate 7**]. The four kneeling figures behind him wear two-toned garments of pink and green;[77] one has a short red cape or hood. None of the kneeling males in this church wear the radically different fashions that would be introduced around midcentury, although the two grooms/standard-bearers here do have extraordinary tall hats [**28.V**].

At other sites with a preponderance of Latin texts, supplicants are dressed in garments of different colors. At the Candelora crypt in Massafra (thirteenth century), a male kneeling beside Saint Stephen is dressed in a tight-sleeved white tunic and red hose with soles attached [**63.B**].[78] Nearby, the male half of the couple in the scene of Christ going to school wears a short blue-gray garment that opens in front over a darker-gray tunic [**63.A; Plate 12**]. At Masseria Lo Noce near Grottaglie (fourteenth century) the kneeling Daniel is dressed in dark blue; a bulge indicates a traveling hat perched on his back [**54.A**]. At San Giorgio di Roccapampina, the supplicant Calogerius sports a white tunic with red trim at the wrists under a long-sleeved light-blue garment, a *iuppa* (γιούππα) that has triangular gores inserted or is slashed at the front and sides to reveal both its red lining and the tunic underneath [**92.B**]. Red hose or shoes complete the outfit. And at Santa Maria di Cerrate, a kneeling fourteenth-century supplicant accompanied by the church's sole Latin inscription witnesses the Koimesis in a blue-green tunic under a tight-sleeved white robe lined in red [**114.F–G; Plate 15**].

Dramatic changes in male attire attested elsewhere in Italy in the mid-fourteenth century penetrated the Salento some decades later. Inspired by French fashions introduced at the Angevin court in Naples during the 1330s and seen in the following years in Rome, Florence, and Milan, fashionable men began to eschew the long tunic in favor of a knee-length, belted woolen *gonnella* over a short padded jacket, the *farsetto* or *jupparellu* (so called in Naples in 1314); this was attached to stockings now visible to the upper thigh and attached by laces to the new shorter breeches.[79] By midcentury the *gonnella* was so tight that laces and buttons were required to put it on, and in the 1360s–70s the *gonnella* was made to adhere not only to the chest but also to the flanks, with these areas emphasized by padding.[80] The wealthy never went out wearing only the *gonnella*, however; status demanded multiple overgarments.[81] The tighter styles were criticized already in a 1335 edict issued by King Robert of Naples, even though it was his own courtiers who were popularizing the style; clergy and moralists also bewailed the decadent new fashions.[82] For practical and economic reasons the peasantry never adopted the short and tight garments, just as they had rejected the change in the twelfth century to longer, trailing ones.[83] Several of the laymen depicted at Galatina, Soleto, and Santi

Niccolò e Cataldo in Lecce [**58.sc.1**] in the early fifteenth century wear the new fashions, while others maintain older sartorial standards.

Distinctive clothing was worn to signal such specialized professions as warrior, monk, cleric, or ruler. Soldiers are rare, surviving only in two late medieval monuments that both contain exclusively Latin inscriptions. At Santa Maria del Casale a helmeted Leonardo di Tocco is presented to the enthroned Virgin and Christ, followed by seventeen similarly outfitted men who kneel with hands clasped while leaning on striped shields [**28.D; Plate 4**]. Di Tocco's image seems curiously unfinished because the blue, and perhaps other colors too, has all but disappeared; witness the Virgin's tunic, which bears only traces of its original hue. (Because much of the scene immediately below has also been lost, I assume water damage affected this part of the nave.) Over a longer white tunic he wears a tight-sleeved red one, and over this is a diagonally striped, apparently quilted garment that has entirely lost its color. This surcoat, or coat armor, either has short red scalloped sleeves or covers another one that does. On his head is a gently curved helmet that dips lower in the back; because the helmet is of one piece and not two it is not a proper *chapel-de-fer* (kettle hat). However, it does appear to have a *bevor*, the attached rigid feature that protects the ears and neck.[84] Like the saint who presents him to the Virgin and Child, di Tocco wears diagonally striped upper-arm ailettes that had a decorative and heraldic function;[85] this is borne out by the fact that the shields and horses at the right of the panel also bear diagonal stripes.[86]

The praying figures who carry shields behind di Tocco are for the most part better preserved [**Plate 4**]. They all wear mail coifs and collars attached to mail hauberks that reach their knees and elbows. Over this is a red surcoat with scalloped sleeves. From the knees down are red leggings, possibly over mail chausses. Their helmets range from plain rounded ones to two-part basinets to elaborately crested or feathered examples. One soldier wears a very tall cap covered with red-and-yellow fabric with a scalloped fabric panel behind the neck. All of them carry flat-topped, diagonally striped shields with curved sides, the standard form of western European shield by the late thirteenth century. What is surprising about this panel is not so much the amount of seemingly realistic detail relative to other figures at Casale as the fact that the armor shown is probably not the most up-to-date; by the 1360s plate armor was widely used, and its complete substitution for mail is apparent from fifteenth-century depictions at, for example, Cerrate and Soleto.

The rowel spur over mail chausses visible on the right presbytery wall at Casale, under the fresco stratum with the well-preserved Virgin and Child, Erasmus, and Mary Magdalene, probably belongs to a lost warrior saint and certainly to the period soon after 1300 [**28.P; Plate 6**]. One of the earliest representations of such equipment is worn by a Byzantine soldier in a *History of Outremer* manuscript

produced in Lombardy circa 1291–95, but it remains unclear whether rowel spurs were Byzantine or Italian in origin.[87]

A knight kneeling beside Saint Antony Abbot at Galatina, just above the saint's pig, is accompanied by an inscription signed by the artist and dated 1432 [47.D].[88] The man is often thought to represent the patron of the church, Raimondello del Balzo Orsini, but I see little reason for this identification. He is dressed in thigh-length chain mail over a tight-sleeved red tunic and leggings, one red and one white. Over this ensemble are a sleeveless green mantle and a wide belt, part of which juts out oddly to visually tether him to the saint's mantle.

Turning now to a more common category of male imagery, there are a few examples of monks represented in the characteristic pose of veneration. Two figures at Miggiano whose *proskynesis* (veneration) is literally (mis)spelled out ("προ[σ]κηνισις") are identified further in Greek as "Leo the monk" and "Nicholas the monk," but with three figures depicted it is unclear whether only two are monastic [73.A–B]. Perhaps they are the two bearded figures, but these two are dressed differently and only Nicholas, the one shown bending over in full proskynesis, wears monastic garb; the other bearded figure, by far the largest and also the only one not named, sports a tight-sleeved garment with decorated wrists under a bluish robe with a decorated hem. The ornamented hem would seem to remove him from the monastic ranks. The uppermost figure, Leo, is dressed like the crouching Nicholas but lacks a beard; perhaps he is a young monk. An enigmatic beardless figure I discovered on the east wall at Li Monaci may be a monk; he wears a red-brown robe with a bunched neckline but his head is uncovered [43.B]. The brown-robed, hooded figure kneeling beside a female saint in the Crocefisso della Macchia cave is certainly a monk [34]. He even has a cord for a belt.

While it is relatively easy to compare the dress of monastic supplicants with the costumes worn by monastic saints, who are plentiful in Salentine churches, it is less easy to know whether a clerical supplicant has been represented in accord with sainted models. While bishops are attested epigraphically as patrons, they are not shown in extant monuments. The same is true for deacons; at least four are attested in inscriptions, but none are identifiable as painted supplicants. The only distinctive article of clothing occasionally worn by saintly deacons is the orarion, the striped prayer shawl worn over the left shoulder by, for example, Saint Stephen in the Candelora crypt at Massafra [63.B]. Unlike these other clerics, Salentine priests are not only cited but also depicted as supplicants. At Vaste in 1379/80, a tonsured priest named George kneels in prayer beside the Virgin and Child [157.G]. He wears a tight-sleeved red tunic under a white surcoat with loose elbow-length sleeves; the surcoat may be slit like that of Calogerius at Palagianello [92.B], though no colored lining is visible. At Otranto, in the same century, a

tonsured priest identified in Latin as presbyter John, son of a magister, wears a similar color scheme [**87.B**]. A white, tight-sleeved tunic is visible under a red cape with a dark decorated neckline; a blue maniple hangs from his left wrist.

The representation of men's footwear ranges, as noted above, from soled stockings in a neutral hue to bright-red socks and pointed, pearl-trimmed strappy shoes. Sandals seem to have been associated in painting only with the classical garb of long-ago saints. On sacred figures shown as nonnarrative icons sandals predominate, although Pope Leo the Great wears soft black shoes at the Candelora crypt, as does Vitus at the Buona Nuova in Massafra [**62**]. Footwear in narrative scenes usually consists of sandals, although in the Flight into Egypt scene at San Vito dei Normanni, the young James leading the donkey on which Mary rides wears what look like soft brown calf-high boots (*botta*) over bright-blue stockings; these "boots" were actually a second pair of rolled-down stockings. Except for children and laborers, who might be barefoot and stockingless, men wore woolen stockings that covered the feet and legs, often with sewn-on leather soles (the distinction between shoes and socks is postmedieval). These stockings were held up by cords and eventually attached by laces to the breeches worn by the well-to-do. *Shibolei ha-Leqet* confirms that men's hose have laces to connect them to their breeches, and also cites a contemporary opinion that a man may wear two outer garments or two sets of stockings when it is cold on the Sabbath.[89] Judah Romano's fourteenth-century glossary contains the injunction that one should not appear before important persons without proper leg coverings,[90] and surely this was true for men of status regardless of religious affiliation. Circular iron shoe buckles have been found at Apigliano and Campi Salentina, and boot hobnails were discovered in one tomb.[91] A bronze shoelace tip was found at Otranto.[92] Some men must have worn sandals, *sandalia*, and *Shibolei ha-Leqet* permits them even though there is a risk that the laces might break, rendering them forbidden footwear on the Sabbath.[93] None of the Salentine men sports either elegant colored shoes or the practical types of medieval footwear made of wood (*patinus*, τζώκουλος) or with cork soles (*summellara*, φελλοκάλλιγον), even though these are attested in notarial sources in Apulia.[94] Finally, very few males wear headgear in local paintings. The red cap at Lecce [**58.C**] and the *coppula* (*chaperon*) at Li Monaci [**43.C; Plate 9**] are rare exceptions.

Female Dress

There is more to say on the topic of female clothing and accessories even though many more female supplicants were included (though not named) in inscriptions than are depicted on walls or carved on tombstones; the disparity here is much greater than it is for males. Nevertheless, here, too, we can bring into

the discussion both archaeological and untapped documentary sources to flesh out the pictorial evidence.

As I have argued elsewhere, the identification of a kneeling figure at Muro Leccese as a mid-eleventh-century Byzantine empress is incorrect [77.A].[95] Marina Falla Castelfranchi identified her as Zoe, wife of Constantine IX Monomachos, and argued that she is present in this church originally dedicated to Saint Nicholas because of imperial involvement in renovations at the original shrine of Nicholas in Myra in 1042.[96] For Falla, the Muro Leccese image records a contemporary historical scene. However, the tiny figure kneels alongside a huge enthroned one who is probably Christ or the Virgin and not Nicholas, because even though only the lower half of this monumental figure is preserved there is no trace of the episcopal omophorion.[97] Such an outsized Christ, or indeed any such oversized devotional focus, is not found in Salento churches before the thirteenth century. Nor can the kneeling figure's attire be dated before the thirteenth century, the earliest possible date for the scooped neck and pearl-like buttons from wrist to elbow.[98] Before the late eleventh century buttons were limited to the front of upper-class male garments. The figure is not dressed even remotely like an imperial personage: she wears a blue-gray tight-sleeved garment cinched by a brown leather or fabric belt, much like many other female supplicants discussed below. While the buttons on the sleeve were certainly expensive items, there is no *loros* (jeweled ceremonial scarf) or any of the expected accoutrements befitting an empress. What appears at first glance to be a crown[99] is, rather, an elaborate hairstyle, parted in the center and bound with a fabric net (*reticella*, ριτικέλλα),[100] seemingly of red silk where it meets the forehead. Because it is the same shade of brown as the long braid that falls down the woman's back it may be a fabric caul (*caia, cala*, κάγια) but it cannot be a crown, although nuptial crowns (*corona*, στέφανος) were used in the Salento until the twentieth century. Fourteenth-century aristocrats, but not empresses, might wear a crown directly over the hair rather than atop a veil.[101] A review of imperial regalia, both surviving and represented in artwork, confirms a lack of parallels with the figure at Muro.[102] In addition, her pallor and the modeling of the exposed neck are thirteenth-century features unparalleled among the extant figures at Muro Leccese. Most telling, perhaps, is her kneeling and hands-clasped pose, which was not introduced until the middle of the thirteenth century and is explored further in Chapter 6.

Also datable to the thirteenth century are two back-to-back females holding lit candles at San Nicola in Mottola [76.E; Plate 13].[103] One faces Pope Leo the Great and the other the empress Helena. While the left-hand figure has a broader face, both have long hair trailing down the back like the woman at Muro Leccese, and they are dressed identically in wide-belted V-neck tunics, one off-white and one greenish-gray. The belts are probably fabric sashes, because they lack the

trailing ends and metal ornamentation of leather belts so well attested archaeo-logically from funerary contexts. Both wear black shoes or soled stockings. Although the elaborateness of their dress is very different, the V-necks and lit can-dles suggest that the painted person of uncertain gender in the rock-cut Santa Marina at Massafra is also a thirteenth-century female [**67.E**]. She abuts a saint who is datable to the thirteenth century on stylistic grounds. The supplicant wears a white tunic under an orange V-neck outer garment that is draped below the bust with a white fabric ornamented with red roundels and red stripes, knotted at the waist. The sartorial details are difficult to understand.

On the south wall at Santa Maria del Casale are five different women, four of them wearing one or two layers of red clothing. In the other case, a woman ven-erates a male saint, perhaps a bishop, with her clasped hands crossing the painted border between them [**28.K**]. Either her hair is light brown or all of it is bound in a fabric caul that matches her golden-brown cloak. On the opposite wall, a kneel-ing woman being presented to the Virgin and Child by a deacon saint wears a white tunic and red mantle trimmed across the shoulders and at the elbow-length sleeves with white fur [**28.R**, top]. These are either extremely wide sleeve openings or the lining of a mantle; because of the height of the panel and its state of preser-vation it is impossible to be sure. The regally attired saint who is the first female to be saved in the Last Judgment on the west wall of the same church has similarly wide bell-shaped sleeves also lined in white, probably the silk-lined *diopezzi*, or διπλούνι, distinct from a simpler *gonnella* [**28.sc.1**].

Another group of female supplicants is found at Vaste in 1379/80, but all of these figures are tiny in comparison to their equivalents at Brindisi. In the apse, all three women wear tight-sleeved dark-red garments, two with white trim at the neck (the last figure, presumably Ioanna, is almost entirely lost) [**157.A–B**]. Maria, but not her mother, has pearl-button trim on her sleeves from elbow to wrist and a long black belt likewise adorned with white dots. Additional women at Vaste are shown individually and are similarly dressed, with only slight variations in belts and in the way the head scarf is worn [**157.I–J, N**]. Two of them have the pendant white loop of a handkerchief like several of the men [**157.C–D, N; Plate 18**]. None hide their bodies in the capacious mantle typically represented as female attire in Orthodox church paintings of the fourteenth century.

No painted female supplicant has distinctive or even very visible footwear. There are no depictions of what the fourteenth-century Hebrew glossary calls *ferri*, chains for the feet; it notes that women may not go outside on the Sabbath with the chains on the feet used by some girls to avoid taking overly long steps that might endanger their virginity.[104] Nor do we find representations of the small bells that were used as ornaments on female clothing. When worn by Jewish women, these bronze or gold *canpanelli*, worn at the throat, had to be muffled on the Sabbath.[105]

The article of female clothing represented with the greatest detail and variety is headgear and, to a lesser degree, belts. The belt fittings of supplicating figures are in every case simplified versions, usually rendered as pearl-like dots, of what were actually metal attachments that varied in form (butterflies, rosettes); buckles, too, were apparently unique to the wearer.[106] The large number of medieval Latin and Greek terms for women's hair coverings and ornaments is paralleled in such Jewish sources as the Maimonidean glossary, where the Hebrew סבכה, *sbakha*, is glossed by a whole series of vernacular terms, including *grata*, a small gilded hairnet; *entreççiatori, reticella, cuffia, coife, parati, cappella,* and others.[107] The most typical form of female hair embellishment is the scarf or mantilla worn by the women at Vaste [**157.A–B, I–J, N; Plate 18**] and one in the south transept at Santa Maria del Casale who predates the more aristocratic women in the nave [**28.M**].[108] The scarf could be tied behind the neck or lowered over the face as necessary.

Neither male nor female supplicants are ever depicted in the finery worn by the saints and even by some ancillary figures in Christian narrative scenes. If we limit our inquiry to belts and headgear of the thirteenth and fourteenth centuries, we find that sacred images offer both greater variety and more detailed representation that must have been based in some reality. Some notable female head coverings may be seen, for example, on the three girls whose dowry Saint Nicholas provides at Santa Margherita at Mottola [**75.sc**]: their head scarves are white, but with red and blue stripes and with long metal *pendilia* (hanging ornaments) attached (perhaps the *masuli* of the notarial sources).[109] The girls' outer garments are also elaborately patterned and two wear a ring brooch at the throat.[110] At Alezio, Saint Marina wears not a simple pearl-decorated hair ribbon but a precious hairnet woven with dozens of pearls, the *kankellata* or *filo di perle*,[111] and one of the midwives in the Nativity there has the same item. At Casaranello, several women in the scenes of Saint Catherine's life wear over their head scarves a *pullurico*, a cap with a rigid border and soft top, although notarial sources suggest that this was earlier worn only by men.[112] The facing vita cycle of Saint Margaret has a wonderful variety of head coverings, including the common bonnet, the coif or *buctarella*, tied under the chin or behind the neck and worn even to bed [**33.sc.2**].[113] Opulent dress is worn by Saint Lucy at the Buona Nuova crypt in Massafra [**62**]—the wall painting invariably cited to illustrate belt fittings in context. Here a blue tunic with jeweled trim at the neckline and golden buttons at the wrists is covered by a red belt studded with metal fittings and a cloak lined in green. In her hair the saint wears an elaborate jeweled headpiece, perhaps the *catasfactulum* or *capistrinculo* of the early sources, a circlet designed to keep her hair under the transparent veil that falls to her shoulders.[114] Equally splendid is a Saint Margaret at San Simeone in Famosa, wearing a gemmed crown over the pearl net that restrains her hair. Over her extraordinary tunic with a red-and-blue roundel pattern

is a red cloak with golden laces and a purple belt with silver and gold cross-shaped ornaments. It is quite clear that not only saints but also nonsainted figures in medieval Salentine art are often shown in clothing of much greater variety and opulence than that worn by painted supplicants. This is especially true of their jewelry.

Jewelry

Women's jewelry is always an aspect of social status, yet none of it is visible in painted depictions of real women; only saints and figures in narrative scenes wear earrings or an occasional brooch. Yet jewelry is well attested in written sources, mostly in the form of prohibitions of excessive public display, and it is also plentiful in the archaeological record. Many pieces have been found in graves where they represent family wealth that was ostentatiously, or at least visibly, buried. I discuss women's jewelry further in Chapter 4, "Status."

Like their modern descendants, some medieval men wore decorated belts, rings, and even earrings.[115] The sage Isaiah of Trani is cited in *Shibolei ha-Leqet* as being uncertain whether men can wear rings in public on the Sabbath; they might be tempted to remove them for display, as women were sure to do, and so violate the day of rest.[116] From this we can deduce that some Jewish men wore rings in Apulia and in Rome in the thirteenth century. Bishops and some other Roman-rite ecclesiastics wore rings on their gloved hands, such as Eligius (labeled in Greek) at Vaste [**157.C**]; an unidentified bishop in the Supersano crypt wears at least ten of them [**118.st.1**].[117] This practice was criticized by the eleventh-century Byzantine patriarch Michael Keroularios as "abominable and heretical."[118] Only a rare late medieval layman, like the elegantly dressed one who has insinuated himself into a group of bishops, monks, and even the pope adoring Saint Benedict in Santi Niccolò e Cataldo at Lecce [**58.C**], is shown with three rings on his white-gloved right hand. His jewelry and garments clearly advertise his social rank.

While the presence of earrings has always been assumed to identify a female burial, earrings have been found in adult men's graves in the Balkans. Dated between the eleventh and early thirteenth centuries, they were often found in conjunction with finger rings.[119] Beginning in the twelfth century, some ancillary male figures in Christian scenes—boys laying down their garments in Christ's entry into Jerusalem, men unwinding Lazarus's shroud—also wear earrings. Maria Parani associated these depictions with a general knowledge of "oriental" dress, with specific local fashions, and with a growing Byzantine interest in representing realistic details.[120] Yet the motives for occasionally representing Christ himself with an earring, also starting in the twelfth century, are more

complex.[121] This occurs at the Crocefisso crypt at Ugento and is such an anomalous detail that it must have been requested specifically by its anonymous patron [**Plate 17**].

The earring worn by the Christ child at Ugento is adorned with a cross hanging from the ring that pierces his ear. This earring type has no archaeological parallels in the Salento or anywhere else, and pictorial comparanda are also difficult to find. There are Roman Republican coins in which female personifications wear a cruciform earring, but those crosses hang heavily from the earlobe and are not attached to a ring;[122] in any case, it seems unlikely that a chance coin find inspired an image nearly fourteen centuries later. To understand Christ's earring we should consider its immediate context [**151.st**]. The Virgin holding the Child is dressed ornately in a blue tunic outlined at the neck, wrists, and hem with gold and jeweled embroidery. Over this she wears a red mantle, open in front, over half of which an additional white mantilla embroidered with red flowers has been obliquely placed; the mantilla matches the textile on the back of her throne. In her hand she holds a lily. The additional veil is often found on Byzantine icons from Cyprus, of which the earliest attestation is a late twelfth-century icon bearing the epithet "covered by God," to which the veil may refer; by about 1260 the diagonal veil is found in southern Italy.[123] The unexpected luxury of this image contrasts sharply with another Mother and Child on the same wall of the crypt that cannot be much earlier in date; there the Virgin sports her usual brownish *maphorion* (hooded mantle) closed over the blue mantle, with no extra veil, and the Child lacks jewelry. A difference in patronage seems obvious. Is one image a response to the other—a humbler and more traditional offering to counter the showier version? Or a fancier-looking one to update and "westernize," via the lily and the Virgin's open mantle, the *retardataire* version down the wall? Neither scenario explains the earring. Perhaps the intent was to include a cross in the scene, thus making explicit the formal and typological link between the Virgin holding the infant Christ and, ultimately, the dead one. Perhaps the benefactor him- or herself wore just such a cross as an earring or pendant.

The function of a small cross at this time was protective; it might or might not contain a relic. While this would seem to be superfluous in the case of Christ, he wears a different amulet in another Salento painting, this one at San Nicola at Mottola [**76.sc.1**]. At the neck of his white garment decorated with parallel red strokes is a red circle with a dot inside. That this is not a brooch—"just jewelry"—is clear from a comparison with the girls aided by Saint Nicholas in the adjacent crypt dedicated to Saint Margaret, where the horizontal pin of the annular brooches is clearly visible [**75.sc.1**]. Christ's "adornment" serves no practical function; it does not close his garment at the throat. Like the cross earring, it seems to be an apotropaic device of the type we shall consider in Chapter 7.

Hairstyles and Beards

In the following chapter on status I assess female head coverings as signifiers of age and marital status. Here I focus on men's hair, which is far more visible than women's because it is so rarely covered in our surviving paintings. Hair and beards were of great importance in the Middle Ages precisely because of their visibility, and the treatment of hair by its owner or by someone else was a social act that signaled group identity and could have important consequences.[124]

Although bearded men are plentiful in narrative imagery [**33.sc.1**], there are few bearded supplicants in the Salento and none with noticeably long hair. In the thirteenth century, two of the three monks at Miggiano have beards [**73.A**] and that of the kneeling Nicholas is fairly long, ending in two distinct points [**73.A.2**]. Even longer is the beard worn by the hooded monk at Casarano [**34.A**]. In the fourteenth century, two panels at Santa Maria del Casale contain a kneeling mail-clad man with a trim beard; the one in Leonardo di Tocco's retinue has a fine mustache as well and is further distinguished by his unique crested helmet [**28.D; Plate 4**]. An earlier panel there [**28.V; Plate 7**] reveals that two of the five figures kneeling behind Nicholas de Marra have short beards, one has a mustache, and several have blond hair to the shoulders. Thus the scant evidence for both longer hair and beards is skewed to the late period. The absence of these features in the earlier medieval centuries reflects the paucity of early devotional figures in general; it does not tell us that the proportions of bearded to nonbearded men differed at opposite ends of the Middle Ages. On the basis of imagery from outside the region, however, we know that fashions in men's hair changed continuously.

The meanings of different hairstyles depended on cultural and historical contexts and varied according to such factors as a man's age, status, profession, and state of mind. Hair could be simultaneously magical, sexual, and social.[125] In many cultures facial hair was a metonym for masculinity or worldliness: Byzantine monks "cast off the hair of the world"[126] when they received their tonsure. We find these notions addressed in eighteenth-century collections of proverbs in the Salentine dialect. Some of these date to the early modern period, but others are probably much older:

> *Bbarba d'ommu e ccuta de cane, guàrdale e nnu lle tuccare.*
>> Beard of man and tail of dog, look but don't touch.
> *Bbarba janca, specchiu de morte.*
>> White beard, mirror of death.
> *La bbarba nu fface l'ommu.*
>> The beard does not make the man.

Guardati da femina barbuta e da uomo senza barba.
 Protect yourself from women with beards and men without.[127]

That the topic of hair and beards resonated in the medieval Salento is proved by a short treatise produced in the 1220s and copied at least four times in the thirteenth century alone. Περὶ Γενείων, *On the Beard*, deals with the hair and beard preferences of "the Greeks" as expressed by Nicholas-Nektarios, the learned abbot of one of the most important Orthodox monasteries in the Salento, San Nicola at Casole, which had been founded under the patronage of the Norman rulers in 1098/99.[128] The bilingual (Greek and Latin) treatise was appended to Nicholas-Nektarios's Τρία Συντάγματα, *Three Constitutions*, which dealt with topics of cultural disagreement that will be discussed in later chapters. It is worth translating the text in full:

> It is not necessary for us to write or collect in this treatise about beards or even about some other things held by custom, but because of some of the ignorant who boast especially in shaving but despise those who heed the [true] form of man, we will write a little about these, by way of a separate note outside of our treatise.
>
> The faithful must not shave, as one finds in the first book of the *Apostolic Constitutions*, chapter three [1.3.11], which forbids this. It says the faithful must not corrupt the hair of their beard and change the form of man against nature. For the law of Moses [Lev. 19:27] says you will not pluck your beards. For God the Creator made this seemly for women (*sc.,* to have smooth faces). He ordained it unfit for men. But you by so doing, because of an allurement, oppose the law and become abominable in the eyes of God who created you in his own image. So if you wish to please God, refrain from all that he hates and stop doing anything that displeases him.
>
> As for the Latin: now the Church of Rome has adopted this, he says, since what the impious did in violence against the Apostle Peter, plucking out his beard, we do reckoning the violence against him an honor even in this, such as also cutting in a circle the heads of the Latin and Greek priests.
>
> Next the Greek: we have adopted this entirely because of the crown of thorns and because men's not growing hair is a precept in both the Old and New Testament, just like not shaving the beard. Who is the one who asserts this against the apostolic tradition, although we know this entirely without a Council? But why, we will not say. Now there was an Anacletus born in Herakleia [in] Thrace, as is written in the Chronicle of the Genealogies of the Apostles of Rome, and we have often read in your books how it was

Anacletus who ordered tonsure and beards to be shaved. He was by birth
a Greek and from Thracian Herakleia.

　　And enough about beards.[129]

Nicholas-Nektarios here asserts that the Latin custom of shaving the beard is
unnatural and unmanly, based on the Westerners' misunderstanding of the third-
century *Didascalia apostolorum*, which states that "you should not corrupt the
traces of your beard or change the natural figure of your face or change it to other
than it is and God created it."[130] While the "Latins" claim that shaving and tonsuring
were introduced in memory of Saint Peter having his hair and beard torn out, the
"Greeks" held these depilations to be unauthorized reforms.[131] The resulting shape
of Peter's torn-out hair was understood as an imitation of the crown of thorns, and
therefore served as a model for Western monks and clerics but not for Orthodox
ones.[132] This was not new: the same issues had been cited as contributing to the
mutual excommunications of 1054.[133] What is relevant here is the specifically Salen-
tine context for the objections, and the possibility of considering the hair of Saint
Peter as emblematic in the thirteenth century when most of the images of suppli-
cants, as well as most of the depictions of Saint Peter, were executed.

Priests and Monks

Clerical shaving and tonsuring had a long history in medieval Europe, as Giles
Constable's extensive treatment of the topic attests. The problem is that the textual
evidence is contradictory; even with repeated anathemas on long hair and beards,
many clerics still wore them. Sometimes this was permanent, a product of personal
preference as a sign of dignity or age; sometimes it was temporary, when the man
was fasting or traveling.[134] Most of the popes and bishops in the eleventh and
twelfth centuries appear to have had a beard. Shaving was certainly laborious and
painful. In the twelfth century, a European monk was permitted to shave only
fourteen, seven, or six times per year, according to the Cluniacs, Cistercians, and
Carthusians, respectively,[135] so few monks were truly beardless if indeed these reg-
ulations were enforced. By contrast, in some twelfth-century Byzantine monas-
teries a haircut required the permission of the abbot or fifty prostrations would
be exacted as punishment, and there was no monastic legislation about beards.[136]
　　Iconography bears out the textual inconsistencies without, unfortunately,
revealing local or chronological patterns. In general, European monks were
expected to cut their beards, but not too closely and not too often, and not all of
them did so.[137] Byzantine monks were not so concerned about this aspect of
monastic comportment and completely beardless eunuchs could become monks
or priests.[138] What was strongly discouraged was religious men paying too much

attention to their hair or letting it grow so long that gender distinctions might become confused. While the general picture of Roman-rite monastics and church-men cutting their hair and beards and Orthodox-rite equivalents growing theirs is probably correct, individuals or communities could easily defy these "dictates."

An angry passage by Eustathios, the archbishop of Thessalonike, who in 1185 was an eyewitness to the sack of his city by Normans from southern Italy, applies to clerics (victims) and soldiers (perpetrators) and should not be construed as referring to laymen in general:

> And even when leaving us alone in other respects, they [the Normans] concentrated their schemes against the heads of each of us, showing an equal dislike both for our long hair and for our long beards. It was not pos-sible to see a man or a boy of any station in life who did not have his hair cut short all around, like the proverbial Hektor's crop I suppose, or cut short in front in the manner of Theseus, whereas their hair previously used to be worn in the opposite manner, like the Abantes, and not like these Latins, who wore theirs cut round in a circle and were, so to speak, hairy-crowned. And in paying attention to our hair, the Latins made use at one moment of a razor, at another of a knife, and the more hasty among them used a sword; and then a man who had been shaved in this way would also be relieved of his beard. It became a rarity to see in any place a Greek whose head was still untampered with. The situation was the reverse of the saying, "Not a hair of our heads shall be touched." For our many sins, for which we have "paid the penalty early" in the words of the one who declared that he would early slay the wicked of the land and would destroy the wrong-doers from the city of the Lord, brought disaster reaching as high as our very own hairs, so that we were completely exposed to the cold, with even our heads stripped bare. And if any man's beard escaped and hung down in an orderly manner in accordance with nature, then these wretched bar-bers grabbed it with one hand, and the hair of his head with the other, and said that all was well with the latter hair but not with the former, jesting over matters which were not fit for mirth.[139]

Hyperbole is a time-tested rhetorical device and such an exaggerated account should not be taken at face value. The real reasons for Norman aggression against Byzantine bodies in 1185 had little to do with opinions about hair and beards and much to do with anger over Byzantine attacks on Europeans three years earlier in Constantinople.

Is the prostrating Nicholas at Miggiano an Orthodox or a Roman-rite monk [**73.A**]? His hair curls down to the nape of his neck but is hardly the unshorn hair

one might have expected from Eustathios's description. "Long" and "short" are relative terms, as are "shaved" and "tonsured."[140] His name is no help, as Nicholas was extremely popular regardless of the holder's religion. Yet because he is identified in Greek in a site that has exclusively Greek *tituli* and Orthodox iconographic details, I think he is likely to be an Orthodox monk—just like his beardless companion Leo.[141] The priest named George at Vaste [**157.G**], kneeling upright next to the Virgin and Child in 1379/80, has a tonsure, and he or his father was an oblate of Saint Stephen, an office that did not exist in the Orthodox world. Was George then a Roman-rite priest despite his supplication in Greek? I argue the contrary in Chapter 8, where Vaste emerges as a paradigmatic work of cultural translation.

Laymen's Hair

Because most of our painted human figures are laymen, we need to ask whether a bearded/Orthodox versus unbearded/Latin distinction held for this group. For these men the dictates of fashion were probably even more mutable than the inconsistent directives for priests and monks, so the caveat about generalizations and exceptions applies even more strongly. In the first half of the eleventh century beards were fashionable in Europe; by the second half most men shaved, and this continued into the twelfth and thirteenth centuries as recorded in both Greek and Latin sources.[142] Italian men alone seem to have revived the full-bearded look in the early fourteenth century,[143] but this proved of short duration.

In Byzantium, as elsewhere, churchmen attempted to influence male fashion. A contemporary of Eustathios, Archbishop Michael Choniates of Athens, criticized the fact that (some) members of his flock were shaving: "Whoever puts off the manly hair of his chin has unconsciously transformed himself from a man into a woman . . . shame indeed it is to don a unisex appearance like the hermaphrodites of ancient Greece!"[144] Yet the reality was that some men were cutting their hair despite what the bishop had to say, and if they were doing it in Athens they were surely doing it in the Salento as well. In addition, a text produced in Otranto in the thirteenth century indicates that "among the Hellenes" (παρὰ τοῖς Ἕλλησιν) one shaved the beard to honor the dead, so it was indeed acceptable at certain times.[145] Generalizations might not hold true for a specific individual at a particular moment in his life.

The figures shown on the so-called dancers' capital now in Brindisi probably reflect in some degree the appearance of real Normans. All eight of the men have short hair and (probably) no beard [**19**]. While the pavements at Taranto (1160)

and Otranto (1163–65) cannot be said unequivocally to depict contemporary men, the males generally have short hair and are beardless. But this does not mean that Normans in general were short-haired like the soldiers who ravaged Thessalonike. We should listen to the Norman historian Orderic Vitalis when he tells us, in 1142, that "effeminate men had dominion throughout the world. . . . They parted their hair in the middle, they let it grow long, as women do, and carefully tended it, and they delighted in wearing excessively tight undershirts and tunics." He goes on to criticize pointed, curving shoes, unnecessary trains, and long, wide sleeves; in short, these men "rejected the ways of heroes, ridiculed the counsel of priests, and persisted in their barbarous style of dress and way of life."[146]

In later medieval narrative scenes that had less of a moralizing ax to grind, variety in hairstyle was eminently possible. We see this in the thirteenth-century Betrayal of Christ scene at Casaranello, where several soldiers have a short beard and mustache [**33.sc.1**].[147] In the early fourteenth-century Last Judgment scene at the Roman-rite Santa Maria del Casale, the saved cleric farthest to the left has a tonsure and a beard [**28.A**]. The reason was surely the desire to communicate a range of ages, rather than the explicit presence of "Easterners" and "Westerners."

In fifteenth-century monuments a bowl-type haircut is favored, as at Nardò and Galatina (1432) [**47.D**]. Laymen followed fashion, and most European men in the thirteenth century had short hair; priests and monks were not their follicular role models. Just as men might change their names to fit into a new social hierarchy, they could easily change their hair for the same reason. Hair was as much a part of a man's situational identity as hair coverings were for women. The public setting of depicted devotional figures meant that their clothing and hairstyle needed to be in the realm of the recognizable, conventional, and acceptable. Yet like the clothing on display, the hairstyle might still be more idealized and symbolic than descriptive.

Saint Peter's Hair

Saint Peter was at the heart of Nicholas-Nektarios's comments on men's head and facial hair and differing attitudes toward it on the part of "Greeks" and "Latins." He would therefore seem to offer an interesting test case: did Peter serve as a model for the hair or beards of depicted monks or priests or laymen? Put another way, did texts—or that particular text—have any effect on local images?

Peter's physical traits are described in accounts written by Epiphanius of Salamis, John Malalas, Elpius the Roman, and others: an older man with gray or white hair and a short beard.[148] Despite this general consensus Peter's specific iconography and attributes varied, which made him a rather unusual case in

Byzantine art. This mutability was noted by Kurt Weitzmann in his study of the thirteenth-century Saint Peter icon at Dumbarton Oaks; moreover, he argued that Peter's iconography in Byzantium after 1054 deliberately responded to political and religious differences between the (so-called) East and West and that the Byzantines deliberately avoided depicting Peter in the roll-type hairstyle associated with Rome.[149] However, a survey of Petrine images challenges Weitzmann's hypothesis. Within the general iconographic parameters there was great variety in the Byzantine world and significant variety even in Rome itself.[150] In the Salento, Peter is seldom represented the same way twice. With a full head of overlapping fish-scale hair, he is paired with a tonsured Pope Leo in the eleventh-century San Nicola at Mottola, probably repainted in the thirteenth century [76.st.1]. In the same church, Peter is also shown with a smooth heart-shaped hairline, and a third time with tight corkscrew curls falling from a central point. None of the Salento supplicants looks remotely like him in any of these depictions; in fact, none of them is shown as elderly. The fact that Peter is depicted with numerous hairstyle variations reflects in a general way the variety that no doubt characterized real men's hair, but in no case does a painted supplicant share specific features of Petrine representation.

How then should we understand the focus on Saint Peter and the sudden appeal of such a treatise in the thirteenth century? It was certainly part of a larger discourse in the period after 1204 when Byzantine and Orthodox identity were under pressure, resulting in an increased production of texts and images not only in the Salento but in Greece as well.[151] Περὶ Γενείων circulated widely because it traveled with the Τρία Συντάγματα, three longer discussions about disparities between Salentine Orthodox practices and Roman ones that I examine in Chapter 8. This leads me to conclude that Peter's ostensibly central role was mainly symbolic: he could serve as a sign for all things "Western." While Peter, with Paul, was highly regarded in the Orthodox world as *koryphaios* of the apostles,[152] and a Byzantine imperial monastery dedicated to Saint Peter was established at Taranto, Peter had a special connection with Rome. The papal claim to primacy over other Christian sees dated to the Council of Chalcedon (451), when it was said that "Peter speaks through Leo" because of Pope Leo the Great's argument for Roman primacy. That connection is implicit in the pairing of Peter and Leo in San Nicola at Mottola. The pope at the time of Περὶ Γενείων was either Honorius III (r. 1216–27) or Gregory IX (r. 1227–41); Gregory was the more aggressive, criticizing aspects of the Orthodox rite and insisting in 1231 that all "Greeks" needed to be rebaptized by Roman-rite clergy. It is possible that Nicholas-Nektarios was responding to a similar provocation with his Τρία Συντάγματα, although memories of 1204 were probably sufficient. These would

have been vivid for Nicholas-Nektarios, who served as translator for the papal legate to Constantinople in 1214–15 and had traveled widely in the former Byzantine Empire.

The art-historical evidence underscores the discrepancy between individually produced texts and images that spoke mainly to an audience unfamiliar with contemporary texts. If we listened only to selected texts, we would conclude that the "Latins" shaved their heads and chins and that the "Greeks" did not.[153] If we look at the images, even though none can be specifically related to Nicholas-Nektarios or his copyists, we would expect a visual polemic of the sort that Weitzmann imagined to be played out on the faces of painted males and especially of Saint Peter. But this polemic is not present in paint.[154] As we shall see, this conclusion is not limited to images of Saint Peter.

Jewish Hair

That some monks sported a tonsure was evident to Italian Jews. Yet the Latin *clerica* (tonsure) took on a different meaning in the Roman Hebrew glossary, where *clerica, ch(e)lerica* refers not to the ring of hair but to a central tuft. Jews are urged not to shave the sides of the head and leave hair in the middle like the Christian "idolaters."[155] If they were sensitive to others' hair, we might well ask what kinds of hairstyles late medieval southern Italian Jews had. We lack firsthand pictorial information, given that there are no painted Jewish suppliants, and many (male) Jews depicted in Christian narrative scenes have their heads covered with a scarf. A royal edict of 1222 enjoined Jews not to cut their hair and to let their beards grow, so clearly some were doing the opposite.[156] In the Rhineland, too, rabbis ordered early thirteenth-century Jews not to wear their hair in the Christian fashion.[157] Despite the long-held prohibition on shaving with a razor (reiterated in the Rhenish legislation), no medieval Jews are shown with long side locks.[158] According to *Shibolei ha-Leqet*, one's hair was not supposed to get too long; again, we have no objective definition of how long was too long. Even if one had consecutive periods of mourning, during which cutting the hair was discouraged, it was permissible to trim it with scissors.[159]

Representations of Jewish hair do not differ significantly from those of all the other males shown in Salentine wall paintings across the medieval centuries. However, many more Jews are shown with a beard than clean-shaven, the latter being the preference—but not the rule—among other depicted males [**Plates 1, 3**]. Maimonides codified that a man who read the Torah in synagogue and represented the Jewish community should have a full beard (and a pleasant voice). Particularly pious Jews were supposed to have a beard, and in this way the beard might

symbolize all Jewish men. Yet depictions of Jewish hair in Christian contexts are not consistent, not even in late medieval representations executed at a time of hardening attitudes and enforcement of laws about Jewish dress. When Saint Catherine disputes with a group of Jews at Santa Maria del Casale [**28.sc.2**], three are bearded but four are not, and when Christ dines in the house of the Pharisee in Lecce's Torre di Belloluogo in the late fourteenth century, the pictorial host is unbearded.[160] The head covering, not the beard or hair itself, was a much more characteristic way of indicating a male Jew. It was a signifier of status that functioned much like female head coverings and was probably intended to suggest Jewish male effeminacy at the same time as it indicated their otherness.

Legislating Appearance

While recording contemporary realia was not the goal of Christian church painting, it is precisely in such ancillary details that an artist's observations of the world around him, rather than mere imitation of iconographic models, come into play. The presence of iconographic details known to have been introduced at a certain historical moment removes the scenes in which they appear from the repetitive conventions of narrative imagery and makes it legitimate to read them as reflecting current local attitudes and realities. The depiction of Jews wearing a distinguishing emblem—the *rotella*—in two scenes of the martyrdom of Saint Stephen at Soleto [**113.sc.1; Plate 14**] provides a point of entry into an investigation of Christian attempts to legislate Jewish appearance and of Jewish clothing more generally.

Enforcing Jewish Difference

Legislation regarding Jewish clothing was intended to underscore Jewish identity and distinguish it from that of the surrounding dominant culture. This had already occurred by the ninth century in the Muslim world,[161] and in 1215, canon 68 of the Fourth Lateran Council decreed that:

> Whereas in certain provinces of the Church the difference in their clothes sets the Jews and Saracens apart from the Christians, in certain other lands there has arisen such confusion that no differences are noticeable. Thus it sometimes happens that by mistake Christians have intercourse with Jewish or Saracen women, and Jews or Saracens with Christian women. Therefore, lest these people, under the cover of an error, find an excuse for the grave sin of such intercourse, we decree that these people

[Jews and Saracens] of either sex, and in all Christian lands, and at all times, shall easily be distinguishable from the rest of the populations by the character [*qualitate*] of their clothes; especially since such legislation is imposed upon them also by Moses.[162]

No specific marks are prescribed to deter potential miscegenation, but only some unspecified distinction in clothing.

The degree to which the council's injunctions were enforced varied widely across Europe, and it is not possible to discern any repercussions in the Salento. I would argue that a visible Jewish identity was not locally mandated until after 1400. This information is recorded a century later by a Franciscan monk, Roberto Caracciolo, who preached in Lecce in the 1490s and was largely responsible for the destruction of its *giudecca* and the transformation of its synagogue into a church (resulting in the reuse of its building materials in a toilet [**56**]). Jews were important in the economic life of Lecce in the fifteenth century; they were routinely called *cives*, citizens, and we know some of their names and have an inventory of one of their libraries.[163] Fra Roberto approvingly cited a law from the time of Maria d'Enghien, whose reign in Lecce in the late fourteenth to early fifteenth centuries marks the end of the period under consideration in this book. Recorded in *volgare* and thus intended to be understood and easily applied, it is worth quoting in full:

> And for some errors that often occur, the said Majesty wants and commands: that all Jewish men or women from the age of six, whether foreigners or citizens of Lecce, the men must wear a red sign in the form of a round wheel [a *rotella*] on the chest over the breast the width of one palm in the form and size written by the court. And the women a round red sign over the chest and breast the width of one palm, wearing it over all the other clothes so that everyone is able to see, and indicate this is a Jew or Jewess, even if they go [out in public] wearing a cloak or a *juppa* or in a *jupparello* and a woman's *gonnella*. And whoever does the contrary will pay the penalty of one ounce [of gold] for each offense. And if someone is so accused and does not have even a *tari* with which to pay the penalty he will be whipped around [throughout] Lecce.[164]

The two images of Jews torturing Saint Stephen at Soleto [**113.sc.1; Plate 14**] suggest that these later, local injunctions were being enforced in the 1430s. Later fifteenth-century travelers' accounts either fail to mention such distinguishing markers or note actively that there were none, so enforcement either waned in later decades or was sporadic and local.[165]

There are no indications in pre-fifteenth-century wall paintings of a specific required element of dress to separate Jews from their neighbors. Yet there was some distinction previously, for the Lateran canon refers to self-imposed Jewish legislation going back to Moses and other sources refer to "Jewish clothing."[166] In the previous chapters I cited midrashic texts that maintain that the Jews merited liberation from Egypt because they kept their Jewish names and Hebrew language (and also avoided slander and maintained chastity). In the Middle Ages, another reason for divine salvation was added: that the Jews did not alter their Jewish clothing. Already in the nineteenth century, Solomon Buber asserted that clothing was not part of the original midrash, but only recently have the medieval sources for this popular misquotation been traced. The earliest citation appears to be an eleventh-century text by Tobias ben Eliezer, a Byzantine anti-Karaite polemicist who lived in Kastoria, in northern Greece. In the thirteenth–fourteenth century it was being repeated by a Spanish Talmudist, and by the fifteenth century the midrash had mutated definitively to include names, language, clothing, and religion as reasons for Jewish liberation and signposts of Jewish identity.[167] We should ask, then, what the medieval commentators meant by "Jewish clothing" and why it was important to add dress to the earlier formulation.

"Jewish" Clothing

For Jews, clothing had always been significant. Several biblical books contain instructions about dress that were intended to sanctify male Jews' external appearance and remind them of the *mitzvot* (the 613 commandments that pious Jews are supposed to observe). The prophet Zephaniah (Sophonias) declaimed against "all those who don foreign vestments,"[168] and the Babylonian Talmud states clearly that "The glory of God is man and the glory of man is his clothes."[169] This statement did not refer to opulent, extravagant garments and finery of the sort to which later Jewish and Christian moralists would strenuously object. Rather, it referred to appropriate, decent, modest attire. Complaints preserved in the Cairo Genizah correspondence about being naked or having nothing to wear are concerns about the appropriateness of one's clothing rather than its absence.[170] Respectable dress was the most immediate signifier of a respectable man: Jews who lacked decent footwear were instructed to sell their roof beams to get money to buy shoes or risk estrangement from heaven.[171] Everyone who could afford it owned weekday wear, a change of clothes for nighttime, and another outfit for the Sabbath and festivals.[172] That this requirement was in force in medieval Italy is clear from *Shibolei ha-Leqet*: those who lacked special Sabbath clothes were enjoined to rearrange their weekday garments in order to look and feel different on the Sabbath.[173] Moreover, clothing was to be kept clean; a scholar with a greasy spot on

his garment ostensibly merited the death penalty,[174] although there is no evidence that this was ever carried out. The Jews in the Pilate scene at San Paolo in Brindisi are well dressed in a variety of colorful dyed garments [**Plate 3**].

Textual evidence for the particulars of Jewish male dress is limited and we should not assume that biblical or Talmudic injunctions were being practiced in medieval southern Italy. Yet if a garment or practice is included in the eleventh-century Otranto Mishnah glosses or the fourteenth-century Roman glossary on Maimonides, these garments or practices are likely to be contemporary. These vernacular glosses were added specifically to clarify terms for a contemporary local readership. *Shibolei ha-Leqet* is a more problematic source because it depends on earlier opinions as well as contemporary ones, but a careful sifting of context and language enables us to use this text as well. For the most part, these medieval Jewish sources confirm that Jews looked like their neighbors of comparable social status.

Shibolei ha-Leqet refers to a *piltaro* hat, made of felt, and to peacock feathers attached to hats worn outdoors on the Sabbath and secured with a strap under the neck so they won't blow away. It also states that one may wear a "borita" or "bavarita," even without such a strap.[175] This is the *biretta* widely worn by Italian men of style in the fourteenth century.[176] The Maimonidean glossary includes the term *cappuçço, cappuççu*, referring to a turban or head wrap in which one might wind phylacteries rather than the "hood" implied by the Italian homonym *cappuccio*; it states that women should take care not to wear such masculine ornaments as a turban or *biretta* (or, for that matter, a cuirass).[177] A pointed hood was supposed to be characteristic of respectable fourteenth-century men, but one source laments that even unworthies, including Jews, wear one.[178] Many Trecento laws reveal severe punishments for striking off a man's hood. Clearly, well-to-do Jews wore a variety of hoods and other types of head coverings [**Plate 3**] and not just the white head scarves seen at San Cesario di Lecce [**108.sc.1**] and Acquarica del Capo [**Plate 1**].

Zidkiyahu Anav, the author of *Shibolei ha-Leqet*, records a practice he witnessed in Speyer that was unfamiliar to him in Rome: during prayer, men wrapped themselves in their *tzitzit*, shorthand for the fringed prayer shawl (*tallit*), during the fast day of Tisha b'Av.[179] Anav's northern contemporary, Rabbi Meir of Rothenburg, indicates in one of his responsa that this practice of wrapping was widespread among the Pietists, the so-called Hasidei Ashkenaz, who preserved many southern Italian (originally Palestinian) practices.[180] This statement, by an authority often cited in *Shibolei ha-Leqet*, clarifies the *cappuçço* glossed by Judah Romano as being used as a head covering, though not as a body wrap, in the thirteenth century. The practice of covering the head had fallen out of favor elsewhere but was still practiced by the Pietists. Anav also cites Rashi's injunction that Jewish

men cover the head every day, but he notes that in thirteenth-century Rome many Jews are not doing this because the "nations of the world" are laughing at them, and even some fellow Jews, "people of the house," are laughing, and because of this they are laughing at themselves. He concludes, regretfully, that "our custom is to not cover the head."[181]

The Talmud enjoins Jews to wear shoes, and clean ones at that; it also says that white shoelaces are required rather than the usual black.[182] On Yom Kippur, leather footwear was entirely forbidden in order to afflict oneself as much as possible. King David allegedly walked barefoot on that day, but Talmudic rabbis accepted sandals made of cork, and one of Anav's contemporaries, a Rabbi Shmuel of Bari, ruled that if there was danger from scorpion bites then even leather shoes were permissible.[183] The custom of walking barefoot on days of mourning, including funerals and Yom Kippur, would have made Salentine Jews stand out among their neighbors.

Gloves had symbolic value as indicators of authority; they were worn by high-ranking clergy and other notables [**58.C**]. Fourteenth-century terms for gloves included *guanti*, *ciroteche* (from the Greek), and *mofele*.[184] *Shibolei ha-Leqet* confirms that medieval Jews also wore gloves and used the first term, rendered in Hebrew letters as גוונטי, in the context of a discussion about accidentally carrying them on the Sabbath when carrying things in public is prohibited.[185] The author says, "I am inclined to be stricter," requiring gloves to be sewn to other garments to preclude any mishaps. Judah Romano's glossary includes additional terms that refer to fourteenth-century male fashions worn by Jews and non-Jews alike. For example, the *cappa* was a heavy cape or a bedcovering in which it was permissible to wrap oneself for protection from inclement Sabbath weather. *Appennagli* refers to pendant fringes; it was permitted to wrap oneself in a mantle bordered with fringe of the kind we see worn by Jewish men in San Paolo at Brindisi [**26.sc.1; Plate 3**].[186]

In the tortures of Saint Stephen at Soleto with which we began this investigation, the figures wearing red *rotellae* (or *rotae*) in accord with Maria d'Enghien's legislation are not otherwise clad or shod differently from others in the same fresco stratum [**113.sc.1; Plate 14**]. Nevertheless, an artist felt compelled to "update" these Jews in accordance with the actual appearance of local Jews following the early fifteenth-century edict. Prior to this time, "regular" Jews looked like their neighbors. Some of the more pious and learned Jews—perhaps the ones who wrote Hebrew chronicles and poetry and scientific works in the ninth to eleventh centuries, or those who made Jewish Bari and Otranto famous as far away as France in the twelfth century—probably did wear the type of white head covering often worn by depicted Jews [**Plate 1**]. This exceptional attribute of piety was then

extended by Christian artists to representations of most Jews. The same process was responsible for the dominant image of Jews with beards.[187] Yet neither convention was consistently applied, and neither was the rule about wearing the *rotella*, as indicated by the diverse and unbranded group of Jews in the Brindisi scene of Pilate Washing His Hands [**Plate 3**].

Sumptuary Laws

Beginning in the early fifteenth century, several Jewish communities in northern Italy imposed sumptuary laws to combat public ostentation that might be interpreted by non-Jews as a claim of status and power. Initially these laws addressed excessive spending for weddings and funerals, but later they focused on clothing, with strict rules about women's dress to be enforced by their husbands.[188] It is clear from these restrictions that Jewish social and juridical inferiority was not reflected in the way they dressed and adorned themselves.[189] However, we have no trace of Jewish sumptuary laws in the south of Italy. Because Jews looked like their neighbors, the Franciscans enjoined Maria d'Enghien to issue a law that distinguished them.

Sumptuary legislation was not only or even primarily for Jews. Limitations on the public display of finery and expensive clothing by Christians became more widespread beginning in the twelfth century with edicts issuing from both the church and secular authorities. The earliest such law in southern Italy dates to 1290, when Charles I of Anjou forbade men from wearing superfluous ornaments associated with women; a similar law was issued in 1308. According to the earlier legislation, no one could wear gilded shoes (*calcareia deaurata*) and only certain women were allowed fringes of pearls, gold, or silk. Doctors, jurists, and professional men could don garments of vair, but for burghers and merchants this fur was restricted to their hoods and hats (*caputio* and *birreta*). No woman could wear more than seven buttons, nor could their value exceed twenty-two *tari*, and pearl garlands adorned with gems and gold were permitted only if they were less than two fingers wide.[190]

This corporate regulation of bodies privileged certain social groups while restricting others, with the aim of limiting competition within the highest social classes and imposing an ideal social order that distinguished classes and genders.[191] Alan Hunt's study of sumptuary legislation found that while more medieval legislation was directed toward men, enforcement of the laws was more rigorous toward women.[192] We can assume, I think, that supplicants represented on Salento church walls were not violating any legislation then in force. The fur-trimmed dress of so many painted individuals at Santa Maria del Casale supports

the conclusion that these individuals belonged to the uppermost social class, while a similarly consistent but certainly different social group seems to be represented in Santi Stefani at Vaste. Whether it is viewed as a form of individual or corporate communication, appearance is among the most public manifestations of economic and social power.[193] All the evidence indicates that status, not faith, determined both actual dress and its representations, and it is to these and other aspects of status that we turn next.

Status

"Status" refers to an individual's position in relation to others, especially his or her social standing within and between groups, and relative status is a major factor in interpersonal behavior. Like other aspects of identity, one's status is imputed by others and interpreted according to subjective cultural categories. It generates expectations that can range from respect and admiration to contempt. A higher position in the social hierarchy, manifested in manifold ways within different social frameworks, is sought not just by humans but also by many kinds of animals (not only primates), which suggests that the pursuit of status may be intrinsic to communal life.[1] Material culture, clothing, funerals, architecture—everything associated with enduring or ephemeral visual experiences—both reflect and constitute the social realities associated with status.[2]

As a postmedieval Salentine proverb sums it up, "Vesti muntone [or zzurrune], ca pare bbarune" (Clothing of fur, or colored blue, makes a man appear to be a baron).[3] The semblance of nobility is vested in clothing associated with and appropriate to that social group—an issue of economic rather than cultural capital.[4] Appearance often constitutes the most immediately perceptible index of social status, and the preceding chapter, particularly the concluding section on the legislation of appearance, would have been appropriate here as well. However, I focus in this chapter on nonsartorial features that also constructed and restricted an individual's place in medieval Salentine society. I discussed surnames in Chapter 1; when these were still rarities, as was the case until the thirteenth century, they stood out from the norm and distinguished their bearers. Supplementing surnames as indicators of special standing are the titles and professions cited in inscriptions or indicated by painted clothing or accoutrements; in addition, certain occupations can be extrapolated from archaeological data. In the later Middle Ages, heraldry became an important signifier of status. The construction and contents of tombs announced family wealth, not only at the moment of burial but also thereafter. Age, gender, and marital status had clear and not-so-clear implications

for social standing as well. Finally, it is possible to discern some facts about the relative status of churches, monasteries, and even communities from the visual and archaeological record. All of this information about status provides a richer context for the individuals depicted or recorded in medieval Salentine art.

Titles and Professions

The most impressive title in or on a Salentine monument belongs to the Byzantine emperor Nikephoros II Phokas: the rebuilt walls of Taranto themselves credit this "pious and all-powerful autokrator" with commissioning new city ramparts in the 960s [**139**]. Other imperial or royal titles included in Salento inscriptions are used mainly as indicators of date and tell us little about the individual commemorated or credited in the inscription.[5] A series of titles occurs only in Latin texts, most ostentatiously at Santa Maria del Casale in 1335 when Nicholas de Marra is identified as royal knight, royal lord of two villages, councillor, familiar, captain general, and justiciar [**28.W**].[6] Of civic titles, most occur only once in the corpus of painted or carved texts: chamberlain [**48**], nobleman (*nobilis vir*) [**141**], royal baron [**144**], leader (*praeses*) [**78.C**], preceptor [**28.T**], village captain (*kephalikos*) [**30**], *spatharios* (a minor title originally applied to a bodyguard) [**32.J**], soldier (*stratiotes*) [**43.A**]. One Hebrew gravestone in Bari bears the title *strategos* even though the Justinianic law code barred Jews from the army and the title of "general" was patently impossible [**10.B**].[7] The only civic titles used more than once are "count" [**48, 58.A–B**] and "judge" (*iudex, iustitiarius*) [**28.W, 79.A**]. The more generically respectful "lord" (*dominus, kyrievontos*) is employed several times [**1.A, 28.T, W, 38, 48, 86.E, 144**] and "lady" (*domina*) twice [**1.A, 81.B**], once for a Jewish woman. A rabbi who was also the son of a rabbi boasts this largely honorific title [**18**] and another has a double titulature, "rabbi" and "master" [**149**].[8] This last is a vague title, but it recurs in Hebrew [**150**] and *magister*/μαΐστωρ precedes names in Latin and Greek [**31, 51.A, 109.A**]. One of these may contain the further specification *magister muratoribus* [**39**],[9] and another two men are identified as sons of a magister [**36, 87.A**]. It is difficult to know whether and to what degree a particular title or profession conveyed status in the Middle Ages, but I have assumed that if it was worth recording in an inscription it probably was noteworthy in the broader social context.

 A wide range of medieval occupations is attested in Hebrew, Greek, and Latin written documents, far more than are attested in public texts and images.[10] Excavations provide further evidence for occupations not recorded in texts (the faith of these workers is unknown): Supersano had linen workers, Otranto had vintners, Apigliano and Quattro Macine had metalsmiths, and several communities pro

duced ceramics used in the region and beyond.[11] If it actually had four mills, as its name implies, Quattro Macine must have had quite a few inhabitants involved in grain production. Yet none of these professionals left a secure visual or verbal record of their presence.

The professions of some individuals can nevertheless be deduced from a variety of nontextual evidence. We can extrapolate that professional stonecarvers were available from the high quality of some of the incised tombstones in all three languages. The example from Oria manifests the comfort of the carver with Hebrew and his relative unfamiliarity with Latin [81]. Many Latin funerary and dedicatory texts, such as those at San Paolo in Brindisi [26.C] and Santa Maria del Galeso [144], betray all the hallmarks of professional carving, with ruled guidelines, word divisions, regular lettering, and careful inlay. The first carver of the Andrano hospital dedication shows a distinctively angular style and a profusion of Greek ligatures [4.A]; he was more of a professional than the second carver [4.B].[12] That professional carvers were not always employed even for highly visible projects seems clear in the case of Taphouros, the ciborium carver at Cerrate; André Jacob argues that he barely knew his Greek [114.C–D].[13]

A partial roster of occupations is visible in the Last Judgment at Santo Stefano in Soleto (ca. 1440) [113.B]. While the artist has essentially followed Byzantine artistic conventions and much of the scene is formulaic (if no less affecting for that), these particular professions would have been rendered in the Greek of the models, not the local *volgare*, if they were irrelevant to fifteenth-century life in the region.[14] Hence we find, among the damned, a builder (with ax) and woodworker, a butcher, tailor (with scissors), innkeeper (with jug), and shoemaker (with oversized tool), all of whom share space with the more obviously moralizing usurer, thief, rich man, and greedy man. Several of the labels that accompany the sinners have clearly been repainted and it is not certain that these were the original occupations, but the roster of professional malfeasance deserves to be included even if it takes us slightly beyond my chronological boundaries. The two other Last Judgment scenes in the Salento, at Santa Maria del Casale near Brindisi [28.A] and San Giovanni Evangelista at San Cesario di Lecce [108.sc], are within our time frame but much less informative: there are the usual clergy, monks, and nuns, but only the innkeeper at Brindisi is labeled and has two jugs around her(?) neck.[15]

In surviving works there is a preponderance of religious titles. One of several possible words used for "priest" is by far the most common title employed in Salentine inscriptions: there is one πρωτόπαπας [46] and one κληρικός [33.G], but a dozen men are titled either ἱερεύς, παπᾶς, or πρεσβυτέρος and two the more poetic θύτης [49] and θυηπόλος [114.B]. Roman-rite priests similarly outnumber all other professionals: one archpriest, one *chlericus*, five *sacerdos* or *sacerdotis*, and nine extant presbyters. Higher and lower clergy are also represented in public

texts: seven bishops or archbishops and four deacons, including one arch- and one subdeacon.

Four men are termed monks in Greek, including one hieromonk [**114.A**], and a group of monks from Otranto added a collective graffito to a dedicatory text at Vaste [**154.B**]. We do not find in the Salento the written record of nuns charac-teristic of church dedications in such areas as southern Greece, and few if any nuns are depicted.[16] I do not assume that such adjectives as "humble," ταπεινός, neces-sarily identify a monk [**143.A**]; others with that adjective are priests. Monastic profession was no obstacle to textual recording, as Roman-rite abbots, a prior [**22.F**], and Orthodox abbots are all associated with inscriptions. One of the Orthodox abbots [**109.A**] and one bishop [**49**] have the additional designation "lord" (κύρ), thus supplementing their religious titulature with a secular one. Finally, there is an ὀβφέρτος (oblate) of Saint Stephen at Vaste, either the tonsured, kneeling priest George or his father [**157.G**]. Because all of these texts were visible to others, albeit in varying degrees, the titles used should be accurate; it is doubtful that anyone could style himself *iudex* or even σπαθάριος in public unless he had been awarded such a title or had that profession, although it is possible that the more vague magister/μαΐστωρ or even *dominus/domina*/κύρ were used without much standardization.[17]

Even when an individual patron or supplicant is untitled, his status could be communicated by proximity to those who are. Thus when George Longo invites four bishops to attend the consecration of his new hospital at Andrano, their pres-ence announces George's social standing at that moment; only one of the bishops, Donadeus of Castro, was required for the consecration [**4.B**]. Whether the coterie of regional bishops might have visited George on other occasions cannot be deter-mined, but on *this* socially significant occasion they were all there, their presence recorded proudly and in perpetuity. George lacks a title, but status accrues to him through the ranks of his guests.

An act of the Latin archbishop of Taranto in 1028 was signed in Latin by ten priests, two deacons, and one subdeacon and in Greek by one protospatharios, one spatharocandidate, and two tourmarchs.[18] Public texts never include so many names and titles, and neither do they address a comparably wide range of topics. Yet even the more limited public titulature confirms the overwhelming presence of Christian priests and other religious titleholders in the local built environment and in the verbal communication of local status. As discussed in Chapter 2, the fact or appearance of literacy was a source of social and cultural power.

One of the most interesting professions, because it is so rarely attested else-where, is surely that of painter or other artist. While none are portrayed, at least not recognizably, and no artists' paraphernalia has been identified archaeologically, a surprising number are attested epigraphically. This is done in Greek with the

phrase διὰ χειρός, by the hand of the (named) artisan. This differs from such other Italian regions as Campania, where the craftsman's role is never acknowledged textually, and is more akin to the situation in Byzantine provinces.[19] The centuries of Byzantine rule, the enduring form of most devotional inscriptions, and the persistence of epigraphic communities who could read them probably explains why there are many Greek painters' names in the Salento.

Some of the oldest dated works in the Database, at the Santa Cristina crypt church at Carpignano, are signed in Greek by painters who work at the behest of someone else: Theophylact in 959 [**32.A**], Eustathios in 1020 [**32.D**], and Constantine in 1054/55 [**32.I**]. In architecture, Michael Korkouas of Corone built an unknown church at or near Vaste at the behest of a patron [**154.A**]. Master Daniel and Mar[tin?] had a hand in the construction or decoration of the San Biagio monastery church at San Vito dei Normanni in 1196; they share credit with the abbot and a financial supporter [**109.A**]. John, son of master Pellegrinus, in 1309/10 built with his own hand (χειρὶ) a church of the Theotokos at Cavallino, but the efforts of the patron are cited first [**36**]. The ciborium of the Orthodox monastery at Santa Maria di Cerrate gives credit to the abbot for its expense, but the priest Taphouros, further identified as the engraver (ξέστης) of the dodeca-syllabic inscription, "constructed" (κατεσκεύαζε) it [**114.C**]. At San Nicola at Acquarica del Capo in 1282/83, painters named N— Melitinos and Nicholas co-signed in Greek a long dedicatory text that they executed in Latin [**1.A**]. A few years later, the rock-cut church at Li Monaci was painted by the hands, ἐζωγραφήθη δὲ χειρὶ, of a father-and-son team, Nicholas and Demetrius of Soleto [**43.A**]. Uniquely, at Santa Chiara alle Petrose in Taranto the undated "humble painter John" explicitly seeks remission of his sins [**143.A**].

As it states more than once, the famous mosaic pavement of the cathedral at Otranto was the work of the "right hand" (*per dexteram, per manus*) of the priest Pantaleon, in conjunction with its patron, Archbishop Jonathan [**86.C–G**]. When the so-called "Madonna della Sanità" in the Benedictine monastery at Nardò was repainted in 1255 it was made by "the skilled hand of Bailardus" (*doctaque manu Baylardi*); two others are said to have "made" it, which generally has a financial implication [**78.C**]. A bronze bell originally in the church of Sant'Anna in Brindisi has on its rim an inscription crediting a prior named Matthew with (initiating?) the work and the hand of a priest named Bartholomew with finishing it and a companion bell [**22.F**]. It is unlikely that Bishop Bailardus actually built the cathedral at Brindisi with his own hands (the verb used is *composuit*) but Peter, son of Gui—, may well have been the architect because his name appears modestly at the base of the apse exterior, even though no verb is preserved [**21.A, C**]. Only in the case of the rebuilt walls of Taranto is a recognized professional architect described as being eminent, renowned, and greatly valued. His social status is apparent from

the adjectives, and in fact Jacob has shown that he is identical with the *magistros* and *strategos* Nikephoros Hexakionites known from other sources [**139**].

More craftsmen sign their work in Greek than in other languages; presumably their patrons permitted or encouraged them to do so. Studies of late Byzantine dedicatory inscriptions indicate that painters' names were included only when they shared the social rank and cultural background of the patron and that this only occurred in monuments outside the major cities.[20] Because the Salentine craftsmen are associated most often with priests or monks, neither of whom enjoyed a particularly high status, a comparable standing likely accrued to the artists as well. We might think of them as locally distinguished (perhaps more for their apparent literacy than for artistic skill) but not among the wealthy elite.

The only secular "profession" recorded pictorially is that of the military man. I disagree strongly with Maria Stella Calò Mariani that the male embracing a woman on the ceiling at Li Monaci is the soldier Souré of the dedicatory inscription [**43.A, C**].[21] The only depicted figures who are inarguably knights are a single figure at Santa Caterina at Galatina and a series of supplicants on the upper walls at Santa Maria del Casale near Brindisi. Both are Roman-rite churches built and decorated with aristocratic support and painted in 1432 and the fourteenth century, respectively. "Franciscus of Arecio" at Galatina [**47.D**] has been identified as the artist rather than the subject image because of the Latin *fecit*, but "made" very likely meant "had this made" rather than "painted it with my own hands." In any case this is a humble supplicant addressing a single saint, even if he is clad in chain mail. That fighting was a high-status occupation is much clearer from the scale of the paintings at Brindisi [**28**] with their subjects often identified by inscriptions and titles, and the fact that the knights are usually accompanied by grooms, horses, and repeated heraldic markers.

The grooms in the retinue of one of the soldiers at Santa Maria del Casale are certainly servants and may even be slaves [**28.D**]. There are numerous documentary references to slaves in the Salento—wealthy members of all three religious groups had them—but their representation is rare. Slaves are referred to in the eleventh-century Stratigoules epitaph [**32.J**], unless ψυχαρίων there refers more broadly to servants.[22] In addition, a southern Italian Hebrew poem of the ninth or tenth century refers to handsome males and females being brought into an unnamed local port by ship and sold by the shipmaster for a quantity of straw (women) or a measure of gold and gems (men).[23]

Salentine Jews were involved in a wide variety of professions, although these are unremarked on their tombstones (nebulous references to "rabbi" are unlikely to indicate a line of work). When Benjamin of Tudela visited in the twelfth century he noted that the Jews of Brindisi were all involved in dyeing.[24] More information comes from the Jewish communities displaced from southern Italy (including

Apulia, Calabria, and Sicily) in the sixteenth century. In Corfu the newly arrived Jews were active in moneylending, dyeing, leatherworking, and commerce; in Thessalonike they were mariners, fishermen, bricklayers, and tavernkeepers, unlike the exiled Jews from Rome, who tended to be merchants, doctors, and lawyers.[25] This accords with scattered documentary information about what the Jews were doing in the medieval Salento.

Heraldry

Beginning in the mid-twelfth century, the ability to employ heraldic symbols systematically on one's person, household, and possessions was one of the most obvious European indexes of status.[26] Heraldry was intimately connected to family identity, kinship, and lineage. Even some Jewish Italian families adopted heraldic symbols in the late Middle Ages in clear imitation of highly regarded contemporaries [**149.B**].[27]

In 1483 the well-traveled Dominican Felix Fabri noted a wide range of ways that visitors to holy sites left a record of their presence: by painting their coats of arms or pasting paper copies to church walls; using chisels and mallets to carve them; or even hanging their shields. He goes on to criticize these visual intrusions into the sanctity of the sites (*parietes deturpabant*).[28] Notwithstanding such criticism, in the material culture of the Salento heraldry appears in the form of painting and carving. There are impressive compositions high on the walls of Santa Maria del Casale, where many of the panels are framed with a series of painted shields or other insignia, sometimes echoed in such compositional details as banners, horse blankets, and shields [**28. I, N, Q, R, V**]. In other panels, one or more painted shields testify to patronage at a high level [**28.C, N; Plate 6**]. At other sites, stemmata (coats of arms) are painted on roof beams.[29] Comparable to this ostentatious painted display is the carved shield on the relief slab of a judge (*iudex*) at Santa Maria dell'Alto [**79.A**] or the tomb of Nicholas Castaldo's unnamed wife at San Paolo in Brindisi [**26.C**] and, in larger format, on a separate slab in the same church [**26.D**]. Whether painted or carved, these constitute formal, public statements of family status just as valid and even more legible than a verbal text. In the Middle Ages, the Anjou or Del Balzo coats of arms were immediately recognizable, and perhaps the Di Tocco and Di Marra were as well, at least to certain audiences. But like most names from the past, the insignia at Santa Maria del Casale and elsewhere have lost their visual impact and are seldom recognizable today.[30]

A curious painted panel at Santa Maria del Casale [**28.J, L**] may postdate the badly abraded frescoes it covers (I was not able to examine the stratigraphy up close). It is certainly medieval. The left part of this "triptych" has a red helmet with

white crest balanced on a white shield with diagonal red cross.[31] The faint letters below, "IOHS / RODI," refer to the order of Saint John of Jerusalem and Rhodes, to whom all the Templar possessions passed within a few years after the formal process against them took place in 1310, quite likely in Santa Maria del Casale itself.[32] It is tempting to read in this panel a commemoration of the local event and a visual assertion of Hospitaller status vis-à-vis the Templars. The adjacent panel is more elaborate: a diagonally balanced shield at the base, decorated with three smaller shields, supports a red mantle, a helmet with visor, a crown with a golden Gothic *m* on top, and two large black-and-white crests. The right-hand panel has a black shield with gold cross supporting a more elaborate black helmet with a visor and what may be a griffon crest. To the right is yet another shield, this time gold with three rampant red lions, on which are balanced a vair-lined red mantle, two crests (unless these are elaborations of the cape), and a large golden *n*. The fur-lined mantles and the crowns are royal or princely emblems,[33] and the diagonal shield that supports additional insignia is the typical representation of the complete armorial image in medieval heraldic rolls. Similarly elaborate crests, one with an animal head, are worn by supplicants elsewhere on the same wall [**28.D**].

While I cannot fully unpack these impressive icons of power, I am confident that they were once readable by those visitors to Brindisi who possessed the heraldic code, including all of the high-ranking patrons of the church's other painted images. Moreover, I would liken these heraldic images to painted or carved texts: their very presence was impressive even to those who could not "read" them, enhancing the status of the entire church. As Detlev Kraack has discussed, noblemen and members of chivalric or fraternal orders proudly demonstrated their presence at important sites—and even at less-important sites en route to those destinations—by means of permanent and ephemeral displays of insignia.[34] These "signs of honor" were important records of passage and of social relations. The insignia at Santa Maria del Casale record the presence of mutually supportive noblemen of equal rank.

A second corpus of heraldic material consists not of formally carved or painted shields but of more numerous small-scale examples, either quickly sketched onto or, far more often, incised into a plastered wall [e.g., **1.pg, 3.pg, 54.pg, 78.pg**].[35] The evidence of subsequent incision provides a *terminus ante quem* for the frescoes, but it is not easy to assign dates because heraldry remained important long after the early fifteenth century. I think that all the small markers of status—or wannabe status—in the Database are from the late Middle Ages or early modern era.[36] In those cases where pictorial graffiti are in close proximity to verbal graffiti, the morphology of the latter can be compared with securely dated examples, such as the graffito of an archpriest at Nociglia of 1472 [**80.B**]). Such details as the pref-

erence for minuscule betrays a late date in Greek graffiti, while classicizing capitals, stylized script, and classical names indicate a postmedieval date for Latin graffiti. Assessing the age of undated graffiti, especially pictorial graffiti, is a risky question of connoisseurship.

A bigger question for the purposes of this chapter is whether all of these graffitists could actually have had a blazon indicating their family status. By the thirteenth century even those who were not of noble birth were permitted coats of arms, a usage formalized in northern Italy in the next century: according to Bartolo di Sassoferrato, so long as one did not falsely claim a title or damage the property or reputation of others, inventing a coat of arms was permissible.[37] Therefore, in some cases a painted or incised *stemma* indicated an aristocratic presence, however that "presence" is defined, while in other cases these might be harmless inventions. I suggest that isolated shield graffiti are expressions of desired rather than real status, whereas groupings of heraldic insignia are likely to be genuine symbolic communications of at least relative social status. This finds some confirmation in the isolated shield incised into a tombstone in Trani that presumably postdates the Hebrew inscription dated 1290/91 **[149]**. The "owner" of the shield could have been a descendant of the person named on the stone, or indeed any person with access to the tomb, although the fact that bones were found undisturbed may indicate that the graffitist was Jewish.[38]

At Masseria Lo Noce, graffiti are clustered exclusively on the archangel Michael who guards an arcosolium tomb on the right wall [**54.st; Plate 10**]. A large, partly cross-hatched shield occupies the space below the angel's left arm and his spear; at the lower-left corner, over and around his legs, are three more shields, all bearing different designs. Their presence on the crypt's sole figure in military pose is clearly quite deliberate and it is tempting to see the careful distinctions among the shields as similarly meaningful. Their "realism" is reinforced by the incision of fictive loops for "hanging" the graffiti shields. But could the different decorations actually be products of creative invention rather than memory? Were the owners of these shields themselves present to insert their mark on Saint Michael, or were they done by members of the household or even by persons more removed from legitimate heraldry? At the moment these questions are unanswerable.

Another assemblage of individualized shields, in this case more deliberately painted, is found in the second fresco layer on a pilaster at Alezio's Santa Maria della Lizza [**Plate 2**]. Here an impression of hierarchy is palpable: two of the shields are significantly larger than the others, prominently "hanging" on painted hooks in the top row. These large shields, like several of the smaller ones, are rendered in more than one color, and both are further associated with a figural outline near the apex: a profiled male head for the left shield and a profiled bird for the right. These profiles are probably additional heraldic elements (crests?). The network

of smaller shields at Alezio asserted to medieval viewers that the holders of the large shields had numerous followers or supporters. Unfortunately, I have not been able to identify any of these individuals.

The presence of white shields with black crosses on the ceiling of the Cripta del Crocefisso at Ugento [**151.D**] has spurred several studies arguing that they signify patronage by the Teutonic Order, which has ample attestation in the Salento.[39] On the other hand, there are also white shields with red crosses, suggesting to one scholar patronage by the Templars, who are entirely unattested in the region.[40] The latest scholar to weigh in on the matter, Hubert Houben, does think this was a Teutonic church, originally Santa Maria dei Teutonici, known from fifteenth-century texts; he considers the red-crossed shields either a matter of artistic license or an "homage" to the Templars on the part of the Teutonic Order.[41] I am not convinced that this ceiling decoration is informative about individual or group patronage, just as I do not think the embracing couple at Li Monaci [**43.C**] represents people named in the dedicatory inscription. Ceilings, which could barely be seen in the dark and smoky interior of a crypt church, were not the place to make personal statements even though some large built churches discreetly, almost invisibly, included shields among the other decorative elements on their painted ceiling beams.

Nonheraldic pictorial graffiti—animals, buildings, faces—are difficult to connect with status in specific ways. They may have had such meaning to their creators, but what subsequent viewers would be impressed by them? Verbal graffiti that included the names of their inscribers might have had additional associations with status but they are more appropriately discussed in Chapter 6 as practices in places of worship.

Family Status

Both Christians and Jews were keenly aware of their family's social standing. Individuals recorded in documents as owning property were certainly among the Salentine well-to-do, and these included the ancestors of Ahima'az, who, in the ninth and tenth centuries, owned one or more vineyards, fields, orchards, and gardens.[42] Participating in literary and cultural life, like Ahima'az himself and his *piyyutim*-composing forebears, also conveyed status among Jews. For Christians, the equivalent may have been life as a cleric or monk, but postmedieval proverbs indicate that these latter activities were not always held in high esteem.[43]

Learned and well-to-do Jewish families whose daughters were betrothed to men of a lower intellectual or social level were keenly aware of the fact. Unequal matches were made rarely, and only under extenuating circumstances, for they

violated the norms of social hierarchy and social mobility.[44] A comprehensive wish list of attributes for a Jewish son-in-law is provided by a ninth-century mother, an ancestor of Ahima‘az, who wants the best for her daughter and balks at an engagement below her station:

> I will not give her out. [Only] if he will be like her father, [learned] in Torah, in Mishnah, in Scripture, in Law and Logic, in Sifri and Sifra, in Midrash and in Gemarah, in meticulous observance of minor and major commandments, in intelligence and wisdom, in astuteness and cunning, in wealth and grandeur, in courage and exercise of authority regarding the observance and precepts and commandments, in fearfulness and humbleness, and that he have every [other] virtue.[45]

Despite her mother's wishes, Cassia is married off to an unworthy relative once her father, the sage Shephatiah, perceives how nubile she has become. It is unlikely that the range and depth of textual knowledge expected by the girl's mother could have been matched by any but the highest levels of local Jewish intellectuals. Of all the material evidence, only a late Hebrew tombstone from Trani commemorates a "very learned" individual [**150**]. The degree to which a comparable "package" of excellence and stature was desired by the region's Christian mothers is unknown.

One very public method of advertising family status was to construct or renovate a church or chapel that would then serve as a repository of family memory, with privileged tombs, texts, or images on the exterior or inside. Such *Eigenkirchen* were very common in thc Orthodox world; they became less common in Europe after the twelfth-century Gregorian reformers' efforts to centralize religious control.[46] When John of Ugento constructed a "basilica" at Acquarica del Capo [**1.A**], he may have been "motivated by the remission of his sins and benefit of his soul and those of his parents," but at the same time he was providing a place of worship for a larger group, the inhabitants of the village where he may have been only an occasional visitor. This is the only regional text that announces a whole basilica rather than a chapel [cf. **35, 47.A**]. Jewish patrons, too, could publicize family and status by renovating parts of their local synagogues; several such efforts were recorded in inscriptions to be read to and by the whole community [**9, 50**]. While there must have been many small family churches, used especially for burials, even family-funded synagogues always served a larger community because a quorum of ten men (a *minyan*) was required for many religious services. A *minyan* is explicitly identified as patrons of a synagogue at Trani [**147**].

By the later Middle Ages, aristocrats and religious elites often had their own spaces for worship, either in separate buildings or in elaborate chapels within existing

structures. At Santa Maria del Casale, the early fourteenth-century vita cycles of Saint Catherine on the south presbytery wall are usually associated with Catherine of Valois, Courtenay, and Constantinople, the second wife of Philip of Anjou, Prince of Taranto [**28.N**].[47] There are later textual references to an Angevin dynastic chapel, but this was probably in the north transept, which contains a large fictive textile with the Angevin arms. It is also possible that, despite their placement high up on the nave walls, the repeated depictions of large shields and of small family groups being presented to the Virgin and Child served as focuses of family devotion within the large basilica, even if these ostensible family spaces were not delimited architecturally.

In 1383, Bishop Donadeus of Castro built a chapel in the local cathedral with money from the property of his deceased parents, endowing it with those funds [**35**]. This literal family chapel was visible to anyone attending services in the cathedral. The early fifteenth-century castle chapel at Copertino [**42**], the "Cappella Maremonti" in the parish church at Campi Salentina,[48] and the "Cappella Orsini" at Santa Caterina in Galatina are all examples of late medieval aristocrats' family spaces inside larger churches. The latter occupied part of the south aisle of the Galatina basilica; a projecting apse in the south wall boasts its own altar and a surrounding decorative program with scenes of the life of the Virgin.[49] How the family used this special space within the five-aisle basilica built by Raimondello del Balzo Orsini is not known, as the cenotaph of the founder and later his son were located in the sanctuary, not here [**47.C**]. I wonder whether this Orsini chapel is equivalent to the "chapel of Saint Catherine" announced in Greek over the doorway into this part of the church [**47.A**].

Postmortem Status

From the moment a person died, his or her status was manifested in the location and form of the tomb and the extent and kinds of activities at the funeral and afterward. In addition, the quality and range of objects found in graves reveals something about the occupants' lives and communal standing. By the later Middle Ages the dead in Salentine villages were interred within their communities; this may not have been the case earlier, when burials seem to have been outside of the settlements, in and around funerary churches.[50] Most inhumations took place in simple rectangular or ovoid tombs cut into the natural bedrock and oriented east to west [**102–103**]. Several of these cemeteries are quite extensive and most have a church as their nucleus. Some of the graves are lined with stone slabs, but in the majority of cases the covering slabs required to seal in the odor of decomposition are missing. Within the grave the tomb could be flat or curved and with or without

a stone "cushion" or terra-cotta tile to keep the head of the deceased lifted up and facing east toward the eventual Second Coming.[51] By the eleventh century, most bodies were interred with heads to the west and feet to the east.[52] In most of the excavated village sites, tombs were reused for subsequent burials, presumably for family members; in these cases most of the earlier, disarticulated bones were removed to an adjacent ossuary or charnel pit, pushed to the foot of the tomb, or left underneath the new corpse.[53] One grave at Quattro Macine (XXIII) contained the remains of seven individuals [**103**].[54] Individual burials were also possible, however, including several fourteenth-century examples inside the church of Santa Maria della Strada at Taurisano.[55]

At the village of Quattro Macine, the graves closest to the north wall of the twelfth-century church were for infants, including one newborn [**103**], and this concentration also occurred at Apigliano. It has been suggested that rain dripping from the church roof would convey a special blessing to these privileged children,[56] but since not all children were interred in this way the location was also likely to have been based on economic factors linked to status.[57] One fetus was interred in an amphora far from the cemeteries around both the Byzantine and Norman-era churches at Quattro Macine; stillborn and probably unbaptized, it may well have been buried at home.[58] I have suggested elsewhere that the container on the ground in front of the praying Daniel at Masseria Lo Noce [**54.A**] may represent a child's amphora burial, although the form of that amphora is not the same as contemporary local production.[59] Daniel and his putative dead child are painted on the intrados of an arcosolium, so even if my amphora suggestion cannot be proved, the arcosolium form underscores the likelihood of a privileged burial there.

The most privileged medieval dead were buried inside a church in an arcosolium, a floor tomb, or a freestanding sarcophagus. The much-loved Stratigoules was interred under an arcosolium in the north wall at the west end of the rock-cut church at Carpignano [**32.J**]. Other arcosolia, such as the pair in the lower church of Santa Lucia at Brindisi, probably served a comparable function. There were several floor tombs for children inside Santa Maria della Strada at Taurisano.[60] In the two-story crypt church of Saint Bartholomew at Casalrotto, near Mottola, the subfloor tombs in the lower church presumably were reserved for important monks.[61]

Stone sarcophagi were used on occasion to hold one or more special bodies. The example of uncertain date inside San Cesario di Lecce may have held the church's founder, a priest, sometime after 1329, but because another sarcophagus was also found under the church this is uncertain [**108.pg**].[62] The figured sarcophagus now displayed in the crypt of the Taranto cathedral is a more status-conscious example, even if the original occupant's name is now unknown [**140.F**], for it depicts

in high relief a deceased man being lifted aloft by flanking angels. Either identifying information was painted alongside and is now lost or the sarcophagus was originally placed in a family chapel such that the occupant's identification was apparent.

The carved multilevel cenotaph of Raimondello del Balzo Orsini (d. 1406) in the church he founded at Galatina is unique in this region and period [**47.C**]. Brightly painted and gilded, its form echoed that of such royal Neapolitan tombs as that of King Robert the Wise in Santa Chiara and it served as a model for the funerary monument of Raimondello's son, Giovanni Antonio del Balzo Orsini, installed in the newly enlarged sanctuary at Galatina in the 1460s.[63] Such an elaborate tomb marker, complete with coat of arms, marks the honoree as one of the most exalted dead.

At Quattro Macine, the small Byzantine church of the tenth or eleventh century contained a single tomb before the altar, housing a male aged thirty to thirty-five [**102**].[64] While it seemed likely that this burial was the raison d'être for the church even though such a location for a tomb was unprecedented in Byzantine churches,[65] carbon-14 dating indicates that the man was actually interred during the thirteenth or fourteenth century.[66] Whatever the date, his was certainly a privileged burial. This was also the case for the seven graves inside the late medieval church (San Nicola?) at Apigliano, where infants' tombs are arrayed nearest the altar and adults farther away. The centralized adult tomb (XXXVI), with three skeletons, is the only one anywhere at Apigliano constructed with squared limestone blocks, another indicator of the occupants' social status.[67]

Although the identity of a single person buried inside a church might not be forgotten quickly, the graves of individuals and families buried outdoors almost certainly required the presence of identifying markers. Carved tombstones, often with decoration on two or more sides, identify the deceased of all three religious and linguistic groups in the Salento. In every case, a formally carved stone must have been a veritable status billboard. Even with its Greek text written in hard-to-read minuscule, the stone that marked the grave of Nicholas, son of Vitalius Ferriaci, in 1330 would have been a credit to the family, attracting viewers' eyes to both sides with their reliefs, compass-drawn rosettes, and alternating colors [**156.A**]. This marker contrasts significantly with a roughly contemporary gravestone from San Cataldo [**107**], which, while much larger, lacks relief or inlay and is carved on one side only with irregularly sized and poorly spaced letters. Nevertheless, the sheer size of this less-well-carved marker surely was meant to impress. The same must have been true for Jewish tombstones: some are extremely large [**16, 135**]; one has text emphasized in red [**16**] and with shofars and menorahs

incised on sides and front; others have Latin and Hebrew texts on two sides and incised menorahs and shofars on the others.

Not everyone could afford a professionally or even an unprofessionally carved tombstone for departed family members. Most people must have been buried in tombs identified by more ephemeral means, perhaps a wooden post or cross or a ceramic marker like the ostracon that marked a family tomb at Quattro Macine [**101**]. Circular holes have been found alongside a few graves at Cutrofiano, roughly in line with the head of the deceased.[68] The only extant grave marker with a circular base, presumably for insertion, is the bilingual Jewish example from Oria [**81**], decorated or inscribed on all four sides and on top.

Any objects in tombs were deposited at the time of burial (or reburial) and were, at least temporarily, publicly visible to mourners. A recent study on the living and the dead in medieval Calabria notes that during the funeral, "the entire community could and would verify the status of the deceased by means of the symbolic objects [*corredi-simbolo*] inserted by relatives into the tomb."[69] The twelve-year-old girl interred at Quattro Macine with two silver earrings likely stood apart from her peers because of her expensive finery.[70] However, not all such objects are relevant to this chapter on status because many seem to have primarily apotropaic or symbolic (religious) implications. So while we might be tempted to associate coins with status, if every tomb contains a coin—as is the case at Apigliano—this can hardly be the case, and other motives for their presence will be sought in Chapter 5. At sites where coins were placed into only one or a few graves,[71] status may indeed have been a motive. After all, if one's family had sufficient wealth to entomb a valuable coin,[72] this would communicate a certain level of distinction especially in periods when few coins were available, as was the case in rural areas in the twelfth and early thirteenth centuries.[73] In the cemetery at Casalrotto, controlled by Benedictine monks, the tombs were devoid of any objects that might signal a differentiation by status, unless the ceramic cups that covered three skulls were meant to be understood in that way.[74]

The clearest indicators of social standing that are found in tombs are metal belt fittings and jewelry, a sizable quantity of which has been found by archaeologists. Moreover, at both Quattro Macine and Apigliano, the tombs with the greatest concentration of such objects are in the immediate vicinity of churches, reinforcing the social hierarchy suggested by proximity to the sacred space.[75]

Belts are very often included in suppliants' images, as noted in the previous chapter, but only rarely are these depicted as being embellished with metal appliqués of the sort common in local tombs and seen regularly on painted saints. Men's belts were also ornamented with metal buckles, and recent excavations at Apigliano unearthed oval and rectangular iron buckles, some with double pins.

Such buckles had practical functions, as tools or pouches would be attached to them, but they also intimate a certain prestige because not everyone possessed an overgarment that required belting. Bronze buckles are more fragile than iron and usually more elaborately decorated, thus more likely to indicate a higher social status.[76] One such buckle, decorated with a rampant lion and stylized grain, was found in a Lombard or early Byzantine context in Manduria.[77] *Shibolei ha-Leqet* cites the opinion of the author's brother in the mid-thirteenth century that Jewish men who wear long garments requiring a belt may wear one on the Sabbath, although belts made of silk or silver are forbidden.[78]

Earrings have been found in tombs at Otranto, Taranto, Quattro Macine, Apigliano, Casalrotto, and elsewhere. The excavated examples are of several distinctive types, and many—including circles with three balls or "apples" (*milelle, mela*), half-moon shapes, and those with hanging "baskets" (*panarellum*)—are cited in Norman charters, which means they were objects of value.[79] Such earrings, and those with other designs as well, are worn by such female saints as Lucy at Massafra [**62.st**] and Barbara at Casaranello [**33.F**]. It seems likely that the jewelry shown on holy figures was actually produced for the highest social class and then imitated by artisans.[80] There are examples for more humble clients made of less precious materials—glass paste instead of gemstones, bronze instead of gold—and earrings made of gold and silver have also been found. Burying a woman in her finery implied that her family could afford this loss of property.[81]

Outside of the Mediterranean region, earrings had fallen completely out of fashion before the fourteenth century.[82] Indeed, in northern Italy pierced ears could be a means of identifying a slave, as a single earring was common for both male and female slaves (although women might have both ears and even the nose pierced).[83] In an often-cited article, Diane Owen Hughes has shown how earrings were associated with prostitutes and Jewish outsiders in late medieval northern Italy.[84] Yet this could not have been the case in the Salento, where, under the influence of the Byzantine world[85] and the continuous Jewish presence, earrings were ubiquitous. The Augustinian monk Jacobus of Verona, passing through the region en route to the Holy Land in 1346, records with astonishment that "in the city of Otranto I saw many women with pierced ears and they wear rings in their ears, some one, some two or three according to wealth. And they wear silver chains similar to earrings as is the custom throughout that region and in all of Sclavonia, Albania, and Romania [Byzantium]."[86] While for Jacobus earrings were a mark of low social standing, in the Salento the opposite was true. Here girls' ears were pierced soon after birth, according to both the eleventh-century glosses on the Mishnah copied in Otranto and

twentieth-century ethnographic observation.[87] Even so, not a single painted female supplicant wears earrings.

Age and Status

Using archaeological and epigraphic evidence it is possible to assess the ages of some of the medieval Salentine dead. We can then consider how different age groups were perceived in the cultural, religious, and linguistic communities that composed the medieval Salento. While age is not one of the components of identity that an individual could change, it was nevertheless a social construction, affected by expectations about the different stages of life.[88]

As is well known, there were extremely high infant and child mortality rates in the Middle Ages: in the cemetery of Santa Lucia alle Malve at Matera, half of the tombs belong to children under fourteen and 70 percent of the those were under age seven.[89] At Quattro Macine, one-third of babies failed to attain one year of age and half of those buried died before reaching adulthood. Of the eighty-one individuals at Apigliano whose remains were identified by 2009, the mortality rate for subadults was very high, especially around age five.[90] In the large cemetery at Casalrotto, with ninety-eight tombs used between the twelfth and fourteenth centuries, the excavators calculated a 71.6 percent infant mortality rate.[91] Women were nearly as vulnerable as children: at Quattro Macine only two were interred over age forty, compared to a third of men who reached that age before dying.[92] Only rarely did women live into old age.[93] Survival rates varied by location: at Quattro Macine, over a quarter of the adult population survived past age forty-five, while at Apigliano half died in their twenties. Of the dozens of supplicants on Salento church walls, not a single one is represented as very young and no one is aged.

Local Greek epitaphs usually give the year of death and often include such particulars as the month, day, hour, and indiction, but they uniformly neglect to indicate the age of the deceased. Three funerary texts in Latin do give the age at death but all of these are bilingual epitaphs that commemorate a Jewish person. It is only the Jewish tombstones, then, whether exclusively Hebrew or bilingual, that provide precise information about age at death; at the same time, these omit any dating information apart from an indication of the year in terms of time elapsed since the destruction of the Temple [**16.A**].[94]

Thirteen Jews' ages at death are known from tombstones ranging in date from the seventh to the tenth century: females at age six [**132.A–B**], seventeen [**16.A**], twenty-something [**17.A**], and fifty-six [**81.B**], and males at age fourteen [**125.B**], sixteen [**131.A–B**], twenty-something [**126.C**], forty [**124.A**], forty-two [**123.A–B**],

fifty-four [**11.A**], sixty [**14**], sixty-eight [**18.A**], and the less helpful four and some-thing (e.g., fourteen, twenty-four, etc.) [**127.A**]. In addition, a twelfth-century syn-agogue renovation commemorates a dead eighteen-year-old boy [**50**]. The ages in this very small sampling correspond generally to the archaeological data, with more men living to old age and the youngest dead almost entirely absent; perhaps the latter group did not have inscribed tombstones because their numbers were so large or their parents less attached. It also corresponds to social expectations: more men than women are commemorated with expensive tombstones, and one with a synagogue pavement and seating, although the most elaborate preserved stone in Hebrew belongs to Leah, the girl who died in Brindisi at age seventeen in 832/33 [**16**]. Her meter-high stela has incised menorahs and shofars and rubri-cated letters, making it an eye-catching statement of her father's social standing as much as his expression of grief at her loss.

The epitaphs of two Salentine Jews who died at an advanced age suggest something about their status in the communities of Oria and Brindisi. Hannah (Anna) of Oria [**81**] has the only bilingual stela for a female. In the Latin text on top she is called "domina" but in the Hebrew she is described as a wise woman, *ishah nevonah*. Her age is given three times, so even if the repetition in Latin is a dittography this was an important datum. Her stela has shofar and menorah decorations in relief, a more painstaking technique than chiseling, and the texts have been neatly carved by a Hebrew speaker. The author of the rhyming Hebrew text is present, in a sense, because "Samuel" is spelled out by the first letter of each line. These features combine to make a unique monument for a woman who stood apart because of her age and "wisdom," however that may have been defined.

Rabbi Baruch, who passed away in the latter ninth century at the advanced age of sixty-eight, was also the son of a rabbi, so two respectful (if imprecise) titles are included in his epitaph [**18.A**]. While the stone is not large, the text is uniquely framed in a decorative border with an incised menorah atop a title set between two horizontal lines: "The resting place of Rabbi Baruch, son of Rabbi Jonah." This is the only epitaph in the region, for any linguistic or religious community, with a separate title line, which may reflect its manufacture in a community of literate Jews habituated to texts with titles. In addition, the last four lines come from a *piyyut* written by Amittai ben Shephatiah of Oria shortly before the date of Baruch's death and still part of the Italian Jewish funerary rite today.[95] These fea-tures combined to make an impressive memorial, albeit one that could only be appreciated by Brindisi's Jewish community, unlike the potentially bilingual audi-ence for Hannah's stela in Oria.

The data from the Salentine Jewish epitaphs correlate rather well with other information about age and gender. David Noy's study of Jewish inscriptions in

Italy, Spain, and Gaul (which includes some of the Salento texts) cites three females deceased at ages five, six, and fifty-six, and six males, dead at ages fourteen, sixteen, twenty-something, forty, forty-two, forty-something[96]—once again, more commemorations of men and boys than of women and girls. This was already true in the region in the Greek and Roman periods, when twenty-one females and thirty-seven males were commemorated in extant tombstones; of those, three women lived until age seventy, but six men lived even longer, from seventy-five to ninety.[97]

If Byzantine life expectancy has been estimated at thirty years or even lower, those living twice or three times as long must have been truly exceptional.[98] That the elderly were viewed as important in Byzantine society, and consequently as having an elevated social status, is evident from accommodations made for old-age homes (γηροκομεῖα) in numerous monastic typika (unfortunately, the only extant Salento typikon—for San Nicola at Casole—is limited to dietary rules and mentions elderly monks only briefly). Comparable facilities for geriatrics are not as well documented in medieval Europe. A study of old age in Byzantium concludes that "age was a sign of power," exemplifying the virtues of Byzantine society.[99] On the other hand, old women and especially widows were sources of concern. They had been sexually active and remained financially active, and as such they posed a potential threat to the normal social order. For this reason they were sometimes accused of being witches or *gelloudes*, child-stealing demons, discussed in the next chapter.

Philippe Ariès's assertion fifty years ago that there was no distinct medieval period of childhood has been challenged in recent decades.[100] Certainly the Salento evidence supports that (some) children were prized: not only are they referred to with some frequency in their fathers' dedicatory or devotional inscriptions, a very few even by name, but some are also singled out for fervent prayer when they are born or when they die. In addition, two unmarried daughters are shown with their parents in the apse at Vaste [**157.A**] and ubiquitous depictions of the infant Christ are supplemented by an unusual image of him as a child, walking with his mother in the Candelora crypt [**63.A**].

Only one childbirth is commemorated epigraphically, on a large but very crudely cut stone found in secondary use at Soleto [**112**]. Despite the poor quality of both the text and the carving, the unnamed child has the distinction of being born the day after the birth of John the Baptist, thus stimulating his unnamed parents' comparison to the saint's parents, Zechariah and Elizabeth and an almost literal citation to a canon of Andrew of Crete.[101] André Jacob, who published the inscription, noted that childbirth notices are fairly common in Salento manuscripts but that this is an isolated epigraphic testimony to a birth. The sheer size

of the stone and the hubris of its contents likely rendered this a notable marker of family status wherever it was displayed.

The most fulsome regional testimony to a parent's love for a dead child is the arcosolium devoted to Stratigoules at Carpignano in the third quarter of the eleventh century [**32.J**]. The Greek text relates that the departed boy is missed by his parents, brothers, cousins, friends, schoolmates, and the slaves to whom he was generous. Right away we find markers of family status: they owned slaves and the boy attended school. His father was a *spatharios*—the modest title is visible even though the name is lost. He was to be interred with his son in the only arcosolium tomb in the century-old crypt church, literally under the eyes of the Virgin and Saints Nicholas and Christine, all of whom are invoked in the colorfully painted epitaph. The form of the tomb and specific details in the text advertise the father's status, which enabled him to construct a compelling visual and verbal space of mourning and commemoration. Fully 50 percent of Byzantine children died before reaching the age of five and I know of no others commemorated with such an elaborate tomb.[102] There is no evidence that infant mortality was any less among other cultural groups in the Salento even centuries later.[103]

The terms used in Greek to refer to an unnamed child or children are consistently τέκνον, τέκνων, τέκνοις. Hebrew epitaphs are more specific, citing names and using *bat* or *ben* for daughter or son of a named parent. The sole Latin text that includes children uses *filiorum* [**25**]. These texts raise the question of when, exactly, was childhood, and where it fit into the larger taxonomy of the "ages of man." Several European writers, following Isidore of Seville, divided the life span into *infantia* (birth–7), *pueritia* (7–14), *adulescentia* (14–30), *juventus* (30–50), *senectus* (50–60), and *senium* (60+).[104] The Byzantine patriarch Photius, on the other hand, wrote about nine ages of life that began with βρέφος (to age 4), παιδίον (4–10), βούπαις (10–18), μειράκιον (18–20), and ἀκμή (20–35).[105] Age was a subject discussed in the Mishnah and the Talmuds, and most later Jewish texts rely on these venerable models. The "Chronicles of Jerahmeel," probably written in medieval southern Italy, describes seven ages of man, just as in the medieval Midrash Tanhuma collection.[106] A few new insights about age were added, however, in *Shibolei ha-Leqet*, which says that boys of nine or ten could count in a religious quorum; the idea that Jewish boys reach adulthood at age thirteen only emerged in the late Middle Ages, although Jewish girls could be married by that age.[107] According to the Fourth Lateran Council (1215), age seven represented a turning point in the life cycle, the "age of discretion" from which time children were supposed to make a confession and receive the Eucharist annually.[108] The significance of this age in the development of the child is also noted in Greek legal compendiums: punishments increased after seven

and betrothals were possible.[109] Age seven is also when Christian children began their schooling, if they had any, while Jewish children started at age five.[110] Because children were legally under parental control, they were inferior to them in status.

Gender and Status

Like age, gender is an "embodied" category that in the Middle Ages (less so today) was less fluid than other components of identity.[111] While archaeology reveals no gender divisions within cemeteries or individual tombs, it is clear from public texts that women, like children, had a status lower than that of men. At least two women—one Jewish and one Roman-rite Christian—are unnamed even on their own tombstones [26.C, 121], which confirms that these monuments are less about the deceased than about family status. Only a few women are named on their own in devotional inscriptions, and all but a few are depicted with an accompanying husband. It is difficult to use these rare exceptions to make a claim about independent female wealth or agency. The Anna who is commemorated alongside Saint Anne at Carpignano [32.B] may not have been personally responsible for commissioning the sacred image; it may have been painted in her honor or memory, rather than at her behest.[112] Two other women are identified by name at Carpignano: Chrysolea, the wife of Leo in the 959 apse inscription [32.A], and Anastasia, wife of a man whose name is now lost [32.H]. This is an unusual concentration of female names in a Byzantine-era church, and not only in the Salento. Only one later site in the region contains more references to specific, named women. In Santi Stefani at Vaste, not only are a woman and her two daughters named in the apse [157.A], but three other female suppliants are also identified by name and depicted independently [157.C, I, M]. In terms of women's relative literacy and status in Greek and Latin cultures, it may be significant that both are Greek-language sites.

Women's Head Coverings

Married women of all faiths were usually distinguished from the unwed by their hair covering; in fact, our word "nuptial" comes from the Latin *nuptus*, covering or veiling the hair.[113] This was already the case for Jewish women in Mishnaic times, based on Numbers 5:18, and it continues for religious Jewish women today.[114] Isaiah of Trani the Younger took the stringent view that covering the hair was a biblical requirement rather than a more lenient rabbinic injunction, although it seems that his grandfather, Isaiah the Elder whom we shall cite frequently, dis-

agreed.[115] Many Christian women also covered their hair, as enjoined by Saint Paul (1 Cor. 11:5) and as suggested by numerous medieval representations. As a sign of piety and modesty, head covering made married women recognizable and thus helped to maintain social order and respectability: it was a metonym for moral status. Uncovered hair came to be associated with immodesty and with uncontrolled grief or distress, and it will figure in our discussion of funerary practice. In the preceding chapter I considered the variety of forms and the terms used for female head coverings; here I wish to underscore their function as indicators of marital or other status. This is confirmed in the Salento by the female figures in the Vaste apse, in which the wife and mother wears a white head covering while the (unwed) daughters do not [157.A]; all of the female supplicants on the piers and pilasters have covered hair and are therefore wives or widows [157.I, Plate 18].

There are, however, some regional images of unmarried women whose hair is covered [75.sc.1] and presumably married women whose hair is not. At the Candelora crypt in Massafra, the praying pair at the feet of the Virgin escorting her child to school is presumably a married couple, but the woman's hair is visible; if she has a veil, which is a possible reading of the yellow stripes, it is quite transparent [Plate 12]. While it might be tempting to conclude that the female head-covering convention was more relaxed in churches used for the Roman rite, the sparse data do not support such a sweeping conclusion. Yet to assert that the convention weakened over time contradicts the ethnographic evidence from southern Italy that married women and widows continued to cover their hair well into the twentieth century. Perhaps uncovered female hair could indicate both unwed status and appearance after death regardless of marital status when alive. I have argued elsewhere that many of the images of supplicants who are traditionally called "donors" may actually be postmortem representations paid for by family members to serve as indexes of family status and as pious exemplars for the faithful.[116]

A woman who wears a full white wimple that covers her head and neck had a different status entirely. In the Magdalene chapel at the castle of Copertino (ca. 1420) [42], the homonymous saint is flanked by two female supplicants. The one on the viewer's left, dressed in contemporary secular clothing, is seen in the usual three-quarter view; opposite her, another woman wearing a large wimple stands or kneels in profile (I discuss these poses in Chapter 6). Sergio Ortese notes that the latter figure seems older than the first one, and suggests that the woman in the wimple is Maria d'Enghien, and that her daughter, Caterina del Balzo Orsini, may be depicted on the left. These identifications derive from the presence in the chapel of the combined arms of Caterina and her husband, Tristan Chiaromonte, who wed in 1415; because Caterina died in 1429, Ortese does not think the painting can be later than that date.[117] Another interpretation is possible, however. Per-

haps the image shows the same woman at two stages of life: in aristocratic secular garb when young and as a nun at a later period, perhaps even after death. (The Magdalene was, of course, a model for nuns.) When shown alive, the woman engages the viewer through eye contact and models the proper devotional attitude; after adopting the habit and moving to a more elevated plane, she is vouchsafed a more intimate connection with the central saint and does not address the viewer. The Magdalene inclines her glance and her gesture toward the nun, who has grown in both stature and status from her previous state.

Good comparisons are found locally as well as elsewhere in in Italy and also in the Byzantine world. The tomb monument for Raimondello del Balzo Orsini at Galatina shows him twice: praying toward the high altar while elegantly dressed in a vair-lined robe on top, and recumbent in a Franciscan habit beneath a curtain held open by angels below [47.C]. This double figuration echoed that of royal tombs in Naples and elsewhere.[118] While there may not be a direct connection, late Byzantine aristocratic tombs also duplicate the figures of the deceased. In the *parekklesion* of the Chora in Constantinople (ca. 1320), Michael Tornikes and his wife are each shown in elegant secular dress and in monastic garb; as described by Robert Ousterhout, "The dual aspects of their lives are thereby represented: they appear as citizens both of this world and of the next."[119] These Italian and Byzantine precedents for the double figuration of a pious aristocrat support my hypothesis that the two female supplicants at Copertino represent a single individual at different stages of life.

Wealth and Status

Evidence of economic productivity beyond subsistence level means that a given community, or at least some of its members, were well-to-do and in a position to contribute to the local visual landscape. Excavations have revealed large-scale amphora production in the early medieval period, and a distinctive new type of Salentine amphora, presumably filled originally with local wine and exported from the tenth to the thirteenth century, has been found over a wide area.[120] By the thirteenth century, Cutrofiano was a center of pottery production (it still is); its medieval wares have been found throughout the southern Salento.[121] Brindisi produced glazed protomaiolica from the thirteenth century onward, and its products were exported to Greece and the eastern Mediterranean.[122] Typical local wares of circa 1430—beakers, jugs, knives—may be seen in a meal scene early in the vita of Saint Stephen on the south wall of Santo Stefano at Soleto.[123]

Evidence for wealth from the other direction, in the form of imported goods, comes mainly from the Salento's coastal cities.[124] A rare exception is Quattro

Macine, where fragments of four Byzantine bowls were found; most rural sites lacked such luxury ceramics.[125] The dishes decorated with pseudo-Kufic in the Last Supper scene at San Simeone in Famosa or with elaborate scrollwork at San Pietro at Otranto [**87.sc.1**] are meant to evoke expensive imported wares. In addition to ceramics, imported objects in other media—soapstone vessels from the Alps, a eucharistic stamp identical to a Byzantine one at Aegina, a Fatimid glass weight, a Samanid silver coin from Afghanistan—are especially well attested in the Byzantine centuries.[126] Imports of Islamic pottery, including *bacini* from North Africa and Raqqa ware, are mostly later,[127] as is a triangular marble stela with a Qur'anic text found near Santa Maria del Galeso but almost certainly brought there from Sicily.[128] Imported coins of all periods have been discovered at every excavated Salentine site.[129]

As is apparent from the great majority of texts and images in the Database, individuals and families with sufficient means often expended resources on church building, renovation, or decoration. Many Salento churches were impressive structures, but some were materially more costly than others. A very visible example is San Pietro at Otranto, where the lapis lazuli used for the bright blue in the second fresco layer (third quarter of the thirteenth century) is very different from the more commonly used blue obtained from azurite [**87.sc.1**]. Lapis was used only in the eastern bay, either because it was too costly or insufficient quantities were available; in either case, the unknown patron was very wealthy indeed.[130] A conceptual world away from Otranto, a Salentine village church might be the only local structure built even partly of stone and with a floor made of something besides tamped earth.[131] From an urban perspective churches built of earth may have been considered inferior to those made of stone, but rural users might not have thought so if they never saw other options. Perhaps only those who had the resources to travel could make aesthetic and cost comparisons between buildings.[132]

Imitation and Novelty

Artistic imitation is connected to status because it testifies to the esteem accorded a preexisting monument, whether this high opinion is based on antiquity, distinguished patronage, material or artistic quality, or other factors.[133] Establishing a visual connection with a model was like forging a bond with a distinguished individual: it was a means of producing authority and claiming a privileged relationship. We find such intervisuality in all kinds of art.

Because many of them feature permanent altars and templon barriers, there is no evidence that excavated churches functioned differently from built churches; they merely cost less. Thus it is no surprise that many of these less costly churches

imitate the spatial layout of an aboveground church, often the Byzantine cross-in-square, and several, including San Salvatore at Giurdignano and the Candelora crypt at Massafra, go so far as to replicate domes, wooden beams, and corbels in excavated limestone.[134] In no case, however, is it possible to ascertain a specific model.

The Franciscan church of San Paolo at Brindisi took its form and many of its decorative features from the nearby Santa Maria del Casale, while the architects of the Orthodox monastery church of Santa Maria di Cerrate (rebuilt in the late twelfth century) looked to Santi Niccolò e Cataldo in Lecce for its open-truss roof, wall articulation, portal sculpture, and round-arched exterior frieze.[135] The Franciscan basilica of Santa Caterina at Galatina seems to have had its plans changed during construction to more closely align with local building traditions represented by Santi Niccolò e Cataldo, built by Tancred [**58.A–B**]; in this way, the new local ruler, Raimondello del Balzo Orsini, would be visually linked to a royal Norman predecessor to whom he was also connected through his marriage to Maria d'Enghien.[136] In the following decades, the extensive decorative program at Galatina mimicked that found in the major Franciscan churches under royal Angevin patronage in Naples.[137] Continuing the cycle of *imitatio*, the painters who worked at Galatina in the early fifteenth century executed other commissions and inspired contemporary and later artists in the region. Already in 1423, the will of a nobleman in Ostuni stipulated that his new chapel of Saint James should be decorated "similitudinem ecclesie Sancte Caterine de Santo Petro de Galatina."[138]

Sometimes, however, artistic novelty was perceived as desirable. This can be assessed through a consideration of extra-regional craftsmen who are thought to have decorated Santa Maria della Croce at Casaranello and San Pietro at Otranto, both in the second half of the thirteenth century. The Casaranello church contains fifth-century mosaics in the vaults of its cruciform sanctuary.[139] It was enlarged or altered in the late tenth or early eleventh century, as attested by a graffito that documents its reconsecration by an Orthodox bishop [**33.D**].[140] The nave walls and vault were painted with Byzantine-looking Christological scenes in the mid-thirteenth century [**33.sc.1**], and the vault was painted again, in a very different style, in either the 1260s or circa 1300.[141] Scholars posit that the vita of Saint Catherine on the north side of the vault was executed by an artist trained in France and that a local painter imitated his work in the companion Saint Margaret cycle [**33.sc.2**].[142] Someone hired an itinerant artist from outside the region and introduced a very new style, iconography based on French sources, and Latin *tituli* into the venerable church.

This is similar to the situation at San Pietro at Otranto, where a local artist trained in the region's long-standing byzantinizing idiom painted alongside an up-to-date colleague skilled in preparing lapis lazuli and acquainted with the new

Palaiologan style. This latter artist, whose contributions were limited to the church's eastern bay, seems to have had no followers and little impact on the region's art, just like the Casaranello innovator. Juxtaposition of divergent styles apparently bothered no one, and there are abundant examples from other post-Byzantine regions.[143] He must have come from across the Adriatic.[144] While I disagree with attempts to associate these east-bay scenes with artists known from texts—the unnamed painter "skilled in pictorial arts" who was sent from Corfu to San Nicola at Casole in the 1230s, or the Paul of Otranto who painted a fountain in Constantinople around 1200—I agree that the former does attest to another "imported" artist working in the region earlier in the thirteenth century.[145] How much it cost to hire the foreign artists employed at Casaranello and Otranto is unknown, but if scarcity increases value they should have cost more than local talent, and hiring them should have elevated both their status and that of their wealthy patrons.

Community Status

Enhanced status could accrue to individual craftsmen and patrons from successful imitation of celebrated models, perceptions of novelty, or visible demonstrations of piety. Other kinds of art are connected to community status. When the walls of Taranto were rebuilt between 965 and 969, it is the city itself that speaks in the inscription and it is the city whose status is elevated along with the wall's named patrons [139]. While we cannot know what the actual inhabitants of Taranto may have felt about their new defensive circuit, it must have afforded them a heightened sense of security and of civic identity. Perhaps the same was true for the inhabitants of Carpignano when a new tower was built by the village head in 1378/79 [30].

The erection in Brindisi of two huge ancient columns also must have heightened the city's inhabitants' sense of themselves. A dedicatory inscription in Latin commemorated the Byzantine rebuilding "from the foundation" of a once-distinguished city that had been abandoned as a result of Arab raids, its bishop transferred inland to Oria [20]. These enormous signposts announced the Byzantines' continuity with the Romans and made Brindisi one of the few cities that could boast two tall columns; Rome and Constantinople were the others.[146] Yet the columns were erected decades after the Byzantine reconquest, in the first half of the eleventh century, after Byzantium had regained control of the Via Egnatia and Brindisi's old center was repopulated.[147] In other words, the victory monument was not raised until there was a population to appreciate its connotations.[148]

I suspect that city folk generally felt themselves superior to their country cousins, but even the smallest village probably had some source of local pride. Without a doubt, the best way to improve local status was to discover a successful

miracle-working image, like the Mary icon at Santa Maria del Casale (fourteenth century) or the Madonna della Coltura at Parabita (early fifteenth century); the former is lost, but the latter is still processed around the town annually. While the miracles endured, they attracted attention from near and far. But when fortunes diminished, or never materialized, community status was vested in verbal insults. This *campanilismo* can be traced back via collected proverbs to at least the early modern era.[149] It takes the form of insults that range from mild to quite harsh. "Melendugno, fimmine bbedde; Calimera, cozze patedde" is harmless enough: "Melendugno has beautiful women, Calimera a certain kind of mussels." "A Ccutrufianu num purtare còtime, a Uggentu nu ccercare sacramentu" means "don't bring clay vessels to Cutrofiano" (like coals to Newcastle, a foolish act) and "don't look for sacraments at Ugento." The residents of Ugento supposedly had "neither faith nor sacraments" (*nè ffede nè ssacramentu*), as asserted in yet another proverb.[150] I noted earlier that people of Alessano and Carpignano were called "Jews," an insult that may have originated before 1541 when there still were Jews in the Salento.[151]

From insults to art, the question of status was never far below the surface. Its construction and maintenance informed much of material culture, the built and visual environment, and daily life, and not only in the medieval Salento. In the next chapter we look more closely at the people whose status concerned us here, considering key moments in their lives through the lens of ritual.

The Life Cycle

In the preceding chapters I have hewed close to the Database to assess how individual and communal identity was communicated visually, textually, and/or spatially through names, languages, appearance, and status. In the second half of the book I continue to explore the question of Salentine identity by reconstructing what the "painted people" actually did and, through their actions, some of their beliefs. Obviously, a medievalist's ability to recover actions and beliefs can only be partial and fragmentary; the region lacks the kind of detailed archival information that historians working in other places have mined so successfully. While the Database remains the foundation for my observations, I also introduce additional types of evidence—folkloric, ethnographic, legal, among others. Combining art with other kinds of information yields a much richer context for the images and texts that survive.

Defining "Ritual"

This chapter deals with the life-cycle rituals of Salentine individuals whose names, languages, appearance, and status we have analyzed in previous chapters. Status in particular could be manifested not only through stationary art but also through performative rituals and other acts that provided opportunities for social display. The field of ritual studies has been a growth industry in recent decades and many definitions have been proposed. I define "ritual" as being constituted by repeated action or series of actions ("cultural performances"), which can be utterances, gestures, or something else. Rituals are intended to do things for the people who perform them. Whether enacted by or for an individual or a group, the performer's goal is to produce a desired outcome in the present or future. Most rituals embody cultural values, model particular behaviors, and reveal a high degree of deference to rituals enacted in the past.[1] While many ritual actions are symbolic and many, perhaps most, are related to religious culture, others are secular and quotidian.

With their relative fixity they offer "a means of measuring, mastering, and making sense of the world at large."[2] Rituals therefore can be important components of and contributors to individual and communal identity.

I am interested in this chapter in the things that local people did, for themselves and for others, at predictable but highly charged moments of life and death: during pregnancy, childbirth, and nursing; upon entering their respective faith communities at the baptism or *brit milah* (rite of circumcision), as well as a new mother's reentry into her community via churching or the Sabbath of the Parturient; children starting formal schooling; betrothal and marriage; death, burial, mourning, and commemoration.[3] These liminal moments or phases of life were enacted mainly in the home or community and not in the place of worship, although the most important components of the baptism and *brit* were indeed formalized there; nevertheless, I consider these events in the current chapter because they were such significant moments in the individual life cycle. Those rituals that are generally thought of as collective religious rites, requiring repeated oral formulas, gestures, and props and taking place mainly or exclusively in churches or synagogues are the subject of Chapter 6, while additional domestic and community practices unrelated (or only tangentially related) to the individual life cycle are discussed in Chapter 7. Information gleaned from material culture and texts forms the basis for additional observations that sometimes lack a visual component. Once again, fleshing out the skeletal images of Salentine Jewry and Salentine women requires recourse to evidence from outside the region.

Unlike the performances enacted largely in the house of worship, life-cycle rituals often involved women as important actors and officiants. There is a growing body of evidence that women communicated about their rituals, and the reasons for them, across faith lines. This habit of "gyno-sociability" among women was often criticized by men concerned with maintaining social boundaries between religious and other groups.[4] Yet the reality was that Orthodox and Roman-rite Christians lived in the same cities and even villages, and so did Christians and Jews. These groups were not ghettoized; they passed in the streets, shared communal bathhouses, and witnessed one another's funerals, festivities, and countless other rituals and routines. In the context of daily life, women likely found opportunities to communicate in the local language about common gendered and nongendered concerns.

Pregnancy, Childbirth, Nursing

In medieval churches, the pictorial narration of the life of Jesus begins with his mother's imminent pregnancy (the Annunciation) and continues with his bath by the midwives and placement in the manger while his mother watches and rests

(the Nativity). Among the rituals most needed by women of all backgrounds were those associated with pregnancy and childbirth, the "medical and cultural event" that was the first stage in the human life cycle.[5] Procreation is itself an index of status, a source of pride and an expansion of patriarchal power, as one ethnographic study of early twentieth-century Massafra asserts.[6] A traditional focus of prayer by pregnant Christian women was Saint Anne, but there were additional precautions that women could take to ensure a safe pregnancy and a positive outcome. Among the most interesting, shared by Jews and Christians alike, was the avoidance of seeing anything ugly or malformed in order to ensure that the child would not share those defects; conversely, looking at beautiful things could produce attractive offspring. Ethnographic studies attest to this habit in southern Italy in modern times,[7] but it is found already in the Bible and in classical and late antique texts, including the Talmud.[8]

In addition to controlling the visual stimuli they received, pregnant women often wore special amulets and belts. In the fourteenth-century Roman glossary of difficult terms in Maimonides, the vernacular term *contana*—otherwise unattested in Italian or any dialect—denotes a stone amulet worn by pregnant women to prevent miscarriage; it could be worn even in public on the Sabbath.[9] Specific materials and stones that prevented miscarriage were encouraged in ancient and medieval literature, including the medical text of Trotula from eleventh-century Salerno.[10] While none of the abundant archaeological or pictorial evidence for belts can be securely connected with this specific function, it is possible that a Roman gem found in a Byzantine context—but not in a tomb—at Apigliano may have been in secondary use as a pregnancy charm before being lost or discarded.[11] It is made of milky chalcedony, the material of some famous medieval birth amulets.[12]

While not readily apparent in most painted scenes of Christ's Nativity, childbirth was one of the most dangerous moments in the lives of women and their newborns. The Orthodox euchologion includes a prayer to God at the birth of a child: "preserve them from all the tyranny of the devil, from envy and jealousy and the evil eye."[13] To alleviate the danger, gemstones and belts inscribed with relevant prayers were placed on the abdomens of medieval Jewish and Christian women.[14] Prayers and incantations are attested in Byzantine texts and in medieval Slavic sources based on Byzantine prototypes.[15] These include invocations to Sarah, Abraham's wife, and a direct address to the child to come out of the mother's body. Saint Blasios also had connections with childbirth because prayers for women in labor are identical to the prayer for removing a bone from the throat.[16] The fact that there are so few "official" prayers for childbirth is an indication that the space of childbirth was in some measure, though not completely, outside of male clerical control. In fact, only women were present during a typical birth. Successful childbirth is commem-

orated once in the Salento with a large inscribed stela that quotes a canonical ode of Andrew of Crete about the birth of John the Baptist [**112**].

In the surviving Nativity scenes, at least one and normally both of the depicted midwives who are bathing the Christ child wear a head covering indicating their status as married women. In fact, only married women could be midwives; their bodies had already been "opened," and indeed their first professional task was to unlock every sealed object in the house to facilitate an easy birth through a process of sympathetic magic.[17] The lost midrash *Esfa*, likely written in southern Italy in the ninth century, contains a parable about a woman who used witchcraft—a closed pot—to stop delivery of a child. The parable is a reference to a story in the Talmud (tractate Sotah) that continued to be relevant: a very similar tale is preserved in the *Arukh* dictionary compiled in Rome circa 1100 and in a twelfth-century document from the Cairo Genizah.[18] Jews could have Christian midwives but not be left alone with them; Jewish midwives were not supposed to attend Christian women but did so anyway, at least in Ashkenaz, although the same restriction about being alone obtained.[19] Midwives were viewed suspiciously because of their charges' vulnerability to the evil eye and their own healing powers. A synod at Otranto in 1679 warned them against "superstitious observances," including placing "anything above [the infants] while they are being baptised, which could be used afterwards in sorcery, or (as they say) for remedies."[20]

Newborns were swaddled for their protection, but of course they needed nursing to survive.[21] It was a mother's responsibility to feed her child, but sometimes wet-nurses were hired instead. In theory, Jews were forbidden to nurse gentile babies, who were considered potential idolaters, with one exception: if, on the Sabbath, when expressing milk was forbidden, a woman was in great pain, she would be allowed to nurse a non-Jewish child.[22] The Third Lateran Council reiterated earlier legislation against Christians wet-nursing Jewish infants, but these may have been enforced only in cases where the Christian women worked in Jewish homes, if at all. Elisheva Baumgarten has shown that medieval Jewish rulings on this matter were contradictory, and that some Jewish children (in northern Europe) did indeed have Christian wet nurses.[23] In the new rules of behavior issued by the Franciscan preacher Roberto Caracciolo in Lecce in the 1490s, the practice of Christian women nursing Jewish babies was strictly prohibited,[24] which may indicate that this local practice was widespread.

Whether nursed by their mothers or by others, children were generally weaned between the ages of two and three, slightly later in Byzantium than in Europe.[25] Jewish wet-nursing contracts usually specify a period of twenty-four months. Saints associated with wet-nursing included Catherine and Pantaleon, both esteemed healers, and especially Agatha, whose breasts figure in her martyrdom; all three were represented regularly in the Salento.[26]

The greatest fear associated with infancy concerned the female demon(s) who might attack a newborn child. Known to Greek speakers as Gylou or Gello, used as both a name and a generic term (Greek, γελλώ, *gello*; plural, γελλούδες, *gelloudes*) and to Jews as Lilith—Michael Psellos equated them in the eleventh century[27]—this female demon is not attested pictorially in the Salento but she is present textually. In the *Chronicle of Ahimaʿaz*, written in 1054 and replete with imaginative recollections of over two centuries of family history, an infant is saved from being abducted and eaten by she-demons.[28] The euchologion's prayer for a new mother includes reference to protecting her and the child from "evil spirits of the day and night."[29] This female demon was so widely acknowledged by both Jews and Christians everywhere in the medieval and postmedieval Mediterranean that we can hardly doubt her presence in the minds of medieval occupants of the Salento as well.[30]

Gylou/Lilith and other unnamed *exotika*[31] could be combated by recourse to any combination of amulets and magical formulas, iron, scriptural verses, and prayers to particular saints. In early modern northern Italy, women might hold a Torah scroll or the legend of Saint Margaret during birth.[32] Beginning in the thirteenth century, various Jewish communities practiced an all-night vigil on the evening before a circumcision when danger from the demon was at its peak. This gathering was supposed to allay the mother's fears, and by the fifteenth century the idea that it protected the child was also made explicit.[33] This *veglia* or *Wachnacht* or *mishmarà* is attested in Rome and Corfu, the latter of special relevance because many Corfiote Jewish rituals originated in Apulia.[34]

The placing of an iron implement under the bed or cradle was rationalized by Jews with an anagram: ברזל (BaRZeL), iron, stood for the matriarchs Bilhah, Rachel, Zilpah, and Leah.[35] For Christians, iron magnetically attracted and thus absorbed any evil (hence the continuing value of horseshoes).[36] Inserting iron (and nuts!) into infants' cradles to banish *striges* (female demons) was condemned in the Salento at a synod at Gallipoli in 1661, but it was still being used to repel the evil eye in the twentieth century.[37]

Although iron tools are not depicted in any Nativity scenes, Christ himself wears a circular amulet while on the lap of his mother in San Nicola at Mottola [**76.sc.1**], and beginning in the fifteenth century he is often shown with protective coral suspended around his neck [**118.st.2**]. Coral, garlic, and other phylacteries were dismissed scornfully by Leo Allatios, the Orthodox-turned-Catholic scholar and physician who wrote about the customs of the "Greeks" in the seventeenth century.[38] According to Allatios, the best way to prevent a *gylou* from attacking a child was baptism: protected by Christ, the child was no longer susceptible to harm. Yet as late as the seventeenth century, Orthodox parents saw no contradic-

tion in using a combination of amulets and Christian rituals, including exorcisms that compelled various saints to remove the *gylou*'s threat.[39]

Baptism and *Brit Milah*

In Roman-rite churches, children were baptized as quickly as possible, at most after ten days.[40] By contrast, Orthodox baptisms occurred either on the eighth day, in imitation of Jesus's circumcision and thus parallel with the Jewish *brit*, or forty days after childbirth, in conjunction with the new mother's churching.[41] Such writers as Allatios were appalled by such a long delay, which rendered the infant vulnerable to the *gylou* and other malign forces.[42] In the Roman baptismal rite infusion replaced immersion in the thirteenth century, but Orthodox practice continued to favor immersion.[43] A font likely used for the immersion of infants was excavated recently near Cutrofiano,[44] and an octagonal stone basin atop a short column in the parish church at Soleto is usually identified as a medieval immersion font; it resembles in form, if not in decoration, the font illustrating the sacrament of baptism (by immersion, curiously) in the Franciscan basilica at Galatina in the early fifteenth century.[45] In the diocese of Nardò in 1579, a pastoral visit records that the population of Copertino was induced to destroy their old, outsized font near the main altar in favor of a new, smaller one appropriate for infusion, located near the door.[46] Sick children were to be baptized immediately to avoid the state of limbo in the Roman-rite church and an uncertain fate in the Orthodox church. The child's naming at baptism has been called one of the most important "performative utterances" in medieval culture.[47]

From an early date, Christian authors had linked baptism and circumcision, asserting that the old method of expressing a covenant with God had been superseded by the new one. In his thirteenth-century treatise against the Jews, the abbot of the Orthodox monastery of San Nicola at Casole briefly compares the two rites: "the holy baptism is not superficial like the circumcision, but it permeates deeply, being branded in the hearts of the faithful."[48] Yet for Jews circumcision had the same salvific potential as baptism, with the blood of the infant specifically associated with the original Temple sacrifices in a *piyyut* written in the thirteenth century by Shabbatai of Otranto.[49] For both faiths, the infant's initiation ritual was a major rite of passage signifying acceptance into the respective community, at least for males. On these occasions male children received their names and community identities.[50] In northern Europe both ceremonies took place in the respective house of worship; in later centuries the *brit*, which required less in the way of fixed furnishings, would be done at home. Among the similarities between the two rites

adduced by Baumgarten are the white clothes worn by the infant, nonparents carrying the infant to the ceremony, the importance of godparents or *ba'alei brit*, meals before and after the ritual, and the washing and preparation of the child before the event.[51] These congruences are strong evidence that the rites of circumcision and baptism were evolving in conjunction with each other.

Baumgarten's evidence comes from medieval Ashkenaz, but not all of that community's customs came from southern Italy and it would be useful to know what finds corroboration in the Salento. As usual, however, the data are oblique and incomplete. The only pictorial datum is the Circumcision of Christ depicted at Santa Caterina in Galatina.[52] For this relatively rare scene the artist had few artistic models, so the representation may have drawn upon contemporary realia. The women, including the Virgin, are outside the Temple structure in which the event takes place, and Joseph peeks in from the doorway. A different couple, surely the godparents, views the action while a third figure, a female (Hannah from the Presentation in the Temple?), holds the Child. The other personnel are the priest-*mohel* and two acolytes carrying candles. The presence of candles and of nonparents corresponds to both the *brit* and baptism, and recent studies have affirmed that the Christian rite affected the Jewish one in significant ways. In an aside about contemporary practice, *Shibolei ha-Leqet* affirms that lights were lit in synagogues for a *brit milah* in part because the Christians use lamps or lanterns for their feasts as expressions of honor and joy.[53] The provision of light was a major expense in places of worship of all faiths.

The earliest mention of the *sandak*, the adult who held the infant on his knees during the circumcision, may be in Midrash Tehillim, originally assigned to medieval southern Italy but perhaps Palestinian in origin (although reworkings in Italy are not excluded).[54] The word *sandak* has two meanings. The first derives from the Byzantine Greek σύντεκνος, a term for a baptized child's godparent, although the *sandak*'s role in the child's later life is much more limited than that of the Christian godparents, which has been described as coparenting.[55] The second, earlier meaning comes from the Greek σάνδυξ, meaning a box or vessel, akin to the space formed by the lap of the *ba'al brit*. A male coparent of Rabbi Shephatiah is mentioned in the *Chronicle of Ahima'az* when his child is about to be abducted by female demons.[56] The presence of two *ba'alei brit* became widespread in Ashkenaz in the tenth and eleventh centuries, probably under the influence of Byzantine southern Italy.[57] Prior to the late thirteenth century in Ashkenaz, mothers or other women could fill this role.[58]

The images of baptism most widespread in the Salento are, as expected, those of Christ by John the Baptist. In addition, there is an image in Santo Stefano at Soleto of others being baptized by John in the Jordan prior to Jesus's immersion, and one of the sacrament of baptism at Galatina. Both of these scenes likely date

to the 1430s or later.[59] In the Soleto scene, the adult male being baptized has several people praying behind him that include a couple prominently kneeling in the foreground. It seems plausible that this couple evokes the godparents at a contemporary baptism, here transplanted to the bank of the Jordan River of fourteen hundred years earlier. Perhaps it is not coincidental that the number of attendant angels at Christ's baptism is usually two as well. One more late fourteenth-century image, part of a mural vita icon of Saint Nicholas at Santi Niccolò e Cataldo in Lecce, depicts a baptism as a posthumous miracle of the saint [**58.sc.1**]. A Jew who had left his treasure in the care of an icon of Nicholas finds them stolen; he strikes the icon, the saint appears, the thieves return the treasure, and the Jew converts. He stands inside a large font in white breeches while a deacon(?) anoints him.[60]

If connections can be adduced between Christian baptism and Jewish *brit*, it is not surprising that the two Christian confessions in the Salento display some overlap in their baptismal rites. The Orthodox and Roman-rite churches maintained slightly different phrasings to mark the critical moment of initiation. The Greek baptismal formula was criticized in a papal letter of 1232 preserved in Bari.[61] From the pope's perspective, the Greek statement "You are baptized in the name of the Father, Son, and Holy Spirit" required replacing by the Roman formula "I baptize you in the name of the Father, Son, and Holy Spirit."[62] But already in the euchologion copied in Otranto in 1177 (Vatican City, Biblioteca Apostolica Vaticana, Ottob. gr. 344), the priest Galaktion had amended the Greek baptismal rite in precisely this way, erasing the original Greek Χρίεται ὁ δεῖνα and substituting Ἐγὼ σὲ χρίω, corresponding to Latin *Ego te lineo*; he also amended the rubrics and added a long passage in Greek that directly translates part of the Roman baptismal ordo.[63] This is an important example of the mutability of a local life-cycle ritual resulting from the proximity of worshippers of another rite. Galaktion, in fact, further identifies himself as *deuteropsaltes* of the "great church"—the Roman-rite cathedral—of Otranto, which at least in the latter twelfth century hosted both Christian rites [**86.A**].

Churching and the Sabbath of the Parturient

A child became fully human in form only after forty days of nursing; this was the reason given in the *Novels* of Leo VI for waiting forty days between birth and baptism.[64] After forty days, when children could smile and recognize their mother, they were ready for integration into human society and the mother, too, was ready for reintegration into the community. Danger from demons had declined and both participants were now able to leave the relative safety of the home.

According to Leviticus 12:2–5, Jewish women required purification forty days after the birth of a son and eighty days after the birth of a daughter. Mary, as the mother of Jesus, had such a purification ritual at the Temple in Jerusalem on February 2; beginning in the sixth century, this was commemorated as the Christian feast of Candlemas or *Hypapante*, the presentation of Christ in the Temple and the purification of the Virgin. By the early Middle Ages, Christian mothers performed this rite of "churching" as an *imitatio Mariae*, carrying candles that had been blessed at the Candlemas feast. The *Sefer Nizzahon Vetus*, a polemical anthology of anti-Christian texts written in Ashkenaz in the late thirteenth or early fourteenth century, reveals that Jews were aware of this Christian public ceremony in which women wore white and walked in procession holding candles.[65]

In medieval churching, the white-clad woman knelt at the church entrance with candle in hand and was escorted inside after psalms were recited. In the Orthodox realm, infant boys were carried by the priest to the altar, baby girls to the sanctuary barrier; in the Roman rite, the woman appears to have been emphasized more than her child.[66] In both cases, candles represented the light of Christ as well as the purity of his mother. One prayer for the mother on the fortieth day is attested in a tenth-century South Italian euchologion as part of an appendix related to confession; a second prayer was introduced a century later.[67]

Jewish postpartum rites eliminated the candles but saw the woman attend synagogue on the Sabbath while her husband recited a blessing on her behalf and the cantor sang special tunes in her honor.[68] Both this *shabbat yetziat ha-yoledet*, literally, the Sabbath of the going out of the birth-giver, and Christian churching may have been empowering rituals for women even if men focused on issues of impurity. In the early modern period, a series of southern Italian church councils argued against women's having to wait for a specific *tempus purificationis* before attending mass, which simply proves that women were doing just that.[69]

In the Salento, there is a possible visual reference to churching in the image of two women standing and holding lit candles on the south wall of San Nicola at Mottola [**Plate 13**]. The light color of at least one of the women's garments, and probably both, may have counted as white in the Middle Ages when color values were far from absolute. Candles were used in many medieval rituals, but women were most closely associated with tapers during Candlemas and at their own churching. That viewers would associate the candle-bearing Mottola women with one or both of these events is confirmed, in my view, by their proximity to Saints Helena and especially Blasius, whose feast day in the Roman calendar immediately follows Candlemas on February 3 [**76.st.1**]. In the *Golden Legend*, the popular compendium of saints' lives and feast days compiled in Italy around 1260, Saint Blasius encourages a woman to make an annual offering of a candle in his church after he expels a bone from the throat of the woman's son.[70] This seems to be the

origin of his association with both throat remedies and candles, and in Catholic practice today, throats are blessed annually with two crossed candles.[71]

Sharing the niche with Saint Blasius at Mottola is the crowned Saint Helena, who was venerated in the West without her son, Constantine. Helena was famous for her maternity, which explains her juxtaposition to images associated with purification and childbirth. Curiously, Saint Helena seems to be visually amalgamated here with Saint Elizabeth of Hungary, who died in 1231 and was canonized in 1235; the *Golden Legend* spends considerable time describing her churching and other activities associated with maternal care.[72] After her husband died in the Salento in 1227 en route to the Holy Land, Elizabeth, the daughter of a king, apparently became a Franciscan tertiary. Later tertiaries wore a corded rope belt, which is exactly what outlines Saint Helena's green cloak at Mottola. On the bases of imprecise verbal description and the widely circulated *Golden Legend* account, an existing image of a crowned Helena (eleventh century?) may have been amplified in the thirteenth century with a rope-edged, vair-lined cloak (neither of which could date to the eleventh century) in order to evoke a new royal saint. How the rope should be worn simply may not have been known at such an early date. Regardless of whether the female saint is Helena or an amalgam of Helena/Elizabeth, the southern aisle of the Mottola crypt contains a constellation of images that cohere around female themes. The candle-bearing women adjacent to Saints Blasius and Helena suggest that this may have been a gendered devotional space of special relevance in the month of February.[73]

Schooling

A relatively minor but still important life-cycle event was when children first attended school. This event is reified visually in the Salento in the unusual image of Jesus being escorted to school by his mother in the crypt church at Massafra dedicated to the Candelora [**63.A; Plate 12**]. Mary holds the Child's hand while he grips a basket filled with round objects usually identified as eggs or bread.[74] Perhaps it is not too far-fetched to connect this image with one in a famous Jewish prayer book, the *Mahzor Vitry*, one manuscript of which, dated 1204, was in northern Italy in the Middle Ages.[75] One folio depicts a father escorting his son to his formal initiation into Hebrew learning. On this occasion the child—wrapped in a *tallit* like a Torah scroll—passes, literally, from parent to teacher.[76] The vocabulary employed in this rite of passage is strikingly similar across religious lines, with the Torah and Christ both referred to as wheat or bread. I am not suggesting that an artist in Massafra knew the Jewish manuscript image or the ritual described therein; rather, the sacred and symbolic depiction at Massafra of an adult accom-

panying a child to school might well have been based on the social realities of local Jewish and Christian boys.

The ages for starting school differed. Jewish boys started their training at age five, usually on the festival of Shavuot (Christian Pentecost), when the Torah was handed down at Sinai. The *Mahzor Vitry* says, "at the age of five one is ripe for Bible."[77] Leviticus was the first subject of study.[78] By the thirteenth century, Christian children began formal schooling at age seven, the same age as their first communion.[79] Boys in particular probably attended primary and secondary school, and some would have gone further.[80] The moving epitaph of Stratigoules at Carpignano [**32.J**] makes it clear that even village boys of fairly modest family background attended school, for the dead boy's schoolmates (συνσκολήτων) are said to miss him.

Greek terms for "teacher" appear frequently in local written sources, although no one is so identified in images or monumental texts. Several Salentine manuscripts contain rosters of books in the possession of a school or lists of miscellaneous texts suitable for classroom use. Schedographies—exercises to teach syntax and grammar—exist in many local copies,[81] and an epigram from Taranto exhorts youths to work on their grammar lessons.[82] A palimpsest manuscript of the early thirteenth century compiled for classroom use (Paris, Bibliothèque nationale de France, gr. 549) reveals that students studied religious texts (biblical, liturgical, and patristic commentaries), classical authors (Homer, Hesiod, Sophocles, and others), and schedographic epigrams of varying levels of difficulty.[83] At least one scholar has concluded that the educational possibilities in the Salento were equivalent to those in Constantinople.[84]

Betrothal and Wedding

Marriage represented a crucial transition in the social and sexual identity of women and men. It marked the creation of a new family unit that was expected to continue and expand existing units, and to this end couples were joined for reasons of property and status, rather than for love [cf. **Plate 9**]. This helps explain the sanctification of even child marriages in the Byzantine Jewish world.[85] Medieval Jewish and Christian parents selected spouses for their offspring and did not leave such an important economic and social decision to chance.[86] Nevertheless, Byzantine and post-Byzantine ketubot (Jewish marriage contracts) affirmed the right of women to consent to the betrothal; no examples survive from southern Italy, but Isaiah of Trani refers to their contents in the mid-thirteenth century.[87] In addition, these Romaniote Jewish women retained full access to their dowry for their personal use; neither the husband nor his family could inherit it

even if the woman died childless.[88] This access to funds was not possible for Christian women in the Salento subject to Lombard or Byzantine law.[89] Remarriage of widows (but not widowers) was frowned on by all faiths.[90] Divorce was almost unheard of in Christian families but was not infrequent among Jews: hence the Lombard ruler Grimoaldus, in Beneventum, divorced his wife in 793 *more hebraico*.[91] In 1204, Isaiah of Trani responded to a query about divorce in matter-of-fact terms, emphasizing that it should be done properly and specifying what should be included in the *get*, the official Jewish bill of divorce.[92] In another responsum, we hear about a man who left his wife in Otranto and went across the straits to "Romania" (the Byzantine world), making it difficult for her to receive her *get*.[93]

Despite ideological differences, Jewish wedding rituals in the Salento owed a great deal to local Christian rituals, which differed in certain ways from both Orthodox and Roman wedding rites elsewhere.[94] Most of our information comes from written sources. The majority of local devotional texts, with the obvious exception of Roman-rite monks and clergy, were produced on behalf of married men; only a few can be connected to men who invoke their parents or cite themselves alone, or to a woman without a husband. In addition, Santa Caterina at Galatina provides a late but relevant image of a wedding as part of the vault devoted to the Christian sacraments. While the notion that marriage was a sacrament was decided by the Roman-rite church only in the thirteenth century, the growing sacralization of this primarily secular ritual was also shared by Jews.[95]

Betrothal and marriage had been combined into a single ceremony in the Roman rite by the early Middle Ages, but Orthodox euchologia used in the Salento in the twelfth and thirteenth centuries indicate that there were distinct benedictions and locations for these two stages. The first, in the church narthex, involved an exchange of rings; the second, in the church proper, featured the imposition of crowns and joining of right hands.[96] Jews in Byzantine Italy also maintained a separation between engagement and marriage; this is the case in *Megillat Ahima'az* and it remained the practice in Italy until modern times.[97] Betrothal (*qiddushin*) was effected before witnesses and with a ring, as had been the case in Palestine; the wedding poem by Amittai of Oria recorded in Ahima'az's family chronicle provides early testimony for this practice in Europe.[98] After the betrothal, but before the wedding (*nissu'in*), Romaniote Jews gave the traditional seven blessings and expected sexual contact between the couple. In the ninth century, another poem by Amittai attests to this practice:

> How fine for the groom on his wedding day
> To show the purity of his wife's virginity,
> With head held high, for the signing of the witnesses to his ketubah

And to make his joy perfect
Until he leaves his canopy.

The bloody sheet that confirmed the bride's virginity was exhibited publicly before the witnesses would sign the ketubah.[99] While other local examples of Jewish wedding poetry neglect to mention this detail,[100] it is well known from Byzantine sources and was still being practiced in southern Italy in the twentieth century.[101] In addition, the custom of confirming the bride's virginity—and paying a "morning gift" for it—was common in Christian Europe until at least the eleventh century.[102]

The time lag between betrothal-cum-intercourse and wedding was noted by Isaiah of Trani in a responsum written in the first half of the thirteenth century:

> On what you wrote me about the female minor whose father arranged her betrothal and performed the seven blessings according to the custom of Romania . . . As for the seven blessings, this was only to allow for him to be alone with her, and this was a custom common in the land of Judah, where they used to bring the bride and groom together, and to prevent a transgression when he sleeps with her, they would pronounce the seven blessings, as prescribed at the beginning of the Ketubot treatise. . . . All the customs of Romania appear to me to follow the customs of the land of Judah: although you allow them privacy and pronounce the seven blessings, you only do so to prevent him from transgressing when he sleeps with her, but she does not thereby immediately become his fully wedded wife.[103]

This custom continued among Romaniote Jews into the early modern era. In fact, when Rabbi Obadiah of Bertinoro, in northern Italy, visited Palermo in 1487, he noted that "most brides enter the marriage canopy already pregnant."[104] These fifteenth-century Jewish Sicilians were maintaining Romaniote customs even though the Byzantines had not been in power in Sicily for six centuries.

Once betrothed, a woman was not permitted sexual relations with anyone but her fiancé. If she were charged with adultery back in biblical times, the *sotah* ritual described in Numbers 5:11–31 would either clear the woman's name or result in her death. Because the ceremony involved holy water and dust from the Temple in Jerusalem and these items were not available after 70 CE, it was assumed that this ritual, like others associated with the Temple, was no longer carried out. Yet it seems to have been done in medieval Oria, because the *Chronicle of Ahima'az* records a ninth-century performance of the ceremony in which spring water and dust from the Torah shrine substitute for the original ingredients. Moreover, the broader medieval practice of this ritual is confirmed by the discovery of two eleventh- or twelfth-century documents in the Cairo Genizah.[105]

Isaiah of Trani provides further precious information about Romaniote Jewish wedding rituals when he asserts that the festivities were called אישטיפנומטא (*istefanomata*), which is clearly the Greek στεφανώματα, the crowning of the bride and groom that is still shorthand for an Orthodox wedding.[106] Centuries earlier Tertullian had criticized the Christian use of wedding crowns as part of pagan and Jewish custom, but his efforts to curtail the practice were unsuccessful.[107] Had the Jews of Romania—including the Salento—borrowed their neighbors' wedding terminology and practice of crowning, or did the Orthodox Christians imitate a continuous Jewish practice? The former must be true, at least for the nomenclature, for there are Hebrew words for "crown" that are here disregarded in favor of the Greek term, and the earlier medieval Hebrew poetry from Oria does not use it.[108]

That crowning was the custom among Orthodox spouses in the medieval Salento is apparent from local euchologia, including the oldest and most complete example (Ottob. gr. 344 of 1177). At the moment of crowning the priest intoned, "The servant of God [name to be inserted] is crowned in the name of the Father and of the Son and of the Holy Spirit (others say: The Father crowns, the Son blesses, and the Holy Spirit sanctifies)."[109] This latter formula seems to be a unique variant of a more widespread Trinitarian prayer that has the Father blessing, the Son being well pleased, and the Holy Spirit doing the crowning.[110] In the late sixteenth century, the wedding records of the Melpignano parish church record two possible marriage formulas. One, preserving the Orthodox tradition, requires the names of the *nunno* (godfather) and other witnesses while omitting any reference to a celebrant; the other follows the Latin rite in highlighting the role of the celebrating priest before that of the couple and the witnesses.[111] In the Greek-speaking villages of the mid-twentieth-century Salento, *instafanosane* still meant "they got married" by exchanging crowns or garlands.[112]

Even if Orthodox marriage rites in the Salento "are structurally and euchologically closest to the Constantinople tradition,"[113] additional local practices are worth noting. Wine sweetened with honey was used in the common cup that was blessed before the communion of the spouses, who drank from it afterward.[114] There were two depositions of the wedding crown, not just the expected one eight days after the ceremony. All of these practices are defended against the "Latins" by Nicholas, a priest of Taranto, in a thirteenth-century text preserved in Florence.[115] Both this treatise and the euchologion reveal similarities between the wedding rite and priestly ordination: in addition to a crown, the groom is vested in a *phelonion* (a large mantle) if he is a lector, while laymen hold a sword.[116] These details derive from the ancient Jerusalem Liturgy of Saint James rather than a Byzantine rite. I wonder whether wearing a *phelonion* had any connection with the Jewish groom donning a prayer shawl; both were ritual garments that were appropriated for a new, nonsacred context in the twelfth or thirteenth centuries.[117]

Elderly informants in Mesagne recall that Christian brides and grooms used to be covered with a single veil during the wedding ceremony,[118] which recalls the Jewish *huppah* (literally, "covering"), often understood as a canopy. A couple under such a shared veil is depicted in an Ashkenazic prayer book of the thirteenth century.[119]

Medieval Jewish weddings were supposed to follow Talmudic dictates to be held on Wednesdays, but they often took place on Friday afternoons in order to have the festive meal do double duty as a Sabbath repast.[120] The epithalamium composed by Amittai for recitation at his sister's ninth-century wedding indicates that this idealized Jewish affair was envisioned very much like a contemporary Byzantine one, including preparation of the marriage chamber, the sumptuous dressing of the couple, the festive escorting of the bride from her parents' home into the public domain and then to the groom's house, and then the banquets held on the following days.[121] Mention is even made of the actual bride's toilette—she is bathed and anointed, given cosmetics, and her hair is braided—in the context of God preparing Eve for her wedding to Adam.[122] Such public theatrics in a town as compact as Oria, a walled *kastron*, would have been visible to Jews and non-Jews alike.

Several traditional wedding practices were condemned as superstitions at diocesan synods in Gravina and Gallipoli in the sixteenth and seventeenth centuries. These included the habit of spouses exiting the ceremony by different doors in order to avoid potential bewitching, which could threaten conjugal relations.[123] The ancient custom of throwing grain or barley (*frumentum vel ordeum*) at the couple was also criticized because of its dual motivation—promoting fertility and appeasing or distracting evil spirits. This shower of grain was also part of the traditional Jewish wedding, for the same (albeit unstated) reasons.[124]

Death, Burial, Mourning

Birth, marriage, and death were the three most critical moments in premodern life: the most fraught with potential and danger. While religious authorities sought to exercise control over these moments, many unsanctioned practices remained in force throughout the Middle Ages and well beyond, and nowhere was this more visible than in the case of death. Texts, material culture, and painting reveal important information about rituals of death among Christians and Jews in the medieval Salento.

As a person lay dying, his or her family members tried to ease this most important passage by removing personal amulets meant to preserve life and opening windows and doors to facilitate the soul's release.[125] If possible, a priest or a learned Jew was present (this was a Jewish borrowing from their Christian neighbors);

having ten Jewish men at the bedside was becoming customary.[126] After death the corpse was washed and wrapped in a new garment of plain linen, for Jews,[127] and a linen sheet, for poorer Christians.[128] Modern mourning songs refer to the clean, white garments of the dead.[129] The presence in graves of such sartorial finishes as belt buckles and appliqués indicates that some Christians of both sexes were laid out and then interred in expensive clothes. The deceased was thus present in his or her "Sunday best" for the most intensive period of mourning, which occurred prior to burial. A Christian corpse would then be carried to church for a funeral ceremony prior to interment at a nearby cemetery.[130] As late as 1637, the Orthodox clergy in Galatone were permitted to accompany the corpse from home to church with Greek songs, without incurring the disapproval of the "Latins."[131] The Jewish dead were brought directly from home to a burial ground some distance away from the inhabited area.[132]

The 1290 Angevin statute that regulated dress also legislated against certain perceived excesses prior to and during funerals.[133] "Let no women dare to go with the bier, or follow behind the bier, when the bodies of the deceased are brought into church or taken to burial," it proclaims, although no penalty is specified if they do.[134] Fines were indicated, however, in the case of excessive lamentation on the part of hired mourners, the *prefiche* or *reputantes* (*répite* in the dialect of Lecce) who engaged in a ritualized dialogue with and paean to the dead.[135] Because "the chant and the music that are performed for the dead overwhelm with grief the feminine spirits of the women present, and upset them in a way that is an insult to the Creator," they and other women were forbidden to engage in these traditional laments in homes or churches, at the grave, or anywhere else.[136] Nor was anyone permitted to play a *guidema* (similar to a cithara), a drum, or any other "usual" musical instruments "because such a performance is more likely to elicit joy than sorrow." The penalty for such infractions was four ounces of gold.[137]

The Angevins' desire to control these rituals indicates that hired mourners and lengthy public dirges were perceived as having the potential to initiate social disorder. The church had legislated against such pre-Christian and allegedly un-Christian behavior for many centuries, but in the Salento these repeated efforts to control "excessive" mourning were unsuccessful.[138] The oldest provincial synod, held at Otranto in 1567, enumerated the abuses: not only were doors of private houses being closed and opened during funerals, an old superstition, but women were lamenting excessively at the gravesite.[139] A 1581 synod at Nardò stated unequivocally (and, unusually, in Italian instead of Latin) that churches must not admit mourning women to accompany the body of the dead in order to avoid the laments and ululations they are likely to utter and thereby disturb the Divine Liturgy.[140] At Lecce in 1663, a synod again prohibited the use of *prefiche*, and such acts as tearing the hair and lacerating one's face continued to be proscribed at the

local level.[141] Yet even in the twentieth century, *prefiche* arrived whenever a body was laid out in the Salento; dressed in black, with disheveled hair, they joined in the *morolòja*—from the Greek *moira*, destiny, and *logos*, discourse—already under way by family and friends.[142]

Christians' expressions of grief at death were paralleled by those of local Jews (in early modern Spain, mourning laments were used as an index of crypto-Judaism or lingering paganism).[143] The *Chronicle of Ahima'az* describes a case in which someone is kept artificially alive so that his brothers can return to Oria in time "to grieve and weep over their deceased brother, to cry, to eulogize, to lament" properly before his funeral.[144] These are the ancient, prescribed stages of Jewish mourning; causing physical trauma to oneself had long been prohibited.[145]

Actions at the Grave

Prompt burial of the Jewish dead in the Salento is evident from the case of an infant abducted by demons in *Ahima'az*; his parents bewail his death all night, then bury the child in the morning.[146] A reference to the burial of Rabbi Shepha-tiah of Oria in the same text notes that "his life was closed and sealed," which the text's most recent editor interprets as a reference to the closing stone placed atop the grave. Christian tombs were sealed in the same way, with the frequent addition of an incised cross on the cover or on the slab at the head of the deceased.[147] One lost tomb slab allegedly bore an epitaph and an excommunication penalty for dis-turbing it [31]. Holes cut into some cover stones at cemeteries at Apigliano and Quattro Macine probably indicate that libations were poured into those Christian tombs.[148] The stone sarcophagi lids and bases found around the late medieval Chiesa Greca at Lecce also were pierced, presumably for the same reason. Never-theless, the paucity of examples indicates that this ancient custom was, by the late Middle Ages, only an occasional practice.[149]

Adult Christian tombs reveal an array of deliberately deposited objects that seem to have primarily symbolic meaning rather than an association with status.[150] At Quattro Macine, Apigliano, and elsewhere, fragments of small handled cooking pots (*olle*) have been found mixed with bones in ossuary pits, indicating that the habit of symbolically depositing in the grave something associated with dining persisted in the late medieval era—an echo of the *refrigerium* of antiquity.[151] At Casalrotto, a scallop shell was reused as a pendant in one tomb. This was an article of adornment and hence associated with family status, but the excavators inter-preted it as possible evidence of pilgrimage to the tomb of Saint James at Com-postela, or at least of devotion to the saint.[152] Two late medieval lead ampullae were discovered at Quattro Macine, one decorated with a scallop shell in relief, but in this case a more generalized association with pilgrimage has been posited

rather than a specific reference to James.[153] Because death was understood as a kind of voyage, evocations of pilgrimage seem appropriately symbolic.

One grave at Corigliano contained a twelve-centimeter ceramic figurine of a woman holding a large bowl that the excavators believe held seeds, symbolic of resurrection.[154] However, a similar figure from Corinth, now on display in the museum at Mistra, is identified as a saltcellar of the Frankish period, circa 1300.[155] Salt is traditionally used in Italy as protection against the evil eye and a comparable protective function in a medieval funerary context should not be ruled out.[156]

Among the most interesting objects found in medieval Salentine tombs are the coins. Despite the proscription of this "pagan" custom by the church fathers and, in 1620, by the archbishop of Otranto, most of the dead at Apigliano were interred with a coin in the mouth.[157] Some were silver coins, others early thirteenth-century pennies from the Frankish Peloponnese. They all date before the abandonment of the cemetery in the first half of the fourteenth century and represent the latest burials, as earlier corpses were removed to make room for the more recently dead.[158] In the Salento, coins were also buried with the dead at Roca Vecchia and San Giorgio near Carpignano; at the other excavated medieval sites, including Quattro Macine, Otranto, and Casalrotto, no coins were deliberately interred.[159] It is unclear whether the difference in practice was based on ethnicity, religion, culture, or something else.

Many authors assert that such coins, usually marked with a cross, represent a Christianization of the ancient practice of providing an *obol* for Charon, the ferryman across the Styx.[160] Lucia Travaini proffers other interpretations, including offerings of the living to the dead, symbolic dowries to transfer the belongings of the deceased to the bereaved, amuletic or apotropaic functions, and "memory tokens."[161] Her suggestion that the coins may have functioned in the sacred economy of *do ut des* is convincing: a relative might place a coin in a grave to effect a special connection with the dead and, through him or her, with the world beyond.[162] In the case of well-struck silver denominations, a connection between the deceased and the value or even the iconography of the coin should not be ruled out. But given the difference in custom between villages only a few kilometers apart, adherence to local or ancestral custom probably trumped other reasons for the deposition of coins in local tombs.

Excavations in the Salento over the past two decades reveal a clear pattern of reuse of medieval Christian tombs, sometimes over many generations; presumably the later occupants were members of the same family, as has been confirmed by DNA evidence in the case of one tomb at Quattro Macine.[163] An ostracon found there reinforces this with its reference to the "tomb of the family of Constantine" [**101**].[164] Similarly, one Jewish tombstone attests that it contains the remains of Samuel, son of Silanus, and Ezekiel, his paternal uncle [**123**].[165] When there was

no more room in the grave, the earlier, mostly disarticulated bones were moved, probably in sacks, to adjacent ossuary pits.[166] Brunella Bruno observed that in the Last Judgment scene at Santa Maria del Casale, the oval full of skulls and bones at the foot of each trumpet-blowing angel echoes the appearance of one of these ossuary pits[167]—a convincing case of realia in medieval wall painting [28.A]. Ethnographers in rural Greece have noted that exhuming bones for reburial results in moral judgments by bystanders about the whiteness of the skeletal remains.[168]

In the case of reused family graves, markers for individuals would seem to be superfluous, but a broken fragment of a stone incised with floral decoration was found in situ next to a tomb at Quattro Macine containing five individuals interred over at least a century.[169] Whether this bore some kind of family insignia or named a specific individual cannot be determined. Perhaps the prestige of a single individual who merited an inscribed and decorated stone accrued to later family members buried in the same tomb, some of whom would have had the same name.

How were these elite grave markers displayed? One was placed "at the head of" the tomb's Jewish occupant [12.B], as its inscription explicitly states, and this location was most likely the norm. The columnar base of the epitaph for Hannah in Oria seems likely to have been inserted vertically into some support, making its top and all four of its upper sides visible [81]. The epitaph of Rabbi Adoniyah at Trani is carved on the sarcophagus lid itself [149]. These were, at least theoretically, visible from more than one vantage point. Yet the most prestigious Christian tombs—judged on the basis of construction technique and contents—were located inside churches, and it is difficult to imagine that the funerary stelae were placed upright in the middle of the church floor. If they were placed along the walls or flat against the grave, their reverses, which are often carefully decorated, would not be visible. While a bilateral marker would honor the deceased even without having an audience for one side, it seems more likely that such markers were intended to be seen from both sides; they must have been displayed in outdoor cemeteries, where they elevated designated individuals by their mere presence. It is also possible that some inscribed stones, particularly those with a prominent cross, were used as headstones in sarcophagi composed of multiple slabs; in such cases the deceased were protected by the apotropaic cross.[170] Examples might include [104] and [158], which are the right size for this hypothetical function.

The pictorial decoration of Jewish tombstones is limited, with two exceptions, to menorahs and shofars that vary in form and occasional rubrication. The exceptions are tombstones from Bari with concentric compass-drawn circles on the frame [13] and a six-pointed star on a now-lost stone from Taranto [121]. Only the Oria stela shows the Temple utensils in relief, a carving method more costly than incision [81]. Christian stones, which more often feature relief carving, also

display greater variety and complexity: inlaid metal crosses [**104, 158**] (now lost), shields [**26.C**], a five-pointed star [**98.B**], rosettes, semicircles, and concentric circles [**41, 99.B, 100.B, 156.A–B**]. The crosses, menorahs, and shofars advertise religious affiliation, but only the shields on the tombstone at Brindisi [**26.C**] are signs of individual identity—in this case, that of the noble widower who commissioned the marker for his dead wife.

Although much of our excavated burial information dates to the Angevin era, the chronology of extant grave markers is skewed to earlier centuries.[171] With the exception of Trani, north of the Salento, the series of Hebrew tombstones ends by the tenth century, and only a handful of the Christian markers postdate the twelfth century.[172] It is assumed that most of the medieval tombstones, and especially the Jewish ones, were simply reused in later construction. The grave markers themselves bear witness to their fate; almost all of them are damaged and some defaced by game boards and other graffiti [**127.C**]. One Jewish stone was reused as a shallow basin [**130**].[173] The presence of game boards on tomb slabs reminds us that cemeteries, like church interiors, were sites of many social rituals even if they were, for Christians, consecrated ground. Cemeteries adjacent to churches could serve as venues for activities of all kinds.[174] In fact, dancing in cemeteries had to be prohibited at a synod held in Nardò in 1581.[175]

Several of the Salento's Jewish tombstones contain excerpts from contemporary liturgical poetry composed for the funeral service. This is the case for the ninth-century epitaph of Rabbi Baruch of Brindisi, which, in addition to its biblical references, quotes from a contemporary *piyyut* written by Amittai of Oria that is recorded in his descendant Ahimaʿaz's eponymous chronicle [**18.A**].[176] The poem would have been familiar to those who saw the epitaph because the congregation was actively involved in reciting these prayers. Familiar pleas for peace appear in the impressive epitaph of Leah, the teenager buried in Brindisi in 832/33 [**16.A**]. Culled from the ancient liturgy, the text also pleads for her resurrection among the just in paradise, as does a contemporary stone from Taranto [**119.A**]. This, the ultimate *rite de passage*, was the aim of Christian funeral rites and presumably of epitaphs as well, although it is rarely expressed [**100.A**]. The far more modest "Rest in peace" appears on one Christian epitaph [**27.A**] and all of the Jewish ones.

Mourning and Commemoration

Jews were supposed to show respect for the dead by walking to and from funerals unshod. Zidkiyahu Anav, the author of *Shibolei ha-Leqet*, cites Talmudic authorities before rendering an opinion that acknowledges thirteenth-century realities: "I found that this is our custom in Rome [*ha minhag shelanu b'Roma*]: to return from the cemetery with shoes and in the house to take them off. This custom is

very difficult for me."[177] Most Roman Jews—and their coreligionists in the Salento—must have worn shoes to the graveside to be less conspicuous, though some would have sided with the stricter preference of Zidkiyahu. Male mourners were enjoined by the Palestinian Talmud to wrap their heads so that their faces would be covered in public during the period of mourning. The *Arukh* dictionary indicates that this wrapping should cover the face along the cheeks and down to the mustache but above the nose. A contemporary South Italian author stated that only the Spaniards leave their heads uncovered: "in most of the world people cover their heads in the style of the Ishmaelites, that is, they cover the entirety of their faces except for their eyes, which they leave exposed."[178] By the thirteenth century, however, Zidkiyahu Anav, following such earlier commentators as Rashi, admits that "it is also our custom not to wrap the head," for even though mourners were required to do so for seven days and nights, they avoided it because the gentiles made fun of them. In Rome the custom fell out of favor sometime between the eleventh and thirteenth centuries, but we do not know what impact this had on Salentine practice; none of the Jews depicted in local wall painting is quite so thoroughly wrapped.

Christians and Jews both assigned special significance to particular intervals after the death of a loved one. For Christians, the third, ninth (or seventh), and fortieth (or thirtieth) days after death were the most significant, along with annual commemorations.[179] It seems likely that individuals of all faiths prayed at the graves of their loved ones, for them and perhaps even to them.[180] The 1290 Angevin sumptuary edict forbade prayer for the dead at their graves: "We also forbid lords and ladies and any others linked to the deceased by any degree of consanguinity or affinity from going to churches or the graves of the dead on feast days or on other customary occasions to pray for the dead, or at the other established times; the penalty is four ounces of gold."[181] Not only was physical presence at the grave to be restricted, but one's appearance during times of mourning was legislated as well: "Let no one except blood relations or those who have the closest degree of affinity with the deceased dare to let their beards grow for more than eight days on account of the death, the exception being sons and brothers, who rightly display grief; we allow them to keep their beards and wear mourning clothes for up to a month if they wish."[182] Regarding women in mourning, the edict states, "let not so many ladies or commoners, namely, those who are marriageable, change their garments because of the death of their kinsmen, or do anything new with their garments or their appearance, but let them do as they were accustomed to do before," except in the case of mourning the death of a husband.[183]

For Jews, the first three days after burial were designated "days of weeping"; the seventh day marked the end of the primary period of mourning as ordained by Moses and reified by Joseph's week of laments for his father, Jacob (PT Ketubot

1:1). *Shibolei ha-Leqet* says that it was the practice in Rome that for seven days candles be kept burning all night on the ground where the body had been prepared for burial, "to please the soul," which mourned for its body and moved between home and tomb during the first week after death.[184] For thirty days a mourner avoided haircutting and new clothing. The thirty-day commemoration derives from the mourning period specified after the death of Moses (Deut. 34:8); only parents were mourned for an entire year. Jews assumed that after one year had elapsed the soul had reached its final destination. Until that time, as *Shibolei ha-Leqet* notes, the soul was rising and falling; in fact, if someone were to drink water at twilight on the Sabbath he would be stealing from the dead because that is the time when the souls have permission to drink.[185]

Food for the Soul

I end this chapter on the life cycle with food, itself a strong component of communal identity but one that is difficult to identify in the visual or material record. Based on the ancient traditions of the land of Israel, Romaniote Jews refrained from eating meat during the first week of mourning, and this was true for local Christians as well.[186] Preferred foods were lentils or eggs, round foods that symbolized the cycle of life. Lentils had additional significance: "the [Jewish] mourner is like a lentil which, unlike other legumes, has no crack or cleft; his lips stay closed and he sits in silence."[187] If the Christ child indeed carries eggs in the Candelora crypt's depiction of him going to school, they may prefigure his death and resurrection [**63.A**].

Another food—*kollyba* (κόλλυβα), boiled wheat, sometimes sweetened—was traditionally distributed to those present at an Orthodox gravesite both at funerals and on memorial occasions.[188] This was an old Greek tradition given a Christian interpretation but nevertheless considered a pagan superstition by adherents of the Roman rite.[189] The Orthodox monastery of San Niceto (Saint Niketas) at Melendugno, by 1392 a dependency of San Nicola at Casole, was obligated to distribute on its annual feast day (September 15) one and a half *tumuli* of boiled grain to the poor, which certainly echoes the traditional ritual.[190] At Casole itself, *kollyba* was served along with beans and wine on Friday of the first week of Lent in honor of the feast day of Saint Theodore Tiro (the Recruit) who first suggested its use.[191] *Kollyba* still symbolizes resurrection, based on such New Testament passages as John 12:24, but it has not been part of funerary ritual in the Salento for many centuries. It survives, however, as *colva* or *coliba*, a wheat-based sweet known elsewhere in southern Italy as *grano dei morti*, grain of the dead, served on November 2, the day dedicated to all the souls.[192]

Rituals and Other Practices in Places of Worship

In the Middle Ages, houses of worship were social spaces par excellence, sites of human interaction as well as places to effect or maintain positive relationships between humans and God. I begin with church and synagogue liturgies and their settings, focusing on the evidence for specifically Salentine variants in both the weekly prayers and those for holidays and special events. I turn next to the considerable evidence for devotion, considering which saints and narrative images adorned church walls, how local worshippers interacted with painted images, and where and why they incised personal graffiti. Once again, the goal of my inquiry is to contextualize not only the painted people but also those who paid for, executed, and responded to their images and inscriptions. Although material evidence for local Jewish practice is nonexistent, Jewish texts allow us to fill some lacunae.

Church Rituals

Christian liturgy—literally, work for the people, from the Greek *leitourgia*—was not a static series of rituals. Even if we assume that medieval South Italian clergymen followed either the Roman or the Orthodox rite, within these two major divisions there were many variants.[1] Adherents of the Orthodox rite in southern Italy used parts of liturgies allegedly composed by Saints Basil or John Chrysostom (in Byzantium), James (from Syria-Palestine), and Mark (from Egypt), as well as the Liturgy of the Presanctified for weekdays during Lent and the so-called Liturgy of Saint Peter, which translated the Roman rite into Greek in the tenth century and combined Orthodox and Roman formulations.[2] Even after the twelfth century, when the Divine Liturgy of John Chrysostom dominated in Orthodox churches except for those Sundays and major holidays on which Basil's liturgy was preferred, Salentine euchologia contained interpolations from these other liturgies as well as formulas not employed elsewhere.[3] In what follows, I do not attempt to provide

a comprehensive overview of liturgical practices, which would be far beyond the scope of this book and the competency of its author; rather, I spotlight these Salentine "peculiarities"—which is to say, differences from Constantinople or Rome—and attempt to integrate the material, textual, and pictorial remains with the liturgical evidence.[4]

At and Near the Altar

Numerous individuals commemorated in Salento church paintings were members of the clergy, mostly priests of the Orthodox or Latin rite but also deacons, bishops, and others. These men had an intimate familiarity with the altar environs. The Eucharist (literally, "thanksgiving") performed at the church's main altar was the central act of Christian worship. While the core of the mass involves blessing and sharing the bread and wine, the Eucharist was preceded and followed by ritualized utterances and actions. A key text for those administering the Orthodox rite was the *Historia Mystagogica,* always attributed in the Salento to Saint Basil rather than to the eighth-century patriarch Germanos.[5] A monk named Theodore of Cursi relied on this text to combat liturgical innovations by an Orthodox archbishop in Calabria in the 1260s.[6] Other liturgical commentaries that were widely used in the late medieval Salento include a metrical adaptation of the eleventh-century *Protheoria* of Nicholas of Andida[7] and a Latin translation of the Divine Liturgy of John Chrysostom produced by an Italian, Leo Toscan, in Constantinople in the 1170s, supplemented by the Divine Liturgy of Saint Basil translated by Nicholas-Nektarios, abbot of Casole, later in the century.[8] All of these texts exist in multiple manuscripts and attest to continued Salentine Orthodox interest in Constantinopolitan liturgical practice in the centuries after the province was lost to Byzantium.

Original rock-cut altars survive in numerous churches, and often these preserve a fictive painted altar cloth; at Mottola's Santa Margherita there is also a painted rock-cut retable with a blessing Christ. [9] A few altar dedications are known although few are incised on the altar itself [**26.C, 38, 67.B–D**]. In addition, there is one inscribed ciborium, still in situ over the altar at the Orthodox monastery of Santa Maria di Cerrate; it proclaims in the first person that it is the "gracious protection of the altar of the Lord" and asks God to sustain the "servants of your altar" [**114.C–D**]. In the same church, the Roman funerary stela that had formed all or part of the high altar was not removed until 1610.[10] Orthodox churches typically had a single altar, while churches of the Roman rite often had multiple altars so that mass (the complete eucharistic service, from the Latin *missa*, dismissal) could be celebrated more than once per day.[11] It is usually assumed that freestanding altars indicate an Orthodox liturgy and altars attached to the wall designate the

Roman rite, but the reality is more complex; the scale of the church and its date may be more significant than its confession, and the presence of an attached altar today does not eliminate the possibility of a detached one in the past.[12] The number of extant altars and their proximity to the apse wall are not secure indicators of the liturgical rite performed thereon: the Riggio crypt church, with tenth-century Byzantine paintings and exclusively Greek inscriptions, has, and presumably always had, an attached altar in its smaller right apse [**52**]. In the rock-cut Santa Marina at Massafra [**67**], the central apse has a freestanding block-type altar, while the two side apses have attached wall altars that also have attached steps, presumably used for kneeling.[13] The side apses and their altars likely were excavated when the church was adapted for the Roman rite, perhaps as late as the thirteenth century when the central and left apses were painted.

Painted altars and clergy are seen in only a few apses. In addition to the apse at Soleto discussed below [**113.sc.2**], a poorly preserved painted altar can be discerned only at Acquarica del Capo [**1.sc**] and at Santa Maria di Miggiano near Muro Leccese, although presumably it was once present between the inclined hierarchs at San Salvatore and San Mauro near Gallipoli as well. These painted altars support a large, footed chalice; the one at Acquarica del Capo is covered by a folded cloth. At San Nicola in Mottola, the scene of the death of John the Evangelist in the right apse has a painted altar in the background with a cross standing on a red altar cloth. The base of a columnar altar made of fictive marble is visible between the hems of standing hierarchs in the church under today's Chiesa Greca in Lecce.[14]

Only one communion scene survives, and its altar is missing. In the crypt of the cathedral of Taranto, datable on stylistic grounds to the thirteenth century, Mary of Egypt receives communion from the priest Zosimus [**Plate 16**]. He holds the chalice, adorned with pseudo-Kufic decoration, in a cloth, and in the same hand he holds a bell, the clapper of which is clearly visible as a dark diagonal. This must be the bell that, by the thirteenth century, was rung prior to the priest's elevation of the host in the Roman rite.[15] Mary is receiving the mingled bread and wine from Zosimus by means of a thin metal implement. If it were a straw it would reinforce the entirely non-Orthodox character of the image, but the implement clearly has a small bowl and so is likely to be a spoon.[16] This makes the scene an interesting liturgical hybrid, with the (post-)Byzantine spoon combined with the Roman-rite bell.

Two earlier spoons and a lance were found in the small tenth-century Byzantine church at Quattro Macine, where a side altar on the north wall of the sanctuary evidently housed the liturgical implements [**102.A**].[17] The lance (actually a two-sided knife) was used to cut out the central part of the leavened bread, the so-called *amnos* (lamb), during the *proscomide* ceremony; the pewter and iron

spoons were used to mix wine and water, remove impurities, and administer communion to the laity.[18] When Paul, the bishop-elect of Gallipoli, wrote to Constantinople in 1174 to ask Patriarch Michael III Anchialios to clarify both these rites and the Liturgy of the Presanctified, the response was inserted into existing service books and typika and spurred the writing of new ones.[19] In this way the Orthodox clergy in the Salento learned that they were supposed to fraction the eucharistic loaf not into three pieces, as they had been doing and as was done in the Roman rite, but rather into four pieces, as in Constantinople.[20] Yet even with these clear instructions from the Byzantine capital, the proper number of pieces of bread was still being discussed in the Salento a century later.[21] Another regional peculiarity was the addition of boiling water just before communion with the chalice rather than before communion with the bread, as is still done in the Orthodox rite.[22] Elevation of both the host and the chalice after the words of Christ and the elimination of the epiclesis, when the priest invokes the Holy Spirit, are features of the Roman-rite liturgy that were added to Salentine euchologia in the fourteenth century.[23]

At least twenty eucharistic bread stamps have been found in the Salento, a larger number than from any other region of Italy. They span several centuries, from the ninth or tenth century to the thirteenth or fourteenth, and come from both urban and village contexts.[24] Made of clay, stone, or bronze and round, square, or quatrefoil in shape, the stamps measure between two and nine centimeters in diameter.[25] Some of them have abstract or symbolic decoration (triangles, crosses) or Greek abbreviations, including IC XC NI KA (Jesus Christ Conquers) and XXXX (Christ Grants Grace to Christians). Some stamps are similar to examples found in Corinth, Aegina, and Constantinople and may well have been imported. An unusual example comes from Soleto: someone incised a quadruped on the top, next to the handle, prior to firing.[26] Presumably this was intended to identify the owner without impressing this identity onto the sanctified *prosphora* (eucharistic bread).

The bread and wine were prepared in the space to the left of the central apse, either the north apse of large churches or merely a niche in the east or north wall of smaller ones. Squared niches survive in such churches as San Giovanni Evangelista at San Cesario di Lecce [108] and Santa Maria de Itri at Nociglia [**80.st.1**, far right]. Inside or over both of these niches is a depiction of the mandylion; the one at Nociglia dates to the sixteenth century but may replicate an earlier image in the same location. The mandylion, the towel on which Christ wiped his face, was tangible proof of the Incarnation, and at San Cesario di Lecce it is supplemented in a nearby niche on the north wall with a Saint Anastasia, whose feast day was on Christmas and so communicates the same message as the Incarnation. The mandylion also has eucharistic associations through the body and blood of Christ prepared in the prothesis niche.[27] This liturgical function for the left niche

clarifies the unique depiction of Christ Emmanuel in that space at Bagnolo.[28] An arched prothesis niche on the east wall of Santo Stefano at Soleto contains a Nativity scene in which the Virgin hands one of Christ's linen swaddling strips to the Magi. This unusual episode, recorded in the apocryphal Arabic Infancy Gospel, spotlights the Magus Balthazar as the putative ancestor of the Del Balzo family, the church's patrons.[29] The swaddling cloths of the Nativity were connected liturgically to the cloths that covered the chalice and paten. In this way, the miraculous incarnate power of both the infant and the wine and bread was not revealed until the proper moment: the historical baptism of Christ and the liturgical transubstantiation.[30]

A few churches contain an additional diakonikon niche, although its function is less clear. While the square one at Acquarica del Capo contains a foliate cross like the one in the prothesis niche across the apse,[31] at San Cesario di Lecce this niche contains a bust of Saint Lucy. This lacks an obvious liturgical significance; perhaps it relates to seeing the truth of the liturgy, given that Lucy was associated with eyes and vision. The shallow niche on the east wall at Carpignano (to the left of the original apse flanked by an Annunciation) cannot have served as a prothesis because it has a painted *podea*—a cloth placed under an icon—only slightly above floor level [**32**, visible to right of pier]. The function of the prothesis was to provide a surface at proper height for preparing the *prosphora*, and this is much too low.[32] A fragmentary niche found at Caprarica has also been identified as a prothesis, but it could just as well be a diakonikon; the remains of a cross on one side would be appropriate to both, as evidenced by the niches at Acquarica del Capo.[33]

The presence of Greek books used at the altar was noted in pastoral visits to many churches, beginning in the 1450s in the diocese of Nardò and somewhat later in other Salento dioceses.[34] These episcopal visits list church property, both fixed and movable, and refer to such items as an "octoychos" (*octoechos*, the liturgical poetry for Sunday and weekly services) or a "horolayo" (*horologion*, book of hours). As late as 1540, Santo Stefano at Soleto had twenty Greek books.[35] Only three Orthodox liturgical books remain in the Salento today, all in the parish church at Galatone [**162**].[36] All the rest were sold, starting in the late fifteenth century, and they have become part of the great manuscript collections in Venice, Florence, Rome, Paris, and elsewhere.[37] The pastoral visits also contain scattered references to *vestimentum unum munitum more grecorum*,[38] church vestments in Greek style, which may refer to a type of decoration or to such articles as the epigonation or epitrachelion, which were not used by officiants of the Roman rite.

Before leaving the altar it is worth noting that both Orthodox and Roman-rite adherents believed that the water used to wash the altar had powerful healing properties. The congregation was anointed with this altar water on Holy Thursday, as well as with the water used on the same day for washing feet in imitation of

Christ.[39] Finally, a thirteenth-century inscription carved on the reverse of an ancient Roman stela formerly in the cathedral of Gallipoli [**49**] records some additional liturgical furnishing. In Byzantine dodecasyllables it speaks in the voice of the *trikerion*, the triple candelabrum of the Orthodox rite that was placed behind the altar near the bishop's throne. On the other side of the throne there must have been a *dikerion*, a double candlestick (a second Roman stela at Gallipoli lacks a medieval inscription). The *dikerion* was used to bless the Gospels before the Trisagion, while the *trikerion* served after that prayer and also to bless the congregation.[40] This liturgical innovation, probably codified in the twelfth century, had reached southern Italy by the thirteenth.

The Apse and Its Environs

Almost any image in an apse can be construed as liturgical in some way. Theophanic visions of God as Pantokrator or Ancient of Days, the Ascension and Transfiguration, the Trinity, the Virgin and Child, and the Annunciation, all figures and scenes found in Salento apses, do echo liturgical texts, and the performance of the Divine Liturgy is the church's most important repeated ritual.[41] The east wall and apse of Santo Stefano at Soleto eventually presented the most complex of these liturgical reifications, its completion spanning several decades [**113.sc.2**]. Yet there is a paucity of specifically eucharistic imagery in the sanctuary area of Salento churches: no Communion of the Apostles scenes, no *Melismos* or *Amnos* or dead Christ on the altar, no celestial liturgy. The rare fictive altars with liturgical implements or a nearby mandylion are supplemented by those few apses that depict concelebrating bishops or have deacons nearby. Taken together, these reveal the region's limited participation in the Byzantine trend toward the incorporation of liturgical imagery in churches.[42]

The bishops in the apses at San Pietro at Otranto, San Nicola at Muro Leccese, Acquarica del Capo, Santa Maria di Cerrate, and Santo Stefano at Soleto are the authors of the principal Byzantine liturgies, Saints Basil and John Chrysostom, supplemented by Gregory the Theologian, Athanasius, and others. All of these are built rather than rock-cut churches, but a few of the latter also depict bishops.[43] In some cases these hierarchs stand upright and do not seem to participate in the liturgy; in others, they lean inward while holding scrolls with the incipits of prayers that real celebrants would say while preparing the eucharistic offerings. There is a liturgical disjunction, however, for the painted bishops rarely hold a scroll with the prayer most often associated with them in other regions.[44] At Santo Stefano in Soleto [**113.sc.2**], for instance, the saint to the left of the Sophia-Logos holds a *rotulus* with the opening of the prayer for taking the monastic habit found in most local euchologia between the twelfth and sixteenth centuries: Δέσποτα Κύριε ὁ Θεός

καὶ πατὴρ τοῦ Κυρίου ἡμῶν Ἰησοῦ Χριστοῦ. The one behind him holds the ancient Trisagion formula from the Liturgy of Saint Mark: Ἅγιε τῶν ἁγίων ὁ Θεός ἡμῶν. John Chrysostom, on the right, has the Cherubikon prayer, Οὐδεὶς ἄξιος τῶν συνδεδεμένων ταῖς σαρκικαῖς ἐπιθυμίαις, while the figure behind him has the first prayer in the Liturgy of the Presanctified—Ὁ Θεὸς ὁ μέγας καὶ αἰνετός ὁ τῷ ζωοποιῷ τοῦ Χριστοῦ σου. From left to right, this is the order in which these prayers appear in the liturgy, even if the usual association of bishop and text is not followed here.[45]

The fact that depicted bishops hold scrolls is not a reflection of local reality. Unlike Greece and Byzantium, liturgical rolls in the Salento were rare and used very briefly: for the most part they were imported into Italy and then cut up to be reused in liturgical codices only a century or so after they were written.[46] None of the roll fragments that survive were written after the beginning of the thirteenth century, precisely when their use was expanding across the Adriatic. Greece was the likely source for the iconography of celebrating bishops holding liturgical scrolls, but this depiction neither reflected nor influenced local liturgical practice. Real Orthodox bishops in the Salento used codices, not liturgical rolls, and when they did so, they may have worn generally Orthodox-looking garments, like the ones at Soleto at the end of the fourteenth century, or they may have sported Roman-rite episcopal accoutrements: Bishop Eligius at Vaste [**157.C**] and the unnamed bishop at Santa Maria di Cerrate both wear the omophorion as a single piece (like the Y- or T-shaped pallium worn by Roman-rite bishops [**118.st.1**]); they have a pointed miter and carry a curved staff. While the depiction of sainted bishops, like other sacred figures and scenes in medieval wall paintings, was mainly conventional, even historical figures were often vested with contemporary insignia that helped make them recognizable role models for celebrants in the liturgical present.

A painted deacon or deacons in the sanctuary is common even when the apse imagery is not overtly liturgical; they are represented in numerous crypt churches even when bishops are not depicted in the apse. Stephen is by far the most popular deacon; Euplos is also represented once [**142.st**].[47] Lawrence and Stephen flank the apse at Poggiardo, but Lawrence is not otherwise depicted in a sanctuary unless he is one of the pair of unidentified deacons above the mandylion on the apse wall at San Cesario di Lecce [**108**].[48] Another pair—one of whom is Stephen—flanked the original templon screen in the sanctuary at Acquarica del Capo [**1.st**].

The most common iconography in Salento apses is the so-called deesis, in which the Virgin and another saint, usually John the Baptist, flank an enthroned Christ.[49] While intercession with Christ for salvation after death seems to be the paramount meaning of this image, its presence in the apse does not rule out that the Divine Liturgy was celebrated there. Important churches in Byzantium fea-

tured this scene in the apse, and the intercession of the Virgin, and less often of John, is referenced frequently in the liturgy—in the Trisagion prayer, at the end of the anaphora, in the thanksgiving prayer, and in the dismissal.[50] The intercession of the Virgin is a recurring image in many other services as well, and of course this was the primary function of depicting sacred figures in churches: to manifest their presence and underscore their ability to act as potent intercessors. Representing the deesis does not mean that the space was primarily funerary, however, or that intercession was needed mainly to ensure postmortem salvation. Marina Falla Castelfranchi found that thirty-three of forty-five rock-cut churches throughout southern Italy had a deesis in the apse, with the greatest concentration in the province of Taranto; in my own Database of sites with individualized texts or images, the apse deesis is restricted to that province.[51] This suggests a localized phenomenon, perhaps based on an authoritative (cathedral?) artistic model rather than a dominant theological explanation.

The Templon Barrier

Marking the border between sacred and nonsacred church space was the templon barrier, a large number of which still survive in the rock-cut churches of the Salento.[52] Stone footings for a templon were excavated in the small Byzantine church at Quattro Macine [**102**].[53] The crypt church of Santi Stefani at Vaste had "an almost perfect iconostasis" three years before Gertrude Robinson saw only traces of it, in 1930.[54] The scars of dismantled barriers can still be seen on the walls that abutted them in the built churches at Acquarica del Capo, San Cesario di Lecce [**108**], and Soleto.[55] Among the extant rock-cut barriers, a few have shallow niches on the naos side and sometimes a door and windows. Similar square or arched niches are found on piers in other rupestral sites, including San Girolamo at Palagianello [**90**] and San Simeone in Famosa at Massafra (which also has a niche on the façade) [**70**]. These face out into the church's "public" space and are embellished with a sculpted frame. An additional square niche, with holes to attach something, is set into the right side of the arcosolium of Stratigoules at Carpignano [**32.J**]. It is likely that at least some of these framed niches were intended to hold portable icons.[56]

Images of saints who were especially revered in a given Orthodox church were usually placed on the sanctuary barrier or immediately adjacent to it. These so-called *proskynetaria* icons received veneration (*proskynesis*) from clergy in procession toward the altar and the laity outside the sanctuary. Such special images were often elaborately framed and perpetually lit by candles or lamps.[57] An example is in the church dedicated to Saint Nicholas at Acquarica del Capo in 1282/83, where a trilobed fictive-marble frame isolates both a huge enthroned Virgin and

Child on the right wall just outside the dismantled barrier and an identically framed (but poorly preserved) Saint Nicholas directly opposite.[58] These are the only trilobed frames in the church, so they announce the importance of these two icons relative to the rest of the choir of saints. Although its frame is not preserved, the image of Saint Peter on the south wall of San Pietro at Otranto would have been just outside the original sanctuary barrier, reinforcing the veneration of the titular saint of the church as a *proskynetaria* icon. The same situation obtains in Sant'Angelo at Uggiano la Chiesa, where the thick screen is intact: the eponymous archangel is on the east end of the right wall [**153.A**]. At Santi Stefani at Vaste, the 1379/80 *proskynetaria* icons are on the west face of the easternmost piers, rather than on the side walls: one depicts the Virgin and Child and the other Saint Stephen, both superimposed over earlier frescoes [**157**]. Alone among the individual saints at Vaste, including other Saint Stephens, only this image has a red-on-white zigzag frame that sets him apart.

A non-Orthodox or a no-longer-Orthodox church might also accord special attention to a specific image. This is the case for a Saint Margaret in the homonymous cave church at Mottola. Under an elaborate fictive arch supported by painted columns and capitals, the saint stands in front and to the right of the apse on an L-shaped pier. Her garments and adornments are painstakingly detailed. Similarly, the Saint Nicholas on the left wall at Santa Maria de Itri at Nociglia is not only larger in scale than the two Virgin and Child images that flank it, but it also has a white background against which two red roundels containing his abbreviated name in the manner of Byzantine icons stand out sharply [**80.st.1**].[59] This early fourteenth-century icon may have imitated the eleventh-century Byzantine images that preceded it in the chapel, adding a note of antiquity to its authoritative scale.

One particularly interesting ritual took place just outside the templon screen in the Orthodox-rite churches of southern Italy. Called καμπανισμός (*kampanismos*), it derives from the Byzantine verb καμπανίζω, "to weigh," but until André Jacob analyzed the ritual in 1972 Orthodox liturgists were reluctant to accept the existence of such a rite.[60] It likely derives from non-Byzantine practice, as *contrepoisage* had long been performed in medieval France and elsewhere.[61] The 1177 euchologion from Otranto records a formula to be recited during the weighing procedure,[62] but another copied nearby in 1579 offers a more complete rubric for the ritual that is worth translating in full:

> After the celebration of the Divine Liturgy the man who is to be weighed goes before the sanctuary. Acolytes bring the scales to the door; they put the man on the right pan of the scale and the bread, wine, and cheese or whatever else on the left pan of the scale. Next, the priest places on the

head of the one who must be weighed a crown made of candles, to which are attached perpendicularly four lit candles arranged in the form of a cross. And then the priest gives the blessing and begins the office.[63]

The ritual seems to have been performed in fulfillment of a vow,[64] and it was intended to call down blessings and abundance on the giver, but exactly how it was accomplished is difficult to imagine. What kind of scale could have been used? The only scenes of weighing in the Salento are those in the Last Judgment, where the souls hoisted by Michael seem lighter than an adult male or his equivalent in foodstuffs. Whatever scale was employed must have been carried into church just for these occasions. It may have looked something like the large scale used in the bakery scenes on the first-century Tomb of Eurysaces in Rome.[65]

Early euchologia reveal that the weighing rite was originally for children, but over the centuries it expanded, at least in the Salento, to adults as well as to animals.[66] Its performance during the mass was condemned at a synod in Monopoli, farther north in Apulia, in 1585, and from this document we learn that the ritual there involved weighing children, also wearing crowns with candles, on the feast days of Saint Donatus or Saint Anthony.[67] Donatus is the saint associated with epilepsy, the so-called *male di San Donato*, and weighing rituals are still performed in a few towns in southern Italy (but not in the Salento) to cure a child of epilepsy.[68] There are no surviving medieval depictions of Donatus in the Salento, and I wonder whether he became associated with the rite partly on etymological grounds; his name literally means "things donated."[69] Depictions of Antony, on the other hand, are ubiquitous, and it is conceivable that his frequent image reminded some viewers of the *kampanismos* liturgy.

Giving donations to churches has a very long history, and providing oil or wax for illumination was probably a more common donation than foodstuffs.[70] Wax could take the form of an afflicted individual or be equivalent to his or her weight. There were life-size and small-scale wax figures in churches of medieval Italy, England, France, Germany, and elsewhere; in the Greek-speaking world they must also have existed, but they are found today only on Cyprus and Crete.[71] I have no doubt that wax *támata* in the form of whole bodies or body parts were a feature in the medieval Salento, although this has been impossible to prove; only in the sixteenth and seventeenth centuries were wax votives noted in pastoral visits to Morigno and Giurdignano.[72] Supporting evidence for the practice elsewhere in medieval southern Italy comes from the famous panel that Simone Martini painted in Naples in honor of Saint Louis of Toulouse after the latter's elevation to sainthood in 1317. It depicts the royal Franciscan saint being crowned by angels while simultaneously crowning his kneeling younger brother, King Robert the Wise; both were older siblings of Philip, Prince of

Taranto, who may have been the work's patron. In the predella are episodes from the saint's life, including a final posthumous miracle in which a child is resuscitated with Louis's help after his father prays to a wax image of the saint.[73] Viewers of the panel must have recognized the efficacy of such an object, which means it was pervasive. Yet wax could illuminate in more than one way. It had practical potential for providing light, of course, but gifts made of wax, particularly votive gifts, were also intended to enlighten viewers about the outcome of successful prayer and sufficient piety. The votive was tangible evidence of gratitude for a miracle that had already occurred, and it made visible the potential for future miracles.

An additional ritual is evoked by a unique painted panel in a crypt church at Ortelle, dated by iconographic and stylistic comparisons to the 1420s or 1430s [85]. Here, God the Father and the dove of the Holy Spirit look down at two female saints who unfurl a large white cloth decorated with three roundels that contain a mini-Passion cycle (Flagellation, Crucifixion, Resurrection).[74] The two saints stand on the sun and moon and the whole is watched from below by a group of figures of whom only one, at the lower left corner, lacks a halo. Actual large veils were used in medieval Europe during Lent, when they covered the altar or screened the whole sanctuary as part of a "visual fast" on the part of the penitent faithful.[75] They were hung on Passion Sunday, the fifth Sunday of Lent, when John 8:59—"Jesus hid himself, and went out of the Temple"—was read in Roman-rite churches and all images, crosses, and statues were similarly veiled.[76] Such Lenten veils were still used in Sicily a century ago.[77] The unnimbed, bearded man who has had himself inserted into the sacred allegory may be the donor of an actual veil, rather than or in addition to the donor of the painting.[78]

Additional Rituals

A few more in-church activities not discussed above and unrelated to the individual life cycle can be inferred from the visual, material, or manuscript remains. These provide hints about the liturgical hours and commemorative prayers and feasts unique to the Salento. We should keep in mind that churches were used for numerous social rituals with only scant connection to religion, even if both churchmen and laypeople participated and if the activities were frequently associated with feast days or their vigils. Such practices as banqueting, dancing, selling candles and other objects *sub divini cultus praetextu*, making noise, playing games, singing, and dissolute spectacles in churches were condemned in several sixteenth-century Neapolitan synods.[79] These social activities are documented elsewhere in Italy and there can be no doubt that they occurred

in the Salento in the early modern era and earlier as well. Sleeping, eating, and perhaps even carnivalesque behavior are also documented occasionally in Byzantine churches.[80]

On the south exterior wall of Santa Maria della Strada at Taurisano is a sundial with Greek inscriptions, unique not only in the Salento but in all of Italy [145].[81] Jacob considers it clear testimony of the church's transition from the Greek to the Latin rite. One fourteenth-century hand carved "The Hours of the Day" and abbreviated "Jesus Christ Conquers," and a different, perhaps slightly later, hand added six letters at the ends of six rays of the sundial. These letters—Π Τ C Ν Β Κ—represent the canonical hours in Latin transcribed in Greek letters, evidently a Latinate religious interpretation of the Greek "hours of the day." While the hours indicate specific times for services inside the church, the sundial's exterior placement could also guide pious individuals in their domestic devotions.

I end this section with a look at rituals associated with death inside Salento churches that complements the discussion in Chapter 5. A will from 1435 records that the lord of the *casale* of Lizzanello, one Lillo Garzia, donated a village to pay for four chaplains to celebrate daily masses for his soul in a church at Copertino; masses on feast days were to be celebrated at Lecce. Yet he was not to be buried in either church, but rather in a separate chapel built in his memory in Lecce.[82] This is hardly a typical commemoration, but it does reveal what one elite member of Salentine society wanted for himself after death. Most people could not afford this kind of constant, individualized commemoration and had to content themselves with eventual inclusion in the diptychs of the dead (or, later, necrologies)—and even these were often accessible only upon payment of a donation, such as feeding a certain number of poor people. Commemoration was not only a liturgical fact, but also a social and economic one—a private event made public.[83]

This is relevant to artistic remains in the Salento because the liturgical formulas used to record both the dead and the living in local service books—the Greek Μνήσθητι Κύριε τοῦ δούλου σου and the Latin *Memento Domine famulo tuo*—are the most common supplications in the region's wall paintings, as noted in Chapter 2. While euchologia often employ a more specific formula that refers to the soul, Μνήσθητι Κύριε τὰς ψυχάς, this is not always the case.[84] The widespread formulas and the painted figures that often accompany them do not necessarily represent living donors of these and adjacent paintings; some may record deceased persons and be paid for by living relatives.[85] Even if they originally evoked specific individuals (and not all depicted supplicants are identified by inscription), naming patterns and the passage of time would ensure that the specific individual was conflated with others and eventually forgotten.

Synagogue Rituals

Jews came to Italy originally as slaves from the land of Israel, and they initially remained in its religious orbit; the explosion of original Hebrew liturgical poetry (*piyyutim*) in medieval southern Italy—some of which was quoted on grave markers [18]—imitates the late antique Palestinian innovation of inserting elaborate poetry into the prayers for festivals, Sabbaths, and other occasions.[86] Later the region came under the influence of the sages of Babylonia, as "documented" in the lengthy sojourn of Abu Aharon of Babylon in the *Chronicle of Ahima'az*.[87] Even with the increasing importance of the Babylonian Talmud, however, Italy preserved many of the older Palestinian customs. A copy of the Palestinian Talmud was produced by a scribe in Otranto in the late eleventh century and the oldest complete extant manuscript was copied in Rome in 1289.[88]

Already in antiquity the Palestinian and Babylonian rites differed in their basic prayers, and the Middle Ages saw an increasing distinction among the rites, mostly due to the selection and quantity of *piyyutim* in different regions.[89] The Romaniote rite used in the Byzantine Empire "owed a great deal to the rites of the land of Israel and even preserved some use of Greek in its prayer formulations."[90] These prayers are best preserved today in the Balkans.[91] The Italian (or Roman) rite preserves some of the now-lost Palestinian traditions, as does the Ashkenazic rite (its founders originated in Italy), but both were strongly influenced by Babylonia.[92] The Sephardic rite preserves the best evidence for the Babylonian prayer book because a complete exemplar, the *Seder Rav Amram Gaon*, was sent from Sura to Spain in the ninth century. In the period covered by this study, Salentine Jews followed the Romaniote rite but were also exposed to Italian and Ashkenazic practices through such "normative" compilations of halakha as *Shibolei ha-Leqet*. Only in the late fifteenth century, after the expulsion of the Jews from Spain, did the Sephardic rite make strong inroads in southern Italy. Unlike Greece, there is no evidence for a Karaite presence in the region.[93]

The Jewish rite as practiced in the Salento must have differed in some degree from Romaniote customs elsewhere because in the mid-fifteenth century we find reference to a distinct "rite of Lecce." In a list of books owned by Abraham de Balmes, a resident of Lecce originally from Provence, the section on prayer books lists two that are unidentified, probably of the Italian rite; one follows the Provençal rite; and three books are listed as כפי סדר ליצי, "according to the Lecce rite."[94] Unfortunately, we do not know precisely what the "rite of Lecce" was or how it differed from neighboring rites. Nevertheless, a recognizably Romaniote *mahzor* (festival prayer book) could still be copied in Lecce in 1485.[95]

Since the destruction of the Temple by the Romans in 70 CE—a date that medieval Jews, including Salentines, misremembered as 68 CE [16][96]—the synagogue had

been considered a "smaller sanctuary," the *miqdash me'at* of Ezekiel 11:16. At the heart of the synagogue liturgy was the reading of the Torah and a related prophetical reading, the Haftorah, and the recitation of statutory prayers, mostly benedictions in praise of God, three times each day by a precentor who, at least until the High Middle Ages, might also be a *paytan*, a composer of *piyyutim*. There was a whole "choreography of behaviors" associated with the Torah and its accoutrements.[97] The Torah was supposed to be read from a scroll, but from *Shibolei ha-Leqet* we learn that codices of the Pentateuch (*chumashim*) were also permitted, at least in Rome, if a scroll was unavailable.[98] The complete Torah portion for each week was read on Sabbaths and a smaller portion on Mondays and Thursdays; festivals had their own readings. According to *Shibolei ha-Leqet*, it was desirable to supplement the weekly Torah portion with a translation in the vernacular.[99] The Babylonian custom of completing the whole Torah in a single year replaced the three-year cycle preferred by the Palestinians, and the fact that Benjamin of Tudela did not note this potential oddity when he visited several Jewish communities in the Salento about 1170 makes it likely that these Jews followed the more widespread annual custom.[100]

Central to the statutory prayers were the *Shema* and the *Amida* (also called *Shemoneh Esreh*, Eighteen Benedictions). The latter was a series of petitions said privately, and then repeated publicly, while standing. The third benediction is the *Qedusha*, which contains the line "Holy, holy, holy is the Lord of Hosts; the whole world is filled with his glory." These lines from Isaiah's vision of the Throne of God (Isa. 6:3) are the same as the Roman-rite *Sanctus* and the Orthodox Trisagion. This human chant was understood to be matched by the seraphim singing the same lines before God; in other words, medieval Jews shared with their Christian neighbors the notion that the liturgy on earth reflected the celestial liturgy (a number of Salento churches, such as Casalrotto, feature painted seraphim near the sanctuary). The twelfth of the *Amida* benedictions addresses various enemies of Israel. In the Romaniote rite, these include apostates (*meshummadim*), *minim* (generally understood as Christians), informers (*malshinim, masurim*), heretics (*kofrim*), and evil governments.[101] The Italian-rite manuscripts list as malefactors only the informers and *minim*, but they also urge the downfall of the "gentile nations who are the enemies of Your people Israel." This part of the prayer book was frequently censored by Jews, for self-protection, and by Christians.[102]

An important monthly ritual was the announcement of the first appearance of the new moon. In southern Italy in the later Middle Ages, this was done not in Hebrew or Aramaic, like the other prayers, but in Greek, as attested by a Romaniote siddur copied in the fifteenth century at an unspecified location.[103] The Greek text is written phonetically in Hebrew script; it is introduced by the statement "And they say in Greek that he shall bless the New Moon" and concludes

with the instruction that the Torah scroll should be returned to the ark after the announcement.[104]

While the Salentine congregation generally listened to the prayer leader chanting before them,[105] they occasionally added verbal responses to the *piyyutim*. Two compositions by Amittai of Oria, the most prolific of the South Italian *paytanim* with over fifty hymns preserved in various European and Mediterranean prayer books, include refrains in what is probably a local vernacular.[106] Amittai was an innovator in other ways, too: he introduced into liturgical poetry contemporary references that included explicit negative comments about non-Jewish practices and beliefs.[107] One *piyyut* avers that "the law of the gentiles is obscenity, their joy sin and blasphemy; trouble, if this were your people."[108]

Another feature typical of Amittai and later Romaniote authors was their appeal to angels and intermediaries to intercede with God on behalf of the Jews. This derives from the corpora of Palestinian mystical literature called Heikhalot and Merkavah in which the ancestors of Ahima'az were well versed.[109] The "Greek" (Romaniote) Jews were much criticized for their familiarity with esoteric knowledge by, among others, Maimonides.[110] While rabbinic literature opposes the glorification of angels, mystical texts affirm it, and criticism of Jewish "veneration" of angels appears in both Christian and Islamic sources. A prayer included already in the ninth-century *Seder Rav Amran Gaon*, "Ushers of mercy, usher in our mercy before the merciful one," was defended by the author of *Shibolei ha-Leqet*.[111] It seems reasonable to consider the unusual "Creation of the Angels" scene at San Pietro at Otranto in this light: the Christian patron, whoever he was, perhaps chose to include it in order to make the point that angels are created beings and do not merit veneration.[112] As discussed below, the inclusion of an unprecedented cycle of scenes from Genesis in the Otranto church is probably connected with a local history of Jewish-Orthodox disputations.

In addition to occasional verbal contributions, the synagogue congregation was supposed to perform certain movements. They should sway while praying, according to *Shibolei ha-Leqet,* whose author says he found the source of this practice in the Merkavah literature[113]—another instance in which human worship was understood to imitate the angels. Full *proskynesis* was mandated during the month of Nissan and during the festival of Shavuot; again, Zidkiyahu Anav states that in Worms this is not commonly done but in Mainz it is, and "our custom [in Rome] is that of Mainz."[114] This is another example of different ritual practices existing in adjacent locales, something we noted with regard to the presence of coins in Salento tombs. Maimonides says that "the custom is for all Jews, in Spain and in the West, in Babylon and the Holy Land, to light lanterns in synagogues and to spread mats on the floor to sit on. But in the cities of Edom they sit on chairs."[115] The "cities of Edom" refers to the descendants of ancient Rome, the Romaniote

Jews (and possibly the twelfth-century Roman Christians). The mention of seats in the extant synagogue inscriptions [**50, 147**] refers to built-in seating around the perimeter, of the sort still visible in numerous crypt churches [**76.st.1**]. Women and children were present at least occasionally, as they were in the synagogues of other rites.[116] In the Scola Nova at Trani they would have sat behind the small triple arches on the west side of the lower story or the more numerous but smaller openings on the north (left) side of the upper story [**148.B**].

Illuminating the worship space was a concern for all faiths, and I have already noted the donations of wax by Christians. The synagogue dedication from Trani records "a window open to the light" [**147**]; the one on a window at Bari is self-referential ("this window") [**9**]. *Shibolei ha-Leqet* addresses the question of whether contemporary Jews should light candles in the synagogue during festivals and articulates their significance in terms of religious competition:

> Even if one doesn't need the light, it is important to honor others and the holiday. Also the non-Jews are used to lighting *ashishot* [lanterns, lamps] for *avodah zara* [idolatry] on the days of their feasts. If there is no honor in using light, why would they do it? There must be honor in it: this is why Israel lights lamps in honor of grooms, and for *brit milah*, and also during Hoshana Rabbah [last day of Sukkot] inside the synagogues. During Hoshana Rabbah everyone brings his own lamp and it is burning inside the synagogue. All of this is in order to give more honor and joy.[117]

Hoshana Rabbah was considered the final day of judgment, culminating a process that began at Rosh Hashanah, and for this reason the Romaniote siddur added *piyyutim* from the Yom Kippur liturgy to that day's prayers. Obadiah of Bertinoro observed an all-night vigil for Hoshana Rabbah in fifteenth-century Palermo: "After the [evening] prayers are finished the two officials open the doors of the Ark and remain there the whole night; women come there in family groups to kiss the scroll of the law and to prostrate themselves before it; they enter at one door and go out by the other, and this continues through the whole night."[118] Elliott Horowitz posits that while the women were inside, Palermitan men were outdoors observing their shadows; a successful sighting was widely believed to indicate that one had passed divine judgment and would live another year. This represents an inversion of the usual situation in which men performed most rituals inside the synagogue.

Other Jewish festivals had their own synagogue rituals. The rabbi from Bertinoro is unwilling even to describe the practices he witnesses in Sicily on Simchat Torah, the day after Hoshana Rabbah, because they were so different from what he expected to see: apparently the Romaniote Jews engaged in carnivalesque

performances that were paralleled in northern Italy's Ashkenazic terrain only on Purim.[119] On Hanukkah, Zidkiyahu Anav does not think that candles need to be lit in synagogue when everyone lights in his own home, but he acknowledges that this is indeed done in Rome in his day; if guests are sleeping in the synagogue they must light their candles there.[120] He also discusses the Sabbath before Passover, called Shabbat Hagadol, which, he says, is not the "Great Sabbath" but the "Sabbath of the Great" or even the "Long Sabbath." This was the day when the greatest local scholar (the *gadol*) gave his traditional annual discourse on the holiday and its many laws; the listeners remained in the synagogue as a captive audience. Zidkiyahu says, with psychological astuteness, "when people do not move about from one place to another but have to stay in one spot for a whole day doing nothing, they say, 'What a great (long) day this is!'"[121]

Images and Rituals

Shephatiah and his son are described in the *Chronicle of Ahima'az* as "going late in the evening and early in the morning to the place of prayer."[122] These were two of the exceptionally pious and learned Jews of early medieval Oria, and their behavior may not accurately represent the synagogue attendance of other adult male Jews. But whenever the Jews were in synagogue, they begged God to intervene in specific and general matters: in the late ninth century, for instance, they prayed that he would "blunt and obstruct the forcible conversion" imposed by Basil I in 868, and also keep the Jews "from defilement and contamination from the polluted waters," a reference to baptism, and "from bowing down to the deaf and the dumb, from worshiping the blind and sightless, from prostrating before statues and icons."[123] Jews were well aware of what Christians did in churches, in part because these interactions with images were also undertaken outside of places of worship, as discussed in Chapter 7.

Moreover, Jews could also gather in churches, or at least inside their doorways (see their view in [**86.A**]), as we learn from the visiting Augustinian monk Jacobus of Verona in 1346: "In that same city of Otranto, in the cathedral, the great church, before the high altar is a candelabrum of gold sixteen cubits high, and it has seven branches with a trunk, with cups and lilies and seven lamps, the form of which is as God instructed Moses to make in the Tabernacle of the covenant of God. And all the Jews in those parts went often to admire it, because it was very costly, beautiful and large."[124] Clearly, the local Jews were not immune to the allure of the visual, and they may have had figural paintings (but not sculptures) in their synagogues. The general view was that flat expanses of color, unlike relief or three-dimensional images, were not going to tempt Jews into idolatry. Only a few

iconographic categories are precluded from two-dimensional representation on walls or in prayer books, and even these only according to strict interpreters.[125] A responsum of the great Ashkenazic rabbi Meir of Rothenburg (ca. 1215–93) is perhaps the best-known medieval statement on this topic, and it is relevant to the Salento because its author corresponded with Zidkiyahu Anav and is cited as an authority by Isaiah of Trani. The proscribed representations include human faces on their own; the combined faces of the Throne of Glory (man, lion, ox, eagle); certain celestial entities; and exact replicas of the Temple and Tabernacle furnishings. It is clear from the great variety of schematic menorahs on Salento tombstones [**81.C, 128**] that none of them approach the accuracy of a prohibited replica, while the great menorah in the cathedral at Otranto was certainly intended to do so.[126]

Narratives, Icons, Devotions

There were several kinds of Christian images on the walls, vaults, and floors of Salento churches: multifigure and pluriscenic narratives of the life of Christ, the Virgin, or the saints; single or paired images of Christ, the Virgin, angels, or saints; and multifigural symbolic images like the Tree of Life mosaic pavement at Otranto [**86.A**] or the Tree of the Cross at Santa Maria del Casale and San Paolo in Brindisi. Nicholas-Nektarios of Casole asserted the pedagogical and anagogical functions of Christian narratives in his disputation with a Jew allegedly at Otranto, preserved in a single manuscript as the Διάλεξις κατὰ Ἰουδαίων.[127] The abbot says he venerates icons

as figures/reflections of saintly men and images of the angels of God, which not only do they not remove us from God, God forbid!, but they draw us close to his faith and love, and indeed they raise the mind of the friends of God toward the creator of all. . . . Because of this we are not alienated from loving God—God forbid!—but we love Him even more, and whenever we paint in our holy houses the narrations of the one who saw God [Moses], they are those excessive and prodigious (works), such as how the Red Sea is cut in two, how Israel crosses it without wetting a foot and the Pharaoh is seen going down under the water along with his followers, how the people of God is guided through the desert by a column of fire and a cloud, and all the rest, those immense (works) of God that one might narrate. Immediately through vision we are drawn to the memory of God who made all these happen, and we are amazed, filled with fear along with joy, saying: *which God is as great as our God. You are a true God, who does such wonderful deeds.*

The Jewish discussant counters with "But doesn't the Holy Scripture narrate all these? What then is the purpose of icons/representations?" to which the Christian responds with the venerable formulation attributed to Gregory the Great:

> The things that the scholars learn from written texts, the laymen, on the other hand, learn the same things from painting. And when they see figured in representations Abraham about to sacrifice his own son, who also was his only child, without mercy because of the love of God, and as they are astounded by this affair—they are wondering who is this extremely old insolent person wanting to kill a young one—but after they learn the cause of this situation, they rush toward his figure with a better jealousy [great zeal] and a willing soul, and they immediately venerate it. And they bring their supplicant voices to God, having as the intermediary to the Lord of All him whose figure is painted; they perceive him not as a god, God forbid!, but as the most faithful servant of God, and they supplicate the original since it has acquired the freedom of speech [παρρησία] in front of God to intercede the divine for them.

When the Jew asks, "And is it possible for the representation to help all of you even if it is of a dead person?" the abbot gives the familiar Orthodox response:

> As one divine man said, the veneration to the icon goes to its prototype, and furthermore, Jew, we consider those who pleased God not dead but living in spirit, and God is greatly pleased with them, who is called the God of Abraham, and the God of Isaac, and the God of Jacob. But you, Jew, at the time when you follow the law, you appear to submit to the parchments and what they contain rather than to the giver of the Law.

The basic contours of this Jewish-Christian polemical debate are certainly familiar,[128] but the details are novel: Nicholas-Nektarios refers unexpectedly to extensive cycles of episodes from Exodus and an isolated scene from Genesis, the sacrifice of Isaac. While the latter appears once in the Salento, at San Simeone in Famosa at Massafra, the former never do, at least not among extant medieval monuments.[129] Interestingly, the same author described scenes of the Jews crossing the Red Sea in an ekphrasis on a phiale in Constantinople where the Old Testament imagery was juxtaposed to a Baptism cycle. The domed phiale was painted by a famous artist named Paul—from Otranto.[130]

The closest comparison in the Salento is the abbreviated Genesis cycle in San Pietro at Otranto, in which four panels, depicting seven episodes, were certainly painted after the time of the alleged debate in Otranto. Two decades ago I dated

these to the third quarter of the thirteenth century based on the stratigraphic continuity between a pendentive image of Saint John, adjacent to the Genesis scenes and by the same artist, and Christological images in the eastern vault by an up-to-date Palaiologan artist of considerable talent.[131] The Otranto Genesis cycle might be an echo, half a century later, of a local debate that probably did occur in Otranto even if Nicholas-Nektarios's account is actually a composite of such discussions.[132] The public debate resulted, as such events always did in the hands of Christian chroniclers, in the Jew's conversion, and it might have been forgotten but for the fact that this was followed by violent Jewish protests. Confirmation of this is found in a letter from the metropolitan of Corfu, George Bardanes, to his friend Nicholas-Nektarios in which the recipient is likened to Saint Stephen because both were victims of Jewish fury.[133]

Beyond the unexpected iconographic information about an extended Exodus cycle, another surprising feature emerges from the Christian-Jewish polemic in Otranto. I refer to the statement about the great zeal and veneration effected by a narrative image of Abraham sacrificing Isaac, an image that, according to Nicholas-Nektarios, compelled its viewers to rush toward it.[134] Normally we do not think of narrative scenes as capable of inspiring Orthodox veneration in the same way that "iconic" images do, not least because the scenes are usually at some remove from their viewers on upper church walls or vaults, as at Otranto.[135] Occasionally such scenes are closer to worshippers, however, such as the floor-level Crucifixion at Soleto [**113.st.1**], the Nativity and Journey of the Magi at San Vito dei Normanni [**109**, left wall], and four Christological scenes at San Simeone in Famosa [**70.sc**]. The Sacrifice of Isaac in the latter church was not as accessible, for it is in the soffit of the arcosolium over the right altar. Almost none of the accessible narrative scenes in the region attracted medieval graffiti, a clear indication that they were not understood as objects of cult. Graffiti as indexes of veneration are discussed at the end of this chapter.

The presence of a stone projection hollowed out to suspend something, presumably a lamp, over the Nativity scene in the San Biagio crypt church at San Vito dei Normanni provides further evidence for noninvasive veneration of a narrative image at ground level [**109**, visible at the upper left]. The lamp would have hung directly in front of the angel plummeting toward the manger, and it was planned from the outset, for it is outlined as part of the original wall decoration. Byzantine typika provide ample evidence that illuminating specific icons in churches was an Orthodox devotional act.[136]

There is additional evidence for the veneration of icons in the Salento, whether these are understood to be single or multifigured images. A painted *podea* is visible at the base of the shallow rectangular niche between the two apses at Carpignano [**32**, visible to the right of the pier].[137] Other painted cloths in the Salento are fictive

altar cloths, but when altars are attached to the wall and decorated above with a half-length image, the line between *podea* and altar cloth blurs. This is the case at Li Monaci, where the oversized half-figure of John the Theologian/Evangelist above the shallow left altar has a painted cloth that, when viewed frontally, amalgamates visually with the saint's icon in the manner of a *podea* [**43.C**]. Many other fourteenth- and fifteenth-century half-length figures are similarly oversized, a large number of them icons of Saint Nicholas whose accompanying name-disks are usually found on panel paintings [**80.st.1**].[138] The scale of these images is indication enough that they were particular objects of veneration, and Nicholas at Nociglia is covered with incised graffiti, both pictorial and verbal. The repetitive iconography suggests an important model that can no longer be identified. This has also been posited for a number of Virgin and Child images in which the Child is supported by his mother's right hand.[139]

Santa Maria del Casale near Brindisi possessed a miracle-working image of the Hodegetria that was on the high altar of the fourteenth-century Roman-rite church until it was accidentally destroyed in the early twentieth century. At some point it received a metal revetment, although this is lost as well.[140] The icon was imitated, albeit loosely, in the numerous images of the Virgin and Child on the walls of the church [**28**]. Other icons garnered special attention because they were understood to have survived from earlier churches; often these were "miraculously" rediscovered and incorporated into later places of worship on the same site or nearby. This includes the numerous venerable images of the Virgin and Child that were later framed in "portholes" of baroque altars, as at Santa Cristina at Carpignano, Santa Maria dell'Alto at Nardò, and Santa Croce at Minervino di Lecce, among many examples.[141] Another method of preserving earlier imagery is represented by the monolithic stela incorporated into the Madonna di Costantinopoli chapel at Morciano di Leuca (overpainted in the sixteenth century), or the Madonna della Coltura at Parabita, still venerated with a civic procession of a replica on the second Sunday after Easter.[142] In the latter, an early fifteenth-century Virgin and Child covers an earlier stratum of fresco, perhaps with the same iconography; on each of the other three sides is a cross and a series of acronyms or cryptograms in Greek. One narrow side of the Parabita monolith is noticeably rough, as if it had been hacked away crudely from its original position as a pilaster or templon barrier.[143]

Devotion in the form of ritualized action is a hallmark of medieval spirituality.. In an Orthodox church, someone in search of a miracle for purposes of healing, childbirth, or another physical, social, or spiritual need, would pray in front of an image of a saint and interact with its prototype by means of touching, kissing, lighting a candle, and the like. If the desired miracle occurred, one returned to the church to offer praise and thanks, quite possibly in tangible form.[144] An allegedly

ancient tradition in the crypt of Santa Marina at Miggiano required women who wished to petition the saint to perform *proskynesis* in an "arch" form in the direction of all four walls, and then three more times for a total of seven *proskyneseis*.[145]

Specific Saints on the Walls

In addition to the miraculous Virgins enshrined in later altars and the oversized iconic saints already discussed, it is critical to recognize that all of the saints frescoed on church walls were objects of devotion. The local proverb "Santu piccinnu, miràculi piccinni; santu crande, miràculi crandi" (Small saint, small miracles; big saint, big miracles) suggests that the "great saints" should be the ones most often represented, and "Ci tene lu santu ggiustu, nu lli màncane miràculi" (If you have the right saint, you won't lack miracles). On the other hand, "Nu ccrìdere al llu santu, prima cu vviti lu miràculu" (Don't believe in the saint before you see the miracle), for "nu ttutti li santi su' ppari" (not all saints are equal). "A ssanti senza crazzie, nu see ddùmane candile" (To saints without graces [who don't deliver], one doesn't light candles).[146] One can find a proverb to suit any eventuality, but the point is that images of saints, whether portable or fixed on church walls, were expected to respond to their devotees with miracles and graces or another saint's help would be sought. In some cases depicted saints may have been chosen by committee, as it were; it was probably unthinkable to decorate a medieval Salento church without including such powerful miracle-working saints as Michael, Nicholas, or Antony Abbot (not to mention the Virgin and Christ). Yet in other cases the choices are so unexpected that a highly personal relationship between individual commissioner and subject seems the only possible explanation.

I consider here which saints were depicted locally with the goal of initiating a productive relationship between human and divine. Even if it was possible to interact with narrative imagery, as noted above, piety was expressed more directly toward sacred persons who were represented facing forward in a way that made them immediately accessible to their human supplicants. Orthodox devotion demanded that such representations be touched and kissed;[147] in addition, candles or lamps were lit before them, objects were placed in their proximity, and family members were buried nearby. This was very much a part of Roman-rite worship as well.

Forty years ago, André Guillou attempted to list all the saints depicted on Salentine church walls.[148] Any such roster is quickly rendered out of date by the discovery of new paintings or the revised identification of older ones. I am not attempting to create a new comprehensive list; rather, I am concerned with those saints who are named in dedications of churches or altars or are objects of verbal or visual supplication (that is, juxtaposed to supplicatory texts or images). The

number of images of and invocations to Christ or to the Virgin and Child is too large to be considered here, but these were certainly the principal objects of local devotion.

In the medieval Salento, churches or altars were dedicated (according to the visual record) to Saints Anne, Barsanuphius, Blasius, Januarius, John the Theologian, Leucius, Marina, Michael, Nicholas, and Sabinus. Of these, only the less-common dedications require comment. Barsanuphius was a monk in Gaza and then in Palestine in the sixth century. His relics were brought to Oria in the ninth century by Bishop Theodosius, whose inscription credits himself in letters much larger than the name of the saint [**83**].[149] Theodosius is the bishop referred to in the *Chronicle of Ahimaʿaz* who bested the author's ancestor in calculating the appearance of the new moon, but was stymied in his conversion effort when God kept the moon hidden so the Jew would win the bet. Robert Bonfil has speculated that Theodosius's relic collecting was aimed specifically at converting the Jews because the chapel containing Barsanuphius's remains, preserved under the present church of San Francesco di Paola, was constructed *apud portam Hebraicam*.[150] The *Vita Barsanuphii* written in Oria in the twelfth century may have inspired an altar dedication to this saint, among others, at Ceglie Messapica [**38**].

Leucius was said to be the first bishop of Brindisi. His remains were stolen by Trani and also claimed by Canosa. In the ninth century, only an arm was restored to the Brindisi diocese, which at that time was based in Oria under Bishop Theodosius. Leucius's extramural martyrium-basilica was demolished in 1720, but the city's center of gravity had long since moved inside the walls where the new cathedral was built in the twelfth century [**21.A–B**]. One part of the old structure was identified as a refuge for those fleeing pursuers [**25**]: for twenty feet in any of three directions, an individual was ensured asylum.

Sabinus, who had an altar restored at Santa Marina in Massafra [**67.C**] and is depicted elsewhere in the church, was the sixth-century bishop of Canosa in Apulia and later the titular saint of the cathedral of Bari. The November rededication of the Massafra altar does not correspond to the saint's feast day, but it may date roughly to the time of the composition of the Latin *Vita di S. Sabini* in the early ninth century. Finally, Januarius is one of the patron saints of Naples. His body was translated to Benevento in the tenth century, but his blood continues to liquefy at regular intervals to this day. Along with Barsanuphius and Anne, he was the dedicatee of the twelfth-century altar at Ceglie whose inscription survives only in a sixteenth-century copy [**38**]. Except for Sabinus, all of these saintly recipients of specific dedications have both Orthodox and Roman-rite feast days.

Individual supplications, painted or incised, were made verbally and/or visually to Saints Anne, Antony Abbot, Barbara, Blasius, Catherine, Christine, Dominic,

Eligius, Erasmus, Eustathios, George, Helena, John the Baptist, John the Evangelist, Julian, Leo the Great, Margaret, Marina, Mark, Martin, Matthias, Michael, Nicholas, Orontius, Peter, Stephen, Theodore, and Vincent.[151] The saints with four or more supplications are Michael (at six invocations, the most popular saint), Barbara (five), Antony Abbot, and Nicholas (both with four). As was the case with dedications, these are all famous miracle-working saints venerated in both churches. I will not review their familiar hagiographies but only comment on their idiosyncrasies and local significance.

Saint Michael (venerated September 29) was often represented at liminal sites within a church. Using only my Database, and not all Salento representations of the archangel, we find him depicted at the intersections (corners) of walls and next to doors, in an apse or on the apse wall, or directly opposite the entry.[152] He guards both ends of the sanctuary at San Nicola at Mottola, at the east end of both the north and south walls. At Masseria Lo Noce he is adjacent to an arcosolium tomb [**54.st**]. Here and in one of two depictions at San Nicola at Mottola, Michael spears a serpent-dragon in accord with European, not Byzantine, iconography. The magically protective potential of this saint was widely recognized, and he was not only a guardian of individuals but also of several communities in the Salento; it is difficult to find an early modern pastoral visit that does not note a church dedicated to Michael specifically or the archangels more generally. The church now known as San Salvatore at Sanarica at some point contained a narrative cycle of his miracles, including the one at Chonae, and it is possible that the church was at some point dedicated to the archangel.[153]

The orb held by the archangel often bears an acronym in Greek. Quite often in Byzantine art the acronym, read from left to right and top to bottom, is Φ Χ Φ Π, for Φῶς Χριστοῦ Φαίνει πᾶσι, "the light of Christ shines for all."[154] In the early fifteenth century, this is the cryptogram seen on the angel's orb at Santo Stefano in Soleto, a church whose apse program reveals a high level of theological sophistication [**113.sc.2**]. Yet the message in the angelic orb is not consistent. At Santa Marina in Miggiano, three monastic supplicants address Saint Michael holding a globe with Μ ΘΥ Π Τ [**73.A.1**], and the same sequence is found at San Mauro near Gallipoli and at San Giovanni at San Vito dei Normanni, although there the final letter seems to be Φ. Perhaps this should be read vertically, as Μ(ιχαήλ) Π(ρῶτος) Θ(εοῦ), "Michael the first [something] of God," a reading suggested for an archangel at the eleventh-century Sant'Angelo in Formis, on the other side of Italy, which may have had among its models the Byzantine mosaics produced at Montecassino for Abbot Desiderius. Indeed, Μ Π is at the beginning of an orb held at Poggiardo in the Salento. At two indisputably Roman-rite churches in Brindisi Greek acronyms are legible on the angel's orb: Μ [?] Π Τ in the upper church of Santa Lucia and IC XC N K, "Jesus Christ Conquers" at Sant'Anna. There was

no consistent model employed for Michael's celestial orb, but Greek abbreviations predominate regardless of the local confession.

The regional supplications to Barbara all appear on her image at Casaranello [**33.F–K; Plate 8**].[155] The large number of painted and incised eleventh- and twelfth-century graffiti on Saint Barbara, especially compared with the paucity of graffiti on the Theotokos on the opposite pier, make it clear that Barbara was considered a highly effective intercessor and perhaps even a vehicle of miracles. The saint (venerated December 4) had several special roles that would warrant her intercessory powers: she was a protector against noxious animals, thunder and lightning,[156] jaundice (thought to be caused by rainbows), and sudden death.

Devotion to Antony Abbot was very widespread, as evidenced not only by textual supplications but also by his many images and church dedications. His resistance to the devil during his lifetime was well known, and it made him an especially effective protector against demonic forces after his elevation to the heavenly court.[157] He was the patron saint of animals and their breeders (because of his pig) and of plagues and skin diseases. Pig fat was useful for curing ergotism, better known as Saint Antony's fire, and above all Antony was associated with fire.[158] The great bonfires lit in his honor on January 17 still mark the middle of winter and the start of the pre-Lenten carnival (see Chapter 7). In the Salento, the one at Novoli is especially well known, although its antiquity is disputable. For nine days wood is brought to the main piazza to make a pyre that would burn for three days, after which one brings home a bit of this magical, propitiatory "sacred fire," or at least some of the ashes.[159] Antony was invoked against demons and, later, against labor pains. In twentieth-century Massafra a bell, associated with the saint and common in late medieval depictions, would be rung when a baby was due.[160]

It is worth examining Antony's portrayal at a few sites. At Soleto, in the second phase of frescoes added circa 1420, he has a V-shaped staff and a small, dark pig at his feet [**113.st.1**, far right]. That the pig is a wild boar is evident from the saint's depiction in the right inner aisle at Galatina, the only case in that church where a kneeling supplicant is accompanied by a patron's or artist's claim to have "made" (*fecit*) the work [**47.D**]. Attempts to identify this "Franciscus of Arecio" among early fifteenth-century painters have proved fruitless and I suspect that he was one of the countless individuals who sponsored, rather than executed, a medieval image.

In Santi Stefani at Vaste, Saint Antony is represented four times holding a T-cross and a scroll that speaks of demons. It is impossible to avoid his image, or his gaze, in the central or right aisle of the church, and it can hardly be coincidental that the male supplicant depicted in the central apse is named Antony [**157.A**]. In two cases the saint is supplicated on behalf of men: the one wearing white on the east-wall pilaster [**157.F**] is, I assume, different from the one named

Stephen in a button-trimmed red garment on the north face of the second south pier [**157.K**].

Nicholas was enormously popular in the Salento, depicted more often than any other saint. Surviving supplications only hint at the tremendous devotion that was spurred by, but did not originate with, the translation of his relics to Bari in 1087. By about 1000 he was already being supplicated in the sanctuary at Casaranello [**33.A**] and in the eleventh century in the arcosolium tomb at Carpignano [**32.J**], where he shares the intrados with the Virgin. At San Nicola at Palagianello he is paired with Mary in the deesis, replacing John the Baptist. Nicholas abuts the Virgin and Child in many more examples, including a pier at Poggiardo [**97.A**], in Mottola's homonymous crypt church, and at Nociglia [**80.st.1**]; in fact, he is shown next to the Virgin so often that it must reflect his perceived stature in the heavenly court.[161] In none of these cases is the supplicant also named Nicholas even though that was among the most popular regional names. Nicholas also is depicted in or near the sanctuary at numerous sites.[162] He occupies the center of the left apse in the eleventh-century fresco layer at Santi Stefani at Vaste, where he is flanked by the authors of the two principal Byzantine liturgies, Saints Basil and John Chrysostom.

Scenes from Nicholas's life also enjoyed a certain local popularity. The oldest known vita cycle of the saint adorned his church in Muro Leccese in the eleventh century,[163] and individual scenes were depicted at the Mottola crypt dedicated to Saint Margaret (where he provides dowries for poor girls [**75.sc.1**]) and at Acquarica del Capo (where he frees wrongly imprisoned generals).[164] Two posthumous miracles of what was originally a more extensive cycle survive at Santi Niccolò e Cataldo in Lecce in the early fifteenth century [**58.sc**]. While none of these narrative images can be connected with an identifiable individual, they testify to the widespread appeal of Nicholas's cult. Thanks to several legendary miracles he was widely associated with children and was to be the titular saint of a planned foundling hospital in Lecce. This hospital—never built—was projected to occupy the site of the synagogue profaned by a mob in 1495 and repainted with images of the Virgin and various saints.[165]

The most venerable and most famous international saints certainly received the lion's share of church wall space. In addition to the saints already discussed, Blasius, Catherine, George, Cosmas and Damian, the two Saint Johns, and Marina/Margaret are ubiquitous. Of the military saints shown on horseback, George was far more popular than Demetrius, Theodore, Hippolytus, and Eustratios. Only George [**24.A, 76.A**] and Theodore [**22.E**] were objects of verbal supplication, and only in Latin. Saint Anne received the only known supplication on behalf of, or from, a woman [**32.B**], which accords with her role as protector of women in general and new mothers in particular.[166] Saints of Italian

origin venerated in both churches were also very commonly represented, especially Agatha; even Leo the Great appears once [**76.st.1**], although Leo of Catania, so common in southern Greece, is absent.[167] Of saints known in only one sanctorale, Augustine attracted graffiti at Nardò, Dominic is supplicated once at Brindisi [**22.C**], and Sabinus and Barsanuphius have already been discussed. Vitus is widely represented but was not an object of extant individual invocation. The local saint Orontius is supplicated as an intercessor in only one graffito [**69.A**], although, like Saint Potitus, he has now been identified elsewhere without a devotional text or image.[168] Saint Nicholas Pellegrinus, who has a miniature supplicant beside him in a thirteenth-century painting in Massafra [**63.B**], had traveled from Hosios Loukas in Greece to Otranto and then through Sogliano, Taranto, and Veglie in the Salento before arriving in Trani, ultimately becoming its patron saint.[169]

Cases of homonymous supplication are, on the whole, quite rare, and seem to be strongly localized phenomena. Saints Vincent, Blasius, John the Baptist, and Mark are addressed by their namesakes in three different churches but only two sites, Carpignano and Massafra [**65, 66.A**]. Chrysolea, the earliest female named at Carpignano, may have had Christine as her preferred saint even though her name appears next to an enthroned Christ [**32.A**]; this permits Chrysolea to be "present" in the apse, the most prestigious part of the church, while Saint Christine, who would not belong there, is close by on the east wall.[170] In addition, it may be a Matthias who supplicates Saint Matthias at Palagianello, but only Ma— is preserved [**95**].

In the Orthodox world, saintly attributes are relatively rare. Beyond the healing saints who carry medicinal implements and military saints with their shields and weapons, only Saint Peter regularly holds something other than a book, scroll, censer, or cross. By contrast, being represented as holding something in the hands is quite typical of Roman-rite saints. A list of objects held by Salento saints underscores the distance of many of these images from the Orthodox tradition: Antony's Tau-cross staff, Catherine's wheel, Parasceve's bread, Leonard's chains, Vitus's dogs, the mallet and/or chains that hold the dragon of Saint Marina/Margaret, a bell in the hand of Zosimus, the heads of Peter and Paul on a salver held by Pope Urban V, and numerous saintly bishops' crosiers. Special mention should also be made of the pilgrimage gear regularly worn or carried by Saint Nicholas Pellegrinus [**63.B**] and Saint James (as well as nearby acolytes).[171] At Casalrotto, where James replaces John the Baptist in the deesis, the saint has two scallop shells adorning his cloak; a similar shell pierced for suspension was discovered in a nearby tomb.[172]

Painting Supplication

One of the most striking features of the Salentine supplicants is that not one offers anything tangible to the object of his or her devotion, unless we count the

candles held by three individuals at Massafra and Mottola [**67.E, 76.E; Plate 13**]; unlike every other erstwhile Byzantine region there are no church models at all. Daniel in the Masseria Lo Noce crypt has an object at his knees but nothing in his hands. The only objects actually carried by any human figures are the beaded strings held by almost every supplicant at Vaste in the 1379/80 fresco layer [**157**].

The beads are paternosters, which could be worn around the neck, arm, or wrist, suspended from a belt, or attached to a brooch. They were prayer mnemonics, used by monks and laypeople of the Roman rite who did not know enough Latin to recite a full complement of psalms and prayers and were thus encouraged (or required) to repeat the Lord's Prayer instead.[173] In the Orthodox world, monks used a knotted prayer string, the *komboschinion*, to count recitations of a different prayer.[174] In the fourteenth century Ave Marias were becoming the principal motive for using prayer beads,[175] and this may be how they were used by the kneeling figures at Vaste who are gazing upon the Woman of the Apocalypse, by then identified as the Virgin [**157.A; Plate 19**]. An old Salento proverb, recorded in a collection made in 1774, states "A santo che non fa grazzie non dire paternostri"—"Don't recite paternosters to a saint who doesn't grant favors."[176] Although paternosters were in wide use in Italy before the late fourteenth century, the miniature versions at Vaste are simplified depictions.[177] By the time these paintings were done more ornate versions were available, with larger beads separating groups of smaller ones as additional aide-mémoire. Although they were devotional objects rather than jewelry, the beads could be expensive and ornate, reflecting the social status of their owners.[178] It seems unlikely that the white dots at Vaste are meant to suggest real pearls; the most common material was wood.[179] To what degree the use of a paternoster, a devotional tool of the Roman rite, was in conflict with the Orthodox rite implicit in the templon barrier and exclusive use of Greek inscriptions at Vaste is a question to which I return at the end of the book.

Despite the "difficulty of measuring the distance between painted gestures and gestures in daily life,"[180] pictorial sources are invaluable for understanding gestures of prayer. Poses, postures, and gestures help us, as they helped the original beholders, perceive the relationship of the supplicating figure to the divine or saintly subject he or she venerates. In addition, they helped construct the contemporary viewer's relationship to the representations before him or her.[181]

Until the thirteenth century, supplicating figures in Europe, Byzantium, and contiguous areas were generally depicted in the traditional prayer attitudes of standing upright or kneeling facedown in *proskynesis* with hands splayed.[182] However, in Italy beginning in the early part of the century and in the Byzantine aristocratic world only at the end, both posture and gesture changed to an upright kneeling pose, with back straight and hands joined together.[183] This so-called "modern devotional attitude" became not only the actual method of prayer but

also the dominant manner of representing human figures adjacent to divine or sacred images. In the Byzantine sphere the change of pose was initially limited to the representation of upper-class figures, but it spread in the fourteenth century to clergy, monks, and laypeople.[184] It seems to have developed alongside spiritual movements that called for direct gaze—or its intellectual equivalent, the gaze of the mind—toward God by the supplicant.[185] In any case, most Byzantine worshippers remained slightly inclined rather than fully upright, and with their hands splayed apart rather than pressed together because the latter was so foreign to Orthodox practice.

In Italy, the new devotional iconography spread quickly and widely.[186] Liturgists in the thirteenth century began to distinguish prostration from kneeling genuflection, noting that the two poses expressed different spiritual states; Mary on her knees in the Last Judgment certainly was not an indication of a sinful state but rather one of pious entreaty and adoration.[187] The new thirteenth-century practice of elevating the consecrated host, the "major elevation," was done with the celebrant's hands together while the congregation kneeled in surrender to God.[188] Courtly culture adopted the pose, too, as knights received tokens from their ladies while kneeling before them.[189] And in practical terms, the upright kneeling pose was well suited to the new habits of lengthy contemplative prayer developed in the thirteenth century and promoted by mendicants and mystics. Still, *genuflexione recta* was only the third of seven or nine "modes" in thirteenth-century Dominican manuals of prayer, intended for monastic use but also translated into the vernacular.[190]

The upright kneeling pose is the one assumed by the majority of Salentine painted supplicants. This is unsurprising, given that most of them are datable on stylistic grounds to the thirteenth or fourteenth centuries, by which time the pose was de rigueur in Europe and increasingly common in Byzantine lands. The fact that the so-called empress kneeling at Muro Leccese assumes this posture supports her redating to the thirteenth century from the eleventh, when such a pose was not yet imagined by those engaged in prayer or supplication [**77.A**]. Assigning a date or cultural context to painted figures who do not assume the "modern" attitude is more difficult. The only example of a figure in more or less horizontal *proskynesis* is one of the trio of monks at Miggiano, identified above his head as "Nicholas, monk" [**73.A.2**] and with the word "proskynesis" painted higher up on the wall. His hands are splayed widely before him in the direction of an adjacent Saint Michael, but there is no penetration into the archangel's painted frame. Nicholas's two companions are standing upright, which is also a traditional Byzantine devotional posture. It is the pose assumed by, among others, Calogerius at Palagianello [**92.B**] and by the two male supplicants at San Vito dei Normanni [**109.B–C**]. One of the figures at San Vito shares with Calogerius a striking prox-

imity to his adjacent sacred figure: both of them touch the edge of the nearby saint's garment with their right hand, without actually overlapping or penetrating the sacred body. Moreover, Saint Andrew, to the right of the San Vito supplicant [**109.B**], actually overlaps the supplicant's tunic hem with his foot, which suggests that the tiny figure is part of the same behind-the-wall pictorial space as the two saints. Calogerius, for his part, is shown with his red boots overlapping the lower border of the panel just as the unknown central saint's feet overlap the same red stripe. In neither case does the saint acknowledge the human figure's presence.

While the woman who adores the Virgin and Christ child going to school at the Candelora crypt occupies the arched panel with them, she is standing behind her kneeling husband and thus removed from direct contact [**Plate 12**]. It is he who touches the Virgin's red mantle and whose frontal body contour is contiguous with the Virgin's lower right side. However, neither the man nor the woman looks up at the holy figure; their eyes face straight ahead, in three-quarter view, and there is neither gestural nor ocular interaction. The two standing candle-bearing women at San Nicola at Mottola have their faces tilted up toward the saints in the adjacent arches, but the large candles they hold in two hands preclude additional gestures of veneration [**76.st.1, 76.E; Plate 13**]. Even when the supplicants' faces are upturned or their hands actually touch the adjacent saint, none of them is acknowledged. Their reduced scale and conceptual separation are analogous to Byzantine icons that depict a supplicant (in which, it has been argued, the image both commemorates the donation and is itself the gift).[191] The analogy is significant because medieval Salentine wall painting in general is characterized by its preference for "iconic" figures of saints rather than narrative scenes.

In Salentine paintings that show supplicants in the "modern" kneeling pose with hands pressed together, the figures can be subdivided according to scale and degree of proximity to the sacred. Some are still tiny [**Plate 18**]; most of them touch or almost touch the saintly garments nearby [**28.M, 157.G, I, K;** the male in **Plate 12**]. The family in the Vaste apse fails to make physical contact with the adjacent Woman of the Apocalypse because she represents a futuristic vision rather than real presence [**Plate 19**]. Presbyter John, kneeling in the apse at San Pietro at Otranto and therefore occupying a privileged space, also cannot be said to adore anyone because he faces only the apse windows [**87.B**]. In other cases the kneeling supplicant appears to be part of a sacred space by virtue of proximity even if he or she is ignored by the adjacent sacred figures. Thus Daniel at Grottaglie's Masseria Lo Noce occupies a separate framed panel, but because he occupies the soffit of a niche entirely filled with Petrine imagery and is directly below the upside-down crucified Peter while facing the enthroned saint and scenes from his life, he seems to be a part of the events depicted [**54.A**]. Peregrinus of Morciano is shown actively witnessing the fourteenth-century Koimesis at Santa Maria di

Cerrate, even though he occupies an aedicula that separates him somewhat from the apostles at the foot of the Virgin's bier [**Plate 15**].

Only in fourteenth-century Roman-rite aristocratic contexts are large-scale human figures fully integrated into the sacred image. They are represented at a sizable scale, sometimes in the middle of the painted panel rather than at its base, and are actively being blessed by the protagonists. This occurs at San Paolo in Brindisi, where a kneeling supplicant's head almost reaches the height of the Christ child who blesses him with two outstretched hands while Mary looks on [**26.F**]. Such integration is also very common at Santa Maria del Casale. A painted supplicant in the presbytery is directly blessed by the right hand of Christ while the Virgin looks out at the beholder [**28.N; Plate 6**]. The Virgin extends her hands across painted columns that are simultaneously breached by the hands of the kneeling figures just below [**Plate 5**]. In the case of Nicholas de Marra, the Child blesses him with both hands while his mother also gestures toward him with her right hand and practically touches his head with her outstretched left [**Plate 7**]. In other cases, an intermediary—a nimbed saint—physically presents a painted person to the Virgin and Child who respond with a gesture of blessing [**28.D, I** (top), **J** (top), **R** (top)]. In one case the intimacy between a human pair and the Virgin and Child is palpable, for the former rest their hands on the Virgin's lap and each is physically touched by one of the sacred figures [**28.Q**]. The question of how a mortal can elide his or her conceptual distance from the divine is an important one. Are these painted supplicants venerating the real Virgin and Child, who respond to them, or were they understood to be addressing their prayers to a painted image that was also capable of response? Were they thought to be alive or dead when they were vouchsafed such intimate contact?

The supplicating human figures in the Salento prior to the fifteenth century are depicted, without exception, in three-quarter view. I contend that this figuration had positive value in itself and that other options were viewed as negative. It is easy to understand why no supplicants are represented frontally: if they were, they would be making their gifts or directing their petitions exclusively to their viewers, the churchgoers, rather than to the sacred figures with whom they share the pictorial surface; moreover, in such a pose they could be construed as objects of veneration themselves. Why, then, are supplicants not shown in profile to emphasize their exclusive focus on the sacred figures they adjoin? There are two reasons. First, the profile had a negative valence in the Middle Ages, when it was a widely recognized symbol of inferiority.[192] We find it used in the Salento for commoners and executioners, as in the vita cycles at Casaranello [**33.sc.2**] and for six of the eight Jews with whom Saint Catherine disputes in the presbytery at Santa Maria del Casale [**28.sc.2**]; it is also used for most of the soldiers in those panels

[**28.N**]. Judas is the sole figure in profile at the Last Supper at San Pietro at Otranto [**87.sc.1**]. Among the damned in the Last Judgment at Santa Maria del Casale, only the dark-skinned demons and the rich man encircled by flames are in profile [**28.sc.1**]. While it is not employed consistently—none of the Jews in the scene of Pilate Washing His Hands at San Paolo in Brindisi is shown that way [**Plate 3**]— the profile is common for lower-class figures and for persecutors of Christ. Therefore, it is likely that when a viewer saw a figure in profile, he or she was primed to react with some distaste. In the fifteenth century, this attitude toward the profile was no longer in force; it is very common for sacred figures at Santo Stefano at Soleto [**Plate 14**, nimbed head at right] and includes a whole group of the saved, not the damned, at the Last Judgment scene there.

The second reason the profile is not used for human figures is that the depicted figures—leaving aside whether they paid for the panel of which they are a part— serve as pious exemplars for their beholders and therefore must be shown to be in eye contact both with their devotional objects (the Virgin, a saint) and, simultaneously, with the worshippers who observe them doing so. The miming of painted persons, no less than that of living models, was an important part of the dynamic process of identity formation.[193] The eyes of the supplicating figures attract the eyes of viewers and their three-quarter pose helps transfer that physical gaze to the adjacent, metaphysical image; they activate the interior church space in an anagogical process that works horizontally as well as vertically.[194] On the rare occasions when a supplicant is shown in profile, such as the nun at Copertino discussed in Chapter 4 [**42**], she evinces enhanced communion with the adjacent saint and may be a postmortem idealization of the (same) woman shown opposite in three-quarter view.

While they are absent from our corpus of painted humans and figure only in narrative scenes, Salentine Jews would have recognized some of the poses of Christians in prayer, both real and pictorial. Prayer postures were also part of the Rabbanite versus Karaite polemic that divided medieval Jewry: the Karaites practiced the eight forms of physical adoration cited in the Temple rites, whereas the Rabbanites retained very few of them.[195] Italian Jews had their own highly developed kinetics of prayer. Judah Romano's fourteenth-century glossary includes the vernacular terms *sdiundano, diungano,* defined as one who separates or divides; as instructed by Rashi, "when one inclines for prayer one must incline until he divides in two parts all the vertebrae of the spine, in the manner of forming an arch."[196] The author of *Shibolei ha-Leqet* speaks about the occasions when Jews "fall on their faces" in prayer, contrasting local practice with that in Worms. Roman Jews instead shared the practice of Mainz, where *proskynesis* was practiced in the month of Nissan (for Passover) and for the whole week of Shavuot. They

also prostrated themselves between Yom Kippur and Sukkot, which was not done in the Rhineland.[197] The most pious subset of Rhenish Jews, the Hasidei Ashkenaz, probably continued ancient Palestinian traditions and looked up when they prayed, while the northern Italians and French gazed downward.[198] There is no information available about the direction of Jewish prayer in the Salento.

In painting supplication, individual representation was, in my view, only a secondary concern. Those who paid for an image and those who were represented while alive might "see" themselves in a painting, but this does not mean that the likeness was accurate or that it differed in any way from representations of other individuals; the physically interchangeable women at Vaste are the best example of this [**157**]. Even among figures supplemented by painted texts, recognition, such as it was, would be limited in duration and in scope. Within a generation, the painted individual's identity must have been subsumed into broader family or communal claims of devotion. The image still functioned—it continued to attract the gaze of worshippers and direct them in the anagogical process outlined above—but in an impersonal way. The same can be said for objects deposited or displayed in churches. While they testify to a personal and successful connection between a pious person and a sacred one, unless they are inscribed and their names are regularly read aloud, their essential anonymity means that they serve mostly as incentives for other worshippers to believe in the potential for similar success. Like painted supplicants, objects could be vivid behavioral models. This also holds true for medieval graffiti, the most personal (because potentially the least public) markers of devotion.

Incising Identity

In this chapter on activities inside places of worship, I have cited both textual and pictorial graffiti as indicators of devotion. The incising of one's name or prayer was a social act because a single graffito often attracted additional graffiti, resulting in a cluster of texts and/or images, such as the "Lord, help" cluster at Santa Chiara alle Petrose [**143.A–C**]. The original act might have witnesses, like the two priests and another cleric recorded in a single incision at San Marco in Massafra [**66.H**]. In comparison with painted or carved texts, graffiti are more likely to contain hortatory injunctions that the reader pray for the author.[199] The accretion of graffiti within a defined area thus constitutes a ritualized (because repetitive) series of individual symbolic actions. These texts should not be understood as acts of vandalism, like much of modern graffiti, but rather as performances that demonstrate a devotee's desire to inscribe himself into the fabric of the church and sometimes into the very body of a holy figure [**Plate 10**].[200] Incising letters or images at a potent

site is a way to create individual memory and inspire collective piety, even if it ensures neither.

Pictorial graffiti are found all over some—but not in all—Salento churches, sometimes prominently and other times in secondary spaces. They often take either a human or animal shape—hunters, riders, horses, birds, faces—or are symbolic abstractions such as crosses, stars, knots, circles, rosettes, shields, ships, and outlines of shoes. Many of these are potent *apotropaia* and are discussed in Chapter 7; shields index status and were addressed in Chapter 4. Ship graffiti have been widely interpreted in other regions as prayers for a safe voyage or ex-votos for a completed one.[201] I see them less as indicators of a sea voyage than as general mnemonics for travel, actual or metaphysical. Early Christian exegetes had likened the church to a ship; this ship would carry the saved to heaven, a conceptual voyage requiring no connection to an actual one. It seems likely that an etymological play on the Greek word for "ship," ναῦς, and the part of the church accessible to the laity, ναός, was familiar and intentional (the "nave" pun works in English, too). Shoe or sandal prints sometimes figure prominently among church graffiti, as on the left doorjamb of Santa Maria di Aurio [**60.pg**], the San Cesario di Lecce sarcophagus [**108.pg**], and numerous, probably early modern, examples in the loggia of Santa Maria di Cerrate [**114.pg.4**]. This image derives ultimately from Exodus 3:5, when Moses was instructed by God to remove his shoes on holy ground; it may even be an abbreviated *locus sanctus* image connoting Mount Sinai, where that meeting took place, and thus elevating the humble Salento churches as similar *loca sancta*.[202]

Only rarely are pictorial graffiti incised into narrative scenes. An example is the tiny archer and lancer who attack a painted lion and elephant that are among the animals gathering before Saint Blasios in his homonymous crypt church at San Vito dei Normanni [**109.pg**].[203] This seems at first a case of an individual (or two) wanting to insert himself into the sacred scene, perhaps to receive the blessing that the saint imparts to the animals. However, it must be said that the incised figures attacking the creatures are more in keeping with normal human activity and not at all akin to what Blasios is doing.

Most often, figures and even scenes are scratched into the lower zones of panels containing icons of individual saints. At San Nicola at Mottola, Saint Peter's feet attracted quadrupeds, a horse and rider, and perhaps a wolf [**76.pg.1**]. At the nearby Santa Margherita, John the Evangelist's panel has been incised with a helmeted, short-skirted figure near a long-eared rabbit (?) and a five-pointed star [**75.pg**]; one scholar considers this a scene of liberation from demonic possession.[204] Across John's waist is a birdlike serpent or a serpentlike bird. In these cases we should probably assume that the images had meaning for

their executor, although the significance may have been less iconographic than spatial: regardless of its particular form, an image incised on a saint probably was considered potent. They may also be playful, and play was another activity that took place in churches, as noted above.

A considerable number of pictorial and textual graffiti lack a specific sacred support and are incised into bare walls devoid of sacred imagery. These incisions speak to the sacred potential of the church space and probably should be associated with its titular saint even if a painted image is lacking. The numerous incisions into the undecorated walls of the rock-cut Santa Lucia at Palagianello indicate that it was a numinous site [**94**]. Something powerful must have happened there for so many graffitists—using both Latin and Greek—to want to insert themselves into the fabric of the church.

In a number of cases pictorial graffiti are combined, seemingly indiscriminately, with textual graffiti. At Santa Maria di Aurio near Lecce, the limestone columns are covered with both kinds, as is the west wall and one of the doorjambs [**60**] (graffiti are preserved under a partial sixteenth-century fresco layer, which provides a *terminus ante quem*). Among the images here are the sole of a shoe, a profiled figure with a shield, five-pointed stars, a nimbed head of Christ, a helmeted figure and helmeted heads, a striding figure, ships, a figure with a lance facing a sea creature, a urinating figure, and several crosses. The verbal graffiti are short words or abbreviations in Greek. Such highly individualized expressions presumably had meaning to an individual and his immediate audience but may not have been comprehensible thereafter. Nor did the presence of preexisting graffiti slow the addition of later ones: it was the act of incising one's identity into the church that was important, not legibility or preservation.

Some pictorial graffiti almost certainly had "magical" significance; some were widely used symbols; others may have made sense only to the person who incised them. Textual graffiti could work in these ways too, but they also had the potential to be included in repeated invocations: like painted texts, the incised words were more durable than spoken prayers. Despite the occasional graffito of Christ or a bishop [**114.pg.1**], it is unlikely that pictorial graffiti were intended to be either focuses or records of prayer. It is also difficult to imagine weapon-wielding figures, quadrupeds, or parallel lines as testimonials of devotion. Similarly, while many textual graffiti take the form of an invocation identical to that used in more formal texts, others are random words or abbreviations. Some, like the archer at San Vito dei Normanni [**109.pg**], should be seen as conscious distractions, reminding us that pious devotions were only one of the reasons people went into a church in the Middle Ages. The church was a site where the living and the dead, the profane and the sacred, could coexist and interact. It was the place to go for help of all sorts, including distraction from the realities of medieval life. I do not

think that anyone attending mass carried a compass and spent time drawing rosette circles; rather, one could enter the church at other times and produce one's very own visual relief—even a urinating figure at Aurio.[205] Physical, spiritual, and social relief were all reasons for going to church and enacting collective and individual rituals therein.

Rituals and Practices at Home and in the Community

Beyond the rituals associated with the life cycle and places of worship, people in the medieval Salento regularly performed other activities in their communities and homes. Taking as a point of entry words, images, and artifacts included or alluded to in the Database of texts and images, I consider in this chapter rituals and practices that were specific to the Salento. I begin with those repeated public activities that are connected to the seasons of the year and the calendar, in which many agricultural activities, processions, and fairs were linked to specific saints' days. Many of these began or culminated in churches, because the worship space was a (and often *the*) center of medieval communal life, social as well as religious. Exorcisms and blessings performed outside the church or synagogue form a bridge between public and private, as some of these had large, public audiences while others were for individual ailments and took place in the home. Within the domestic sphere, a concern for physical health can be extrapolated from some of the material and visual evidence, and food, bathing, and personal protection through material and oral means are examined through this lens and others. The chapter ends with a consideration of the region's aural environment insofar as that can be known from local texts. Local traditions created a visual and environmental framework for images and inscriptions and helped reinforce a moral framework as well.

A significant methodological difficulty in this chapter is that while many rituals are considered "ancient" by their practitioners and viewers, they actually date only to the early modern era or even later. This is the case for some of the best-known and most colorful local festivals, such as that of the Perdoni at Taranto, who parade between selected churches, hooded and barefoot, on Holy Thursday.[1] I discuss here only those civic and domestic rituals and practices that have a good chance of antedating the important changes introduced during the period of Aragonese rule (fifteenth century) and especially the even more sweeping changes

that followed the Council of Trent, including the establishment of numerous Marian sanctuaries.

Civic Rituals and Cosmic Concerns

Many of the practices discussed in this section are connected with what we might call communal health, rather than individual physical health addressed later. Communal well-being depended largely on good weather—on an absence of environmental calamities and presence of good harvests—and on such ritualized behaviors as processions, bonfires on certain saints' days, public exorcisms, and the proper foundation of places of worship and charitable institutions. The seasons and the calendar provided regular occasions for public gathering, often in the form of fairs and processions. These always involved some kinds of ritualized actions, such as regular starting and ending points, prescribed paths or props, and repeated behaviors. Such occasions brought individuals together into a temporary community and often buttressed episcopal or clerical control. All of these attempts to regulate time and space served to manufacture community identity and maintain both public and cosmic order. The medieval universe was an interconnected whole, animated not only by God, angels, and saints but also by demons and spirits. All parties had to be placated.

The Seasons

The medieval seasons are evoked in the mosaic pavement of the Norman cathedral at Otranto [**86.A**] under the familiar, Europe-wide schema of the labors of the months. At Fasano, north of the Salento, these labors were painted, with Latin labels, in the narthex of the San Giovanni crypt church.[2] They were a visual means of enshrining the cyclic, divinely ordained passage of time and are a good illustration of how even medieval urban time was bound up with—indeed, dependent upon—agrarian activities. At the same time, the changing months and seasons were intimately linked with relevant feasts or saints' days (or, for the Jews, Torah readings and festival-specific activities). Proverbs that date back at least to the early modern era enliven this passing of time.[3]

The experience of time according to the rhythms of nature is not identical to the manmade calendar, but there are significant overlaps. Winter began with All Saints' Day (November 1): "de Ognissanti, cappottu e guanti" (from that day, coats and gloves are needed). You must "simenta alli campi," plant every field, because by Saint Martin (November 11), "lu jernu è vicinu," winter is near, and on Saint

Catherine's Day (November 25), "la cisterna è cchina," the cistern is already full of rain. Winter continued through Saint Nicholas (December 6), Saint Lucy (December 13), "la cciù ccurta dia," the shortest day of the year, and on past Christmas to Saint Antony Abbot (January 17), with "lampi e trroni," lightning and thunder, marking the start of Lent. By Candlemas and Saint Blasius (February 2–3), "ddo' ure quasi," the day has grown longer by nearly two hours, and therefore "la marenna trase," one stops work for a snack. Eight months later, at Saint Luke (October 18), "la marenna è pperduta," the days are short again and the snack break is lost.

In what we would call spring, feast days included Easter, Saint Vincent (April 5), Saint George (April 23), and the translation of the relics of Saint Nicholas (May 9). Spring was a difficult season for peasants because so much of the rest of the year's well-being depended on it: "Tre sono i nemici del contadino: marzo, aprile e maggio" (the three enemies of the peasant are March, April, and May). On Saint Vitus's Day (June 15), "ogni fica ole 'mbruficu" (figs start to ripen) and "se chiòe de santu Vitu, lu mieru è fallitu" (if it rains on San Vito, the wine is ruined), and other crops, too: "acqua de giugnu rruvina lu munnu" (June rain ruins the whole world). The solstice falls around John the Baptist's feast day (June 24); Saint Anne's Day (July 26), marked the height of summer, and "Sant'Anna l'acqua è mmanna" (in late July, rain is like manna from heaven). As another proverb says, "San Vicenzu, fioritura; san Larenzu, cran calura: l'una e ll'àutra picca dura" (flowering on Saint Vincent, great heat on Saint Lawrence [August 10], but neither one endures). At Saint Matthias (September 21), the days and nights are of equal length ("tanta la notte quanta la dia"). In September, "ua e fica penne," the grapes and figs are hanging low, and the grape harvest begins. If you fail to plant by Saint Luke (October 18), you won't be able to feed yourself ("De San Luca, ci nu simmina nu manduca").

In Brindisi, where his relics were venerated beginning in the early thirteenth century, Saint Theodore (the Recruit) was twice feted and doubly associated with the change of seasons: "San Ghiatoru d'Ogni Santi, leviti lu suttili e mittiti lu pisanti; San Ghiatoru di aprili, leviti lu pisanti e mittiti lu suttili" (on Saint Theodore, during All Saints' Day, take off the light clothing and put on heavy garb; in April, do the reverse).[4] In the premodern era there were only two seasons for clothing, not our four. Interestingly, there is no "official" veneration of Theodore in April in either the Roman-rite or Orthodox calendar; the proverb preserves a local tradition that Theodore's relics were translated from Euchaita to Brindisi on April 27, 1210.[5]

Another saint is unexpectedly associated with summer: "De santa Esterina, la vigna è cchina" (from July 1, the vines are full). A Saint Esterina is unknown in medieval Orthodoxy or Catholicism; this diminutive of Esther belongs exclusively

to Judaism and commemorates the savior of the Jewish people on the Purim holiday, which occurs in the spring, a month before Passover. How did she appear in the Salento? The name, along with a holiday called the "Fast (or Festival) of Esther," is well attested among crypto-Jews in Portugal and the American Southwest. These emigrés brought memories of the Jewish Esther with them upon their expulsion from Spain, and they still maintain some of the penitential practices associated with the long-ago Jewish queen.[6] Presumably the local proverb preserves a distant memory of a crypto-Jewish presence that accords perfectly well with the number of forced conversions known to have taken place in the region in the course of the medieval centuries. Unfortunately, there is no good answer to the question of why "Esterina" was moved to July. Possible associations with Mary Magdalene (July 22 in the Roman calendar), due to shared penitential practices, are known only from distant contexts, and any links to the Orthodox saints commemorated on July 1, the holy healers Cosmas and Damian, are still more far-fetched.[7]

Judeo-Italian proverbs link the changing seasons with the Torah readings. Thus on "Vaiachel gava l'mantel, Pikudey turnlu a buté": over a span of two weeks in March, or only one week if the two Torah portions are read together, one goes from wearing a mantle to discarding it.[8] The Jewish calendar is very attuned to the seasons, with Passover in the spring and the archetypal harvest festival, Sukkot, in the fall. According to Numbers Rabbah, a medieval midrashic collection, Nissan was the most suitable month for the Exodus from Egypt because it was "neither too hot nor too cold, nor a rainy month."[9] Although the evidence for local Jewish attitudes is hardly plentiful, there is no doubt that Salentine Jews were just as aware of the seasons as their Christian neighbors and just as dependent on their predictable occurrence, even if they tied them to a different set of names.

The Calendar

Calendars conceptualize time according to traditions invented for measuring it. They are not fixed: the Gregorian reform of the Julian calendar in 1582 is the best-known large-scale change, but there were also less sweeping emendations and variations. In the Salento, at least three calendars were in use, distinguished by when their years officially began: January 1, according to the Roman rite (but adopted in the Orthodox typikon of Bova Cathedral in Calabria in 1522), September 1 for the Orthodox, and sometime in the fall (Rosh Hashanah) for the Jews.[10]

The Jewish calendar adds an extra month when necessary, holidays have extra days outside of the land of Israel, and consistency within the Jewish calendar meant that the relationship of Jewish feasts to the secular calendar used by non-Jews changed annually (and the medieval Karaite and Rabbanite calendars dif-

fered).[11] But even within the Jewish world, methods of dating used in the early medieval Salento differed from those employed elsewhere. A Hebrew tombstone in Brindisi [**16.A**] and contemporary examples from Venosa (822) and Matera (830) give the date of death in years since the destruction of the Temple, rather than since the creation of the world.[12] A manuscript copied in Otranto in 1072/73 also uses the destruction of the Temple as a distinctive point of reference.[13] No other regional Jewish community seems to have used this formula, and it is tempting to connect its use with the desire to maintain ties to ancient Palestine and the memory that the Jewish communities in Italy traced their origin to the Temple's loss and forced resettlement by its Roman destroyers.

Shabbetai Donnolo of Oria produced a unique calendar in the form of a complicated astronomical table. It is dated 4706 years postcreation, according to Palestinian (not Babylonian) custom. The calendar compares a Jewish lunar month in the year 946 with its Julian, Persian, and Egyptian equivalents and also includes days of the week, planets, and the zodiac. Donnolo calls this month Elul, but in rabbinic calendars elsewhere it is known as Tishri; in addition, it is one month behind those other reckonings. This may indicate an attempted local correction for the very early date of Passover that year (March 21), before the spring equinox.[14] Despite the claim of the great Saadia Gaon in the 920s that the Babylonian rabbinic calendar was being universally followed, this was not true in tenth-century southern Italy.[15] Shabbetai Donnolo engaged in astrology as well as astronomy; his *Sefer Hakhmoni* is a commentary on the *Sefer Yetzirah*, a late antique mystical text.[16] The eleventh-century *Chronicle of Ahima'az* deals matter-of-factly with stars, prognostications, and esoteric practices. In terms of the calendar, it records that on one occasion, the most precise calculation of the new moon was done not by the author's ancestor, a Jewish sage in Oria, but by the local bishop, probably Theodosius [**83**]. The calculation seems to have been accomplished by means of rooftop observation.[17] While the ritual of announcing the exact time of the new moon's appearance continued in the synagogues of southern Italy, the eventual standardization of the calendar meant that direct observation was no longer necessary.

Calculating the division of days into hours was done with the help of a more permanent device. The stone sundial displayed on the south exterior wall of Santa Maria della Strada at Taurisano is the sole surviving regional example of this visual tool [**145**]. The Greek inscription "The hours of the day" refers to the liturgical hours of the Roman rite, but indicated here by their initial letters in Greek. However, both the inscription and the letters seem to be have been added (paleographic analysis indicates a fourteenth-century date); the original sundial simply had six

lines to indicate the solar hours. No doubt such sundials were more common in the medieval cityscape than is evidenced by the rare survivors.

Attempts to standardize the Christian calendar in Italy did not occur until the Council of Trent and the institution of the Congregazione dei Greci (1573), which was supposed to expunge calendrical and liturgical "abuses" by the Orthodox and Albanian communities in southern Italy.[18] The Spanish archbishop of Otranto insisted in 1580 on the need to "levar via questi abusi dei quali è infettata tutta questa mia diocesi."[19] Prior the sixteenth century, and to some degree thereafter, variations abounded. Leandro Alberti, a Dominican who visited the Salento in 1525, noted that the feast of Saint Philip the Apostle was being celebrated there in November rather than in May—in other words, according to the Orthodox rather than the Roman-rite date.[20] Days on which saints were venerated might distinguish local religious communities, but nothing kept an individual from participating in multiple public festivities, just as nothing kept a patron from financing prayers on his behalf by monks using a different language [e.g., **114.E–G; Plate 15**].

The medieval Christian calendar in the Salento included days in honor of saints absent from the religious calendar of other nearby regions. In addition to different feast days observed by the two Christian denominations in the Salento, local Greek liturgical manuscripts preserve several feasts that do not find corroboration elsewhere in the Orthodox world. The North African hieromartyr Maurus and his companions (May 1), the Apulian or Lucanian martyr Vitus and his companions (June 15), and the Madonna della Neve (August 5) are recorded in the rare texts that still survive in Galatone.[21] Of these, Saint Vitus was the most popular pictorially, usually shown with his dogs because he protected against bites. He is the central figure in the Buona Nuova triptych at Massafra [**62.st**]. Vitus was also venerated at San Vito del Pizzo, an important Orthodox monastery near Taranto known since the twelfth century (its abbot is cited in [**144**]), and was the name saint of many other churches and towns, including San Vito degli Schiavoni, later renamed San Vito dei Normanni [**109**].[22] From a calendrical perspective, Vitus's feast day marked the first maturation of local figs (*culummì*) and, later, olives.[23]

A liturgical service for Saint Francis is found in a fifteenth-century manuscript in Galatone. This akolouthia was to be sung at the end of vespers on October 3, the eve of Francis's feast day, and again at matins on October 4.[24] The Franciscans had been installed nearby in the church of Santa Caterina at Galatina since the late fourteenth century [**47**], and Francis is depicted there and elsewhere, always identified in Latin. At Minervino, where in 1577 both rites were still being celebrated,[25] the church of Santa Croce preserves the inscription ΦΡΑΓΚΙCΚΟϚ, the saint's Latin name rendered in Greek letters; the painted saint himself is lost, but he was juxtaposed to a still-extant Saint Peter. The most recent study assigns this diptych to the end of the thirteenth century on stylistic grounds, but I would date

it slightly later.[26] The Minervino image thus reinforces the manuscript evidence for the acceptance of Saint Francis in the Salento's Greek-speaking milieu.[27] Other saints depicted in local frescoes—Sabinus of Canosa, Orontius, Cataldus, Nicholas Pellegrinus—must have had corresponding local commemorations and most likely entire feast days. All of these probably saw the saint's image carried through the public space, as is still done today.

Among the most characteristic public rituals of the Salento are those that involve fire. As noted in Chapter 6, many communities today build enormous pyres for the feast of Saint Antony Abbot (January 17), and wall paintings of the saint occasionally include a small fire. The bonfires are known locally as *falò* or, in the Lecce dialect, *focara*; the plural, *focareddhe*, is used when multiple bonfires are lit throughout a town, as in Gallipoli since at least the sixteenth century. On January 31 in Grottaglie, an image of its patron saint, Cyrus, is burned "alive" atop a pyre; the following day, a different statue of the saint is processed through the town.[28] Such fire-related spectacles have roots in antiquity and lack unambiguous attestation in the Middle Ages. They are believed to have a purgative effect on the community, providing participants an opportunity to burn old habits, figuratively, and usher in the new season of Lent while keeping warm with their neighbors in the dead of winter.

Processions

Processions are a form of collective prayer that bring a community together, and such prescribed activities as processing through a town or landscape toward a particular destination would help integrate local spaces into cognitive maps. Even processions undertaken at irregular intervals or ad hoc create communal memories that can be passed down through generations.

Churches regularly served as the starting point for processions held on important Christian feast days or episcopal inaugurations. One such event was the installation of Bishop Theodosius of Oria in the ninth century; when he wagers the date of the new moon with the Jew Hananel, he offers the horse and its trappings, worth an extraordinary three hundred pieces of gold, that had been used on the day of his episcopal elevation.[29] This bit of realia in the *Chronicle of Ahima'az* indicates an outdoor processional extravaganza—one that probably would not be repeated with a Jewish protagonist even though, in this version, God helped Hananel win the bet. A few centuries later, in Brindisi, another episcopal parade on horseback was initiated. This was the *cavallo parato* procession held on Corpus Domini, sixty days after Easter, during which the archbishop rode along the principal city roads on a caparisoned white horse, displaying a monstrance while pious laymen held a silk textile over his head.[30] The horse went into the sea, in imitation of the city's

reception of Louis IX, who had landed at Brindisi after being released by Saladin and whose chaplain handed the then-archbishop a consecrated host. Supposedly inaugurated in 1264 along with the Corpus Domini feast, this urban procession brought blessings to the city and its inhabitants while simultaneously reinforcing its ties to the sea.

Other processions involved carrying candles in public as well as in churches. The feast of Epiphany (or Circumcision) on January 6 was still known in the mid-twentieth-century Salento by the Greek term *ta fota* (the lights).[31] *Hypapante* (Latin Candlemas), celebrating Christ's Presentation in the Temple and the Virgin's purification (February 2), marked the public celebration of individual women's churching and was marked by candlelit processions of white-clad women [cf. **Plate 13**].[32] The thirteenth-century manuscript written by an Orthodox priest in Taranto that told us about local marriage customs also describes the end of the Easter vigil. Individual candles were lit from the one carried by the priest and everyone processed around the church, chanting, until the Gospels were read and the resurrection proclaimed before the church's closed doors. The celebration then continued both inside and outside the church with an "uproar" much criticized by the non-Orthodox viewers.[33] In sixteenth-century Galatone, there were still several annual processions in which Orthodox priests blessed the local Catholic population before retreating inside the church.[34]

Statues, icons, and relics would often be processed between churches, as attested in the vita of Saint Nicholas Pellegrinus (d. 1094):

It was in fact the habit of the citizens of Otranto to transport the image of the glorious Virgin in procession from church to church, with psalms and hymns asking pardon for one's own sins and everyone else's. One day, while the litany was being celebrated and the saint followed the processing singing "Lord have mercy" with the others, he met an old man and, turning toward him, said "Hello, my brother and lord, formed by the same maker," and he embraced him. The people around him said, "Look, you addressed and hailed a Jew!" And placing him [the Jew] before the image of the Virgin Mother of God they said to him, "Father, adore our Lady Mother of God." But he did not condescend to do so. And after they mistreated him they said, "Adore, father!" To which he responded, "I do not wish to adore her." After receiving many blows from them, he unexpectedly rose from the ground and began to sing the hymns and render praise and grace, raising his eyes to heaven he said, "Glory to you, Lady, glory to you, Lady of the world and queen, because of your excellent name and your glory, today my soul is glorified."[35]

There are several points worth making here. First is the evidence for portable icons and urban icon processions at a relatively early date, if we accept the hypothesis that these began in Constantinople only in the eleventh century.[36] Second, although there are no extant portable Hodegetria icons in the Salento contemporary with this text (icons of all periods are scant), there is a relief example in Trani that bears the name of a Byzantine official known in 1039.[37] Third, the old Jewish man who is initially mistreated and then, because this is a hagiographical text, converts under pressure, was out in public during the Christians' religious procession. Even if specific details have been invented, they could have resonated with listeners or readers as true (or possible) events in the saint's life only if this were the normal state of affairs.

Even Jews who were not directly objects of processional scorn were certainly aware of such processions and considered them idolatrous. A mocking poem written in Rome in the eleventh century surely represents the opinions of Jews elsewhere in Italy as well:

> The idolaters kneel and bow down even as they stumble;
> Destroy the platforms of the idols and bring dread to their palaces;
> They have gathered to place the statue on their shoulders;
> They carry it, since it cannot walk.[38]

Such processions of statues still take place in the Salento, although these are less well attended than in the past.

The church of San Pietro in Bevagna (rebuilt in the fifteenth century) was the starting point for a procession to pray for rain. Participants walked almost a dozen kilometers to the cathedral of Manduria bearing a miraculous statue of Saint Peter and images of other patron saints, as well as tree branches or even entire trees; formerly a crown of thorns was carried as well (now they carry crosses and heavy stones). These were supplemented by small family or neighborhood altars. At rest stops, bread and water that had been blessed was distributed. An image of the Virgin Immacolata was introduced in the seventeenth century, but the icons of Saint Gregory and Saint Peter are part of an older tradition; they remained in Manduria only until the drought ended.[39]

Jews had outdoor celebrations, too. The prince of Taranto, Philip I (son of King Charles II of Anjou), forbade Christians in Corfu from interfering in the ones that émigré Apulian Jews were holding there. This privilege, probably issued in 1324, was confirmed in 1338 and again in 1370/72.[40] In the Salento itself, even the anti-Jewish Franciscan preacher Roberto Caracciolo specifically stated in the 1490s that Jewish feasts, ceremonies, and Sabbath observances were to be respected.[41] However, even the most public of Jewish festivals in Italy did not include a civic

procession. On Hanukkah, Italian Jews were enjoined to advertise the miracle by lighting lamps or candles, increasing in number each night of the holiday, outside the entrance to the house or visibly in an upper window, although in times of danger it was sufficient to place the light on an interior table.[42] On Purim, there were audible sounds of merriment and a distribution of charity to the poor in the form of money and food, described by the author of *Shibolei ha-Leqet* as "a custom in our place."[43] We have no specific information about Salentine practices on Purim, so it is impossible to say whether this so-called "Jewish Carnival" witnessed the kind of interfaith violence attested in other places beginning in the fifth century.[44]

Pilgrimage

Pilgrimage is a special kind of procession. Certainly the medieval Salento was implicated in long-distance pilgrimage to the Holy Land through its principal ports, first Otranto and later Brindisi, although the Italian notary Nicholas de Martoni arrived via San Cataldo, the port of Lecce, in 1395.[45] Hospitals specifically for pilgrims, run by the Teutonic Knights and the Hospitallers, are attested at Brindisi, Taranto, and possibly Ostuni.[46] Hospitals were also located adjacent to the two principal pilgrimage sites in the Salento: Santa Maria di Leuca at the tip of the peninsula, also known as "Finibus Terrae," and Galatina, which drew visitors particularly in late June in honor of Saints Peter and Paul (like Leuca associated with healing rituals). Indulgences were awarded at both sites.[47] The smaller village hospices at Andrano and Fulcignano, known from material-culture evidence rather than texts [4, 46], are unlikely to have hosted pilgrims in significant numbers.[48] That eventually there were one or two such establishments in every village and town is suggested by textual evidence for Martano from the beginning of the sixteenth century.[49]

Evidence for long-distance pilgrimage by individual residents of the Salento is scant; a single scallop shell and two ampullae are suggestive, but not indicative, of travel to Compostela. It is likely that some residents paid their respects to Saint Nicholas in Bari and some probably went as far as Saint Michael's sanctuary in the Gargano, but most pilgrimage was regional or even more local. Those afflicted with epilepsy or other nervous disorders traveled to local sites, such as the chapel of Saint Donatus at Montesano (literally, "healthy hill"), where in early August they could join a community of fellow sufferers.[50] The medieval sanctuary of Saints Cosmas and Damian at Oria, known as San Cosimo alla Macchia, is still an object of regional pilgrimage. It has visible medieval substructures and a notable collection of postmedieval ex-votos.[51] But it is important to recognize that as recently as fifty years ago, very few inhabitants (and almost no women) of the village of Calimera, in the Grecìa salentina, had gone as far as the provincial capital in Lecce,

only fifteen kilometers away.[52] Even regional pilgrimage must have been quite exceptional in the Middle Ages.

Commercial Gatherings

It was not uncommon for people of diverse social levels to travel for commercial reasons, especially because large-scale gatherings for this purpose were invariably linked with the Christian calendar and places of worship. Regional fairs and markets were scheduled to convene throughout the year outside cathedrals, monasteries, or smaller churches. They are attested at Brindisi, Taranto, and Corigliano in the later thirteenth century, and additional fairs at Brindisi, Taranto, and Lecce date to the fourteenth or early fifteenth century.[53]

"La Paniera" is the name of the fair held at San Pietro in Bevagna for three days at the beginning of April, presumably the one recognized in a royal decree of 1414.[54] The term *paniera*, denoting both a market and a religious festival, is derived from the ancient Greek πανήγυρις (*panegyris*) via Byzantine πανηγύρι; it is also used in the Salento and elsewhere as a toponym for sites that hosted such activities.[55] Thus, at Castro, "Lu Panaru" is still the local name for an area that hosted a festival of the Virgin as late as the fifteenth century, and Grottaglie's enigmatically named Lama "di Pensiero" [53] may be a distant echo of the same word.[56] Major fairs could attract a large clientele from quite far away and were significant sources of revenue for the church, monastery, or community that was permitted to host them tax free. According to legislation issued by Maria d'Enghien of Lecce around 1400, these fairs began either at the thirteenth hour or at sunrise and finished at midnight.[57]

In the fifteenth century, Taranto had three fairs per year, of which two were certainly medieval: in 1234 Frederick II inaugurated the event that lasted from August 24 to September 8; another, from April 26 to May 4, began under Ladislao of Durazzo in 1407.[58] The latter ruler established four fairs at Lecce, in April, June, August, and November, supplementing the smaller weekly markets.[59] These were exempt from taxes for the first four days, but lasted seven days in all.[60] A fair inaugurated at Santa Maria di Cerrate in 1452 was later moved to outside the walls of Lecce. At Brindisi, the fair in honor of Saint Leucius is attested by 1264; it lasted for eight days in late April and early May [25]. King Robert of Anjou later granted permission for two more eight-day Brindisi fairs, one sixty days after Easter (on Corpus Domini) in front of the cathedral and the other six months later on the feast of Saint Antony Abbot.[61] Smaller fair venues included Corigliano, attested in 1275–77, and the aforementioned fair at Bevagna, near Manduria. There were

weekly markets at Soleto on Tuesdays and at Sternatia on Wednesdays, and the latter also had three *panieri* on certain saints' days.[62]

There was a clear concentration of fairs, including both the principal regional ones and more local secondary fairs, in the spring (April–May) and in January.[63] The January fairs clustered around Saint Antony Abbot's feast day, appropriate because of his association with pigs and their winter slaughter and also because the great bonfires in his honor were already occasions for communal gathering. The April concentration corresponded roughly with Saint George's Day, April 23, and the Greek γεωργός (*georgos*) means "farmer" or peasant, which is an indication of one of the principal functions of these community events: the sale and acquisition of agricultural surplus, coupled with the return of the flocks and resulting production of cheese.[64] On Saint George's Day in early medieval Corigliano, there was a communal blessing of cows at the local monastery.[65] A Greek euchologion copied around 1320 contains two prayers for the weighing of cows that may have been used in this ceremony.[66]

Churches and Other Foundations

One type of personal or communal devotion that was always accompanied by public ritual was the consecration of churches, synagogues, and hospitals. Churches and chapels had to be consecrated by a bishop who placed the necessary relics within or under the altar, as indicated in a dedicatory text for the altar of the main church of Ceglie, which contained relics of three saints [38]. In the Orthodox rite this was done by washing, anointing, censing, and prayer; a procession of relics translated from a nearby church on the following day constituted the inauguration (ἐγκαίνια). In chapels of the Roman rite, the relic procession preceded the consecration, which was effected by anointing the altar or pavement at key points marked by painted crosses.[67] Regardless of rite, the relics procession surely attracted more than just the founder's family and the relevant clergy.

A long incised graffito next to the Virgin and Child on a pier at Santa Maria della Croce in Casaranello records the consecration of that church in the late tenth or early eleventh century [33.D].[68] This is the only monumental record of an Orthodox consecration in the region. The event was performed by the bishop of Gallipoli and recorded by a participating priest named Akindynos whose "official" graffito is followed by a smaller and less elegantly incised one that marks the death of L(eon?) Kephalas and asks God to help him on the day of judgment [33.E]. André Jacob has proposed that Leon Kephalas—a person of note given the fact that he has a surname at this early date—was the consecrating bishop.[69] According to this convincing interpretation, the bishop's passing was recorded by local clergy

adjacent to the original notice because of the importance of his original action. The one Roman-rite church whose record of consecration is preserved announced the event in more monumental form than the Casaranello graffito. At Santa Maria del Galeso, two plaques on the west wall record that the archbishop of Taranto performed the ceremony in 1169 before the abbots of the three most prominent Orthodox monasteries in and around Taranto and the entire urban clergy [**144**].[70] Presence at the anniversary of the consecration earned the visitor twenty days of remission from penance; in 1215, the Fourth Lateran Council would increase that indulgence to a maximum of one year.

The preferred months for church construction, according to the very small number of public texts that provide this information, appear to be April [**1, 57, 154.A**] and October [**108.A, 109.A, 144**]. One of three altar consecrations also occurred in October [**38**]; the others were in November [**67.C**] and December [**67.B**]. August through October was a period of intense agricultural work devoted to sowing, plowing, woodcutting and fruit harvesting,[71] but by the end of that period patrons may have been eager to commemorate their successes with pious dedications. The long Greek graffito at Casaranello records the consecration of Santa Maria della Croce on the first of July [**33.D–E**], but this unexpected date falls at the peak of the grain harvest; perhaps the church was actually completed earlier or later. Dated paintings were added to existing churches in the months of February [**28.W**] and May [**32.A, 32.D**], and the ciborium at Santa Maria di Cerrate was completed in March [**114.C**]. While all of these activities must have involved more than a few individuals, the only church dedication for which we have information about a larger spectacle is Santa Maria del Galeso, where the Latin dedicatory inscription emphasizes that the ceremony took place in the presence of important Orthodox abbots and "all the clergy" of Taranto [**144**]. This surely implies a formal procession to the church in addition to the necessary rituals inside. For the hospital dedication at Andrano, one Orthodox and three Roman-rite bishops participated [**4.B**] and implicitly authenticated the penalties against alienation of the property fixed by the local bishop, Donadeus of Castro (known also from [**35**]). Again, a gathering of high-level ecclesiastics indicates a very public spectacle.

Towers [**30**], walls [**139**], and other prominent features in the urban landscape [**20**] often received prominent dedicatory inscriptions and may well have had some kind of formal civic inauguration. In a now-lost inscription that records a whole village being inaugurated, the local *vicarius*—a civic, not a religious, office— "marked out the chora as it should be built" [**48**]. Behind this simple statement is a series of actions, from negotiation with neighboring villages and individuals about borders to regular treks around the perimeter to confirm the boundaries and pass this knowledge on to future generations.[72]

One last foundation deserves special attention here, as it elides the difference between religious and secular in the urban space of medieval Brindisi. The original basilica dedicated to Saint Leucius there had an area identified as a "sanctuary . . . for those in peril" [25]. Under threat of the triple anathematization normally accorded heretics, pursuers were forbidden to penetrate this area. The basilica was razed in the early eighteenth century and the form and furnishing of this space of sanctuary are entirely unknown. The donors may have been Byzantines—her name, Thecla (Thekla), is Greek—and the epigraph is said by its early recorder to be composed of "caratteri, ch'in parte hanno del greco, dirozza, e male latinità" (letters that are partly crude Greek, and of poor latinity).[73] Even though the refuge was erected to ensure the salvation of a single family, their donation was recorded and activated in public.

The Lithic Landscape

While churches were larger and more durable than all other medieval village buildings, other tall structures probably served as additional visual and ritual focuses in the Salento. The numerous freestanding menhirs are located, for the most part, near churches, cemeteries, or crossroads [152]. They may have served as starting points or destinations for religious or other rituals, as sites of sanctuary, or as safe touchstones at spiritually dangerous intersections (crossroads were well-known venues for maleficent magic).[74] Despite a long tradition that identifies the Salentine stelae as prehistoric monuments, Paul Arthur has pointed out that none of them has ever been found in association with prehistoric artifacts and they are more likely to be early medieval ecclesiastical markers.[75]

In Martano, near Apigliano, there were formerly four such menhirs; now only one, known as San Tòtaru (Saint Theodore), still stands, at approximately five meters tall.[76] Other towns, or former towns, have one or two menhirs, usually three to four meters tall and with front and back sides oriented north–south and wider than the two short sides. The example at Trepuzzi is in the shape of a cross and cross arms are also preserved at Diso, raising the possibility that more menhirs originally had the form of monumental crosses.

One particular type of erect cross became a civic focus once a year. These "Osanna" or "Sannà" evoke the ritualized shout of praise that met Jesus upon his entry into Jerusalem. Outside the walls of Brindisi, a white limestone cross atop a Proconnesian marble column was erected near the original basilica of Saint Leucius, the city's legendary first bishop, where, on Palm Sunday, the Epistles and Gospels were read in Greek. When the deacon concluded the readings with "Hosanna," the faithful, throwing olive and palm branches, repeated "Sannà, sannà" before the procession returned to the cathedral, in imitation of Christ's

entry.[77] This cross column is probably the one now housed inside Santa Maria del Casale (just below **28.C**). A document of 1183 notes that on Palm Sunday at Ostuni, the clergy and faithful process with palm branches to "the Cross," apparently located outside the town's southern gate; the procession probably began and ended at the cathedral.[78] In this way, venerable (but probably not ancient) monoliths and biliths were incorporated into later medieval civic performances that created Turnerian *communitas* on a very local scale.

Other Communal Rituals

At Santi Niccolò e Cataldo in Lecce [**58**], the fourteenth-century frescoes of the life of Saint Benedict include a scene of the saint exorcising a cleric; a red demon emerges, arms raised in defeat, from the kneeling man's mouth.[79] While many exorcisms were performed more or less in private on behalf of individuals, others were done in public and for communal benefit. Evidence for these is mostly limited to marginal notations in service books. The best known of the communal exorcisms in Greek was associated with Saint Tryphon, who protected fields and gardens against noxious creatures. Surprisingly, evidence for local veneration of this saint is scarce and pictorial evidence nonexistent.[80] In the margin of a manuscript dated 1287 (Vatican City, Biblioteca Apostolica Vaticana, MS gr. 2383) is an exorcism for the protection of sheep, and two others (Milan, Biblioteca Ambrosiana, MS C 11, second half of the twelfth century, and Vatican City, Biblioteca Apostolica Vaticana, MS gr. 1276, first third of the fourteenth century) contain longer ones that invoke Saint Michael as *archistrategos* [cf. **43.A**] against damaging hailstorms. The latter manuscript describes the reality of such a storm in the voice of God: "What are you asking me, chief general? This mass of clouds is the distress of the earth and the crashing of the sky came on to earth and spread on the sky and contains moving fury and goes in order to obliterate lands and towns, to uproot vineyards, to change the course of rivers, move streams, cast out snakes, and crush the heads of birds." Michael begs God for mercy on behalf of humanity, and Elijah and Enoch are also invoked because neither suffered terrestrial death.[81] These exorcisms both conclude with references to the sun and moon standing still, from Joshua 10:12, a shorthand for divine might that is also very common in nonliturgical charms (one of these is discussed below).[82] Exorcisms like these were very likely performed in the countryside near the potentially afflicted fields and flocks, although they could also be performed in urban public spaces.

Outside Calimera, a chapel of San Vito erected in 1684 houses a much older pierced stone [**29**]. Only one person at a time can pass through its narrow aperture, but this ritualized activity could be done both privately and as part of a group. It

is included here because on the Monday after Easter, well into the twentieth century, men and women of all ages essayed the tight passage, which supposedly conferred health and, for women, fertility or easy childbirth.[83] Crawling may also have had penitential associations.[84] The timing of the ritual fits well in the Christian calendar with the connotation of rebirth after Easter, and a comparable rite was practiced on the same day at nearby Martano, where people passed through a forty-centimeter hole in a menhir also housed in a chapel.[85] In the open air, people and animals had been deliberately passing through stones and trees for millennia for all sorts of reasons, and Christian penitentials had long criticized them for doing so.[86] Similar stones are found around the Mediterranean and beyond.[87] While the now evanescent painting on the Calimera stone plays no role in modern devotions, it may have done so in the past: a notice from 1748 indicates that the chapel's "miraculous image of San Vito" was a goal of pilgrims from well beyond the village.[88]

There is an echo in the Salento of the ancient ritual of measuring something and making a donation of equivalent value. While most such activities are intensely personal and bring spiritual rewards to an individual, in some cases the practice could be more public. At Santa Maria della Strada in Taurisano [**145**], a text of 1711 notes that "anticamente"—long ago—the community used to donate a cord or sash embroidered in silk and gold (later silver) to the church. On the feast of the Virgin's birth (September 8), a corresponding length of cord made of red wax was used to encircle the church, after which the wax was divided among the priests (the source does not make clear whether the precious fabric was also shared).[89] This was all done "in signum protectionis B. Mariae," as a sign of the Virgin's protection and in commemoration of her having saved the church's founder, a luxury-goods merchant, from harm in 1008. By the nineteenth century, and perhaps earlier, this "prohibited" practice of girdling the church in wax was supplemented by a procession that involved a statue of the Virgin and the church's ostensible founder; the custom disappeared in the 1970s.[90] Communal donation of valuable wax complements the discussion in Chapter 6 about comparable donations inside places of worship.[91]

Finally, familiar rituals could also be pressed into service for extraordinary events, such as fierce storms, severe drought, plague, or an eclipse. Such embodied collective prayers, constituted as they were by local values, could bring hope to beleaguered communities. Jews had to be discouraged repeatedly from following the Christian practice of processing images in times of distress. Responding to a solar eclipse that was visible in Rome (and, obviously, in the Salento) in the eleventh century, Yehiel ben Abraham writes as if from the perspective of God himself:

Abhor the idols of the gentiles; do not envy them;

> Reject the habits of the nations; be joined in the fear of Me . . .
> Madmen and fools day and night act as if smitten
> And terrorized when the sun and moon change;
> Fear and tremble and be in awe of my name
> And do not dread the signs of the skies.

A Jew, he continues, must "put his faith in You and be blessed hereafter, rather than hope in a man like him [i.e., Jesus], splayed, a statue he carved from the forest wood."[92] Jews were to turn to the holy text, the Torah, and its almost-as-holy commentaries to find proof of God's love for his chosen people and to stimulate sincere repentance for whatever had brought about the disaster.

Domestic Rituals and Individual Concerns

There is considerable overlap between the public and private spheres of well-being and in some measure my taxonomy is merely convenient. In general, private well-being depended more on good health than on good weather. The rituals and practices addressed in this section are connected with individuals' desires to maintain their group identity or to ease, avert, and occasionally effect suffering. The methods by which these objectives were achieved span a wide range of local religious culture and supplement material discussed in the previous two chapters. Concerns for individual well-being were felt by Jews and Christians alike, resulting in a surprising number of common solutions to shared problems.

Local Religious Culture: A Definition

Not so many decades ago, "religion" and "magic" occupied very different conceptual categories; the latter was seen as primitive, popular, and superstitious, the former enlightened, elite, and "true." Today we recognize that such judgments, and the prejudices that underlie them, are etic constructions that depend entirely on who is labeling what. For the medieval period it makes sense to see "magic" simply as one aspect of "religion," or of the cultural and symbolic system of which religion is a part. Magic occupies space along a continuum of local religious culture that encompassed many different forms of piety by practitioners from different social categories. Consumers along the whole continuum believed that specific actions, utterances, and objects could effect solutions to their problems, and communities were united by such shared beliefs.

There was great debate in medieval Judaism about the magical end of the continuum. Rabbinic literature, following the Torah, proscribed a long list of objec-

tionable practices and practitioners, particularly sorcerers, but other practices that modern rationalists might label "magical" were deemed acceptable. Definitions of unacceptable magic changed depending on time and place. The Karaites were strongly opposed to what they viewed as Rabbanite magical praxes,[93] and Maimonides criticized Romaniote magical texts and all such customs. Yet even he was unable to eradicate the use of amulets and the conjuring of supernatural powers. In any case, the halakhic writings of Maimonides were not accepted in Italy until the 1290s, when his *Mishneh Torah* commentary became known, and the glossary composed by Judah Romano in the early fourteenth century shows that the text remained unfamiliar for decades.[94]

Christians, too, had a range of responses to local religious practices. As we have seen throughout this book, many practices were condemned at postmedieval diocesan synods as educated clerics tried to repress traditional behaviors and standardize church practice. And yet, the elite/clerical and popular/folkloric categories were fluid, not fixed; local clergy participated in both, and many practices transcended social categories. While so-called magical practices have traditionally been seen as part of the realm of "popular culture," many of them occurred in the "clerical underworld" that combined officially recognized religious practices with unofficial ones that might still be performed by churchmen.[95] There is no popular-elite dichotomy here, but rather local religious culture that involved individuals of all social levels. David Gentilcore's compelling analysis of a whole "system of the sacred" in the early modern Terra d'Otranto—in which both sufferers and practitioners combined magical, medicinal, and spiritual methods of attaining help—was no less true in the preceding medieval period, although our sources, as usual, are much more sparse.[96]

Ritual Bathing

After her menstrual period and following childbirth, a Jewish woman was supposed to observe ancient laws of ritual purity and immerse herself in a mikvah after sundown. Men could immerse at other times, and they did so especially before the Sabbath and festivals. No mikvahs from the Salento have been identified, not even in conjunction with the converted synagogues in Trani (although a vaulted space below the Scola Nova may have served this function [148]), but each community should have had a source of flowing water deep enough for full-body immersion. But as Isaiah of Trani complains in the first half of the thirteenth century, Romaniote Jewish women routinely undertook their immersions in the public bathhouse, if at all, with its "drawn" (pumped, not flowing) water. When a husband from Crete tried to enforce his wife's proper immersion somewhere else in Byzantine or formerly Byzantine lands, they were both criticized for not respect-

ing local custom. The sage became very angry and argued with that community—the men were in the synagogue and the women outside in its courtyard—until they acknowledged their error and agreed to excommunication if it should happen again. Other communities, however, refused to change their behavior, much to Isaiah's dismay.[97] When Obadiah of Bertinoro (near Ravenna) visited Palermo in 1487, he found 850 Jewish families and no one observing the purity laws.[98]

Some Romaniote women never immersed because "of the stink of the bathhouses," but the sea, which would seem an obvious option in much of the Salento, was also problematic if the women could be seen by fishermen and passersby.[99] They had to choose between modesty and purity.[100] If they immersed at all, most Salentine Jews probably used a local bathhouse. Jews could own baths (as attested in Naples in 1153), but we do not know anything about baths or their owners in the Salento.[101] At the end of the fifteenth century the fiery Franciscan Roberto Caracciolo was still criticizing Christians who took public baths together with Jews,[102] so the bathhouses must still have been functioning and Salentine women may still have been using them improperly.

Food

Chapter 5 considered the use of food in life-cycle rituals, so the focus here is on ordinary food consumption and its use in the construction of identity. Repeated legislation going back to the Justinianic Code stated that Christians were not supposed to eat with Jews (or bathe with them, or rely on their doctors); the fact that Roberto Caracciolo restates this in Lecce in the late fifteenth century probably means that it did occur.[103] Fra Roberto adds to his list of rules a personal insight: the wife of a Jewish doctor in Lecce had sent him some fat hens as a gift, but the hens stank so much when cooked that they had to be taken away.[104] Clearly this is a moralizing tale, but to resonate it had to be based in a reality in which exchanging foodstuffs was not unfamiliar.

Cattle, sheep, and goats were the animals raised most frequently in the Salento, followed closely by pigs.[105] Their slaughter for food and wool were seasonal communal efforts, standardized but probably not ritualized with accompanying words. Horses were butchered at Apigliano beginning in the Angevin period; the eighth-century papal proscription of hippophagy by newly converted Germans may never have been enforced in Italy. Horsemeat is still an Apulian delicacy.[106] Smaller animals, like the single hedgehog whose remains were found at Apigliano or the cat skinned at Quattro Macine, were butchered by individuals without reference to the calendar.[107]

If the Jewish home had long been understood as a smaller version of the lost Temple, the Jewish table was its miniature altar. Kosher dietary laws proscribed all of the meats just cited except for cows and caprines. Jews owned butcher shops in Lecce that served the whole city, selling animal parts not consumed by Jews to willing Christians (there is a butcher among the damned in the Last Judgment at Soleto [**113.B**]).[108] Maintaining the intricate laws of *kashrut* and of ritual slaughter was certainly important to learned medieval Jews. In the ninth century, Amittai of Oria wrote a *piyyut* about the fifth day of creation in which he includes the kosher dietary laws pertaining to fish and birds who were created on that day.[109] In the thirteenth century, Isaiah of Trani was asked to opine on whether the lungs of a just-slaughtered animal were *trayf* (unclean); he claimed that Elijah himself appeared in a dream to confirm his ruling.[110] But attention to *kashrut* "on the ground," by regular Jews, may have been less rigorous. For instance, following the Ashkenazic Pietist Eleazar ha-Rokeach, Isaiah of Trani ruled that kosher and nonkosher meat (or dishes) can be cooked together in communal ovens.[111] If this was the case in thirteenth-century Romaniote communities, then it is difficult to extrapolate from the incident recounted earlier in the *Chronicle of Ahima'az* that describes women in Venosa (northwest of the Salento) emerging from their homes with the long staves used for scraping their own charred ovens.[112] If communal ovens were in use, as they must have been in some places, they may well have produced both bread and matzo in the Easter-Passover period, in contravention of kosher laws. Bread baked by non-Jews was permitted as long as a Jew participated in the process,[113] but differences of opinion about consuming bread made by Jews and non-Jews are apparent in *Shibolei ha-Leqet*.[114]

The most contentious issue, for religious and economic reasons, was probably wine. As an essential component of Jewish religious rituals, wine had a sacramental status that was made more fraught because of its importance in pagan and Christian rites. Wine (or the grapes alone) had been produced or traded in the Salento by the early Middle Ages, as evidenced by seventh- or eighth-century grape seeds retrieved at Supersano, and evidence for its production and transport thereafter is abundant.[115] That Jews were involved in this activity is suggested by an eleventh-century bill of sale from Taranto in which a Byzantine man sells a plot of two vineyards to a Jew with a double Greek-Hebrew name.[116]

Obadiah of Bertinoro, writing in 1488, notes that "in all the communities that I visited, *except for Italy*, Jews are extremely careful to abstain from the wine of the gentiles."[117] He draws a clear contrast between practices in northern Italy, Rome, Naples, and Salerno and those in Palermo and the eastern Mediterranean. In Palermo the Jews "are extremely zealous and meticulous . . . in observing the

prohibition," and in Rhodes they "are as careful in abstaining from wine of the gentiles as they are in the avoidance of pork."[118] This begs the question of whether the Jewish Salento was more like Palermo and the eastern Mediterranean or more like Naples and Rome. Isaiah of Trani refuses to give a written opinion about "the wines of our kingdom," which suggests that he was aware of halakhic concerns.[119] One suspects that the Salentine Jews were not as strict as they should have been.

Protection for the Home

Some dwellings in the Salento were carved out of the soft local stone and were partly or wholly subterranean. Others, in the early Middle Ages, took the form of oval huts built on a wooden frame over a pit.[120] Rural built houses, such as those in the village of Apigliano from both the Byzantine and Angevin eras, were made of such perishable materials as unbaked brick and perhaps some wood; early houses had a straw or reed roof, while later ones were tiled. Each dwelling had a few meters of surrounding space for gardens, animals, and subterranean grain silos.[121] By the fourteenth century, single-story houses at Roca Vecchia were built of limestone coated with clay and had tiled roofs.[122] While some urban dwellings may have been more durable, not until the fourteenth or even the fifteenth century did stone replace earth as a widespread domestic building material.[123] The two-story stone house with a double-lancet window in which the Trani mezuzah nestled was exceptional; most medieval houses, like their occupants, were in desperate need of divine protection to withstand destructive acts of God and man.

They received this protection through several rituals that migrated from places of worship to homes. Houses were blessed by a priest during Epiphany and the Easter season, especially on Holy Saturday, by sprinkling each room with holy water. After the public distribution of holy water on Easter and following Orthodox blessing of the water on Epiphany, the liquid was conserved at home to bring domestic blessings throughout the year. Ashes from Saint Antony's public bonfire were used in the same way. In the Roman rite, prayers used when sprinkling a house with holy water were already combined with those for the sick by the ninth century.[124]

Jewish homes looked the same as those of Christians and in many places were interspersed with them, as Jacobus of Verona noted with surprise in 1346. Only in 1463, under the Aragonese king, were the Jews of Taranto compelled to live in a *giudecca*, a neighborhood of Jews, "and no longer live among the Christians."[125] It is difficult to know how many Jewish homes were identified by a mezuzah, as required by Jewish law, because textual evidence from Italy is lacking. In Ashkenaz,

Rabbenu Tam—who in the twelfth century knew that Apulian Jews felt that "from Bari comes forth the Law, and the word of God from Otranto"—stated that a decade before his time there were no mezuzot in northeastern France, but by his day there were some, and in the following century the sage Meir of Rothenburg was said to have twenty-four mezuzot in (and on?) his home.[126] Some Jews certainly had them, and one intact example has been preserved in Trani. The parchment, in a thirteenth-century hand, contains the required beginning of the *Shema* prayer (Deut. 6:4–9; 11:13–21) with the particular orthography recommended by Isaiah of Trani.[127] The text, wrapped in cloth, was enclosed in a hollow reed and placed, as prescribed, in a hole in the right doorjamb of the so-called House of the Rabbi opposite the Scola Nova synagogue [148].[128] This modest installation probably rendered the mezuzah invisible to the non-Jewish public, although if visitors regularly touched the area around the hole that might have inspired some curiosity by onlookers.

Crosses and icons served the same protective purpose on Christian homes, and Jews were aware of this: as one sage from Mainz said in the twelfth century, in "the lands of Greece they are certainly skilled [in idolatry], as they put [images/objects of] idolatry on all their gates, on all their doors, in their houses, and on the walls of their houses."[129] This seems to indicate that house exteriors were marked as Orthodox. By the thirteenth century, European Jews no longer saw Roman-rite Christians as merely unskilled in idolatry in comparison with Orthodox Christians; now, stated one of the teachers of Isaiah of Trani, the Roman Christians "do not adhere to idolatry" at all. This attitudinal change probably made Jewish figural art possible in Europe, even though the earliest extant example from the Salento is the Hebrew medical manuscript copied at Specchia in 1415.[130] It is impossible to determine whether Salentine houses revealed the Christian confession of their occupants.

The mezuzah was a mitzvah, a commandment, but both Jews and Christians also understood it as a kind of amulet.[131] The use of amulets and other apotropaia is uncontroversial in Talmudic Judaism as long as the amulets are "approved"; they need to have shown their value by healing three times.[132] Some mezuzot contained additional names of God or of angels on the exterior or even on the text side; others added graphic signs, like stars, although no such supplements were found on the example from Trani. All these additions were understood as affording the household extra protection from sickness (caused by demons) and death.

Protecting Bodies Through Artifacts and Signs

For Christians, life after the sin of Eve and Adam was full of pain and suffering that would only be fully alleviated in another world. In this world, responses to

individual illness and misfortune could be effected in manifold ways. As discussed in the previous chapter, saints were probably the first recourse for an individual in need, but if a particular saint failed to perform, devotion would be transferred to a different patron. Doctors were also available, if too expensive for most people, and so were hospitals; bloodletting is illustrated in the Jewish medical manuscript copied at Specchia, and there is skeletal evidence from Quattro Macine for the repair of a man's femoral fracture.[133] Shabbetai Donnolo was allegedly one of the four founders of the medical school at Salerno,[134] and his *Sefer ha-Mirqahot* (Book of Mixtures) is the oldest extant medical work from medieval Italy and the oldest Hebrew version of a Greek pharmaceutical text.[135] Nevertheless, recourse to physicians, veneration of saints, and participation in communal rituals did not obviate the possibility of employing additional material, symbolic, and oral aids in response to life's challenges. Doing so gave a seemingly powerless victim the ability to exert some control over his or her circumstances.

Some of the evidence for personal protection was discussed in Chapter 5 because defending mothers and newborns against the evil eye was of special concern. Texts make it very clear that fear of the evil eye transcended ethnic, cultural, and social differences, and a more limited selection of visual material bears this out.[136] The Wisdom of Sirach says, ὀφθαλμὸς πονηρὸς φθονερός: "the evil eye is caused by envy; it is envy."[137] One of the devil's motivations was envy, and in Greek βάσκανος was a term for the devil, homonymous with βασκανία, the evil eye. That the devil was present at the birth of Christ was a topos in Orthodox theology, and in the second half of the thirteenth century the Evil One suddenly appears in Nativity scenes in churches in Aegina, Crete, the Mani, and in San Pietro at Otranto, in the form of a barking dog with fangs bared at the right edge of the scene [**87.sc.2**].[138] We see here a visualization of the idea that even the Virgin and Child are in danger during childbirth and in early infancy, and in this context we should recall the circular amulet worn by the infant Christ at Mottola [**76.sc.1**] and also note the presence of another powerful protective sign, the cross, worn as an earring in a thirteenth-century image at Ugento [**Plate 17**]. In many later Italian images, the Christ child sports a coral necklace, thought to have a similar protective power [**118.st.2**; **61.sc**].[139]

The stylized eye pattern, enlarged to form concentric circles, protects Christian churches [**79.pg**] and tombstones [**2.A, 41, 99.A**] and also at least one Hebrew epitaph from Bari [**13**]. It had a widespread apotropaic significance that crossed religious lines.[140] Among other signs that resonated as apotropaia, the most prominent is the cross, incised in many Salentine sites [**70.pg, 94.F**] and painted or carved in virtually all Christian inscriptions. Less recognizable now is the use of red as a protective device—perhaps the reason so many painted supplicants are shown clothed in that color. One of the gravestones from Quattro Macine

[**99.A–B**] features a cross, circles, and red pigment for maximum protection. Some personal defenses against the evil eye were perishable and deliberately invisible (like cloth amulets, *brevi*, that contain exorcised salt and a bit of metal, worn hidden on the body); others were more durable and publicly visible. It is a mistake to dismiss belief in the *mal'occhio* or to underestimate its importance in medieval daily life. As Herbert Kessler recently argued, it should be "added to other medieval models of viewing art that existed side-by-side with it."[141]

For Jews, anything that successfully healed was not magic, not tainted as being among the forbidden "ways of the Amorites." According to rabbinic literature, amulets could be worn for help against the evil eye, demons, pirates, and robbers, and to protect against barrenness, abortions, and epilepsy.[142] Men, women, children, and animals either wore or carried them. In *Tanya Rabati*, the late thirteenth-century Italian abridgment of Zidkiyahu Anav's *Shibolei ha-Leqet*, the author, a Roman relative of Zidkiyahu, says: "I found in *Shibolei ha-Leqet* about letters used for healing, like *gut-gut* and others; these are not permitted to be worn on Shabbat unless they become expert [approved]. Once I, Jehiel the scribe, was walking with a simple ring without a seal, but I was carrying it for healing [*refuah*]; my teacher, Rabbi Meir, asked me about the ring and whether I carry it on Shabbat; and I said I don't wear it on Shabbat, and he said 'Yasher Koach' [congratulations], you are doing the right thing."[143] Here we have evidence for both jewelry and letters—graphic signs—being used for healing.

We have no Jewish jewelry, and it is impossible to say whether the jewelry found in local Christian graves was understood as having a healing function like the ring worn by Jehiel. A protective function does seem likely for the small bronze bells found in an infant's tomb at Apigliano.[144] They were permitted in the Babylonian Talmud, especially for children's garments.[145] Bells were well-known apotropaia because they frightened demons; for this reason they also protected livestock. Saint Antony's pig is occasionally shown with one, as in the crypt of the Taranto cathedral, and both a boar and ox on the ceiling of the Ugento crypt also sport a bell [**151.C**].

There is no mistaking the apotropaic function of the 3.5-cm pendant found at Apigliano [**8**]. Made of bone and with a suspension hook for easy wear, this amulet is in the shape of a fist with the thumb pushed out, a variant of the so-called *mano fica* in which the thumb emerges from between two fingers.[146] This gesture has a sexual connotation today, as it did in the Middle Ages; it is an expression of defiant fertility in the face of envious attack from a human or demonic gaze.[147] We can consider it one of many hand gestures used as amulets, of which the *hamsa* and Hand of Fatima are the best known. All of them are still being used today.[148] In the Annunciation scene on the ceiling of the dated crypt at San Vito dei Normanni,

the Virgin holds a large spindle whose finial is in the shape of a hand, echoing her own raised hand immediately above [**109.sc.1**].

Returning to Jehiel's graphic signs, among the most common of these is the pentalpha, the five-pointed star. It was supposedly used by Solomon, who had been given a ring with this sign by God to exercise mastery over all demons. The pentalpha is frequently found in Salentine churches, both painted and in graffiti [e.g., **60.pg, 75.pg, 94.E, 94.pg**], not so much because Christians had great respect for what some called "Jewish magic" (which they did) but because the sign had become divorced from any Jewish connotations. It was frequently used in documents of learned magic and has been interpreted as symbolizing the name of God, a shorthand akin to the Alpha and Omega.[149] Four-, six-, and eight-pointed stars and rosettes are also very common on funerary stelae [**2.B, 41.E, 99.B, 156.A–B, 159**]. These sometimes resemble a classical wind rose and may evoke a similar notion of cosmos or divinity. The reverse of one tombstone from Quattro Macine [**98.B**] has both a pentalpha and an eight-petaled rosette incised between its recessed quatrefoils.

The pentalpha is a simplified knot. A more complex amuletic knot often seen in medieval Salentine monuments is also associated with Solomon: two interlaced ovals that form a cross at the center and a quatrilobed exterior.[150] This "nodo di Salomone" spans cultural groups and centuries: three examples were incised into the templon barrier of the Byzantine church at Quattro Macine, along with isolated letters and other graffiti [**102.pg**]; one was carefully painted onto the pallium of a late-medieval Roman-rite bishop-saint in the Supersano crypt [**118.st.1**]; another is incised onto the red frame of the figure of Saint Mark at San Marco in Massafra [**66.pg**]; and still another is carved into the loggia of the monastery of Santa Maria di Cerrate. A larger, more elaborate knot was incised inside this church, on the west wall [**114.pg.2**]. At Supersano, the original artist has carefully inserted the knot between two crosses, as if both types of symbol had equal merit—and equivalent value—on the episcopal pallium. I think we can assume that similar knots adorned the garments of living Salentines where they had much greater protective agency. The artist of the relief on the reverse of the mid-fourteenth-century Scorrano epitaph clearly wished to combine the power of Solomon's knot with that of the living cross; the resulting form is a sort of floriated knot [**110.B**].

A very interesting page (fol. 310) in a late fifteenth- or early sixteenth-century Galatone manuscript illustrates two of the apotropaic forms just discussed: a forearm and hand, complete with outstretched thumb, that closely resembles the Apigliano bone amulet [**8**], and a simple, squared form of Solomon knot [**162**]. The pen flourishes at the corners of the knot evoke the serpents attacking the evil eye in late antique amulets and a Dura Europos synagogue ceiling tile, among many other examples.[151] Both pictograms are outlined in red, like the most important let-

ters on the page [**Plate 20**]. These protective images are placed between readings associated with the feast days of Saint Anne (July 25) and Saint Panteleimon (July 27). In this Orthodox liturgical manuscript—an *anthologion*, a kind of florilegium containing many liturgical offices—two "unofficial" healing devices are sandwiched between two official healing saints. Anne was especially, but not exclusively, associated with curing infertility, and Panteleimon was one of the unmercenary (*anargyroi*) physicians capable of all manner of healing. This folio shows very clearly the degree to which the entire range of potential healing methods participated in local religious culture at the end of the Middle Ages, and also suggests that the church was trying to place them all under its control.

Knots have a very long and multicultural history as protective devices. Their efficacy is rooted in the notion that demons or witches would become entangled in a knot, or any sufficiently complex form, and not be able to fulfill their evil objectives. Knots were believed effective in many other areas of human life as well.[152] The importance of binding and unbinding something was made plain in the Gospels, where God gives Peter the power to bind and loose with the keys of heaven (Matt. 16:19). Even earlier, Jewish men understood that their phylacteries (*tefillin*), tied with specific knots that imitate Hebrew letters, bound them to God.[153] Perhaps the knots between paternoster beads made the latter doubly effective; while the official church might not admit this possibility, a medieval user might take it for granted.

The Jewish phylacteries and their knots resembled *qamiʿot*, amulets, and were often considered together with them. Indeed, the Hebrew singular for "amulet," *qameʿa*, originally meant a knot or something attached to a knot. It is a mysterious word, perhaps of Arabic origin and possibly the origin of our "cameo."[154] *Shibolei ha-Leqet*, cited in the *Tanya Rabati*, makes very clear that textual amulets written by experts are perfectly acceptable for Jews and can even be carried outside on the Sabbath; if a nonexpert should write one that then proved to be successful three times, that one is acceptable as well. Zidkiyahu Anav asserts that all "expert" (successful) amulets are acceptable; there is no difference whether there is writing on it or not, or whether it is used by a sick person who is in danger for his life or a sick person whose life is not endangered, or whether it is for an epileptic or a nonepileptic.[155] Such amulets were also employed "when useful," an Aramaic euphemism for virility.

I want to consider a few more graphic signs in this discussion about individual protection. The many compass-drawn circles and rosettes are protective features well attested in magical practice.[156] Some are found in conjunction with sixteenth-century frescoes or verbal graffiti, so at least some of the circles are early modern in date, which only attests to their enduring power.[157] The ubiquitous menorahs on Jewish tombstones may be more than just identifying markers; after all, the

location of the grave in a Jewish cemetery and the presence of Hebrew script would be enough to identify a tomb's occupant as Jewish. The menorahs of late antiquity have been interpreted as symbols of light, divinity, and the messianic future as well as polemical visual counters to the growing popularity of the cross.[158] But to whom was the medieval menorah's message directed? I propose that they functioned less as necessary signs of Jewish identity than as personal protective devices. As in Zechariah's vision (Zech. 4:10), the menorah asserts that God's eyes are present at this site, leaving no room for the evil eye.

Finally, I want to suggest that the many incised game boards are, in fact, elaborate types of knots. Examples scratched on stone are preserved on tomb slabs at Apigliano,[159] Torre Santa Susanna,[160] and on a Jewish epitaph from Taranto (in secondary use, or abuse) [**127.C**]. These may well have been used to play games in the public space of the cemetery, but if not employed for entertainment they served the purpose of knots discussed above; when placed on graves, they trapped potential attackers. This interpretation helps clarify the presence of vertical examples—in the narthex at Uggiano la Chiesa [**153.pg**] and on a doorjamb behind Santa Maria della Grotta near Galatina[161]—which cannot be understood as surfaces for play.[162] The most visually compelling specimens in the Salento are incised on the sarcophagus inside a church at San Cesario di Lecce [**108.pg**]. Three game boards of the types used for *tris* (Nine Men's Morris) and checkers (Quirkat or Alquerque), are flanked on the upper front of the sarcophagus by two crosses and the outline of a shoe.[163] It is possible that the sarcophagus was at one point turned on its side, making the boards potentially functional, but this seems unlikely because the graffitists availed themselves only of a narrow strip of space rather than the whole side (the sarcophagus was one of a pair found upright under the floor of the church). It may be more productive to consider the possibility that the game boards and other signs were deliberately placed at the top edge of the casket, bringing the protective power inherent in the crosses and the knotlike game boards to the space closest to the opening. When discovered, the sarcophagus lacked its lid, and I wonder whether it was a reused early medieval specimen that was covered only with something organic before being interred under the church floor. In any case, the multiple symbols on the sarcophagus both protected the occupant and kept anything untoward from getting out.

Verbal Aids

In addition to using artifacts and graphic symbols, individuals facing personal crises also had recourse to exorcisms and verbal charms; the latter are prayerlike but uncanonical texts that are practical in nature. Like the other means of protection already discussed, the oral realm involved actors and recipients of all faiths

and social levels. And like the communal exorcisms, personal exorcism involved clergy who adjured the demon in the name of Christ or other holy persons; the presence of witnesses made these, too, public activities.

Salentine euchologia and a few specialized booklets preserve exorcisms in Greek against rheumatism, stomachache, and a host of other ailments. A twelfth-century manuscript now in Milan contains the following example:

> Exorcism that causes worms to fall from the wound of every kind of animal and even a man. In the morning when the sun is stinging the man stands [and says] "Lord Jesus Christ God, have mercy on us. Amen. You who made the sun stand toward Gabaoth [Gibeon] and the moon toward Pharanx, make this shiver and the fever of your servant [name to be inserted] stop, through the intercessions of the most holy Theotokos and Saint Nicholas and the saint first among the martyrs and first among the deacons, Stephen, and Saint Anastasia the Poison-Curer and all the saints. Amen. Let us stand appropriately, let us stand with awe."[164]

The scriptural injunction here refers to Joshua, who with God's help made the sun stand still in the hills and valley, or ravine (Greek, φάραγξ, *pharanx*) (Josh. 10:12). This phrase, which encapsulates divine power in a vivid image, is very common in charms having to do with bleeding[165] and was also part of the exorcisms discussed above.

We can compare this formal, clerical exorcism with a verbal charm against a similar ailment: intestinal worms. This exorcism is recorded in dialect, so it may not predate the fourteenth century: "Saint Nicholas in the midst of the sea, crack the wood of this stump, take away the evil eye, Holy Thursday, Holy Friday, Holy Saturday, Holy Easter, take away the worms from this belly."[166] Whereas the "official" exorcism gives a time of day and directions for standing appropriately, the extra-canonical one leaves the time and posture open, refers to only one saint (but to more holidays), and explicitly references the evil eye as the cause of the ailment. There are differences, but on the whole the two are strikingly similar; the disparities likely resided more in the kind of performance or the sound of the speaker's voice.[167] Users of this charm probably felt it was just as efficacious as the official version, as both depend on saintly invocation and a priest may have been involved in both. This was certainly the case for the numerous short incantations and magical formulas collected in Paris, Bibliothèque nationale de France, MS gr. 549, including a SATOR-AREPO square in Greek.[168]

The Cairo Genizah preserves a number of recipes for oral recitation drawn from elements of the standard Hebrew liturgy, thus harnessing "the power of the religiously sanctioned" in a way familiar from Christian charms that reference the

saints.[169] Psalm 91 was especially popular among medieval Jews although it was also used much earlier.[170] In the *Chronicle of Ahima'az* we hear how Shephatiah exorcised the daughter of Emperor Basil, in the Bukoleon Palace in Constantinople, by using five different versions of the name of God. When he emerged, the demon was seized, sealed inside a lead vessel, and cast into the sea.[171] Thus exorcism was not foreign to Salentine Jews, although none of these verbal methods of protecting individuals has left traces in the visual record.

Calling on saints or on Christological feast days is well within the spectrum of religious acts, but using the names of God or demons to obtain a certain result moves us into the realm of what is often called "black magic." These practices are aggressive rather than defensive; they actively seek to make something happen rather than respond defensively or proactively to sickness or aggression. Such occult practices conjure supernatural powers in order to expand the summoner's own power. Witches and wise women can do this, in theory, but the occult was mostly the province of learned men who relied not on oral traditions but on handbooks that described in detail the specific rituals to be performed in order for the higher powers to appear.

We met some Salentine witches in Chapter 5, where they were involved with childbirth and child-snatching, but more men wield magical powers. The *Chronicle of Ahima'az* tells the story of Rabbi Aharon of Baghdad, who came to Italy bringing esoteric knowledge that had allowed him to harness a lion to a millstone back home, rescue a boy who had been turned into a mule by a sorceress, and recognize a dead man attempting to pray in a synagogue. The *sotah* ritual that he established in Oria has already been discussed. Aharon is represented as bringing ancient magical knowledge from Babylonia that inspires Ahima'az's own illustrious ancestors, who by dint of their piety and sagacity know how to use it properly. (When the Ashkenazic Pietists of the thirteenth century evoke Aharon's magic it is intended to legitimate their own practices.)[172] The restricted transmission of this esoteric knowledge is emphasized, as are the cosmic consequences of it falling into the wrong hands. A rare nonillustrious ancestor of Ahima'az named Baruch owned a copy of the *Book of the Chariot* (*Sefer ha-Merkavah*) that had been in the family's hands for generations; Shephatiah had used it for mystical purposes "all his life."[173] This book clearly contained some part of the Merkavah corpus of esoteric Hebrew literature.[174] As the Sabbath drew near, the candle that was routinely (ritually) lit before this book had not been lighted. A menstruating woman took it upon herself to light the candle, and the resulting plague wiped out much of the family. As Robert Bonfil put it, this improper lighting by an impure woman turned "a godly beneficial instrument into one of demonic deadliness" until a knowledgeable Jew was able to place the powerful book

into a lead vessel—as if it were a demon—and cast it into the unwilling sea (which receded for a mile), ending the plague and also the lineage of the unfortunate Baruch.

As discussed in Chapter 1, the name of God was an extremely effective tool. People of all faiths attempted to summon aid by using the divine name or adjuring divine intermediaries who were understood to have a supernatural power. The use of names in magic depends on precise physical and spiritual preparations undertaken by the operator of the ritual: clearly, not everyone is able to summon angels, demons, or God himself.[175] Isaiah of Trani permitted divination with holy names (*shemotav ha-qedoshim*) but not the conjuring of demons (*shedim*), which would push a legitimate form of ritual inquiry into the realm of sorcery.[176] We have already seen how learned Jewish practitioners in the Salento manipulated the name of God to keep someone alive or to travel a great distance quickly for a worthy cause.[177]

Christians were keenly interested in this Jewish magical tradition that suppos-edly harked back to King Solomon himself, as indicated by magical texts that include the Byzantine Greek *Hygromanteia Salomonis*, the Latin (but probably originally Byzantine) *Clavicula Salomonis*, and a vast range of parabiblical litera-ture of varying dates and in numerous languages.[178] In one manuscript of uncertain provenance but with Otrantine traits, the *kampanismos* (weighing) ritual described in Chapter 6 is connected unexpectedly with divine names. Vatican City, Biblioteca Apostolica Vaticana, MS gr. 1228, written in the first quarter of the fourteenth century, contains four prayers for weighing, two for infants and two for cows; the presence of these beasts induces me to see this as an outdoor ritual rather than one performed inside a church. The second prayer is very curious:

> Lord master our God, you who blessed the three oxen Helion, Kornelion, and Triskelion and [as a result] they feared no diseases, but they lived long. You who blessed the Jerusalem ox, which was carrying the venerable wood [True Cross?] and made him live long and last a long time, and they feared no diseases. As with that blessing, bless the oxen of your servant [name to be inserted] through your holy name and through the intercessions of our pure lady Theotokos and ever-virgin Mary, the venerable incorporeal and heavenly powers, and the glorious saint [name to be inserted] and all the saints, amen. May it be so.[179]

The inclusion of the three named cattle in a religious ritual is strange indeed, as is the mysterious reference to a blessed Jerusalem ox. Are Helion, Kornelion, and Triskelion *voces magicae*, mystical names? "Helion" almost certainly originated in one of the Hebrew names of God, *Elion*, meaning "most high"; it was adopted

in some Greek magical texts.[180] Comparable strings of divine epithets ending in *–on* are less common than groups of angels' names, which almost always end in *–el*, but they do appear in such learned compilations as the *Clavicula Salomonis*, which has, for example, the *–on* series Tetragramathon, Cedyon, Agnefeton, Stimulaton, and Primenaton.[181] The *Rationes libri Semiphoras*, supposedly translated from Hebrew to Latin, includes Patryceron, Cefferon, and Barion.[182] Even if it has not been possible to find the exact trio of names used in Vat. gr. 1228, it seems likely that the bovine series has its origins in divine names recorded in learned ritual texts.

Sounds of the Salento

I conclude this chapter on civic and domestic activities by considering some of the sounds in the public and domestic domain. Some unusual sounds were attributed to witchcraft: in 1536, two Moorish slaves purchased for the monastery of Santa Maria de lo Mito, near Alessano, were imprisoned for being "experts in magic and incantations." When they died, they were buried in the monastic cemetery, which became the site of noises and apparitions. A request was made to the pope to disinter the slaves and rebury them in profane ground (his answer has been lost).[183] Associations between what John Haines calls "two of the greatest arts in history," music and magic, are just beginning to be studied.[184]

Sounds associated with worship were certainly more common than those of sorcery. Bells were used to summon the faithful in churches, and the typikon of the monastery at Casole refers to a bell being struck;[185] presumably such Orthodox monasteries also had a *semandron*, a wooden beam struck by a mallet, but this may not have been audible outside the immediate premises. A number of churches have late medieval belfries and one bell is still preserved, although not in situ [22.F]. The text on its rim suggests that it was originally part of a pair.

The Jews occasionally held a very loud worship service; in Reggio Calabria in 1306, local Christians complained to the ruler about synagogue noise.[186] On Purim, when the story of the Jewish Queen Esther is twice read aloud, the name of the archenemy Haman is drowned out by sound. On Rosh Hashanah and adjacent days, the Jews blew the shofar repeatedly; the Torah actually calls the holiday "a day of blowing the shofar" (Num. 29:1) or "a commemoration of blowing the shofar" (Lev. 23:24), not "New Year." It was certainly sounded again on Yom Kippur, ten days later,[187] and it must have been audible throughout a village or urban neighborhood. In the ninth century, according to the *Chronicle of Ahima'az*, the aged and ailing Shephatiah was prevailed upon to blow the shofar but "the sounds of the *shofar* were not as they should have been." Shephatiah left the synagogue

and died soon after predicting the death of Emperor Basil I, "the oppressor and sorcerer" who had persecuted the Jews; the prediction was fulfilled at the moment it was announced.[188] As later confirmed by Isaiah of Trani, the South Italian Jews preserved an ancient method of blowing the shofar that differed in pattern and duration from the custom of the Babylonians (Isaiah also reports that women were blowing the shofar for themselves).[189] Bonfil suggests that the desire to have Shephatiah execute this commandment indicates the Oria community's conscious identification with Palestinian customs and rejection, in this case, of Babylonian innovations.[190]

Musical instruments are shown in Salento wall paintings, especially the Nativity, in which a shepherd playing the flute is standard. Less common is the inclusion of dozens of instruments played by angels in the early fifteenth-century apocalyptic scenes in the vaults of Santa Caterina in Galatina, constituting a very large and varied display of instruments from the period.[191] Many of the depicted instruments are still in use today, including the *zampogna*, a kind of bagpipe made of goatskin. This is referenced in the Maimonidean glossary of Judah Romano as well as in the early modern proverb collections, and it is safe to assume that it, along with other instruments, was played at medieval festivals and fairs.[192]

The Jews in Italy have rich musical traditions for synagogue and family life.[193] The convert Obadiah, formerly the priest John of Oppido, used the modes of Gregorian chant and composed Hebrew synagogal music with Lombard neumes; his is the earliest Hebrew musical notation.[194] "Echad Mi Yodea" (Who Knows One?), by contrast, is sung at home during the Passover seder in countless languages (and numerous Italian dialects). It is a cumulative recitation that begins "Who knows one? I know one; One is our God, in heaven and on earth" and ends with "Who knows thirteen? I know thirteen; thirteen are the ways/attributes of God" (derived from Exod. 34:6–7). There are equivalent Christian songs that overlap with verses in the Jewish version to a surprising degree, except that the former all have twelve verses. Did the Jews, aware of Christian superstition, deliberately add a thirteenth verse and change the words of a preexisting song with Christian content, or did the Christians appropriate the song from the Jews?[195] I cannot answer this thorny question, but I do want to underscore the possibility of a shared musical vocabulary, a common tune that was part of local religious culture.

This chapter, like the first one, ends with a nod toward public musical experience, an important agent of communal identity. Singing and dancing in conjunction with Christian feasts was resolutely condemned by the early modern church synods, which means that it was a common occurrence. There is no regional evidence for the dance manias that go by the name of "Saint Antony's Fire" elsewhere in Europe. Some individuals may have been afflicted with Saint Vitus's dance (*ballo di San Vito*), a form of chorea characterized by jerky movements of the extremities

and face.[196] These misfortunes did not contribute to the Salentine soundscape, however, in the way that one other ailment did and still does.

I refer to the culture-specific phenomenon of tarantism, the earliest evidence for which originated in fourteenth-century southern Italy and may even be named after Taranto.[197] Individuals, mostly women, claimed to be bitten by a tarantula, and their distress was only relieved with vigorous music played by hired musicians summoned to the invalid's home or courtyard. There they played different melodies to initiate the frantic dancing, the *pizzica* (bite), that was believed to correspond to the individual spider's bite and would exorcise its poison. Colored cloths also correlated with the spider, so the phenomenon was both aural, visual, and spectacular. The afflicted person danced until exhausted (the musicians followed suit), sometimes for days on end, with short breaks in between. The "bite" could recur at intervals throughout the person's lifetime, and the only release was through dance, before a domestic audience, and visits to the chapel and well of Saint Paul in Galatina.[198] Paul was the patron saint of bites and their cures because of his experience on Malta (Acts 28:3–5), and every June 29 the *tarantati* sought public relief at the feast of Saints Peter and Paul at Galatina, drinking from a sacred well and climbing on the altar of the saints' chapel.[199] Recent anthropological and performance-based studies suggest that those afflicted by the tarantula were expressing resistance to their circumstances through the socially acceptable media of music and dance (an earlier image of ritualized dance may be seen in an eleventh-century capital or well head now in Brindisi [19]). This same resistance, coupled with a desire for local pride (not to mention additional sources of income), fuels the current phenomenon of the *neo-tarantati* who play the "traditional" tunes and the much larger number of those who dance and sing along. This "revived" local identity, constructed from a partly imagined medieval past, now attracts half a million spectators and participants each year. Medieval Salentine identity was no less a constructed phenomenon, but, as I argue in the final chapter, that did not make it any less real.

Theorizing Salentine Identity

Ask an Italian where he is from and the response will be the name of a province—"sono Pugliese," "Toscana"—except in the case of the largest cities ("Milanese," "sono Romana"). As a highly mobile North American, I am perpetually astonished by my Italian acquaintances' enduring connection to the land. Many who have worked outside of Apulia and even outside Italy tell me that they longed to establish their families not far from where they themselves were raised; they were willing to leave their familiar terrain only temporarily. In today's Salento there is a clear sense of regional belonging, encouraged by the kinds of cultural activities discussed in the Introduction. The fate of the soccer squad in Lecce, the capital of the Salento, is a source of boundless pride or great shame, depending on whether it has superseded traditional rival Bari (the capital of Apulia) and whether it is in Serie A, B, or C, among the top Italian teams or only second (or third) tier.

If you inquire in the Salento about a person's place of origin, he may tell you that he lives in Lecce but will stress that the family is, for example, Grottogliese. Distinct dialects are maintained in all the cities and many towns. Locals are proud of their individual towns and the special features that distinguish them: Otranto has *lu mare* (the sea), Maglie has manufacturing, Cutrofiano ceramics. There is considerable *campanilismo*, as discussed in Chapter 4. Local patronal or food-based festivals are the focus of competition and comfort. One example among many is the feast of Santa Domenica at Scorrano, noted for the extensive *luminarie*, elaborate illuminated arcades and pavilions that transform the town between June 5 and 7 every year. These provide a dramatic setting for both the religious rituals centered on the local saint (vigil, masses, procession of her statue) and the music, food, artistic, and commercial activities that accompany it, all capped by a pyrotechnic display and the symbolic presentation of the keys of the city to Santa Domenica. These aspects of Scorrano's civic identity compete with the festivals of neighboring towns.

As discussed in the Introduction, a proud sense of local identity is apparent in the Salento today on both the regional and local levels. At issue is whether there was such a thing as Salentine identity in the Middle Ages, what that identity meant, and how we can trace its processes of construction and modification from our distant vantage point. Identities are continually changing because they are products of social interaction and individuals have the agency to transcend some boundaries and to adopt desirable cultural features and associate with different groups.[1] Art, broadly defined as visual and material representation, was a principal means of proclaiming and maintaining likeness and difference. Because art was displayed and performed in such social spaces as churches, cemeteries, and streets, it served as a vehicle for altering identity through processes of acculturation, appropriation, resistance, and the like. In this final chapter, I investigate concepts of ethnicity and of ethnic and cultural border crossing. I present several visual case studies and then review current ways of thinking about cultural contact. I then argue for a more nuanced characterization of the population of the medieval Salento as it changed over the course of the ninth through early fifteenth centuries.

Ethnicity: Beyond "Greeks" and "Latins"

"Ethnos" appears only once on a Salentine monument [**104**]: on a funerary inscription in Greek, the author begs Christ to "protect, guard, defend your people [ετνιου, corr. ἐθνίου]," probably indicating Christians in general. The Norman king Roger II knew that "varietas populorum nostro regno subiectorum"—a variety of people were subjects of his southern Italian kingdom—and that these people had different usages, customs, and laws.[2] Nevertheless, many subsequent medieval texts and most modern scholarship not only reduce this *varietas* to the seemingly homogeneous terms "Greeks" and "Latins" but also imply a clear opposition between them. It should be obvious, however, that such sweeping generalizations are reductive, used mainly for convenience, and that "a bounded, monolithic cultural cum ethnic unit is . . . a modern classificatory myth."[3] I have assiduously avoided ethnic labels so far, but they are discussed in this section as a component of Salentine identity.

Cultural identity and ethnicity often have been understood synonymously, but on occasion the latter is construed as the major component of the former, and sometimes race enters the equation as a synonym for ethnicity.[4] Despite some abhorrent assertions to the contrary, most notably in the twentieth century but still lingering today, there is no such thing as a pure racial or ethnic group. Such a thing did not exist even in the early days of human evolution, if we accept the

recent discovery that *Homo sapiens* mated with Neanderthals between sixty thousand and a hundred thousand years ago.[5]

While ethnicity, and by extension identity, was for a long time perceived as something immutable, inherent, and objective, more recently it has come to be understood by social scientists less as an objective "thing" than a behavioral idea, a social construction that has to be learned and is able to change. Members of ethnic groups *choose* to do certain things—naming, speaking, dressing, worshipping, burying their dead—in similar ways that may differ from those of other people. Ethnic groups are "culturally ascribed identity groups, which are based on the expression of a real or assumed shared culture and common descent (usually through the objectification of cultural, linguistic, religious, historical and/or physical characteristics)."[6] Genuine or imagined kinship is what distinguishes ethnic groups from other kinds of human groups.[7]

That such kinship can be fictive is apparent from a 1054 church dedication in Greek [**154.A**] in which the patron and builder had family origins, based on their surnames, in Africa and Corone (Greece), respectively.[8] A man who was probably a converted Arab from North Africa and his builder from the Peloponnese can hardly be said to share an actual place of origin or a common descent. What binds them is cultural choices, not origin. Nevertheless, they were almost certainly seen by others as "Greeks" because of their shared language and common religious enterprise. In the same vein, the "Greeks" who in the ninth century were transferred to Gallipoli from Herakleia in Pontos did not share a common origin with the slaves resettled from the Peloponnese, even if outsiders may have thought otherwise.[9] Ethnicity primordialists say that these two "Greek" ethnic groups would bond as a way of facing their spatial disorientation, while ethnicity instrumentalists suggest they would reinforce their commonalities to maximize shared economic and political interests.[10] But it is also possible that they did not bond at all, that one group looked down at the other's inferior social status and felt that a shared fate of forced resettlement was not much of a basis for a social or cultural relationship. The ex-slaves are unlikely to have been from Greece originally and may not have shared such cultural markers as language, religion, or appearance among themselves or with the émigrés from Pontos. A common "Greek" origin here could only have been imposed from outside.

In the tenth-century *Vita* of Saint Neilos of Rossano, who went on to establish the Orthodox monastery of Grottaferrata south of Rome, the saint finds a wolfskin and wraps it around his head before walking the streets of his Calabrian hometown. Children who see him in this strange headgear cry out, " 'Oh, the Bulgarian monk,' while others called him a Frank, and others an Armenian."[11] Neilos clearly looked different, but the Greek-speaking children could not distinguish his place

of origin; the saint looked like an outsider and might have come from anywhere. In other words, while otherness was notable and significant, the specific ethnic group was not.

"Normans," "Franks," "Italians," and "Latins"

"Normans," "Franks," and "Italians" are all ethnic labels used by the medieval inhabitants of the Byzantine world to describe the non-Orthodox, non-Byzantine, and not Jewish or Muslim inhabitants of lands to the west of the empire. "Normans" is a problematic label, given that a quarter of the "Normans" who arrived in southern Italy were not from Normandy.[12] These not-from-Normandy "Normans" must have blended in with the actual ethnic Normans (who had a myth of common origin) by already sharing some cultural markers, such as the Roman rite, and adopting others, including a common language and Norman names: men of Arab (in Sicily) and Lombard origin took such names in order to rise in the Norman hierarchy after 1071, just as the Lombards had done when the Byzantines took over.[13] This mutability is just one of many reasons not to equate cultural markers with common origin.[14] The Greek-speakers in southern Italy called these people "Franks" or *ethnoi*, barbarians.[15] As is well known, Norman-Byzantine antipathy grew in response to perceived or actual massacres in twelfth-century Constantinople and Thessalonike, but to what degree this affected relations on the ground in southern Italy is unknown. The Salentine Normans' own attitudes toward ethnicity have been studied only through the evidence of charters and the information they contain about names and kinship.

While "Franks" were understood by some Byzantine historians to be Germanic people occupying a specific landmass north of the Alps, the term eventually became a synonym for "Normans."[16] Already in the sixth century Procopius had described the "Franks" as "the most treacherous in matters of trust . . . they still made sacrifices, even human sacrifices."[17] Six centuries later, in 1178, a lengthy Greek *Opusculum contra Francos* was translated into Latin, and in 1281 a literate Byzantine could consult Αἱ τῶν Φράγγων αἱρέσεις καὶ παρατηρημάτων, "The Heresies of the Franks and Their Neighbors."[18] These lists of perceived theological blunders, magnified and generalized as ethnic flaws, have been well studied by Tia Kolbaba.

In the late twelfth century, another Greek polemic was titled Περὶ τῶν Φράγγων καὶ τῶν λοιπῶν Λατίνων, "Against the Franks and the Other Latins."[19] By this time "Latins" had become a falsely homogeneous ethnic term for what were actually quite disparate linguistic and theological markers. It was very rarely employed before the "schism" of 1054, but after that date, and especially after the First Crusade, Λατῖνοι were equivalent to Ἰταλοί (or, in Anna Komnene's *Alexiad*,

to Celts or Franks).[20] Whereas before the Crusades the Byzantines had recognized distinct lands and peoples, now "the notion of Latin peoples (and of Latin habits) was firmly established" and the people geographically to the west of the empire merged, conceptually, into a unified entity.[21] The Byzantine literati were especially piqued by the arrogance of the "Latins," by their stiff necks and arched eyebrows, the latter signs of *superbia* (pride) since antiquity.[22] "Italians," too, were blond (a conflation with the Normans?), bellicose, stupid, cowardly, effeminate, and supercilious.[23] "Latins" were ἰταμότης, reckless, and so were the homonymous hasty "Italians": Ἰταλός–ἰταμός.[24] In the 1270s, Meletios Homologetes wrote a long poem of which the third book is titled "Against the Italians or Against the Latins" (Τρίτος ὁ λόγος κατ᾽ Ἰταλῶν, ἤγουν κατὰ Λατίνων);[25] the terms had become interchangeable.

Well-educated authors in the Salento also participated in such pseudo-ethnic stereotyping. Two independent manuscripts preserve a fictional debate about azymes between a "Greek," called by the term the Byzantines used for themselves, Ῥωμαῖος (*Romaios*), and an opponent identified as a "Frank," Φράγκος.[26] The manuscripts allude to the *Opusculum contra Francos* and also mention another ethnic group, the Goths (Γότθοις), who had been corrupted by Arius and are the source of the Latins' errors.[27] A 180-page miscellany assembled in the Salento in the fourteenth century (Vatican City, Biblioteca Apostolica Vaticana, MS gr. 1276) contains, in addition to sacred texts and the work of numerous local poets, fully thirty pages of polemics that include a false patriarchal act and a poem, κατὰ Λατίνων (Against the Latins), by Pseudo-Psellos.[28] Abbot Nicholas-Nektarios of Casole wrote several of these texts. When he composed his Τρία Συντάγματα on the Holy Spirit, azymes, and other topics (preserved in a different manuscript), the implicit emphasis was on religion—the "Latin" (Roman) rite and its erroneous ways—but it is likely that both the author and his readers unconsciously generalized beyond this to other non-Orthodox cultural markers and an assumed "Latin" ethnicity.

The perception of errors also occurred on the other side. For instance, a South Italian treatise against the "Greeks" also elides ethnic differences, for the so-called Greeks who are the object of criticism in a *Trattato contra Greci* of 1579 were actually Orthodox Christians from Albania.[29] For users of Latin and followers of the Roman rite, "Greek" referred to any Christians from east of Italy, which included people of Armenian origin as well as Byzantines.[30]

Among these essentialized ethnic critiques it is refreshing to find an alternative local view. In the second half of the twelfth century an intellectual named Theorianos—Emperor Manuel Komnenos's *litzios* (liege man) and envoy to the Armenians and the Syrian Jacobites—wrote to the Orthodox priests of Oria (Ὀρινῇ ἱερεῖς) to instruct them about priestly marriage, Saturday fasting, clerical beards,

and eucharistic breads.[31] He personally subscribed to the Roman rite's use of unleavened bread, an interesting detail unexpected of a Byzantine envoy. Theorianos urged his Salento addressees to "love the Latins as colleagues, for they are Orthodox and children of the Catholic and Apostolic church just like yourselves."[32] Because of his unusual moniker, found only in the Salento, I do not doubt that Theorianos came from Oria and acquired his ecumenical leanings in situ.[33]

On the whole, medieval sources indicate that ethnicity, vested in one's place of origin, was less important to outsiders than the cultural markers that were associated with it. When such cultural features as names, languages, appearance, or religion were widely shared, the details of who, exactly, was sharing them and whether they actually came from the same place became irrelevant. In this way, what were originally distinct ethnic categories—albeit not entirely accurate and by no means pure—became in the course of the Middle Ages increasingly essentialized, homogenized, and unmoored from both factual and fictional place of origin. Such epithets as "Franks," "Greeks," and "Latins" were easy to apply to others even if one might not self-identify with any of these terms. In the Salento, however, ethnic nomenclature had a special twist.

"Griki" and "Gregi"

The inhabitants of Byzantium routinely referred to themselves as Ῥωμαῖοι, "Romans." If they preferred an even more classicizing name, it was "Ausones" (Αὔσονες), an ancient name for southern Italy.[34] But despite the etic employment of the term "Greeks," or perhaps in response to its negativity, the medieval Byzantines very rarely called themselves "Γραικοί." In the early Byzantine period this term was an insult derived from the Latin *graecus*, and after 1204 it "came to encapsulate every western prejudice against the Byzantines and was foisted upon them by the Latins."[35] In the thirteenth century the term "Hellenes"—not Γραικοί—became a statement of pride, having overcome its earlier associations with paganism: *Hellen* ameliorated the negative *Graikos*.[36] Thus it is surprising to find positive uses of the latter term in the Salento. Nicholas-Nektarios repeatedly employs the term as an adjective for "church" early in the thirteenth century.[37] In a letter that Theodotos of Gallipoli sent to Theodore of Cursi in the 1270s, the addressee—who staunchly defended against the liturgical innovations of a Calabrian Orthodox archbishop—is called τὸ πάγιον στήριγμα τοῦ Γραικῶν μέρους, "the solid bulwark of the Greek part." Theodotos uses Γραικοί as a matter-of-fact statement of identification that goes beyond language; he does not say that Theodore is the bulwark of the Greek speakers but instead something like "of the 'Greek' population."[38] In the famous quadrilingual funerary inscription from

twelfth-century Sicily, the Greek clergy are also identified by the unusual *Graikos*.[39] In southern Italy alone, it seems, a term used elsewhere as a pejorative was adopted as a positive, or at least as a neutral, term.

We should recall from Chapter 2 that the Greek language that survived the longest in the Salento was called by its speakers *griko* or *grika*. This does not derive linguistically from either Latin *graecus* or Greek γραικός; it may have been the term their ancient Italic neighbors used for local Greek speakers, although this is only one linguistic hypothesis among many. The oldest attestation of the term appears in in an eleventh-century Calabrian book of exorcisms. In a prayer attributed to Gregory the Wonder-worker, evil demons are enjoined to return to whomever engendered them, whether Persians, Egyptians, Jews, Sardinians, Slavs, Moors, Spaniards, Lombards, or Greeks, male or female—Γρῆκος ἤ Γρῆκα. These *Griki*, foreign to Calabria, cannot be Hellenes from Greece or local Calabrians, who were called *Graikoi*. They may well be Salentines, as suggested by André Jacob.[40] *Griko* was maintained throughout the Middle Ages and beyond by the ever smaller number of communities that compose the *Grecìa salentina*.

In addition, the displaced Salentine Jewish community on Corfu was called the *qehilla griqa* or *griga*.[41] Although Benjamin of Tudela recorded only one Jew there in the twelfth century, this number was augmented by more Jews from southern Italy when Corfu was part of the kingdom of Naples (1266–1386). The "Greek" Jews from the Salento maintained their identity on the island in the hope of returning to Italy. They were distinguished by rite, language, and place of origin from the *ciciliani* and *apulyanit* (or *pugliesi*) communities on Corfu, which spoke a Judeo-Italian Romance dialect called *pugghisu* and hailed from outside the Salento. Corfiote festival prayer books (*mahzorim*) used by the *griqa* community are very close to those produced in the Salento,[42] both in content and in the use of Byzantine Hebrew square script. Thus *griko*, the language, became a distinctive ethnonym both in the medieval Salento and in an émigré community of *Gregi* across the Adriatic.

A Jewish Perspective on Ethnicity

The Jews saw themselves as *klal Yisrael* (the community of Israel) and were also perceived by others as an ethnic group that shared not only a common origin but also distinctive cultural traits. Nevertheless, the monolithic etic view of the "Hebrews" is challenged by its internal divisions into Rabbanites and Karaites (Benjamin of Tudela reports that a wall separated these two groups in Constantinople)[43] and into emerging cultural blocs of Romaniote, Ashkenazic, Sephardic, North African, and Mizrahi ("oriental" or Near Eastern) Jews, distinguished by language, rite, and *minhagim* (customs). The status and the cultural expressions

of Jews in predominantly Christian and Muslim lands differed dramatically, and their views of the majority cultures around them diverged as well. In general terms, the relationship of medieval Jews embedded within what they called "Ishmaelite" culture may have been, on the whole, less fraught than in Europe and Byzantium, where emperors and local potentates engaged in persecutions and forced baptisms. In fact, the first medieval Jewish martyrdoms, predating by a century and a half the better-known ones that occurred at the beginning of the First Crusade, occurred at Otranto when three sages of that community took their own lives in response to an unspecified anti-Jewish policy or action.[44] Their names and actions are recorded in a letter sent from Bari to a famous Babylonian sage, Hai Gaon, then residing in Cordoba—a good example of premodern globalism. The apocryphal Byzantine "Vision of Daniel," written in Hebrew during the tenth century, describes these persecutions and seems to mention the Salento as a region suffering currently from Christian persecution but destined for future redemption and divine blessing.[45] A flourishing polemical literature in Hebrew detailed Christian errors,[46] and while it rivals the one between the Orthodox and Roman-rite Christians discussed above it similarly did not preclude day-to-day interfaith or interethnic encounters. Jews were fully involved in the medieval economy and, apart from moments of crisis, they brokered a successful coexistence in their local communities.[47]

What did Jews in the Salento call the Christians around them? In general they used *goyim,* the biblical term for all non-Jews. The word could be used neutrally or negatively, as in a *piyyut* by Amittai of Oria that begins "The law of the gentiles is obscenity."[48] More polemical terminology included "idolators," "idol worshippers" who venerate statues, and "the uncircumcised" (in contrast to Muslims).[49] As noted in Chapter 7, Roman-rite Christians were perceived as lax in their idolatry and then, beginning in the thirteenth century, as nonidolaters, in contrast to Orthodox Christians and their ubiquitous icons.

"Franga," derived from Francia, signified in medieval Jewish texts any Christian country, not just the homeland of the Franks; in this it resembles Byzantine usage.[50] More widespread, however, was the use of "Edom," a Bible-era kingdom associated with Esau, to refer to both the pagan Roman empire and the Christian Byzantine one, including Byzantine Italy.[51] This was extensively developed in the historical chronicle *Sefer Josippon,* written in mid-tenth-century southern Italy although not in the Salento itself. In the *Chronicle of Ahima'az,* penned in Capua in 1054 but concerning events in Salentine Oria over the preceding two centuries, the king of the "Edomites"—"a man of evil, a treacherous murderer . . . a king whose name was Basili"—is clearly the Byzantine emperor Basil I, who had indeed murdered his predecessor to attain the throne.[52] Byzantine (including Salentine) Jews were called Romaniotes after "Romi" or "Romania," regular terms for the

empire of New Rome and its inhabitants, the Ῥωμαῖοι.[53] When the future physician and scholar Shabbetai Donnolo was ransomed in Otranto after the Arabs sacked Oria, he wrote that Otranto is located in the Roman (meaning Byzantine) kingdom, the *malchut Romi*.[54] *Ahimaʿaz* also uses the terms "Macedonian" (מקדוני) and "Greek" (יוני) to denote "Byzantine."[55] Like the episode with Neilos in the wolf-skin, such fungible ethnic terms suggest that specific place of origin was less important than a general connotation of alterity.

Visual Evidence for Ethnic Identification

The visual and material evidence for an awareness of distinct ethnic groups in the Salento is extremely scanty and limited to the latest monuments in the Database. The depiction of the *rotella* on the chests of two of the torturers of Saint Stephen on the right wall of Santo Stefano at Soleto was discussed as an aspect of appearance, and it also had clear implications for status [**113.sc.1; Plate 14**]. The *rotella* represents a local and short-lived reification of Christian proscriptions against miscegenation. Ethnic mixing would not occur, the church hoped, if Jews were singled out in this highly visible way. Although the regulations were frequently renewed, they were rarely enforced, and this is the only Salentine monument to include such legislated indicators of ethnic alterity.

Other representations of Jews in the Salento lack any evocation of contemporary realia; while they are stereotypical, there is nothing approaching the exaggerated, demonic depictions that characterize northern European art.[56] This was probably due to the almost complete avoidance of such ugly extremes in Byzantine art.[57] "Bad Jews" are implicated in several Christological scenes, but these are individuals required by the narrative, not added as a result of patronal or artistic anti-Semitism. So, for example, Judas is always recognizable in the Last Supper: at San Pietro at Otranto he is the only figure in profile, alone on one side of the table, and the only one who extends his hand aggressively toward the victuals [**87.sc.1**]. Yet these are artistic conventions, and there is no deformation of his features, although, curiously, his outstretched hand reveals both palm and fingernails. While this is not conventional, it is an error innocent of significance because an infant Christ depicted in the nearby cathedral has the same anomaly.[58] At the Betrayal of Christ, Judas is a necessary protagonist, but nowhere in the Salento is he distinguished physically [**33.sc.1**]. A trio of Jewish men—old, young, and middle-aged, with heads covered—has joined the group of Roman soldiers in that scene at San Nicola in Acquarica del Capo [**Plate 1**]. The Jews' faces are entirely neutral, in contrast to the exaggerated visage of the Roman soldier directly behind them who wears an anachronistic chain-mail coif. The oldest Jew is singled out

by holding in his left hand a sharp knife that has no pictorial parallels in the region.[59] Nevertheless, the knife is not an ethnic signifier even if it does embroider the narrative to indicate Jewish malice.

In scenes of Christ and the Jews before Pilate [**26.sc; Plate 3**] and the Jew Jephonias at the Dormition of Mary [**27.sc; excised in 114.sc; Plate 15**], the sole indicators of Jewish identity are the narrative context and the pious head coverings. For those who knew the apocryphal story, the depicted moment of Jephonias's hands being severed by Saint Michael for daring to touch the Virgin's bier anticipates his conversion after the hands are miraculously reattached.[60] There is no mistaking who the Jew is in the story, but a person unfamiliar with these Christian episodes would not be able to pick out the Jewish protagonist on ethnic grounds. In the Last Judgment, too, a lone Jew (identifiable by his head scarf) is shown in a crowd of men being punished at Santa Maria del Casale near Brindisi [**28.sc.1**]. While a serpent is emerging from his mouth, in this he is greatly outnumbered by the Christian clerics and monastics who share the same unpleasant fate.

The only case of physical exaggeration indicative of Jewish alterity in the Salento is in scenes from the life of Saint Catherine at Santa Maria del Casale [**28.sc.2**]. When the saint disputes with the pagan philosophers who are trying to persuade her to renounce the Christian faith, her opponents are contemporary Jews wearing head scarves. Most of them are shown in profile with exaggerated fleshy lips, but this trait is shared by the Roman soldiers in the flanking scenes [**28.N**]. Only the Jews, however, are shown from the rear with what must be construed as embarrassingly articulated buttocks despite their being clothed. Only in a monument under elite Angevin patronage in the fourteenth century do we find a group of people marked in a way that goes beyond clothing, which obviously could be altered, to emphasize an ostensibly intrinsic component of physical appearance that may have been intended to suggest moral traits or elicit a humorous response.

In the thirteenth century, some of the Roman soldiers in the Betrayal of Christ scene at Casaranello are shown with mustaches, and a couple of those also have a beard [**33.sc.1**]. Marina Falla Castelfranchi argued that these figures were meant to represent Mongols as a distinctive ethnic group,[61] updating the persecutors of Christ as thirteenth-century enemies of Christendom. Mongols, also known as Tartars, were the "ethnic" group best represented among medieval Italian slaves, so their appearance is well documented. Their most distinctive feature was not their facial hair, however, which is never mentioned in slave accounts, but rather their skin color and the shape of their eyes. While their eyes are regularly described as concave or inset, Tartars came in six different colors.[62] The supposed ethnic group that slave owners called "Tartar" was a constructed identity that masked a

great deal of variety. None of their supposedly distinctive features is evident in the Casaranello paintings, and mustaches appear regularly enough in Salentine painting to suggest that no ethnic identity was intended by their representation.[63]

If such a small proportion of the extant visual material reveals any inclination to document ethnic minorities, we would not expect the region's ethnic majorities, the so-called Greek and Latin communities, to be identifiable as "others." As far as I can determine, there was no attempt in medieval Salentine art to represent "Greek" or "Latin" ethnic identities. Perhaps the members of these groups recognized, better than modern scholars have done, that place of origin was not particularly significant in a region that had seen migrants and conquerors come from every direction only to mix genetically and culturally with the local inhabitants.

Crossing Ethnic Borders

Proximity to neighbors with different cultural features had the potential to transform not only long-held practices and beliefs but also ethnicity itself. Ethnic boundary crossing can result from immigration, conversion, intermarriage, or other forms of sustained contact, underscoring the fact that ethnicity is situational and not primordial.[64]

The invaders of southern Apulia throughout the Middle Ages, or at least the ones who stayed—Lombards, Byzantines, Normans, Germans, and Angevins (but not Arabs)—can all be considered immigrants. Less bellicose examples of immigration include the movement of an "African" to Italy [154.A] and the forced relocation of people from the Black Sea and Peloponnese regions, both of which were cited above as challenges to a view of fixed ethnicity. Armenians are attested in the Salento [111, 159], and immigration from the Balkans is strongly suggested by the practice in some villages of inhumation with a coin.[65]

Religious conversion is another important type of border crossing. Two famous eleventh-century cases of conversion to Judaism took place just north of the Salento. The archbishop of Bari, Andrew, was circumcised in 1066 in Constantinople, an event that, unsurprisingly, goes unrecorded in Christian sources but is known from the memoirs of a different convert. That man, a Norman named John from Oppido (Basilicata), in 1102 took the name Obadiah, the traditional name for Jewish male converts based on the homonymous Old Testament prophet who had previously been an Edomite.[66] John-Obadiah is known from six fragments in the Cairo Genizah that testify to his travel among Jewish communities in Syria, Palestine, Mesopotamia, and Egypt (where the ex-archbishop Andrew ended his days); his contributions to Hebrew musical notation were noted in Chapter 7. The only kind of conversion acknowledged in medieval Christian sources goes in the

other direction, such as Nicholas-Nektarios's disputation with a Jew in Otranto in the 1220s that resulted in the Jew's baptism. Similarly, Jacobus of Verona, who remarked on women's pierced ears and Jews gazing at the cathedral menorah when he visited Otranto in 1346, claims to have convinced many of them of the truth of Christianity.[67]

A case of temporary conversion is attested in a 1230 letter of George Bardanes, metropolitan of Corfu and frequent correspondent of Nicholas-Nektarios. An unnamed Corfiote Jewish woman had converted to Christianity but then married a Jew and fled to Otranto.[68] Bardanes urges the archbishop of Otranto to bring the apostate to her senses or else bring "the sharpness of the law" to bear on her and her family. The end of the story is unknown, but Bardanes writes, "It behooves us, moreover, to gain a healthy profit from this business" (*Oportet enim nos salutaria lucrari lucre etiam ex huiusmodi commerciis*), by which he may have meant spiritual profit among the Christian flock or hefty fines from the Jews who harbored the apostate.

Normally converts had to abjure their former faith in harsh terms that were supposed to make it difficult to return to the fold,[69] but Christian authorities rarely were convinced of the ex-Jews' newfound faith in Jesus. Although forced conversions were generally avoided, there were notorious exceptions: in the ninth and early tenth centuries under several Byzantine emperors; in the 1290s, under the Angevin ruler Charles II;[70] and in the later fifteenth century by the Aragonese. These efforts produced large groups of *neofiti* or *cristiani novi*, usually called *cristiani novelli* after the mid-fifteenth century (equivalent to the better-known Iberian *conversos* and later *marranos*). They held an anomalous legal status and occupied a liminal cultural space, no longer Jewish if the conversion was sincere but not quite Christian even if it was.[71] The Inquisition charged many with Judaizing, and it was often converted Jews who guided the authorities about just what (or whom) to look for.[72] The large numbers of *neofiti* and their descendants in such cities as Trani occupied a separate social class and even had their own representatives on the city council.[73] Recent work on non-Romaniote Jewish communities has demonstrated that unforced conversion by Jews was more common in Europe than previously thought and that these ex-Jews and their former co-religionists might well maintain "unrestricted social and cultural intercourse" and be separated only by a "low barrier of beliefs and taboos."[74] The Corfiote Jewish woman mentioned above would seem to be a good example of crossing the conversion line with relative ease, at least from the Jewish perspective. Rabbenu Tam, who in the twelfth century reported the South Italians' claim that "from Bari comes forth the Law, and the word of God from Otranto," said that apostates divorce their Jewish wives every day. While this is probably hyperbole, it suggests fluidity in Jewish

self-identification.[75] Despite frequent scholarly assertion that Jewish apostates were essentially dead to other Jews, David Malkiel has shown that there is no medieval support for this notion. Apostates neither died nor disappeared; they remained "part of the panorama of Jewish society, and they interacted with their former coreligionists on a daily basis."[76]

A Muslim traveler to Sicily in the tenth century remarked on the frequency and acceptability of Muslim-Christian intermarriage there, which he found very distasteful.[77] Although Jewish-Christian intermarriage is entirely undocumented in the Salento, there might be analogies to marriage across Jewish sectarian lines. Intermarriage between Rabbanites and Karaites is well documented in the Cairo Genizah, where cultural sticking points about food, the calendar, and other issues are worked out ahead of time in marriage contracts.[78] Christian interconfessional marriage is well attested elsewhere in southern Italy and in the wider medieval world but without such attention to practical details. Beginning in the twelfth century, the Byzantine imperial family in particular contracted numerous marriages with Roman-rite Christians and others in the interests of foreign policy, status, and diplomacy.[79] Foreign brides were required to convert formally to the Orthodox creed. John Barker raised the issue of whether frequent intermarriages, especially by the Palaiologoi, eroded their "Greek" ethnic identity and decided that "Byzantine" (political) identity trumped "Greek" ethnicity.[80] Local Salentine identity similarly trumped other allegiances, as discussed below.

Intermarriage between the two principal Christian groups was a less dramatic way of assimilating across ethnic borders. The Normans married local women, reducing and ultimately eradicating any supposedly "pure" Norman identity especially among the lower social classes.[81] When a Greek-speaking person married a Romance-speaking one, to which ostensible "ethnic" group would their offspring belong? Perhaps the very Greek-sounding Doulitzia (literally, "little servant") in the crypt church at Vaste [157.A–B], married to Antony and with one daughter modishly named Ioanna, was an Orthodox woman married to a Roman-rite man, although we saw in Chapter 1 that names are poor indicators of ethnicity. According to traditional art history, this would help explain the presence at Santi Stefani of iconographic features unexpected in a church inscribed entirely in Greek and in which a templon barrier was in place until the 1920s.[82] Yet inconsistency in patronal confession seems a facile way to explain the supposed anomalies at Vaste.

The question of intermarriage has been especially well studied in Venetian Crete, where it was not uncommon and where medieval documents are more plentiful. There language was not considered an ethnic marker, whereas attendance at an Orthodox church or wearing a beard might deprive a man of free Latin status; nevertheless, these transgressions did occur.[83] "Mixed breeds" had a name in

Greek, γασμοῦλος or βασμοῦλος, of unknown origin.[84] We might recall here the Byzantine epic hero Digenis Akritis, the "twice-born" product of a "Roman" mother and a non-Byzantine father; in fact, the oldest manuscript of this work was copied in the Salento in the late thirteenth century.[85] It appears that mutable cultural traits (language, religion, appearance) did not greatly separate the "Greek" and "Latin" communities on Crete and, indeed, that these categories were often dispensable: as Sally McKee put it, "ethnic identity provided no more of a basis for group solidarity than the status of married, single or divorced does today."[86] In addition, she avers that "the outward appearances of the communities had become blurred by the end of the fourteenth century. The Latin community's adoption of some outward characteristics of Greek culture, such as language, dress, and religion, changed their perception of Venice and of themselves."[87] This was true in the Salento, too, and probably even earlier. For example, on the evidence of wall paintings such as the one showing three monks in *proskynesis* at Miggiano, beardlessness did not exclude one from the monastic profession [**73.A.1–2**].

Intermarriage can have both negative and positive sociocultural consequences. The past century saw notable rates of intermarriage between the Arbëreshë, descendants of Albanians who migrated to southern Italy beginning in the fifteenth century, and other Italians; as a result, the Arbëreshë language is considered endangered by UNESCO.[88] At the same time, intermarriage is one of the most effective methods of lessening potential ethnic conflict. In the former Yugoslavia in the 1990s, conflict was absent in Vojvodina, the region that had the greatest percentage of intermarriage and cultural mixing, while in Kosovo, where intermarriage between Christians and Muslims was extremely rare, at only 0.02 percent, ethnic conflict was fierce.[89] In the medieval Salento, unrecorded intermarriage almost certainly increased assimilation and decreased cultural demarcation.

Crossing Cultural Borders

In a pioneering study produced over forty years ago, Fredrik Barth argued that culture is defined by liminal individuals on the cultural peripheries, where identity is constantly being negotiated.[90] The Salento is one of these intriguing peripheries; it was indisputably on the far western edge of the Byzantine world and the southern and eastern edge of the European medieval one. In a postscript written a quarter century later, Barth further asserted that: "Whereas radical cultural alterity plays an important role in much Western thought, ethnic relations and boundary constructions in most plural societies are not about strangers, but about adjacent

and familiar 'others.' They involve co-residents in encompassing social systems, and lead more often to questions of how 'we' are distinct from 'them,' rather than to a hegemonic and unilateral view of 'the other.'"[91] Proximity, not distance, informs judgments about alterity and permits such things as intermarriage and conversion. It is therefore important to review the evidence for cultural proximity, the sine qua non for the blurring of borders that would have clear effects on so much of the region's material and visual culture.

Jews and Christians

Evidence for regular social relations between Jews and Christians is readily traced on both European and Byzantine soil, especially before the eleventh century.[92] In southern Italy, Saint Neilos had cordial encounters with Shabbetai Donnolo, and Hananel of Oria seems to have been on chatting terms with the local bishop, Theodosius [83].[93] A Jew witnesses an icon procession in Otranto and is eventually won over by a visiting saint.[94] In addition to such isolated contacts recorded in texts, it is obvious that processions, fairs and markets, and public sermons and disputations were all opportunities for unnamed individuals from different groups to mingle in their community and beyond. Additional opportunities were afforded by such life-cycle events as births, weddings, funerals, and commemorations, as well as by shared natural calamities. Daily-life practices—baking at the communal oven, getting water from a shared well, using the public baths[95] and oil press, visiting the miller, butcher, wet nurse, and just being neighborly—also resulted in contact between individuals and groups.[96] Jacobus of Verona, visiting from northern Italy, was astonished that Jews and Christians lived side by side in Otranto.[97]

Pictorial support for regular socialization is found in a painting from a cycle depicting the life of the Magdalene in the Torre di Belloluogo at Lecce, possibly painted for Maria d'Enghien in the 1380s [59; Plate 11].[98] The lunette shows the saint's eviction from the Holy Land, cast adrift with her supporters in a boat without a sail. Two-thirds of the scene is devoted to activities inside the city wall of a fictional Jerusalem. There are male Jews in head scarves, including two looking at a church and one in conversation with a turbaned figure. The numerous *turbanti* lend an exotic note, representing the inhabitants of the Holy Land; the Jews, in contrast, are just part of the regular (southern Italian) scene. Elsewhere in the cityscape are well-dressed women at a well, a tailor and his customer, and a seated man examining a no-longer-recognizable object in his lap (a shoe?).[99] For the painter in Lecce and the noble viewers, the proximity of Jews to well-dressed, presumably Christian men and women was a matter of course.

Orthodox and Roman-Rite Christians

The appearance of a half dozen double-apsed basilicas in the Salento in the twelfth century led Brunella Bruno to propose that these churches were administered by both Orthodox and Roman-rite clergy, with one altar per apse for each rite (an example is the Norman church at Quattro Macine [**103**]).[100] This would have been a practical liturgical and political solution for the new Norman rulers. In the late medieval period, the duplication of rites was taken in a different direction when the Orthodox archpriest of Galatone decided in 1423 that the Eucharist could be administered with both leavened and unleavened bread.[101] As late as 1587, one bishop in the Salento advocated the use of very thin but leavened bread (*subtiliorem fermentatam conficiant hostiam*) as a way to satisfy communicants of both rites.[102] By this time, some priests were keeping both azymes and leavened bread available for the communicant to choose his preference.[103] Of twenty-four churches inside Soleto in 1607 and thirteen more outside, two hosted both rites while the others appear to have maintained the Orthodox rite exclusively.[104]

A note in a Salento euchologion of 1348 indicates that the *protopapas* (archpriest) of Galatone performed the Orthodox Blessing of the Waters on the eve of Epiphany (January 6) both in his own village and in the Benedictine monastery church at Nardò (in 1412 it became the Roman-rite cathedral).[105] The Orthodox and Catholic clergy of Nardò were joined by Greek-speaking priests, deacons, and subdeacons from throughout the diocese. After processing to the church narthex, where lit candles and censers flanked the holy-water basin, two choirs chanted the Psalms and litanies antiphonally, alternating Greek and Latin.[106] The list of saints receiving bilingual acclamations includes Thekla and Ursula, who belonged to one sanctorale but not both. The blessing ritual at Galatone and Nardò was continued, seemingly without interruption, until at least 1490.[107] In Galatone in 1637 "Greeks" still sang at both vespers and mass on all Saturdays and numerous feast days, while the "Latin" priests kept silent; during the Epiphany vigil the clergy of both confessions participated in mass and vespers but only the Orthodox priests blessed the water, and into the 1960s the Epistles and Gospels were read at Nardò in both Greek and Latin on the major feasts of the Nativity, Epiphany, Easter, and Pentecost.[108]

A euchologion written in Galatina around the mid-fourteenth century was updated with the addition of several blank folios filled with contracts, numerous obituaries, and other notices from the fourteenth through sixteenth centuries.[109] One of these records the marriage in 1416 of Antonia Pierri, daughter of the Orthodox priest who then used the book. Two years later, when Antonia's son was baptized, this priestly family had the rite performed by the Franciscan chaplain

of Maria d'Enghien, by then the wife of King Ladislao of Durazzo and widow of Raimondello del Balzo Orsini. This attests to good relations between two Christian communities in Galatina, a reality confirmed by a notation in the euchologion about the death of the Franciscan bishop of Gallipoli and especially by the name of the infant: Francis.[110]

Rather than summarize the abundant evidence for social and cultural contact presented in the previous thematic chapters—things like names that cross "ethnic" categories and shared ways of highlighting them in inscriptions, Jewish and Christian weddings that feature crowns, common superstitions, protective measures, and cures—I focus here on a few case studies of cultural border crossing drawn from the material and visual sources in the Database. These expand the information available from texts in important ways, not least because they indicate that traditional East/West, Greek/Latin antonyms cannot do justice to what we see in the visual and material culture of the Salento.

The Otranto Cathedral

Christine Ungruh has recently identified a coherent program in the seven hundred square meters of pavement in the cathedral of Santa Maria Annunziata at Otranto: a monumental depiction of Psalms 148–150 in praise of the Lord and, through him, the Norman ruler, with a particular emphasis on the Easter liturgy [86.A].[111] Yet some of the figures in the Latin-inscribed pavement only make sense in a Greek linguistic and Orthodox liturgical context. These include the personifications of Earth and Ocean, represented by a griffin and Thalassa, usually identified erroneously as a siren, and especially the personification of Kairos (Opportunity), depicted in the north transept as a winged male nude [86.B].[112] The blade he holds is easy to confuse with his (now missing) forelock; as the classical epigram of Poseidippos says, one can grab Opportunity as it is arriving but not once it has passed. Across the tree trunk that divides the damned from the saved, a blessed soul ascends a smaller paradisiacal tree, perhaps an allusion to Acts 3:19 ("Repent [μετανοήσατε], and turn to God, so that your sins will be wiped out and times of refreshing [καιροί] will come"). Immediately behind Kairos, a nude man falls into a large vessel, the "pit of destruction" of Psalm 54, having failed to repent.

Holding a balance and poised near the northern staircase to the crypt, Kairos encapsulates the human choice between repentance and punishment. This choice was articulated verbally by the deacon, who uses the words καιρός and μετάνοια when preaching Mark 1:15 ("The time has come . . . repent!").[113] At Salerno, whose ordo, unlike that of Otranto, is extant, the deacon received penitents on the north

side of the cathedral during the Easter liturgy. If this was the case at Otranto, the penitents were confronted by images of Heaven, Hell, and Kairos, and for this last image to resonate, parts of the liturgy must have been recited in Greek. In fact, performance of the Orthodox liturgy at the cathedral is confirmed by the euchologion copied by its second chanter, Galaktion, in 1177 (Ottob. gr. 344), soon after the completion of the mosaic pavement in 1163–65 [**86.E–F**].[114] In the later twelfth century, at least, the Roman-rite cathedral at Otranto hosted both rites and the Latin inscriptions on the pavement were complemented by classical Greek personifications.

Stressing other aspects of the pavement's "interculturality," Laura Pasquini broached the possible use of Jewish and Islamic sources for the mosaic depictions of Alexander the Great, Solomon, and Jonah.[115] That Jews and Christians mixed socially in twelfth-century Otranto is supported by Benjamin of Tudela's assertion that there were five hundred Jewish households in the city—a significant proportion of the urban population if the figure is accurate. This superabundance of Jews may have continued in later centuries, given Jacobus of Verona's observation about the physical proximity of Jews and Christians there in the mid-fourteenth century. Unfortunately, there is no way to know whether the Kairos was still comprehensible in the centuries after it was represented and activated in Greek on the cathedral's mosaic pavement. There were still Greek speakers and three Orthodox churches in Otranto in the seventeenth century, but there was no longer a Greek second chanter in the cathedral.[116]

The Andrano Hospital Stela

Some of the most suggestive monuments of Orthodox–Roman-rite contact (the terminology of cultural *métissage* is discussed below) belong to the fourteenth century, and one of them is the stela that marked the foundation of a hospital at Andrano in 1372/73 [**4**]. It featured in previous chapters for its inclusion of personal names; its introduction of a vernacular term, *spitali*, into the Greek text; its contributions to our understanding of local status and of the scribal profession; and as part of a civic ritual. As analyzed extensively by André Jacob, the stela warns against the alienation of hospital property by invoking the curses of the 318 church fathers who supposedly attended the Council of Nicaea and also of the ecumenical pope of Rome. Both Roman-rite and Orthodox bishops attended the consecration, which earned the patron forty days of indulgence from his local bishop, as stipulated in canon 62 of the Fourth Lateran Council.[117] Thus the patrons, George Longo and his wife, Gemma, do not adhere to the customs we might have expected given his Greek-sounding name and the language of the text; instead, they readily accept authorities (the Roman-rite bishop of their diocese and the "ecumenical

pope") and practices (indulgences) that were alien to the Orthodox faith. Similarly, in a thirteenth-century Greek compilation of Old Testament historical books and apocrypha (Vatican City, Biblioteca Apostolica Vaticana, MS gr. 1238), additional notes in Greek mark the death of the Roman-rite bishop of Castro in 1300 and, in the same year, the first jubilee. This last was held "in the time of the most holy Pope Boniface of Rome" (ἐν τῷ καιρῷ τοῦ ἁγιωτ(ά)τ(ου) παπ(ᾶ) Ῥώμης Βενεφατίου) and offered indulgences that, as in the Andrano stela, are apparently accepted without criticism in a Greek and Orthodox milieu.[118]

The "ecumenical" title for the pope was the one that Emperor Michael VIII Palaiologos had urged the Byzantines to accept before the Second Council of Lyons in 1274; it was, he said, the first of three conditions necessary for the union of the churches.[119] The swift rejection of Michael VIII's unionist goal (until another attempt at church union in 1438/39) means that few with Byzantine leanings would have approved the titulature at Andrano, at least not publicly. Yet the fourteenth-century inhabitants of the Salento were not Byzantine in any political sense; officially they were subjects of the Roman church although, as the Venetian diplomat Marino Sanudo Torsello noted a few decades earlier, they were not necessarily faithful subjects.[120] Did George Longo identify himself as Orthodox, like Michael VIII, but express here his pro-union sentiments? Had he accepted the Roman rite and papal titulature while maintaining his ancestral language? In later centuries this would be the choice, or the reality, of many in the Salento who had abandoned Orthodoxy (which was eradicated throughout the region during the seventeenth century) but continued to speak Greek.[121] Or had George made another kind of personal accommodation, still thinking of himself as Orthodox while superficially accepting things that no theologian would countenance? The Andrano stela shows how the components of identity do not necessarily combine to form a unified and easy-to-label picture of an individual or community; rather, pieces of the medieval cultural puzzle merge in novel and unexpected ways.

Santi Stefani at Vaste

The rock-cut church at Vaste has appeared repeatedly in this book: it is rich in names and data about appearance, somewhat informative about language and status, and among the most valuable sites for considering habits of veneration. Its apse, like much of the interior repainted in 1379/80, suggests that a Greek textual source could coexist harmoniously with practices usually associated with the Roman rite. The unprecedented juxtaposition of the prophet Zechariah's vision of the Temple menorah flanked by olive trees (on the east wall above the apse) with John the Evangelist and the Woman of the Apocalypse from Revelation (in

the conch) seems to be based on a Greek homily and arguably on a specific man-uscript [**Plate 19**].[122]

By the fourteenth century, the unnamed woman in John's Apocalypse was firmly identified with Mary because the child she bears in Revelation 12:5 is called the Messiah. The inscription addresses her as *despoina*, Lady [**157.A**]. Proclus, the archbishop of Constantinople in the 430s, linked Mary with Zechariah's lampstand in his second homily, "On the Incarnation":

> "And [the angel] said to me, 'What do you see?' And I said, 'I looked and saw a lampstand all of gold'" [Zech. 4:2]. What is this lampstand? It is holy Mary. Why a lampstand? Because she bore the immaterial light made flesh. And why is the lampstand all of gold? Because she remained a virgin even after giving birth. And just as the lampstand is not itself the source of the light but the vehicle of the light, so too, the Virgin is not herself God, but God's temple.[123]

In Proclus's text, Mary is herself a golden menorah and, like gold, she is not sus-ceptible to decay or corruption.[124] No previous theologian so explicitly connected Mary to the lampstand of Zechariah and no later text elaborates on Proclus's vivid description. For instance, even though the Akathistos hymn is full of Marian metaphors and Old Testament prefigurations, there is no reference to Zechariah's lamp even when Mary is likened to a torch-bearing light who kindles immaterial fire.[125]

Proclus's interpretation is unique, and the only extant manuscript witness to Proclus's second homily was produced in southern Italy. Vatican City, Biblioteca Apostolica Vaticana, MS gr. 1633 is a collection of homiletic texts that was copied in the late tenth century in an Orthodox monastery in Calabria. By 1300 the man-uscript was at Grottaferrata, the Orthodox monastery founded by Neilos of Rossano, and from there it entered the Vatican library three centuries later.[126] While the manuscript contains no information about its own loan history, there were certainly contacts between monks in the Salento and their brothers at Grotta-ferrata; in fact, the typikon of Grottaferrata was copied in 1299/1300 by a scribe trained in the Salento.[127] Thus this manuscript may well have served as textual sup-port for the unprecedented iconography at Vaste.

The fortuitous or deliberate possession of a manuscript containing Proclus's second homily may not have been sufficient to stimulate the apse paintings in Santi Stefani, however. A likely catalyst was in place some sixteen kilometers to the northeast: the monumental menorah in the Otranto cathedral that was described in 1346 by Jacobus of Verona. In Pierre Bourdieu's terminology, the Otranto menorah was a kind of cultural capital, ripe for appropriation.[128] In a clear

case of interpictoriality, the painted lampstand at Vaste evoked the precious-metal one at Otranto, which was unique in the region and surely very famous. Not only did this citation make the modest rock-cut church an imitation of the cathedral and of the houses of God (the Jewish Temple and Tabernacle) that preceded it; it also made Vaste and Nociglia, home of Santi Stefani's principal patrons [**157.A**], part of an ongoing dialogue with the numerous Jewish inhabitants of the Salento. I think it is no coincidence that the Jews read chapter 4 of Zechariah on the Sabbath of Hanukkah and Proclus's second homily was read on the feast of the Nativity; the dates would be very close every year.

Other calendrical and textual contiguities suggest that the planners of Santi Stefani's late medieval program anticipated intensive use of the church around Christmastime. The Vaste church is dedicated to Saint Stephen, whose feast day is December 27 in the Orthodox church and December 26 in the Roman calendar. Proclus's Incarnation homily in Vat. gr. 1633 is immediately followed by three homilies on Saint Stephen,[129] who is—coincidentally or not—depicted three times in the 1379/80 fresco layer. In addition, Saint John, the apostle and author of Revelation, is celebrated on December 27 in the Roman church.[130] Perhaps the "oblate" (ὀβφέρτου) George, who kneels beside the Virgin and Child, was the church's custodian during the rest of the year [**157.G**]. That this was not a monastery church is evident from the painted presence of an unprecedented number of female supplicants in addition to at least five secular males.

While the Vaste crypt almost certainly served a funerary function, like most medieval churches, burial rites did not require three apses or a templon barrier. Santi Stefani must have hosted the Orthodox liturgy, at least around the year 1000, the date of its earliest, very Byzantine-looking frescoes. At issue is whether the church continued to serve that function, or whether the barrier might have remained intact even if the rite in the church later changed. Numerous iconographic and compositional features here—the absence of bishops in the sanctuary (cf. **113.sc.2**), the kneeling devotional poses, the paternosters held by many supplicants—suggest a significant distance from Orthodox wall paintings both inside and outside the Byzantine realm. Yet the saints are the traditional ones [**157.st**], with the exception of Eligius (and even he wears some Orthodox ecclesiastical accoutrements [**157.C**]) and the apocalyptic Woman in the apse. The inscriptional language is Greek throughout. Like Otranto and Andrano, Vaste is a case in which features that are usually associated with different cultural groups are mixed or accommodated in a single site or monument.

Cultural contact and cultural transfer (the German term *Kulturtransfer* was coined in the 1980s) occur most readily within social strata. Artists appropriate from other artists when their professional identity is more important than their ethnic or religious identity.[131] Women were agents of culture through daily

gynosociability. Elite patrons imitated others of their class regardless of confessional and linguistic group. We have seen how they commissioned formulaic inscriptions that emphasize personal names and intricacies of dating, and they are most often represented wearing red, the most expensive dye and the most potent apotropaic hue.

Beyond "Influence": The Terminology of Cultural Contact

How should we characterize the medieval Salento? With its waves of foreign invaders, the region fits the definition of a "contact zone," a "space of colonial encounters . . . in which peoples geographically and historically separated come into contact with each other and establish ongoing relations."[132] Cultural mixing (and cultural transfer) occurs most easily in contact zones, although in the right circumstances it can happen anywhere. Mariam Rosser-Owen reports an observation by Peregrine Horden, coauthor of *The Corrupting Sea*, that cultural mixing is the norm in all societies but is simply more visible in the Mediterranean.[133] I do not claim that cultural mixing and its visual and material manifestations are unique to the medieval Salento; the whole crusader-era Levant is certainly another such zone, as are Spain, Norman Sicily, and Cyprus. Yet it is worth recalling Jacobus of Verona's astonishment about the proximity of Jews and Christians here, in one of the few areas in the central or western Mediterranean in which Orthodox and Roman-rite Christians also interacted at all social levels over many centuries.

An older term to describe the effects of cultural contact on the medieval visual and material record is "influence." Influence implies powerful artistic centers or individuals imposing their artistic choices on less-powerful recipients incapable of resistance or independence. This notion is currently unfashionable;[134] it has largely been superseded by "appropriation." Appropriation emphasizes agency; it is not unlike "borrowing" but lacks the latter's implication of someday being repaid.[135] The term thus responds to "influence" by restoring power to those doing the appropriating.[136]

At the Orthodox monastery of Santa Maria di Cerrate, a large-scale, Latin-inscribed supplicant and Gothic-looking architecture are included in the Koimesis fresco installed over earlier paintings in the fourteenth century [**114.E; Plate 15**]. Into a scene familiar to adherents of both Christian confessions the artist has inserted fictive architecture quite foreign to the region; indeed, he may have had specific structures in Bologna in mind.[137] This novelty is a highly personal one-off without any progeny or impact. Large kneeling supplicants were already depicted frequently in churches that hosted the Roman rite [e.g., **28**] but, in sharp

contrast to the supplicants at Santa Maria del Casale, at Cerrate the praying figure is isolated in a separate aedicula that precludes direct interaction with the figures in the Koimesis. Thus the innovations make the fresco only slightly less Byzantine-looking (keeping in mind that "Byzantine" is not a monolithic entity), and perhaps the deviations are visible mostly to sharp-eyed art historians.[138] Overall, the Marian image remains the "canonical" one and the monks at Cerrate must have approved, because this painting was never covered by another one. It was possible to alter iconography in minor ways without abandoning the Orthodox "horizon of expectations" for religious representation (to use Hans Jauss's term). Inserting the Woman of the Apocalypse into the apse at Vaste rather than a more traditional image of the Virgin—which would have worked just as well in conjunction with Proclus's Incarnation homily, Zechariah's lampstand, and the Otranto menorah—is another unique appropriation that, on its own, is insufficient evidence of a broader phenomenon such as acculturation.

This last term, derived from anthropology, was initially used by historians to explain cultural processes in medieval Spain. It was recently introduced into South Italian history as the subtitle of a book by Annick Peters-Custot.[139] She identifies a process of *acculturation en douceur*—gradual acculturation, not imposed from above or outside—in the region's historical record. The main difficulty with "acculturation" is its implicit assumption that individuals and groups acculturate progressively, inexorably proceeding along a continuum toward some ultimate completion of the cultural process.[140] It further implies that change (in this case, the introduction of novel visual forms) occurs in one direction only and that the subaltern culture merely imitates rather than adapts these forms to its own uses.

This definition leaves little room for what we might call an anti-acculturation impulse, for which there is abundant, if indirect, local evidence. Resistance to Norman cultural absorption has been posited on the basis of naming patterns in Latin charters,[141] and the persistence of Greek inscriptions and graffiti long after the widespread penetration of Italian is another example [**80.B**]. Peters-Custot observes an "explosion of Italo-Greek culture" from the mid-thirteenth to the mid-fourteenth century, while André Jacob, focusing on increased copying of Greek manuscripts in the Salento, narrows this to the period between 1280 and 1320. He interprets this manuscript production as a form of resistance by Orthodox priests to increasing "latinization"[142] under the Angevins, but perhaps we should read this not so much as a reaction to external pressure as an internal concern for identity, a fear of losing self-definition. The biggest body of evidence for resistance to Roman-rite acculturation in the Salento is the long survival of Orthodox churches. Similarly, Jews opposed Christian pressures to convert by continuing to renovate synagogues even into the fifteenth century [**56**] and by switching from bilingual epitaphs to exclusively Hebrew ones—and then, for a time, eschewing

stones entirely, if that is the correct way to read the absence of Jewish tombstones between the ninth century and 1290 [**149**] (and this stone is outside the Salento proper).

What we do not see in the Salento, given the paucity of preserved Jewish material, is the kind of "inward acculturation" described by Ivan Marcus for Jews in medieval Ashkenaz and Katrin Kogman-Appel for Jews in medieval Spain. Marcus coined the term to describe the Jews' selective absorption of parts of Christian culture in order to negate and reshape them polemically.[143] He rightly notes that "the medieval Christian environment contributed to the process of Jewish self-definition," but the reverse is also true; Christianity has always defined itself through and against Judaism.[144] Moreover, he writes, "this interactive dynamic was possible in medieval Europe because of the public character of Jewish rites of passage," a statement that can readily be expanded to include Christian public rituals and practices. The representation of Jewish male head coverings very likely records those worn by some local Jews. Perhaps the knife held by the elderly Jew at Acquarica del Capo evokes local Jewish butchers, inserted here to underscore the malice of the Jews [**Plate 1**]. Between the two Christian groups in the Salento it is impossible to recognize a single polemical episode in the visual and material record.

Other terms engage with the teleological and imitative assumptions of "acculturation." The Cuban ethnographer Fernando Ortíz proposed that his neologism "transculturation" is a more accurate term because cultural contact affects both sides.[145] Imitation or acquisition of culture here gives way to more complex adaptations, both a diminishing "deculturation" and the creation of new cultural phenomena ("neoculturation"). Thus the subordinated groups in contact zones—both the Greek-speaking Orthodox and the Jewish minorities in the Salento—select from forms transmitted by the dominant (Latinate, Roman-rite) culture and create something new.[146] At the same time, dominant groups select from minorities. For instance, most of the stylistically "progressive" church interiors of the fourteenth and early fifteenth century [**113.st.1**] adopt the typically Byzantine composition of standing saints in the lower zones that was used four centuries earlier at Carpignano [**32**], and some of these saints are identified with medallion abbreviations that imitate those used on Orthodox icons [**80.st.1**]. The emphasis of transculturation is on the diverse creative aspects of cultural contact, on hybridity as constitutive of local culture.[147] This dynamic activity occurs in multiple directions and results in texts, artifacts, and cultures that are "hybrid" or mixed. Nevertheless, as Finbarr Barry Flood put it in his recent study of Hindu-Muslim encounters, "to emphasize the historical importance of . . . transcultural communication is to deny

neither the existence nor the perception and representation of cultural, ethnic, linguistic, and religious difference."[148] Transculturation implies heterogeneity.

"Hybridity" is a term derived from botany and biology, but beyond the cross-breeding of species it refers to disparate elements combining to form a new whole. Hybridity, in John Hutnyk's concise words, "evokes all manner of creative engagements in cultural exchange."[149] It is prominent in cultural studies where it "denotes a wide register of multiple identity, cross-over, pick-'n'-mix, boundary-crossing experiences and styles."[150] Indeed, the recent popularity of the term has evoked an "anti-hybridity backlash," with critics dismissing it as "multiculturalism lite."[151] William Tronzo has critiqued assumptions about "cultural hybridity" as it pertains to the medieval Mediterranean. He questions the emphasis on commonalities rather than differences and points out that the term is imbued with a positive ideal of cross-culturalism.[152] While I have highlighted creative fusion where it occurs, it is not apparent in every Salentine object or monument and perhaps not even in a majority of them. The sites spotlighted above under "Crossing Cultural Borders" are particularly revealing about the complexities of local culture, but to say that these works occupy a culturally hybridized realm takes the agency away from their producers and users. It is best to resist the term "hybridity" in these cases.

An older term that deserves to be restored to the already crowded semantics of cultural process is "syncretism." It has been contentious because nineteenth-century missionaries employed it to signal religious contamination and deviance, but if we move beyond that it is a useful portmanteau. Some scholars limit it to the sphere of religion and ritual, but "cultural syncretism" has been employed to describe the southern Italian situation under Norman rule.[153] As Rosser-Owen argues, "syncretism has the merit of permitting the recognition of disparity without imposing a need to study only those elements which are perceived to be held in common," thus addressing Tronzo's concern about "hybridity."[154]

"Translation" has been a frequent metaphor in many disciplines since translation studies emerged as a field around 1980.[155] As the social and cultural historian Peter Burke puts it, "Individual translators adapt exotic items (texts, religions, styles of building and so on) to local cultural contexts, and these adaptations are sometimes successful in the sense of being taken up by other people and eventually becoming part of local tradition."[156] The linguistic terminology is appealing, not only because cultural features are often mediated through language but also because we tend to infer the presence of specific visual languages even when defining them is difficult and, as here, it is impossible to associate them with different faith or language groups. In addition, the various types of textual bilingualism in the Salento echo and in some cases compose the visual evidence (see Chapter 2). Acts of translation both recapitulate and alter the original, and historically the

introduction of new translations has brought about social change (examples include the introduction, via translation, of Arabic science into twelfth-century Europe, or Anglo-Saxon missionaries in Frankish Germany).[157] By lowering cultural barriers and making formerly unknown and unattainable things accessible, translation leads to transculturation. Because the translation process is performed by individuals and is not automatic, the term presumes individual agency (of artists, patrons, readers, viewers) in contrast to the seemingly inevitable and depersonalized processes of acculturation and hybridization.

New terms to describe intercultural complexity are being proffered with rather frightening regularity: "rhizome," "palimpsest," "entanglement" all have their supporters.[158] In the end, which locution best expresses the visual choices made in the medieval Salento? This matters less than the recognition that the cultural materials being translated are always already transcultured themselves; they are moving between cultures in process, porous rather than finite entities.[159] We should understand the overlapping theoretical models of cultural contact and the processes they illuminate as potentially simultaneous and continuous. There never was a time when the medieval population of the Salento—whether or not one agrees with the chronological and geographical parameters outlined in the Introduction—was not already selectively appropriating from its neighbors and producing syncretized visual forms in a process of continuous multidirectional transculturation.[160] However, as visual syncretism increased there was less artistic variety. Peters-Custot identified the major "rupture" in the independent identity of the shrinking population of Greek speakers in the mid-thirteenth century,[161] and Vera von Falkenhausen observed that by the end of the Middle Ages, few traces of earlier diversity remained.[162] Homogenization only increased with the forced eviction of the region's Jewish population beginning in the late thirteenth century and ending definitively in 1541, and the declining Orthodox population entirely disappeared by the seventeenth century.

Thinking in terms of cultural translations and transculturation helps shift emphasis away from the notion of hostile or oppositional borders. Despite being historical and social constructions, conceptual borders such as those between "East" and "West" or "Greeks" and "Latins" have been, and remain, cognitive barriers.[163] But while the latter paired antonym appears in textual sources that are not public and not art, it is not visible "on the ground," where engagement with cultural differences is just as often consensual as conflictual.[164] It is impossible to assess art in the Salento (or any region) responsibly if it is only viewed from the perspective of the ostensibly less messy and certainly larger political, geographical, and cultural entities that frame it. Nor can we permit ourselves to fall into old-fashioned value judgments about centers and peripheries. It is the inherent

and unstable in-betweenness that makes the region intriguing. Its already syn-cretic medieval identity was constantly in the process of construction and nego-tiation and its visual and material landscape reflected and abetted this transculturative process.

Whether or not an individual is named in Salentine medieval art as an artist, patron, or supplicant, dead or alive, that individual was always part of a public whole—what one scholar has described as a kind of knot or node within a larger cultural fabric.[165] Despite the presence of names, it is impossible to recover most individuals' historical identities from the kinds of data considered here: only two are "known" from more than a single monument (Bishop Donadeus of Castro [**4.B, 35**] and the priest Sarulus of Mottola, if he is indeed a single entity [**75.A, 76.C**]). I have examined the material and visual results of choices made by other-wise unknown individuals under the impact of larger collective trends. In other words, no one forced Antony and Doulitzia to be depicted in a certain way at Vaste [**157.A**], but presumably they collaborated with others—an artist, spiritual adviser, family, neighbors, the local "priest George" [**157.G**]—in electing to be shown in particular ways in a specific narrative context accompanied by text in a chosen language because they and their communities in Nociglia and at Santi Stefani had certain expectations, values, tolerances, and goals. Such patrons and supplicants were free to select and adapt features and forms from everything in their collective visual and material environment, including things they may never have seen but only heard about, like the monumental menorah at Otranto or a venerable homily by Proclus. Nevertheless, the presence of kneeling figures and paternosters does not necessarily confer the same meaning when we see those things in other sites, and the menorah at Vaste and the one at Otranto had related, but also very differ-ent, makers, audiences, and messages.

Beyond Hyphenation

What should the art of the Salento be called, and should the same term refer to the local makers and users whose practices and beliefs both effected it and were affected by it? None of the ethnic and pseudo-ethnic labels discussed earlier in this chapter, whether etic or emic, is able to account for the complexities on the ground because they all attempt to circumscribe changing peoples and cultures. What we need is terminology that accounts for both the easily categorized artifacts and the messy transcultured ones. A sizable subset of both these categories is con-nected with users of Greek. In his many important publications André Jacob has called them "Byzantines," "Greeks," or "Italo-Greeks," depending on whether he

is discussing liturgy, paleography, or ritual. Peters-Custot prefers "Italo-Greeks" to "Greeks" (too univocal) or "Byzantines" (too political), but acknowledges that this is merely the "least imperfect" term.[166] I agree that neither of the latter is appropriate for the people and their products after the period of Byzantine rule. "Italo-Greek" is the noun and adjective most often used.[167] Yet on the one hand, that term is too broad because it refers to the whole of southern Italy, to Calabria, Basilicata, and sometimes to Sicily in addition to the Salento, even if these regions had quite different cultural developments. On the other hand, "Italo-Greek" is too narrow: it excludes any but Greek users and, by extension, the non-Orthodox population; it ignores those who used Latin, Hebrew, or local dialects in conjunction with Christian Roman or Jewish Romaniote rites; and it does not accommodate the linguistic and cultural "bilingualisms" and syncretisms we have traced throughout this book. Even if we limit the term the way Peters-Custot does and include only those mainland southern Italians formerly under Byzantine rule who spoke Greek, we have seen that at least some identified themselves as *Graikoi* or *Gregi* and not as "Italo-Greeks." Clearly, the hyphenated phrase cannot accommodate the range of people or visual culture produced in this region, and using it for the whole of the Italian South elides important and numerous differences.[168]

In the twenty-first century we are used to such hyphenated (or nested or plural or diasporic) identities as Jewish-American, French-Canadian, German-Turkish. Even if we do not intend to "harden" these identities by associating them with specific practices and with a single hypothetical "Jewish-American" or "French-Canadian" or "German-Turkish" culture, it is very difficult to speak about them in a nonbounded way. Anthropologists, sociologists, and others who work on such "hyphenated communities" have demonstrated that there are countless ways to respond to the situation of multiple identities, which ultimately makes such terms not very useful unless one is fully cognizant of their open-endedness. Similarly, no hyphenated term can truly represent the range of cultural transfers and cultural products in the medieval Salento.[169]

My own preference for nomenclature is by now obvious. We should identify these people and their ever-adapting culture and art with a regional noun or adjective: Salento or Salentine. The varied medieval visual culture of the region has more in common with intraregional works than with external ones. The extant Jewish tombstones have a unique method of communicating the date, there is a specific "rite of Lecce," and tenth-century Jews in Constantinople were already, it seems, using the term "Salento." Greek devotional inscriptions favor formulas that differentiate them from supplications in other regions. Both the Greek and Hebrew book hands in the region are *sui generis* and so are many of the region's social and cultural practices and rituals. The region as a whole shares history, geography, and

even some DNA: Michael McCormick identified a specific genetic trait in the population of southern Italy since early Byzantine times.[170] Local history and memory contributed to an unconscious habitus that forged regionally specific sensibilities.[171] Even if it is popular to talk about the Mediterranean as a unifying entity,[172] it is important not to lose sight of regional variation.

On the many occasions when I have shown images of medieval Salentine painting to scholars of Byzantine or European medieval art, they have been puzzled—and fascinated—by the unexpected blend of strangeness and familiarity. These paintings, tombstones, and other public art rarely fit comfortably into larger categories because they were made to meet the needs of people in a very particular regional and historical context. We can look disdainfully at this art as provincial or peculiar, or we can relish it on its own terms and appreciate how it opens a window onto a world whose inhabitants are otherwise largely inaccessible; visual and material production overlaps with, but also differs from, the world of nonpublic book texts. While local art reveals formulaic qualities, like all medieval art, it is also characterized by an openness to variety, especially stylistic heterogeneity. I doubt that viewers were troubled by the multiplicity of styles visible in such palimpsest sites as San Pietro at Otranto or Santi Stefani at Vaste. With few exceptions, stylistic distinctions are likely to have taken the form of "new" versus "old" rather than "Byzantine" versus "Western" or "Orthodox" versus "Roman-rite." There is no evidence to suggest that different styles or altered iconographies were equated locally with different cultural groups[173] and even less to indicate that these groups did battle through the medium of art.

In the end, medieval identity is a collective issue more than a personal one. This book has shown how groups, through their individual members, constructed and maintained their social and cultural identities through visual means. While a Greek-speaking Salentine villager could not read the high-level hexameters in some Latin tombstones at Brindisi, the visibility of those texts—their visual and material existence—helped form his view of the significance of texts as a whole, just as the presence of individuals or family groups in one painted church persuaded users of another to include similar images, to exclude them, or to alter them to satisfy their own desires and circumstances. Seeing how people were born or buried or conducted their religious or daily activities in public activated the same series of potential responses—imitation, rejection, adaptation—and when the actors and audience belonged to different groups (cultural, linguistic, religious, economic, or social) translation and transculturation could occur. The proximity of these groups facilitated and probably compelled such interaction.

Historical evidence is always fragmentary, but it is possible to form a more complete picture of the past if disciplinary boundaries are crossed and multiple theoretical and methodological perspectives are brought to bear. Small as the Salentine fragments are, when put together they form a rich mosaic, a textured microhistory. This Salento story has involved Byzantine, Jewish, and "Western" medieval studies, art history, archaeology, ethnohistory, and other fields. At the very least, it provides data that will permit others to flesh out the story from their own perspectives. While I have tried here to animate the medieval Salento, I am confident that this multitextured approach will prove rewarding for other places and times. After all, the finest mosaics are made of very small tesserae.

Sites in the Salento
with Texts and Images
Informative About Identity

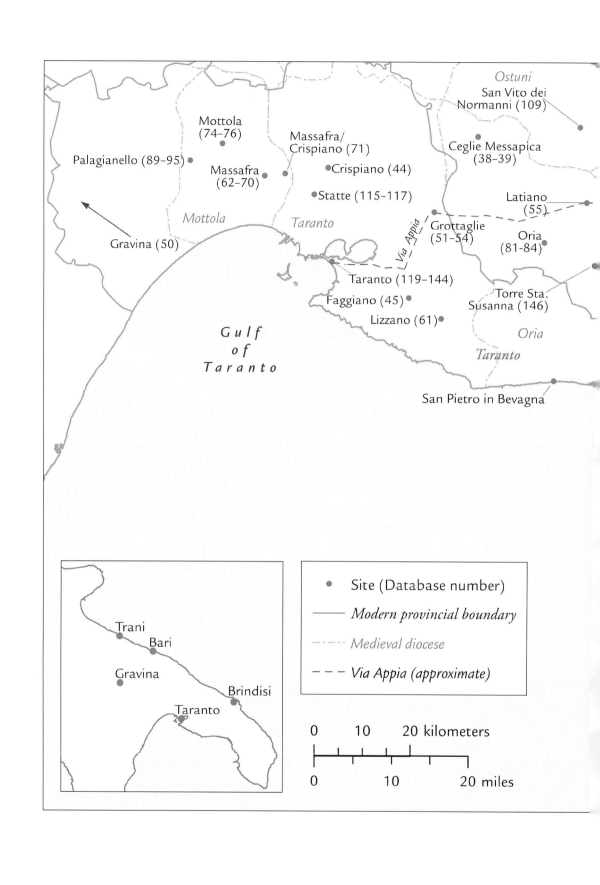

Ostuni

San Vito dei
Normanni (109)

Mottola
(74–76)

Massafra/
Crispiano (71)

Ceglie Messapica
(38–39)

Palagianello (89–95)

Massafra
(62–70)

Crispiano (44)

Statte (115–117)

Latiano
(55)

Mottola

Taranto

Via Appia

Grottaglie
(51–54)

Oria
(81–84)

Gravina (50)

Taranto (119–144)

Faggiano (45)

Lizzano (61)

Torre Sta.
Susanna (146)

Oria

Taranto

G u l f
o f
T a r a n t o

San Pietro in Bevagna

Trani

Bari

Gravina

Brindisi

Taranto

● Site (Database number)

— *Modern provincial boundary*

–·–·– *Medieval diocese*

– – – *Via Appia (approximate)*

0 10 20 kilometers

0 10 20 miles

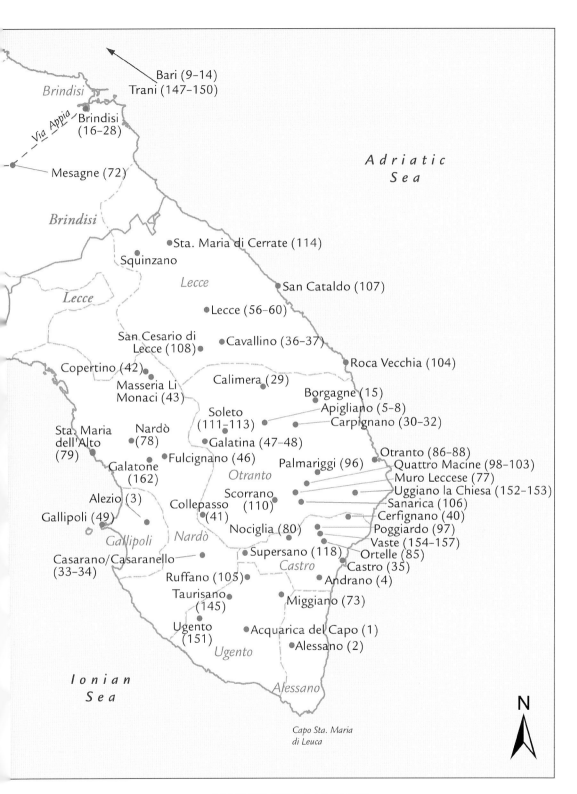

Bari (9–14)
Trani (147–150)

Brindisi

Via Appia

Brindisi
(16–28)

Mesagne (72)

Brindisi

A d r i a t i c
S e a

Lecce

Sta. Maria di Cerrate (114)

Squinzano

Lecce

San Cataldo (107)

Lecce (56–60)

San Cesario di
Lecce (108)

Cavallino (36–37)

Copertino (42)

Roca Vecchia (104)

Calimera (29)

Masseria Li
Monaci (43)

Borgagne (15)
Apigliano (5–8)
Carpignano (30–32)

Soleto
(111–113)

Sta. Maria
dell'Alto
(79)

Nardò
(78)

Galatina (47–48)

Otranto (86–88)
Quattro Macine (98–103)
Muro Leccese (77)
Uggiano la Chiesa (152–153)
Sanarica (106)
Cerfignano (40)
Poggiardo (97)
Vaste (154–157)
Ortelle (85)
Castro (35)

Galatone
(162)

Fulcignano (46)

Palmariggi (96)

Otranto

Alezio (3)

Gallipoli (49)

Collepasso
(41)

Scorrano
(110)

Nociglia (80)

Gallipoli

Nardò

Casarano/Casaranello
(33–34)

Supersano (118)

Castro

Ruffano (105)

Andrano (4)

Taurisano
(145)

Miggiano (73)

Ugento
(151)

Acquarica del Capo (1)

Alessano (2)

Ugento

I o n i a n
S e a

Alessano

Capo Sta. Maria
di Leuca

N

MAP OF THE SALENTO
WITH SITES IN THE DATABASE

Courtesy Margretta de Vries

Note to the Reader

The Introduction (pages 15–16) discusses the criteria for inclusion in the Database. Sites are arranged and numbered alphabetically, with the name of each city, town, or village followed by its modern Italian province in parentheses and by the name of the specific structure or kind of work within each site. If the work can be dated, this appears in boldface type. This is followed by measurements or other specific details.

Every relevant inscription or image within that site is identified; if there are several, they are labeled with capital letters (**A**, **B**, **C**, and so on). Each inscription is given in the original language, followed by an English translation (unless otherwise indicated, translations are mine). If both inscriptions and images exist, the former precede the latter. Works of unknown provenance are alphabetized according to their current location.

Pictorial graffiti (**pg**) are listed separately from textual graffiti, which are considered inscriptions. These are followed by a list of narrative scenes (**sc**) and identifiable saints (**st**). With very few exceptions, representations of Christ and the Virgin are not included because they are ubiquitous and uninformative about matters of personal or regional identity.

Each entry concludes with a short bibliography that emphasizes recent literature. Notes in the text do not duplicate this bibliography.

An asterisk (*) indicates an accompanying photograph.

The standard format for a Database entry follows.

LOCATION (MODERN PROVINCE)

1. Name of Monument or Artifact, overall date of medieval texts and images
Details about monument, location, measurements (height × width × depth)

1.A, B, C… inscription/graffito/image, position in monument, date
Transcription†
English translation

1.pg list of pictorial graffiti
1.sc list of narrative and multifigure scenes
1.st list of identifiable saints (excludes Christ and the Virgin except in special cases)

Brief bibliography (bibliography on specific inscriptions follows some entries).

† Unless otherwise indicated, the original Greek inscriptions are in unaccented capitals. The Database provides diplomatic transcriptions, in which the Greek texts retain their original spellings, breathing marks, and accentuation but are lowercased (except for proper names) to facilitate readability; in addition, abbreviations have been resolved and obvious missing text restored.

Descriptions and directions are from the perspective of the viewer.

Conventions for inscriptions
 n.v. = *non vidi*
 () = resolution of abbreviation
 [] = restoration of lost text
 ? = reading of letter uncertain
 < > = corrected text
 { } = superfluous text, to be ignored
 . . . = missing letters
 // = background color change
[- - -] = broken Hebrew text

ACQUARICA DEL CAPO (LECCE)

1. San Nicola, 1282/83

Single-nave basilica at base of later tower in abandoned Masseria Celsorizzo (former *casale* of Cicivizzo)

1.A* dedicatory inscription, west wall

ANNO AB I(N)CARNATIO(N)E . D(OMI)NI [MILLESIMO]
DVCE[N]TES(IMO) OCTA[GESIMO TERCIO INDICTIONE] /.VND(E)CI(M)A .
REGNA[NTE ILLU]STRISS(IM)O D(OMI)NO NOSTRO KAR[O]LO
[IHERVSALEM ET SICILIE] / REGE . D[IE . MENSIS . . . APR]ILIS
IOH(ANNE)S D(E) OGE(N)TO CASALIS CICIVICI D(OMI)N(V)S
[V]NA CV(M) DOM[I]N[.] / [. . .]IE . S [UORUM] DVCTUS P[ECCATORUM]
RE(M)ITIO(N)[E] ET BENEFICATIO(N)E ANIME SVE [ET] PAR[ENT]V(M)
SVOR(VM) / [BA]SILICA[M ISTAM CONST]RVI (ET) PI(N)GI
FEC(IT) [A]D HO(NO)RE(M) DEI (ET) BEATI NICOLAI EP(ISCOP)I /
[G]LO(RIO)SI CO(N)F[ESSORIS]. + Εζωγραφήθη [διὰ] / χειρος N[. . .]
Μελιτίνου κ[αὶ] / [N]ικολ[άου . . .]

In the one thousandth two hundredth and eighty-third year from the Incarnation of the Lord, eleventh indiction, while our most illustrious lord Charles, king [of Jerusalem and Sicily] was reigning, on the [. . .] day in the month of April, John of Ugento, lord of the casale of Cicivizzo, together with the lady [. . .]ie, motivated by the remission of his sins and benefit of his soul and those of his parents, had this basilica built and painted in honor of God and of blessed bishop Nicholas, the glorious confessor. It has been painted by the hand of N[. . .] Melitinos and [N]ichol[as . . .]

line 4, cf. Berger and Jacob, "S [......] DVCTUS P(RO) RE(M)ITIO(N)[E]"

1.pg concentric circles, circles with incribed eight-petal rosette, bird, shield, standing figure with arms akimbo, standing figure with arms akimbo holding sword and shield, standing figure with small round object, circle divided into eighths, striped triangle (sail?)

1.sc Annunciation, Nativity, Presentation, Baptism, Transfiguration, Lazarus, Entry into Jerusalem, Last Supper, Betrayal of Christ [**Plate 1**], Transfiguration, Crucifixion, Anastasis, Vision of Daniel/Ancient of Days

1.st Basil, John Chrysostom, Vincent, Agatha, George on horseback, Hippolytus on horseback, Nicholas, Cosmas, Damian, Stephen

Berger and Jacob, "Nouveau monument"; M. Berger, "Représentation byzantine"; M. Berger, "Fresques du chevet"; Safran, "Language Choice," esp. 875–79.

1.A

ALESSANO (LECCE)

2. Funerary inscription, 1130

Lecce, Museo Provinciale "Sigismondo Castromediano," no. 5164; 58 × 37 × 10 cm

2.A front

+ Ἐκοιμήθη ὁ / δουλος τοῦ / θ(εο)ῦ οὖβου / μη(νι)
ἀ[π]ριλ(ίῳ) εἰς τ(ας) κ̄ ε̄ / ἐτ(ει, ους, ος) ͵[ϛ̄] χ̄ λ̄ η̄

The servant of God Hugh died on April 25, 6638 (=1130).

row of dots enclosed by circles at top left probably continued across damaged side

2.B back

four-petal floral/star

2.C left side

nimbed figure (*n.v.*)

Jacob, "Notes," 74–78; Guillou, *Recueil*, 168–69, no. 152.

ALEZIO (LECCE)

3. Santa Maria della Lizza (formerly Cathedral of Sant'Agatha and before that Santa Maria de Cruciata), thirteenth–fifteenth century

Single-nave basilica with vaulted pronaos

3.pg thirteen (?) painted shields, profile faces, bird, on right pilaster

 See Plate 2

3.sc Annunciation, Nativity, Dormition

3.st Stephen, Elijah, Marina, Nicholas

Jacob, "Gallipoli," 288–98; Falla Castelfranchi, *Pittura monumentale*, 222–33.

ANDRANO (LECCE)

4. Dedicatory stela with two inscribed sides, 1372/73

Lecce, Museo Provinciale "Sigismondo Castromediano," no. 54; 46.5 × 46 × 21 cm

4.A* front (wide)

Ἀνικοδομ[ηθη] ο [π]αρον ξε/νόνας ίτη σπητάλη δια κόπου /
κα[ι ε]ξόδου κυροῦ Γεωργίου / τοῦ Λόγγου και τη[ς] συμβίου
αυτοῦ / Γέμας ή τις δὲ ποτὲ καιρῶν βου/λήθη αφελην απο
τον πραγμάτω/ν τοῦ σπηταλίου να ἔχη τιν αρὰν / τον τ̄ῑη̄
Θεοφορων π(ατε)ρων και του ηκου/[με]νηκοῦ πάπα Ρόμης
εγεγόνη επὶ ετ(ους) ϛ̄ ω̄ π̄ ᾱ / ιν(δικτιῶνος) ῑᾱ. / continued from
side: [αρ]ακοντα η[με]ρα[ς σ]υνχω/[ρη]/σεως.

4.B* side (narrow)

Γεώργι Λόγγου του / χωρίου Ανδράνου / θελήματι Θ(εο)υ
ἐπο[ι]/ήσε σπηταληου κε / παρεκάλεσε Δουνα/δδεος
επισκοπου / Καστρου Ιωάννην / επίσκοπου Ουγιέν/του κ(αὶ)

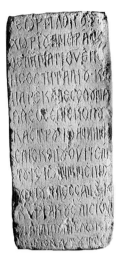

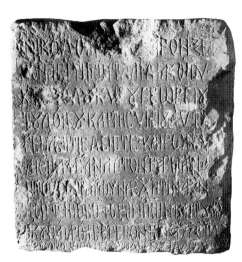

4.A (right)
Photo: Museo Provinciale di Lecce.

4.B (left)
Photo: Museo Provinciale di Lecce.

Ιωάννην ἐπισ/κοπου Αλεσσανου κ(αὶ) / Κυρίακου επισκοπ/
ου Γαλλίοπουλι εδω(και) κ(αι) / λειπον αυτου τεσσ/ + last line
on front

*The present hostel, that is, hospital, was built by the efforts and at the expense of
George Longo and his wife, Gemma. If anyone should some day try to remove the
property of the hospital he will receive the curses of the 318 theophoric fathers and of
the ecumenical pope of Rome. This was done in the year 6881 (=1372/73) during the
eleventh indiction.*

*George Longo of the village of Andrano made this hospital by the will of God and
invited Donadeus, bishop of Castro, John, bishop of Ugento, and John, bishop of
Alessano, and Cyriakus, bishop of Gallipoli. And thus he accords him forty days of
indulgence.*

Jacob, "Fondation d'hôpital"; Safran, "Jewish and Greek"; Guillou, *Recueil*, 174–75, nos. 162–63.

APIGLIANO (LECCE)

Abandoned village near Martano

5. Metrical funerary inscription, first third of eleventh century

University of Salento, Museo storico-artistico, no. 164187; limestone fragment reused in
child's tomb #13; 26 × 23 × 8.8 cm

πηλθ[ο]νχ. . . / .[..]εξω μπιασ . . . / . . . σηρο[. .] .ρον ωδο . . .
βι[. . .] / [φύ]λαττε ουτ[ο]ν κα[. . .]ον[. . .] / ρις ημερων ηξ
[. . .]οσσ[. . .] / μνου ταύτης χ[ε]ρσιν [. . . Λέ]/οντος
πρ(εσ)βύτ(έρου) + τοῦ πα[. . .]τος μενία + ὀψὲ κ(αὶ) νύξ κ(αι)
ε . . . / ἡ ἐξ ὀμμάτων εμ / κ(αι) ποδῶν αι κινίσις + α / πτος
λαλία + πανταπει. . . / [κα]λυπτει + μόνον [φ]ύλαττε θύτ[η]ν
/ λας + επεῖχανδῶν λ. . . / ις. . .

*. . . / outside / . . . protect him [and] /. . . days . . . grant / . . . of her hands . . . / . . .
priest Leo / . . . after and night and . . . / or from eyes . . . / and movements of feet /
. . . and any kind of calling(?). . . covers/protects the sacrificer . . .*

Piliego, "Iscrizioni bizantine," 97–103; unreliable transcription partly corrected by Jacob, "Apigliano,"
134–37; Jacob, "Épigraphie," 170.

6. Funerary inscription, first third of eleventh century

Two pieces: left = University of Salento, Laboratorio di archeologia medievale,
AP 98.SF.338.56; 25 × 18 × 8 cm; right = AP 97 400.SF.1 (found in later hole dug inside
apse of church); 26 × 15 × 7 cm.

left:

κ / δε / δώ / γουν / λωλυ / ρασαι / ++υς / + εκ μη φ

right:

ε / + μρ / μονα / θει / γόν / μας+ / ων κ / ντε / + ας μα /
σφά[λ]ε / του[τ]ο εκ / μα εσύλας / συ]νθρόνου αλ / ντ

. . . the servant of God died . . . month of February (?)

Jacob, "Apigliano," 138, linked the two fragments, correcting Piliego, "Iscrizioni bizantine," 103–6,
with unreliable transcription.

7. Funerary inscription, 1028/29

University of Salento, Laboratorio di archeologia medievale, AP 06, C.S.L. 1000;
23 × 20 × 5.06 cm

. . . τῆς ηνδ(ικτιῶνος) δεκ[α] / δ[ευ]τ(ερας) ετους ,[ϛ] φ̄ λ̄ ζ̄

twelfth indiction, year 6537 (=1028/29)

Jacob, "Apigliano," 127–32, correcting Piliego, "Iscrizioni bizantine," 107–9.

*8 Photo: P. Pulli. Courtesy Laboratory for
Medieval Archaeology, University of Salento.*

8.* Amulet in form of *mano fica*, tenth–fourteenth century (?)

Bone, with bronze suspension ring; 3.5 cm long

Bruno, "Chiese e religione," 30.

BARI (NORTH OF THE SALENTO)

9. Synagogue inscription, 1313/14

South window architrave, in situ in private house (former synagogue) on Via San Sabino
(formerly Via Sinagoga) (*n.v.*); 100 × 83 cm

שנת הדסה חלון זה נעשה[ש]
נדבת עם ביד משה דטריויש

*In the year "Hadasah" (=74), this window was made as an offering of the people by the
hand of Moses of Trivis (Trier?).*

Colafemmina, "Testimonianze epigrafiche," 42; Colafemmina, "Due nuove iscrizioni" (dated 1312–13).
The superscript abbreviation *s* indicates *al yadei*, "by the hand."

10. Funerary inscription, ninth century or later

Formerly Museo Archeologico Provinciale, no. 32401; lost (*n.v.*); clay; 28 × 28 × 4 cm

 10.A front

אליה בן
משה

Elijah son of Moses.

10.B back

אסטרטיגו
ס

Istrategos.

Colafemmina and Gramegna, *Sinagoga Museo*, 27; Colafemmina, "Insediamento ebraico," 519;
U. Cassuto, "Iscrizioni ebraiche a Bari," 322.

11. Funerary inscription, ninth century or later

Formerly Museo Archeologico Provinciale, no. 32402; lost (*n.v.*); limestone;
25.5 × 35 × 8–5.6 cm

11.A front

פה ינוח [בזכרו]ן
טוב דויד בן
מנשה אשר חי
ארבע וחמשים
שנה יבוא שלו[ם]
[וינוח על מנוחתו]

*Here lies in good memory David son of Menashe, who lived fifty-four years; may peace
dwell on his rest.*

11.B back
menorah between two shofars

Colafemmina, "Insediamento ebraico," 519; U. Cassuto, "Iscrizioni ebraiche a Bari," 320.

12. Funerary inscription, ninth century or later

Formerly Museo Archeologico Provinciale, no. 32403; lost (*n.v.*); limestone;
20 × 31 × 8.3–8.7 cm

12.A upper part of frame, rhymed prose

אורו יזרח כהיער ממזרח

His light shall shine like light from the east.

12.B recessed writing surface

[--ון] הלז הוקם
לראש זה משה בן
אליה שהיה [ז]היר
בדת הח[זויה וב]כל
[--------]

*This monument was erected at the head of Moses son of Elijah, who scrupulously
observed the religion [seen in prophecy, and in] all . . .*

12.C back
five-branch menorah flanked by shofars(?)

12.D top

[זכר]ונו לב[ר]כה

May his memory be for a blessing.

12.E right side

six-branch menorah over text

<div dir="rtl">

משנשבחו

שירי הימן

שבון[-]

</div>

The praise of Heman's songs

12.F left side

six-branch menorah, date

<div dir="rtl">

משנברא

העו (לם) [-]

</div>

From the creation of the world . . .

Colafemmina, "Insediamento ebraico," 519–20; U. Cassuto, "Iscrizioni ebraiche a Bari," 321–22.

13. Funerary inscription, ninth century or later

Formerly Museo Archeologico Provinciale, no. 32404; lost (*n.v.*); tufa; 49 × 33 × 10 cm

13 Photo: Cesare Colafemmina. Courtesy CeRDEM–Centro di Ricerche e Documentazione sull'Ebraismo nel Mediterraneo "Cesare Colafemmina."

13.A* front

<div dir="rtl">

פה נ[א]סף יוסף

בר ש[מוא]ל

[-------]

תנוח [----]

עד [--] בכוסף

יבוא שלום

[ו]ינוח על משכבו

</div>

Here is received Joseph son of Samuel . . . may he rest . . . in the bond of life until . . . with desire. May peace and rest repose on his tomb.

13.B frame

nine(?) concentric compass-drawn circles

Colafemmina, "Insediamento ebraico," 521; U. Cassuto, "Iscrizioni ebraiche a Bari," 321–22. There is another stela in Bari "with frame decorated with concentric circles" but with few remaining Hebrew letters; see Noy, *Jewish Inscriptions*, no. 194 (*n.v.*).

14. Funerary inscription, ninth century or later

Formerly Museo Archeologico Provinciale, lost (*n.v.*); dimensions unknown

<div dir="rtl">

פה שכב

משה בן

מדי בן ששים

שנים זכרנו

לברכה

</div>

Here lies Moses son of Madai, age sixty years. May his memory be for a blessing.

Colafemmina, "Insediamento ebraico," 521; U. Cassuto, "Iscrizioni ebraiche a Bari," 320–21.

NEAR BORGAGNE (LECCE)

15. Funerary inscription, 1135

Lost Greek text; transcribed in Italian by Cosimo De Giorgi in 1915

The servant of God Maria died November 7, 6644 (=1135), second indiction.

Jacob, "Deux épitaphes," 169 n. 23.

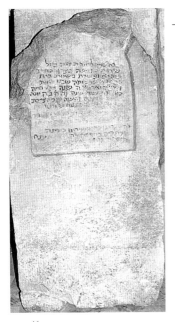

16

BRINDISI (BRINDISI)

16.* Funerary inscription, 832/33

Museo Archeologico Provinciale "F. Ribezzo," no. 1318; 106 × 54 × 30 cm

16.A front

פה שכ(ב)ת לאה בת יפה מזל
שתהא נפשה בצרור החיים
שהיא נפטרת משחרב בית
המקדש עד מותה שבע מאות
וששים וארבעה שנה וימי חייה
היו שבע עשר שנה דהקבה יזכה
אותה להקים נפשה עים הצדקת
ותבוא שלום ותנוח על מנוחתה
שומרי גינזי גן עדן פיתחו לה שערי
גן עדן ותבוא לאה לגן עדן פיתחו
לה שערי גן עדן מחמדים בימינה
וממתקים בישמואלה זאת תענה
ותאמר לה זה זה דודי וזה ריעי

Here lies Leah, daughter of Yafeh Mazal [=Eutychios], may her soul be in the bond of life, who died in the year 764 since the destruction of the Temple, at the age of seventeen. May the holy one, blessed be he, grant that she resurrect her soul with the pious woman, and may she enter into peace and repose in her resting place. Guardians of the treasures of the Garden of Eden! Open for her the gates of the Garden of Eden, and Leah may enter the Garden of Eden. Open for her the gates of the Garden of Eden, that she may have delightful things to her right and sweet things to her left. This [you] should answer and tell her, "This is my beloved, my companion."

16.B ornament

front
menorah base

sides
shofars

Colafemmina, "Insediamenti e condizioni," 220; Colafemmina, "Iscrizioni ebraiche," 100–104; *Corpus Inscriptionum Hebraicarum*, ed. Khvol'son, cols. 163–64, no. 83; Ascoli, *Iscrizioni*, 66–67, no. 24.

17. Funerary inscription, eighth–tenth century

Museo Archeologico Provinciale "F. Ribezzo," no. 234; 40 × 45 × 12 cm

17.A front

[מ]שכב יוכבד
[בת צ]פורה וריבי
ומת מבן עשרים
[– –]ע שנים יבא שלום
[על] מנוחתה

Resting place of Yocheved [daughter of] Zipporah and Ribai . . . She died at twenty-[something] years. Peace be upon her rest.

17.B top

[משכ]ב יוכבד
[בת צפ]ורה ורי[ב]י
[שלו]ם על מנוחתה

Tomb of Yocheved daughter of Zipporah and Ribai. Peace on her rest.

Colafemmina, "Iscrizioni ebraiche," 92–96; *Corpus Inscriptionum Hebraicarum*, ed. Khvol'son, no. 70.

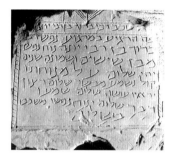

18 Photo: Cesare Colafemmina.
Courtesy CeRDEM-Centro di Ricerche
e Documentazione sull'Ebraismo nel
Mediterraneo "Cesare Colafemmina."

18. Funerary inscription, second half of ninth century

Museo Archeologico Provinciale "F. Ribezzo," no. 230; 44 × 47 × 11 cm

18.A* text

מ[שכב רבי ברוך בן רבי יונ]ה[

פה הרגיע במרביע נפש ר[בי
ברוך בן רבי יונה נוח נפש
מבן שישים ושמונה שנים
יהי שלום על מנוחתו
קול נשמע מבשר שלום רצון
יראיו עושה שלום שמעו
דבר שלום ינוח נפשו משכבו
בשלום

The resting place of Rabbi Baruch son of Rabbi Jonah.

Here reposes in the quiet of his soul Rabbi Baruch son of Rabbi Jonah, rest on his soul,
age sixty-eight years. May peace be upon his resting place. A voice is heard announcing
peace; the desire of those who fear the maker of peace. Listen to a word of peace; may
his soul rest, may his resting place be in peace.

18.B ornament

flanking text are two vertical columns, diagonally hatched (spirals?); on top, angular
menorah with nine branches

Colafemmina, "Iscrizione brindisina"; Colafemmina, "Iscrizioni ebraiche," 96–100; *Corpus Inscriptionum*
Hebraicarum, ed. Khvol'son, no. 71; Ascoli, *Iscrizioni*, no. 23.

19.* Capital or well head, eleventh century (>1059)

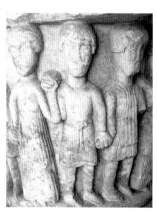

19

Museo Archeologico Provinciale "F. Ribezzo," originally from Sant'Andrea all'Isola;
marble; 95 × 95 × 95 cm; base diam. 76 cm

twelve figures under continuous arcade, two men and one woman on each side

Belli d'Elia, *Alle sorgenti*, 212, 214–15; Jurlaro, *Storia e cultura*, 76–77.

20. Dedicatory inscription on column base, first half of eleventh century

Letters approx. 5 cm tall

ILLVSTRIS PIVS ACTIB(US) . ATQ(UE) REFVLGENS /
P(RO)TOSPATHA[RIUS] LVPVS VRBEM HANC STRVXIT AB [IMO] /
QVAM IMPERATORES MAGNIFICIQ(UE) . BENIGNI . . .

Illustrious and pious in his beneficent actions, Lupus Protospatharios rebuilt this city
from the foundation, that the magnificent and benign emperors . . .

Alaggio, *Brindisi*, 137–40, 163–71; Jacob, "Reconstruction," 15–16. Good photo at http://it.wikipedia.
org/wiki/File:LupoP.jpg.

21. Cathedral of the Visitation and San Giovanni Battista, 1139–43 and later

21.A dedicatory inscription, now in sacristy
marble; 25 x 59 cm

COMPOSVIT TEMPLVM / PRESVL BAILARDVS HONEST(V)M /
AVDIAT IN CELIS: / GAVDE BONE SERVE FIDELIS

Bishop Bailardus constructed this worthy temple. May he hear in heaven, "Rejoice,
good and faithful servant!"

21.B dedicatory inscription, now in sacristy, formerly over main door
marble; 25 x 59 cm

> GLORIA VERA DEI / T(IBI) SIT REX MAGNE ROGERI / AVXILIO CVIVS / TE(M)PLI LABOR EXTITIT HVIVS.

> *May the true glory of God be yours, great King Roger, with whose help the work of this temple has come to pass.*

21.C didactic inscription, base of right apse exterior

> PETRVS FILIVS GVI(DONIS?) DE L(OC)O C[ONS]E

> *Peter, son of Guidonis (or Guilelmus) of . . .*

Jurlaro, "Epigrafi," 246–48; Jurlaro, *Storia*, 87.

21.D mosaic pavement, 1178

> (H)OC OP(VS) FIE(RI) (F)ECIT . . . [Guglielmo]

> *This work [William] had made . . .*

21.sc Adam and Eve, Cain and Abel, Noah and ark, Noah and sons; Trojan War scenes; Song of Roland

Carrino, "Il mosaico pavimentale della cattedrale di Brindisi."

22. Sant'Anna

Small basilica with sculptural frieze over door, eleventh–twelfth century; interior paintings, thirteenth–fourteenth century

22.A south wall, to lower right of enthroned archbishop
standing figure, dressed in red-brown, hands upraised toward bishop

22.B devotional inscription, brown letters (Latin) on yellow ground, above 22.A

> . . . E / MA . . . S / . . .

22.C devotional inscription, south wall, to lower right of Saint Dominic, white letters on blue

> +MEM(EN)TO D(OMI)NI [FAM]VLO [T]V[O] E . . .

> *Remember Lord your servant E . . .*

22.D devotional inscription, north wall, to lower right of enthroned Virgin and Child

> ME[MENTO DOMINE ...]

> *Remember Lord ...*

22.E devotional inscription, west wall, left of door, between hooves of Saint Theodore's horse

> (M)EM(ENTO DOMI)NE / (FA)M(UL)I (T)V(I) THE/[O]DORI DE . . .

> *Remember Lord your servant Theodore of . . .*

22.F didactic inscription on rim of bell (originally one of a pair), now in Museo Diocesano

> +DU(M) P(R)IO(R) HIC MATHEUS ERAT NOS CONDIDIT AMBAS / +SET NOS PRESBITERI MANUS EGIT BARTOLOMEII

> *While he was prior here Matthew began work on us both, / but the hand of the priest Bartholomew completed us.*

22.pg compass-drawn circles, grid, parallel lines

22.sc Presentation in Temple (Symeon with Child), Vita of Saint Margaret

22.st Michael, Theodore on horseback, Dominic, Margaret, Anna and Virgin (?), Mary Magdalene (?), Nicholas

Jurlaro, "Epigrafi," 250–51; Guglielmi, *Affreschi*, 106, 116–19; Sciarra Bardaro, "S. Anna."

23. Cristo dei Domenicani, thirteenth century
Basilica

> **23.A** didactic inscription on exterior, left of door, 1232
>
> > 1232 A(NNO) FV(N)D(ATIO) CO(NVE)NTVS
> >
> > *1232, year of foundation of the convent*
>
> **23.B** dedicatory inscription on interior, adjacent to Saint Nicholas *(n.v.)*
>
> > B. NICOLAUS PALIA A JUVENATIO FUNDATOR HUJUS CONVENTUS A. 1232
> >
> > *Blessed Nicholas Pa(g)lia of Giovinazzo founded this convent, year 1232.*

Jurlaro, "Epigrafi," 249; Ribezzi Petrosillo, *Guida*, 91.

24. San Giovanni al Sepolcro, thirteenth–fourteenth century
Rotunda church of former male monastery; fresco palimpsest

> **24.A** devotional inscription, south side, first fresco stratum, palimpsest with George versus dragon
>
> > [MEMEN]TO D(OMI)NE . . .
> >
> > *Remember Lord . . .*
>
> **24.B*** devotional inscription, northwest side, to lower left of Saint Blasius
>
> > MEM(EN)TO / D(OMI)NE FAMV[/LI TVI] GEOR/GIV [ET] UXOR / EIUS ET FI/[LI]US . . .
> >
> > *Remember Lord your servant George and his wife and son . . .*

24.B

24.sc Baptism, Crucifixion (2), Deposition, Lamentation, Ascension

24.st Blasius, Nicholas (2), George on horseback, John the Baptist

Guglielmi, *Affreschi*, 32–33, 36–37; Diehl, *Art byzantin*, 45; Lunardi, Houben, and Spinelli, eds., *Monasticon*, no. 78.

25. San Leucio
Basilica destroyed 1720 *(n.v.)*
Dedicatory inscription, marble, tenth century (?)

> SANCTUS ET VENERABILIS LEUCIUS AMICUS XR(IST)I, / HUNC ARCU(M) VOLUIT ESSE IN REMEDIU(M) P(ER)ICLITA(N)TIBUS, / UT OMNIS, Q(UI) [FURIOSAM] VIM PATITUR, / PER VIGI(N)TI PEDES IN ANTE DEXTRA, VEL LAVA, A P(ER)ICULO / RESOLVATUR. QUIA SIC PLACUIT, PATRI / ET FILIO, ET SP(IRITU)S SA(N)CTI. SI QUIS AUTE(M) HOC NO(N) / OBAUDIERIT ANATHEMA, ANATHEMA, ANATHEMA SIT, ANTE DEO. / IOA(N)NES ET TECLA PRO SE SALUTEM SUOR(UM) FILIOR(UM) FECIT.
>
> *The holy and venerable Leucius, friend of Christ, wished this sanctuary to be a haven for those in peril, so that anyone who is being subjected to wanton violence may be safe from danger within twenty feet <of it>, to the front, to the right, or to the left.*

Because to do so was pleasing to the Father and to the Son and to the Holy Spirit. If, however, anyone does not heed this, let him be anathema, anathema, anathema before God. John and T(h)ecla made this for their salvation and that of their children.

Text as in Della Monaca but with abbreviations as in the manuscripts consulted by Jurlaro and with the addition of *"furiosam."*

Jurlaro, "Epigrafi," 243–44; Jurlaro, "Martyrium"; Lunardi, Houben, and Spinelli, eds., *Monasticon*, no. 74; Della Monaca, *Memoria*, 265.

26. San Paolo, fourteenth century

Single-nave Franciscan basilica, wooden truss roof (painted sixteenth century); after 1322

26.A funerary inscription, right wall

+ HIC IACET IOHS / DEA(N)DREA AMERI / DEFIORENCI / . . . IE

Here lies John de Andrea Ameri of Florence.

26.B inscription, right wall, above Saint Margaret and unidentified saint

. . BHISE . . .	NIS: THOA . OS . . .	B . . .
OMVIAS A . . .	CAFFARELLI D . . .	ITIS
ATAVDA . . .	EED/: RIPAVOCAT . . .	VD
IOB . . S . . .	MIST.HIC SVP . . .	ANO

26.C* funerary inscription, right wall, 1300

Marble plaque; three small shields incised below text show Castaldo coat of arms (diagonal waves) plus lion striding left (family unknown)

+ MENTE DEO COMPTA IACET hIC ET NO(M)I(N)E COMPTA / CUI IUXTA TUMULUM P(RAE)SENS ALTARE PARAT(UR?) / IN QUO CONTINUE DEVS hOSTIA VERA LITATUR / ET QUIA SPONSA FUIT NICOLAO TAM PROBA CARA / CASTALDO P(ER) EUM MERITO TUMVLUS FIT ET ARA / UTQUOS VNIUIT ThOR(US) UNICVS hOS COMITETVR / VNIC(US) ET TUMVLUS COMUNIS ET hOSTIA DETUR / ANNIS MILLENIS TRECENTUM NON BENE PLENIS / APRELIS QUINTO CARO CLAUDIT(UR?) hOC LABERINTO / SET MENS IN CELIS REGNAT SINCERA FIDELIS

With her mind adorned for God, and adorned in name, here lies she for whom, near her tomb, is raised the present altar, on which God, the true host, is offered up forever. And because she was such an honest and beloved wife to Nicholas Castaldo, by him a tomb is fittingly made and an altar, so that those whom one bed united, a single tomb may also hold and sacrifice be dedicated. On the fifth of April, one thousand three hundred years not fully complete, she is enclosed in this dear labyrinth, but her pure and faithful mind reigns in heaven.

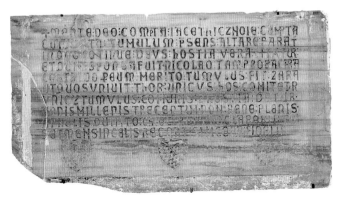

26.C

26.D stone slab to right of door
relief shield with same pattern as smaller incised examples in 26.C: lion facing left
　　above the diagonal waves of the Castaldo family crest

26.E right wall of choir, to right of unidentified saint
figure with clasped hands, only face and hands preserved

26.F * right wall of choir, adjacent to Virgin and Child
kneeling male, facing left to adjacent Virgin and Child with hands clasped; wears red
　　outer garment with white fur lining, trim on cuff; two-armed acknowledgment
　　from Child, Virgin also faces him

26.F

26.sc.1

26.sc Vita of Saint Mary Magdalene, Tree of the Cross, Pilate Washing His Hands

26.sc.1* Pilate Washing His Hands
 See Plate 3 for detail

text above the group of Jews at right: PR[ESBITERI?] or PR[AESES]; SACERD[OTE]M

26.st Paul, Stephen, Francis, John the Baptist, Margaret

Guglielmi, *Affreschi*, 124–46; Jurlaro, "Epigrafi," 251–52, 256; Calò Mariani, "Echi," 255–58. For the Castaldo crest, see Amorosi, Casale, and Marciano, "Famiglie," fol. 91.

27. Santissima Trinità (now Santa Lucia), thirteenth–fourteenth century

Three-aisle basilica (upper church) of female monastery, over vaulted lower church

27.A

 27.A* funerary inscription on pseudo-curtain, upper church, left wall near west end, second fresco layer, thirteenth century

 (MEMEN)TO . D(OMI)NE . FAMVLI . TVI . IACOBINI . /
 Q(VOD) . A(N)I(M)A. REQVIESCAT . IN . PACE AMEN

 Remember, Lord, your servant Iacobinus so that [his] soul may rest in peace. Amen.

 27.B inscription, lower church, east wall

 CE / O BAPBONOC / ABCΛB

 untranslatable

 27.C lower church, west wall, pilaster adjacent to female saint
 standing figure; short red tunic, red-brown hose

27.sc *Upper church:* Vita of Saint Peter Martyr, Dormition with Jephonias, Women at the Tomb, Presentation in Temple, Vita of Saint Margaret (lost)

27.st *Upper church:* Vitus with dogs, Michael (2), Agatha, Donatus, Martin, Barbara, Demetrius on horseback versus Kalojan, James (?), unknown bishop, John the Baptist, John the Evangelist, Constantine and Helena (?), Mary Magdalene, Nicholas, Peter, Bonaventure, Mark. *Lower church:* Nicholas (2), Peter, Mary Magdalene, Margaret

Guglielmi, *Affreschi*, 80; Sciarra, "Affreschi della chiesa superiore"; Lunardi, Houben, and Spinelli, eds., *Monasticon*, no. 78; Jurlaro, "Epigrafi," 251–52.

NEAR BRINDISI (BRINDISI)

28. Santa Maria del Casale, thirteenth–fourteenth century

Single-nave basilica with projecting transepts, wooden truss roof, ca. 1300; paintings, fourteenth century, at least two phases

 28.A* didactic inscription, west wall, over doorway, below Last Judgment (see also 28.sc.1)

 HOC OPVS PINCXIT RINALDVS DE TARENTO

 Rinaldus of Taranto painted this work.

 28.B* west wall, over doorway, below Last Judgment
 relief shield with pattern of Greek crosses inset into lunette after 28.A was frescoed

28. A–B

28.C* south nave wall, west end
upper register: see 28.D

lower register, right panel: two small kneeling figures in red above one small figure in
blue precede larger figure with buttons on sleeve, all to left of standing saint; all
figures with raised hands pressed together; additional figures at left too abraded
to describe

28.D* south nave wall, west end, upper register with Leonardo di Tocco
See Plate 4 for detail

kneeling, helmeted male (Leonardo di Tocco, count of Cephalonia, 1362–64)
presented by military saint to enthroned Virgin and Child; both saint and
supplicant wear prominent ailettes; they are followed by seventeen armed men
with hands clasped at chin height; behind them, one standing votary and two
standing horse grooms; diagonally striped gold and blue shields, banners

28.E inscription below 28.C (earlier stratum?)
two lines on white ground, very faint

> [H]OC OP[US] . . . RIVE . TERR . . .
>
> *This work . . . ? . . .*

28.F south nave wall, lower register, central panel (see in 28.C)
one standing figure in dark red garment to left of enthroned Virgin and Child; one
red shield with gold diagonal stripe

28.G south nave wall, lower register, left panel (see in 28.C)
standing female saint (Catherine?) flanked by large blond female and male kneeling
figures, red robes; saint extends orb (?) to male; two large shields with black-on-
white checkerboard pattern

28.H south nave wall, center of nave between windows, upper register (see 28.I)
kneeling male in chain-mail helmet, faces left toward enthroned Virgin and Child;
supplicant presented by crowned female saint (Catherine?), followed by two
grooms, two horses wearing red and yellow diagonally striped cloths; varied
heraldic framing

28.I* south nave wall, center of nave between windows, lower register
See Plate 5 for detail

large triptych, framed with trees alternating with circular bosses; enthroned
Christ in center; right panel figures abraded, but at top are three blue shields on
which are two gold swords, shields separated by trees; in left panel, five shields
(unfinished?) on top separated by trees; below, two standing female figures at
left, red robes, larger right female has white fur collar, both have splayed hands
at chest height, both blessed by Christ child standing in lap of Virgin and by
her outstretched arm; at right, standing male in red tunic, mantle with pointed
turned-back sleeves and vair-lined hood

28.C

28.D

28.1

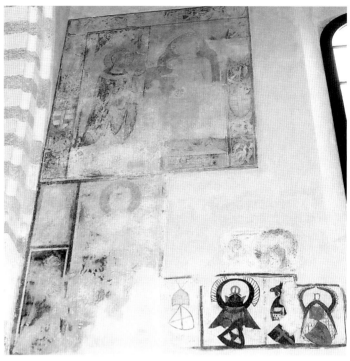

28.J

28.J* south nave wall, between transept and window
upper register: in heraldic frame, enthroned Christ on lap of Virgin blesses abraded
 figure followed by a saint; for lower register, see 28.K–L

28.K* south nave wall, between transept and window, lower register (visible to lower left of 28.J)
standing female at left, in brown outer garment and white fabric coif, adores
 oversized saint at right; supplicant's clasped hands cross painted border

28.L* heraldic panel with shields and crested helmets (see also 28.J)
three groups of heraldic symbols, including open vair-lined cloak, shields, helmets,
 and crests
text below left shield

> IOHS / RODI

> *[Saint] John [of Jerusalem, convent] of Rhodes (?)*

28.K

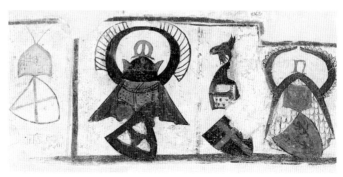

28.L

28.M

28.M* south transept, east wall, middle register

kneeling female with white head scarf, dark garment, adjacent to standing female
 saint

28.N* south side of presbytery, south wall left of transept

 See Plate 6 for detail

top: Saint Catherine "vita icon" (detail in 28.sc.2)

bottom left: kneeling male, blessed by Christ on lap of enthroned Virgin; hands
 clasped at face height, wears tight long-sleeved red tunic under red robe trimmed
 with white fur, pointed sleeves have white lining; pageboy hair; at top, two
 shields with white castle towers on blue ground

bottom right: see 28.O

28.O south side of presbytery, left of transept, right part of lower register, upper fresco layer (see 28.N)

 See Plate 6

kneeling male, facing left toward Saint Erasmus, with back to Mary Magdalene;
 hands clasped at face height; tight long-sleeved tunic under red robe trimmed
 with white fur, pointed sleeves; pageboy hair

28.P south side of presbytery, left of transept, right part of lower register, lower fresco layer (see 28.N)

 See Plate 6

rear of kneeling figure wearing pointed, pearl-trimmed black shoes, who precedes
 an equestrian figure wearing a rowel spur over mail chausses; red horse trappings
 with golden scallop shell (?), identical to fictive cloth at top of east and south
 walls of presbytery

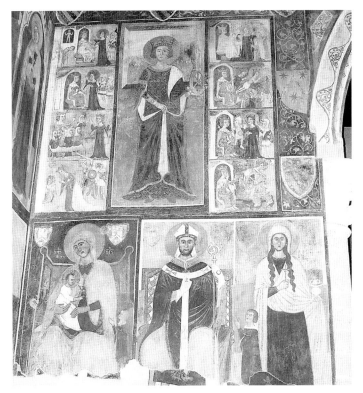

28.N

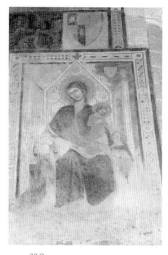

28.Q

28.Q* north side of presbytery, east wall, middle register below heraldic frame of Del Balzo Orsini shields

two figures adjacent to Virgin and Child, both with hands clasped on Virgin's lap. To left, female (?) with light hair, red garments, touched by Virgin. To right, male with blond, wavy pageboy hair, light-red garments, red hood, head being touched by Christ.

28.R* north side of presbytery, north wall, right of transept, upper register

two kneeling figures adore central Virgin and Child, presented by two saints; left is female, light hair in net, white tunic under fur-trimmed red mantle with long sleeve openings; right is kneeling male, bearded, in mail coif and hauberk over tunic and under red surcoat with short sleeves; lower frame with Del Balzo Orsini shields

28.S north side of presbytery, north wall, right of transept, middle register (above 28.T and earlier Saint Nicholas)

faint figure kneels before enthroned Virgin and Child; heraldic frame; poor condition

28.T didactic inscription, north side of presbytery, north wall, right of transept, lower register (left of Saint Nicholas from earlier stratum), 1366

> + HOC OP(US) FIERI FECIT / D(OMI)N(U)S GAVCIERIUS PR(A)E/
> CEPTOR S(ANC)TI JOANNIS / YEROSOLIMITANI AN(N)O D. MCCCLXVI
> / . . . M . . .

> *Lord Gaycierius, preceptor of Saint John of Jerusalem, had this work made in the year of the Lord 1366*

28.R

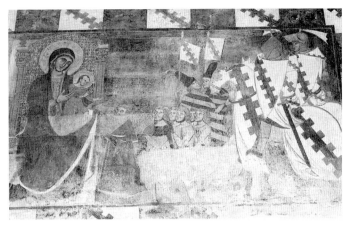

28.V

28.U north wall, left of transept, upper register, 1335

very faint; to left of enthroned Virgin and Child, male saint presents large kneeling
 figure in white, hands clasped, behind two small kneeling figures in red, light hair;
 on right, male saint presents kneeling male wearing red hooded mantle with fur
 trim; heraldic frame

28.V* north wall, left of transept, lower register with Nicholas de Marra, 1335
See Plate 7 for detail

kneeling male in red robe being blessed by Christ in lap of Virgin; hand of Mary
 nearly touches his forehead; followed by five kneeling males, two standard-
 bearers dressed in diagonal red-gold garments and tall hats, and two mounted
 knights at right; counter-embattled shields, banners, horse trappings match
 heraldic frame

28.W* didactic inscription, north wall, left of transept, lower register, above head
of kneeling male, 1335

> HOC OPVS FIERI FECIT DOMINUS / NICOLAVS DE MARRA MILES
> REGIVS ROC/CAENOVAE ET STILIANI ET SANCTI / ARCHANGELI
> DOMINVS REGIVS CONSILI/ARIVS ET FAMILIARIVS ET GENERALIS /
> CAPITANEVS ET IVSTITIARIVS TERRAE YDRVNTI ANNO / DOMINI
> MILLESIMO CCCXXXV III INDICTIONIS / DIE III MENSIS FEBRUARII

> *Lord Nicholas de Marra, royal knight of Roccanova and royal lord of Stigliano and
> Sant'Arcangelo, councillor and familiar and captain general and judge of the Terra
> d'Otranto, in the one thousandth three hundredth and thirty-fifth year of the Lord,
> third indiction, on the third day of the month of February.*

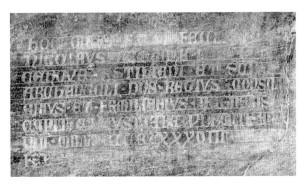

28.W

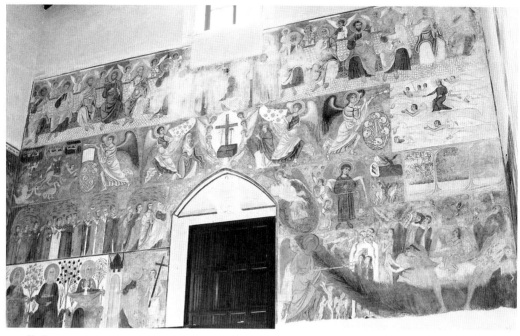

28.sc.1

28.sc.2

28.sc Dormition (?), Annunciation (3), Nativity, Last Supper, Hospitality of
Abraham, Crucifixion (2), Deposition, Entombment, Christ Rising from Tomb, Tree of
the Cross, Vita of Saint Catherine (2), Last Judgment

28.sc.1* west wall, Last Judgment

28.sc.2* detail of 28.N, Saint Catherine disputing with the philosophers

28.st Michael, Nicholas, Paul, Erasmus, Theodore

Leone de Castris, "La pittura," 411; Maddalena, "Maria"; Calò Mariani, *Arte del Duecento*, 186–91; Calò
Mariani, "Echi," 240–55; Calò, *Chiesa di S. Maria del Casale*; Jurlaro, "Epigrafi," 252–53.

CALIMERA (LECCE)

29

29. San Vito

*Pierced stone now inside seventeenth-century church

CARPIGNANO (LECCE)

30. Dedicatory inscription for a tower, 1378/79

Lecce, Museo Provinciale "Sigismondo Castromediano," no. 53; 47.5 × 21 × 5 cm

> Ανοικοδομηθη η πυρ/γοποιηα αυτη δ/ι<α> προσταξεως
> Παυλου / Σουλλιανου κεφαλικου / της χωρας ταυτης
> ,ϛ ω̃ π̃ ξ̃ / ινδ(ικτιων) α̃

This tower has been built by the order of Paul of Sogliano, captain of this village, in
6887 (=1378/79), first indiction.

Guillou, *Recueil*, 176, no. 164; Jacob, "Inscriptions byzantines datées, 58–62.

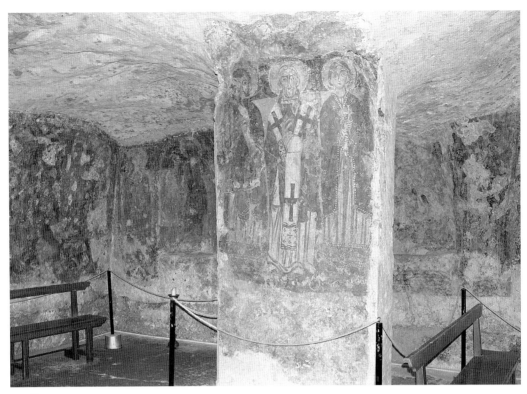

32

31. Tomb slab with funerary inscription, 1119

Lost (*n.v.*)

+HIC JACET CORPUS MAGISTRI MARI: QUISQUIS APERIET EUM EST
EXCOMMUNICATUS AB ARCHIPISCOPO. A. 1119

*Here lies the body of Master Mari: Whoever opens his tomb is excommunicated by the
archbishop. Year 1119.*

C. De Giorgi, *Provincia*, 2:365–66. The Arabic numerals for the date are given in De Giorgi (366), as is
the possible association of the epitaph with a chapel of San Giovanni Battista.

32. Santa Cristina (formerly Sante Marina e Cristina), tenth–eleventh century

Rock-cut church

*View of northeast corner, east wall, and pier

32.A

32.A* devotional inscription, east wall, in right apse adjacent to Pantokrator
flanked by Annunciation, 959

+Μνησθ(η)τι Κ(υρι)ε του / δ(ου)λ(ου) σ(ου) Λεων/τος
πρεσβυτ[ε]ρου / κ(αι) τ(η)ς συμβιου / αυτ(ου) Χρυσο/λεας
κ(αι) παντ(ος) / τ(ου) οικου αυτου / Αμην. + Γραφεν δι/α
χειρ(ος) Θεοφυλα/(κ)του ζωγραφου μηνι / μαιω ινδικτιων(ος)
β̄ / ετ(ου)ς ,ϛ ῡ ξ ζ +

*Remember, Lord, your servant Leo the priest, and his wife Chrysolea and all his family,
Amen. Painted by the hand of Theophylact, painter, month of May, second indiction,
year 6467 (=959).*

32.B

32.B* devotional inscription, east wall, left of right apse adjacent to Saint Anne holding infant Virgin (at right edge of 32)

+Μνησθ[ητι Κυρι]ε της δ(ου)λη σ(ου) Ααναϛ κε (τοῦ) τεκν/(ου) αυτ[ης] / Α[μεν]. . .

Remember, Lord, your servant Anna and her child. Amen.

Safran, "Deconstructing 'Donors,'" 134–39; Safran, "Byzantine South Italy," 257–63 (misidentified as narrative scene).

32.C devotional inscription, east wall, left of Saint Christine, right of archangel Michael

. . . τι / κε . ε. (ου) / σ(ου) κ. . . / κλ / . . συμβ[ι](ου) / κε τε[κνον?] / αυτ. . (ου) . . .

Remember, Lord, your . . . his wife and child(ren) . . .

Unpublished.

32.D devotional inscription, east wall, in left apse adjacent to Pantokrator, 1020

+ Μ[νη]σθ[ητ]ι Κ(υρι)ε / τ(ου) δουλου σ(ου) Α/πρηλη(ου) κ[αι] τ(ης) / συμβιου αυτοῦ κ[αι] / των / τ[ε]κνω ν αυ/τ(ου) / τ(ου) ποθ(ω) πο/λω ανοικοδομη/[σ]αντ(ος) κ(αι) ανηστο/ρησαντ(ος) τας παν/σεπτας υκονας / ταυτας μηνὶ Μαη/ω ινδικτιωνος : γ̄ : / ετ(ος) ,ϛ φ̄ κ̄ η̄ γραφ/εν δηα / χιρ(ος) Ευ/σταθιου ζω/γραφου αμη[ν].

Remember, Lord, your servant Aprilios and his wife and children, he who with an intense desire had [these walls] built and had these venerable images painted in the month of May of the third indiction, 6528 (=1020). Painted by the hand of the painter Eustathios. Amen.

Jacob, "Inscriptions byzantines datées," 41–51.

32.E

32.E* devotional inscription on pier in 32, left side, first fresco layer under later Saint Theodore (adjacent to bishop saint)
Red ruling.

Εξ ευχης / αθ . . . φε / . . .ντιω / λου.τ / Λεωντ[ου?] / ου . . . σ . . . α . . . ου / ξ̄θ̄ or, more likely, Ч̄θ̄.

From the prayer . . . Leo . . . of Leo . . . [9]78(?) or 99 (=Amen).

Unpublished. This may well be the fourth isopsephic Amen in the Salento, and quite likely the oldest example; see Jacob, "Nouvelle Amen."

32.F devotional inscription, north wall, right of Saint Christine

Μνησθ(η)τι / Κ(υρι)ε τ(ου) / δουλου σου / Απρη/λη κ(αι) τη(ς) / συμ/βηου / αυτ(ου) / και / των / ται/κνω/ν αυ/τ(ου) Ч̄θ̄

Remember, Lord, your servant Aprilios and his wife and his children. 99 (=Amen).

32.G devotional inscription, north wall, east end, between Saint Vincent and Virgin and Child (at left edge of 32) (*n.v.*)

[Μν]ησθ[ητι] Κ(υρι)ε της ψιχις του δουλου [σ]ου Ιω(αννου) [κ]ε του [δου]λ[ου σου] Βικεντιου κε [κ]αταταξο[ν] αυτους εν τοπο φοτινο [αμ]ην.

Remember, Lord, the soul of your servant John and your servant Vincent and assign them to the place of light. Amen.

Jacob, "Culte de Saint Vincent," 291.

32.H devotional inscription, north wall, adjacent to leftmost of two adjacent Saint Christines

[Μνήσ]θ[ητι Κ(ύρι)ε . . .] / κ(αὶ) τ(οῦ) συμ/βι(ου) αυτ(οῦ) / Αναστ[α]/σηα [καὶ τέ]/κν(ων) / αὐτ(οῦ)

[Remember, Lord, . . .] and his wife Anastasia [and] his children . . .

32.I devotional inscription, north wall, in two parts to left of Saint Catherine, 1054/55

upper part:

[Μνησ]θιτη Κ(υρι)ε / τ(ου) δ(ου)λ(ου) σ(ου) / Ιω(αννου) Πρ(εσ)β(υ)τ(ερ)(ου) / Π[α]νκιντζ[ης] / . (ου) ν / . . . α / . . . κνο / τ . . . πα / γ(ου) . . . κ . / τ . . . ε / (τ)α ποθ(ου) πολλ(ου) / [ανι]στορησα(ντος) / της αγια(ς) / ικωνας / ταυ / τας / [α] μη/ν.

lower part:

. . . ετος ͵ϛ φ̄ ξ̄ γ̄ / ινδ[ικτωνος . . .] / γρα[φεν] / [δ]ια χειρος / Κωνσταν/τιν(ου) ζω/γραφ(ου).

Remember, Lord, your servant John Pankitzes the priest [and his children] who with intense desire had these holy images painted. Amen.

Year 6563 (=1054/55), indiction . . . , painted by the hand of Constantine, painter.

32.J* funerary inscription, in arcosolium, west end of north wall, 1055–75

left side:

+ Εν[θα τε]θαπτε Στρατηγουλαις / ο πραος, ο φιλτατ[ος] μου και ποθητος / τοις π[α]σιν, πατρος τε λεγῶ και τις μ(ητ)ρ(ο)ς / του πανυ, των αδελφων του ομου κ(αι) ε/ξαδελφων, των [φ]ιλ[ω]ν παντων ομου / κ(αι) συνσκολειτων, τ[ω]ν ψυχαριων α/φθονος χοριγια. ωσπερ στρουθη/ον ε [. . .] εν ε κ(αι) χειρων μας, ελυπ/ησεν ται πατ[εραν] κ(αι) μητεραν, / τους κασιγνιτας συν των / φηλτατων φηλ[ω]ν. Αλλ ὦ Μαρια, / θεοτις κ(αι) κυρια, ως ουσα πιγη των / χαρισματων παντων, // συν Νικολαο τω σωφω / πυμεναρχει, συν αθλιφορω / κ(αι) μ(α)ρ(τυρι) Χριστηνι, εν [κο]λποις ταξον / το φυλτατον μου τεκνον / τ[ου] πατριαρ[χου] Αβρααμ του με[/γαλου], . . . ου του . . . ου κ[αι] δ . . . / . . . εν [τ]ο . . . /

right side:

[Ε]παμφιασα ϊκόνας κ(αι)/νουργιας, τυμβον ῶρυ/ξα προς ταφην και κιδιαν / του σωματος του γη/ινου πλασθεντος. Περη / δε αυτου του ωνοματος / λεγις. η της εῖ κ(αι) ποθεν η / ο μερωψ ουτος; [. . .]υρα[. . .] / τουνο[μ]α, καλος τοις τρῶπ(οις], / σπ[α]θ[αριος τ[ε] οικον εν Καρ[πι]/νιανα, υπου[ργος] Χριστ[ου κ(αι)] τῶν // αγιων τουτων, της πα/ναχραντου δεσποινης / Θεοτοκου κ(αι) [Νι]κολαου / τ[ου] Μυρ[ο]ν . . . / μενο . . . ν . . .

Here is buried the gentle Stratigoules, my very dear [child] loved by all and above all, I would say, by his father and his mother, by his brothers and at the same time by his cousins, by all his friends and at the same time by his schoolmates, a generous benefactor of slaves. Like a sparrow, he [flew] from our hands and filled with sadness his father and his mother, his brothers and his beloved friends. O Mary, divine mistress, since you are the source of all graces, // with Nicholas, the wise shepherd, with the victorious martyr Christine, place my very dear child in the bosom of the great patriarch Abraham . . .

32.J Photo: Valentino Pace.

I have recovered with new images, I have excavated a tomb for the shrouding and burial of my body, which was formed of earth. But regarding the name itself, you say, Who could this mortal have been, and from where is he? . . .yra. . . is his name, virtuous his habits, spatharios and resident of Carpignano, servant of Christ and of the // saints seen here, the all-immaculate Lady Theotokos and Nicholas of Myra . . .

Jacob, "L'inscription métrique"; Rhoby, *Byzantinische Epigramme auf Fresken*, 267–72.

32.K devotional inscription, northwest corner, left of arcosolium, adjacent to Saint Blasios

> +. . .σ . . . / Β . .τ. . . ι c. / Βλασι(ου)ς ε . / πεφυλι /μενον . / γνισιου . . / πι . . τεη / σ. κ(αι) . . ιν / . . . / . . . ω: / Β . . . κοις / σ . ρὶ / συνγυ / νε . ε.. / κ(αι) . . / [συμβί/ ου] / . ατ(ο) / τε/κν/οις /

> *. . . Blasios. . . beloved, true . . . and . . . with his wife and children.*

32.sc Annunciation

32.st Anne and Virgin, Michael (2), Christine (6), Nicholas (3), Vincent, John (?), Theodore (2, one on horseback), Agatha, Paul (?), John the Baptist, Blasios, Antony Abbot, Catherine (?)

Guillou, "Notes d'épigraphie"; Jacob, "Deux épitaphes," 170; Jacob, "Anthroponymie," 363; Jacob, "Inscription métrique"; Safran, "Cultures textuelles," 259–60; Falla Castelfranchi, "Cripta delle Sante Marina e Cristina"; Falla Castelfranchi, *Pittura monumentale*, 45–70; Fonseca et al., *Insediamenti*, 59–80.

CASARANELLO (LECCE)

33. Santa Maria della Croce

Three-aisle basilica added to early Christian cruciform church with preserved vault mosaics

33.A devotional inscription, left sanctuary wall adjacent Saint Nicholas, ca. 1000

Μνησ/θητη Κ(υρι)ε / του δου/λου σου / Γεοργι/ου και των / τεκνων / αυτου /ᴛ̄Θ̄ (= Αμην)

Remember, Lord, your servant George and his children. Amen.

33.B devotional inscription, left sanctuary wall adjacent unknown saint, ca. 1000

Μνησθ(ητι) / Κ(υρι)ε του δ/ουλου [σ]ου Δη/[μ]ιτρ[ι]/[ο]υ . . . / . . .

Remember, Lord, your servant Demetrios . . .

33.C devotional inscription, second pier on left, left of Theotokos

. . . υ ι / . . . ου / . . . c . / . . . ρ . / . τ . / . . . / . . . / . . .
. . . [δουλ]ου . . .

[Remember, Lord, your?] servant . . .

33.D* devotional graffito, second pier on left, graffito on yellow background to right of Theotokos above her hand level, 988, 1003, 1018, or 1033

Μνησθ(η)τη Κ[(υρι)ε] του / δουλου σου Ακη[ν]/δυνου πρεσβ[υτερου] / του εν[θ]ρον[ισαντος] / τον ναον τ[ουτον] / της αγιας [θε(οτο)κου] / ενθρ[ο]ν[ισθη] / δε / μη(νὶ) ϊ{ι}ουλ[ιω εἰς τὴν[/ ᾱ ινδ(ικτιῶνος) ᾱ /ετους ‚ϛ . . . / υ . . . / τ . . . ο / επηισκό[που] / Καλληπ(ολεως)

Remember, Lord, your servant the priest Akindynos, who participated in the consecration of this church of the holy (Theotokos). It has been consecrated 1 July of the first indiction, in the year 6 . . . by . . . , bishop of Gallipoli.

33.E* funerary graffito added to 33.D, bottom

+ Λ[ε(ων) ο] / (Και)φαλας + / μακαριωτατο[ς] / Κ(υρι)ε βοηθ(ει) αυτ(ω) / εν ειμερα πο/νιρα

+ L(eo?) Kephalas + Deceased. Lord, help him in the evil day.

Jacob, "Consecration."

33.D–E

33.F–K* second pier on right, Saint Barbara
 See Plate 8 for detail

33.F Saint Barbara pier, painted devotional text at left, knee height

Μνησθη/τι Κ(υρι)ε του / δουλ(ου) σ(ου) / Ιωαννου / και του / συνβιου / αυτου κ[αι / του] . . .

Remember, Lord, your servant John and his wife and his . . .

33.G Saint Barbara pier, devotional graffito added below 33.F

+ Μν(ήσ)θ(ητι) Κ(ύρι)ε τοῦ / δούλου τοῦ Θ(εο)ῦ Μη/χαὴλ κληρηκοῦ

Remember, Lord, the servant of God Michael, cleric.

33.H Saint Barbara pier, graffiti added above 33.F

ϛ̄ χ̄ κ̄ β̄ = 6622 = 1113/14
επι ετους ‚ϛ̄ χ̄ λ̄ ε̄ = 6635 = 1126/27

33.I Saint Barbara pier, funerary graffito on right side, top, 1094/95

Εκιμιθ(η) ο δου[λος του Θ(εο)υ] Ιω(αννης) ‚ϛ̄ χ̄ γ̄

The servant of God John died in 1094/95.

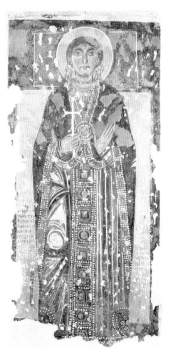

33.F–K

Jacob, "Deux épitaphes," 169.

33.J Saint Barbara pier, funerary graffito on right side, top, 1098/99

Εκιμιθ(η) ι δ[ουλη] του Θ(εο)υ Μαρι[α] / ,ϛ χ̄ ζ̄

The servant of God Maria died in 1098/99.

Jacob, "Deux épitaphes," 169.

33.K Saint Barbara pier, right side, incised graffiti below knee level

1047/48
1076/77 αποθανε *(died)*
1088/89 αποθανε *(died)*

33.pg graffito on right knee of Theotokos
long-necked bird adjacent to letters OY, T, E

33.sc Last Supper, Betrayal of Christ, Myrophores, Anastasis, Vita of Saint Catherine, Vita of Saint Margaret

33.sc.1* left nave wall, Betrayal of Christ

33.sc.2* left nave vault, Vita of Saint Margaret, ca. 1260 (Leone de Castris) or ca. 1300 (Tortorelli)

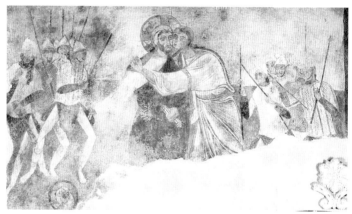

33.sc.1

33.sc.2

33.st Nicholas, John the Evangelist, Barbara, Urban V with heads of Peter and Paul (after 1370), Bernardino of Siena (after 1450) [Antony Abbot, Eligius (?), 1538]

Jacob, "Inscriptions byzantines datées," 51; Jacob, "Anthroponymie," 363; Safran, "Cultures textuelles," 261; Safran, "Redating," 326–32; Falla Castelfranchi, "Chiesa di Santa Maria della Croce"; Falla Castelfranchi, *Pittura monumentale*, 144–50; Leone de Castris, "La pittura," 396, 399; Leone de Castris, *Arte di corte*, 105–6; Prandi, "Pitture inedite"; Tortorelli, "Aree," 123–24, 132–37.

CASARANO (LECCE)

34. Crocefisso della Macchia
Natural-cave church

34.A* left wall, lower left of standing female saint
kneeling bearded male, brown robe and hood (Franciscan?), hands apart at face level

34.st Michael, Nicholas (?), female saint

Fonseca et al., *Insediamenti*, 83, identifies the saint as Michael.

34.A

CASTRO (LECCE)

35.* Dedicatory inscription, 1383
Now on north exterior wall, above doorway, of former cathedral; originally in an interior chapel; slab 53 × 87.5 cm, inscription on left, relief with blessing Christ in center, episcopal arms at right

> + AN(N)O : D(OMI)NI : MILL(ESIM)O / CCC : LXXXIIIO : EP(ISCOPU)S / DONADEVS : FIERI / FECIT : HA(N)C : CAPP(E)LL/A(M) : PECV(N)IA : REDIT/VV(M) : BONORV(M) : Q(U)O(N)DA(M) / PARE(N)TV(M) : EIVS : DO/TATAM : BONO/RV(M) : P(RE)D(I)CTORV(M) :

> *In the one thousandth three hundredth and eighty-third year of the Lord, Bishop Donadeus had this chapel built with the money from the revenues of the goods of his deceased parents and endowed it with the aforesaid goods.*

Jacob, "Fondation de chapelle"; Safran, "Cultures textuelles," 253–54.

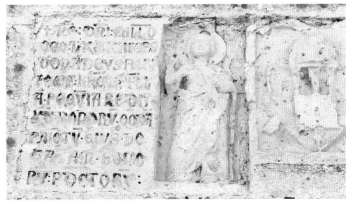

35

CAVALLINO (LECCE)

36. Dedicatory inscription, 1309/10

Now on exterior of Santa Maria del Monte cemetery church; 23.5 × 42.2 cm

+ Ἐθεμελιώθη καὶ ωκοδομήθη ο / πανσεπτος ναος της αγιας
Θεοτοκ/ου δια πονου και μοχθου Νικολαου / Μαρκιαντου
χειρι Ιωαννου του [μ]/αιστωρ Πελεγρι[ν]ου. ετι ͵ϛ ῶ ῑ ῆ
ινδ(ικτιωνι, -ωνος) ῆ

*The most venerable church of the holy Theotokos was founded and constructed thanks
to the labor and toil of Nicholas Markiantos, by the hand of John, son of master
Pellegrinus, in the year 6818 (=1309/10), indiction 8.*

Jacob, "Iscrizioni bizantine di Cavallino," 241–44; Jacob, "Inscriptions byzantines datées," 51–53.

NEAR CAVALLINO (LECCE)

37. Funerary inscription, 1238

Lost; 1847 drawing extant in Biblioteca provinciale di Lecce (*n.v.*); inscription on ruled
lines in four fields formed by central cross; 66 × 38.5 × 13.2 cm

+ Εκο[ι]μηθη ο δοῦλος τοῦ θ(εο)ῦ Γεωργιος / [μηνι δε]
κεμβριω ει[ς] τες . κ̄ δ̄ . [η]μέρα πα[ρα]/σκεβοὶ ωρα . ᾱ[.] /
ἐτο(ς) . ͵ϛ ψ̄ μ̄ ζ̄

*The servant of God George died Friday, December 24, at the first hour, the year 6747
(=1238).*

37.pg circle-rosette on back

Jacob, "Iscrizioni bizantine di Cavallino," 245–46; Jacob, "Inscriptions byzantines datées," 54–55.

CEGLIE MESSAPICA (BRINDISI)

38. Chiesa Matrice, 1180

Sixteenth-century copy of lost text (*n.v.*)
Altar inscription

DEDICATUM EST HOC ALTAR(E) AD HONOREM DEI
O(MN)IPOTE(N)TIS ET / BEAT(A)E ANN(A)E BEATOR(UM) QUOQ(UE)
JANUARIJ MARTIRIS ATQ(UE) / PONTIFICIS ET BEATI BARSENOFIJ
CO(N)FESSORIS ATQ(UE) AB/BATIS, QUOR(UM) HIC RELIQUI(A)E
CO(N)DIT(A)E SU(N)T A D(OMI)NO RO/GERIO LEUCADENSI EP(ISCOP)O
ROGATU JOAN(N)IS ARCHDIACONI / ET TOCIUS HORITANI
CAP(ITU)LI ANNO AB INCARNATIONE / DOMINICA MILL(ESIM)O
CENTESIMO OCTUAGESIMO REGNI / VERO D(OMI)NI N(OST)RI
GLORIO(SI)SS(IM)I REGIS W(ILIGELM)I SEXTO DECIMO / QUARTO
OCTOBRIS IND(IC)TIONE 14

*This altar was dedicated to the honor of omnipotent God and of blessed Anne and also
blessed Januarius, martyr and bishop, and blessed Barsanuphius, confessor and abbot,
whose relics were placed here by lord Roger, bishop of the diocese of Alessano at the
request of John, the archdeacon, and the whole chapter of Oria in the one thousandth
one hundredth eightieth year from the Incarnation of the Lord, but the sixteenth of the
reign of our lord, the most glorious king William, on the fourth of October, indiction 14.*

Jurlaro, "Epigrafi," 259–60. If the date is accurate, this is the earliest reference to the diocese of
Alessano; cf. Jacob, "Ecclesia Alexanensis," 490.

39. Santa Maria della Grotta, fourteenth century

On façade of unused church on Ceglie–Francavilla road
Didactic inscription

> HOC OP(US) AEDI(FICAVIT) / MAG(ISTER) M(URATORIBUS) DOMIN/
> IC(U)S DE JULIANO

> *This work was built by master builder Dominic de Juliano.*

Jurlaro, "Epigrafi," 260.

CERFIGNANO (LECCE)

40. Funerary inscription, twelfth century (?)

Found in fill of Chiesa dell'Immacolata (formerly San Nicola?)

40. A incised on arms of relief cross

> I[ησου]ς / X[ριστο]ς / [Νι]/κα

> *Jesus Christ Conquers.*

40.B incised above left and right cross arms

> . . . / M[ηνη] I(ου)νιω / [ετ]ους / εις τας ῑγ̄ ινδ[ικτιωνος] ῑγ̄

> *. . . / in the month of June. / . . . year. . . / the 13th, indiction 13..*

40.C back
incised quatrefoil

Safran, "Scoperte Salentine," 73; corrected by André Jacob (e-mail, April 29, 2011)

COLLEPASSO (LECCE)

41. Funerary inscription

Found ca. 1879 near Chiesa della Santissima Trinità, now lost; known from nineteenth-century drawing (*n.v.*)

41.A in large circle

> I[ησου]ς / X[ριστο]ς / Νη/κα

> *Jesus Christ Conquers*

41.B top

> +(ου) εκοι . .

> *Sleeps*

41.C left

> ιθ / αλυδ / τον θεος / κυρπομ / .γρνον / σ / .κνη / .ην. / βλοτο / θε

41.D bottom

> Εκιμηθι αυτ(ου) / ε.δρη θωκυνη

> *of . . . / fell asleep / . . .*

41.E ornament

four-petal rosette inscribed in and over circle, concentric circles in four corners; four circles with letters between petals

Cazzato, "Collepasso," 137, 152.

COPERTINO (LECCE)

42. Castle Chapel, 1415–29

* **Northwest wall of rectangular chapel**

two kneeling (?) women with hands pressed together flank Mary Magdalene; one on left, in three-quarter view, wears rounded cap, low-cut blue cotte under red sleeveless surcoat through which ornamented sleeves show; one on right, in profile, wears white wimple around head and neck

42.sc Vita of Saint Mary Magdalene; Flight into Egypt; Nativity; Noli me tangere; Crucifixion

42.st Francis; Mary Magdalene with pyxis

Ortese, "Ciclo della Maddalena"; Ortese, "Committenza Del Balzo Orsini," posits Caterina del Balzo Orsini on left with Maria d'Enghien on right.

NEAR COPERTINO, MASSERIA LI MONACI (LECCE)

43. San Michele Arcangelo, 1314/15

Rock-cut church inside *masseria* (now a wine cooperative)
* **view of east wall**

43.A* **dedicatory inscription, east wall over the apse**

Ανοικοδομήθη και εζωγραφήθη ὁ πανσεπτος ναὸς οὗτος τοῦ / ἀρχιστρατήγου Μιχαὴλ διὰ συνδρομὴς κ(αὶ) κόπου Coυρὲ στρατιώ[τ](ου) / ἄμα συν συνβίῳ αὐτοῦ κ(αὶ) τ[έκνοις, ἔκνω] [ρη]γατεύοντος δὲ Ρωμβέρτου / Καρούλλου τριτέου : ἐπι [ετους ͵ϛ ω̄] κ̄ γ̄ . ἰνδ(ικτιωνος) ῑ γ̄ . [ἐζ]ωγραφήθη δὲ / χειρὶ Νικολάου κ(αὶ) Δη(μη)τριου υ[ιου α]υτοῦ ἀπὸ της Cωλεντοῦς : κ(αὶ) οἱ ἀ/ναγινόσκοντες . ευχεσθαῖ υπερ αυτοὺς προς τον Κ(ύριον) : ἀμὴν.

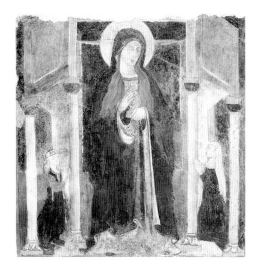

43

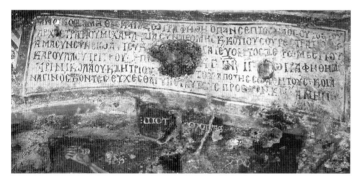

43.A

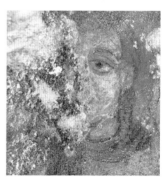

43.B

This most venerable church of the archistrategos Michael was built and decorated with paintings with the cooperation and effort of the soldier Souré and his wife and child[ren] during the reign of Robert, third (son) of Charles, in the year 6823 (=1314/15), thirteenth indiction; it was painted by the hand of Nicholas and his son Demetrios of Soleto. You who read this, pray to the Lord for them. Amen.

43.B* **east wall, at far right**
beardless male, standing, red-brown robe

43.C* **left apse and adjacent ceiling**
 See Plate 9 for detail

apse with John the Evangelist/Theologian holding Gospel book, above altar cloth and below fish of Jonah; adjacent to angel of Annunciation; on ceiling, embracing couple amid stars; beardless male wears blue-gray midcalf-length tunic, black shoes, gray couvre-chef; female wears yellow and red belted, full-length tunic

43.sc Annunciation, Crucifixion

43.st John, Michael, Onouphrios

43.st.1* east wall, left side: fish of Jonah over Saint John the Evangelist/Theologian

Jacob, "Dédicace de sanctuaire"; Safran, "Cultures textuelles," 252–56; Safran, "Language Choice," 872; Calò Mariani, "Echi," 238–39; Montefrancesco, "Nuove ricerche"; Valchera and Faustini, "Documenti," no. 2175.

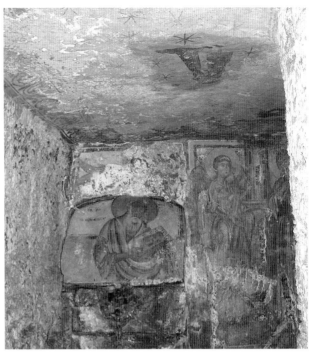

43.C

43.st.1

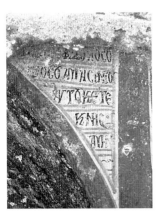

44.A

CRISPIANO (TARANTO)

44. Santi Crispo e Crispiniano (formerly Santa Maria), thirteenth–fourteenth century

Rock-cut church

> **44.A*** spandrel to right of apse niche
>
> > . . .του δ(ου)λ(ου) σ(ου) / βοσ(ου) αμα σηνβιο / αυτ(ου) κε τε/κνης / αμην
> >
> > *. . . your servant Bosos and his wife and children. Amen.*

44.st Deesis, Nicholas

Jacob, "Nouvelle Amen," 190; Caprara, "Iscrizioni inedite," 8–9; Caprara, *Società*, color pl. XXIII.

FAGGIANO (TARANTO)

45. San Nicola, thirteenth century (?)

Rock-cut church; some frescoes now in Bari, Pinacoteca Provinciale

45.A devotional inscription on base of right pier *(n.v.)*

ασ . στ Νικ/ τ . ου ιερεος πιγονατηος

[Remember, Nicholas (?)], priest Pigonatios

45.sc Baptism

45.st Vincent, Theodore on horseback, George on horseback, Stephen, Elijah

Caprara, *Società*, 167; Belli d'Elia, ed., Bari, *Pinacoteca*, 25–27; Medea, *Affreschi* 1:186; Medea, "Mural Paintings," 21–22.

FULCIGNANO (LECCE)

46. Hospital dedication, 1148/49

Greek text on destroyed church of the Virgin *(n.v.)*

Θεόδωρος πρωτόπαπας ὑπηρέτης ἁγίας θεοτόκου ξενικὸν κατεσκεύασεν ἔτει ͵ϛ ͞χ ͞ν ͞ζ

Theodore protopapas, servant of the holy God-bearer, built this hospice in the year 1148/49.

Jacob, "Fondation d'hôpital," 691; Zacchino, *Galatone*, 43 n.49; Aar, "Studi storici," corrected.

GALATINA (LECCE)

47. Santa Caterina, fourteenth–fifteenth century

Five-aisle basilica built for Franciscans, ca. 1385–91; interior frescoes ca. 1415–30

47.A* didactic inscription over right door

+Ενταυθα εστιν η καππελλα τ[ῆς] . . . α[γιας] Κατ[ερινας] / . . .εντος και . . . ρθ . . .

Here is the chapel of Saint Catherine . . . inside and . . .

47.B didactic inscription over left door (postmedieval)

A D MCCCLXXXXI

A.D. 1391

47.A

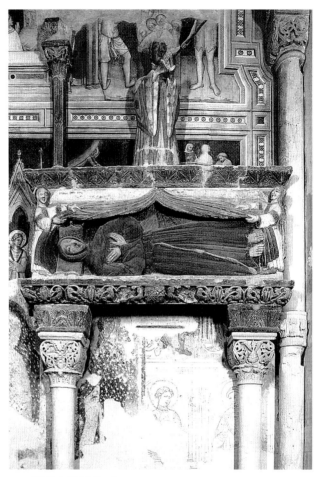

47.C Photo: Michele Onorato.

47.C* cenotaph of Raimondello del Balzo Orsini, now on left prestbytery wall, 1406

47.D* right inner aisle, adjacent Saint Antony Abbot

FRANC/ISCUS / DE ARE/CIO / FECIT / A.D. M/CCC/XXX II

Franciscus of Arecio (Arezzo?) made this [had this made], A.D. 1432

47.E* right inner aisle adjacent to 47.D
kneeling male, hands together at face level, wears chain mail over one red and one
white legging

47.sc cycles of the Apocalypse, Sacraments, Genesis, Life of Christ, Life of the Virgin;
Vita of Saint Catherine

47.st Francis (4), Damian, Nicholas, Peter, Paul, Antony Abbot, John the Baptist,
John the Evangelist, George, Solomon, Onouphrios, Menas, Louis of Toulouse, John
of Capestrano, James delle Marche, Catherine, Lucy, Agatha, Apollonia, Marina
(Margaret), Agnes, Clara, Ursula, Parasceve

Mersch and Ritzerfeld, "Lateinisch-griechische," 261; Safran, "Cultures textuelles," 254; Cassiano and
Vetere, eds., *Dal Giglio all'Orso*; Belli d'Elia, "Principi"; Leone de Castris, "La pittura," 439; Russo,
ed., *La Parola*; Presta, *Basilica*; Presta and Marsicola, *Basilica orsiniana*.

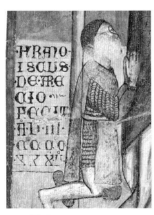

47.D–E

48. San Giovanni, dedicatory inscription, 1354/55

Originally on architrave of church near Porta Nuova, now lost; accents as in *Corpus Inscriptionum Graecarum* (*n.v.*)

Ἔτει ͵ϛ ῶ ξ̄ γ̄ [ινδ.] ἣ εἴληφεν ἀρχὴν ἡ χώρα τοῦ Ἁγίου
Πέ/ τρ(ου) τῶν Γαλατηνῶν τοῦ κτισθῆναι ἐπικρατοῦντος
ρη/ γὸς λογησίου σὺν τῇ ρηγὶ Ἰωάννα. Κυριεύοντος τῆς
χῶρας / ἁγίου Πέτρ(ου) εὐγενοῦς καμμαραρή(ου) κώμετος
ραημούνδου τοῦ / βα(ου)ξίως σὺν ὁμοζύγῳ αὐτοῦ
[Ἰ]σαβέλλα. Ὑπάρχοντες τὸν τ(οῦ) / τὸν καιρὸν Βικαρί(ου)
τῆς χώρας Γ(ου)αρίνου Μοντεφούσκ(ου). Οὗτος / γὰρ πρῶτος
ἐσημαιόσατο τὴν χώραν [ὡς δ]ε[ῖ] κτισθῆναι. Καὶ αὐ/
τὸς τὴν ἀρχὴν ἐποίησε. Τὸ ὅθεν ὀφείλομεν εὔχεσθαι ὑπὲρ
αὐτ(οῦ).

In the year 6863 (=1354/55), eighth indiction, the chora of Saint Peter of Galatina started being built when King Louis was ruling together with Queen Joanna. Lord of the village of Saint Peter was the noble chamberlain Count Raimondo del Balzo together with his spouse, Isabella. At the time Guarino Montefusco was the vicarius of the village: he first marked out the chora as it should be built, and he made the start. Hence we ought to pray for him.

Safran, "Greek"; Papadia, *Memorie*, 5, 67–68; *Corpus Inscriptionum Graecarum*, ed. Böckh et al., 355, no. 8770, with corrections; Foscarini, *Armerista*, 108, 210–11.

GALLIPOLI (LECCE)

49. Cathedral of Sant'Agata, before 1268

Reused Roman marble stela; 109 × 54 × 50 cm (broken)
Metrical altar inscription (*n.v.*)

[Δωρ]ον τιμαλφεστατον . . . πελω. / Εγω προσαχ[θεν τη]
τραπεζη τη ξενη / . . . ηπερ ην Μαρζηλιου / [. . . τριφε]γγους
και τριφω[του . . .]. / Αυθις δε πει[σθεις τη προ]θυμια παση /
Μαγι[. . .]ου πατρωνος αμα και θυτου, / κυρις καθυφιζανεν
ευσεβοφρον(ως) / Παντολεων Προεδρος τουδε του θρονου.

I am a most precious gift . . . I was placed on the remarkable altar . . . , which belonged to Marsilios, three times glittering and three times luminous. Acceding to the ardent desire of Magi . . . os, patron and priest, lord bishop Pantoleon, holder of this throne, sits with great piety.

Jacob, "Chandelier"; Vergara and Fiaccadori, "Cippo iscritto."

GRAVINA (NORTH OF THE SALENTO)

50. Synagogue dedication, 1184/85

Lost; facsimile in Bari, Biblioteca Nazionale (*n.v.*)

מכתב זה חקקנו לברוך
בר משה שרצף הכנסת
[ו]החצר ברצפת אבנים
ואיצטבאות סביב לנפש
בנו משה הנאסף בן שמנה
עשרה שנה להזכירו בשבת
[ו]ביום טוב ותשלם הרצפה
בשנת דתתקמה נפשו צ
רורה [בצרור החיים] אמן

This inscription we have carved for Baruch son of Moses, who has paved the synagogue and the courtyard with a pavement of stones and built seats around for the soul of his son, Moses, who was received [died] at the age of eighteen years, so that he will be remembered on the Sabbath and festivals. The pavement was completed in the year 4945 (=1184/85). May his soul be bound [in the bond of life]. Amen.

Colafemmina, *Ebrei e cristiani*, 11–16; Colafemmina, "Testimonianze epigrafiche," 40; Colafemmina, "Iscrizione sinagogale"; Safran, "Cultures textuelles," 251–52.

GROTTAGLIE (TARANTO)

51. Chiesa Madre (San Ciro)

51.A didactic inscription on façade near Annunciation angel, 1379

+hoc opus fecit ma[gister] / d(omen)ic(us) d ma(r)tina an(n)o d(omi)ni / incarnacio(n)is m(i)ll(esim)o ccc lxxix / s?us (pre)sul.itu Iacobi p(re)sul(us) tar(ant)in(us)

This work was made by Master Dominic of Martina in the year of the Lord since the Incarnation 1379 . . . [by] James, bishop of Taranto

NEAR GROTTAGLIE, GRAVINA DI RIGGIO (TARANTO)

52. Cripta Anonima, tenth–eleventh century
Rock-cut church with attached altar in right apse

52.A devotional inscription, east end of right wall under standing bishops

[M]νησ[θητι] Κ[υρι]ε της [. . .]λις . . . σ . . .

Remember, Lord, your [female] servant . . .

52.sc Elijah gives cloak to Elisha, Crucifixion (Christ in colobium), dove on book

52.st Michael (2), George, Andrew, Potitus

Falla Castelfranchi, "Cripta anonima"; Falla Castelfranchi, *Pittura monumentale*, 90–100; Safran, "Scoperte salentine," 83; Attolico, "Cultura artistica"; Attolico and Miceli, "Edificio."

NEAR GROTTAGLIE, IN LAMA DI PENSIERO (TARANTO)

53. Cripta delle Nicchie, 1392 (?)
Rock-cut church

53.A didactic inscription *(n.v.)*

ANNO 6900. XV INDIZIONE

1392, 15th indiction

Year read by De Giorgi, *Provincia*, 1:359; Peluso and Pierri, *Cripte*, 22, report a Latin inscription beginning ANO DOM[INI].

53.B

53.B* devotional inscription adjacent to Saint John the Baptist

Μνη[σ]/τητι / . . . πρ(εσ)β(υτερος) α /. . .σ του /. . . σ . . ./. . . εριος / αμα σην/βηου αυ/το[υ]

Remember, [. . .] priest . . . and his wife . . .

53.D

53.C devotional inscription adjacent to Saint Michael

Κ(υρι)ε βοη[θει . . .] / λ[. .]ς εκα . . . / κε τ . . . [τ]εκν[. . . αυ]/τ(ου). Αμην.

Lord, help . . .eka. . . and his children. Amen.

Caprara, "Iscrizioni inedite," 11, read Εκα[τερίνες] (Catherine).

53.D* lower left of Virgin and Child enthroned

kneeling male, red garment, bearded, pageboy hair, hands together at chest level

53.sc Annunciation, Anunciation to Shepherds, Nativity, Presentation in Temple, Entry to Jerusalem, Last Supper, Crucifixion

53.st* John the Baptist, Nicholas (2), Mark, Michael (2), George (?), John, Stephen

Caprara, "Iscrizioni inedite," 10–12; Peluso and Pierri, *Cripte*, 16–27; Fonseca, *Civiltà rupestre*, 78; Medea, *Affreschi*, 1:188–90; Diehl, *Art byzantin*, 127–29.

NEAR GROTTAGLIE, MASSERIA LO NOCE (TARANTO)

54. San Pietro, fourteenth century

Rock-cut church

54.A* left niche, right wall, under Crucifixion of Saint Peter

ME[M]E(N)TO D(OMI)NE FAMV/L[I TU]I DA[NI]HEL . . ./. . . LONIA Q(UI) FIE[RI FE]/CIT HO[C OPU]S.

Remember, Lord, your servant Daniel . . . lonia who had this work made.

54.B adjacent to 54.A

kneeling male, short hair, no beard, dark blue robe, hands pressed together at face height, large hat on back

54.pg right wall, on Saint Michael the Archangel versus dragon

See Plate 10 for detail

shields, postmedieval verbal graffiti

54.A

54.sc Peter and Andrew, Christ and Peter Walk on Water, Denial of Peter, Beheading of Paul, Crucifixion of Peter

54.st* Peter enthroned; *right wall: Michael versus dragon, Nicholas, James with staff and shell-decorated scrip over arcosolium tomb

Safran, "Scoperte salentine," 84–89; Peluso and Pierri, *Cripte*, 45–49.

LATIANO (BRINDISI)

55. Santa Maria di Cotrino

Preserved in sanctuary library *(n.v.)*; 23 × 33 cm
Didactic inscription, fourteenth century

P(RES)B(ITE)R GEORGIUS / DE HORIA. ARCHI/PR(ES)B(ITE)R LATIANI ME / FECIT.

Priest George of Oria, archpriest of Latiano, made me.

Jurlaro, "Epigrafi," 262–63.

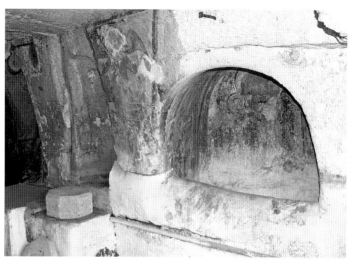

54.st

56

LECCE (LECCE)

56.* Synagogue inscription, fifteenth century

Reused as latrine architrave in Palazzo Adorno; ca. 30 × 55 cm

> *This is none other than the house of God [=Gen. 28:17].*

Colafemmina, "Due nuove iscrizioni," 390–95; Colafemmina, "Frammento di iscrizione."

57. Cathedral of Santa Maria

Dedicatory inscription in Leonine hexameters, 1114 *(n.v.)*

> HAEC IN HONORE PIAE QVAE VISITVR AVLA MARIAE / CVRA FORMOSI
> BENE PRAESVLIS OFFICIOSI / TVNC FVNDARI CAEPTA EST, SIMVL ET
> FABRICARI / CVLTV<S> NON VILIS CVM PRATIS RIDET APRILIS / ATQVE
> DEO FIDO LYCII DOMINANTE GOFFRIDO / TRANSACTIS MVNDO CVM
> TEMPORE IAM MORIBVNDO / CENTVM MILLE DECEM POST HOS
> QUOQVE QVATVOR ANNIS / ASTRA REGENS POSTQVAM NOSTRAE
> VOLVIT FORE CARNIS

> *Under the supervision of the dutiful archbishop Formusus, this church in honor of pious
> Mary that is being visited had begun to be built, and at the same time a by no means
> unworthy cult organized, when April smiled on the meadows, and Godfredus, faithful
> to God, was ruling Lecce, the world and time, too, already dying, one hundred one
> thousand and ten, and after these, four, years having passed since our Co-heir who rules
> the stars wished to be of our flesh.*

Amended from De Leo, "Contributo," 11–12; C. De Giorgi, *Provincia*, 2:391–92; Vetere, "Civitas," 93,
102–3.

58. Santi Niccolò e Cataldo

Three-aisle basilica of Benedictine monastery

> **58.A dedicatory inscription on west façade portal, 1180**
>
> > HAC IN CARNE SITA. QVIA LABITVR IRRITA VITA / CONSVLE DIVES ITA.
> > NE SIT PRO CARNE SOPITA / VITE TANCREDVS COMES ETERNVM SIBI
> > FEDVS / FIRMAT IN HIIS DONIS. DITANS HEC TEMPLA COLONIS

Wealthy ones, in whom life inheres in this our flesh but rapidly passes away, such that this same flesh is never soothed, Count Tancred, in these donations, assures for himself a pact of eternal life, enriching this temple with serfs.

58.B dedicatory inscription on south portal of cloister, 1180 *(n.v.)*

ANNO MILLENO CENTENO BIS QVADRAGENO / QVO PATVIT MVNDO CHRISTVS SVB REGE SECVNDO / GVILLELMO MAGNVS COMITO TANCREDVS ET AGNVS / NOMINE QVEM LEGIT NICOLAI TEMPLA PEREGIT

In the year one thousand one hundred eighty since the year in which Christ appeared in the world, in the reign of William II, the great Count Tancred brought to completion the temple of Nicholas and (together with?) Agnus whom he had chosen for his renown.

Pellegrino and Vetere, eds., *Tempio di Tancredi*; De Sanctis, "La chiesa di San Nicola e Cataldo."

58.C

58.C* left aisle, lower left corner of Saint Benedict scenes, 1420s

full-size supplicant behind haloed pope and two haloed bishops at death of Saint Benedict; kneeling, hands pressed together at chest height, wears three rings and episcopal gloves; short beard, brimmed hat

58.sc Vita of Saint Benedict, Vita of Saint Nicholas

58.sc.1* Baptism of a Jew

58.st Benedict, Nicholas

Calò Mariani, "Dal chiostro," 724–26; Calò Mariani, "San Nicola nell'arte," 115; Lunardi, Houben, and Spinelli, eds., *Monasticon*, no. 154.

58.sc.1

59. Torre di Belloluogo, late fourteenth century

Wall paintings in second-story chapel

59.A* Departure of Mary Magdalene from Palestine to Provence
See Plate 11 for detail

59.sc Vita of Saint Mary Magdalene; Crucifixion

Calò Mariani, "Note," 141–42, 146; Cassiano, "Momenti"; Cassiano, "Arte al tempo," 286–94.

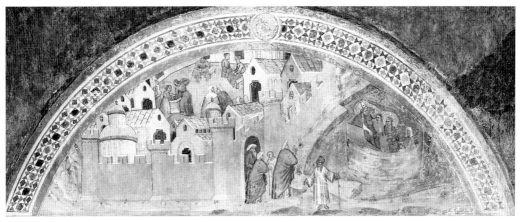

59.A

NEAR LECCE (LECCE)

60. Santa Maria di Aurio

Three-aisle basilica with carved capitals and architrave, twelfth century; letters shown in relative scale

> 60.A east wall, right engaged column capital
>
> ς Χ Ξ Κ
> 6660 = 1152
> Κ = ?

> 60.B first column on left
>
> αεχσω . . . οφοβλ ο

> 60.C second column on left
>
> ΜΕ / CT. . .
> cΜΙΟΗΚΕΡΘ / C . . . εραοι . . . ΟΥΚ

> 60.D second column on left
>
> ΟΥΚΕΡ . . . ΒωΕ

> 60.E* second column on right
>
> +ωρ / ευλ[ογία?] / φ κουτ
> +κολλεγιω, collegium
> +CE / ΕΑΕΟ / Κ Κ . . . ΠΕ
> ΡΙω / ΜΤΡΑ βυω φω / Ει 宁
> ΥΔV ες / γρου πλα
> . . . ισ μ[α]κροτυτι ε Θ / ερ ΘΟΥ Κ Β ΟΥΚ: εις μακρότητα, to
> the length of days / Θεου Κ[υριε] β[οήθει?], Lord God help(?)
> το, τα, α, της / παπάς
> πατρι / τ[ρ]ιτων / τρι / τη[. . .] / ω πιγκ?

60.E

60.pg incised in various locations

left doorjamb
 vertical sandal outline
west wall interior, left of door
 letters M and I flanking cross above bar; profile figure with shield
west wall, right of door
 shield (?) within zigzag lines; ship (?); four pentalphas
first column on left
 verticals, cross-hatchings; ΛΚΟ; nimbed Christ blessing; profile head facing left
second column on left
 short vertical slashes on bottom; helmeted figure, plus later urinating figure;
 figure striding left, facing right; cross in circle
first column on right
 vertical slashes on bottom; crosses
second column on right
 helmeted heads; profile figure facing left
south wall
 ships (4); figure with lance, facing right; sea creature (?)

Safran, "Scoperte salentine," 73, 75; Ortese, "Sulla chiesa di Santa Maria d'Aurio"; Laporta, "Surbo," 313–33.

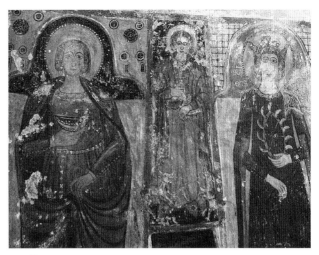

62.st

LIZZANO (TARANTO)

61. Santa Maria Annunziata, twelfth century (?)

Rock-cut church

61.A hortatory inscription on left wall, now lost *(n.v.)*

SCA MARIA . . . O . . . LLO
SANCTA MARIA ORA PRO CIRILLO (?)

Saint Mary, pray for Cyril (?)

61.sc Annunciation (2), Flight Into Egypt, Crucifixion *(n.v.)*; sixteenth-century Virgin and Child, the latter wearing coral necklace

61.st James, Nicholas, John the Baptist, Peter, pilgrim saint, Michael, Martha (?), Antony Abbot (only Peter, Marina, Michael extant)

Robinson, "Some Cave Chapels," 196; Farella, "Chiesa," 376–83.

MASSAFRA (TARANTO)

62. Madonna della Buona Nuova, fourteenth century

Rock-cut church

62.st* Lucy, Vitus, Catherine

Fonseca, *Civiltà rupestre*, 108–11; Abatangelo, *Chiese-cripte*, 1:71–74.

63. Candelora, thirteenth century

Rock-cut church, originally imitating a cross-in-square plan, with fictive beamed ceiling

63.A* north wall, to lower left of Mary escorting Jesus to school

See Plate 12 for detail

two figures, man kneeling in gray cotte and surcoat, female behind him in long gray garment, long belt; both with hands clasped at chest height

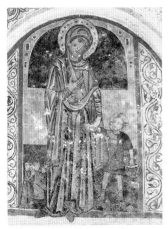

63.A

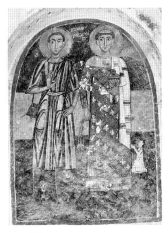

63.B

63.B* west wall, adjacent to Saint Stephen paired with Saint Nicholas Pellegrinus
male figure in white garb, red hose with soles, hands clasped at face level

63.C west wall, to lower right of Saint Mark
tiny figure in red garment (holding a censer?) with traces of "Memento Domine" inscription (*n.v.*)

63.sc Presentation in the Temple, Mary escorting Jesus to school [63.A]

63.st Stephen, Nicholas Pellegrinus, Nicholas, Matthew, John, Peter, Antony Abbot, Mark

Safran, "Scoperte salentine," 76, 87, 89, 92; Falla Castelfranchi, "Del ruolo," 196–205; Falla Castelfranchi, "Anche i santi"; Falla Castelfranchi, *Pittura monumentale*, 201–9; Abatangelo, *Chiese-cripte*, 1:162–77; Fonseca, *Civiltà rupestre*, 114–19.

64. San Giovanni, thirteenth century
Rock-cut church

64.A devotional inscription, east apse

+Κ(υρι)ε βοη/[θει τ]ου δου/λ(ου) σ(ου) Ση/νατορο(ς) / Αμην

Lord, help your servant Senatoros. Amen.

64.st Nicholas (?)

Caprara, *Chiese rupestri del territorio*, 115–16; Abatangelo, *Chiese-cripte*, 1:236–46.

65. Madonna delle Rose, thirteenth century
Rock-cut church

65.A devotional inscription, west wall, inscription to left of Saint John the Baptist paired with Saint Nicholas

MEMEN/TO D(OMI)NE / FAMVLV(M) / TVVM IOH/(A)N(N)E(M) ET / OMNES Q(VOS) / FECIS/TIS / [DI]GN[OS] T[VAE] P[I]/E[TATIS?]

Remember, Lord, your servant John and all who properly observe (your piety?).

Abatangelo, *Chiese-cripte*, 114, reads "TE P[OPULUM?] ET [SACERDOTES?]"

65.sc Deesis

65.st John the Baptist, Nicholas, Peter, Paul

Fonseca, *Civiltà rupestre*, 146; Abatangelo, *Chiese-cripte*, 1:111–15.

66. San Marco, thirteenth–fourteenth century
Rock-cut church

66.A devotional graffito in narthex, south wall, between feet of Saint Mark

ME(MEN)TO / D(OMI)NE FAMV/LV(M) TV(UM) / MARCV(M) ET / VXORE(M) [E]IVS. / [AMEN.]

Remember, Lord, your servant Mark and his wife. [Amen.]

66.B adjacent to 66.A
kneeling male figure to right of Saint Mark and inscription; white long-sleeved garment

66.C didactic graffito in narthex, left arcosolium *(n.v.)*

EGO [C]ECCAR(IUS)

I am Ceccarius

66.D **didactic graffito in narthex, south arcosolium** *(n.v.)*

RADELC[HIS?] MON[ACHUS?] . . .

Radelchis the monk . . .

66.E **devotional graffito, first pier on left, south face** *(n.v.)*

. . . DI ORA PRO EIS

. . . pray for him

66.F **devotional graffito, second pier on left, south face** *(n.v.)*

Μνη(σθητι) Κ(υρι)ε . . .

Remember, Lord . . .

LEO DE NU[C]ILIA

Leo of Nociglia

66.G **devotional graffito, first pier on right, west face** *(n.v.)*

Κ(υρι)ε Βοηθου του δουλ[ου . . .]

Lord help your servant . . .

. . . UPI[US?]TRA . . . PIRI . . . HOD.NI

petra? terra? propitiation [PITRA]? spiritus?

66.H **hortatory graffito, second pier on right, north face**

. . . / SACERDOS / PETRUS SA/CERDOS URSUS / CH(LERIC)US O(MN)ES Q(UI) / HUC I(NC)ORSATIS ORA/TE PRO [. . .]IS

. . . priest, Peter the priest, Ursus the cleric, all who enter here pray for them.

66.I **hortatory graffito, second pier on right, west face**

+EGO IO(HANNES) / CO(N)VEN(I)E(N)ES / AD ISTUM / . . . SIDI / ORATE O(M)NE(S) / PRO ME

I, John, coming to this... [...sidi?], all pray for me.

66.pg female or beardless face; two bearded, earless male faces

66.pg.1* Solomon knot on red frame of Saint Mark (see 66.A)

66.st Mark, Cosmas, Damian

Caprara, *La chiesa rupestre di San Marco*, 64, 78–84; Caprara, *"Singularità,"* 45–48; Caprara, *Società*, 213–14; Fonseca, *Civiltà rupestre*, 120; Abatangelo, *Chiese-cripte*, 1:152–61.

66.pg.1

67. Santa Marina, twelfth–fourteenth century

Three-apsed rock-cut church; block altar in central apse; side apses have stepped wall altars

67.A **devotional graffito, right side of central apse**

Μνεσ[θητι . . . τοῦ δου]λ(ου . . . Αμην.

Remember (Lord?), you (servant?) . . . Amen.

67.B* **didactic graffito, south face of left pier**

SEPTIMO DIE INTRANTE / MENSE DECEMBER / (A)EDIFICATVM X AL/ TARE HOC IN (HO)NORE(M) / BEAT(A)E MARIN(A)E

On the seventh day from the beginning of the month of December this altar in honor of blessed Marina was built.

67.B

67.E

67.C didactic graffito, south side of right pier

[MENSE] N(OVEM)B(R)I X R[E]S[T]I[TVTV]R S<A>BINI . / ALTARE / S(AN)C(T)I SABINI

In the month of November is restored to Sabinus the altar of Saint Sabinus.

67.D didactic graffito, exterior right bay

SC / S bA
ALTARE S. BASILI (?)

Altar of St. Basil (?)

67.E* left wall, adjacent Saint Marina
standing figure; white tunic, orange V-neck surcoat; cloak has red-on-white roundel print; figure holds large lit candle

67.sc Deesis (2)

67.st Leonard, Paul, Sabinus, Margaret/Marina (3)

Castronovi, *Tracce*; Fonseca, *Civiltà rupestre*, 122; Fonseca, "Civiltà rupestre in Puglia," 86; Jacovelli, ed., *Affreschi bizantini*, 26; Jacovelli, "Discussion," 524–26; Abatangelo, *Chiese-cripte*, 1:178–95.

68. Mater Domini, fourteenth–fifteenth century
Rock-cut church

68.A east wall, at feet of Saint Marina
praying figure

68.sc Deesis

68.st Marina, Nicholas

Fonseca, *Civiltà rupestre*, 148; Abatangelo, *Chiese-cripte*, 1:144–51.

69. Sant'Oronzo, fourteenth century
Rock-cut church *(n.v.)*

69.A devotional graffito, below Saint Orontius

MEME[N]TO D(OMI)NE FAMVLO TVO GRISIVS

Remember, Lord, your servant Grisius.

69.st Orontius

Caprara, *Società*, 97, correcting Abatangelo, *Chiese-cripte*, 1:226–30; Jacovelli, "Discussion," 527 ("Brizius").

70.* San Simeone in Famosa, fourteenth century
Rock-cut church with two square apses, icon frames in relief; tomb on left wall

70.pg incised cross over entrance, icon frame to right

70.sc Sacrifice of Isaac, Annunciation, Baptism, Last Supper, Deposition, Deesis

70.st Benedict, Michael with dragon, Margaret (2), John the Baptist, Peter, Martin, Sylvester, Luke or Isaiah, Erasmus, Vitus, Cataldus

Safran, "Language Choice," 867; Abatangelo, *Chiese-cripte*, 1:83–105; Fonseca, *Civiltà rupestre*, 134–35.

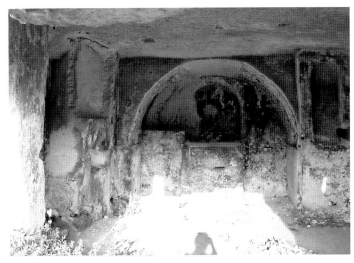

70

MASSAFRA/CRISPIANO (TARANTO)

71. San Posidonio (formerly Cripta-Pozzo in Carucci), thirteenth century (?)

Rock-cut church

> **71.A** right wall, to lower right of bishop (Saint Nicholas?)
>
> > .E BO / . . . T / X / E
> > [Κύριε?] βοηθει . . .
> >
> > *[Lord?] help . . .*

> **71.B** apse graffiti
>
> figure on horseback, Solomon knot, cruciform monogram

71.pg at least fifteen crosses; five- and six-pointed stars

71.st Posidonios (only secure figure); Blasios (?), Athanasios (?), Nicholas (?), Damian (?)

Caprara, *Società*, 183 (proposes "iconostasi lignea" in Byzantine era for which there is no evidence), 221; Fonseca, *Civiltà rupestre*, 132; Abatangelo, *Chiese-cripte*, 1:116–19.

MESAGNE (BRINDISI)

72. San Lorenzo

Late antique triconch with late medieval paintings

> **72.A*** devotional graffito, left conch
>
> > + Μνε(σ)θ[ιτι] . . . [δ](ου)λ(ου) σ(ου) Πορφηρ[ιου] κ(αι) . . .
> > ε / [συ]μ[βιου] . . . τεκν[ου α]υτ(ου) Γα . . . / . . . οδρ . . .
> > Ετ [ους] . . . / . . . ??? . . . Ετ[ους]
> >
> > *Remember . . . your servant Porphyrios and ? his wife . . . and his child Ga[briel?] . . . year . . . year*

72.st Catherine or Marina (-PHNA)

Bruno, "Triconco di San Lorenzo"; Andreano, "Tempietto"; Campana, *Tempietto*.

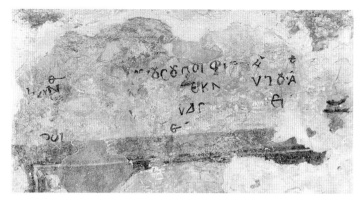

72.A

MIGGIANO (LECCE)

73. Santa Marina, thirteenth century(?)

Rock-cut church in cemetery

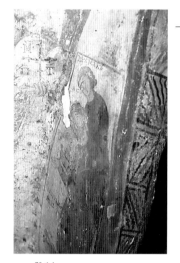

73.A.1

73.A.1* three figures to lower right of Saint Michael on perpendicular wall
one male standing, head inclined, hands extended at chest height, beardless, wears long red-brown garment; second standing, head inclined, hands splayed at chest height, bearded, wears tight sleeves and long blue robe with decorated hem

73.A.2* lowest of three figures in 73.A.1
third male smaller, bent over, hands splayed, bearded, wears tight-sleeved orange garment, dark boots

73.B didactic inscriptions adjacent to 73.A.1

Λε(ου) μ[ον]ακ(ου) / Προ[σ]κηνισις / Νικολα μονακ(ου)

of Leo, monk / proskynesis / of Nicholas, monk

73.sc Koimesis

73.st Michael, Nicholas, two deacon saints, female saint

Safran, "Scoperte salentine," 72, correcting M. De Giorgi, "*Koimesis* bizantina"; Fonseca et al., *Insediamenti*, 32, 121; Fonseca, "Civiltà rupestre in Puglia," 84.

73.A.2

MOTTOLA (TARANTO)

74. Sant'Apollinare (San Lorenzo?), thirteenth century?

Rock-cut church

74.A devotional inscription, right wall, left of Virgin and Child

ME/ME(N)/TO/ D(OMI)NE / FA/MV/LE / TVE / MAR/CIA/NE

Remember, Lord, your servant Marciana.

74.pg compass-drawn circle

74.sc Martyrdom of Saint Bartholomew

74.st Laurence (2)

Safran, "Scoperte salentine," 83–84; Caprara, *Società*, 208.

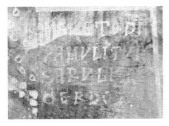

75.A

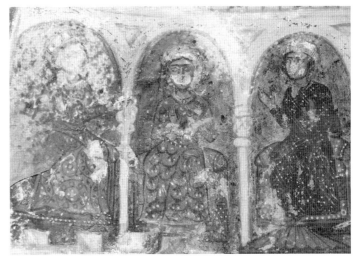

75.sc.1

75. Santa Margherita, thirteenth century

Rock-cut church

75.A* east wall, adjacent Saint Margaret

MEME[N]TO D(OMI)N[E] / FAMVLI TVI / SARVLI SA/CERDOT[IS]

Remember, Lord, your servant Sarulus, priest.

75.pg graffiti on Saint John the Evangelist
winged creatures; helmeted, short-skirted figure; smaller standing figure; long-eared
quadruped; five-pointed star

Caprara, *"Singularità,"* 49 ("ex-voto for liberation from demonic possession").

multifigure hunting scene (*n.v.*), location unknown

απλατι[ς] (ου)ρση

terrible bear (Greek + Latin)

Caprara, *"Singularità,"* 42; Caprara, *Società*, 221–22; Jacovelli, "Discussion," fig. 11, without graffito.
"Ἀπλάτις" can also mean "small"; perhaps the graffito was added to the (now invisible) scene as an
ironic comment.

75.sc Deesis, Nicholas miracle (three girls' dowry), Vita of Saint Margaret

75.sc.1* three girls in 75.sc

75.st Antony (Abbot?), Michael (2), James, Nicholas, Lawrence, Mark, George on
horseback, Demetrius on horseback defeating Kalojan, Stephen (2), Margaret (3),
John the Evangelist, Peter, Orontius, Vitus, Agnes (?)

Jacovelli, "Discussion," figs. 11–13; Safran, "Scoperte salentine," 77, 83; Tortorelli, "Aree"; Fonseca,
Civiltà rupestre, 172–81; Medea, *Affreschi*, 1:224; Guillou, "Art des 'moines basiliens,'" 296.

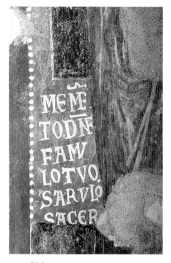

76.C

76. San Nicola, eleventh–fourteenth century

Rock-cut church

> **76.A** devotional inscription, south wall, under horse of Saint George
>
> MEM(EN)TO / DOMINE FAMV/LO TVO IO(HANNES) / CRISPV[LUS]
>
> *Remember, Lord, your servant John Crispulus.*

> **76.B** devotional inscription adjacent 76.A *(n.v.)*
>
> Μνυσ[θητι], Κ(υρι)ε, του δουλου . . .
>
> *Remember, Lord, your servant . . .*

> **76.C*** devotional inscription, north wall, adjacent Saint Nicholas
>
> MEME[N]/TO D(OMI)NE / FAMV/LO TVO / SARVLO / SACER[DOTE]
>
> *Remember, Lord, your servant Sarulus, priest.*

> **76.D*** devotional inscription, south wall, adjacent Pope Leo (see 76.E)
>
> ME(MEN)/TO / (DOMI)NE / [F]A/MV/LO / O C O
>
> *Remember, Lord, servant . . .*

Diehl, *Art byzantin*, 146, read "Meme(n)to D(omi)ne famulo tuo Leone." .

> **76.E*** south wall pilaster, adjacent 75.D
>
> ### *See Plate 13 for detail*
>
> two standing female figures holding tall, lit candles; the one at left in tight-sleeved V-neck white dress with red belt, black shoes; the other, in tight-sleeved V-neck gray dress with gray belt, black shoes

76.pg graffiti in various locations

apse intrados *(n.v.)*
 exorcism scene (?); woman with feline

Caprara, *"Singolarità,"* 48–49.

north wall, adjacent to Saint Peter
 standing short-skirted figure with shield

76.pg.1* right pier, below Saint Peter
wolf (?), quadrupeds, horse and rider

Caprara, *"Singolarità,"* 31–32.

76.sc Deesis, Dormition of John the Evangelist

76.sc.1* Christ child wearing amulet, north wall

76.st John Chrysostom (?), Julian, Pelagia, Peter (3), Theodore, Lawrence, Basil, Nicholas (3), Michael (2), Stephen (2), George on horseback (2), Leo I, Helena, Blasius, Leonard, Lucy, Parasceve, Wise and Foolish Virgins

76.st.1* view of south wall, west end, with saints in niches and supplicants on pilaster

Safran, "Deconstructing 'Donors,'" 143–48; Safran, "Scoperte salentine," 86, 88–92; Tortorelli, "Aree"; Pace, "Pittura delle origini," 340–42; Jacovelli, "Discussion"; Guillou, "Arte e religione," 374; Fonseca, *Civiltà rupestre*, 182–203; Lavermicocca, "Programma decorativo."

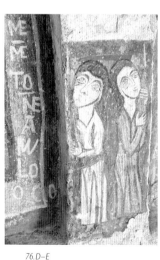

76.D–E

76.pg.1

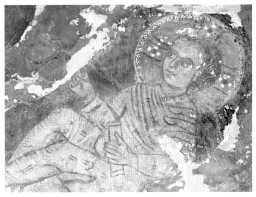

76.sc.1

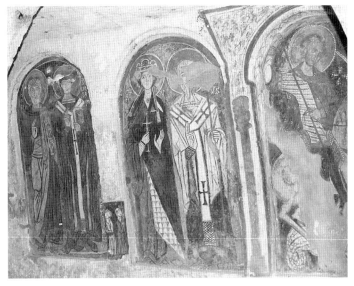

76.st.1

MURO LECCESE (LECCE)

77. San Nicola (now Santa Marina), eleventh–thirteenth century

Single-nave basilica with later vestibule

77.A* south wall adjacent to enthroned figure (Christ?)
female kneeling to lower right, hands pressed together at face height; blue-green garment with pearl-edged tight sleeves; long braid of hair with pearls interwoven

77.pg north wall, on equestrian saint and Saint John the Baptist
multiple horses, frontal stick figures, frontal face

77.sc Ascension, Vita of Saint Nicholas

77.st Basil, John (?), Gregory of Nazianzos, Onouphrios, Makarios, Barbara, John the Baptist, Antony Abbot, military saints on horseback

Safran, "Scoperte salentine," 70–72; Falla Castelfranchi, "Chiesa di Santa Marina"; Falla Castelfranchi, *Pittura monumentale*, 101–6; Imperiale, Limoncelli, and De Giorgi, "Due chiese."

77.A

NARDÒ (LECCE)

78. Cathedral of Santa Maria

Three-aisle basilica; Benedictine monastery by eleventh century, cathedral after 1413

> **78.A** west façade tympanum, 1354 *(n.v.)*
>
> ABBAS AZZOLINUS DE NESTORE / ANNO DOMINI MCCCLIIII
>
> *Abbot Azzolinus de Nestore, year of the Lord 1354.*
>
> **78.B** roof beams, restored 1332–51 *(n.v.)*
>
> . . . TERTA SOLO TE(M)PLUM FUIT HOC RE(STITUTUM?) / (P)ASTORIS BARTHULOM(EI) . . . SE(DENTE?) / DOMIN[E] . . . SEPTI(M)U<M>(?) / REGALE TENE(N)TI : PRINCIPA(TU) ROBERTO NOSTRO / DOMINANTE A(NNO) M . . .
>
> *. . .(terta. . .) (alone? on the ground?) this temple/church (of Bartholomew the shepherd) was restored . . . when the lord was sitting . . . holding the regal . . . : when our Robert was ruling over the principate in the year one thousand . . .*
>
> Amended from Gelao, *Capitolo*, 23–26, and Micali, "Fabbrica," 203, with "TARENTI" instead of "DOMINANTE."

> **78.C** dedicatory inscription, originally fourth or fifth pier on left, 1255
> now-lost poem in Leonine hexameters *(n.v.)*
>
> GOSFRIDI CVRA VIRGO GENITI GENITVRA / FIO BISARDI DOCTAQVE MANV BAYLARDI / HIC SVB FELICI REGNO DIVI FRIDERICI / PRAESES ERAT QVANDO ME FECIT TE VENERANDO / ANNVS MILLENVS CHRISTI DECIESQVE VICENVS / QUARTVS AGEBATVR QVINDENVS TER COMITATVR
>
> *Under the supervision of the noble Gosfridus I, the Virgin, bearer of the Begotten, am made by Bisardus and the skilled hand of Bailardus. He [Gosfridus] was leader (praeses) during the happy reign of divine Frederick when he made me while venerating you. The thousand-plus-ten-times-twenty-fourth year of Christ was passing. Three times a fifth attends it [i.e., 1255].*

> **78.D** originally adjacent to 78.C and to "Madonna della Sanità," 1255; now under lower left corner of early fifteenth-century "Madonna della Mela"
> figure in red outer garment, hands pressed together (Gosfridus)

> **78.E** inscription, third pier on left, below Saint Antony Abbot
> text in fifteenth-century script
>
> . . . MV.IPARADISO. /DRACE AEVD / . . . VL.IHS.DR / . . . SIA.COT
>
> *. . . paradise . . .*

> **78.F** figure before Saint Antony Abbot
> male in white, buttons on front; white miter over black head covering; arms crossed over chest (deceased)

78.pg first pier on left with Saint Nicholas, after fourteenth century
shields, profile faces, winged creature, horse

78.sc Flagellation, Crucifixion

78.st Nicholas (2), Antony Abbot, John the Baptist, Augustine, Bernardino da Siena (preached here in 1433), Onouphrius

Mazzarella, *Cattedrale di Nardò*; Vetere and Micali, *Nardò*, 11–30; Gelao, "Chiesa cattedrale," 433–40; Micali, "S. Maria di Nardò"; Gaballo, ed., *Civitas Neritonensis*; Falla Castelfranchi, "Monumenti di Nardò", with traditional date 1249; Lunardi, Houben, and Spinelli, eds., *Monasticon*, no. 228; *Rerum italicarum scriptores*, ed. Muratori, vol. 24 (1738), col. 898.

NEAR NARDÒ (LECCE)

79. Santa Maria dell'Alto, fourteenth–fifteenth century

Former Benedictine monastery church

79.A* didactic inscription on relief slab, 1473

> + AN(N)O D(OMI)NE M CCCC LXXXIII V AVGVSTI VI IND / + HOC OPVS
> FIERI FECIT IVDEX LAVRE(N)CI(VS) VETAN(VS) DENERITONE

> *+ In the year of the Lord 1473, fifth of August, sixth indiction, + Judge Laurence*
> *Vetanus of Nardò had this work made.*

79.B* on 79.A

shield with raised diagonal containing three rosettes and two six-pointed stars in
 reserved fields; flanked by two kinds of foliage in relief

79.C* devotional graffito in back room

Accented minuscule letters

> Μνύσθητ(ι) Κ(ύρι)ε τ(οῦ) δούλου σου / Νηκόλαος υἱος τ(οῦ)
> . . . / Ματθαίος τοῦ Σπίκλης

> *Remember, Lord, your servant Nicholas, son of [according to Guillou,* ιερέ(ως), *the*
> *priest] Matthew of Spicla [=Specchia or Secli]*

79.D devotional graffito in back room

Accented minuscule letters

> . . . Τοῦ Λουκᾶ μνίσθ[ητι]. . .

> *. . . your Luke remember . . .*

79.pg concentric circles, ship; postmedieval male head with high collar, below 78.C

Guillou, *Recueil*, 177–78, no. 166; Lunardi, Houben, and Spinelli, eds., *Monasticon*, no. 230; Mennonna,
 ed., *Nardò Sparita*, 24.

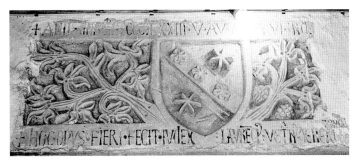

79.A–B

79.C

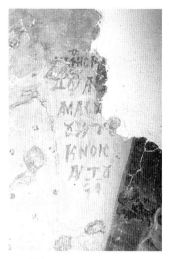

80.A

NOCIGLIA (LECCE)

80. Santa Maria de Itri, eleventh–fifteenth century
Single-nave basilica of San Nicola behind postmedieval Hodegetria chapel

> **80.A*** devotional inscription, north wall, mid- or third quarter of eleventh century

> + Μνησθ(ητι) κ(υρι)ε [του] / δου(λου) Ανδ[ρεου] / αμα
> συ[μβι]/ου κ(αι) τε/κνοις αυτου / ϟ̄Θ̄

> *Remember, Lord, servant Andrew with his wife and children. 99 (= Amen).*

> **80.B** didactic graffito, apse archivolt, left side
> minuscule letters

> + Ἰάκωβος Πιπίνος ἀρχιερεὺς Πουάρδου ινδ(ικτιῶνος) ε̄
> ἡμέρα δ̄ /
> anno domini m(illesim)o ccc lxxij v ind(ictionis)

> *James Pipinos, archpriest of Poggiardo, fifth indiction, Wednesday / year of the Lord 1472, fifth indiction.*

80.st Julian (?), Parasceve, John Chrysostom (?), Nicholas, Cesaria

80.st.1* north wall, view of early fourteenth-century triptych and prothesis niche with sixteenth-century mandylion

Ortese, ed., *Nociglia*; Jacob, "Nouvelle Amen."

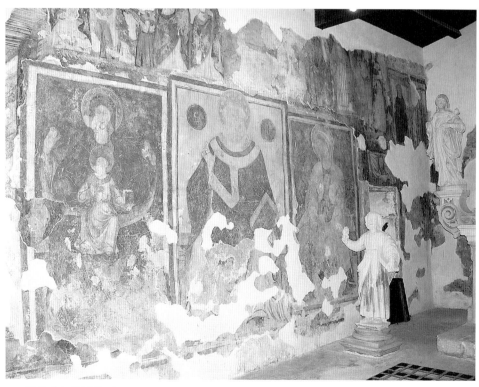

80.st.1 Photo: Michele Onorato.

ORIA (BRINDISI)

81. Funerary inscription, eighth century (?)

Biblioteca Comunale De Pace-Lombardi, no. 1437; 46 cm (+ 19 cm base); top 14 × 14 cm; Hebrew field 24 × 11–9.5 cm

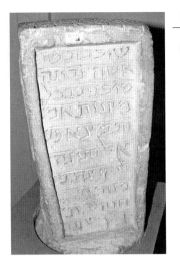

81.A

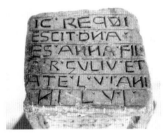

81.B

81.C

81.A* front

<div dir="rtl">

שוכבת פה

אשה נבונה

מוכנת בכל

מצוות אמנה

ותמצא פני

אל חנינה

ליקיצת מי

מנה

זו שנפתרה

חנה

בת

נ ו שנה

</div>

Here lies a wise woman, ready in all the precepts of the faith. May she find the benevolent face of God upon the reawakening of the countless [progeny of Jacob]. She who died is Hannah, age fifty-six years.

81.B* top

IC REQVI/ESCIT D(OMI)NA / <ES> ANNA FILI/A R(EBBITIS) GVLIV ET/ ATE LVI ANI / NI LVI.

Here rests Lady Anna daughter of R. Julius, age fifty-six years, fifty-six.

81.C* sides

menorah, two shofars

Noy, *Jewish Inscriptions*, no. 195; Colafemmina, "Epigrafi e cimiteri"; Colafemmina, "Note su di una iscrizione"; Safran, "Cultures textuelles," 257–58.

82. Devotional inscription, twelfth century

On marble column, now in cortile of Palazzo Vescovile

+MEMENTO / D(OMI)NE FAMVLI / TVI ROGERII / MORAVILLE / ET VXORIS / EIVS ROGAIE / AMEN

Remember, Lord, your servants Roger Moraville and his wife, Rogaie. Amen.

Jurlaro, "Epigrafi," 267–68.

83. San Barsanofio, late ninth century

now crypt of San Francesco di Paola
* Didactic inscription on right wall

THEODOSIVS EPISCOPVS /
CORPVS S(AN)C(T)I BARSANOFII CONDIDIT ET DEDICABIT

Bishop Theodosius interred and dedicated the body of Saint Barsanuphius.

Jurlaro, "Epigrafi," 265; Jurlaro, "Commento," 45, 148–49; Falla Castelfranchi, "Note preliminari"; Falla Castelfranchi, "Chiesa di San Barsanofrio."

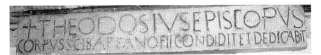

83

84. Santi Crisante e Daria

Now a fireplace mantel in castle of Oria, Sala degli Stemmi
Dedicatory inscription, late ninth century

> VIRGO SACRATA D(E)I PRAESVL TIBI CO(NDI)DIT ISTVD.
> MAGELNAMQ(UE) POTVS DVCTVS AMORE TUO.
>
> *Bishop Magelpotus, guided by your love, founded that [church] of yours, holy virgin
> of God.*

Jurlaro, "Epigrafi," 264; Bertelli, "Arte bizantina," 221; Lepore, "Chiesa."

ORTELLE (LECCE)

85. Santa Maria della Grotta

Rock-cut church
* detail of right wall, ca. 1430

Two female figures hold painted Easter cloth with Christological roundels (Flagellation,
 Crucifixion, Resurrection); one unnimbed male figure at lower left

Ortese, "Enigma iconografico"; Ortese, "Rilettura."

OTRANTO (LECCE)

86. Cathedral of Santa Maria Annunziata, twelfth century and later

Three-aisle basilica; mosaic pavement, 1163–65 with numerous restorations, measures
 approximately 700 square meters in five sections

86.A* view east from west entry

86.B* mosaic pavement, north transept, detail of Kairos

86.C mosaic pavement, west threshold, part of dedicatory inscription

> EX IONATH[E] DONIS PER DEXTERAM PANTALEONIS / HOC OPUS
> INSIGNE EST SUPERANS IMPENDIA DIGNE

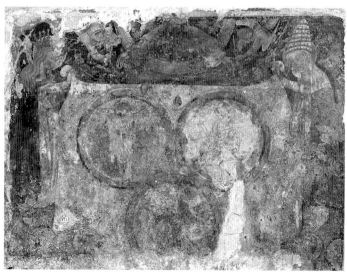

85

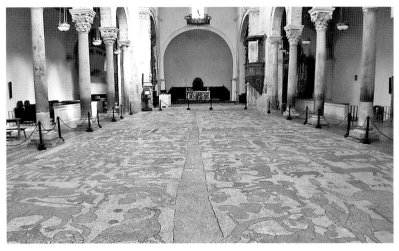

86.A Photo: © Adrian Fletcher, www.paradoxplace.com

*By the donation of Jonathan, by the right hand of Pantaleon, this decorated work
fittingly exceeds its expense.*

86.D **mosaic pavement, nave, part of dedicatory inscription**

HUMILIS SERVUS [CHRISTI] IONATHAS HYDRUNTIN[US]
ARCHIEP[ISCOPU]S / IUSSIT HOC OP[US] FIERI P[ER] MANUS
PANTALEONIS P[RES]B[YTE]RI

*The humble servant of Christ Jonathan, archbishop of Otranto, had this work made by
the hand of the priest Pantaleon.*

86.E **mosaic pavement, center of nave, part of dedicatory inscription**

ANNO AB INCARNATIONE D[OMI]NI N[OST]RI IH[ES]U
CHR[IST]I MCLXV I[N]D[I]CTIO[N]E X IIII REGNANTE DO[MI]NO
N[OST]RO WI[LLELMO] REGE MAGNIF[ICO]

*In the year 1165 since the Incarnation of our lord Jesus Christ, fourteenth indiction,
during the reign of our lord the magnificent king William.*

*86.B Photo: © Adrian Fletcher,
www.paradoxplace.com.*

86.F **mosaic pavement, near altar steps, part of dedicatory inscription**

[ANNO] AB [INCAR]NATIO[N]E D[OMI]NI NOS[T]RI IH[ES]U[S]
CH[RIST]I MCLXIII I[N]DIC[TION]E XI REGN[] FELICIT[ER] D[OMINO]
N[OSTR]O W[ILLELMO] REGE MAGNIFICO ET TRIUMFATORE /
HUMILIS SE[RVUS] IONAT[AS] . . .

*In the year 1163 since the Incarnation of our lord Jesus Christ, under the happy reign of
our magnificent and triumphant king William, the humble servant Jonathan . . .*

86.G **mosaic pavement, presbytery roundel, didactic inscription around King
Solomon**

IONATHAS HUMILIS SERVUS CHR[IST]I IDRONTINI /
ARCHIEP[ISCOPU]S IUSSIT HOC OP[US] FIERI

Jonathan, archbishop of Otranto, humble servant of Christ, had this work made.

86.pg shields, boat, knot on nave and crypt columns

Ungruh, *Bodenmosaik*; Pasquini, "Interculturalità"; Bertelli, "Arte bizantina," 229–31; Frugoni,
 "Mosaico"; Gianfreda, *Mosaico*; Corchia, ed., *Iscrizioni latine*, 16–17; Safran, "Cultures textuelles,"
 248; Vasco Rocca, ed., *Mosaici*, 161–67.

87.A

87.B

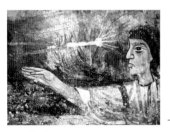

87.sc.1

87.sc.2

87. San Pietro, late tenth–fourteenth century

Cross-in-square church with parekklesion

87.A* devotional inscription, right side of apse wall, fourteenth century

MEME(N)TO D(OMI)NE / FAMULI TUI / P(RES)B(YTE)RI IOH(ANN)IS / MAG(IST)RI NIC(O)LI / DE NERITONE

Remember, Lord, your servant the priest John, son of Master Nicholas of Nardò.

87.B* adjacent 86.A

tonsured male, kneeling, faces left in three-quarter view; white tight-sleeved tunic, red mantle with decorated neck, blue maniple over left wrist

87.sc Creation of Angels, Creation of Heaven and Earth, Creation of Adam, Creation of Eve, Creator with Adam, Reproach and Denial of Adam and Eve, Annunciation, Nativity (2), Arrival of the Magi, Presentation in Temple, Baptism, Washing of the Feet, Last Supper, Betrayal of Christ, Anastasis, Pentecost

87.sc.1* Last Supper, detail of Judas, ca. 1000

87.sc.2* east bay, south wall, Nativity, detail of barking dog, late thirteenth century

87.st Basil, James, Peter, Paul, John, Matthew, Mark, Luke

Safran, *San Pietro*; Falla Castelfranchi, "Chiesa di San Pietro a Otranto."

NEAR OTRANTO, VALLE DELLE MEMORIE (LECCE)

88. San Nicola

Three-apsed rock-cut church

88.A devotional graffito, left wall, twelfth century (?) *(n.v.)*

Μνησθητι Κυριε του δουλου σου π[ρεσβυτερου] Λεοντος. Αμην.

Remember, Lord, your servant (the priest?) Leo. Amen.

Fonseca et al., *Insediamenti*, 138, says no longer extant.

PALAGIANELLO (TARANTO)

89. Sant'Andrea, twelfth–thirteenth century

Rock-cut church

89.A devotional graffito, narthex

Μνησ(ητι) Κ(υρι)ε θ. . .

Remember, Lord, . . .

89.st George on horseback, Andrew, Nicholas

Caprara, *Insediamento rupestre di Palagianello*, 69–99.

90. San Girolamo

Rock-cut church with carved templon and icon frames

90.pg horse and rider, ship are undatable underdrawings (*sinopie*) for never-completed paintings

Caprara, *Insediamento rupestre di Palagianello*, 101–18.

91. Santi Eremiti, twelfth–fourteenth century

Rock-cut church with block altar

91.A devotional inscription, east wall, adjacent Saint Eustathios

Μνησ(θ)ητ(ι) Κ(υρι)ε / του δ(ου)λ(ου) σ(ου) /
[Λ](ου)ναρδ(ου) μο/ναχ(ου). Αμην.

Remember, Lord, your servant Leonard, monk. Amen.

91.st Michael, Eustathios on horseback with stag

Caprara, *Insediamento rupestre di Palagianello*, 37–60 (corrects older readings, p. 58); Guillou, "Art des
'moines basiliens,'" 296.

92. San Giorgio di Roccapampina, thirteenth–fourteenth century

Rock-cut church

92.B

92.A devotional inscription, south wall

MEMENTO D(OMI)NE / FAMVLO TVO / CALOGERIO

Remember, Lord, your servant Calogerius.

92.B* adjacent 92.A
standing figure; long white tunic visible at wrists with pearl-dot buttons, under
 light-blue surcoat with folds outlined in red, red boots; hands splayed at chest level

92.st Demetrius, John the Baptist, George, Mark

Fonseca, *Civiltà rupestre*, 182; Caprara, *Società*, 208–9.

93. Jazzo Rivolta, twelfth–fourteenth century

Rock-cut church

93.A didactic graffito, right of apse niche

EGO SACE[RDOS?] MAGERI[US?]

I am the priest Magerius

93.B didactic graffito, right of apse niche

EGO IO(H)A(NNE)S

I am John

Caprara, *Insediamento rupestre di Palagianello*, 137–55.

94. Santa Lucia, twelfth–fourteenth century

Rock-cut church

94.A devotional graffito, narthex *(n.v.)*

Μνηστητη Α[ρ]χ[αγγελλ]ε του / δουλου{ς} σου Νι{σ}κο/
λαου και αδ[ελφ](ου) / . . . σο

Remember, Archangel (?), your servant Nicholas and brother (?) . . .

Caprara, *Società*, 215, adds at end "τῆς Αγίας Ο," "of Santa O."

94.B hortatory graffito, narthex, intrados of west niche *(n.v.)*

EGO . . . [INDIG?]NUS / P(RES)B(YTE)R FILIUS IAQUINTI / SACERDOTIS
. . . / O[MN]E[S] HIC INCORSATI[S] / . . . RDO / . . .

I am . . . humble priest, son of the priest Iaquintus; all who enter here (pray for me?). . .

94.F

94.C didactic graffito, narthex, below 94.B *(n.v.)*

+ EGO BASTIANUS

I am Sebastian.

94.D devotional graffito, narthex, west arcosolium *(n.v.)*

Κ[υρι]ε βοε[θει] . . .

Lord help . . .

94.E graffito, narthex *(n.v.)*

PRESBITERI / BLASIUS

of priest Blasius (plus large pentalpha)

94.F* didactic graffito, intrados of south arcosolium

EGO PETRUS STEA /SACERDOS H[IC] S[CRIPSI] NO[MEN](?)

I, Peter Stea, priest, here write [my] name.

94.G didactic graffito, intrados of south arcosolium

EGO . . . PECA[TOR] . . .

I . . . sinner . . .

94.H didactic graffito, intrados of south arcosolium *(n.v.)*

Μνες[θητι] ημη δουλη ση (?)

Remember me the servant Se. . . (?)

94.I didactic graffito, intrados of south arcosolium *(n.v.)*

+EGO BEATI PET[RI?] [IN]DIGNUS D[IACONUS?]

I am blessed Peter, humble deacon (?).

94.J hortatory graffito, apse wall *(n.v.)*

+ EGO LEO INDIGNUS / PRE[S]B[ITE]R. O[MN]ES QUI LEGITIS OM[NE]S / ORATE PRO EO PECCA/TOR.

I am Leo, humble priest. All who read, all pray for this sinner.

94.K graffito, apse wall *(n.v.)*

IOANNES P[RESBITE]R NEPUS MICHAELIS D . . .

John the priest, grandson of Michael of . . .

94.L devotional graffito, apse wall *(n.v.)*

MEM[ENTO] D[OMINE]

Remember, Lord . . .

94.M didactic graffito, apse wall *(n.v.)*

EGO ESPEDITOS

I am Espeditos

94.pg intrados of west arcosolium
crested bird and serpent (?) *(n.v.)*; pentalpha

94.st Lucy (?)

Caprara, *Insediamento rupestre di Palagianello*, 119–36; Caprara, "*Singularità*," 36–37.

95. San Nicola, thirteenth–fourteenth century

Rock-cut church
Devotional inscription, south niche, adjacent Saint Matthias

> MEME(N)TO D(OMI)NE / FAMVLO TVO / MA. . .O [ET] V/[XOR]I[S] [EI]VS
>
> *Remember, Lord, your servant Ma[tthias?]. . . and his wife.*

95.sc Deesis (with Nicholas for John the Baptist)

95.st Peter, Matthias, Nicholas

Caprara, *Insediamento rupestre di Palagianello*, 15–34.

PALMARIGGI (LECCE)

96. Funerary inscription, 1304

Found near church of the Madonna della Palma; current location unknown *(n.v.)*;
 37 × 53.5 × 11.5 cm

> + Εκοιμηθη ο δου[λος του Θ(εο)υ Ιωα]/ννης μηνι ιανουαριω ει[ς τ(ας) ζ] / ἡμέρα δ̄ ετει ,ϛ ω̄ ῑ β̄ ινδ(ικτιονος) β̄
>
> *The servant of God John died Wednesday, [7] January, 6812 (=1304), second indiction.*

Jacob, "Deux épitaphes," 167–78.

POGGIARDO (LECCE)

97. Santa Maria degli Angeli, twelfth century (?)

Rock-cut church; frescoes now in Museo degli Affreschi Bizantini, under Piazza Episcopo

97.A devotional inscription, northwest pier, between Virgin and Child and Saint Nicholas

> [Μνησθητι / Κυριε του δου]/λου σου λε/οντος αμα / [συμ]βιου / αυτου / Αμην.
>
> *Remember, Lord, your servant Leo and his wife. Amen.*

97.B east wall niche below Saint Stephen
tiny male in Byzantine armor, including shield and sword, with inscription at left

> ινδικτιωνος / ει γενους / ζραγ (?)
>
> *indiction / of the family (?) / date (?)*

97.st Nicholas (3), George (2, one on horseback), Peter with three keys, John the Theologian (2), Mary Magdalene, Anastasius (?), Demetrius, Lawrence, Michael (3), Gabriel, Stephen, Cosmas, Damian, John the Baptist, Julian

Jacob, "Nouvelle Amen," 189; Fonseca et al., *Insediamenti*, 155–66; Falla Castelfranchi, *Pittura monumentale*, 111–23, 138 n. 44; Medea, "Mural Paintings," 22–23, 25.

QUATTRO MACINE (LECCE)

Abandoned village near Giuggianello

98. Funerary inscription, 1117

Lecce, Museo Provinciale "Sigismondo Castromediano," no. 4471

98.A front

+[Ε]κοιμηθ[η] ο δ/[ου]λος του Θ(εο)υ /. . .εος μη[νι] μαρτι[ω]
/ κ̄η̄ ημέρα δ̄ / [ετει] ͵ϛ χ̄ κ̄ ε̄

*The servant of God . . .-os died . . . month of March, on the 28th day, year 6625
(=1117).*

98.B back

recessed quatrefoil with pentalpha, eight-petal rosette in relief triangles

Guillou, *Recueil*, 168, no. 151.

99.* Funerary inscription, 1174/75

University of Salento, Laboratorio di archeologia medievale, SF 188. Found on surface;
limestone, circular, 42 cm diam. × 8 cm thick

99.A front

relief cross inside circle within raised circular frame; text between cross arms

[. . .] / κη / [. . .]ω εις [τ(ας)] λ̄ ᾱ / (ωρα) γ̄ / ετου(ς) ͵ϛ χ̄ π̄ γ̄
/ ηνδ(ικτιωνος) η̄

*[Here lies?] [died on the] 31st of the month of . . . , third hour, year 6683 (=1174/75),
indiction 8.*

99.B back

sunken quatrefoil inscribed inside concentric circles; traces of red pigment

Jacob, "Arménien," correcting Piliego, "Iscrizioni bizantine," 90–96; Piliego, "Un'iscrizione bizantina";
Guillou, *Recueil*, 168, no. 151; Arthur, "Masseria Quattro Macine," 203 and fig. 21.

100. Funerary inscription, fourteenth century

Lecce, Museo Provinciale "Sigismondo Castromediano," no. 5167; originally circular;
now 29 × 21 cm

100.A front

accented cursive script

. . . παντων κ . . . α . . . ων . . .μερ- . . . ιων ταῖς ἄνω- . . . γίσιν
ον γῆς μετέστης(αν). / νοικ() ἀξίωσον τοῖς ἄνω εἴκτειρον
εἰ . . .ἀσυλώτου τ(ῆς) . . .κληρουχίας π.ν τ / θείης
τούτους τετ()ρῶν δ' αὐνό . . . ος τ(οῦ) . . . αὐτ().

*All . . . up . . . departed from the earth make them worthy of the upper things (?) and
have pity . . . inviolate inheritance (?) . . .*

100.B back

relief cross within raised circular border

Guillou, *Recueil*, 172, no. 158.

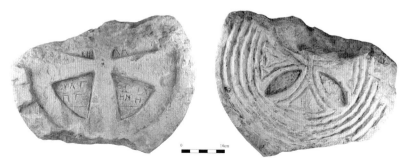

99 Photo: C. Napolitano. Courtesy Laboratory for Medieval Archaeology, University of Salento.

101. Ostracon, first half of eleventh century or later

University of Salento, Laboratorio di archeologia medievale, QM 91. SPOR.[83]; found on surface. 4.4 × 11 cm

<div align="center">

ΚΟΝϹΤΑΝΤΙΝΟΥ / ΚΟΙΝѠΤΑΦΗΟΝ

Tomb of the family of Constantine
</div>

Jacob, "Apigliano," 138–39; Arthur, Calcagnile, et al., "Sepolture multiple," 297; Arthur, "Casale medioevale," 170; Arthur, "Masseria Quattro Macine," 202.

102.* Byzantine church and cemetery plan, tenth–eleventh century

102.A small finds
iron lance for eucharistic liturgy; pewter liturgical spoon, one side with paired fish, other with confronted feline and griffin flanking tree

Arthur, "Masseria Quattro Macine," 198–99, 211.

102.pg on templon barrier
three Solomon knots, letters

Bruno, "Chiesa bizantina a Giuggianello"; Arthur, "Masseria Quattro Macine," 197–200, 210–11.

102 Courtesy Laboratory for Medieval Archaeology, University of Salento (originally appeared in Arthur, "Masseria Quattro Macine").

103 *Courtesy Laboratory for Medieval Archaeology, University of Salento (originally appeared in Arthur, "Masseria Quattro Macine").*

103.* Norman church and cemetery plan, twelfth century

Arthur, "Masseria Quattro Macine," 200–203; Bruno, "Chiese medievali," 446.

ROCA VECCHIA (LECCE)

104.* Funerary inscription, originally with inserted metal cross, twelfth century (?)

Lecce, Museo Provinciale "Sigismondo Castromediano," no. 52; mix of minuscule and capital letters; 85 × 58 cm max.

> K(υρι)ε Ι(ησο)υ Χ(ριστ)ε ο / Θ(εο)ς μ(ου), ο / [φι]λως δεξα /
> μενος τ(ου) τε/ λον(ου) / των / στε/ναγμ[ον] / . . .αν / . . . ο / . .
> . τα / . . . απ. / καμ(ου) τ(ου) [α]μαρτ/ολ(ου) B/ασηλ/η(ου) τη
> δ/υναμη τ/(ου) τημ/ι(ου) σ(ου) / στα[υρ(ου)] / σκε/πε
> φ/ρ(ου)[ρησον] / φυλατ[τε] / τον σων / ετνι(ου)

in larger letters flanking cross:

> Ι(ησοῦ)C Χ(ριστὸ)C ΝΙ ΚΑ

104

Lord Jesus Christ, my God, you who received with favor the lament of the publican [=Luke 18:13] . . . and of me, the sinner Basil, by the power of your venerable cross, protect, guard, defend your people . . .

Jesus Christ Conquers.

Translation modified from Guillou, *Recueil*, 169, no. 153.

RUFFANO (LECCE)

105. Funerary inscription, twelfth century

Lecce, Museo Provinciale "Sigismondo Castromediano," no. 5189; 22 × 46.5 cm

[Ο] παντα ποιησας κ(αι) συναρμω/σας κ(αι) την πεσ(ου)σαν φυσιν / συναναστησας Χ(ριστ)ε / ο Θ(εο)ς σοζε τον δ(ου)λον / Χ(ριστ)ου Παντολεοντα ὑπο/διακονα

in recessed fields between diagonal quatrefoil cross arms:

Φ / C Z / H (φώς ζωή)

O you who has created and ordered everything and made the fallen nature rise again with you, Christ the God, save the servant of Christ, Pantaleon the subdeacon.

Light of life.

Guillou, *Recueil*, 167, no. 150; Jacob, "Anthroponymie," 366.

SANARICA (LECCE)

106. San Salvatore, eleventh–fifteenth century

Three-aisle basilica

106.A south wall
small supplicant in dark overgarment, hands together, facing right toward wing of angel (Michael?)

106.sc Annunciation (?), Journey to Bethlehem (?), Nativity, Magi, Presentation in Temple, Baptism, Transfiguration (2), Crucifixion, Marys at Tomb, Anastasis, Theophanic Vision

106.st Moses, Elijah, Michael, John the Baptist

Safran, "Scoperte salentine," 69–70; Safran, "Language Choice," 869–71; Falla Castelfranchi, *Pittura monumentale*, 107–9; Falla Castelfranchi, "Chiesa di San Salvatore a Sanarica"; Falla Castelfranchi, "Chiesa di San Salvatore e la sua decorazione"; M. Berger, "Représentation byzantine," 195–96.

SAN CATALDO (LECCE)

107. Funerary inscription, thirteenth–fourteenth century (?)

Lecce, Museo Provinciale "Sigismondo Castromediano," no. 4821; minuscule letters; 75 × 40 cm

+ Εδω μνοιμεια τ(ων) δ(ου)λ(ων) / Θ(εου) Δυμηνος / κ(αι) την χηρ(αν) / . . . Θεο/καρι (?).

Here are the tombs of the servants of God Dymenos and the widow Theokari.

Guillou, *Recueil*, 173, no. 160.

108

SAN CESARIO DI LECCE (LECCE)

108. San Giovanni Evangelista, 1329

Single-nave basilica, postmedieval reorientation put entry in east wall
* View to northeast corner

108.A* dedicatory inscription on south wall, over blocked doorway

> + Ανοικ(οδομηθη) καὶ (εζωγ)ραφιθη ὁ πανσεπτος να/ὸς
> τοῦ ἁγίου (αποστο)λου καὶ ευαγγελιστου Ἰωαννου / τοῦ
> θεολ(ογου) δια δαπάνης ἱερέως Νικολάου / Στερνατι(ας) εν
> ετη ‚ϛ ω̄ λ̄ η̄ ἐν μη/[νὶ ὀκτωβριω]. . .

*This most venerable church of the holy apostle and evangelist John the Theologian was
built and decorated with paintings at the expense of the priest Nicholas of Sternatia, in
the year 6838 (=1329) in the month of October.*

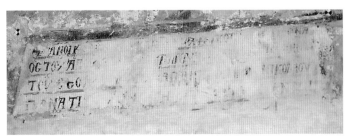

108.A

108.pg

108.pg* graffiti on upper edge of sarcophagus now against south wall
cross, shoe outline, leaf, three game boards, cross with flared arms

108.sc Inspiration of Saint John on Patmos (?), Nativity, Presentation in Temple,
Baptism, Transfiguration, Last Supper, Betrayal, Crucifixion, Anastasis, Last
Judgment

108.sc.1* north wall, Jews in Betrayal

108.st Mandylion, Antony Abbot, Anastasia, Julian, James, Nicholas, Andrew,
Demetrios, Irene, George, Theodore, Lucy

Jacob, "Inscriptions byzantines datées," 55–58; Safran, "Scoperte salentine," 76–77; Cassiano, "Chiesa
di San Giovanni Evangelista."

SAN VITO DEI NORMANNI, FORMERLY SAN VITO DEGLI SCHIAVONI (BRINDISI)

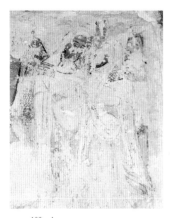

108.sc.1

109. San Biagio, twelfth–thirteenth century
Rock-cut church
* View of ceiling, south wall (left), and west wall

109.A* dedicatory inscription on ceiling, near door, 1196

[Ανοι]κο[δ]ομηθη και α[νιστορη]θι ο πανσεπτος ναος τ(ου)
αγι(ου) ιερομαρτηρος Βλα/[σιου του π]ατρος [ημων επο του]
κηρ(ου) ηγουμεν(ου) Βενεδιτ(ου)ς και δια συνδρο/(μην)
του Μ[ατθ]αιου τεν . . . και δια χειρος μαιστρου Δανηηλ
κ(αι) Μαρ/[τιν(ου)?] (μη)νι Οκτ(ωβ)ρ(ι)ο η ετ(ους) ͵χ̄ ψ̄ ε̄
ινδ(ικτιωνος) ῑε̄

*The most sacred church of our father the holy hieromartyr Blasius was built and
decorated by the lord abbot Benedict and with the financial support of M(atthias?) …
and by the hand of Master Daniel and Mar(tin?), on the 8th of October, year [6]705
(=1196), indiction 15.*

109.B* north wall, to left of door, between Saints John and Andrew, facing Saint
John
standing male, hands splayed at chest level, in gray-green belted cotte with red
hose, black shoes

Diehl (*Art byzantin*, 59) read abbreviation "Ιω" (*n.v.*).

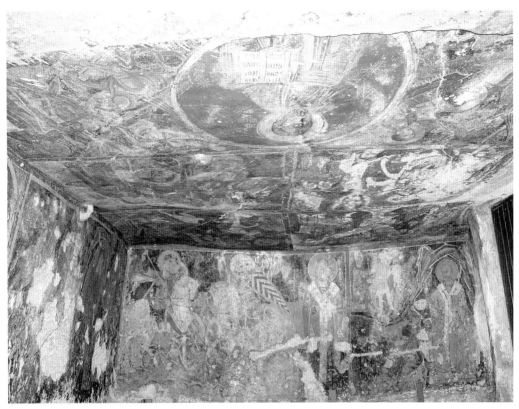

109

109.C* left edge of former templon or east wall
frontal male figure in tight light-brown garment to knees, red belt, red hose; hands
 at his right side raised toward adjacent saint (Andrew?)

109.pg* west wall, on Saint Blasios scene
archer with bow, facing right to red lion in Saint Blasios narrative scene; also figure with
 lance, facing left to yellow elephant in same scene

Caprara, *"Singularità,"* 51.

109.sc Ancient of Days (Vision of Daniel), Annunciation, Nativity, Journey of the Magi,
 Presentation in the Temple, Flight into Egypt, Entry into Jerusalem, Vita of Saint
 Blasius

109.sc.1* ceiling, detail of Annunciate Virgin with weaving implements

109.st Daniel, Ezekiel, George on horseback, Demetrius versus Kalojan, Andrew, John
 the Evangelist, Stephen, Sylvester, Nicholas, Blasius

Guillou, "Arte e religione," 371; Chionna, "Lunga storia"; Milella, "Cavalieri di Dio," 216; Chionna, *Beni culturali*, 15–35; Pace, "Pittura bizantina nell'Italia," 458–59; Semeraro-Herrmann, *Il santuario*; Medea, "Mural Paintings," 27–28; Diehl, *Art byzantin*, 51–64; Lunardi, Houben, and Spinelli, eds., *Monasticon*, no. 73.

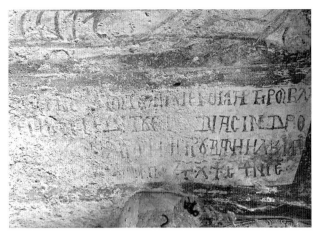

109. A

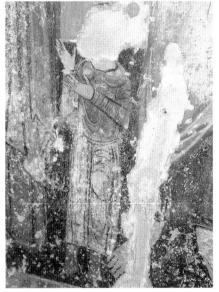

109. B

109.C

109.pg

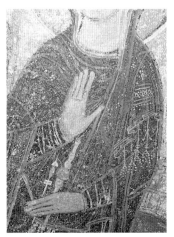

109.sc.1

110.B

SCORRANO (LECCE)

110. Funerary inscription, 1347/48

From tomb near chapel of Madonna della Luce; current location unknown; 26.5 × 32 × 9 cm

110.A front

+ Ἐκοιμήθη ὁ δούλος / τοῦ θ(εο)ῦ Ἰάκωβος ὁ / υἱὸς τοῦ ἱερέως / Γεοργιου + / ετους ͵ϛ ῶ ν̄ ϛ

The servant of God James, son of the priest George, died in the year 6856 (=1347/48).

110.B* back
cross with floral arms emanating from Solomon knot

Jacob, "Deux épitaphes," 168–69.

SOLETO (LECCE)

111. Funerary inscription, 1109

Formerly in the collection of Giuseppe Manca; now lost (*n.v.*); limestone

+ Ενθαδε / κοίτε το / μακάρι/ον σωμα / του δου/λου του / Θ(εο)υ Ασω/τη ἐκοι/μ[η]θ(η) (δε) εν / Κ(υρι)ω μη[νι] Α/ πριλλιω / εἰς τ[ας] ζ̄ / ετ(ους) ͵ϛ χ̄ / ῑ ζ̄ ινδ(ικτιῶνος) / β̄

Here lies the blessed corpse of the servant of God Asotes. He went to sleep in the Lord on April 7 of the year 6617 (=1109), second indiction.

Guillou, *Recueil*, 182–83, no. 174; Jacob, "Notes," 71–74.

112. Childbirth inscription, late eleventh century

Reused in Castle of Soleto, original location unknown; now in University of Lecce, Institute of Classical Archeology (*n.v.*); 52–53 cm × 22 (originally over 100 cm wide) × 11–13 cm

+ Εγενισεν / υ(ιο)ν υμιν {κ̄ε̄ }/ υς τεις κ̄ε̄ ηου/(ν)η(ου) υμερα σα/βατον {σαβα} / {βατον}. / Ευφρανθητι Ζα/χαρια (και) Ελυσαβε/λ μετα σου οτι (και) / μετα γιρας (και) με/τὰ νεκροση / μελον τεξασα / [τ]ον προφιτην / (και) προδρομον / του Κ(υριο)υ.

A son is born to us on Saturday, June 25. Rejoice, Zachariah, and Elizabeth with you, because despite age and bodily decrepitude she has brought into the world the prophet and precursor of the Lord.

Jacob, "Notes," 66–71; Guillou, *Recueil*, 166–67, no. 149.

113. Santo Stefano, frescoes ca. 1380–1440s

Single-nave basilica

113.A dedicatory inscription, north wall, deliberately effaced

ανειγερθη. . . ͵ϛ ω̄ ν̄ ε̄ ?

Reconstructed . . . 6855 (=1347)?

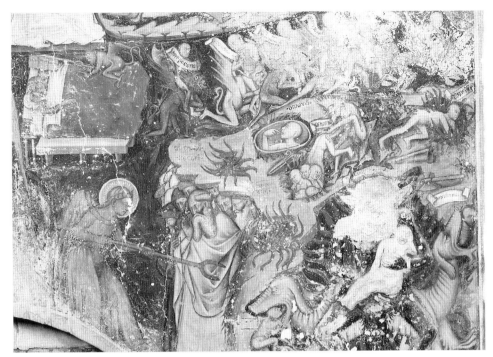

113.B Photo: Michele Onorato.

113.B* west wall, labeled sinners in Last Judgment, 1430s–40s
some labels repainted

ω κτήστης, wall builder / ο πλούσιο, rich man / ο ράπτης, tailor / κλέπτης, thief / σουραρης, usurer / τζαπατούρο[ς], farmer / ο μαστρου δασηα, "master of the ax," woodworker / ταβερναρ[ιο]ς, innkeeper / αβαρος, greedy / βουρτζέρης, butcher / κουρβεσερις, shoemaker / Αριο, Arius / Cαβελιο, Sabellius / Nεστορηο, Nestorius

113.sc Apocryphal Passion of Saint Stephen; Annunciation, Magi, Flight into Egypt, Massacre of Innocents, Mountain of God Receives Elizabeth, Baptisms in the Jordan, Baptism of Christ, Temptation, Healing of Blind Man, Healing of Deaf-Mute, Resurrection of Lazarus, Entry into Jerusalem, Last Supper, Transfiguration, Betrayal, Christ Before Pilate, Flagellation, Christ Carrying the Cross, Christ Affixed to the Cross, Crucifixion (2), Deposition, Burial, Resurrection, Pentecost, Last Judgment, Deesis, Ancient of Days

113.sc.1* south wall, torturer of Saint Stephen with *rotella*

See Plate 14 for the second torturer

113.sc.2* apse

113.st Daniel, Ezekiel, John Chrysostom, Basil (?), Athanasios, Onouphrios, George, Joachim, Anna, Thecla, Mary Magdalene, Catherine, Simon (?), Michael, Lucy, Stephen (2), John the Almsgiver, John the Baptist, Antony Abbot, Nicholas

113.st.1* south wall, row of standing saints and first-layer Crucifixion

Berger and Jacob, *Chiesa di S. Stefano*; Ortese, "Sequenza"; Folgerø, "Vision of Daniel"; M. Berger, "Peintures de l'abside"; M. Berger, "S. Stefano di Soleto"; M. Berger, "Inedit italo-grec"; Romanello, "Affermazione," 35–36; Diehl, *Art byzantin*, 93–110; Safran, "Betwixt or Beyond?" 130–35.

113.sc.1 Photo: Michele Onorato.

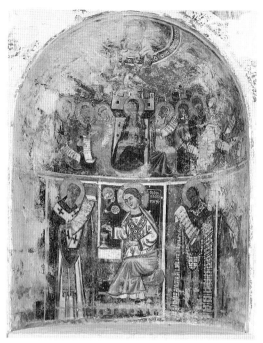

113.sc.2 Photo: Michele Onorato.

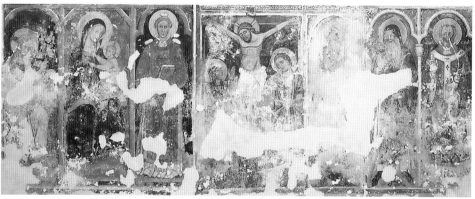

113.st.1 Photo: Michele Onorato.

NEAR SQUINZANO (LECCE)

114. Santa Maria di Cerrate, twelfth–fourteenth century

Three-aisle basilica with added loggia on north side

114.A* funerary inscription, 1096/97

reused on west façade to right of door; 24 × 25 cm

+ Εκειμηθη ο δου[λος του] / Θ(εο)υ Νικοδιμος . . . κ/αι
ιερομοναζ[(ων κ(αι) προεσ]/τος μηνι οκτοβρ(ιω εις τὰς) / κ̄ᾱ
ημερα β̄ ορα . . . [ινδικτιωνος] / χ̄ ετος ,ς̄ χ̄ ε̄

*The servant of God Nikodemos, (founder?) and hieromonk (and abbot?), died on
Monday, October 21, of the year 6605 (=1096/97), at the hour . . . indiction 6 (?).*

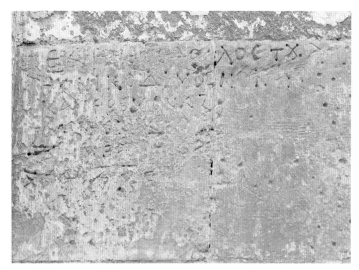

114.A

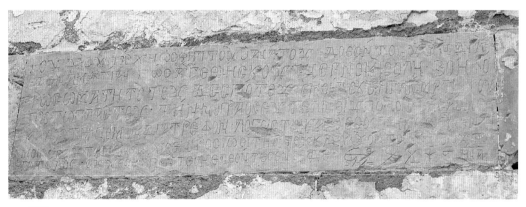

114.B

114.B* metrical funerary inscription, 1197/98
reused on west façade to left of door; 82 × 25 cm

+ Οὐδης ὑπάρχη ὥς φηγι τὸν θανάτου δοθέντος υμην διὰ /
τὴν ἁμαρτίαν. Πῶς ἄραγε θνήσκου(σι)ν ἐγ νόμης ὅλη. ζοηφό/
ρω σώματη τὸ τοῦ δεσπότθυ; ἐμοι δοκοῖ πταίσματι τοῦ /
π(ρ)οτωπλάστου. τήνην ὁ π(ρ)άος εὐτελις θίυπόλος.
ζήσας μὲν / καλος τὴν νομιν διατρέφον. λόγοις ται καλοῖς
σοστηκοῖς καὶ ἐντί/ μοις. ταύτα μὲν λεχθὲν π(ρ)ὸς Ἰω(άννην)
θίτην. τοῦ καὶ λαχόντος [τοῦ] βίου τοῦ / τὸ τέλος. ἐύχεσθαι
πάντες η ἐλθόντες ἐνθάδε. ἔτ(ους) ˌϛ {χ} ψ ϛ ηνδ(ικτιωνος) ᾱ

*There is no one who can escape death, which was given to us because of sin. How, I
wonder, are all subjected to this law and die despite the life-giving body of the Lord?
I think because of the protoplast's [=Adam's] transgression. [This applies also to] the
meek and wretched priest who spent his life nurturing the flock with comely, saving, and
noble words. The above has been said about John the priest, who was allotted his life's
end. All you who come here, pray [for him]. Year 6706 (=1197/98), first indiction.*

Safran, "Greek"; Rhoby, *Byzantinische Epigramme auf Stein*, 372–75; date discussed in Jacob, "Fondation
du monastère," 216–17.

114.C

114.C* metrical ciborium inscription, 1269

+ Δουλους τρεφε τραπεζη (και) στοᾶ σκεπε τον Cυμεων τε κτητορα ῥακενδ[υ]την : Ταφουρον αῦ δειμαντα τον ξεστην Θ(ε)έ. Α[μην] / εν ετεί ͵ϛ ψ ō ζ μηνὶ μάρτίο της ἰνδικτοιῶνις ῑβ̄.

+ Πύκασμα τερπνὸν τῆς τραπὲζης Κ(υρι)ω ὸπερ κατεσκευαζέ Ταφουρος θύτης κο/ποις Cυμεών . τοῦ προεστωτος, τόδε ὸρον θε<α>τά δόξαν υψίστω νεμε ἐξ ου κάτεισιν ἁγαθων πασα δοσοις.

Sustain, O God, servants of your altar and protect under your portico Symeon, the rag-wearing patron, as well as he who constructed it, Taphouros, the engraver. Amen. In the year 6777, in the month of March in the twelfth indiction.

Gracious protection of the altar of the Lord, which the priest Taphouros constructed thanks to the expense of the abbot Symeon; when you see it, visitor, give glory to the Highest, from whom all good things come.

Jacob, "Ciborium," correcting Guillou, *Recueil*, 171, 179–181, no. 169; Rhoby, *Byzantinische Epigramme auf Stein*, 375–79.

114.D* ciborium inscription, detail of left side

114.E* Koimesis and Assumption of the Virgin, originally on left wall, first half of fourteenth century
now in adjacent Museo Provinciale delle Tradizioni Popolari

See Plate 15 for detail

114.F devotional inscription, in aedicula to right of 114.E

MEMENTO D(OMI)NE / FAMVLI TVI / . . . GRINI DE MORC[I]ANO

Remember, Lord, your servant Peregrinus of Morciano.

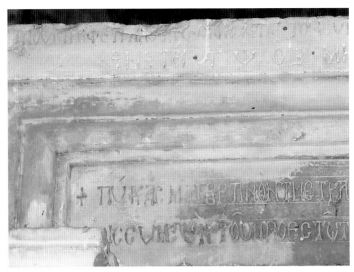

114.D

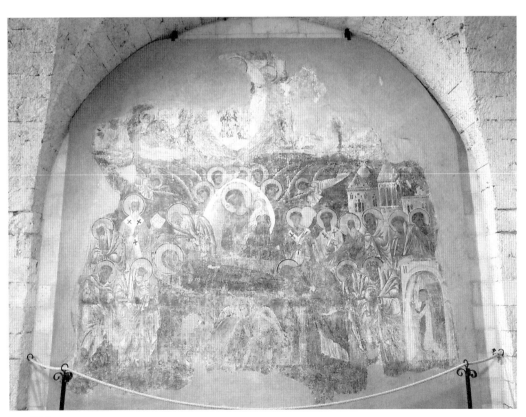

114.E

114.G

114.G* adjacent to 114.F

kneeling male, hands together at chest height, facing left toward scene; white robe outlined in red over dark blue-green tunic; pageboy hair

114.H devotional graffito, center column on left side of nave, fourteenth century?

Μεμνησθ . . . κ / δ . ορλ(ου) κ. . . γ(ου)μένου μεταμορφόσι / .
. . Βοντ / . . . μο.κ / τ. . . Βραρί(ου) ιζ τοῦ ὁσί(ου) Ἀντονί(ου),
Μαρτίν(ου) / τ(ῆς) δ . πρώτης /
[C . . . qre presbute][... priest]
δ . . . / .τ . . τωσπα / παρτε . . .

Remember, (Lord?), your servant and abbot at the Transfiguration (church?) . . .
February 17 of holy Antony, of Martin . . . the . . . first . . .

Guillou, *Recueil*, 179–80, no. 170.

114.I devotional graffito, left jamb of west door

+Δεησε του δου

Prayer of the ser[vant] . . .

114.J verbal graffiti on columns

προβατα ρρμδ αυριρριε

sheep; abbreviations?

BITPI(OY), *a name?*

114.pg.1

114.pg.1* west wall, right of door
haloed bishop; pomegranate (?); ornament panel

114.pg.2* to lower right of 114.pg.1
Solomon-like knot

114.pg.3 interior graffiti
rosettes, concentric circles, abstract figure (?), head of Christ

114.pg.4 exterior graffiti
ships, bristle-haired figures, soles of pointed shoes, Solomon knot

114.sc Koimesis (2, one originally with Jephonias), Ascension, Anna with the infant Virgin and Joachim; portal sculpture: Annunciation, Visitation, Adoration of the Magi, Nativity, First Bath

114.st Basil, John Chrysostom, Makarios, Onouphrios, Paul the Hermit, Benedict, John of Damascus, Sabas (?), Antony Abbot, Theoktistos, George, Luke, Nicholas Pellegrinus, Barbara, Michael, Stephen, Nicholas (2), Theodore [or Demetrios?], John the Baptist, Moses, Aaron, David, Solomon, Jeremiah

114.pg.2

Jacob, "Fondation du monastère"; Jacob, "Cerrate en Terre d'Otrante"; Kemper, "Iscrizione greca"; Safran, "'Byzantine' Art," 488–94; Safran, "Scoperte salentine," 73, 75; Safran, "Betwixt or Beyond?" 116–20; Gabellone, "Virtual Cerrate"; Falla Castelfranchi, *Pittura monumentale*, 131–37, 220–21; Pace, "Chiesa di Santa Maria"; Cassiano, "Arte al tempo," 304; Fontana, "Riferimenti"; Lunardi, Houben, and Spinelli, eds., *Monasticon*, no. 152; Spedicato, "Testimonianze."

NEAR STATTE (TARANTO)

115. Grotta de Leucaspide

Ostracon, 974 (?)
As transcribed by Caprara in Latin letters (*n.v.*)

+ BIKENTIO <V> TH<O>M<BOS> + I 6482 ET +(OY)<S> IY LI EtzoE + IO

Tomb of Vincent. Year 6482 (?). July. He lives. John [put this up]. . .

Roberto Caprara, originally published at http://www.speleologiaas.it/index.php?option=com_conte
nt&view=article&id=9&Itemid=12 (no longer online). I do not see this date; only the two names and
the word "tomb" are entirely legible.

116. San Giuliano (or San Cipriano), fourteenth century (?)

Rock-cut church

116.A hortatory inscription, south wall of funerary chapel, adjacent Saint Julian

+ / ADIVVA / Q(UAESIMU)S D(OMI)NE / FAMVLV(M) / TVV(M) IA/
QUI[NTUM] / P[RESBYT]E/RVM. / OMNES Q(UI) / LEGITI[S] / ORATE /
PRO EO. [A]M[EN].

*Protect, I pray, O Lord, your servant Iaquintus, priest. All who read this pray for him.
Amen.*

116.B didactic inscription, east wall of funerary chapel, above tomb *(n.v.)*

+IAQUINTVS . . . VS

Iaquintus [presbyter beat]us (?)

116.st Julian, Marina (?), Peter (?), Cyprian (?), Nicholas

Caprara, *Società*, 145; Caprara, *Chiese rupestri del territorio*, 143–68; Caprara, Crescenzi, and Scalzo,
Iconografia, 76–86; Safran, "Cultures textuelles," 256–57.

117. Sant'Onofrio a Todisco, thirteenth century

Rock-cut church

117.A graffito in apse conch

[EGO] PETRV[S] IND(ICTIONE) XII [MENSIS] / MAI BONA . . .

I, Peter, in the twelfth indiction, month of May, good . . .

117.B didactic graffito, north wall, adjacent Saint Eustathius, 1416

AN MoCCCCXVI FUIT / NIKOLAUS BERTI/NI IN TARANTI

In the year 1416 Nicholas Bertini was in Taranto.

117.st Catherine, Marina, James, Nicholas, Onouphrius, Lucy, Leo of Catania,
Eustathius, John the Baptist

Caprara, *Chiese rupestri del territorio*, 169–94; Caprara, Crescenzi, and Scalzo, *Iconografia*, 88–107;
Caprara, *Società*, 214 and color pl. XX.

SUPERSANO (LECCE)

118. Cripta della Celimanna, thirteenth century

Rock-cut church under modern sanctuary

118.st Lawrence, Stephen, Nicholas, John the Baptist, Andrew, Michael Synkellos

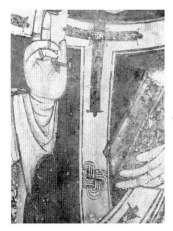

118.st.1

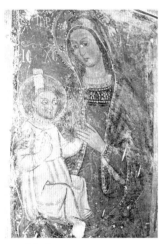

118.st.2

118.st.1* Solomon knot on pallium of bishop wearing multiple rings

118.st.2* postmedieval Virgin and Child with coral necklace and brooch

Falla Castelfranchi, *Pittura monumentale*, 171, 178–80; Falla Castelfranchi, "Decorazione pittorica bizantina"; Fonseca et al., *Insediamenti*, 205–11.

TARANTO (TARANTO)

119. Funerary inscription, eighth–ninth century

Museo Nazionale Archeologico di Taranto, no. 37316; soft limestone; max. preserved dimensions 39 × 34 × 15 cm (broken)

119.A front

<div dir="rtl">

נו[------]

ה בסיומו[-----]

בה יבא שלומו[--]

[אלהי]ם עמם יקימו

</div>

> *. . . at his end . . . may he have peace. God with them [the just] will resurrect him.*

incised shofar on frame

119.B back

menorah, shofar

Colafemmina, "Ebrei a Taranto," 125.

120. Funerary inscription, seventh–eighth century (?)

Museo Nazionale Archeologico di Taranto, no number

back

angular menorah with trident base on upper half

121. Funerary inscription, eighth century (?)

Lost (*n.v.*)

<div dir="rtl">

פה ינוח אשת

לאון בן ✡

דויד מן

מילו

</div>

> *Here rests the wife of Leon, son of David from Melos.*

Noy, *Jewish Inscriptions*, no. 125; Colafemmina, "Ebrei a Taranto," 114.

122. Funerary inscription, seventh–eighth century

Museo Nazionale Archeologico di Taranto, no. 37319; soft limestone now cemented to tufa; 14 × 28 × 5 (broken)

122.A front

<div dir="rtl">

[פ]ה ינוח [---]

[---]ם ושבע [---]

</div>

> *Here lies . . . and seven . . .*

123.A

122.B top

[hic r]equiesc[it . . .]

Noy, *Jewish Inscriptions*, no. 123; Colafemmina, "Ebrei a Taranto," 116–17.

123. Funerary inscription, seventh–eighth century

Museo Nazionale Archeologico di Taranto, no. 37315; soft limestone; 53 × 50 × 18 cm

123.A* front

פה ינוח בזיכרון טוב
שמואל בן סילנו עם
יחזקאל אחי אביו שחיה
ארבעים ושתים שנה יהי
שלום על מנוחתם אמן

Here rests in good memory Samuel, son of Silanus, with Ezekiel his father's brother, who lived forty-two years. May there be peace on their resting place. Amen.

123.B top

HIC REQUISC[IT BENEM]EMORI[US] / [S]AMUEL FILIUS SILANI [CU]M EZIH[I]/[E]L BARBANE SUUM QUI VIXIT ANNOS / [X]XXXII. SIT P[AX] SUP(ER) DORMITOR[IUM] / [EORUM. AMEN.]

Here rests Samuel, remembered for good, son of Silanus, with Ezekiel his paternal uncle, who lived forty-two years. May there be peace on their sleeping place. [Amen.]

123.C back

incised menorah with seven U-shaped branches, M-shaped base

123.D sides

one stylized shofar incised on each side

Noy, *Jewish Inscriptions*, no. 121; Colafemmina, "Ebrei a Taranto," 122–23.

124. Funerary inscription, seventh–eighth century

Current location unknown; parallelepiped stone; writing area 60 × 15 cm (*n.v.*)

124.A front

HIC REQUEISCIT BENEMEMORIO AN/ATOLI FILIO IUSTI QUI VIXIT ANNOS / XXXX. SIT PAX IN REQUIE EIUS

seven-arm menorah below text

Here lies Anatoli(us), remembered for good, son of Justus, who lived forty years. May there be peace on his rest.

124.B back

אור זרוע לצדיק ולישר[י-לב] שמחה
נזכר צדיק לברכה אנתולי

MEMORIA IUS/TORUM AD BE/[NEDICTIONEM]

Light is sown for the just man, and joy for the upright of heart [Ps. 96 (97):11]. The just man Anatoli(us) is remembered for a blessing.

The memory of the just for a blessing [Prov. 10:7].

one menorah on each side

Noy, *Jewish Inscriptions*, no. 120; Colafemmina, "Ebrei a Taranto," 123–24; Colafemmina, *Ebrei a Taranto: Fonti*, 30–31.

125. Funerary inscription, seventh–eighth century

Current location unknown; soft limestone cemented to tufa; 14 × 24 × 12 cm (*n.v.*)

125.A front

<div dir="rtl">

[---]לו[דומנו]לו בן דומנו

[מנוחתו] יהי [שלום על [---]

</div>

Domnolo son of Domnolo . . . May there [be peace on his resting place].

125.B back

[HIC REQUIESCIT DOM]/NOLO FILIO D[OMNOLI] / [QUI VIXIT ANN]I
XIIII. S[IT PAX] / [IN REQUIE EIUS]

Here rests Domnolus son of Domnolus, who lived fourteen years. May there be [peace on his rest].

Noy, *Jewish Inscriptions*, no. 128; Colafemmina, "Ebrei a Taranto," 118–19.

126. Funerary inscription, seventh–eighth century

Current location unknown; soft limestone; 16 × 32 × 20 cm (broken) (*n.v.*)

126.A front

<div dir="rtl">

[--]יק[לצד

[--] יעקוב

</div>

For the righteous man . . . Jacob . . .

126.B back

<div dir="rtl">

זכר צדיק [לברכה]

</div>

The memory of the just man for a blessing.

126.C top

BEN]EMEMORI[O IACOB, QUI] / [VIXIT] ANNI XX . . . [SIT PAX] /
[IN RE]QUIE EI[US]

For Jacob, remembered for good, who lived twenty[-something] years. May there be peace on his rest.

Noy, *Jewish Inscriptions*, no. 122; Colafemmina, "Ebrei a Taranto," 115–16.

127. Funerary inscription, seventh–eighth century

Museo Nazionale Archeologico di Taranto, no. 37320; soft limestone; max. 53 × 36 × 9
cm (broken)

127.A front

<div dir="rtl">

ל[---]

ינוח [---]

שמו כ[---]

בן ארבע[---]

כי ניגעו יה וש[---]

בצרור החיים ת[הי נפשו]

ולחיי עד תהי נשמ[תו]

אמן

</div>

. . . rests . . . his name as . . . aged four and [something] . . . because the Lord touched him and . . . May his soul rest in the bond of life and his spirit be for eternal life. Amen.

127.B top

HIC RE[QUIESCIT . . .] / FILIVS . . . / II. SIT PA[X IN REQUIE EIUS]

Here rests . . . son . . . May there be peace on his rest.

127.C back

incised shofar, menorah, game board

Noy, *Jewish Inscriptions*, no. 129a; Colafemmina, "Ebrei a Taranto," 119–21.

128. Funerary inscription, eighth century (?)

Museo Nazionale Archeologico di Taranto, no. 37317; soft limestone; top 55.5 × 21 × 10 cm

128.A front

traces of Hebrew letters

128.B* top

זכר [צד]יק לברכה

The memory of the just man for a blessing.

128.C* back

menorah with trident base

Noy, *Jewish Inscriptions*, no. 131; Colafemmina, "Ebrei a Taranto," 117; D'Angela, "Rinvenimenti," no. 11.5 (upside down).

128.B–C

129. Funerary inscription, seventh–eighth century

Museo Nazionale Archeologico di Taranto, no. 37314; soft yellow limestone; 45 [38 writing field] × 27.5 × 14.5 cm (broken)

129.A front

ב[---]
יבוא [שלום]
על מ[שכבו]
שלום [שלום]

Peace will come on his resting place, Peace, [Peace].

129.B top

traces of Hebrew letters

129.C back

menorah, shofar

Noy, *Jewish Inscriptions*, no. 132; Colafemmina, "Ebrei a Taranto," 117.

130. Funerary inscription, seventh–eighth century

Museo Nazionale Archeologico di Taranto, no. 37321; carparo (tufa), broken into five pieces; 55 × 45 × 15 cm

130.A front

excised (shallow basin)

130.B top

זכר צדיקים לברכה

The memory of the just for a blessing.

menorahs precede and follow Hebrew text

130.C back
angular menorah with square trident base

Noy, *Jewish Inscriptions*, no. 133; Colafemmina, "Ebrei a Taranto," 124–25.

131. Funerary inscription, seventh–eighth century
Museo Nazionale Archeologico di Taranto; soft limestone; letters approx. 2.5 cm high (*n.v.*)

131.A front

פה ינוח שבתיי בן
לאון מבן שש
עשרה שנה
יהי שלום על
מנוחתו

Here rests Shabbetai, son of Leon, age sixteen years. May there be peace on his resting place.

131.B top

[HIC REQUIESCI]T SABATAI / [. . . QU]I VIXIT AN(NIS) XVI.

Here rests Sabatai . . . who lived sixteen years.

131.C back
menorah with seven branches between shofars

Noy, *Jewish Inscriptions*, no. 126; Colafemmina, "Ebrei a Taranto," 114–15.

132. Funerary inscription, seventh–eighth century
Museo Nazionale Archeologico di Taranto, no. 37312; soft yellow limestone; 27 × 38 × 15 cm

132.A front

פה ינוח ארפידיא
בת [--] מבת
שש שנים יהי
שלום על מנוחתה

Here rests Erpidia daughter of . . . , age six years. May there be peace on her resting place.

132.B top

[HIC R]EQUIESCIT ERPIDIA / [QUAE VIXIT A]NNI VI. SIT / [PAX IN REQUIE EIUS]

Here rests Erpidia, who lived six years. May there be [peace on her rest].

132.C back
menorah with nine branches

Noy, *Jewish Inscriptions*, no. 127; Colafemmina, "Ebrei a Taranto," 118.

133. Funerary inscription, seventh–eighth century
Museo Nazionale Archeologico di Taranto; limestone; 18 × 16 × 9 cm (broken) (*n.v.*)

133.A front

[--] ינוח [--]

. . . will lie . . .

133.B back

[--] אהרון [--]

. . . last . . .[or: Aharon (name)]

133.C top

[HIC REQUIESCIT B]ENE ^{me} M[ORIUS . . .] / [FILIUS . . . ET] ASTER Q[UI VIXIT] / [ANNIS . . .] SIT] PAX IN [REQUIE EIUS.]

Here rests ?. . . , remembered for good, son (?) of . . . and Esther who lived . . . years. May there be peace on his/her rest (?).

Noy, *Jewish Inscriptions*, no. 130; Colafemmina, "Ebrei a Taranto," 121–22.

134. Funerary inscription, ninth century (?)

Museo Nazionale Archeologico di Taranto, no. 37318; soft limestone; 42 × 22–32 × 14 cm

134.A front

זכר לטוב
לאסתר
בת בסילי פה
ינוח יבוא
שלום וינוח
על משכבה

To the good memory of Esther, daughter of Basil. Here rests. May peace and repose be upon her resting place.

134.B back
traces of letters

134.C top
menorahs?

134.D left side
shofar

Colafemmina, "Ebrei a Taranto," 125–26; D'Angela, "Rinvenimenti," no. 11.6.

135. Funerary inscription, seventh–eighth century (?)

Museo Nazionale Archeologico di Taranto, no. 37311; soft limestone; 83 × 72 × 15 cm

135.A front
letter traces in recessed field high up on surface

135.B* back
shofar / IN / menorah with M-shape base / VI

Noy, *Jewish Inscriptions*, no. 129; Colafemmina, "Ebrei a Taranto," 119.

136. Funerary inscription, ninth century or later

Museo Nazionale Archeologico di Taranto (lost; *n.v.*); dimensions unknown

קובר
יוסף
בר יוסף

Tomb of Joseph son of Joseph.

Noy, *Jewish Inscriptions*, no. 193 (identified as Aramaic); Colafemmina, "Ebrei a Taranto," 113.

135.B

137. Funerary inscription, 1135

Museo Nazionale Archeologico di Taranto, no. 37325; carparo (tufa); 31 × 32 × 11.5 cm

137.A front

+ Εκυμηθη η δου[λη] / του Θ(εο)υ Μαρια [μηνι] / νοεμβρ(ι)ς εις τ(α)ς ῑδ̄ ετ[ους] / ͵ϛ̄ χ̄ μ̄ δ̄ ωρ(α) . . .

The servant of God Maria died November 14, 6644 (=1135), hour . . .

137.B back
four recessed petal-like ovals

Guillou, *Recueil*, 184–85, no. 176; D'Angela, "Due stele bizantine," 386–88; Jacob, "Notes," 82.

138. Funerary inscription, twelfth century

Museo Nazionale Archeologico di Taranto, no. 37324; carparo (tufa), 47 × 23 × 11 cm

138.A front

Ι(ησου)C Χ(ριστο)C (Νι)κα
+[Εκοι]μηθη η [δουλη του Θεου] / . λαληα μη(νι) /
(ο)κτ(ω)βριω / Κυριακη . . . / τ[ης] ινδ(ικτιωνος) / ῑᾱ.

Jesus Christ Conquers.
The servant of God [Eu]lalia died Sunday, October ?, in indiction 11.

138.B back
four recessed petal-like ovals
[IC XC NI] KA

Guillou, *Recueil*, 185, no. 177 (reads date October 21); D'Angela, "Due stele bizantine," 388–90; D'Angela, "Rinvenimenti," no. 11.3.

139. Dedicatory inscription on city walls, 965–69

Lost; reproduced as published

Ἔβλεψάς με πρώην ὅσον δυστυχῶς ἀνεστρέφθην. Λίαν μὲν ἐπιφανὴς ἐγενόμην καὶ λαμπρὰ καὶ καινοῖς ἐπιτειχίσμασι κεκοσμημένη. Ταῦτα δὲ ὅμως ἐπὶ τῶν μοχθηρῶν πραγμάτων ἐμὲ σώζειν οὐκ ἐδυνήθη. Νῦν δὲ ἀγαθῇ τύχῃ πάλιν ἐπεσκεύασμαι. Νικηφόρος ἀρχιτέκτων ἔξοχος ἀμφὶ τὴν ἑσπέραν τὸ θέμεθλον ἤρξατο θεμελιοῦν. Πρὸς πέρας ἔπειτα παρελθῶν ὅ νῦν οἰκοδόμημα βλέπεις ἐτεκτήνατο. Καὶ μὴν Νικηφόρος αὐτοκράτωρ κράτιστος καὶ εὐσεβὴς ἐμὲ προσορῶν κειμένην — καὶ γάρ με ἐκ τῆς Λιβύης βάρβαροι καὶ πάλαι οἱ Σαρρακηνοὶ ἐξ Ἄφρων ἐκδραμόντες ἐκ θεμελίων κατέβαλον — ἀνόρθωσε θαυμαστῶς καὶ ἐκέλευσε Νικηφόρον τοιχοποιὸν κατ'ἐκεῖνον τὸν χρόνον πολυώνυμον καὶ ἄριστον ἰδίᾳ τῇ τέχνῃ ἐπιτηδείοις πράγμασιν ἐμὲ διακοσμῆσαι.

You have seen in what an unhappy situation I find myself. Once I was very illustrious and resplendent with new ramparts. Yet these were not sufficient to ensure my safety in difficult circumstances. Now, by happy fortune, I have been newly restored. It was to the west that Nikephoros, the eminent architect, began the foundations. Then, advancing until the end, he built the structure that you can see. In effect, the pious and all-powerful autokrator Nikephoros, seeing me collapsed (because the barbarians from Libya and, once, the Saracens coming from Africa had razed me to the ground), rebuilt me in remarkable fashion and instructed Nikephoros, the most renowned builder of ramparts in that time and greatly valued, to provide me with indispensable things using his knowledge.

Jacob, "Reconstruction"; Falkenhausen, "Taranto in epoca bizantina," 138.

140. Cathedral of San Cataldo

Three-aisle basilica, 1094–1160 and later, with earlier crypt under apse and transept

140.A inscription in crypt, apse conch, before tenth century (lost; *n.v.*)

ITAKIA

a name?

Belli d'Elia, "La cattedrale di Taranto," 134 n. 12.

140.B didactic inscription on transept, north façade, adjacent to relief with male figure kneeling before enthroned male

ROSEMANNVS ARChIEPISCOPVS

Rosemannus archbishop

140.C dedicatory inscription in three parts, mosaic pavement, 1160

HOC DI(STIN)XIT OP(US) DIVERSO FLORE PETROIUS

This distinctive work made by Petroius [Petronius?] was given by

140.D dedicatory inscription in three parts, mosaic pavement, 1160

GIRALDUS ARCHIEP(ISCOP)US TAREN(TINUS): ANNO 1160

Archbishop Giraldus of Taranto, year 1160

140.E dedicatory inscription in three parts, mosaic pavement, 1160

(ANNO MCLX AB INCARNATION)E D(OMI)NI

Year 1160 of the Incarnation of the Lord

140.F* sarcophagus, late thirteenth–fourteenth century, in the crypt
tub-shaped sarcophagus, flat lid; on front, two angels holding staffs flank
 (deceased) male figure, his arms upraised; shoulder-length hair curls up at ends;
 split skirt over tunic

Belli d'Elia, "La cattedrale di Taranto," 138–39.

140.sc Zosimus, holding chalice and bell, gives communion to Mary of Egypt
See Plate 16

140.st Cataldus, Mary Magdalene, Nicholas, Antony Abbot, Peter, Anthony of Padua, Erasmus

Carrino, "Mosaico pavimentale della cattedrale di Taranto"; Vasco Rocca, ed., *Mosaici*, 170–72; D'Angela, *Taranto medievale*, 118; D'Angela, ed., *Cripta della Cattedrale*; Porsia and Scionti, *Taranto*.

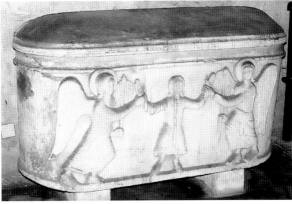

140.F

141. San Domenico, fourteenth century

Benedictine male monastery, former Orthodox monastery of San Pietro Imperiale
Didactic inscription on façade, 1302
At apex of doorframe, between lamb of God and bull of Taurisano

> HOC OPVS : FIERI FECIT : NOBI(LI)S VIR IOh(ANNES) /
> T(AU)R(IS)ANENSIS : SUB : A(NNO) : D(OMINI) : MCCCII

> *The nobleman John of Taurisano had this work made in the year 1302.*

Calò Mariani, "Echi," 263; Ceschi, "Rosone"; Falkenhausen, "Taranto in epoca bizantina," 157–59;
 Lunardi, Houben, and Spinelli, eds., *Monasticon*, no. 311.

142. Chiesa del Redentore, thirteenth century

Rock-cut church

143.A

142.A devotional inscription, apse

> (Μνησ)θητη Κ(υρι)ε τ(ου) δ(ού)λ(ου) [σου . . .]αράλδ(ου)
> κ(αι) / τ. . . αυτου κ(αι) αη . . .

> *Remember, Lord, your servant [M?]araldus and his [. . .] and . . .*

142.pg incised graffito on left doorjamb
deer with large antlers

142.sc Deesis

142.st Basil, Euplos, Blasios

Caprara, *Chiese rupestri del territorio*, 19–44; Caprara, *Società*, 219; Caprara, Crescenzi, and Scalzo,
 Iconografia, 28–40; D'Angela, "Nota."

143. Santa Chiara alle Petrose, twelfth–fourteenth century

Rock-cut church

143.C–D

143.A* devotional inscription, northwest wall, lower stratum, detail

> [Υ]περ αφεσεος αμαρτηων (του) ταπηνου / Ιω(αννου)
> ζ(ου)γρα[φου]

> *For remission of sins of the humble painter John.*

143.B devotional inscription, northwest wall, adjacent Saint Catherine

> + Μνησθη[τ]ε δ(ου)λ(ου) σ(ου) [Β]ενεδη/[του]ς αμα συμβιου
> και / τη[χνης] . . . [A]μην.

> *Remember the servant of God Benedict with his wife and child[ren]. Amen.*

143.C* devotional graffito, northwest wall

> Κ(υρι)ε β[οηθει τον δουλον] σου . . . ξεν . . . υ πρου . . . μ . . .
> γυνναικ[α]

> *Lord help your . . . wife . . . (?)*

143.D* devotional graffito below 143.C

> Κ(υρι)ε βοεθει μη Στε[φα]νος

> *Lord help me, Stephen.*

143.E devotional graffito on northwest wall adjacent Saint Michael *(n.v.)*

> Κ(υρι)ε βοη[θει] Αντων[ιου] δουλο[ν] σου Ιωα[ννου]
> [δου]λου Δ(ι)ονισους . . . ,ͼ χ̄ θ̄ (?)

> *Lord help Antony your servant, John servant, Dionysos [servant] . . . [date].*

143.pg
ships

143.sc Deesis, Ascension or Ancient of Days; ceiling originally frescoed with apocalyptic imagery (Ancient of Days)

143.st Nicholas (2), Michael, Marina, Venerdia, Theodore (?), Cataldus, Catherine

Caprara, *Chiese rupestri del territorio*, 45–78; Caprara, "*Singularità*," 34; Caprara, Crescenzi, and Scalzo, *Iconografia*, 42–58; M. Berger, "Représentation byzantine."

NEAR TARANTO (TARANTO)

144. Santa Maria del Galeso, twelfth century
Former Benedictine monastery church
* Dedicatory inscription on west wall, two slabs, 1169
Ruled lines, white infill of letters partly extant. Abbreviations resolved.

144

+ANNO DOMINICE INCARNATIONIS . M. C. LX. IX . [DIE] / XX
OCTOBRIS INDICTIONE . II . REGNI VERO DOMINI NOSTRI /
SERENISSIMI REGIS . WILLELMI TERTII DEDICAVIT HOC / TEMPLUM
. IN HONORE DEI ET BEATE / EIUS GENITRICIS MARIE GIRALDUS
VENERABILIS / ARCHIEPISCOPUS TARENTI PRESENTIBUS IO/
HANNICIO MAGNE INSULE COSMATE / PARVE INSULE ET LUCA
SANCTI VITI

ABBATIBUS : ET UNIVERSO CLERO / TARENTI . FUNDATUM A RICAR/
DO TARENTI REGIO BARONE . / DIE AUTEM ANNIVERSARII HUC
/ VENIENTIBUS : A PRESULE . XX . / DIERUM . DE INIUNCTA SIBI /
PENITENTIA . REMISSIO DATUR

*In the year of the Lord's Incarnation 1169 on the twentieth day of October, second
indiction, in the reign of our true lord the most serene king William the Third, Giraldus,
venerable archbishop of Taranto, dedicated this temple in honor of God and his blessed
mother Mary in the presence of abbots Ioannikios of [the monastery of San Pietro
on] Insula Grande, Cosmas of [the monastery of Saints Peter and Andrew on] Insula
Parva, Luke of San Vito [del Pizzo], and all the clergy of Taranto. Founded by Richard
of Taranto, royal baron. However, to those coming here on the day of the anniversary a
remission of twenty days from the penance enjoined on them is granted by the bishop.*

Jamison, "Carriera del logotheta," 177, 185–87; Farella, "Note," 33; Lunardi, Houben, and Spinelli,
eds., *Monasticon*, no. 302; D'Angela, *Taranto medievale*, 191–94.

TAURISANO (LECCE)

145. Santa Maria della Strada, fourteenth century
Basilica with façade sculpture
* Sundial on south exterior wall, late fourteenth century

145

Ι(ησου)ς Χ(ριστο)ς Νι Κα. / Αι ὡρ[αι] [τη]ς ἥμ[ερ]ας
Π Τ C Ν Β Κ

Jesus Christ Conquers. The Hours of the Day.
*Prima (=Prime) – Tertia (=Terce) – Sexta (=Sext) – Nona (=Nones) – Vespera
(=Vespers) – Completorium (=Compline)*

Jacob, "Cadran solaire"; Guillou, *Recueil*, 186–87, no. 179; Arthur, Gravili, et al., "Chiesa di Santa
Maria."

TORRE SANTA SUSANNA (BRINDISI)

146. San Pietro (or Santa Maria) in Crepacore

Church with two cupolas on axis

146.A dedicatory inscription at base of apse conch, detail, ninth/tenth century (Safran, Castelfranchi) or seventh century (Berger-Jacob)

... [α]μαρ[τιων] συνβιου αου(του) Βενεριας ...
τεκνον α(ου)τον. Αμην

sins (?) ... his wife Veneria [and his] children. Amen.

Felle's reconstruction:

[ὀικοδομήθη αὐτος ὁ ναὸς ὑπερ ἀφέσεως α]μαρ[τ]ι[ῶ]ν [τοῦ
δούλου τοῦ Θεοῦ ... καὶ τ.]ς συμβιου α(ου)τοῦ Βενερίας
[κ(αὶ τῶν] τέκνον α(ου)τον ἀμήν.

This church was built for the remission of the sins of the servant of God ... and his wife, Veneria, and their children. Amen.

146.B devotional inscription on right wall of main (eastern) space

του δουλ[ου]

your servant

146.sc Blessing or Mission of the Apostles; Ancient of Days (?)

146.st Peter

Berger and Jacob, "Des peintures pré-iconoclastes"; Falla Castelfranchi, "Decorazione pittorica
 d'epoca macedone"; Falla Castelfranchi, "Chiesa di San Pietro di Crepacore"; Safran, "Byzantine
 South Italy," 267–72; Felle, "Documentazione epigrafica"; M. Berger, "Représentation byzantine,"
 200.

TRANI (NORTH OF THE SALENTO)

147.* Synagogue dedication, 1246/47

Originally inside main Trani synagogue, the "Scola Grande," rededicated as Santi Quirico
 e Giovita and then Sant'Anna; now in sacristy of San Giovanni; 25 × 39.5 cm

בשנת חמשת אלפים ושבע ליצירה
נבנת זאת הבירה על יד מנין נעים
החבורה בכיפה גבוה והדורה וחלון
פתוח לאורה ושערים חדשים לסגירה
ורצפה למעלה סדורה ואצטבאות
לישיבת עורכי שירה לחיות צדקתו
שמורה לפני שוכן בשמי שפרה

*In the year 5007 since the creation, this sanctuary was built by a congenial minyan of
friends, with a lofty and elegant cupola and a window open to the light and new doors
for closing; the well-ordered upper pavement was laid, and seats for those who conduct
the singers, in order that their piety be witnessed by he who inhabits the beautiful
heavens.*

Colafemmina, "Testimonianze epigrafiche," 40–41; Colafemmina, "Cultura nelle giudecche,"
 113–15; D. Cassuto, "Costruzioni rituali ebraiche," 1033; Bertagnin, Khuri-Makdisi, and Miller,
 "Mediterranean Jewish Quarter," 39.

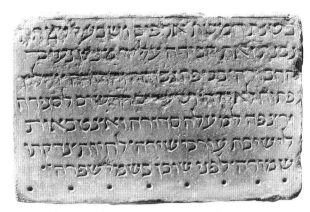

147 Photo: Cesare Colafemmina. Courtesy CeRDEM-Centro di Ricerche e Documentazione
Sull'Ebraismo nel Mediterraneo "Cesare Colafemmina."

148. Scola Nova, thirteenth century

"New Synagogue," returned to Jewish community in 2005 after serving as church of Santa
 Maria Nova (or Santa Maria in Scolanova); hall approx. 15 × 6.4 m

148.A* exterior view

148.B* view of interior toward the Torah niche

Colafemmina and Gramegna, *Sinagoga Museo*, 81–92.

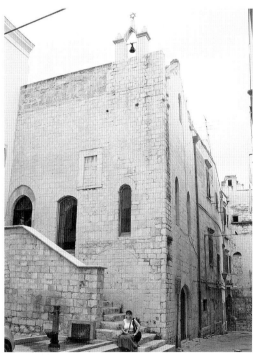

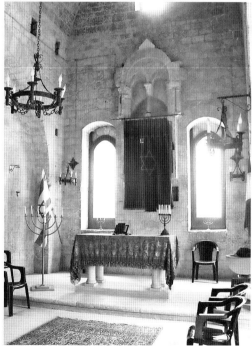

148.A 148.B

149. Funerary inscription, 1290/91

Museo Diocesano Sant'Anna (former Scola Grande synagogue); limestone; hemispherical tomb lid; dimensions unknown

149.A text

<div dir="rtl">

הציון הלז על קבר הרב רבי אדניה

בר ברוך נע אשר גוע בשנת נא

לפרט תנצבה

</div>

This mark/monument is on the grave of great Rabbi Adoniyah, son of Baruch, may his rest be in Eden, who died in the year 51 of the lesser computation. TNTsBH (=May his soul be bound in the bond of life).

149.B shield to left of text

pointed shield triparted per fess with three stars in the chief

Colafemmina and Gramegna, *Sinagoga Museo*, 192–93; U. Cassuto, "Iscrizioni ebraiche a Trani."

150. Funerary inscription, April–May 1450

Museo Diocesano Sant'Anna; limestone; hemispherical tomb lid, 1.72 m long

<div dir="rtl">

זאת מצבת קבורת החסיד החכם השלם כמהר תנחום בר משה

דבלקייירי תנצבה שנפטר לבית עולמו ברצון השם בחדש

אייר שנת אשרי הגבר

</div>

This is the tombstone of the pious, very learned and honored master Tanhum son of Moses of Beaucaire—TNTsBH (=May his soul be bound in the bond of life)—who departed for his eternal home by the will of God in the month Iyyar, year "Blessed be the man" (=1450).

Colafemmina and Gramegna, *Sinagoga Museo*, 196–97.

UGENTO (LECCE)

151. Cripta del Crocefisso, thirteenth–fourteenth century

Rock-cut church

151.A* right wall, to left of Saint Michael

kneeling female figure, hands clasped, wearing long-sleeved red garment, pearl-trimmed hair laces

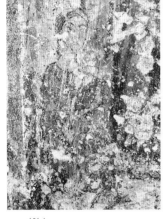

151.A

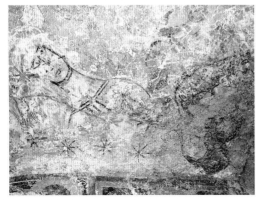

151.C

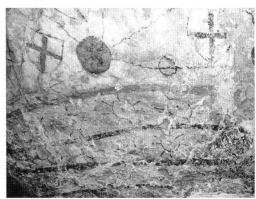

151.D

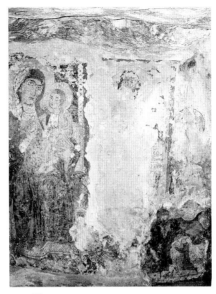

151.st

151.B right wall, to lower right of Saint John the Baptist (see in 151.st)
kneeling male, beardless, hands clasped, wearing vertically divided red and yellow
 garment, black shoes or stockings

151.C* ceiling with harpy, human figure, boar with bell, stars

151.D* ceiling with shields, quatrefoils, circle stars

151.sc Annunciation

151.st* Nicholas, Michael, John the Baptist, Christ child with earring
 See Plate 17 for detail of Christ child

Curzi, "Segni"; Falla Castelfranchi, "Decorazione pittorica della cripta"; Houben, "Grotte di proprietà";
 Houben, "Ordine Teutonico"; Pace, "Pittura delle origini," 366–71; Fonseca et al., *Insediamenti*,
 217–25; D'Elia, "Aggiunte."

UGGIANO LA CHIESA (LECCE)

152.* Menhir "San Giovanni Malcantone," probably sixth–eighth century

Pillar adjacent to homonymous masseria named after former Orthodox monastery;
 400 × 72 × 48 cm

Palumbo, "Inventario," 130–31.

153. Sant'Angelo, twelfth–fourteenth century (?)

Rock-cut church in Valle dell'Idro

152

**153.A devotional inscription on south wall, east end, under right wing of Saint
Michael**

 [Μνησθητι] Κ(υρι)ε του δ(ου)λ(ου) σ(ου) Βα[σι]λη ου κε
 τ(ου) [πατερα του και την μητερα του. Αμην]

 Remember, Lord, your servant Basil and his father and mother. Amen.

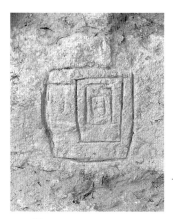

153.pg

153.B inscription on east wall, adjacent bishop

S? / T(OY)? / ? /AM[EN]

153.st Michael (2), Peter with three keys, bishop

153.pg* north narthex wall
vertical game board

Fonseca et al., *Insediamenti*, 141–43 (no inscriptions); Guillou, "Arte e religione," 372; Guillou, "Art des 'moines basiliens,'" 296; C. De Giorgi, *Provincia*, 2:279.

VASTE (LECCE)

154. Dedicatory inscription, 1054

Original location unknown; now in south wall of Salone Parrochiale adjacent to Chiesa Matrice; 64 × 22 cm

154.A text

+ Κ(υρι)ε βοηθη του δουλου σου(?) Μειχα(η)λ Αυφρηκιν /
του ανικοδομησαν[τος] τον δομον τουτων υπ(ερ) / αφεσεος
των αμ(α)τηων αυ[τ]ου κ(αι) κτησ/ θεντα παρα Μιχαη[λ]
Κορκουα Κορον/νεον μη(νι) απριλιω ει[ς] τ(ας) η(μερα)
ωρ(α) θ̄ / ετους ͵ςφ̄ξ̄β̄ ινδ(ικτιωνος) ζ

Lord help your servant Michael the African, who had this house built for the remission of his sins by Michael Korkouas of Corone on April 28 (or 20), at the ninth hour, in the year 6562 (=1054), indiction 7.

154.B Didactic graffito added to 153.A, eleventh century (?)

ΑΧΧ ΙΔΡς ΣΟ / ΠΡ ΒΥ
(μονα)χ(οι) Ιδρ(οθντινοι) σο . . . πρ(εσ)βυ(τερος)

Monks of Otranto . . . priest (?).

Jacob, "Vaste," 244–53; Guillou, *Recueil*, 193–94, no. 183.

155. Funerary inscription, 1143

Lecce, Museo Provinciale "Sigismondo Castromediano," no. 3678; 24–28 × 31–39 × 8 cm

155.A front

Εκοιμηθη ο δου/λος του Θ(εο)υ Στε/φανος ιερευς /
μηνι μαρτιω κ̄ ζ̄ / [ετει, ἔτους ͵ς] χ̄ ν̄ ᾱ

The servant of God Stephen, priest, died on March 27, 6651 (=1143).

155.B back

Χ(ριστ)ε σωτερ το<ν> / σον δουλον / βουθη

Christ Savior, help your servant.

155.C top
central hole surrounded by incised circle; continuous X pattern

Jacob, "Vaste, 253–25; Jacob, "Notes," 83–85.

156. Funerary inscription, 1330

Lecce, Museo Provinciale "Sigismondo Castromediano," no. 4395; 46.5–52 × 31 × 16.5 cm; accented minuscule letters

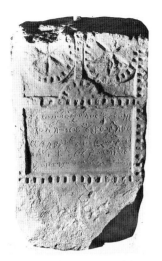

156.A Photo: Museo Provinciale di Lecce.

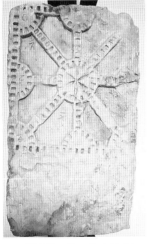

156.B Photo: Museo Provinciale di Lecce.

156.A* front

+Ἐκοιμήθ(η) ὁ δοῦλος τοῦ Θ(εο)ῦ Νι/κολάου υἱὸς τοῦ
Βεταλ(ίου) Φε/ρριάσζι {ζ}ἐν μην(ὶ) σεπτε(μβ)ρ(ίω) κ̄α /
ἡμέρ(α) γ̄ ὥρ(α) ζ ε(τει) ‚ς̄ ῶ̄ λ θ ινδ(ικτιωνι, ος) ῑ ε̄ / κ(αὶ) οἱ
ἀναγνῶσται εὔχεστ(ε) ὑπ(ὲρ) αὐτοῦ.

*The servant of God Nicholas, son of Vitalius Ferriaci, slept at the seventh hour on
Tuesday, September 25, 6839 (=1330), fifteenth indiction. And you who read this, pray
for him.*

rosettes inscribed in raised disks above framed text field

156.B* back

eight rays in relief emanate from central disk and terminate in semicircles; central
boss has incised six-petal rosette; incised letters (all with macron) on termini and
between rays; rays and frame outlined with rectangular indentations as on front

on rays

O	E	.
E		H
E	O	.

recessed

AB	T.
TX	ΛP

Jacob, "Vaste," 255–56; Jacob, "Notes," 78-83; Guillou, *Recueil*, 173–74, no. 161.

157. Santi Stefani, late tenth/early eleventh–fourteenth century

Rock-cut church imitating three-aisle basilica; original height 2.6 m (now 3.2 m)
*View east in central nave, showing height of adult viewer

157.A* devotional inscription, apse, 1379/80 (see 157.sc)

Μνήσθ(η)τ(ι) δεσπηνα τ(οῦ) δ(ού)λ(ου) [σ](ου) Ἀντωνίου
κ(αι) τ[ης συμ]βι(ου) α[υτ(ου)] / Δ(ου)λητζηας κ(αι) των
τέκνων αυτων Μαρίας / Ἰὸαννας / [α]πο χορας / Ν(ού)τζη
ἔτος ‚ς̄ ῶ̄ π̄ η̄

*Remember, Lady, your servant Antony and his wife Doulitzia and their children Maria
and Ioanna, of the village of Nuci [Nociglia], year 6888 (=1379/80).*

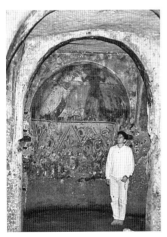

157

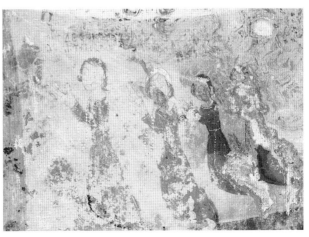

157.A–B

157.C–D

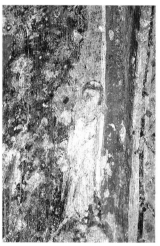

157.G–H

157.B* adjacent 157.A

four kneeling figures: large male on left has belted red robe, white loop at waist, pageboy hair, white-beaded paternoster over forearm; large female has red robe, white head scarf with dark stripes near fringed ends, white-beaded paternoster over arm; two smaller females at right have tight-sleeved red dresses, neckline edged in white, pearls in hair, ornamented belts, sleeves buttoned below elbow

157.C* devotional inscription, east-wall pilaster between left and center apses, to the right of Saint Eligius

Μνησθ(η)τ(ι) Κ(υρι)ε της δου/λη(ς) σ(ου) / Καλήας

Remember, Lord, your servant Kalia.

157.D* adjacent 157.C

kneeling female, hands clasped at chest height; red dress, white loop at waist, white veil; paternoster

157.E devotional inscription, east-wall pilaster between right and center apses, adjacent Saint Antony Abbot

[Μνησ]θ(η)τε Κ(υρι)ε τ(ου) (δου)λ(ου) σ(ου) . . .

Remember, Lord, your servant . . .

Fonseca et al., *Insediamenti*, 238, says inscription is lost; not included in Jacob, "Vaste." Visible in 1988.

157.F to lower right of 157.E

male, hands clasped at face height; white garment with tight pearled sleeves; blond hair curled up at neck

157.G* devotional inscription, eastern pier on north side, west face, adjacent Virgin and Child

Μνήσθ(η)τ(ι) / Χ(ριστ)ὲ τ(οῦ) / δ(ου)λ(ου) / πάπα Γεωρ/γί(ου) υἱ(ου) / Λαυρεν/τ[ι(ου)] ὀβφέρ/τ(ου) τ(ου) αγι[(ου)] / [Στ]εφαν(ου)

Remember, Christ, your servant the priest George, son of Laurence, oblate(?) of Saint Stephen.

157.H* adjacent to 157.G

kneeling male, hands clasped at face height; wears tight-sleeved red cotte with white surcoat; tonsured

157.I* devotional inscription, second north pier, south face, adjacent Saint Martin

Μ[νησ]θ(η)τ(ι) ἅγιε τῆς δ(ού)λις / Μαρ[γαρι]τα

Remember, saint, your servant Margaret.

157.J* adjacent 157.I

kneeling female, hands clasped at face level; red dress with pearl belt, pearl sleeves below elbow; white headdress, pearls in hair

157.K* devotional inscription, second south pier, north face, adjacent Saint Antony Abbot

Μνησθ(η)τ(ι) ἅγιε τ(ου) / δ(ού)λ(ου) σ(ου) / Στ[εφαν](ου)

Remember, saint, your servant St[ephen].

157.L* adjacent 157.K

kneeling male, hands clasped at face height; dressed in knee-length tight-sleeved red cotte with row of pearls to waist, pearl buttons to elbow; red hose; pageboy hair

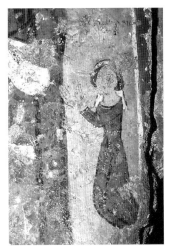

157.I–J

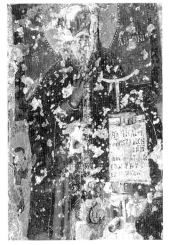

157.K–L

157.M devotional inscription, right wall, second pilaster, adjacent Saint Catherine

Μνήσθ(η)τ(ι) Κ(υρι)έ τὴς δ(ού)/λή<ς> σ(ου) Δόνας

Remember, Lord, your servant Donna.

157.N adjacent 157.M

See Plate 18

standing female, hands clasped at face height; wears long red-brown robe, slit at center below waist and outlined with pearls; white head scarf with dark stripes at fringed ends; holds white-bead paternoster on black cord; white loop at waist

157.sc Vision of Zechariah, John the Evangelist with Woman of the Apocalypse

See Plate 19

157.st Michael (2), Basil, Nicholas (2), John Chrysostom, Eligius, Antony Abbot (4), Gabriel (2), Catherine (2), Peter, Martin, Stephen (3), Philip, Pantaleon, Andrew, George, Bartholomew

Safran, "Betwixt or Beyond?" 121–30; Safran, "Deconstructing 'Donors,'" 139–43; Jacob, "Vaste"; Falla Castelfranchi, *Pittura monumentale*, 53–60, 75–81, 233–37; Fonseca et al., *Insediamenti*, 227–43; C. De Giorgi, *Provincia*, 2:15–23.

INSCRIPTIONS OF UNKNOWN PROVENANCE NOW IN LECCE

158. Funerary inscription with inserted cross, twelfth century (?)

Museo Provinciale "Sigismondo Castromediano," no. 55, 58 × 48 cm

Ἰ(ησοῦ)ς Χ[ριστὸ]ς νικᾶ /. . . φεν παπα /. . . σην /. . . χυο /. . . κ(αὶ) ορεότιτα /. . . λον τ(ου) σο /. . . δεξάμεν /. . . πετον /. . . Κονσταν[τῖνος] /. . . ὁ δηάκο[νος] /. . . [Ἀ]μήν.

Jesus Christ Conquers . . . beauty . . . your servant . . . receive . . . Constantine the deacon. Amen.

Guillou, *Recueil*, 170–71, no. 155.

159.* Funerary inscription, late tenth–eleventh century

Museo Provinciale "Sigismondo Castromediano," no. 56; continuous text encircles eight curving rays in high relief; 36 × 29 cm

+Υπερ κυμησεως και αναπαυσ<ε>ος του δουλου του θ(εο)υ Αρσακι αμα συν τω τεκνω αυτου

For the sleep and repose of the servant of God Arsakes along with his child.

Guillou, *Recueil*, 172–73, no. 159 (thirteenth–fourteenth century); Jacob, "Dédicace de sanctuaire," 706; Jacob, "Notes," 73 n. 25.

160. Funerary inscription, twelfth century (?)

Museo Provinciale "Sigismondo Castromediano" no number; 41 × 23 cm (broken)

Κ(υρι)ε Ι(ησο)υ . . . / δ(ου)λ(ου) τ(ου) . . .

Lord Jesus . . . your servant . . .

Guillou, *Recueil*, 171, no. 156; Passarelli, "Epigrafi," 54; Rugo, *Iscrizioni*, 93, no. 120.

159 Photo: Museo Provinciale di Lecce.

162 Photo: Roberta Durante. Courtesy Ufficio diocesano per i Beni culturali ecclesiastici, dir. Don Giuliano Santantonio, Diocesi Nardò-Gallipoli.

161. Funerary inscription, fourteenth century

Museo Provinciale "Sigismondo Castromediano," no number

Ἐκοιμήθη ὁ δοῦλος τοῦ Θεοῦ Νικολου . . . (1322?)

Sleeps the servant of God Nicholas . . .

Rugo, *Iscrizioni*, 95, no. 124.

GALATONE

162.* *Anthologion*, late fifteenth–early sixteenth century

Chiesa Matrice, cod. Galat. 3, colored drawings on fol. 310

See Plate 20 for detail

Petta, "Tre manoscritti," 15–20, for manuscript contents.

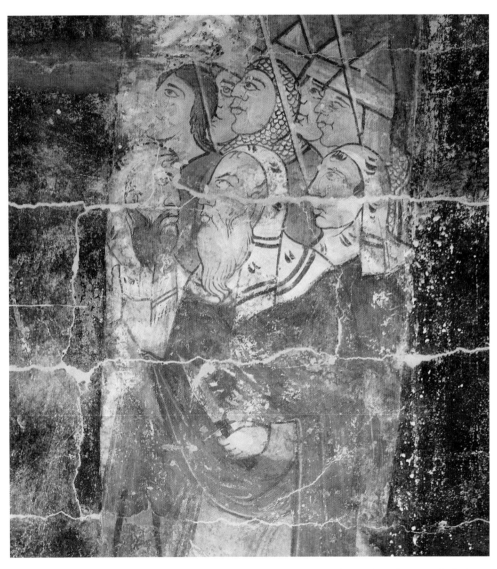

Plate 1. Acquarica del Capo, San Nicola, north wall. Betrayal of Christ, detail of Jews.

Photo: Louis Duval-Arnould.

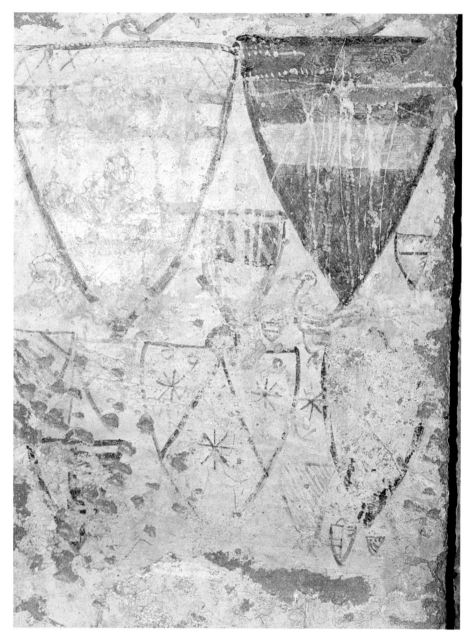

Plate 2. Alezio, Santa Maria della Lizza, right wall pilaster. Painted shields, profile faces, bird.

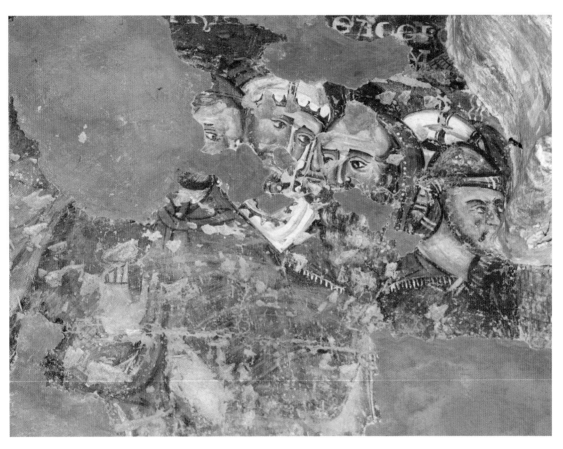

Plate 3. Brindisi, San Paolo, right wall. Pilate washing his hands, detail of Jews (detail of 26.sc.1).

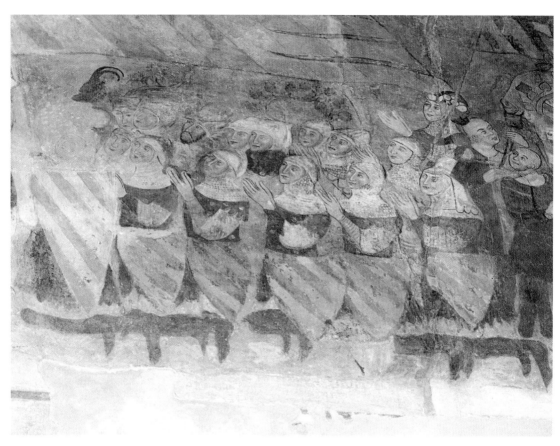

Plate 4. Brindisi, Santa Maria del Casale, south nave wall, west end, upper register with Leonardo di Tocco (detail of 28.D–E).

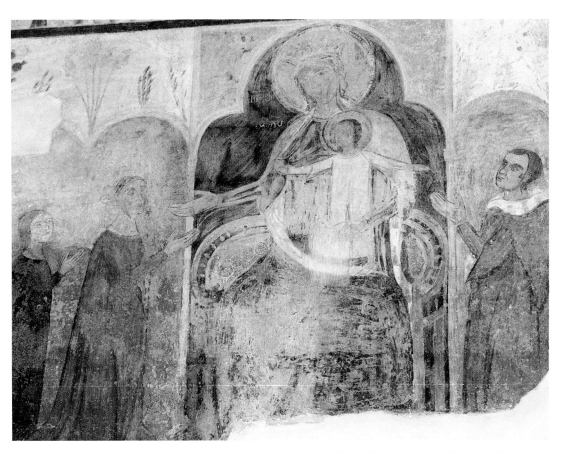

Plate 5. Brindisi, Santa Maria del Casale, south nave wall, center of nave between windows (28.I).

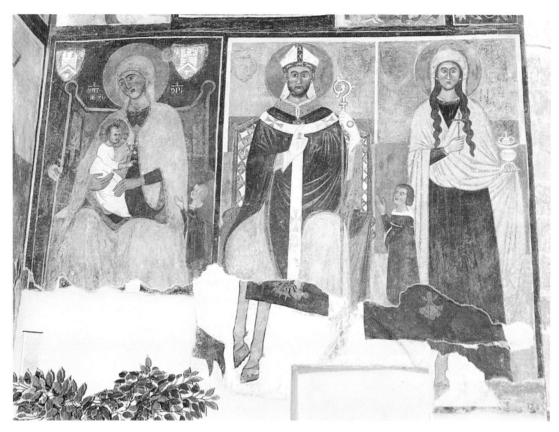

Plate 6. Brindisi, Santa Maria del Casale, south side of presbytery, left of transept. Supplicants venerating the Virgin and Child and Saint Erasmus, with Mary Magdalene (detail of 28.N–P).

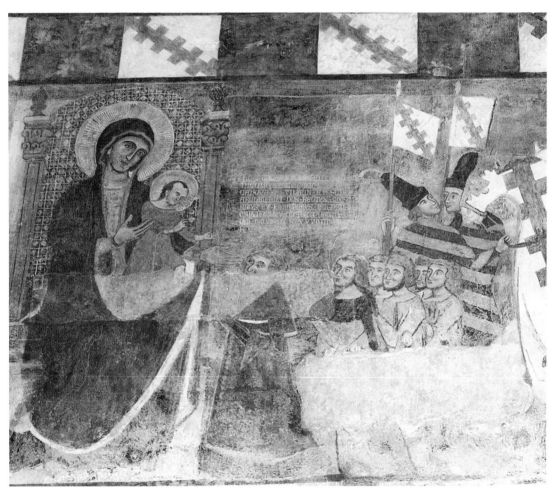

Plate 7. Brindisi, Santa Maria del Casale, north nave wall, lower register. Devotional scene with Nicholas de Marra, 1335 (detail of 28.V).

Plate 8. Casaranello, Santa Maria della Croce, second pier on right. Saint Barbara with painted and incised devotional texts (detail of 33.F–K).

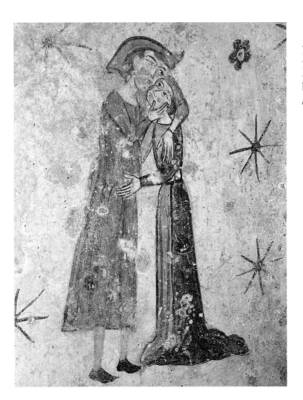

Plate 9. Near Copertino, Masseria Li Monaci, San Michele Arcangelo, ceiling before left apse. Embracing couple (detail of 43.C).

Plate 10. Near Grottaglie, Masseria Lo Noce, San Pietro. Right wall, shields and verbal graffiti on Saint Michael the Archangel (detail of 54.st).

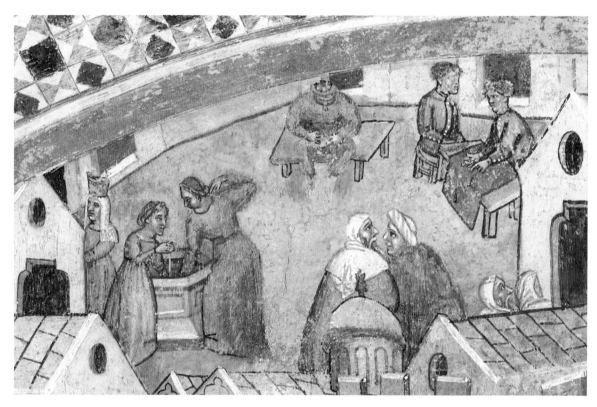

Plate 11. Lecce, Torre di
Belloluogo, second-story
chapel. Departure of Mary
Magdalene from Palestine
to Provence, view inside city
(detail of 59.A).

Photo: Michele Onorato.

Plate 12. Massafra, Candelora, north wall. Mary escorting Jesus to school with pair of supplicants at lower left (detail of 63.A).

Plate 13. Mottola, San Nicola, right wall pilaster. Two women holding candles between Saint Leo the Great and Saint Helena (detail of 76.st.1).

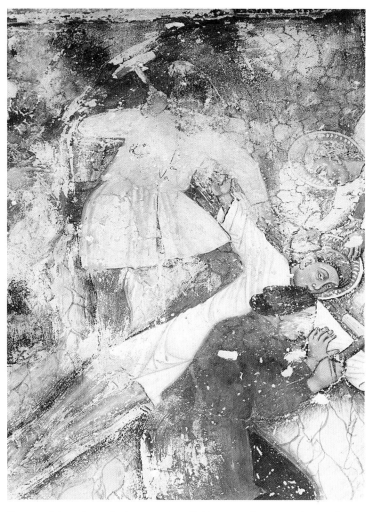

Plate 14. Soleto, Santo Stefano, south wall. Torturer of Saint Stephen with rotella (cf. 113.sc.1).

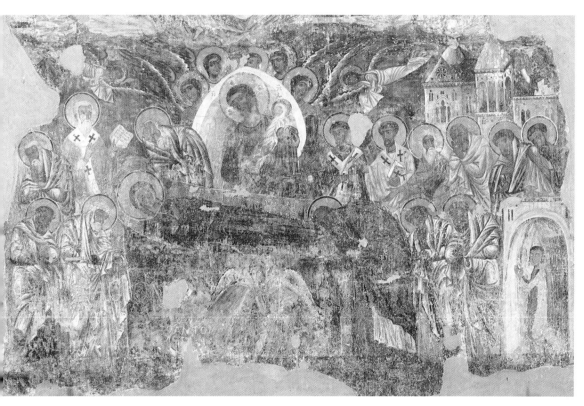

Plate 15. Santa Maria di Cerrate. Originally on north wall (now in Museo Provinciale delle Tradizioni Popolari). The Sleep (Koimesis) of the Virgin with supplicant (114.E).

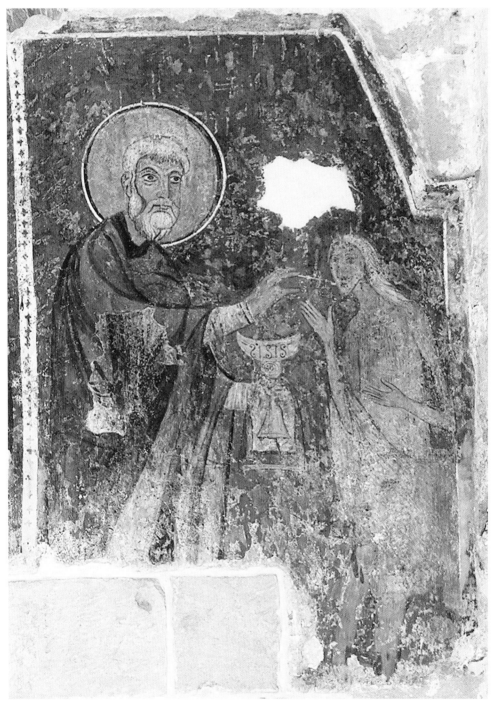

Plate 16. Taranto, Cathedral of Santa Maria (now San Cataldo), crypt, right wall. Zosimus gives communion to Mary of Egypt.

Plate 17. Ugento, Cripta del Crocefisso, right wall. Detail of Christ child with earring (detail of 151.st).

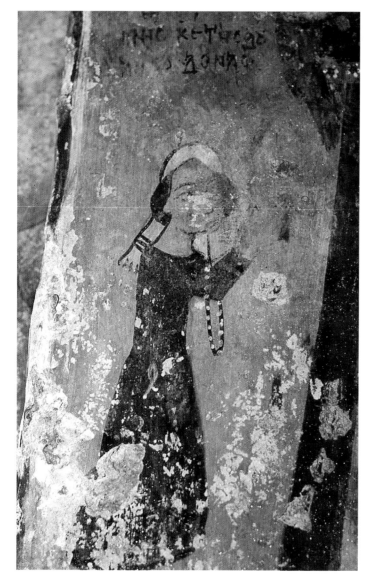

Plate 18. Vaste, Santi Stefani, right wall pilaster. Supplicant Donna adjacent to Saint Catherine, 1379/80 (157.N).

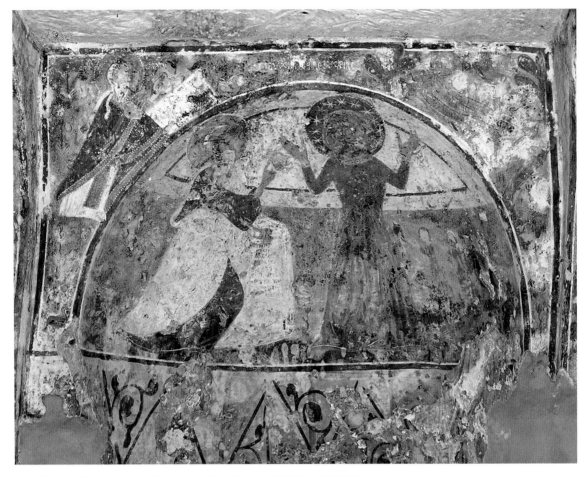

Plate 19. Vaste, Santi Stefani. Apse wall and conch, 1379/80 (cf. 157.A).

Plate 20. Galatone, Chiesa Matrice, cod. Galat. 3, fol. 310, *anthologion*. Amulet and squared Solomon knot between commemorations of Saint Anne and Saint Panteleimon (detail of 162). Courtesy Ufficio diocesano per i Beni culturali ecclesiastici, dir. Don Giuliano Santantonio, Diocesi Nardò-Gallipoli.

Photo: Roberta Durante.

Notes

Introduction

1. For the legitimacy of using early modern and more recent ethnography to inform historical periods, see Gould, "Ethnoarchaeology"; and the College Art Association conference session organized by Linda Safran and Sharon Gerstel, "Ethno-Art History? Understanding the Art of Pre-modern Cultures Through Ethnography and Ethnohistory," February 21, 2003.

2. Even Renaissance art historians are beginning to reject the "high art" trinity of painting, sculpture, and architecture as exclusively representative of Renaissance art; see the essays in Elkins and Williams, eds., *Renaissance Theory*.

3. Gell, *Art and Agency*, 23–24.

4. See Bahn, "Art," 48–49. I admit, however, that ceramics receive less attention in my text.

5. The literature on visual and material culture is vast even though the fields are fairly recent. Essential references are Mirzoeff, *Introduction*; Evans and Hall, eds., *Visual Culture*; Hicks and Beaudry, eds., *Oxford Handbook*. Recent historical studies include Skeates, *Visual Culture*; Starkey and Wenzel, eds., *Visual Culture*; Hamling and Richardson, eds., *Everyday Objects*.

6. Belting, *Likeness*; Freedberg, *Power*.

7. Belli D'Elia, ed., *Icone*.

8. Among the fundamental studies of individual and social identity are Erikson, *Identity*; Abrams and Hogg, *Social Identity*; and the essays in Breakwell, ed., *Social Psychology*. For pre-modern cultural (but often called "ethnic") identity, see Geary, "Ethnic Identity"; Hales and Hodos, eds., *Material Culture*; McGuire, *Birth of Identities*; Hall, "Introduction." For some contemporary challenges to identity, see Campbell and Rew, eds., *Identity;* Bouchard, "Critical Reappraisal."

9. Trexler, "Introduction," 3.

10. Díaz-Andreu and Lucy, "Introduction," 1.

11. Hall, "Cultural Identity," 234.

12. Hakenbeck, "Situational Ethnicity," 20.

13. Roccas and Brewer, "Social Identity"; Lickel et al., "Varieties."

14. This includes ethnic identity, which has received the bulk of attention by medievalists. See, e.g., Pohl, "Introduction"; Pohl, "Telling the Difference"; and the trenchant critique by Curta, "Some Remarks," with earlier bibliography.

15. Geary, "Ethnic Identity."

16. Jacob, "Culture grecque," esp. 61–62; Jacob, "Formazione"; cf. Cavallo, "Libri greci."

17. McKee, "Sailing," 300; she further points out that the Constantinopolitan nobility living in Venice since the fifteenth century "felt they had nothing in common with fellow Greek-speaking worshipers in the Greek Church" (p. 298, citing Ersie Burke, "The Greek Neighborhoods of Sixteenth-Century Venice, 1498–1600," Ph.D. diss., Monash University, 2004).

18. Shohat, "Struggle," 167.

19. Hall, "Cultural Identity," 234.

20. See, e.g., Baumgarten, *Mothers*; Green, "Conversing"; Cuffel, "From Practice."

21. Burgers, *Constructing*; Daquino, *Messapi*; Pugliese Carratelli, *Magna Grecia*.

22. Martin, *Pouille*, 116.

23. Falkenhausen, "Réseaux routiers," 713; Uggeri, "Via Traiana." The Via Appia-Traiana was also known as the Via Augusta-Sallentina; see Uggeri, *Viabilità*; and Dalena, *Strade*. For the cadastres, some of which are still visible, see Compatangelo, *Cadastre*; and Arthur, "Verso un modellamento," 216.

24. Ferorelli, *Ebrei*, 5. Titus is said to have brought five thousand Jewish prisoners to Italy.

25. Mørch, "Location," 42, 48; Martin, *Pouille,* 128.

26. The evidence for now-lost forests is linguistic (e.g., toponyms derived from the Lombard *wald*, forest; see Novembre, "Per una geografia," 241); documentary (e.g., references to the great Forest of Lecce; Visceglia, *Territorio*, 205); and archaeological (e.g., the lack of traces of centuriation and remains of red deer and stags, which prefer a wooded habitat; Arthur, "*Grubenhauser*," 174).

27. Mørch, "Location," 48.

28. Visceglia, *Territorio*, 115–41; Martin, *Pouille*, 332–47; Massaro, "Territorio," 258; Lefort and Martin, "Organisation"; Sakellariou, *Southern Italy*, 326–27. Gallipoli did not become the premier European oil-trading center until the sixteenth century (ibid., 329).

29. Martin, *Pouille*, 401–26.

30. Personal communication with Paul Arthur, July 12, 2012; on the "Centoporte," Arthur and Bruno, eds., *Complesso tardo-antico*; Arthur, "Masseria Quattro Macine," 185–95.

31. According to Paul the Deacon; see Martin, *Pouille*, 163. Schipa, "Migrazione," argues for a slightly earlier date.

32. The so-called "Limitone dei Greci," marking the hypothetical border between Lombards and Byzantines, is more likely to have been a feudal division of property datable to the Angevin period. See Stranieri, "*Limes* bizantino."

33. The Muslim raids left little in the toponomastic or archaeological record. See Arthur, "Islam," 166.

34. See Chapter 7.

35. Martin, "Origine calabraise." The linguistic debate is discussed further in Chapter 2.

36. Falkenhausen, *Dominazione*, 23–25.

37. Jacob, "Fragments liturgiques"; Parenti, "Christian Rite"; Parenti and Velkovska, eds., *Eucologio*. Specific liturgical peculiarities are discussed in Chapter 6.

38. Codrington, *Liturgy*.

39. Bonfil, "Tra due mondi."

40. The Pontic group was sent by Basil I ca. 873 to populate Gallipoli and three thousand ex-slaves of the Peloponnesian widow Danielis were sent by Leo VI ca. 888; see Falkenhausen, *Dominazione*, 26; McCormick, "Imperial Edge," 35. Not only would these groups have spoken different dialects, but because many were former slaves they probably did not share a sense of "Greek" ethnicity (see Chapter 8).

41. The cities are Taranto, Brindisi, Oria, Lecce, Gallipoli, Ugento, Otranto, Castro, Leuca, and Nardò; all except the last were also the seats of bishops. See Novembre, "Per una geografia," 250; Martin, *Pouille*, 266–92; Martin, "Hellénisme," 197; Visceglia, *Territorio*, 33–52; Arthur, "Verso un modellamento."

42. *Chora* can have the sense of a locality, a town, or a city; it is often used interchangeably with *polis* and κώμη. See references in Jacob, "Nom de famille," 82 and n. 34. The Latin equivalent is *terra* or *locus*. See also Martin, "Hellénisme," 197; Vallone, "Galatina," 24.

43. Arthur, "Tra Giustiniano," 195, says "almost 200" villages; the same figure is in Martin, *Pouille*, 282. The updated figure of ca. 360 villages is given by Paul Arthur in "Economic Expansion," 390, and in "Salento bizantino," 187.

44. Martin and Noyé, "Campagnes," 559, 564.

45. Martin, *Pouille*, 830 and chap. 9.

46. Martin demonstrates that the conquest was the work of a few thousand Normans and Bretons in search of land and aristocratic Lombard wives (ibid., 521). See also Poso, *Salento*.

47. Martin, *Pouille*, 801, 804; Martin, "Naissance," 30–33.

48. Massaro, "Città," 347.

49. Fonseca and Pace, eds., *Federico II*; Calò Mariani, *Arte del Duecento*.

50. See Abulafia, "Bad Rulership."

51. Jacob, "Épidémies"; Visceglia, *Territorio*, 9, 44.

52. Ferorelli, *Ebrei*, 59–60 (regarding an uprising in Brindisi *cum fustibus seu lignis et armis*); Shatzmiller, "Angevins."

53. Starr, "Mass Conversion"; U. Cassuto, "Ignoto capitolo."

54. Shatzmiller, "Angevins," 291–96. Under Robert, the Jews could "conversari, mercari et praticari" with Christians, "et alia facere more hebrehorum." Ferorelli, *Ebrei*, 63.

55. Ferorelli, *Ebrei*, 66.

56. Visceglia, *Territorio*, 173; Kiesewetter, "Principi"; Kiesewetter, "Ricerche"; "Principato di Taranto" website.

57. In addition to sources cited in the previous note, see Cassiano and Vetere, eds., *Dal Giglio all'Orso*; Cutolo, *Maria d'Enghien*.

58. Arthur, "Archeologia del villaggio," 111; Visceglia, *Territorio*, 51; Licinio, *Masserie*.

59. Romanello, "Affermazione," 19–21; Coluccia, "Lingua e politica"; Coluccia, "Puglia," 692.

60. Mersch and Ritzerfeld, "Lateinisch-griechische," 245 and passim; Visceglia, *Territorio*, 174, 207–8.

61. Sakellariou's *Southern Italy in the Late Middle Ages* begins in ca. 1440.

62. Visceglia, *Territorio*, 23.

63. Baldassare, "Civiltà rupestre," also omits Fasano from what she calls the "alto Salento," by which she means the province of Brindisi. In his collection of surnames, Rohlfs (*Dizionario storico*, ix), defines the Salento as an "extension of the name previously more in use, the Terra d'Otranto, including also the northern part of the modern province of Taranto (zone of Massafra–Mottola–Castellaneta)." My contours of the Salento are the same as those in the map in Baldacci, *Puglia*. Matera was part of the administrative Terra d'Otranto until 1663 but is not included in this study.

64. Arthur, "Salento bizantino," 187 and fig. 1. There were about 230 villages in the late medieval province of Lecce alone. See Arthur, "Verso un modellamento," 221.

65. Visceglia, *Territorio*, 50–51.

66. Egidi, "Ricerche," 747. His method of counting results in figures higher than that of previous scholars. The difficulties of counting inhabitants given the inconsistencies and inadequacies of the available data are reviewed in detail in Vallone, "Galatina."

67. Visceglia, *Territorio*, 51; cf. Da Molin, *Popolazione,* 19, who cites 59,400 (assuming 4.5 persons in 13,200 households).

68. Visceglia, *Territorio*, 51; Da Molin, *Popolazione,* 29. The port of Lecce, San Cataldo, was built up at the turn of the fourteenth century [**107**], and Lecce only became a true provincial capital after this point even though its development had been anticipated in the Norman period. See Massaro, "Territorio," 284.

69. Visceglia, *Territorio*, 51.

70. Da Molin, *Popolazione*, 27.

71. Pellegrino, *Terra d'Otranto*, 310–11.

72. Using the Angevin registers, Shatzmiller, "Angevins," 292, cites 172 converts at Taranto, while Ferorelli, *Ebrei,* 55, cites "over 170"; in addition, Shatzmiller records 310 at Trani versus "over 300" in Ferorelli.

73. Lelli, "Ebrei."

74. Ferorelli, *Ebrei*, 78, 97.

75. Arthur, "Byzantine and Turkish," 250; Arthur, "Albania," 81–83.

76. For a perspective by one of the protagonists, see D. Durante, *Spartito.*

77. Discussed further in Chapter 7.

78. De Martino and his associates began fieldwork in 1959 for *La terra del rimorso.*

79. Lüdtke, *Dances*; Lüdtke, "Tarantism," 303–4; Lapassade, *Intervista.*

80. Lüdtke, "Tarantism," 307.

81. The festival began in 1998; see http://www.lanottedellataranta.it/ for the latest iteration. I myself have danced the *pizzica* in Nardò.

82. Clark, "On the Brink."

83. Caroli, "Entre renaissance culturelle."

84. See, e.g., Lelli, "*Odissea.*" The murals of Tzvi Miller are now part of the Museo della Memoria e dell'Accoglienza at Santa Maria al Bagno, site of one of the former displaced-persons camps, on which see http://www.dpcamps.org/SantaMariaBagno.html. The museum was inaugurated in 2009; http://www.culturaitalia.it/opencms/it/contenuti/focus/focus_0378.html.

85. Colafemmina and Gramegna, *Sinagoga Museo.*

86. See http://www.provincia.brindisi.it/Down/GrandeSalento_Accordo_Tavolo_Consultazione_Permanente.pdf.

87. For this taxonomy of Salento inscriptions, see Safran, "Cultures textuelles"; Safran, "Public Textual Cultures."

88. Important recent discussions of microhistory that include a brief historiography of the term are Brown, "Microhistory"; Peltonen, "Clues"; Trivellato, "Is There a Future." See also, in the previous generation of microhistorians, G. Levi, "On Microhistory"; Ginzburg, "Microhistory"; Chartier, "Intellectual History." That a *microstoria* of Byzantine Italy is mandated by the paucity of available sources was noted by Corsi, "Territorio," 55.

89. Geertz, *Interpretation*, esp. 6–10, 25–28.

90. For a brief overview, see Fenster, "Preface"; cf. the perceptive comments in Sharon Gerstel's review of Mati Meyer, *An Obscure Portrait: Imaging Women's Reality in Byzantine Art*, online in *TMR* 11.03.21 (https://scholarworks.iu.edu/dspace/handle/2022/13109).

91. While popular sources assert that "Catholic" is synonymous with "Roman-rite church" after the so-called schism of 1054, this broader term is problematic because it includes other churches and rites in addition to the Roman one (e.g., Ambrosian, Mozarabic, Dominican). Until the late Middle Ages none of these alternatives was in use in the Salento, so I prefer the narrower term "Roman-rite Christians." An acceptable alternative might be "Latin-rite Christians," given that the language of ritual in the Roman rite was Latin, but the other "Catholic" rites used this language as well. I therefore use "Roman rite" consistently in this book.

92. There is a curious triangular marble stela inscribed in Arabic, but it tells us only about the acquisition habits of someone associated at an unknown time with the church near which it was found, Santa Maria del Galeso [**144**]. See D'Angela, *Taranto medievale*, 194–96.

93. This has already been done, and admirably, by Martin, Falkenhausen, Ditchfield, Vetere, and other historians. In any event, there is a complete absence of archival documentation for the southern part of the Salento. See Martin, *Pouille*, 35. See also the list of extant documentary sources compiled in Falkenhausen, "South Italian Sources," 114–17.

94. R. Durante, "Miniature," connects motifs in local Greek manuscripts to those in Salentine wall paintings.

95. Gell, *Art and Agency*; Knappett, *Thinking*; cf. Layton, "Art and Agency."

96. E.g., Medea, *Affreschi*; Fonseca, *Civiltà rupestre*; Fonseca et al., *Insediamenti rupestri*; and the numerous seminar proceedings edited by Fonseca as part of the Convegno internazionale di studio sulla civiltà rupestre medioevale nel mezzogiorno d'Italia (1970s) and Il popolamento rupestre dell'area mediterranea (1980s). These gatherings have been revived recently by the Fondazione San Domenico under the rubric Convegno internazionale sulla civiltà rupestre; see http://www.fondazionesandomenico.com/.

97. Some inscriptions have been signaled but not published, and either I have not gained access to them or was unable to decipher them. These include fragmentary texts in the structure that predates the current cathedral at Castro (cited in Jacob, "Fondation de chapelle"); graffiti in the natural grotto behind Santa Maria di Presicce, signaled by Jacob, "Testimonianze bizantine," 60; and graffiti in the grotto of San Cristoforo at Torre dell'Orso (noted by Jacob, "Vaste," 248).

Chapter 1. Names

1. See the suggestive study of nineteenth- and twentieth-century German naming patterns in Wolffsohn and Brechenmacher, "Nomen." "Adolf" is outlawed in Germany.

2. See, e.g., the study of discrimination in Switzerland by Fibbi, Kaya, and Piguet, *Nomen*.

3. Price, "Name It."

4. Baun, "Fate of Babies," 123; Alexandre-Bidon and Lett, *Children*, 26; Wilson, *Means*, 99, says only that naming was incorporated into the baptismal ritual by the eleventh century.

5. Jacobs, "Names (Personal)," 152; Golinkin, "Episodes"; Trachtenberg, *Jewish Magic*, 42; Di Segni, "Cultura folklorica"; Bonfil, *Jewish Life*, 248. The modern custom for girls is to name them at the first Torah reading after their birth.

6. Ladiana, "Culla," 367–68, presents ethnographic information from ca. 1900. This is also the practice in Greece (Stewart, *Demons*, 56) and elsewhere. See, however, the only reference to a grandparent in a Salentine public text [**94.K**], in which John is a grandson of Michael.

7. Kazhdan, "Names," 2:1436.

8. Ladiana, "Culla," 367; Stewart, *Demons*, 55.

9. Krohn, "Names."

10. Midrash Tanhuma, trans. Townsend, Ha'azinu 7.

11. BT Brachot 3b and Gittin 11a.

12. The oldest such statement appears in the Mekilta, a midrashic commentary on Exodus. See Ginzberg, *Legends*, 2:300. Additional references include Midrash Rabbah, Shir ha-Shirim 4.12.1 ("as Reuben and Simeon they went down to Egypt, and as Reuben and Simeon they went up from it; they did not call Reuben Rufus, or Simeon Luliani, or Joseph Listis or Benjamin Alexander . . ."); Bamidbar Rabbah 20:22; Shoher Tov 114; Shemot Rabbah 1:28; Midrash Tehillim 114:4. Note that the Hebrew title for the book of Exodus is *Shemot*, Names.

13. Jacobs, "Names (Personal)," 154.

14. Kant, "Jewish Inscriptions," 673.

15. *Sefer Hasidim* 13C, 195, p. 74; cited in http://jerusalemlife.com/torahkids/jwquotes.txt.

16. Ecclesiastes Rabbah 7.1.3 says that every man has three names: the one his parents gave him, the one that others call him, and the one he acquires for himself (http://jerusalemlife.com/torahkids/jwquotes.txt); this third name is clearly a behavioral metaphor.

17. Trachtenberg, *Jewish Magic*, 74.

18. M. N. Adler, *Itinerary*, 9–10.

19. The chronicle was discovered in Spain in 1895. The edition of Salzman, *Chronicle*, is now superseded by Colafemmina, *Sefer Yuhasin,* and Bonfil, *History and Folklore.* All references here are to the latter edition.

20. Falkenhausen, "Ebraismo," 43.

21. These theophoric *–el* names were both drawn from the Tanakh and newly invented. See Klar, *Mehkarim ve-ʿiyunim*, 69.

22. Falkenhausen, "Ebraismo," 37, 42; see also Sharf, *Universe*; Colafemmina, "San Nilo." Shabbetai is a festal name, from "shabbat," that was very popular in diaspora communities. See Williams, "Jewish Festal."

23. Martin, *Pouille*, 493; Mann, *Texts*, 14; Roth, "Italy," 108.

24. On Amnon as a typically South Italian Jewish name, see Fraenkel, "R. Amnon," 132–33. In the early fifteenth-century diptychs of the dead recorded in Milan, Biblioteca Ambrosiana, MS C7 sup., an Amnon is one of the Christian dead, no doubt a member of a formerly Jewish family. On this Salentine manuscript, see Jacob, "Annales d'une famille," esp. 42.

25. Caleb is a "typically Byzantine Jewish name"; similarly, Meiuchas (a Hebraicization of Eugene) is not found outside of Byzantium. See de Lange, "Jewish Sources," 367.

26. Later, Isaiah b. Mali of Trani (the RID)'s father's name was either Emanuel, as stated in *Even Sapir* (thirteenth or fourteenth century), or Malkiel. For Emanuel, see Ta-Shma, "Rabbi Jesaiah," 412; for Malkiel, see Zidkiyahu Anav, *Shibolei ha-Leqet*, ed. Hasida, cited in Mirsky, "R. Isaiah."

27. Schirmann, "Beginning," 256–57; see also the South Italian (but not necessarily Salentine) poets listed in n. 29 (p. 430); also Sonne, "Alcune osservazioni."

28. Early medieval Jewish male names have been culled from *Corpus Inscriptionum Iudaicarum*, ed. Frey, 444–54, with corrections and additions from Noy, *Jewish Inscriptions,* 150–81, 273–77; Colafemmina, "Insediamenti e condizione," plus discussion, 229–39; Colafemmina, "Iscrizioni ebraiche"; Colafemmina, "Ebrei di Bari"; Mann, *Texts*, 13; Roth, "Italy," 111; Sharf, *Universe*, 9; Adler, *Itinerary,* 9–10; U. Cassuto, "Lettera ebraica"; Trinchera, *Syllabus*; Schirone, *Giudei*; Bonfil, *History and Folklore*; Geula, "Midrašim," n. 7; Richler, *Hebrew Manuscripts*; and Skinner, "Gender."

29. Cassuto, "Lettera ebraica," 109 n. 3. Chimaria (Shemaria)-Theophylact are two names of a single individual in Taranto in 1033–39 (Trinchera, *Syllabus*, 29, 36). On Greek equivalents for Hebrew names, see M. Cassuto, "Corrispondenza."

30. In addition to the sources for names cited in n. 28, these later names are found in Colafemmina, *Ebrei e cristiani*; Colafemmina, *Documenti;* Colafemmina, "Di alcune iscrizioni ebraiche"; Colafemmina and Gramegna, *Sinagoga Museo*; Colafemmina, Corsi, and Dibenedetto, eds., *Presenza ebraica*; Hoeck and Loenertz, *Nikolaos-Nektarios*, 82–88; Külzer, *Disputationes*, 192–95; Romanello, "Affermazione"; and U. Cassuto, "Iscrizioni ebraiche a Bari" and "Iscrizioni ebraiche a Trani." Medieval Jews did not have hereditary surnames.

31. Cristio Maumet is identified as an "ebreo di Lecce" in 1447 in Colafemmina, Corsi, and Dibenedetto, eds., *Presenza ebraica*, 23; cf. also Mahomet, a Jew of Troia in 1534, cited in Colafemmina, *Ebrei e cristiani*, 143. This may reflect the tendency for Jews (or former Jews) to reinforce originally Hebrew names with semantic referents from local culture (De Felice, *Cognomi*, 183), and in fact the name Cristi is attested in Lecce in the 1420s; see Romanello, "Affermazione," 47. In the late twelfth century Benjamin of Tudela noted, without irony, that the head of the Jewish community of Arta in northwestern Greece was Rabbi Hercules.

32. Starr, "Mass Conversion," 204; cf. the bull of Alexander IV, issued September 3, 1257, regarding the Talmud, in *Codice diplomatico,* ed. del Giudice, 3:200.

33. Fraenkel, "R. Amnon," 133.

34. Early medieval Jewish female names are culled from from *Corpus Inscriptionum Iudaicarum*, ed. Frey, 451–54; Salzman, *Chronicle*, 82; Noy, *Jewish Inscriptions*, 167, 170, 195, 274–77; Colafemmina, "Insediamenti e condizione," 220; Colafemmina, "Note su di una iscrizione"; Colafemmina, "Ebrei a Taranto nella documentazione." The later female names are from Colafemmina, *Documenti*, 37–53; and Colafemmina, Corsi, and Dibenedetto, eds., *Presenza ebraica*.

35. "Mazal" has been translated as an augurial surname, but it could be the beginning of the following clause (i.e., "fortunate [*mazal*] may her soul be . . .").

36. Jacobs, "Names (Personal)," 154. An example is Amittai, Shephatiah ben Amittai, Amittai ben Shephatiah of Oria; Colafemmina, "Insediamenti e condizione," 217; Salzman, *Chronicle*, 83. This is also the traditional naming pattern in medieval (and later) Christian families.

37. Colafemmina, *Ebrei e cristiani*, 200. Non-Ashkenazic Jews still have the custom of naming children after parents, but Ashkenazic Jews avoid naming children after living relatives. These different practices were not yet crystallized in the early Middle Ages.

38. Noy, *Jewish Inscriptions*, 322.

39. "Leon" is probably already equivalent to "Judah"; *min* corresponds to "de" or "del."

40. Romanello, "Affermazione," 36–37; De Felice, *Cognomi*, 33.

41. According to Sonne, "Alcune osservazioni," 73; Schirmann, "Beginning," 257, dated him to the twelfth century.

42. Sonne, "Alcune osservazioni," 76.

43. Zimmels, "Science," 439 n. 2; Sharf, *Universe*, 113.

44. De Felice, *Cognomi*, 33.

45. Cited in Colafemmina, *Ebrei e cristiani*, 19–25.

46. Ibid., 173–74, 177.

47. On the pairing of Hebrew names and their vernacular equivalents in northern and central Italy from the thirteenth century through the early nineteenth, see Colorni, "La corrispondenza," in *Italia Judaica*, esp. 71; Colorni, "La Corrispondenza," in *Judaica minora*.

48. Jacob, "Anthroponymie."

49. Martin, "Italie méridionale"; Drell, "Cultural Syncretism."

50. Martin, "Italie méridionale," 37.

51. Veneria is the wife cited in the apse inscription at San Pietro in Crepacore (Torre Santa Susanna), the date of which is disputed: first half of the seventh century (Berger and Jacob, "Des peintures pré-iconoclastes") or tenth century (Safran, "Byzantine South Italy"; Falla Castelfranchi, "Decorazione pittorica d'epoca macedone"; Falla Castelfranchi, "Cultura artistica").

52. Jacob, "Anthroponymie," 363.

53. Jacob considers evidence from Taranto and Calabria. In Calabria, the onomastic preference is Leo, Nicholas, John, Constantine, in descending order of popularity; see Guillou, "Noms, prénoms."

54. Gambacorta, "Culto," 38.

55. Martin, "Italie méridionale," 38, found that only 2 percent of the male population of Bari was named Nicholas in the eleventh century; by 1220, the name was borne by over 11 percent of Bari men.

56. Wilson, *Means*, 102, notes over eight hundred churches dedicated to Michael by the late seventh century but says the name was not common before the twelfth century. This accords with observations made for the Byzantine world, where Michael is not among the personal names used before the ninth century, then is popular in the eleventh and twelfth centuries (Kazhdan, "Michael.") Cf. Villani, "Contributo," who says the name Michael was widely diffused in the Salento.

57. Jolivet-Lévy, *Églises byzantines*, 343–44; compare the index entries for Nicholas and Michael in Delatte, *Anecdota*, 704, 702. See also Keck, *Angels*, 45; Martin-Hisard, "Culte."

58. Nor should we rule out Michael's prominence in the mystical literature that circulated in local Jewish communities and perhaps in Christian ones as well.

59. Milella Lovecchio, "Alcune note."

60. Fully two-thirds of women in Bari were not identified by surnames even in the fourteenth century; see Martin, "Devenir," 85. On female surnames elsewhere, see Wilson, *Means*, 172–77.

61. Jacob, "Consecration," 161, posits that Leo Kephalas is the bishop of Gallipoli referred to in an adjacent graffito; his obituary does not state this specifically, but Jacob is surely correct.

62. Ibid., 160.

63. Jacob, "Vaste," 252; Falkenhausen, "Between Two," 154. The name is Armenian in origin.

64. Martin, "Devenir," 85.

65. Jacob, "Vaste," 252–53.

66. Corsi, "Comunità d'Oriente," 161; McCormick, "Imperial Edge," 35.

67. Arthur, "Masseria Quattro Macine," 208; Patterson, "Contatti."

68. Peregrinus became a fairly common surname in Apulia after the mid-twelfth century; see Dalena, "Itinerari."

69. Carpignano, Casaranello, and the grottoes of Torre dell'Orso and Presicce.

70. Brindisi: Sant'Anna, the Cathedral of the Visitation and San Giovanni Battista; near Brindisi, Santa Maria del Casale; Massafra: San Marco; Nardò: Cathedral of Santa Maria Assunta; Palagianello: Santa Lucia; near Squinzano: Santa Maria di Cerrate; Taranto: Santa Chiara alle Petrose; Vaste: Santi Stefani.

71. Jacob, "Anthroponymie," 366, connects the new popularity of Pantaleon to the diocese of Gallipoli.

72. Ibid., 365, 369. John and Peter were the most popular names in Byzantine Bari, followed by Melo, Bisanzio, Caloiohannes, and Leo; see Falkenhausen, "Gruppi etnici," 135 n. 11.

73. Jacob, "Anthroponymie," 365.

74. Caffarelli, "Liste," 197–98. After Peter, the most common clerical names are William, Roger, Andrew, James, Thomas, Bartholomew, and Leo. Only in southern Italy (Sicily, Sardinia, and Apulia–Lucania–Calabria) was John displaced by Nicholas or Peter as the name most often recorded in the papal tax registers.

75. Before ca. 1100, names were a better indicator of the holder's ethnic origin than they became subsequently. See Loud, "How 'Norman,'" 28.

76. Jacob, "Anthroponymie," 365; see also Wilson, *Means*, 103–4.

77. The widely reported inscription "Magister Franciscus Colaci/Suburbien MCCCXCVII" on the Soleto bell tower is a phantom; see Manni, *Dalla guglia*, 32–34, correcting such sources as Calò Mariani, "Dal chiostro," 721.

78. Cf. Jacob, "Anthroponymie," 372–73, who attributes the new popularity of Antony to the Paduan saint, and Villani, "Contributo," 258, who credits Antony Abbot as patron of the Hospitallers.

79. Jacob, "Anthroponymie," 373.

80. Villani, "Contributo," 253.

81. Jacob, "Anthroponymie," 373.

82. Villani, "Contributo," 257; Wilson, *Means*, 87, notes that Christianization of female names in Italy lagged behind those of men and that, except for Maria, saints' names were uncommon.

83. Wilson, *Means*, 117–18.

84. Martin, "Devenir," 87.

85. De Felice, *Cognomi*, 192.

86. Bertaux, *Art*, 149; identified as Morciano di Leuca at the southern tip of the Salento by Falla Castelfranchi, *Pittura monumentale*, 222; cf. Safran, "Betwixt or Beyond," 119–20.

87. De Felice, *Cognomi*, 229–32.

88. Rohlfs, *Dizionario storico*, xi; De Felice, *Cognomi*, 231–33; Wilson, *Means*, 129–30.

89. De Felice, *Cognomi*, 110–13, 233; Rohlfs, *Dizionario storico*, 94. Giorgio, De Giorgi, Di Giorgio, common in all parts of the Salento, derive from Greek *georgos*, "peasant" or "farmer"; see Kazhdan, "Peasantry," 71.

90. Rohlfs, *Dizionario storico*, 113; De Felice, *Cognomi*, 33, 110–11. "Greco" is supplemented by the toponymic surnames "Romano" in Brindisi and "Albano" in Taranto, home to many Albanian colonies since the fifteenth century.

91. De Felice, *Cognomi*, 110–12. Rohlfs, *Dizionario storico*, 131, found the surname Longo in all three modern Salentine provinces.

92. De Felice, *Cognomi*, 111; Leo, Di Leo, Leone are surnames found throughout the Salento (Rohlfs, *Dizionario storico*, 124–25).

93. De Felice, *Cognomi*, 111.

94. Jacob, "Anthroponymie," 370.

95. This trend increased in the fourteenth century, so that by the end of his study 83 percent of laymen had some type of surname (including indirect identification via paternal surname), 70 percent of clergy, but only 38 percent of women; see Martin, "Devenir," 85.

96. For these hortatory texts, see Safran, "Cultures textuelles," esp. 256–57.

97. The depiction and naming of the daughters at Vaste is exceptional in the region, but it accords with attitudes already developing elsewhere in Europe that adolescent children were individuals with a distinct social status. See Marcus, *Rituals*, 102–28; and below, Chapter 4.

98. "Husband and wife" are noted in Falla Castelfranchi, "Del ruolo," 207 n. 93. See also Safran, "Scoperte salentine," 92. The image is reversed in Falla Castelfranchi, *Pittura monumentale*, fig. 182.

99. The problematic identification is made by Calò Mariani, "Echi," 238.

100. Also at Carpignano [**32.K**], the painted inscription alongside Saint Blasios highlights in red both the first letter of the saint's name and the letter *B* immediately above it, which might begin the supplicant's name.

101. E.g., Via Giudecca at Scorrano, still extant in the eighteenth century (see Colafemmina, *Ebrei e cristiani*, 195); the Vico degli Ebrei (Vico Vecchio) at Casalnuovo, now Manduria (Belli d'Elia, "Cultura artistica," 207); the "ruga Lame Iudaice" in Brindisi, attested in 1320 (Alaggio, *Brindisi*, 256).

102. *Giudecche* (Jewish neighborhoods; sing. *giudecca*) located at the edges of towns usually indicate a post-fifteenth-century date (Colafemmina, *Ebrei e cristiani*, 198); the term referred originally to the community of Jews, not to their place of residence (Martin, *Pouille*, 498). There are some exceptions, such as a reference in 1086 to the *giudecca* of Bari, when Sikelgaita, wife of Robert Guiscard, gave the Jewish community and all its inhabitants to the archbishop of Bari; see *Codice Diplomatico Barese* I, no. 30, 56–57, cited in Martin, *Pouille*, 613; Colafemmina, "Cultura nelle giudecche," 102. See also Falkenhausen, "Ebraismo," 40; Colafemmina, *Ebrei e cristiani*, 195 (Scorrano), 198 (Alessano); for a reference to Jews "in vico separato a chisticolis," see Ferorelli, *Ebrei*, 56, citing the Angevin registers.

103. Pellegrini, *Toponomastica*, 57, 59; Alessio, "Sul nome di Òtranto."

104. Rohlfs, *Toponomastica*, 3–12.

105. Pellegrini, *Toponomastica*, 311–12, 405; Rohlfs, *Toponomastica*, 18–21; Susini, *Fonti*, 203–6.

106. Colella, *Toponomastica*, 443. An interesting overview of southern Salentine micro-toponyms of postmedieval date, many of which are phytonyms, is in Palumbo and Marra, "Presicce," 190–94, 199–200.

107. Now Specchia, in the province of Lecce. The manuscript is Vienna, Österreichische Nationalbibliothek, Cod. Hebr. 30; the colophon reads "The work was completed on Monday, 9th of the month of Kislev, 5176 [November 11, 1415] by David son of Elijah Nezer Zahav in his right hand, I copied it for myself, here in Specchia de la Mendolea. May God help me to understand properly all the details of this book." Steimann and Sternthal, "Dawid Nezer Zahav"; http://cja.huji.ac.il/manuscripts/ONB-Cod-Hebr-30/Hebr30_gen_final.html.

108. Arthur, "Casale medioevale," 172.

109. Pellegrini, *Toponomastica*, 285.

110. Jacob, "Mention d'Ugento"; Arthur, "Economic Expansion," 402, implies such an origin for the name Racale, which local historians derive instead from "Heracles."

111. So called in 1447; see Da Molin, *Popolazione*, 75.

112. Martin, *Pouille*, 270–71.

113. Paul Arthur, personal communication, July 31, 2001.

114. See Vetere, "Civitas," 127–28. The oldest document that refers to *pictagia* in Lecce dates to 1335; further subdivisions are elsewhere called parishes.

115. See Pellegrino, *Terra d'Otranto*, 293, 301, 305, 310–11, 323, 331, 333, 343.

116. Tentative list of hagiotoponyms of medieval *casalia* culled from C. De Giorgi, *Provincia*; Poso, *Salento*; Visceglia, *Territorio*; Cassandro, "Inventario," 50; Mancarella, *Salento*, 81–83; and information kindly provided by Paul Arthur. Despite its tempting prefix, Sanarica does not appear to be a hagiotoponym; it may derive from the name of an early Latin landholder, Asinarius (Rohlfs, *Toponomastica*, 5). In Vendola, *Rationes*, 110, no. 1516, Sanarica is rendered as "Senaria."

117. Villani, "Contributo," 263.

118. Imbrighi, "Santi," 26. Lucy, twelfth in popularity, is the only female saint on the list. According to Villani, "Contributo," 265, Nicholas is not even among the sixteen most common pan-Italian hagiotoponyms.

119. For Martin's cult in the Salento, see now Jacob, "Culte de Saint Martin." Churches dedicated to Martin are quite common in the region, and neighborhoods around those churches often took his name, but this is not the same as a whole-village toponym.

120. Poso, *Salento*, 78 n. 139.

121. Ibid., 77 n. 138.

122. Martin, *Pouille*, 129; D'Angela, "Origini," 30–37; Lavermicocca, "Memorie."

123. Imbrighi, "Santi," 26.

124. D'Angela, "Vestigia." This cult may have been familiar from the odes of the Three Hebrew Children that were included in the Byzantine Psalter.

125. Holweck, *Biographical*.

126. De Simone, "Dana."

127. Del Re, "Potito"; Cioffari, Tripputi, and Scippa, *Agiografia*, 222–23. For a newly identified image of Saint Potitus, see Safran, "Scoperte salentine," 83.

128. Villani, "Contributo," 257.

129. Based on data from France and Italy, Wilson, *Means,* 102, concludes that "local cults and church dedications rarely had much impact on naming."

130. Something like 12 percent of place names in all of modern Apulia are hagiotoponyms. Apulia is one of the provinces with a minor diffusion of hagiotoponyms; Basilicata has even fewer, while Campania and Sicily have many more. Imbrighi, "Santi," 43.

131. Kaplan, *Sefer Yetzirah*.

132. The divine names are derived from Exodus 3:14 and 14:19–21. See now Izmirlieva, *All the Names.*

133. Ibid.; Dan, "Beginnings," 283, 289; Bonfil, "Cultura ebraica,"150; Gruenwald, *Apocalyptic*, 104–9, 145, 174–78; Scholem, *Jewish Gnosticism,* 80–81.

134. Elior, "Merkabah"; Lesses, *Ritual Practices.* Jews believed that Jesus had used sorcery to gain access to the divine name.

135. Bonfil, *History and Folklore*, 164, 236; Harari, "Scroll," 190.

136. Bonfil, *History and Folklore,* 160, 282–84.

137. Ibid., 266.

138. Izmirlieva, *All the Names,* 17–24.

139. Jacob, "Esorcismo," 24, 30, 33. See Chapter 7.

140. See, e.g., Stewart, *Demons*, 214–15.

141. The arch-heretics named in the scene are menaced by a fiery angel, not a demon.

142. Alexandre-Bidon and Lett, *Children*, 27–29.

143. Isaacs, *Divination*, 118; Trachtenberg, *Jewish Magic*, 204–6.

144. Falkenhausen, "Gruppi etnici," 138. A Raimardo, certainly a Western-sounding name, signed a donation charter in 1026 in Greek, as did a count Madelfrit in 1049 (Corsi, "Testimonianze," 94). The eleventh-century Roman-rite archbishop of Bari was named Byzantius, but is recorded as being "terrible and without fear against all Greeks" (Falkenhausen, *Dominazione*, 174). Cf. Angelov, "Prosopography," esp. 117–18.

145. See above, n. 31.

146. Colafemmina, *Ebrei e cristiani*, 197.

147. For examples in modern Greece, see Stewart, *Demons*, 57–58.

Chapter 2. Languages

1. For further discussion of this taxonomy, see Safran, "Cultures textuelles"; or Safran, "Public Textual Cultures." In several cases a text is so fragmentary that, in the absence of supporting images, it is impossible to be sure about its categorization [**27.B, 78.E** (probably funerary)**, 97.B, 140.A, 154.B**].

2. Nine towns compose the so-called *isola greca*, or Grecìa salentina, covering about one hundred square kilometers south of Lecce. See Nucita and Bolognini, *Guida*; http://www.greciasalentina.org; and http://www.enosi-griko.org.

3. See especially Colafemmina, *Ebrei e cristiani*, 169–205; Colafemmina, *Documenti*; Manchia and Serini, "Comunità."

4. E.g., Cuomo, "Antichissime," 222, attributing the division to the Byzantine-Lombard (or Greco-Gothic) quarrel. On the so-called "Limitone dei Greci," an earthwork barrier long considered a visible mark of this division, see Stranieri, "*Limes* bizantino." Martin is surely correct in stating that north of Taranto and Brindisi, important Greek minorities cohabited with the Latin-Lombard majority (*Pouille*, 518).

5. Safran, "Language Choice."

6. At Trani, where four synagogues were transformed into churches beginning in the thirteenth century (Belli d'Elia, "Cultura artistica," 208–12), the sole surviving inscription is now in a church sacristy [**147**]. In the same town, Jewish epitaphs have been reused around the doorway of Palazzo Broquier-D'Amely (Colafemmina and Gramegna, *Sinagoga Museo,* 178–79) and in a suburban garden gate (Colafemmina, "Di alcune iscrizioni ebraiche"). At Lecce, the synagogue inscription was deliberately reused in a palace latrine [**56**], while at Bari an inscription [**9**] remained in its original location but was forgotten when the synagogue became a private house.

7. Carrino, "Mosaico pavimentale della cattedrale di Brindisi"; Romanello, "Affermazione," 14. Later, the impact of French is seen in some of the didactic labels on the Last Judgment at Soleto [**113.B**]; see Romanello, "Affermazione," 35.

8. Fontana, "Byzantine Mediation"; Fontana, "Riferimenti."

9. Corsi, "Testimonianze," 97; Martin, *Pouille*, 519.

10. Fanciullo, "Latino," 430–32; Coluccia, "Puglia," 685.

11. Wolfson, "Theosophy," 297; Gruenwald, *Apocalyptic*, 11.

12. Dan, *Jewish Mysticism*, lix.

13. Gruenwald, *Apocalyptic*, 70–71.

14. Leviticus Rabbah 9.9. In addition to keeping their names and language, the Jews merited freedom for having avoided slander and maintained chastity.

15. De Lange, "Hebraism," 131–35.

16. Zidkiyahu Anav, *Shibolei ha-Leqet*, ed. Buber, sect. 282, insists that prayers addressed to the angelic "ushers of mercy" do not violate the injunction against comparing God to something created. Malkiel, "Between Worldliness," 176.

17. Zidkiyahu Anav, *Shibolei ha-Leqet*, ed. Buber, sect. 78; Freudenthal, "Arav," 143.

18. *Shibolei ha-Leqet* was compiled ca. 1260. The first part is a compendium of practical Jewish laws and customs (*minhagim*) that relies on older as well as contemporary sources, including the opinions of other rabbis in Italy (especially the author's brother, Benjamin, and the deceased Isaiah of Trani the Elder) and Germany (Avigdor Katz, Meir of Rothenburg). Editions are listed under Zidkiyahu Anav among the primary sources in Works Cited. The second part of the work consists of technical legal decisions and responsa (ed. Hasida). For the author's background, see esp. *Shibolei ha-Leqet*, ed. Mirsky, sect. 58.

19. Colafemmina, "Di una iscrizione greca-ebraica," 132.

20. Colafemmina, "Ebrei a Taranto," 115–24; Falkenhausen, "Taranto," 152.

21. Colafemmina, "Ebrei a Taranto," 125–26; Colafemmina, "Insediamenti," 220. The last epitaphs in the Venosa catacombs are also exclusively in Hebrew; see Noy, *Jewish Inscriptions*, 156.

22. Zimmels, "Scholars," 177; Zimmels, "Science," 297–301; Dan, "Beginnings," 286. There was no tradition of using Hebrew for theology, philosophy, or science before Shabbetai Donnolo began writing in the tenth century, nearly two hundred years before a Hebrew literature would be created in Spain, Provence, or the Rhineland; see Dan, "Cultura ebraica," 345.

23. Rabbenu Tam (Jacob b. Meir), a grandson of Rashi and one of the Tosafists, gave this paraphrase of Isaiah 2:3 in his *Sefer ha-Yashar*, no. 620 (ed. Vienna, 1811), 74a. Twersky, "Contribution," 388, accepts it at face value, while Bonfil, "Cultura ebraica," 123, is more skeptical. Geula, "Midrašim," points out that the aphorism is attributed by Rabbenu Tam to the people of Bari themselves, and while this makes the statement somewhat ironic it does not diminish it as evidence for the dissemination of Apulian Jewish scholarship.

24. Colafemmina, "Archeologia," 204.

25. Colafemmina, "Ebrei a Taranto," 127. At Venosa, hundreds of Hebrew tombstones were used to build the walls of a thirteenth-century church.

26. Farther north, the series of stones in Bari also ends by the tenth century, although there are later epitaphs from Trani [**149, 150**], including several from later in the fifteenth century.

27. Colafemmina, "Di alcune iscrizioni giudaiche," 235.

28. Ibid., 238–39.

29. *Corpus Inscriptionum Hebraicarum*, ed. Khvol'son, nos. 71, 83, cols. 163–64.

30. Colafemmina, "Hebrew Inscriptions," 78.

31. Noy, *Jewish Inscriptions*, no. 125.

32. For the connection with *piyyutim*, see Colafemmina, "Iscrizione brindisina di Baruch"; also his "Ebrei a Taranto," 125; "Insediamenti," 220; and "Hebrew Inscriptions," 78.

33. Colafemmina, "Note su di una iscrizione," 643.

34. This occurs in elite Latin texts also [e.g., **21.A**].

35. Colafemmina, "Note su di una iscrizione," 648–49. Cf. comparable dittographies in Greek in [**94.A, 112, 156.A**].

36. Noy, *Jewish Inscriptions*, no. 124.

37. Ibid., 159.

38. Colafemmina, "Due nuove iscrizioni," 392–95.

39. Colafemmina, "Iscrizione sinagogale," 180–81; Safran, "Public Textual Cultures," 120.

40. Jacob, "Nouvelle Amen," 187–91. For an Apulian manuscript colophon of 1455 that uses a Hebrew *gematria*, see Colafemmina, "Ebrei, la Puglia," 311.

41. Colafemmina, "Note su di una iscrizione," 649.

42. Noy, *Jewish Inscriptions*, 160.

43. Parma, Bib. Pal. 3173 (ex-De Rossi 138). The marginal glosses include what must be local pronunciations and translations for 154 Mishnaic terms, concentrated mainly in tractate *Kila'im* (incompatible mixtures) and the first part of *Zera'im* (seeds). See Cuomo, "Antichissime"; Cuomo, "Sintagmi"; Romanello, "Affermazione," 11–14, 27–28. For the manuscript and its context in Hebrew book production in southern Italy, see Richler and Beit-Arié, *Hebrew Manuscripts in the Biblioteca Palatina*, no. 3173; Mancuso, "Manuscript Production"; and Perani and Grazi, "Scuola." Interestingly, the Parma Mishnah is half vocalized, which is rare; perhaps these copyists had particular reasons for wanting a copy of the Mishnah with a pronunciation guide.

44. Treves, "Termini."

45. Cuomo, "Antichissime," 229, 259.

46. Bonfil, "Cultura ebraica," 133–34.

47. De Lange, "Hebraism," 131–35.

48. Jews were distinguished by their competency in local languages. In the 1280s, the well-traveled mystic Abraham Abulafia—who almost certainly passed through the Salento on his way from Greece to Capua—noted that "the Jews who live among the Ishmaelites speak, like them, the Arab language, and those who live in Greek lands speak Greek, and those who live in the lands of Italy speak the Italian vernaculars (*lo'azot*, Jewish versions of a foreign language) and the Jews of Germany German, and the Jews of Turkey Turkish, and so on. But a rather strange thing occurs among the Jews of the whole of Sicily, who do not speak only the vernacular (*la'az*) or Greek, like the population who lives in those zones, but they preserve the use of Arabic language which they had learned in the past, when the Ishmaelites lived there." In *Sefer 'osar 'eden ganuz* (Oxford, Bodleian Library, MS Bodley 1580), cited in Falkenhausen, "Babele di lingue," 33–34; translated in Minervini, "Contributo," 127–28. Unless he was engaged in Mediterranean trade or had dealings with the Muslim community at Lucera in northern Apulia, a Salentine Jew would not know Arabic.

49. Bonfil, *History and Folklore*, 256, sect. 9.

50. Paris gr. 1255, fol. 15v, cited in Patlagean, "Dispute," 22. The manuscript is unpublished, but an edition and commentary is in preparation: Lars Hoffmann, "Nikolaos/Nektarios." For a summary see Hoeck and Loenertz, *Nikolaos-Nektarios*, 82–88; and Külzer, *Disputationes*, 192–95.

51. Hoeck and Loenertz, *Nikolaos-Nektarios*, 86–87.

52. There are more Latin epitaphs in Jurlaro, "Epigrafi," than I have included in my study, as well as numerous postmedieval inscriptions. For the province of Lecce, see Peluso, "Iscrizioni."

53. Ware, "Medieval Chronology," 266.

54. Favreau, "Commanditaires," 697.

55. Professions are discussed in Chapter 4.

56. Caprara, Crescenzi, and Scalzo, *Iconografia*, 105–6, identifies Bertini as a Tuscan, probably Florentine, but Bertini is still the third most common surname in Pisa and fourteenth in Livorno; see De Felice, *Cognomi*, 87–88.

57. Berger and Jacob, "Nouveau monument," 235.

58. Prandi, "Pitture inedite," 253, 258, 291 n. 31.

59. Tortorelli, "Aree," 133; Leone de Castris, "La pittura," 396; Leone de Castris, *Arte di corte*, 105–6; Prandi, "Pitture inedite."

60. Prandi, "Pitture inedite," 259.

61. Abantangelo, *Chiese-cripte,* 171.

62. Cited in Fanciullo, "Latino," 477. For Salentine literary production in Greek, see Gigante, *Poeti*; Canart, "Aspetti"; Cavallo, "Cultura italo-greca"; Cavallo, "Libri greci"; Jacob, "Culture grecque"; Jacob, "Épigraphie."

63. On the use of "house" for a church, see Jacob, "Vaste," 248–49. I include proper accents and breathings in this discussion even if they are missing or incorrect in the original; cf. the diplomatic transcriptions in the Database.

64. On the accumulation of dating indicators, see Jacob, "Arménien," 370–71. See Chapter 7 for discussion of the months in which churches were built and painted or supplications executed.

65. At Santa Lucia in Palagianello [**94.A**], the invocation may be to an archangel, but other readings are possible.

66. Jacob, "Vaste," 248.

67. Djurić and Tsitouridou, *Namentragende*; Kalopissi-Verti, *Dedicatory Inscriptions*; Philippidis-Braat, "Inscriptions"; Bernardini, "Donateurs."

68. Jacob, "Épidémies," 103–8; Jacob, "Annales d'une famille," 42.

69. Jacob, "Deux épitaphes," 169.

70. Ibid., 169–70.

71. Jacob, "Épidémies," 103–5.

72. Multiplication of dating elements is also seen occasionally on Cyprus; see Stylianou and Stylianou, "Donors," 98, 101.

73. Jacob, "Épidémies," 103, gives examples of undeclined names in liturgical commemorations.

74. Other didactic labels at Soleto are in *Romanzo* or derived from French; see Romanello, "Affermazione," 35–36.

75. Jacob, "Fondation d'hôpital," 688.

76. From the Latin *offerre* (*ob* + *fero*); see Jacob, "Vaste," 259.

77. Jacob, "Chandelier," 194.

78. Jacob, "Cadran solaire."

79. The following observations were investigated in Safran, "Language Choice," which includes a more complete catalog of each type of language mixing.

80. See Romaine, *Language*, 55–63.

81. Haarmann, *Language*, 228; Romaine, *Language*, 57.

82. M. Berger, "Peintures de l'abside," 135.

83. Andrew at Palagianello [**89**], Michael at Li Monaci [**43**]; the dedication of the Cripta delle Nicchie at Grottaglie is uncertain, but might have been to Michael [**53**].

84. See Safran, "Art of Veneration."

85. Safran, *San Pietro*, 127 and figs. 33–35.

86. The Roman liturgy offers no comparable connection: John 1 is read on Christmas Day, but Jonah is absent from the annual cycle of readings.

87. Cosmas, Ode 6, in a rhyming nineteenth-century translation (Neale, *Hymns*, 141): "As Jonah, issuing from his three days' tomb, / At length was cast, uninjured, on the earth; / So, from the Virgin's unpolluted womb / the Incarnate Word, that dwelt there, had his birth."

88. Oikonomides, "Literacy," 255–56. On Salentine notaries, see Falkenhausen and Amelotti, "Notariato"; D'Oria, "Documento notarile."

89. Cavallo, "Manoscritti," 171. There are many more Greek acts than Latin ones from Taranto; see Falkenhausen, "Inedito documento," 11–12.

90. "If he knows his letters, let him read. If not . . ." (Miller, trans., "*Kasoulon*," 1328).

91. Cordasco, "Alfabetismo," 143.

92. Browning, "Further Reflections," 73–74.

93. Ibid., 80–81, citing Jack Goody, *The Interface Between the Written and the Oral* (Cambridge: Cambridge University Press, 1987), xv.

94. See, e.g., MacMullen, "Epigraphic Habit," and Meyer, "Explaining."

95. Bowman and Woolf, "Literacy," 8.

96. Jacob, "Inscription métrique," 114.

97. It derives from Psalm 114:1, referencing Egyptians as people "of strange language."

98. Judah Romano, *Chiarificazione*, ed. Debenedetti Stow, 2:66. Judah is said to have taught Hebrew to King Robert the Wise of Naples.

99. Ibid., 40 n. 142.

100. Gold, "Glottonym"; cf. Cuomo, "Italchiano." Italkian is the name for the colloquial Jewish Romance dialect attested from the seventeenth century onward.

101. Mayer Modena, "Spoken," 312–14. See the Jewish Language Research Website, http://www.jewish-languages.org/judeo-italian.html. See also Sermoneta, "Considerazioni"; after the prayer book translations, the new Judeo-Italian vernacular came to be used in ever more literate arenas—philosophy, medicine, astronomy, grammar, and exegesis (ibid., 26).

102. The nine communities in which Greek is still (occasionally) spoken are Calimera, Castrignano dei Greci, Corigliano d'Otranto, Martano, Martignano, Melpignano, Soleto, Sternatia, and Zollino. A late sixteenth-century manuscript in Naples (Biblioteca Nazionale, MS Brancacciano I.B.6) contains two slightly differing catalogs of which towns spoke Greek and/or Latin at that time; see Coco, *Vestigi,* 23–25; Corsi, "Comunità bizantine"; Spano, *Grecità,* with maps.

103. Rohlfs, Latinità, 20; Rohlfs, "Linguaggio greco," 31; Rohlfs, *Calabria e Salento*, 65–70; De Angelis, "Introduzione." Modern Greeks call the language Κατωϊταλιώτικα, southern Italian.

104. The ancient origin of southern Italian Greek was forcefully argued by Rohlfs on lexical and grammatical grounds. An early statement of his position in "Autochthone" was reiterated in *Etymologisches Wörterbuch*, *Scavi linguistici*, *Grammatica storica*, and other works. Arguing just as strongly for a new infusion of medieval Greek were the Italians Orazio Parlangeli and Giovanni Alessio; see, e.g., Parlangeli, *Sui dialetti*; and Alessio, "Nuovo contributo" and "Grecità e Romanità." Jean-Marie Martin affirmed that this new infusion of Greek was a result of immigration from Sicily and Calabria; see Martin, "Origine calabraise"; Martin, "Hellénisme"; Martin and Noyé, "Campagnes," 564–65. For a good review and bibliography, see Fanciullo, "Latino."

105. Admittedly, the uses of *griko* cited in Trinchera, *Syllabus*, are drawn from Calabria. See "*Grêkos [gríkos]*" in Kahane and Kahane, "Greek in Southern Italy," 413.

106. See Clark, "On the Brink."

107. Lelli, "Influenza," 201–5.

108. Ibid., 205.

109. On the regional infrequency of the designation "barbarian," see Peters-Custot, "Barbare," esp. 154.

110. Fanciullo, "Latino," 443. Compare the white South Africans' pejorative term for some South Africans, "Hottentots," from the Dutch verbs "to stammer" (*hateren*) and "to stutter" (*tateren*); see Smith, *Relating*, 238.

111. One example among many: "Nel reportage il Salento viene circoscritto alla parte più estrema del tacco italico, circoscritto a quella parte di territorio che va da Lecce a Santa Maria di Leuca da Otranto a Gallipoli o meglio come noi 'ppoppiti' lo definiamo a 'lu capu' dove tutto è diverso, dove tutto scorre e si muove con una cadenza difficile da descrivere e da paragonare a qualsiasi altro posto, dove luci e ombre non hanno uguali, dove tutto è: 'salentitudine'" (http://www.sancassianodilecce.it/spip/spip.php?article41).

112. Lombardi Satriani, *Santi,* 217.

113. E.g., http://it.wikipedia.org/wiki/Salamelecchi.

114. Di Segni, "Cultura folklorica," 20.

Chapter 3. Appearance

1. While this statement is often attributed to Mark Twain, the same sentiment was expressed much earlier by Quintilian, *Insitutio oratoria* 11.3.137: "There is no particular dress for an orator, but in the orator's case it attracts more attention. Accordingly it should be—as is proper in the case of all well-bred persons—resplendent and manly, for when it comes to one's toga and shoes and hair, excessive care as well as negligence are equally blamable." See, e.g., Gunderson, *Staging*, 71.

2. Roach-Higgins and Eicher, "Dress," 5.

3. See the excellent short overview by Eicher, "Introduction." McCracken, *Culture*, makes a persuasive argument against the prevalent metaphor of clothing as a language.

4. Most scholars employ the term "donor" (*committente*) uncritically when referring to standing or kneeling human figures engaged in a devotional relationship with representations of saintly or divine figures, regardless of whether they have an accompanying text that secures their identification as donors. I interrogate this term in Chapter 6 and have also done so in Safran, "Deconstructing 'Donors'"; see also L. R. Jones, "*Visio Divina.*"

5. Parani, *Reconstructing.* Kalamara's work on the Byzantine *système vestimentaire* addresses developments up to the eleventh century, earlier than most of the Salento monuments, but I agree with her contention that real people contemporary with the artist are likely to be represented realistically because the artist has immediate experience with their clothing, whereas biblical figures, angels, and personifications are not often shown in contemporary garb. Kalamara, *Système*, 1:22, 244–52.

6. Arthur, "Masseria Quattro Macine," 219.

7. Anderson, "Popolazione," 50. When compared with some data from medieval Greece, however, the Salentine specimens, at least the males, are relatively tall: skeletons from an urban cemetery in Boeotia (Thebes) averaged 166 cm, while a suburban sample in Attica (Spata) averaged 161.8 cm. See Tritsaroli and Gini-Tsophopoulou, "Who, Where."

8. Anderson, "Popolazione," 50.

9. Arthur, "Masseria Quattro Macine," 220.

10. Arthur, "Casale medioevale," 170.

11. D'Angela, "Saggio di scavo," 145.

12. Hahn, "Difference."

13. E.g., a slave freed in 1103; a Slavic father and daughter sold in 1121; and thousands of Muslim slaves sold in 1300 when Charles II of Anjou destroyed the Muslim colony at Lucera; see S. Epstein, *Speaking*, 71, 87, 161.

14. Pellegrino, *Terra d'Otranto*, 311.

15. S. Epstein, *Speaking*, 79.

16. Colafemmina, Corsi, and Dibenedetto, eds., *Presenza ebraica*, 58.

17. S. Epstein, *Speaking*, 108.

18. Ibid., 105.

19. Ibid., 110.

20. Bereishit (Genesis) Rabbah 12.

21. Ladiana, "Culla," 361; Boustan, "Rabbi Ishmael's."

22. See, e.g., D'Angela, "Documentazione," 168; Cedro, "Abbigliamento," 41, 43.

23. Ditchfield, *Culture matérielle*; Koukoules, "Περί τὰ βυζαντινὰ φορέματα," in *Βυζαντινῶν Βίος* 6:267–94.

24. Arthur, "Masseria Quattro Macine," 210.

25. Cartledge, Clark, and Higgins, "Animal Bones," 334. See also Ditchfield, *Culture matérielle*, 341–46; on wool working, 347–55.

26. Ball, *Byzantine Dress*, 88. Textual sources suggest that goatskin was used in Apulia for blankets rather than clothing: Ditchfield, *Culture matérielle*, 346.

27. Arthur, "*Grubenhauser*," 175; Davis, "Some Animal Bones" (unpublished paper kindly shared by Paul Arthur).

28. There is documentary evidence for flax being soaked in a pool near Gallipoli in 1200 and Frederick II in 1219 ratified the tithe on linen collected by the archbishop of Otranto; see Martin, *Pouille*, 354. Flax was exported from Gallipoli in the fourteenth century; see Visceglia *Territorio,* 145. Linen did not dye well and was often left white. On linen, see Ditchfield, *Culture matérielle*, 373–81; Poso, *Salento*, 178–79; Sakellariou, *Southern Italy*, 372–77.

29. Lapadula, "Oggetti," 150; Arthur, Calcagnile, et al., "Sepolture multiple," 299.

30. Ditchfield, *Culture matérielle*, 425–27.

31. Sakellariou, *Southern Italy*, 368, asserts that within Apulia, the Salento was the region that specialized in cotton production. In the second half of the sixteenth century it was being cultivated in, and collected as tax from, Oria, Francavilla, Mesagne, Sogliano, Cutrofiano, and Galatina.

32. See Cedro, "Abbigliamento," 43. Iron slag and a kiln likely used for ironworking were also found there; see Arthur, "*Chôrion* bizantino?" 16–17. The evidence for ironworking in Salentine villages is assembled in Arthur and Piepoli, "Archeologia del metallo."

33. A cat mandible with knife marks, evidence of cat skinning, and what is probably a wolf tooth were found at Quattro Macine. Davis, "Some Animal Bones," places the skinned cat in the Angevin period; Albarella in Arthur, "Masseria Quattro Macine," 223–24, does not date the mandible.

34. On furs, see Ditchfield, *Culture matérielle*, 427–35. Ball, *Byzantine Dress*, 86–88, states that fur was not prized in the Middle Byzantine world, but her sampling is very small and ignores evidence from all of the Byzantine borderlands (including Cyprus and Italy) except Cappadocia and Kastoria.

35. Guillou argued that silk was produced in Apulia ("Italia bizantina," 61–63), and the same is asserted by Sakellariou, *Southern Italy*, 384, 387, for the fifteenth–sixteenth century; but cf. Jacoby, "Silk in Western Byzantium"; Martin, *Pouille*, 419; and Ditchfield, *Culture matérielle*, 382–425.

36. According to Benjamin of Tudela, the twelfth-century Jewish traveler; see M. N. Adler, *Itinerary*, 15; Benjamin, *World*, 110. Alaggio, *Brindisi*, 307–8, suggests that tanning and dyeing were both done in the area of the "Giudaica."

37. Caprara, *Società*, 155.

38. Martin, *Pouille*, 421–22. Between 1090 and 1190 Jewish *tintorie* are attested in documentary sources for Brindisi and Taranto; see Ditchfield, *Culture matérielle*, 357.

39. Sakellariou, *Southern Italy*, 359.

40. Ditchfield, *Culture matérielle*, 357.

41. Cuomo, "Antichissime," 259. For *sabanon*, see Ditchfield, *Culture matérielle*, 133, 170, 378–79; Aprile, "Frammenti," 107.

42. Cuomo, "Antichissime," 238–39, no. 40.

43. Ibid., 239, no. 40a. Cf. Jacoby, "Jews and the Silk," 11, which asserts that Jews could make, weave, buy, and sell *shaʿatnez* and were only proscribed from wearing the composite fabrics.

44. The tendency to mix fibers (different wools, cotton or silk with wool or linen, linen with gold) is underscored by Ditchfield, *Culture matérielle*, 437.

45. Judah Romano, *Chiarificazione*, ed. Debenedetti Stow, 1:239.

46. When a mordant was needed, it was almost always alum (in Europe and Egypt) or gall nut (for fixing black dyes); see Goitein, *Mediterranean*, 405. Gall was produced in the Salento; see Sakellariou, *Southern Italy*, 344, 359.

47. Ginzberg, *Legends*, 2:188.

48. Ibid., 5:393.

49. Munro, "Medieval Scarlet," 39, 54, 55; Benjamin, *World*, 112; Judah Romano, *Chiarificazione*, ed. Debenedetti Stow, 2:21, 201.

50. Munro, "Medieval Scarlet," 39.

51. A desire for deep, rich colors is the first thing that would indicate nuns are hypocritical about their profession, according to the late thirteenth/early fourteenth-century Byzantine ecclesiastic Theoleptos of Philadelpheia; Sinkewicz, *Theoleptos*, 267.

52. Ditchfield, *Culture matérielle*, 363, observes that green garments are common in the Exultet rolls, but he does not consider whether they are more or less common than other colors.

53. M. Berger, "S. Stefano di Soleto," 104. See further below.

54. Manchia and Serini, "Comunità," 158. The Latin name of this fish is *corius julius*; in Italian, *donzella*.

55. Generalizations about color symbolism are difficult to make for any specific region and time, but it has been stated that yellow was a color looked down on between the twelfth and fourteenth centuries, when it was worn in (northern) Italy by insolvent debtors; reddish brown was also a fashion no-no, especially when worn near yellow. See Mérindol, "Signes," 202. However, yellow seems to have been relatively prized in the south. Its combination with red in a single garment is attested not only visually but also in a document of 1065 from Brindisi; see Ditchfield, *Culture matérielle*, 363–64.

56. J. Harris, "Fact," 112: "Careful scrutiny of works of art proves beyond doubt that the medieval artist was usually recording what he saw, and not simply working from a prototype."

57. Zidkiyahu Anav, *Shibolei ha-Leqet*, ed. Mirsky, sect. 284.

58. Alexandre-Bidon, "Du drapeau," 125, refers to spiral bands used for swaddling in Italy, compared with herringbone elsewhere, but in the south I have seen only the latter.

59. Ladiana, "Culla," 372; see also Ditchfield, *Culture matérielle*, 470, on the infant *sabanon.*

60. Judah Romano, *Chiarificazione*, ed. Debenedetti Stow, 1:100; also *nfasamu, infasamo, n(e)fasate.*

61. Ditchfield, *Culture matérielle*, 470.

62. A short-sleeved tunic; Aprile, "Frammenti," 109.

63. Ball, *Byzantine Dress*, 41–42, 88.

64. Hennessy, *Images.*

65. The Byzantine word for breeches or trousers, *brakion*, is common in texts, but the garment is rarely seen in paintings; see Kazhdan, "Peasantry," 60.

66. Milella, "Raffigurazione," 173.

67. Levi Pisetzki, *Storia del costume*, 1:334, 2:197.

68. Ibid., 1:196; Belli d'Elia, "Romanico," 148–49, 185.

69. Levi Pisetzki, *Storia*, 1:153; Gervers, "Medieval," 310.

70. The *gonnella* is usually listed separately in wills, but the older term *tunica* survived in southern Italy until the late fifteenth century; see Levi Pisetzki, *Storia,* 1:196; 2:94. In the first South Italian sumptuary laws, issued by Charles I of Anjou at Naples in 1290, the *tunica* and *cotta* are equated with a surcoat: *syrcotum* ("Syrcotum et sarcotium, Gallis surcot, domesticae vestis species, forte sic dicta quod cotis idest tunicis sper indueretur"); see Del Giudice, *Legge suntuaria*, 174. According to Ditchfield, *Culture matérielle*, 458–59, *cotta* (κοττέλλα) refers to a unisex garment.

71. Ditchfield, *Culture matérielle*, 491.

72. Waugh, "Well-Cut."

73. Parani, *Reconstructing*, 66. A good comparison is the kneeling male in the Hamilton Psalter frontispiece, ca. 1300, with his white-looped item wrapped around his belt (color plate in Evans, ed., *Byzantium: Faith and Power*, no. 77). Although such handkerchiefs seem always to have been worn on the man's right side, it has been moved to the left at Vaste presumably in order to be visible.

74. Kalamara, *Système,* 1:204–5; Papanikola-Bakirtzi, ed., *Everyday Life,* 397; Goitein, *Mediterranean*, 400 n. 104, asserts that the first functional buttonholes appeared in central Germany in the 1230s. See Levi Pisetzki, *Storia*, vol. 1, plates 113, 171.

75. Hicks and Hicks, "Small Objects," 313. Late Byzantine spherical buttons and a mold for making them were found at Mistra; see *City of Mystras,* 156–58.

76. Ditchfield, *Culture matérielle*, 432–33.

77. Their sleeves appear to be slashed at the elbow for mobility, with the white underclothing puffing out, but I could not examine this firsthand because of the height of the panel.

78. Soled stockings were common in the thirteenth century; see Levi Pisetzki, *Storia*, 1:300.

79. Ibid., 2:32–37; Piponnier, "Révolution," 225–42.

80. Levi Pisetzki, *Storia*, 2:42, 44.

81. Ibid., 2:46.

82. Blanc, "Vêtement," 243–53; Piponnier, "Révolution," 226, 230.

83. Piponnier, "Révolution," 234.

84. Cf. Blair, *European Armour*, 48, fig. 16C, a kettle hat and bevor from a manuscript dated 1326–27.

85. Ibid., 45–46; Nicolle, *Arms*, 1:316, no. 796 and 2:803, no. 796; 1:373, no. 978 and 2:836, no. 978 (both early fourteenth century); 1:448, no. 1237 and 2: 908, no. 1378A–B ("clearly for heraldic recognition purposes") (ca. 1320). These examples are from France, England, and Germany. From Italy, a bronze aquamanile in the Bargello of ca. 1340 shows this feature (ibid., 1:494, no. 1361 and 2:903, no. 1361).

86. Di Tocco is dressed very much like the kneeling "cavalieri Minutolo" painted by Roberto d'Oderisio in the Naples Cathedral in the 1340s (http://www.panoramio.com/photo/3046568).

87. Ibid., 1:487, no. 1339 and 2:899, no. 1339B. The manuscript is Paris, Bibliothèque nationale de France, fr. 2631, fol. 205r.

88. Most publications misread the date as 1436.

89. Zidkiyahu Anav, *Shibolei ha-Leqet*, ed. Mirsky, sect. 107. According to Isaiah of Trani, who is cited by the Roman author, if a man is not wearing hose he must not wear the superfluous laces.

90. Judah Romano, *Chiarificazione*, ed. Debenedetti Stow, 1:147–48.

91. Cedro, "Abbigliamento," 43; Bruno and Tinelli, "S. Maria delle Grazie," 699.

92. Hicks and Hicks, "Small Objects," 284.

93. Zidkiyahu Anav, *Shibolei ha-Leqet*, ed. Mirsky, sect. 107.

94. Ditchfield, *Culture matérielle*, 492–93.

95. Safran, "Scoperte salentine," 71–72.

96. Falla Castelfranchi, "Chiesa di Santa Marina a Muro," 204–5; reiterated by Imperiale, Limoncelli, and De Giorgi, "Due chiese bizantine."

97. Either Christ or the Virgin on a decorated throne have local precedents; for another sainted figure shown as enthroned, one has to look to Archbishop Romualdus at the feet of John the Evangelist in the left apse of Bari Cathedral.

98. Levi Pisetzki, *Storia*, vol. 1, plates 113, 171. Parani, *Reconstructing*, 59, cites late medieval buttons from the Balkans and notes that the buttons might be decorative or functional.

99. Damage to the wall surface at just this point appears to emphasize two "lobes" of a crown, but in fact the edge of the coiffure is not identical with that curved line of missing fresco.

100. Ditchfield, *Culture matérielle*, esp. 479–80; Aprile, "Frammenti," 110.

101. Parani, *Reconstructing*, 79.

102. Piltz, *Kamelaukion*; Emmanuel, "Some Notes"; Parani, *Reconstructing,* 25–30, 38–41; Rousseau, "Emblem."

103. The flanking pairs of saints are thought to date to the eleventh century, with retouchings in the thirteenth or fourteenth century. The angular *E*s of the devotional text that accompanies the pair—which is, like so much in this crypt church, drastically overrestored—has similarities only with the Crispulus text farther east on the same wall [**76.A**]. In both cases one *O* has a compressed, almost figure-8 shape.

104. Judah Romano, *Chiarificazione*, ed. Debenedetti Stow, 2:10–11.

105. Ibid., 1.156–57.

106. Belt fittings have been found at Apigliano, Quattro Macine, Gallipoli, Roca, Calimera, Tabelle, Squinzano, Specchia, and elsewhere. See Bruno and Tinelli, "S. Maria delle Grazie," 699–700; Cedro, "Abbigliamento," 40–43; Lapadula, "Accessori"; Lapadula, "Oggetti."

107. Judah Romano, *Chiarificazione*, ed. Debenedetti Stow, 1:239, 258; 2:41, 168, 194. The reason Maimonides was interested in the terms for a small head covering was that one is permitted to transport on the Sabbath only the quantity of peels or skins of nuts or pomegranates, or indigo, *robbia*, or other colors sufficient to dye a small garment like a girl's hairnet.

108. These were distinguished in the earlier notarial sources by type of material. The general local term, at least in earlier centuries, appears to be *pannus*, παννίον, κεφαλοδέσμιον; the winter one was known as *tobalea, mappa, sabanon*, and the summer specimen as *mandile* or μανδύλιον; see Ditchfield, *Culture matérielle,* 473–75, 524; cf. Aprile, "Frammenti," 106. The term used more generally in the Byzantine world was οθόνη; see Emmanuel, "Some Notes," 777.

109. Ditchfield, *Culture matérielle*, 487.

110. Such ring brooches are known from the thirteenth century on; see Lightbown, *Mediaeval European*; in D'Onofrio, ed., *Normanni*, cat. nos. 112–13a are circular brooches with straight pins dated to the second half of the twelfth century.

111. Ditchfield, *Culture matérielle*, 482, citing the Greek term used in an eleventh-century charter from Bari and the late medieval vernacular phrase; cf. Bevere, "Vestimenti," 326.

112. Ditchfield, *Culture matérielle*, 477–78.

113. Ibid., 475–76; Aprile, "Frammenti," 110. The bedtime bonnet is visible on the head of individuals oversleeping, missing church, and consequently among the damned in the Last Judgment scenes at Soleto and Galatina.

114. Ditchfield, *Culture matérielle*, 485.

115. Lightbown, *Mediaeval European*, esp. 66–78.

116. Zidkiyahu Anav, *Shibolei ha-Leqet*, ed. Mirsky, sect. 107.

117. On clerical jewelry, see Lightbown, *Mediaeval European*, 91–95.

118. Kolbaba, *Byzantine Lists*, 53.

119. Marjanović-Vujović, "Finds."

120. Parani, *Reconstructing,* 221, 225

121. Discussed in Marjanović-Vujović, "Finds," 164–65; Parani, *Reconstructing*, 248–49; Baltoyianni, "Christ."

122. E.g., a silver denarius of Sulla, 82 BCE, with Roma in a heavy cruciform earring (http://www.wildwinds.com/coins/sear5/s0287.html); denarius of Brutus, 54 BCE, showing Liberty similarly adorned (http://www.freemanandsear.com/displayproduct.pl?prodid=4084).

123. For the Cypriot version, see Sophocles Sophocleous, "Icon with the Virgin Kykkotissa," in Evans, ed., *Byzantium: Faith and Power*, no. 93; an Italian example is the "Madonna del Pilerio," Cosenza, 1260s (see A. W. Carr, "Byzantines," 355; and Di Dario Guida, *Alla ricerca*). Later images associated with the Cypriot Kykkotissa type include a double-sided Sinai icon with Saint Prokopios (Vassilaki, ed., *Mother of God,* no. 71), ca. 1280, and a Kykkotissa icon from Cyprus, thirteenth–fourteenth century (Evans, ed., *Byzantium: Faith and Power*, no. 91).

124. Bartlett, "Symbolic," 43; Constable, "Introduction," 62–64. Constable's lengthy introduction to Burchard's twelfth-century *Apologia de Barbis* is the most important study of medieval hair and beards.

125. Leach, "Magical Hair"; Hallpike, "Social Hair."

126. The "worldly locks" were cut upon entry into the monastic life—but it was not necessarily more than a symbolic, slight haircut. See, e.g., Jordan, "*Evergetis: Typikon*," chap. 37.

127. De Donno, *Dizionario*, nos. 1485–90; Congedo, "Raccolta," 59.

128. Vatican City, Biblioteca Apostolica Vaticana, MS Pal. gr. 232 is the autograph copy of the 1220s; it gives the title of the work on fol. 131v but the text of *On the Beard* has been lost. The copies are Florence, Biblioteca Medicea Laurenziana, MS Laur. gr. 5, 36, fols. 8r–8v, of the thirteenth century; Paris, Bibliothèque nationale de France, MS Suppl. gr. 1232, fols. 12r–14v, bilingual, copied before 1236 and sent by Nicholas-Nektarios to a notary, Andrew of Brindisi; and Vatican City, Biblioteca Apostolica Vaticana, MS Barb. gr. 297, fols. 5Av–6v, dated June 15, 1236, by its copyist, the priest John of Nardò. There are two fifteenth-century copies: Paris, Bibliothèque nationale de France, MS gr. 1304 (olim Reg. 2972), fols. 11r–12r, and Moscow, State Historical Museum, MS Synod. gr. 240. Paris, Bibliothèque nationale de France, MS Suppl. gr. 109, dates to the early sixteenth century and Moscow, State Historical Museum, MS Synod. gr. 250, to the seventeenth century. See Hoeck and Loenertz, *Nikolaos-Nektarios*, n. 74; Acconcia Longo and Jacob, "Anthologie," 156–57. On Nicholas-Nektarios, see Hoeck and Loenertz, *Nikolaos-Nektarios*; on Casole, ibid., 9–21; Kölzer, "Zur Geschichte"; Daquino, *Bizantini*; Miller, trans., "*Kasoulon*."

129. There are no references to beards or hair in the 1174 typikon of Casole (Miller, trans., "*Kasoulon*"). For the Apostolic Constitutions, *Patrologia Graeca* 1:565A–568A.

130. Translation from the Latin copy of the lost Greek original in Constable, "Introduction," 87. Constable was unaware of Nicholas-Nektarios's treatise and his use of this late antique source.

131. Hoeck and Loenertz, *Nikolaos-Nektarios*, 106. The same statement is made in a false patriarchal act included in Vat. gr. 1276, analyzed in Darrouzès, "Faux acte," 233–34.

132. Constable, "Introduction," 72–75, esp. 74 n. 136, citing Latin authors and texts on the resemblance of a tonsure to the crown of thorns.

133. Ibid., 111–12.

134. Ibid., 107, 113.

135. Ibid., 116.

136. Bandy, trans., "*Mamas: Typikon*," chap. 24; Bandy, trans., "*Machairas: Rule*," chap. 133 and n. 25: the same punishment would be meted out for putting on a garment or shoes.

137. In the southern Italian Exultet rolls, all used in the Latin rite, the clergy are unbearded and short-haired, while the temporal authorities and some members of the "*populus*" are bearded and with longer hair.

138. Constable, "Preface," xix, xxii.

139. Eustathius of Thessaloniki, *Capture*, trans. Melville Jones, 119.

140. On such fuzzy terms, see Safran, "'Byzantine' Art."

141. M. De Giorgi, "*Koimesis* bizantina." There is no evidence for which rite or languages were in use in Miggiano at a later date.

142. Constable, "Introduction," 94–95, 99.

143. Ibid., 102.

144. Cited in Magdalino, *Empire,* 385.

145. Darrouzès, "Faux acte," 234–35.

146. Orderic Vitalis, ed. Chibnall 4:188ff.; cited in Waugh, "Well-Cut," 16.

147. Falla Castelfranchi's attempt (*Pittura monumentale*, 137) to identify the bearded figures in this scene as having been inspired by Mongols is, to my mind, misguided; see Chapter 8.

148. Thümmel, "Bilderfeindlichen Schriften," 185, lines 35–37; John Malalas, *Chronicle*, 135. Elpius the Roman copied from Malalas; see Winkelmann, "Über di körperlichen Merkmale," 119; Lowden, *Illuminated*, 51–55, 61, 89. Despite this, the Anglo-Saxon tradition depicted Peter tonsured and minus the beard.

149. Weitzmann, *St. Peter*.

150. Menna, "Iconografia"; C. K. Carr, "Aspects."

151. This increase in manuscript production corresponded with an increased use of paper; see Jacob, "Copiste," 209.

152. Falkenhausen, "San Pietro."

153. By the fourteenth century, the time of most of our paintings with supplicants and the majority of Christological images, there are abundant references in (northern) Italian texts to both *barba longa* and *barba rasa*; Levi Pisetzki, *Storia*, 2:62

154. The paucity of surviving monastic supplicants does not undermine this conclusion when we realize that none of the known copyists of the Περὶ Γενείων treatise was a monk. This was typical—in the list of books loaned by the monastery of San Nicola at Casole, very few were borrowed or copied by monks. Jacob, "Formazione," 224 and n. 1; Foti, *Cultura*, 10.

155. Judah Romano, *Chiarificazione*, ed. Debenedetti Stow, 1:200–201. Just this type of hair is seen on one of the grooms behind Leonardo di Tocco at Santa Maria del Casale [**28.D**].

156. Metzger and Metzger, *Jewish Life*, 148.

157. Lipton, *Images,* 161, n. 27.

158. Also observed by Metzger and Metzger, *Jewish Life*, 147.

159. Zidkiyahu Anav, *Shibolei ha-Leqet,* ed. Mirsky, 264. On Roman-rite Christians' hair during periods of mourning, see Chapter 5.

160. Safran, "Raffigurar(si)," fig. 2.

161. Metzger and Metzger, *Jewish Life*, 143–47. Much earlier, Eusebius recorded the story of the Egyptian ruler Chenefres who died because "he ordered the Jews to wear linen garments and forbade them to wear woolen clothing, so that they might be conspicuous and be punished by him"; see Ginzberg, *Legends*, 5:413.

162. Grayzel, *Church*, 308–9; Revel-Neher, *Image*, 40, 51; Medieval Sourcebook: http://www.fordham.edu/halsall/source/lat4-c68.asp. I translate *qualitate* as "character" or "nature," not "quality."

163. Massaro, "Territorio," esp. 282–314; Schmelzer, "Fifteenth Century."

164. Semeraro, "Fra Roberto Caracciolo," 52: "Et per alguni erruri chi solenu succedere: dicta Maiesta vole et comanda: che omne iudeo masculo o femina de anni sei in suso forastieri

oy citatino de leze masculi debiano portare un segno russo a modo de rota rotundo sul pecto sopra la menna per una pianta per la forma et grandezza e scripta alla corte. Et le femine un segno russo rotundo sopra lo pecto et de la menne per una pianta portandolo avanncti sopra tucti l'altri panni per poterse vedere de omne uno, et essere indicato ca è Iudeo et Iudea, tanto se andasse vestito con un mantello quanto con ioppa, et se andasse a iupparello et a gonnella de femina. Et chi nde fara lo contrario cadera alla pena de unza una per omne volta. Et chi lo accusara ne avera tari uno, et se non havesse da pagare la pena essere frustrato per Leze." I thank Claudia Rosenzweig for assistance with this passage.

165. For example, when Dietrich von Schachten visits Brindisi in 1491, he estimates that a third of the population is Jewish and notes that they wear no distinguishing signs, such that "no one is able to distinguish a Jew from a Christian"; cited in Houben, "Nord e sud," 315.

166. Something recognized as Jewish dress may have existed in northern Europe, for in the ninth century Anskar, the so-called Apostle of the North, had a vision of Jesus "dressed according to Jewish custom" (*Anskar*, 35).

167. See Segal, "Dressing," 12–13.

168. Exod. 13:1, 3:16; Num. 15:37–41; Deut. 6:4–9, 11:18, 22:11; Zeph. 1:8.

169. BT Yevamot 63b, cited in Metzger and Metzger, *Jewish Life*, 146.

170. Goitein, *Mediterranean*, 153.

171. BT Shabbat 129a. Soiled boots were a disgrace; BT Shabbat 114a. Cited in Abrahams, *Jewish*, 311 and 297, respectively.

172. Joseph had given his brothers a set of clothing for weekdays and another set for the Sabbath: Ginzberg, *Legends*, 2:114. See Judah Romano, *Chiarificazione*, ed. Debenedetti Stow, 2:265, on ways to wear a mantle to differentiate Sabbath style from weekday style if one doesn't have a change of clothes.

173. Zidkiyahu Anav, *Shibolei ha-Leqet*, ed. Mirsky, sect. 58.

174. BT Shabbat 114a, cited in Goitein, *Mediterranean*, 395 n. 11.

175. Zidkiyahu Anav, *Shibolei ha-Leqet*, ed. Mirsky, sect. 107.

176. Levi Pisetzki, *Storia*, vol. 1, plates 95, 106.

177. Judah Romano, *Chiarificazione*, ed. Debenedetti Stow, 1:168–69.

178. "Capuciis etiam omnes incoeperunt uti, tam rustici, judaei, pastores." Anon. Leobiense, 1336, cited in Levi Pisetzki, *Storia*, 2:65.

179. Zidkiyahu Anav, *Shibolei ha-Leqet*, ed. Mirsky, sect. 270.

180. "*Tallitot* made like *chaperons* are like the *tallitot* of Hasidei Ashkenaz. It has four corners and when it is removed, one folds it and then wraps oneself in it." Cited in Marcus, *Rituals*, 98.

181. Zidkiyahu Anav, *Shibolei ha-Leqet*, ed. Buber, sect. 27. I discuss head covering during the mourning period in Chapter 5.

182. BT Sanhedrin 74a–b treats the archetypal mitzvah of little consequence: changing one's shoelaces (I thank Alan Corre for this reference). See commentary in Maimonides, *Mishneh Torah*, Hilchot Yesodey haTorah [The Laws (which are) the Foundations of the Torah] 5.3, trans. and notes Eliyahu Touger (New York: Moznaim, 1989), bk. 1, pt. 1, 212. Also BT Ta'an. 22a, in which a Jewish jailor reports that he wears black shoes so that the non-Jews among whom he works will not know he is Jewish.

183. Zidkiyahu Anav, *Shibolei ha-Leqet*, ed. Mirsky, sect. 314.

184. Levi Pisetzki, *Storia*, 2:73.

185. Zidkiyahu Anav, *Shibolei ha-Leqet*, ed. Mirsky, sect. 107.

186. Judah Romano, *Chiarificazione*, ed. Debenedetti Stow, 1:102. The men—both bearded and unbearded—are identified in Latin as (Temple) priests. See Safran, "Raffigurar(si)," 247–48.

187. Lipton, *Images*, 20.

188. Bonfil, *Jewish Life*, 105; Finkelstein, *Jewish Self-Government*, 86–95, 281–315.

189. Toaff, "Vita," 257.

190. Del Giudice, *Legge suntuaria,* 162–69; Musella Guida, "Regno del lusso."

191. Hunt, *Governance,* 26–27.

192. Ibid., 27–28.

193. For dress as a kind of language, with its own syntax and grammar, see Roach and Eicher, "Language," and Hunt's critique, *Governance,* 58–72; cf. McCracken, *Culture.*

Chapter 4. Status

1. See, e.g., Gouldner, "Cosmopolitans," esp. 284; Marsh, "Identity," 19; Magee and Galinsky, "Social Hierarchy"; Kokko and Johnstone, "Social Queuing."

2. Babić, "Status."

3. De Donno, *Dizionario,* nos. 16439, 16441.

4. Bourdieu, *Distinction.*

5. E.g., the reigns of kings named William [**38, 58.B, 86.E–F, 144**], Louis [**48**], or Charles [**1.A**].

6. In 1302, the archbishop of Oria and Brindisi was described as "doctor of theology, logic, and philosophy" in a now-lost inscription that I am unable to confirm; see Jurlaro, "Epigrafi," 269.

7. Starr, *Jews,* no. 75.

8. "Rabbi" was a longtime term of respect and not necessarily a religious title; see, for the period up to the seventh century, S. J. D. Cohen, "Epigraphical Rabbis"; and the remarks in de Lange, "Jewish Sources," 363–64. In Shabbetai Donnolo's introduction to his *Sefer Hakhmoni* (tenth century), he reports that ten rabbis and other wise men and civic leaders were killed during the sack of Oria in 925. Here "rabbi" may have a more narrow meaning of "learned man." This was probably true also for the "Rabbi Samuel" who disputed with Nicholas-Nektarios of Otranto in the 1230s; see Külzer, *Disputationes,* 194.

9. Jurlaro, "Epigrafi," 260.

10. Cf. for Calabria, Burgarella, "Lavoro"; Colafemmina, "I mestieri degli ebrei."

11. On linen, see Arthur, "*Grubenhauser,*" 175; wine, Arthur, "Archeologia," 109; metalwork, Arthur, "Masseria Quattro Macine," 204, 211; Arthur, "*Chôrion* bizantino?" 16; ceramics at Brindisi, Taranto, Ugento, Cutrofiano, and elsewhere, Tagliente, "La ceramica," 32; Arthur, "Archeologia," 108–9.

12. Jacob, "Fondation d'hôpital," 687.

13. Jacob, "Ciborium," 122.

14. Romanello, "Affermazione."

15. At least some of the figures in the Last Judgment at San Cesario di Lecce were labeled, but the scene's poor state of preservation precludes any identifications.

16. Gerstel and Talbot, "Nuns"; Kalopissi-Verti, "Church Foundations." See below on women's head coverings.

17. Martin, *Pouille,* 707, avers that the title *dominus* was applied to every important person.

18. Martin and Noyé, "Les villes," 55; Constantelos, "Clerics."

19. Delogu, "Patroni."

20. Kalopissi-Verti, "Painters."

21. Calò Mariani, "Echi," 238.

22. Jacob, "Inscription métrique," 116.

23. Malachi, "Hebrew," 289.

24. Benjamin, *World,* 110.

25. Lelli, "Influenza," 204, 211.

26. Lillich, "Early Heraldry"; Manarese, "Araldica"; Michael, "Privilege." The role of heraldry in Byzantium was, if not nonexistent, far less extensive. It has been studied by Ousterhout, "Symbole der Macht," and idem, "Byzantium Between East and West." For some heraldic insignia on Salento ceramics see Arthur, "Byzantine and Turkish," 246.

27. Bascapè and del Piazzo, *Insegne*, 443.

28. Felix Fabri, *Wanderings*, 87; Kraack, *Monumentale Zeugnisse*, 343–53.

29. Gelao, *Capitolo*, 35, cites the *stemma* of Matteo della Palma, bishop of Otranto from 1253–82. The beams of Bitonto Cathedral, north of the Salento, bore the Angevin coat of arms. For the terminology, see Boulton, "Insignia," 120 n. 6.

30. Among the noble families represented heraldically at Santa Maria del Casale were the Anjou (princes of Taranto), Di Tocco, Sanseverino, Pandone, Del Balzo, Gattola, and Cossa. I rely here on the discussion at http://www.iagiforum.info/viewtopic.php?f=1&t=4038 by members of the Forum Italiano della Commissione Internazionale permanente per lo Studio degli Ordini Cavallereschi dell'Istituto Araldico Genealogico Italiano e di Famiglie Storiche d'Italia.

31. Fanciful three-dimensional crests become popular in the early fourteenth century; see Boulton, "Insignia," 105.

32. Schottmüller, *Untergang*, 113, 419.

33. Manarese, "Araldica," 935.

34. Kraack, *Monumentale Zeugnisse*.

35. A large number of very detailed shields are inscribed in spaces used for incarceration after the Middle Ages: under the Castello at Lecce and in a tower at Tricase. The authors of these graffiti evidently had ample time to leave their insignia. On the former, see http://www.castellolecce.unile.it.

36. Cf. examples from the Holy Land in Kraack, *Monumentale Zeugnisse*, esp. 124–248, passim.

37. Weber, "Heraldry," 496.

38. U. Cassuto, "Iscrizioni ebraiche a Trani," 173.

39. For example, D'Elia, "Aggiunte."

40. Pace, "Pittura delle origini," 366–71.

41. Houben, "Ordine Teutonico," esp. 147–48, with earlier bibliography

42. Bonfil, *History and Folklore*, 117–18; Trinchera, *Syllabus*, 29–31, 36–38; Starr, *Jews*, 194 no. 137.

43. Examples: "Dio ci scansi da pioggia, vento e monaco fuori dal convento" (God protect us from rain, wind, and monks outside the convent); "Odio di preti, vendetta di monaci e rogna d'ebrei, miserere miei" (priest hatred, monastic vendetta, Jewish itch [or scab], my grief), cited in De Donno, *Dizionario*, 54, 104.

44. The cases of Tophilo's (Theophilos's) and Shephatiah's daughters are related in the *Chronicle of Ahima'az* and discussed by Bonfil, *History and Folklore*, 135–38.

45. Ibid., 295–96.

46. For Byzantine private churches, see Thomas, *Private Religious*; for private foundations of the Roman rite, a starting point is Lemaître, ed., *Prieurs et prieurés*.

47. Pace, "Arte di età," 244.

48. Ortese, "Rilettura." The chapel, ca. 1420, features Old Testament prophets and repeated *stemmata* of the Maremonti family, who in the late medieval Salento were second in power only to the Del Balzo Orsini.

49. Based on the painted heraldry, the chapel's *terminus post quem* is 1415–17. See Ortese, "Committenza Maremonti," 410; Belli d'Elia, "Principi," 276 n. 37.

50. Bruno, ed., "Area cimiteriale," 234.

51. Ibid., 212–13; Fonseca and D'Angela, eds., *Casalrotto*, 65.

52. Bruno, ed., "Area cimiteriale," 213. There are some fourteenth-century exceptions at Taurisano; see Arthur, Gravili, et al., "Chiesa di Santa Maria," 191.

53. Multiple burials are attested at Cutrofiano, Quattro Macine, Apigliano, Merine, Vanze, and Maglie, all in the province of Lecce; see Bruno, ed., "Area cimiteriale," 213; Anderson, "Popolazione," 50; Anderson and Arthur, "Informazione," 62.

54. Anderson and Arthur, "Informazione," 62.

55. Arthur, Gravili, et al., "Chiesa di Santa Maria."

56. Anderson, "Popolazione," 50; Anderson and Arthur, "Informazione," 63; cf. more generally Alexandre-Bidon and Lett, *Children,* 30.

57. Bruno, "Cimiteri e il rito," 35–36.

58. Anderson and Arthur, "Informazione," 63.

59. Safran, "Scoperte salentine," 84.

60. Arthur, Gravili, et al., "Chiesa di Santa Maria," esp. 187–92.

61. Fonseca and D'Angela, eds., *Casalrotto,* 67.

62. Bruno, ed., "Area cimiteriale," 213. An early Christian necropolis at Vaste contains seventeen sarcophagi, the contents of which suggest that these special dead were of high social rank; see D'Andria, Mastronuzzi, and Melissano, "Chiesa," 254–64.

63. Michalsky, "Sponsoren"; Belli d'Elia, "Principi," 269–73.

64. Arthur, "Masseria Quattro Macine"; Anderson, "Popolazione."

65. I know of only one comparison, a tomb in the apse of the Chora *parekklesion* in Constantinople (scholars disagree whether the occupant was Byzantine or Ottoman); see Gerstel, "Chora," 135.

66. Arthur, "Economic Expansion," 392.

67. Bruno, "Chiesa di S. Nicola?" 29.

68. Bruno, "Area cimiteriale," 214. Such holes are more widely attested in Basilicata.

69. Di Gangi and Lebole, "Luoghi," 749.

70. Arthur, "Masseria Quattro Macine," 201.

71. Arthur, "Cimitero."

72. E.g., near Carpignano, a late medieval village tomb contained, among other things, a silver Angevin coin minted in Clarenza (D'Andria, "La documentazione archeologica negli insediamenti," 162); *denari tornesi* of Charles I Anjou, minted in Brindisi, were found in quantity at Apigliano (Degasperi, "Monete," 37–38).

73. Arthur, "Tra Giustiniano," 194; Arthur, "Casale medioevale," 172.

74. Fonseca and D'Angela, eds., *Casalrotto,* 65–66.

75. Bruno, "Cimiteri e il rito," 37.

76. Cedro, "Abbigliamento," 41.

77. D'Angela, "Saggio," 148, 153.

78. Zidkiyahu Anav, *Shibolei ha-Leqet,* ed. Mirsky, sect. 107.

79. Ditchfield, *Culture matérielle,* 495–98; D'Angela, "Orificerie"; D'Angela, *Ori bizantini,* 34–37, 40–45; Caprara, *Società,* 192; Cedro, "Abbigliamento," 43; Baldini Lippolis, "Half-Crescent." Outside the Salento, the hoop with three small spheres has also been found in a late Byzantine context at Mistra; see *City of Mystras,* cat. 24e.

80. This has been suggested for earrings found at Otranto, possibly produced on-site from Constantinopolitan models, as is implied by a now-lost stamp model for four types of earrings discovered elsewhere in Apulia in the nineteenth century; see D'Angela, "Orificerie," 192; D'Angela, "Rinvenimenti."

81. I wonder whether the jewelry was retrieved when the grave was reopened for another burial, or whether it was again made ostentatiously visible to reinforce the impression of family wealth.

82. Lightbown, *Mediaeval European,* 293.

83. S. Epstein, *Speaking,* 110.

84. Hughes, "Earrings," and "Distinguishing Signs."

85. Papanikola-Bakirtzi, ed., *Everyday Life,* 432, 434, 437, 562; Parani, *Reconstructing,* 79–80.

86. "In illa civitate Oltranti, vidi omnes mulieres habentes aures perforatas, et quelibet portat anulos in auribus, alieque unum, alieque duos vel tres secundum quod sunt majores. Et cathenalas argenteas portant similiter ad aures et talis consuetudo servatur per totam illam regionem et per totam Sclavoniam et Albaniam et Romaniam." Jacobus of Verona, ed. Röhricht, 173–74, and ed. Khull, 49. This account finds confirmation in the account of a medieval Irish pilgrim, Symon Semeonis, who in 1323 visited Crete and observed that "the wives of the Jews and of the Greeks at Candia . . . usually wear earrings of which they are proud" (Judeorum vero et Grecorum mulieres ibidem ornatum habent valde singularem . . . cum quibus inaures portant indifferenter et in illis summe gloriantur); see Murphy, "Early Irish Visitor."

87. *Centre komu fila* glosses קמסמין, *quisemin,* referring to the "stick" (κέντρον) that is placed in the ears of infant girls to maintain the earring holes in the same way that thread might be used for the same purpose; see Cuomo, "Antichissime," 250. Immediately after birth and washing and powdering, baby girls in Bari have their ears pierced with a needle containing silk thread to prevent the hole from closing; when healed, the silk is replaced by gold earrings given by her godmother (Interesse, *Puglia,* 101–2).

88. Lucy, "Archaeology of Age," 43; see also Chapter 5.

89. Bruno, "Archeologia medievale," 147; Talbot, "Death."

90. Arthur, "Riflessioni," 51–52.

91. Fonseca and D'Angela, eds., *Casalrotto,* 197.

92. Anderson and Arthur, "Informazioni dai casali," 63.

93. Fonseca and D'Angela, eds., *Casalrotto,* 197. For comparative statistics in early medieval England, see Fleming, "Bones," 35–38.

94. In medieval Ashkenaz, neither Jewish nor Christian tombstones note children's ages at death; see Baumgarten, *Mothers,* 235 n. 76. For the method of dating from the destruction of the Temple, see Chapter 7.

95. Colafemmina, "Iscrizione brindisina di Baruch."

96. Noy, *Jewish Inscriptions,* 323–24.

97. Susini, *Fonti,* 217.

98. Gilleard, "Old Age," 628; Aykroyd et al., "Nasty, Brutish."

99. Gilleard, "Old Age," 638.

100. Ariès, *Enfant.* For a historiography and overview see Hanawalt, "Medievalists"; Papaconstantinou and Talbot, eds., *Becoming Byzantine;* Hennessy, *Images;* Kanarfogel, "Attitudes"; Lucy, "Archaeology of Age," esp. 53–61.

101. Jacob, "Notes."

102. Talbot cites the 50 percent mortality rate but does not include Carpignano in her study ("Death," 286, 291). The small (child's?) arcosolium tomb in **[54.st]** is similarly sheltered by icons of the Virgin and Child and Saints Nicholas and James (wearing a scrip complete with scallop shells), but it lacks a verbal testimonial to the deceased.

103. Hanawalt, "Medievalists," gives a figure of 30 percent to 50 percent for infant mortality.

104. Alexandre-Bidon, "Du drapeau," 133.

105. Prinzing, "Observations," 17; cf. Tritsaroli and Valentin, "Byzantine Burials," 94.

106. Jerahmeel, *Chronicles,* ed. Gaster, 22.

107. Abrahams, *Jewish,* 183.

108. Alexandre-Bidon and Lett, *Children,* 29.

109. Prinzing, "Observations," 24–28, 34.

110. Marcus, *Rituals,* 43, citing a medieval addition to Mishnah Avot 5:21 that mandates learning Scripture at age five, Mishnah at ten, commandments at thirteen, and Talmud at fifteen.

111. Díaz-Andreu and Lucy, "Introduction," 8; Díaz-Andreu, "Gender Identity." *Shibolei ha-Leqet* refers to a third gender category, those with dual sexual characteristics, by the Talmudic designation "androgynous" (these individuals, like everyone else, are required to hear the shofar), but it is not clear whether the term had any currency in thirteenth-century Rome. Zidkiyahu Anav, *Shibolei ha-Leqet*, ed. Buber, 295.

112. See Safran, "Deconstructing Donors," 134–39.

113. Bromberger, "Hair," 388; M. Levine, "Gendered," 100. Chapter 3 addressed the variety of depictions and terms for women's hair coverings.

114. See, e.g., Herzfeld, "Searching"; Broyde, "Hair Covering."

115. Broyde, "Hair Covering," 129 (*Piskei Ri'az* to Ketubot 72).

116. Safran, "Deconstructing 'Donors.'"

117. Ortese, "Committenza Del Balzo Orsini," 2, and "Ciclo della Maddalena," 98.

118. Belli d'Elia, "Principi," 270; Michalsky, "Sponsoren."

119. Ousterhout, "Temporal," 73–74. Similarly, in a chapel at Mistra, the deceased Kyra Kale Kavalessa is shown both in lay garb and as the nun Kallinike. Such double images were appropriate at the end of one's lifetime; A. W. Carr, "Byzantines," 341 n. 15.

120. Arthur, "Tra Giustiniano," 194; Arthur, "Economic Expansion," 400, cites finds at Venice and Athens; Arthur and Auriemma, "Search," posits possible finds as far away as Marseilles.

121. Tagliente, "Ceramica," 32.

122. Sanders, "Three Peloponnesian," 189–99.

123. Color figs. in Ortese, "Sequenza," 365–66.

124. There is even a fragment of Chinese porcelain at Otranto, although most of its imports came from Greece and the Aegean, especially in the ninth through eleventh centuries; see Arthur, "Tra Giustiniano," 198; Patterson, "Contatti."

125. Arthur, "Masseria Quattro Macine," 208; Tagliente, "Ceramica," 35.

126. Arthur, "Tra Giustiniano," 198; Arthur, "Islam," 166; Arthur, "Economic Expansion."

127. Arthur, "Islam," 166–67.

128. Taranto, Museo Nazionale, I.G. 40999; see D'Angela, *Taranto medievale*, 194–96.

129. In addition to the sources already cited in this section, see Travaglini, *Inventario.* Coins in tombs are discussed in Chapter 5.

130. Safran, *San Pietro*, 27. Lapis lazuli, also known as ultramarine, had to be imported from Afghanistan. It has been found in thirteenth- and fourteenth-century ceramics in northern Apulia, perhaps in imitation of Islamic ceramics; see Catalano et al., "Lapis Lazuli."

131. Arthur, "Case, chiese," 43–44.

132. The financial status of different churches can be deduced, at least in relative terms, from the amounts they paid in taxes. The Benedictine monastery-turned-cathedral of Santa Maria at Nardò was assessed in 1310 at forty ounces of gold; in the same year, the Orthodox monastery of Santa Maria di Cerrate near Squinzano paid twenty ounces. On taxes collected from institutions and individuals on behalf of the Holy See, beginning in 1310, see Vendola, *Rationes* and "Decime"; unfortunately, the tax records for the region are woefully incomplete.

133. Anthony Cutler notes that an image's authority can come from its novelty or modernity as well as from its antiquity or presumed period of origin ("Questione bizantina," 335).

134. See Dell'Aquila and Messina, *Chiese.*

135. Mersch and Ritzerfeld, "Lateinisch-griechische," esp. 237.

136. Ibid., 262; Calò Mariani, "Predicazione," 474 and n. 7.

137. Belli d'Elia, "Principi," esp. 284–89.

138. Calò Mariani, "Predicazione," 474.

139. Vasco Rocca, ed., *Mosaici*, 158–60.

140. Jacob, "Consecration"; for the architectural phases, see the somewhat unsatisfactory reconstruction by Spinosa, "S. Maria della Croce."

141. Tortorelli, "Aree," 123–24, pushes the frescoes' date to the end of the thirteenth or beginning of the fourteenth century based on a particular iconographic feature, the belt of Saint Margaret; this contrasts with the date in the 1260s proposed by Leone de Castris in "La pittura," 396; Leone de Castris, *Arte di corte*, 105–6.

142. In addition to the sources in the previous note, see Prandi, "Pitture inedite" and "Elementi," 1372.

143. One of the best examples is the church of the Holy Cross at Pelendri, in Cyprus, painted a century later than Otranto, which in the later fourteenth century reveals at least three different artistic styles, including paintings by a superb Palaiologan artist; see A. W. Carr, "Byzantines," 345.

144. Safran, *San Pietro*, esp. 27, 140–55.

145. On the Corfiote painter, see Hoeck and Loenertz, *Nikolaos-Nektarios,* 180. The connection is made by Falla Castelfranchi in "Sul Bosforo," 306, and "Cultura artistica," 89; cf. Safran, *San Pietro*, 159. Paul of Otranto executed the phiale of the Evergetis Monastery and perhaps one at Hagia Sophia in the late twelfth century; see Magdalino, "Evergetis Fountain."

146. These famous columns were previously thought to be Roman markers of the end of the Via Egnatia.

147. Marella, "Brindisi," 135, 167.

148. Alaggio, *Brindisi*, 137–40, 163–71.

149. Montinaro and Carliano, "Campanilismo," 159.

150. De Donno, *Dizionario*, nos. 148, 15878.

151. Local tradition in Carpignano holds that the population had abandoned a statue of Christ during the Holy Friday procession after beseeching him to stop a rainstorm; see Colafemmina, *Ebrei e cristiani*, 197. The Alessano designation, as far as I can determine, is related to stereotypical Jewish commercial skill.

Chapter 5. The Life Cycle

1. This definition emerges from my reliance on the following stimulating essays: Snoek, "Defining 'Rituals'"; Rao, "Ritual in Society"; Michaels, "Ritual and Meaning"; Laidlaw and Humphrey, "Action"; Grimes, "Performance"; Wulf, "Praxis"; M. Bloch, "Deference"; Muir, *Ritual*; Walsham, "Review Article"; Pössel, "Magic."

2. Blier, "Ritual," 189.

3. On these life-cycle moments as liminal and dangerous *rites de passage*, see Van Gennep, *Rites of Passage*.

4. Cuffel, "From Practice," 401.

5. Green, "Conversing," 111. Green also points out that we must be careful not to exclude men from the activities surrounding childbirth: they might be needed for their medical expertise.

6. Ladiana, "Culla," 357.

7. Ibid., 361; Interesse, *Puglia*, 100.

8. Gen. 30:25–39; Boustan, "Rabbi Ishmael's." See also Doniger and Spinner, "Female Imaginations."

9. Judah Romano, *Chiarificazione*, ed. Debenedetti Stow, 1:214.

10. Baumgarten, *Mothers*, 48; Forbes, "Chalcedony."

11. On the amulet and its potential but unspecified "magical-religious" function, see Arthur and Bruno, eds., *Apigliano*, 23 (Henig, "La gemma di Giove").

12. Forbes, "Chalcedony," 394.

13. Goar, *Euchologion*, 261. The evil eye in contexts not related to the life cycle is discussed in Chapter 7.

14. Baumgarten, *Mothers*, 48.

15. Delatte, *Anecdota*, 619–20; Angusheva-Tihanov and Dimitrova, "Medieval Slavonic."

16. Angusheva-Tihanov and Dimitrova, "Medieval Slavonic." Already in the sixth-century medical writings of Aëtius of Amida, a physician was to invoke Blasios in a conjuration for objects stuck in the throat: "'Come up, bone, whether bone or stalk or whatever else, as Jesus Christ brought back Lazarus from his tomb and Jonah from the whale.' Then take him by the throat and say 'Blasios, martyr and servant of Christ, saith, 'Either come up or go down.'" See Aetius Amidenus, *Libri medicinale* 8.54.18–22; Rolleston, "Laryngology," 528.

17. Hartnup, *On the Beliefs*, 153–54.

18. Geula, "Lost Aggadic," 142.

19. Baumgarten, *Mothers*, 49; Green, "Conversing," 112.

20. Gentilcore, *From Bishop*, 146.

21. Saint Stephen is nursed by his mother at Soleto; see Ortese, "Sequenza," 367.

22. Baumgarten, *Mothers*, 143–44. *Shibolei ha-Leqet* confirms the proscription on expressing milk without mentioning the possible reprieve; see Zidkiyahu Anav, *Shibolei ha-Leqet*, ed. Mirsky, sect. 121.

23. Baumgarten, *Mothers*, 134–44, and "A Separate People?" 217–19.

24. Semeraro, "Fra Roberto Caracciolo," 53.

25. Bourbou and Garvie-Lok, "Breastfeeding," 79.

26. Dal Pino, "Santi protettori," 361–62. In cases where a mother's milk had dried up and nefarious practice was suspected, women in the early modern era were encouraged to make a pilgrimage to seven shrines (the "Sette Madonne") in the Salento dedicated to the Virgin; see R. Orlando, *Taurisano*, 152.

27. Magdalino and Mavroudi, eds., *Occult*, 15–16.

28. Bonfil, *History and Folklore*, 292.

29. Online at http://www.christopherklitou.com/prayers_for_a_woman_in_childbed_euchologion.htm.

30. See Sorlin, "Striges"; Resnick and Kitchell, "Sweepings"; Patera, "Exorcismes." For modern views, see Epifani, *Stregatura*; Stewart, *Demons;* Sabar, "Childbirth"; Schechter, "Child"; Hartnup, *On the Beliefs*, chap. 4.

31. Hartnup, *On the Beliefs*, 157; Stewart, *Demons,* 100.

32. Adelman, "Religious Practice," 205. St. Anne was the most common focus of medieval childbirth prayer, but in the modern era the list expands to include Antony, Vitus, Cosmas and Damian, Lucy, Rocco (Roch), Michael, Joseph, and others; see Ladiana, "Culla," 363.

33. Horowitz, "Eve," 45–48; Karsenty, "Mishmarà."

34. Lelli, "Influenza," esp. 204–6. Salentine Jews emigrated to Corfu in 1541 after being expelled by the Spanish ruler Charles V.

35. Baumgarten, *Mothers,* 49; Bohak, *Ancient Jewish Magic*, 286. Karsenty, "Mishmarà," gives a different explanation about knives protecting against evil forces.

36. Appel, "Myth," 17.

37. "Ferrum et nuces in cunabulis infantium apponere ad striges fugandas" (Corrain and Zampini, *Documenti*, 178); De Martino, *Sud e magia*, 24.

38. Hartnup, *On the Beliefs*, 96.

39. Ibid., 96–103.

40. Miele, *Concili provinciali*, 501; from ten days in the sixteenth century the wait was reduced in the seventeenth century to as few as three days.

41. Baun, "Fate of Babies," 117; Parenti, "Christian Initiation," 34–35, 39–40.

42. Hartnup, *On the Beliefs*, 110–11.

43. Nocent, "Christian Initiation," 63.

44. Bruno, ed,. "Area cimiteriale," 203–5, proposes the infant-font identification.

45. C. De Giorgi, *Provincia*, 2:66, repeated in Lisi, *Fine del rito*, 119–20. Color plate in Cassiano and Vetere, eds., *Dal Giglio all'Orso*, 26. The font seen in [**58.sc.1**] is not as close.

46. Palma, "Antiche registrazioni," 154. Miele, *Concili provinciali*, 502, cites two councils at Bari (1567 and 1628) that still sought to prohibit baptism by immersion, considered dangerous for the infant; thus immersion was still being practiced in that diocese as well.

47. Stewart, *Demons*, 196, cited in Baun, "Fate of Babies," 124, and limited initially to baptism and Greek culture.

48. The Greek text was shared by Lars Hoffmann from his unpublished "Nikolaos/Nektarios."

49. Colafemmina, "Valenza sacrificale," 926: "O Dio, mirabile nei cori, riguarda il sangue del circonciso come il sangue degli olocausti."

50. For naming, see Chapter 1.

51. Baumgarten, *Mothers,* 79.

52. Color image in Massaro, "Economia e società," 158.

53. Zidkiyahu Anav, *Shibolei ha-Leqet*, ed. Mirsky, sect. 242; ed. Buber, sect. 7–9.

54. Newman, "*Sandak*," esp. 5–9, explores the complex etymology.

55. Ibid., 12–13, 27.

56. Bonfil, *History and Folklore,* 292.

57. Baumgarten, *Mothers*, 73.

58. Ibid., 65–77; Hoffman, "Role of Women," 106.

59. Ortese, "Sequenza."

60. Calò Mariani, "Chiesa dal XII," 99, 105.

61. Giannelli, "Documento," 41.

62. Ibid., 43.

63. Strittmatter, "Liturgical Latinisms," 55–60; Parenti, "Christian Initiation," 44. The changed baptismal formula was also written in Italian in Greek letters. For a later period, see Palma, "Antiche registrazioni."

64. Hartnup, *On the Beliefs*, 125.

65. Baumgarten, *Mothers*, 106.

66. Jacobus de Voragine, *Golden Legend*, 1:148–49; Gibson, "Blessing"; Pierce, "Green Women"; Roll, "Churching." For Byzantine prayers for the fortieth day after childbirth, see Arranz, "Les Sacrements"; Goar, *Euchologion*, 267, 307.

67. Angusheva and Dimitrova, "Monks, Women," 470 and n. 5; Parenti, "Christian Initiation," 44–45.

68. Baumgarten, *Mothers*, 107.

69. Miele, *Concili provinciali*, 502, including a council at Taranto in 1595.

70. Jacobus de Voragine, *Golden Legend*, 1:152. Old photographs show the letters A/IVS alongside the head of the elderly saint whom I identify as Blasius; others have suggested Sabinus, depicted elsewhere in the crypt. In the Orthodox calendar Blasius's feast day is February 11 (Pope Leo's, in the next niche, is February 18).

71. Rolleston, "Laryngology," 531. This blessing is regularly given in the modern Salento.

72. Jacobus de Voragine, *Golden Legend*, 2:303–18.

73. Ibid., 281, 283; Safran, "Scoperte salentine," 89; Safran, "Deconstructing 'Donors, 143–48.'"

74. Falla Castelfranchi thoroughly examined the Christian textual and pictorial sources for this scene in "Anche i santi."

75. Formerly in Reggio Emilia and now in the Jewish Theological Seminary, JTS Mic. 8092. Aspects of the initiation ceremony are also preserved in *Sefer Rokeach*, a book in the circle of the Hasidei Ashkenaz, who preserved many South Italian customs.

76. Marcus, *Rituals*; Kanarfogel, *Peering*, 156–57.

77. *Mahzor Vitry* 428, cited in Baumgarten, *Mothers*, 127.

78. Stemberger, *Introduction*, 260; Marcus, *Rituals*, 37.

79. Marcus, *Rituals*, 104.

80. Efthymiadis, "Enseignement," 260.

81. Jacob, "Formazione," esp. 227–31; Jacob, "Bibliothèque médiévale," esp. 303–4; Acconcia Longo and Jacob, "Anthologie"; Mazzotta, "Monaci."

82. Unedited epigram in Paris gr. 2773, cited in Jacob, "Annales du monastère," 131.

83. Jacob, "Bibliothèque médiévale"; Efthymiadis, "Enseignement," 274.

84. Efthymiadis, "Enseignement," 275.

85. Bowman, *Jews,* 123, 213. The four-year-old bride cited here (and in Assaf, "Family," 169 n. 2) was soon abandoned and did not receive her bill of divorce for eight years.

86. Hartnup, *On the Beliefs*, 133–35.

87. Friedman, *Jewish Marriage*, 1:40. The early modern ketubot of Corfu, which had a big infusion of Romaniote Jews from the Salento and maintained many of their customs, were dated from the destruction of the Temple, like Salentine Jewish tombstones, as well as according to the more traditional year since Creation; see Lelli, "Liturgia, lingue."

88. Ankori, *Karaites*, 256; Friedman, *Jewish Marriage*, 1:40, citing Isaiah of Trani's *Sefer ha-Makhria*, 47; Assaf, "Family," 173–75; Bowman, *Jews*, 125. This was not the case for non-Romaniote Jewish women.

89. See the essays by Jean-Marie Martin and others in Bougard, Feller, and Le Jan, eds., *Dots et douaires*; also Martin, "Empreinte." Martin asserts that Byzantine women but not Lombards could alienate their own property (*Pouille*, 536).

90. For a discussion of slightly later public rituals associated with remarriage, see Klapisch-Zuber, "Medieval Italian."

91. Cited in Roth, "Italy," 404 n. 32.

92. Mirsky, "R. Isaiah"; Bowman, *Jews*, 217.

93. Bowman, *Jews,* 212.

94. See, in general, Cohen and Horowitz, "In Search"; Hilton, *Christian Effect*.

95. Cohen and Horowitz, "In Search," 226, 242, 249.

96. Petta, "Ufficiatura," 96–98.

97. Bonfil, *History and Folklore*, 140.

98. "Thus these modest ones [Israel] have made it their custom for all generations / To make matches at the time of engagement, and to enact *qiddushin* by means of a ring / And at the time of their huppah to rejoice with the joyfulness of grooms." L. Lieber, "Poetry of Creation"; Bonfil, *History and Folklore*, 142–43.

99. Weinstein, *Marriage*, 400; Bonfil, *History and Folklore*, 143; Langer, "*Birkat Betulim*"; Sperber, *Jewish Life*, 324. The text is translated by Langer (p. 75) as: "How fitting for the groom on his wedding day exultantly to exhibit the purity of his wife's maidenhood (the blood-stained garment) so that witnesses can sign his *ketubah* and make his joy complete."

100. Colafemmina, "Epitalami di Meiuchas," on wedding poems written in Otranto perhaps in the tenth/eleventh centuries; Bonfil, *History and Folklore*, 139–41, on the *piyyutim* by Amittai for his sister Cassia's wedding.

101. Koukoules, *Βυζαντινῶν Βίος* 4:116–18; De Martino, *Sud e Magia*, 24, describes the wedding night at Grottole. The display of the bloody sheet was practiced in Cyprus until 1950; see Argyrou, *Tradition*, 80–82.

102. Hughes, "From Brideprice."

103. Isaiah of Trani, resp. 47, adapted from Bowman, *Jews*, 122, 211–12; Weinstein, *Marriage*, 338; Assaf, "Family," 169–70.

104. Horowitz, "Towards a Social History," 140.

105. Bonfil, *History and Folklore*, 119, 254; Bohak, *Ancient Jewish Magic*, 293–94; Harari, "Scroll."

106. Schechter, "Notes," 99 and n. 1 (the Hebrew can also be read as אישפנומסא); Bowman, *Jews,* 123, 215.

107. Tertullian, *De corona*, 13.4. http://www.thelatinlibrary.com/tertullian/tertullian.corona.shtml.

108. In the *Chronicle of Ahimaʻaz*, section 35, Amittai is described as writing a special poem to "ornament and crown" his sister's betrothal, but he uses the terms *keter,* crown, and *lehakhlilah*, to crown; see L. Lieber, "Piyyutim le-Hatan"; Bonfil, *History and Folklore*, 299–301. Isaac Abrahams refers to marriage crowns made of myrtle leaves for medieval women (*Jewish*, 211).

109. "Στεφανοῦται ὁ δοῦλος τοῦ Θεοῦ ὅδε εἰς τὸ ὄνομα τοῦ Πατρὸς καὶ τοῦ Υἱοῦ καὶ τοῦ ἁγίου Πνεύματος (ἄλλοι δὲ λέγουσιν Ὁ Πατὴρ στεφανοῖ, ὁ Υἱὸς εὐλογεῖ, τὸ Πνεῦμα τὸ ἅγιον ἁγιάζει." Ottob. gr. 344, fol. 190; online at http://www.ktistes.altervista.org/eucologio.html.

110. Arranz, *Eucologio*, 323–32; Parenti, "Christian Rite," 263.

111. Palma, "Istituzioni"; Palma, "Antiche registrazioni," 147.

112. Maraspini, *Study*, 222; also Cazzato and Costantini, *Grecía salentina,* 297 (*stafanomeni*); there is also a description here of the marital bed being examined by the groom's mother and her closest female friends on the morning after the wedding.

113. Parenti, "Christian Rite," 264; see also Passarelli, "Stato della ricerca," 244.

114. Petta, "Ufficiatura," 101.

115. Laur. gr. 5, 36, fols. 1–3v; Quaranta, "In difesa."

116. Quaranta, "In difesa"; Petta, "Ufficiatura," 97, 101. Two Salentine euchologia use the term *sticharion* instead of the more common *phelonion* (Quaranta, "In difesa," n. 44). For the sword, cf. the Palestinian euchologion Sinai, Holy Monastery of Saint Catherine, MS 973, and Psalm 44:3–4; for the *phelonion*, cf. Isaiah 61:10. Both scriptural texts are cited by Nicholas of Taranto.

117. Cohen and Horowitz, "In Search," 229.

118. Polito, "Del rito," 94.

119. The Worms Mahzor, ca. 1272 (Jerusalem, Jewish National and University Library, fol. 72); Metzger and Metzger, *Jewish Life*, 224–25.

120. BT Ketubot 5a, "a virgin is married on Wednesday." Abrahams, *Jewish*, 212; Horowitz, "Way We Were," 80, with additional bibliography; Sperber, *Jewish Life*, 176–77.

121. Colafemmina, "Epitalamio"; Bonfil, *History and Folklore*, 139–44, relying on Koukoules, *Βυζαντινῶν βίος* 4:98–119; Pertusi, "Sopravvivenze," 33, 37–38, for the same practices in Calabria. English translation of Amittai's epithalamium in *Penguin Book of Hebrew Verse*, trans. Carmi, 235–38.

122. L. Lieber, "Poetry of Creation."

123. Corrain and Zampini, *Documenti*, 182.

124. Marcus, *Jewish Life Cycle*, 151, cites the Maharil in fifteenth-century Mainz; Sperber, *Jewish Life*, 289–91.

125. Iacovelli, "Senso," esp. 309.

126. Bonfil, *Jewish Life*, 273.

127. This was customary from the second century CE after Rabban Gamliel specifically asked to be buried in this way to avoid ostentatious competition (BT Moed Kattan 27b).

128. Arthur, Gravili, et al., "Chiesa di Santa Maria," 192; Arthur and Bruno, eds., *Apigliano*, 37. For the production of linen, see Chapter 3. In the twentieth-century Salento the dead person was washed, dressed in his or her best clothes, and shod in new shoes; see Montinaro, *Canti*, 28. See also Catenacci, "Lamento."

129. Montinaro, *Canti*, 51, 59.

130. For Orthodox funerary practice, including the liturgies for burial and commemoration, see Velkovska, "Funeral Rites in the East"; Velkovska, "Funeral Rites According." The oldest Byzantine funeral ritual comes from southern Italy, although not from the Salento; it refers to the corpse, whether lay or monastic, "lying in the middle of the church." For Roman-rite practices, see Owusu, "Funeral Rites."

131. Megha, *Galatone*, 44–47.

132. For Jewish practice, see N. Rubin, *Life's End*.

133. Del Giudice, *Legge suntuaria*, 171–72. The following quotations come from this text.

134. "Quod nulla domina, sive mulier, audeat ire cum feretro, seu post feretrum, cum corpora defunctorum deferuntur ad Ecclesias, vel sepulturas."

135. *Riputare* is the Salentine verb for "singing the funerary elegies"; Parlangeli, *Sui dialetti*, 16. In the glossary of Maimonidean terms composed in Rome in the fourteenth century, *repeto, lo repeto* also indicates female lament; it is likened to "the brief repeated sound mentioned in the Torah (Jud. 3:27); we do not know if it is like the lament that women make among themselves when they make the lamentation for the dead" (Judah Romano, *Chiarificazione*, ed. Debenedetti Stow, 2:191).

136. "Item, quoniam reputationes, et cantus, et soni, qui propter defunctos celebrantur, muliebriter animos astantium convertunt in luctum, et movent eos quodammodo ad injuriam Creatoris, prohibemus reputantes funeribus adesse, vel aliae (*sic*) mulieres, quae earum utantur ministerio, nec in domibus, seu ecclesiis, vel sepulturis, vel alio quocunque loco."

137. "Quae ars magis ad gaudium, quam ad tristitiam adinvenit: poena unciarum auri quatuor multandis iis."

138. Similar complaints had been made in the toe of the Italian boot centuries earlier; see the homilies of Bishop Luke of Bova (late eleventh–early twelfth century), who blamed funeral excesses on Arab influence (Pertusi, "Sopravvivenze," 32–36).

139. Corrain and Zampini, *Documenti*, 183.

140. Vacca, "Sui primordi," 205.

141. Corrain and Zampini, *Documenti*, 183. At Castellaneta in 1595, pulling out one's own hair to place it on the chest of the deceased was prohibited; at Castro in 1656, cutting one's head (*crinium dilacerationibus*); and at Otranto in 1641 women are admonished "ne mulierum capillos avulsos, et laceros cadavera secum deferant humandos" (ibid.). Bo, *Religione*, 216, citing the Otranto synod, notes that widows and female mourners would not be permitted to hear mass on three consecutive Sundays if found guilty of excessive mourning. On synodal treatment of funerary lament in general, see Cirese, *Pianto*.

142. Alexiou, *Ritual Lament*; Montinaro, *Canti*, 15, 19; and numerous examples in Morosi, *Studi*, who notes that in 1870 the tradition remained alive only in the Greek-speaking

villages of Martano, Sternatia, and Zollino and a few formerly Greek villages, including Galatina (p. 93).

143. Amelang, "Mourning," esp. 21–23.

144. Bonfil, *History and Folklore*, 282–83 (sect. 27) and n. 290; also p. 185 on the need to eulogize the dead.

145. On weeping and eulogizing, see Gen. 23:2; prohibition of injury to self, Lev. 21:5, Deut. 14:1. Jeremiah inveighs against such acts in Jer. 16:6, 41:5. See, in general, A. Bloch, *Biblical and Historical*.

146. Bonfil, *History and Folklore*, sect. 33. Burial on the day of death, unless it occurred on the Sabbath, is mandated in BT Sanhedrin 46a.

147. Bruno and Tinelli, "Testimonianze," 218–20.

148. Arthur, "Cimitero," 53. An eleven-centimeter opening in the lid of tomb XXIV at Quattro Macine seems too big for this purpose; perhaps it anchored something instead, such as the base of a cross [**103**].

149. See "Archeologia urbana a Lecce: Le indagini nell'area della Chiesa Greca," Agenzia per il Patrimonio culturale Euromediterraneao, online at http://www.agenziaeuromed.it/parag.php?id=12&id_pag=13&id\eparag=48.

150. Late medieval infant graves reveal very few objects interred (Arthur, Gravili, et al., "Chiesa di Santa Maria," 192).

151. Arthur, "Cimitero," 53; D'Andria, " La documentazione archeologica negli insediamenti," 162; Bruno, "Cimiteri e il rito," 37; Valchera and Faustini, "Documenti," no. 2148 (*anforetta*). In the early modern era, a fruit was often placed into the hand of the deceased; naturally, there are no archaeological traces of such objects. This was prohibited in 1620; see Lombardi Satriani, "Moneta," 334.

152. D'Angela, "Ricerca archeologica," 227.

153. Arthur, "Ampolle," 382; both mold-made objects were found on the surface, although they may have come from tombs.

154. Vetrugno and Vetrugno, "Scoperte."

155. Snyder and Williams, "Frankish Corinth," 18, cat. no. 11 and plates 6–7. I thank Sharon Gerstel for this reference.

156. De Meo, *Civiltà contadina*, 82; De Martino, *Sud e magia*, 24; Di Segni, "Cultura folklorica," 12. The evil eye is discussed in Chapter 7.

157. Even in the case of a coin's disintegration or disappearance, the presence of copper can be deduced from the green stains on the skeleton's mandible; see Degasperi, "Monete," 39. In 1620, the Otranto archbishop prohibited the placement of a coin in the mouth of a corpse or any object in the hands of the deceased; see Travaini, "Saints," 180n95.

158. Bruno, "Cimiteri e il rito," 36.

159. Arthur, "Cimitero," 51. For Carpignano and Roca, see D'Andria, "Documentazione." A coin in the mouth was also common in the late medieval Balkans and immigration from across the Adriatic is a possible source of the custom; see Arthur, "Albania," 79–81.

160. D'Angela, "Constesti tombali"; Peduto, "Osservazioni."

161. Travaini, "Saints."

162. Ibid., esp. 173, 180; also DiGangi and Lebole, "Luoghi."

163. Arthur, Calcagnile, et al., "Sepolture multiple."

164. The ostracon was a fragment of an amphora. See Arthur, "Masseria Quattro Macine," 202–3; Arthur, Calcagnile, et al., "Sepolture multiple," 297; Jacob, "Apigliano," 138–39.

165. Two maidens (ריבות) were buried together in a (lost) Oria grave not included in my Database; see Colafemmina, "Epigrafi e cimiteri," 92.

166. Bruno, "Cimiteri e il rito," 36; for shifting of still-articulated skeletons, see Arthur, "Masseria Quattro Macine," 45.

167. Bruno, "Cimiteri e il rito," 36 and fig. 28.

168. Galt, "Magical Misfortune," 744.

169. Arthur, Calcagnile, et al., "Sepolture multiple," 297–301.

170. Bruno and Tinelli, "Testimonianze," 218–20. Brunella Bruno posits (ibid., 220) that Jewish tombs may have used slabs decorated with a menorah in the same way, but the evidence (Colafemmina, "Insediamento ebraico," 516) is very slim.

171. At Quattro Macine, none of the grave goods predates the fourteenth century even though there are tombstones from earlier periods and the village was founded in the eighth century. See Arthur, Calcagnile, et al., "Sepolture multiple," 297.

172. For a summary, see Jacob, "Deux épitaphes."

173. One cover slab at Quattro Macine has graffiti in the form of numbers, a cross, a ship, and a checkerboard; see Arthur, "Masseria Quattro Macine," 203 and fig. 19. The author of *Sefer Hasidim*, the Ashkenazic compilation that retains a number of ancient Palestinian practices filtered through southern Italy, remarks in the thirteenth century that gentiles are reusing Jewish gravestones for the foundations of their houses; see Isaacs, *Divination*, 164.

174. Lebbe, "Shadow Realm," 67.

175. Vacca, "Sui primordi," 205. Such dancing was earlier condemned in a synod at Naples in 1542; see Corrain and Zampini, *Documenti*, 148.

176. Colafemmina, "Iscrizione brindisina di Baruch." See also the recent dissertation of Lehnardt, "Studies."

177. Zidkiyahu Anav, *Shibolei ha-Leqet*, ed. Buber, sect. 15.

178. Wieseltier, *Kaddish*, 481, citing Solomon the Son of the Orphan; Sperber, *Jewish Life*, 550–54.

179. These anniversaries, already present in antiquity, became in Christian thinking an *imitatio Dei*, commemorating Christ's resurrection on the third day, his appearance to his disciples on the ninth, and his ascension on the fortieth. See, in general, Abrahamse, "Rituals"; Velkovska, "Funeral Rites According"; Paxton, *Christianizing Death*; Binski, *Medieval Death*.

180. See, e.g., Horowitz, "Speaking"; McLaughlin, *Consorting*; Whaley, ed., *Mirrors*.

181. "Prohibemus etiam a dominis, et mulieribus, aliisque quantumcumque consanguinitate, vel affinitate jungantur jam mortuis, ire ad ecclesias seu sepulcra defunctorum diebus festivis, vel aliis, occasione consuetudinis ad plorandum ibidem propter defunctos, vel temporibus statutis: poena unciarum auri quatuor." See Del Giudice, *Legge suntuaria*, 172. The following quotations also come from this source.

182. "Nullus praeterea consanguineus, vel affinis maxime defunctorum, audeat ultra octo dies barbam deferre, propter obitum eorum, exceptis filiis, et fratribus, qui juste dolorem prosequntur; quibus permittitur usque ad mensem, si voluerint barbam, et lugubres vestes portare; poena." For beards, see Chapter 3.

183. "Item quod dominae, vel plebeae, scilicet maritatae, propter mortem consanguineorum, non mutent sibi vestes, nec aliquam novitatem in vestibus, et habitu faciant, sicut hactenus consuevit, nisi pro morte maritorum suorum tantum; sub poena."

184. Zidkiyahu Anav, *Shibolei ha-Leqet*, ed. Buber, sect. 21; Sperber, *Jewish Life*, 573.

185. Zidkiyahu Anav, *Shibolei ha-Leqet*, ed. Mirsky, sect. 127; Wieseltier, *Kaddish*, 100–101.

186. Lelli, "Influenza," 213, citing Sicilian Jews in Thessalonike.

187. Wieseltier, *Kaddish*, 313.

188. De Meester, *Rituale*, 124–31.

189. Taft and Kazhdan, "Kollyba"; Podskalsky, Stichel, and Karpozilos, "Death," 594. The wheat-based tradition presumably originated in rites to Demeter.

190. Tautu, "Badia," 1191.

191. Miller, trans., "*Kasoulon*," 1322, 1326. Theodore's relics were translated to Brindisi in the thirteenth century.

192. Tanga, "Dolci"; Parenti, *Monastero*, 393–94, notes additional monastic uses of *kollyba*.

Chapter 6. Rituals and Other Practices in Places of Worship

1. On medieval Christian liturgies, see the sources at http://medieval.illinois.edu/resources/library/liturgy.html, to which should be added Taft, *Byzantine Rite*, and http://analogion.gr/glt/; http://www.myriobiblos.gr/liturgical_en.html; http://www.christopherklitou.com/. A useful overview is in Woolfenden, "Eastern Christian."

2. Codrington, *Liturgy*; Jacob, "Euchologe de Sainte-Marie."

3. See these works by André Jacob: "Épidémies"; "Deux formules"; "Evoluzione dei libri"; "Fragments liturgiques"; "Fragments peu connues"; "Nouveaux documents."

4. In dealing with liturgical matters I rely heavily on the work of André Jacob, who has examined the manuscript evidence for Orthodox liturgy in the Salento and beyond over many decades. Because his work has never appeared in English and has often been published in highly specialized journals and books, I often summarize his observations as part of my broader integration of textual and material evidence.

5. Jacob, "Formazione," 233.

6. Ibid., 234; Mercati, "Non Russia"; Acconcia Longo and Jacob, "Anthologie," 220–21.

7. Jacob, "Opuscule didactique."

8. Jacob, "Traduction de la Liturgie de saint Jean Chrysostome" and "Traduction de la Liturgie de saint Basile." There was already a South Italian Latin translation of both the Basilian and Chrysostomian liturgies; see Strittmatter, "Missa Grecorum."

9. Rock-cut altars can still be seen at San Salvatore at Giurdignano; Li Monaci near Copertino [**43**]; Casalrotto; Santa Maria Assunta at Sanarica; San Nicola, Santa Margherita, San Gregorio at Mottola; San Leonardo and San Simeone in Famosa at Massafra [**70**]; San Girolamo and Santi Eremiti at Palagianello; Santa Chiara alle Petrose at Taranto; and elsewhere. Numerous plans showing the altars are reproduced in Dell'Aquila and Messina, *Chiese*.

10. Spedicato, "Testimonianze," 261. The stela is now inside the west entry.

11. Orthodox churches could have multiple altars to accommodate what Thomas Mathews called the "privatization" of the liturgy, which came to be celebrated on a small scale in personal or family oratories following the earlier monastic practice of celebrating mass communally only on Saturdays and Sundays. See Mathews, "Private."

12. See, e.g., Caillet, "Image cultuelle"; Kroesen and Schmidt, *Altar*.

13. Castronovi, *Tracce*, 49.

14. Falla Castelfranchi, *Pittura monumentale*, 239; Cassiano, ed., *Iconostasi*. Skimpy textual evidence puts the dedication of the church (perhaps San Giovanni del Malato) in 1304/5, but the architecture dates to the eleventh century. The colorful tassels of the visible ends of the hierarchs' epitrachelions suggest a late-fourteenth century date. Such tassels are found on Saint Eligius at Vaste in 1379/80 [**157.C**] and Saint Basil in Santo Stefano at Soleto [**113.sc.2**] in the 1380s. The framing ornamental bands of the Chiesa Greca apse also support a late date, with the best comparisons for the ornamental streamers and fictive-marble roundels on a white ground found in the Parabita monolith and the "Cappella Orsini" in Santa Caterina at

Galatina, both dated to the 1420s. On these, see Ortese, "La pittura tardogotica nel Salento leccese," 318–20.

15. M. Rubin, *Corpus Christi*, 58–59. Medea identified the bell, but not the scene, in *Affreschi,* 1:253–54; also cited in Pasculli Ferrara, "Dipinti," 38.

16. Taft, "Byzantine Communion," 218–19.

17. Arthur, "Masseria Quattro Macine," 197–99, 211. Excavators at San Nicola at Cisternino (province of Brindisi) found an iron knife in conjunction with thirteenth- and fourteenth-century ceramic and glass fragments; they interpret this as a storehouse of liturgical furnishings no longer in use; see Carrieri, "Antica chiesa," 54.

18. Taft, "Byzantine Communion"; Constantelos, "Liturgy," esp. 119.

19. Jacob, "Lettre patriarcale," esp. 144, 160–63; Jacob, "Gallipoli," 285–86; Daquino, *Bizantini,* 52. Ottob. gr. 344, written in 1177, reflects the updated liturgy.

20. Jacob, "Lettre patriarcale," 161; Jacob, "Opuscule didactique." In the Roman rite, the unleavened bread was not cut with a knife; a large host was used for mass and a third of it was broken into particles for distribution to the laity.

21. See P. Hoffmann, "Aspetti" and "Lettre." Stefano Parenti notes that in Calabria and Campania some service books continued to include the fraction in three parts as late as the sixteenth century; the practice evidently derived from the Liturgy of Saint James, although it is also attested in the Georgian version of the Liturgy of Saint Peter developed in tenth-century Campania ("Frazione," 210–12, 217–18).

22. Parenti, "Frazione," 208.

23. Jacob, "Épidémies," 113–14; for practitioners of the Roman rite, the epiclesis was superfluous because the words of Christ recited by the celebrant were sufficient to consecrate the bread and wine (114).

24. Arthur, "Stampo eucaristico," with an appendix of all known stamps from the Salento on p. 529.

25. Jurlaro, "Nuovi stampi."

26. Arthur, "Stampo eucaristico," 525 and figs. 2, 3.

27. Safran, "Scoperte salentine," 67; Falla Castelfranchi, "*Mandylion* nel Mezzogiorno," 193–94; Jolivet-Lévy, "Note sur la représentation."

28. M. Berger, "Église Mater Domini."

29. Berger and Jacob, *Chiesa di S. Stefano*, 31–32.

30. The connection between *fasciae* and veils was made by Cabasilas, among others; see Berger and Jacob, *Chiesa di S. Stefano*, 32 and n. 75. Of the additional niches at the east end of the adjoining walls at Soleto, that on the left preserves Saint John the Almsgiver, dated ca. 1440. John became the patron saint of two Salento villages, Casarano and Morciano di Leuca.

31. M. Berger, "Représentation byzantine." Such foliate crosses, often accompanied by cryptograms, frequently decorate the reverses of icons and the altar side of the templon barrier; see Gerstel, "Alternate View," 146–47.

32. Cf. Falla Castelfranchi, "Cultura artistica," 82, who identifies it as the prothesis.

33. Ibid., 84 and fig. 8, assumes it is a prothesis. The niche is published upside-down, as the starry sky can only have been intended for the top.

34. See, in general, Coulet, *Visites*; and in the Salento, Vetere, "Visite pastorali"; Centonze, De Lorenzis, and Caputo, *Visite*; Boccadamo, *Terra d'Otranto*; Jacob and Caloro, eds., *Luoghi.*

35. Cassoni, "Tramonto," 76: "item viginti libros graecos."

36. An *Anthologion* and *Akolouthion* of the fifteenth century and a *Praxapostolos* of the sixteenth or seventeenth century; see Petta, "Tre manoscritti"; Petta, "Manoscritti liturgici"; Cioffari et al., eds., *Codici liturgici,* 394–97.

37. Petta, "Codici greci."

38. E.g., in Vetere, "Visite pastorali," 97.

39. Hartnup, *On the Beliefs*, 74, 242, 264.

40. Jacob, "Chandelier," 196.

41. M. Berger, "Fresques du chevet" and "Représentation byzantine."

42. See Gerstel, *Beholding*; and, most recently, Jolivet-Lévy, "Images des pratiques." Medieval churches of the Roman rite do not share the Byzantine liturgical focus.

43. Additional bishops appear at San Mauro and the rock-cut San Salvatore near Gallipoli, as well as other sites not included in my Database because of their lack of information about individual identity.

44. Gerstel, "Liturgical Scrolls"; M. Berger, "Peintures de l'abside," 139–45.

45. Berger, "Peintures de l'abside," 144; Falla Castelfranchi, "Del ruolo," 195.

46. Jacob, "Rouleaux grecs."

47. Stephen is near the apse with a censer and/or book, at Acquarica del Capo [**1**], San Nicola at Mottola [**76.st**], Poggiardo [**97**], San Vito dei Normanni [**109.st**], and Santa Maria di Cerrate [**114.st**]; he is depicted far from the sanctuary even more frequently.

48. Safran, "Scoperte salentine," 67 and fig. 29. Lawrence is outside the sanctuary at Sta. Margherita [**75.st**] and San Nicola at Mottola [**76.st**].

49. Falla Castelfranchi, "Del ruolo"; Althaus, *Apsidenmalereien.*

50. Brightman, *Eastern Liturgies,* 314, 331, 342, 344. The deesis, as part of a Maiestas Domini image, was the subject of the apse mosaic of the Stoudios Monastery in Constantinople; see Woodfin, "*Maiestas Domini.*"

51. Falla Castelfranchi, "Del ruolo," 188.

52. Sant'Angelo at Uggiano la Chiesa; Santa Maria Assunta at Sanarica; Santa Chiara alle Petrose at Taranto; San Leonardo and San Simine in Pantaleo at Massafra; San Salvatore near Gallipoli; and originally at San Cesario, Mottola. On sanctuary screens in southern Italy, see Dell'Aquila and Messina, "*Templon*"; for screens in cross-cultural perspective, see Gerstel, ed., *Thresholds.*

53. Arthur, "Masseria Quattro Macine," 197. There are also traces of a barrier in the original built church under the current parish church of San Nicola at Cisternino; see Carrieri, "Antica chiesa," 56.

54. Robinson, "Some Cave Chapels," 206; Robinson notes on p. 207 that the nearby Santa Maria at Poggiardo had remains of a templon and altars, which are indeed visible in the excavation photographs.

55. And also at San Mauro near Gallipoli; see Berger and Jacob, "Nouveau monument," n. 67. Such dismantling probably occurred as a result of the post-Tridentine suppression of the Orthodox rite initiated in 1573; see Lisi, *Fine del rito*; Coco, "Cause."

56. For the evidence of icons in medieval southern Italy and their terminology, see Martin, "Quelques remarques" (no examples from the Salento); for icons in Apulia, see the catalog edited by Belli d'Elia, *Icone.*

57. Kalopissi-Verti, "Proskynetaria."

58. Berger and Jacob, "Nouveau monument," 231–32, 236; Berger, "Fresques du chevet," 49–50.

59. Ortese, ed., *Nociglia.*

60. Jacob, "Rite du καμπανισμός."

61. Van Heurck, "Contrepoisage." An intriguing comparison may be made with a late antique Jewish source, *Eicha Rabbah*, which tells (at 1.51) of a mother who measured (not weighed) her child daily and gave the amount of his increase each day in gold to the poor. Later, a Jewish butcher in medieval Prague allegedly weighed his children three times a year and gave their weight in meat to the poor. See Abrahams, *Jewish*, 336.

62. In addition to Ottob. gr. 344 (1177), Salentine witnesses include Sinai, Holy Monastery of Saint Catherine, MS gr. 966 (thirteenth century); Vatican City, Biblioteca Apostolica Vaticana, MS Barb. gr. 443 (thirteenth century), with a new prayer taken from that used to bless bread at the table; Vatican City, Biblioteca Apostolica Vaticana, MS gr. 1228 (possibly from the Terra d'Otranto, first quarter of fourteenth century), with two prayers for animals and two for children); and Rome, Biblioteca dell'Accademia Nazionale dei Lincei e Corsiniana, MS Corsin. 41 E 31 (1579). See Jacob, "Rite du καμπανισμός."

63. Corsin. 41 E 31: Μετὰ τὸ λέγεσθαι τὴν θείαν λειτουργίαν ἔρχεται ὁ μέλλων καμπανίζεσθαι ἔμπροσθεν τοῦ θυσιαστηρίου . Οἱ δὲ ὑπηρέται βάλλουσι τὸν ζυγὸν ἐπάνω τῆς θυρίδος καὶ τὸν μὲν ἄνθρωπον εἰς τὸ δεξιὸν μέρος τοῦ ζυγοῦ. Εἶθ᾽οὕτως ὁ ἱερεὺς τίθησι ἐπάνω τῆς κεφαλῆς τοῦ μέλλοντος καμπανίζεσθαι στέφανον ἐκ κηρίων πεποιημένον καὶ τέσσαρας κηροὺς τῷ στεφάνῳ κεκολλημένοις ὀρθοὺς σταυροιδῶς καὶ ἁπτομένους. Καὶ εὐθέως ὁ ἱερεὺς εὐλογεῖ καὶ ἄρχεται τῆς ἀκολουθίας. Jacob, "Rite du καμπανισμός" 239.

64. Parenti, "Christian Initiation," 45, calls it a propitiatory rite. In Calabria the ritual is associated with the sick, but this does not seem to be the case in the Terra d'Otranto.

65. See Petersen, "Baker."

66. Cows were weighed at Corigliano on Saint George's Day; could this be a reference to the καμπανισμός ritual and done inside a church? See Vat. gr. 1228, a euchologion copied in 1320 (Jacob, "Rite du καμπανισμός," 236–37).

67. Corrain and Zampini, *Documenti,* 178, regarding a synod at Monopoli (*Da abusibus,* chap. 12): "In festo SS. Antonii, Donati, et similium, morem illum superstitiosum ponendi filios in stateris ex una, et ex alia parte munera, ut aequo sint pondere, cum corona candelarum inter missarum solemnia."

68. De Meo, *Civiltà contadina,* 40; F. Salerno, "Epilessia"; Nolé, "Rituali," esp. 91–102.

69. For processions to his chapel at Montesano, see Chapter 7.

70. In the Jewish Sabbath liturgy, too, people who give oil for lighting the synagogue lamps are singled out with a special blessing that is very ancient; see Elbogen, *Jewish Liturgy,* 162.

71. Handaka, ed., *Tokens,* figs. 130–31; Panzanelli, ed., *Ephemeral Bodies*; interesting observations in Didi-Huberman, "Ex-voto"; Sigal, "Ex-voto."

72. Boccadamo, *Terra d'Otranto,* 60 (thirty wax votives at Santa Maria delle Grazie, Giurdignano, in 1607); 86 (votives of silver and wax at Morigno in 1522).

73. Norman, "Politics," 600. While the miracle occurred in Provence, it was recorded in a manuscript produced in Naples and it had to make visual sense there.

74. The saint at left holds lilies and wears a crown with twelve points that seem to terminate in stars; she is therefore akin to the Woman of the Apocalypse, often interpreted as Mary, in the apse at Vaste [**Plate 19**]. Her companion at the right wears a tall tiara with seven crowns and holds two keys; she is thus an allegory of the Roman church and also akin to Mary.

75. For insights, see now Ortese, "Rilettura," 8–21; the apposite phrase *digiuno visivo* is on p. 10.

76. Monti, *Week of Salvation,* 75.

77. Ibid., 74.

78. Cf. Ortese, "Rilettura," 16–17.

79. Viscardi, *Tra Europa,* 290, 292. Eating and dancing had already been condemned locally in 1542; see Corrain and Zampini, *Documenti,* 148.

80. Marinis, "Byzantine Church."

81. Jacob, "Cadran solaire." See above, p. 51.

82. Pastore, "Fonti," 245, no. 18.

83. Houben, "Tradizione," 81. A necrology containing over 1,100 medieval entries at the Trinità at Venosa indicates that mortality was highest in August and January and lowest in June and July. See Houben, *Libro del capitolo*, esp. 154.

84. Some examples in Jacob, "Épidémies," 104, 118–19; Jacob, "Annales d'une famille," 42, which also includes several invocations on behalf of the deceased "and his wife" (fourteenth century).

85. Safran, "Deconstructing 'Donors.'"

86. On southern Italian *piyyutim* and *paytanim*, see Fleischer, "Hebrew Liturgical"; Weinberger, *Jewish Hymnography*; Hollender, "*Piyyut* italiano"; and Lehnardt, "Studies," who lists seventeen *paytanim* (authors of *piyyutim*) from Rome and Apulia between the ninth and eleventh centuries (chap. 3).

87. Bonfil, *History and Folklore,* 53–66 and 238–80; Eliezer of Worms says that Aharon transmitted the "secrets of prayer" to Moses of the Kalonymos family, certainly of South Italian origin, who then brought them to Lucca and thence to Ashkenaz. See Idel, "Dall'Italia."

88. The fragments from Otranto were recently rediscovered as part of the "Italian Genizah" in the Archivio di Stato, Bologna, nos. 564, 574: Perani, "Nuovo inventario," 336; Perani and Grazi, "Scuola," 22–24. The Roman copy of the Palestinian Talmud, executed by Jehiel ben Yekutiel ben Binyamin Anav ha-Rofeh (a relative of Zidkiyahu Anav who wrote *Shibolei ha-Leqet*), served as the basis for the printed edition of 1523–25 by Daniel Bomberg in Venice. A second, partial manuscript was also copied in Italy, probably in the thirteenth century. See Sirat, *Hebrew*, 242.

89. Elbogen, *Jewish Liturgy*, 8.

90. Reif, "Some Changing," 100.

91. Elbogen, *Jewish Liturgy*, 278; Zunz, *Ritus*, 78–79.

92. The contents of an Ashkenazic festival prayer book are closely analyzed in comparison with those in other rites by Fleischer, "Prayer."

93. I do not include Rabbanites and Karaites as two of the Jewish rites because even though the Rabbanites were Romaniote Jews, the Karaites are branded as heretics for their dismissal of the whole corpus of oral law (the Talmuds and other exegesis); they follow only the Pentateuch. In his dialogue against the Jews, on which see below, Nicholas-Nektarios of Casole demonstrates his awareness of the differences between the Rabbanites and Karaites (whom he calls "Rabbanim" and "Karanim") and claims to have assisted in their controversies in Greek towns; see Patlagean, "Dispute," 22–23. For the Karaites, who still maintain synagogues along the Golden Horn, see Ankori, *Karaites*.

94. Schmelzer, "Fifteenth Century," 88–89, 93. Balmes was a doctor; among his clientele was the prince of Taranto.

95. Lelli, "Influenza," 214 n. 88.

96. Based on the second-century *Seder Olam Rabbah*; see Stemberger, *Introduction*, 326.

97. The apt phrase is from Fishman, "Rhineland," 10. For medieval practice, see Marcus, *Rituals*, 77, 124; Fine, "Arts of Calligraphy," 318–19. For contemporary Italian practices connected with the Torah, see Di Segni, "Cultura folklorica."

98. Zidkiyahu's brother, Benjamin, got a halakhic opinion permitting this from Rabbi Meir ben Moshe, although the great Ashkenazic rabbi Avigdor Katz disagreed. In addition, the Haftorah readings were to be done from a *chumash*, as in Ashkenaz, whereas the Jews of the Maghreb and Sicily used scrolls for these prophetical readings. Zidkiyahu Anav, *Shibolei ha-Leqet*, ed. Mirsky, sect. 31. This is restated in the *Tanya Rabati*, the basis for the Italian prayer book,

99. Zidkiyahu Anav, *Shibolei ha-Leqet*, ed. Buber, sect. 78; Freudenthal, "Arav," 143.

100. Vogel, *Medieval Liturgy*, 378.

101. Ehrlich and Langer, "Earliest Texts."

102. Ibid., 83, 86.

103. Parma, Palatina 1791, formerly De Rossi 435. The manuscript was copied in a Byzantine and a Sephardic hand; see Richler and Beit-Arié, *Hebrew Manuscripts in the Biblioteca Palatina*, 284, no. 1090; Niehoff-Panagiotidis and Hollender, "ἔχομε ראש חדש," esp. 102–4, which suggests that Greek was used for this prayer as early as the thirteenth century.

104. Niehoff-Panagiotidis and Hollender, "ἔχομε ראש חדש," 104.

105. Cf. Amittai: "Standing, I sing, in the presence of those who sit in Your house"; Hollender, "*Piyyut* italiano," 29.

106. Weinberger, *Jewish Hymnography*, 141, 153: "It is likely that the language of the refrains is a contemporary Apulian vernacular with which the congregation was thoroughly familiar." I have searched for these phrases—*diqlo diqlo lah* and *hiddaleh let dallah*—in local sources without success.

107. For more differences between Amittai and classical (meaning late antique) *paytanim*, see Hollender, "*Piyyut* italiano," 24–29.

108. Ibid., 28.

109. Weinberger, *Jewish Hymnography*, 202; *Penguin Book of Hebrew Verse,* trans. Carmi, 233; Bonfil, *History and Folklore,* 124; Elior, "Mysticism"; Bar-Ilan, "Prayers," which includes a *piyyut* of Amittai; Idel, "Dall'Italia." On the Heikhalot corpus, see now Boustan, "Study."

110. For the Maimonidean criticism, especially of the late antique *Shiur Qomah* treatise, which gives actual dimensions for God's limbs and was written, he says, not by the sages but by recent *darshanim al-Rum* (Byzantine commentators) and best forgotten, see Maimonides, *Teshuvot ha-Rambam*, 3 vols., ed. Joshua Blau (Jerusalem: Mekitse nirdamim, 1958), 200–201, para. 117, cited in Geula, "Midrašim," n. 9. See also Weinberger, "Note," 144.

111. Zidkiyahu Anav, *Shibolei ha-Leqet*, ed. Mirsky, sect. 282, in the name of Zidkiyahu's teacher R. Avigdor Katz; Kanarfogel, *Peering*, 134 n. 4.

112. This harks back to the Arian controversy over whether Christ was a creature, and thus slightly lesser in stature than God the Father, or was—as the Orthodox position maintained—uncreated and coeternal.

113. Cited in Kanarfogel, *Peering,* 55.

114. Zidkiyahu Anav, *Shibolei ha-Leqet,* ed. Mirsky, sect. 30.

115. Maimonides, *Mishneh Torah*, Hilkhot tefillah 11, 5, cited in Hilton, *Christian Effect*, 175.

116. Cohen-Harris, "Where."

117. Zidkiyahu Anav, *Shibolei ha-Leqet,* ed. Mirsky, sect. 242.

118. Horowitz, "Towards a Social History," 147. See also Sperber, *Jewish Life*, 373–77.

119. Horowitz, "Towards a Social History," 148–49.

120. Zidkiyahu Anav, *Shibolei ha-Leqet*, ed. Mirsky, sect. 185.

121. Ibid., sect. 205.

122. Bonfil, *History and Folklore*, 301–2.

123. Ibid., 302. Elsewhere, when Ahima'az describes Muslim attacks in the Salento in the ninth and tenth centuries (which resulted, among other calamities, in the razing of Oria and the taking of such prisoners as Shabbetai Donnolo), he characterizes the Christian territory as a "kingdom of the uncircumcised . . . land of the idolaters, worshippers of idols who bow down to statues" (272).

124. Jacobus of Verona, *Liber*, ed. Monneret de Villard: "In illa civitate similiter Oltranti. in archiepiscopatu. in majori ecclesia ante majus altare. est unum candelabrum ereum altitudinis xvj cubitorum. et habet vij ramos cum trunco. speculos et lilia et vij lucernas. omnia de ere factum totum ad illam formam. quam precepit Dominus Moysi. ut feceret candelabrum in tabernaculo federis Domini. Et omnes Judei. qui sunt in illis partibus. sepissime vadunt ad visitandum

illud candelabrum: magnam pecuniam constitit ad perficiendum ipsum. quia est valde pulcrum et magnum." Jacobus was cited in Chapter 4 for his observations about earrings; see Chapter 8 for the role of the Otranto menorah as a catalyst for paintings at Vaste.

125. See, e.g., Bland, "Icons," 207–10; Bland, "Defending."

126. On *menorot* in medieval churches, see P. Bloch, "Siebenarmige Leuchter"; P. Bloch, "Seven-Branched Candelabra."

127. For the disputation, preserved on 101 folios of Paris, Bibliothèque nationale de France, MS gr. 1255, see Hoeck and Loenertz, *Nikolaos-Nektarios*, 82–88; Patlagean, "Dispute"; Chronz, "Der Beitrag," 569–71; Külzer, *Disputationes*, 192–95. Lars Hoffmann kindly shared five pages of his edition ("Nikolaos/Nektarios") in March 2005.

128. See, e.g., Dahan, *Christian Polemic*; Limor and Stroumsa, *Contra Iudaeos*; D. Berger, "Mission."

129. There is a cycle with several Moses scenes on the upper register of the north wall at Santa Croce in Minervino di Lecce, dated to the third quarter or end of the fifteenth century; see Ortese, "Per il ciclo pittorico," 427–29.

130. Magdalino, "Evergetis Fountain."

131. Safran, *San Pietro*, 27, 155–61, 195. This date has been challenged recently on stylistic grounds, with the Genesis scenes (and others) pushed back to ca. 1200 and connected with the Paul of Otranto mentioned by Nicholas-Nektarios as having worked in Constantinople. However, that early date completely ignores the stratigraphic evidence that links these paintings with the others despite their differences in style. Moreover, it relies on the coincidence that we happen to have both a named painter from about the "right time" and an ekphrasis of a cross-in-square church in the early thirteenth century (on the latter, see Safran, "Medieval Ekphrasis"). This reasoning is circular and relies on coincidence: just because we know one "famous" artist's name, and that artist worked in the Byzantine capital, and the east-vault paintings at San Pietro seem sufficiently high in quality to be the work of a Constantinopolitan painter, that does not necessarily make this relevant to San Pietro at Otranto. Falla Castelfranchi never acknowledges the stratigraphic evidence in "Cultura artistica," 89, "Chiesa di San Pietro a Otranto," 190–92, or "Sul Bosforo," 306–9. Cf. Pace, "San Mauro," n. 17.

132. Patlagean believes the debate did occur: "rien d'empêche de situer réellement la scène à Otranto" ("Dispute," 21). Centuries earlier, some of Amittai's *piyyutim* refer specifically to Jewish-Christian polemical debate in ninth-century Oria; the Christians are referred to as "knowers of the book" (i.e., the Bible).

133. Hoeck and Loenertz, *Nikolaos-Nektarios*, 82–88, 200–203; M. Berger, "S. Stefano di Soleto," 105.

134. I have not seen the unique manuscript of the debate and am unable to determine whether this scene was isolated or part of a series.

135. Metzger, "Peintures 'placées haut.'"

136. E.g., sections 6–7 in Jordan, trans., "*Pantokrator: Typikon*, 740–41. The preserved portions of the Casole typikon focus on dietary regulations and omit information about lighting.

137. On *podea*, see Woodfin, "Clothing"; Frolov, "Podea."

138. Ortese, "Chiesa di Santa Maria de Itri," 44.

139. E.g., the three in close proximity at San Giovanni al Sepolcro in Brindisi; see Guglielmi, "Appunti," 86–87.

140. Ibid., 87–89.

141. The last example is discussed in Ortese, "Per il ciclo pittorico," 419–20 and n. 22; Ortese dates the original to the late thirteenth/early fourteenth century.

142. The Parabita stela measures 170 cm tall × 55 cm wide × 27 cm deep; it is discussed in Ortese, "La pittura tardogotica nel Salento leccese," 318–22. Ortese dates the visible portion to the 1430s and provides earlier bibliography.

143. The pilaster (or pier) suggestion is made by Ortese (ibid.), but if it were a pilaster one would expect attachment on a wider side, and if it were a freestanding pier one would not expect one of the sides to be rougher than the others. For this reason I suggest that it was originally part of a screen, an argument developed in a paper, "Greek Cryptograms in Southern Italy (and Beyond)," delivered at the Forty-Eighth International Congress on Medieval Studies, Kalamazoo, Mich., May 9, 2013. See http://art-hist.edel.univ-poitiers.fr/index.php?id=73.

144. Marinis, "Byzantine Church."

145. Negro, "Miggiano."

146. De Donno, *Dizionario*, nos. 13704, 4560, 10224, 10688, 662, respectively.

147. Gerstel, "Layperson."

148. Guillou, "Art et religion."

149. Falla Castelfranchi, "Note preliminari," esp. 119–21.

150. Bonfil, *History and Folklore*, 158, 284–90.

151. Supplications to unidentifiable saints are not included here, and those saints shown with both a devotee's image and text that clearly belong together are counted as a single supplication.

152. Michael is depicted in corners, at Santa Lucia at Brindisi (upper church), Carpignano, Grottaglie (cripta di Riggio), Miggiano, Mottola's San Nicola (twice), Poggiardo, Uggiano la Chiesa, and Vaste; adjacent to doors, at Cerrate, Sanarica, and Soleto; in apse area, at Carpignano and Poggiardo; opposite doorway at Li Monaci.

153. Safran, "Scoperte salentine," 70.

154. Seen, for instance, at Monagri and H. Neophytos on Cyprus and the Mavriotissa at Kastoria in Greece. This phrase comes originally from the liturgy used at the Holy Sepulcher in Jerusalem on Holy Saturday.

155. Barbara is also represented at Muro Leccese, Santa Maria di Cerrate, and in the upper church of Santa Lucia at Brindisi.

156. Parts of the southern Salento are extremely susceptible to sudden, fierce storms and catastrophic flooding, and there is ample reason to assume comparable conditions in the Middle Ages. See, e.g., Forte, Strobl, and Pennetta, "Methodology."

157. A traditional paean-cum-invocation to Saint Antony sung on the vigil of his feast day in Abbruzzo (recorded in 1913) is in Canziani, "Abruzzese Folklore," 216–18, with the refrain "Long live then Saint Antony, Protector against the Devil!"

158. Rivera, *Mago*.

159. Malecore, *Magie,* 213; Lombardi Satriani, *Santi*, 231.

160. Ladiana, "Culla," 358, 363.

161. Each day of the week was devoted to particular saints, and Nicholas shared Thursday with the apostles.

162. For church dedications, see, e.g., Boccadamo, *Terra d'Otranto*, 28.

163. Falla Castelfranchi, *Pittura monumentale*, 101–5; Falla Castelfranchi, "Chiesa di Santa Marina a Muro," 202–4.

164. Safran, "Scoperte salentine," 72–73.

165. Tamblé, "Antisemitismo," esp. 40.

166. Safran, "Deconstructing 'Donors,'" 134–39; Gerstel, "Painted Sources," 96–98.

167. Safran, "Art of Veneration," 185–86.

168. Safran "Scoperte salentine," 77, 83.

169. Tridente, "Santo"; Efthymiadis, "D'Orient en Occident," 220; Latin text in Limone, *Santi monaci*, esp. 143–44.

170. Safran, "Deconstructing 'Donors.'"

171. Safran, "Scoperte salentine," 76.

172. Fonseca and D'Angela, eds., *Casalrotto*, 66.

173. The Our Father derives from Matt. 6:9–13 and Luke 11:2–4. The number of 150 repetitions, corresponding to the number of psalms, became de rigueur by the twelfth century. For paternosters, see Thurston, "Chapelet"; Lightbown, *Mediaeval European*, 342–58; Levi Pisetzki, *Storia*, 2:140; Day, "Knots."

174. The "Jesus Prayer," Κύριε Ἰησοῦ Χριστέ, Υἱέ τοῦ Θεοῦ, ἐλέησόν με τὸν ἁμαρτωλόν, as commended by John Klimakos, probably derived from Luke 18:10–14.

175. Lightbown, *Mediaeval European*, 343.

176. Congedo, "Raccolta," 7.

177. Thurston, "Chapelet," col. 402, cites an illustration of a paternoster on a French tombstone dated 1273, but Italian depictions on walls and panel paintings seem to date to the late fourteenth century.

178. Bruno and Tinelli, "S. Maria delle Grazie," 699.

179. Postmedieval paternoster beads of glass paste and amber were found in a tomb at Taurisano; see Arthur, Bruno, and Limoncelli, "Notizie scavi Taurisano," 346; and Arthur, Gravili, et al., "Chiesa di Santa Maria," 192. Beads of glass paste were found in two infant tombs at Apigliano roughly contemporary with Vaste, but these could be necklace beads; see Cedro, "Abbigliamento," 44.

180. Burke, "Language of Gesture," 73.

181. L. R. Jones, "*Visio Divina*," 25.

182. Mrozowski, "Genuflection"; Ladner, "Gestures"; Kalopissi-Verti, *Dedicatory Inscriptions*, 27–28 and plates 79–97; Rodley, "Patron Imagery"; Stylianou and Stylianou, "Donors"; Franses, "Symbols," chap. 1.

183. On this change, see Lane, "Development"; Mrozowski, "Genuflection"; Ladner, "Gestures," 209–10; Jones, "*Visio Divina*"; Gougaud, *Devotional*, 26.

184. Teteriatnikov, "New Image," esp. 312–13.

185. Sinkewicz, *Theoleptos*, esp. *Monastic Discourse* 1 (early fourteenth century); cf. Teteriatnikov, "New Image," 315–16.

186. Mrozowski, "Genuflection," 25–26, suggests that this was due in part to its diffusion on seals.

187. Ibid., 22.

188. Ladner, "Gestures," 228–29.

189. Mrozowski, "Genuflection," 24; Le Goff, "Gestes," 724.

190. Schmitt, "Entre le texte"; Hood, "Saint Dominic's."

191. Ševčenko, "Close Encounters," 278–79; Ševčenko, "Representation," 157.

192. Garnier, *Langage,* 1:142–46; Schapiro, *Words*, 37–49.

193. Trexler, "Introduction," 16.

194. That humans are attracted to eyes has been corroborated scientifically; see, e.g., Keil, "I Look," esp. p. 11; Safran, "Scoperte salentine," 89. In his study of slaves in medieval Italy, Steven Epstein noted that attention, and description, often focused on the eyes (*Speaking*, 110).

195. M. Epstein, *Dreams*, 44, 136 n. 15. Dominican modes of prayer echo these genuflections because both groups looked to Scripture as their model.

196. Judah Romano, *Chiarificazione*, ed. Debenedetti Stow, 2:231. This echoes the female prostrations "in the form of an arch" in the crypt at Miggiano (see above, p. 161).

197. Zidkiyahu Anav, *Shibolei ha-Leqet,* ed. Mirsky, sect. 30.

198. Marcus, "Prayer Gestures."

199. Favreau, "Commanditaires," 706. Cf. Griffith, "Handwriting," 188, regarding the "community of intercession" desired by the graffitists.

200. Plesch, "Memory."

201. Meinardus, "Mediaeval Navigation"; Arduini and Grassi, *Graffiti*; Delouca, "Graffitis"; Karasu, *Alanya Ships*. Caprara proposes that ships signify freedom from slavery ("*Singularità*," 33).

202. The shoe print can perhaps be connected with footwear graffiti, mostly in the form of boots, found in Bulgaria and Ukraine; these are interpreted as pilgrims' signs ultimately connected with Sinai in Kostova, "Lust."

203. Caprara, "*Singularità*," 51.

204. Ibid., 49. While my interpretations may differ in some cases from those of Roberto Caprara, he saw these graffiti in better condition decades ago and he deserves credit for recording them long before the postmodernist interest in such marginalia.

205. Safran, "Scoperte salentine," fig. 24d.

Chapter 7. Rituals and Practices at Home and in the Community

1. Licata, "Festa."

2. Only November, represented by a hunting scene, is now visible. Semeraro-Herrmann and Semeraro, *Arte*, 156–77.

3. Most of these proverbs are in De Donno, *Dizionario*; I recorded others firsthand.

4. Caputo, "San Teodoro," 1, calls this an "antico proverbio."

5. This tradition has proved difficult to document; indeed, several printed and online sources indicate that the translation occurred not in April 1210, but either in November of that year or at the wedding of Frederick II in 1225.

6. See, e.g., J. L. Jacobs, *Hidden*, esp. 58–63.

7. Ibid., 61.

8. Di Segni, "Cultura folklorica," 9.

9. Horne, *Sacred*, 109.

10. For the contents of the Bova typikon, see Follieri, "Culto," 574.

11. See Ankori, *Karaites*, 281.

12. For the Basilicata tombstones, see Colafemmina, "Iscrizione venosina" and "Tre iscrizioni ebraiche."

13. Vatican City, Biblioteca Apostolica Vaticana, ebr. 31, containing three midrashic texts (Sifra, Seder Eliyahu Rabbah, and Seder Eliyahu Zuta, the first of which is mentioned in the contemporary *Chronicle of Ahima'az* (Chapter 4, n. 45). See Mancuso, "Manuscript Production," 419–20; Stern, *Calendar*, 88–89.

14. Stern and Mancuso, "Astronomical Table," 37, and "Corrigenda."

15. Stern and Mancuso, "Astronomical Table," 39. The Karaites followed a different calendar as well; see Ankori, *Karaites*, esp. 271–79, 292–94.

16. The "fuzzy border" between astronomy and astrology is explored by Holo, "Hebrew Astrology."

17. Bonfil, *History and Folklore*, 284–90 (sect. 29–31).

18. Peri, "Congregazione"; Gaspari, "Francesco d'Assisi," 176.

19. "Dispose of these abuses that have infected my diocese"; Pietro Corderos, cited in Visceglia, *Territorio*, 98.

20. "Passando de'l mese di Nouembre, intesi da loro, che celebrauano la festa di .s. Philippo Apostolo, la qual celebra la Chiesa Romana, il primo giorno di Maggio"; Leandro Alberti, *Descrittione*, fol. 213r, cited in Jacob, "Testimonianze bizantine," 68. November 14, Saint Philip's feast day, began a period of pre-Christmas fasting in the Orthodox church; see Darrouzès, "Faux acte," 230–31.

21. Petta, "Tre manoscritti," 6; in Petta, "Manoscritti liturgici," the office of Santa Maria della Neve is singled out on pp. 699, 703. See also Follieri, "Culto," 563. Maurus was the patron saint of the important Orthodox male monastery of San Mauro, near Gallipoli, and there were a few other local churches dedicated to him although no images have thus far been identified. The Madonna della Neve dates back to Roman times—Santa Maria Maggiore in Rome is connected with this cult—but has no pictorial support in the Salento and no dedications before the sixteenth century.

22. Farella, "Note"; Jacob, "Annales du monastère"; Falkenhausen, "Inedito documento." The famous monastery of San Vito at Polignano was farther north in Apulia.

23. V. Orlando, *Feste*, 156.

24. Galatone codex 4; see Danieli, "San Francesco d'Assisi"; Danieli, *Rito greco*, chaps. 2, 3; Gaspari, "Francesco d'Assisi"; and Gaspari, *Ricco sposo*.

25. Corsi, "Comunità," 47.

26. Ortese, "Per il ciclo pittorico," 419, 421.

27. Francis is not depicted at Santi Stefani at Vaste, pace Fonseca et al., *Insediamenti*, 232, who perhaps confused him with one of the Antony Abbots.

28. Esposito, "Feste," 203.

29. Bonfil, *History and Folklore*, 286.

30. Esposito, "Feste," 200; Alaggio, *Brindisi*, 19, notes that the oldest attestation dates to the sixteenth century but does not dispute its putative origins in the mid-thirteenth century. The comparable ceremony in honor of Saint Theodore, whose relics were translated to Brindisi in the early thirteenth century, dates only to 1776, although the silken textile that originally wrapped the relics and the medieval silver reliquary depicting the translation are still preserved in the Diocesan Museum.

31. Maraspini, *Study*, 222.

32. See Chapter 5, n. 66.

33. MS Laur. gr. 5, 36; see Quaranta, "In difesa."

34. Megha, *Galatone*, 47.

35. Limone, *Santi monaci*, 144, lines 298–314; Efthymiadis, "D'Orient," 220; Bacci, "Legacy," 325.

36. Pentcheva, *Icons*.

37. See Belting, "Byzantine Art," 23 and fig. 33.

38. Weinberger, *Jewish Hymnography*, 147 (by Yehiel ben Abraham of Rome, d. before 1070).

39. Tragni, "San Pietro," 81–84; Esposito, "Feste," 203; V. Fiore in Lombardi Satriani, *Santi*, 235.

40. Kiesewetter, "Principi," 92.

41. Semeraro, "Fra Roberto Caracciolo," 51.

42. Zidkiyahu Anav, *Shibolei ha-Leqet*, ed. Mirsky, sect. 185.

43. Ibid., sect. 202.

44. Horowitz, *Reckless*.

45. M. Salerno, "Domus"; for Martoni, see Le Grand, "Relation," 666.

46. Massaro, *Società*, 112–13.

47. Ibid., 122.

48. Jacob, "Fondation d'hôpital," 691. In addition to the hospitals known from surviving visual information, Giovanni d'Aymo of Lecce left money in his 1394 will to support the hospital of San Giovanni Battista that he had founded in Lecce two years earlier (Massaro, "Territorio," 307, and *Società*, 115) and Raimondello del Balzo Orsini founded a hospital attached to his new Franciscan foundation, Santa Caterina at Galatina.

49. Bruno, "Borgo Terra a Martano," 68.

50. Appel, "Myth," 21–22; Rivera, *Mago*, 319–326; Puce, "Male"; Gentilcore, *From Bishop*, 118, 137.

51. Kriss and Kriss-Heinrich, *Peregrinatio*, 200. For other churches and monasteries dedicated to Cosmas and Damian in the Salento, see Falla Castelfranchi, "Culto e immagini," 63, 74.

52. In 1968; see Maraspini, *Study*, 14.

53. Sakellariou, *Southern Italy*, 479–80.

54. Bekakos, "*Panaiere*," 43. Sakellariou, however, dates this fair to 1463 (*Southern Italy*, 480).

55. Bekakos, "*Panaiere*," 30; Rohlfs, *Scavi linguistici,* 83.

56. Bekakos, "*Panaiere*," 37. Neither is listed in Grohmann, *Fiere.*

57. Cited in Bekakos, "*Panaiere*," 43: "Et ultra questo che li turni de dicti panieri franchi se intendono solamente a fareli fare da xiij hore: oy dal levare del sole per fini alle xxiiij hore de giorni de li panieri predicti tanto del comparare, et vendere."

58. Ibid.

59. Arthur, "Medieval Fairs," 424; Massaro, "Città," 373.

60. Novembre, "Per una geografia," 258.

61. Grohmann, *Fiere,* 143.

62. Massaro, "Economia," 169.

63. Grohmann, *Fiere,* 140; Sakellariou, *Southern Italy*, 479–80.

64. Esposito, "Feste," 199.

65. Rodotà, *Dell'origine*, 1:382.

66. One of these prayers is discussed below as a verbal charm.

67. Calabuig, "Rite," 347–48.

68. Jacob, "Consecration." The fifth-century mosaic in the sanctuary vault indicates that the consecration was for the newly enlarged church. See Spinosa, "S. Maria della Croce."

69. Jacob, "Consecration," 161.

70. Jamison, "Carriera del logotheta," 177, 185–87; Falkenhausen, "Inedito documento," 8. For a group of bishops gathering for the consecration of a hospital, see [4].

71. Cherubini, "Il contadino," 143.

72. Gies and Gies, *Life*, 18, cites the custom in England of "a-ganging" on "gang-days," when the whole village population traced the perimeter in tactile fashion. The initial marking-out of the boundaries harks back to walking the *pomerium* of ancient cities.

73. Della Monaca, *Memoria,* 265.

74. Ibid., 248; Quave and Pieroni, "Ritual Healing," 60; Stewart, *Demons*, 152, 263 n. 11. The practice of carrying a protective ring at crossroads was condemned by a synod at Gravina in 1569: Corrain and Zampini, *Documenti*, 178.

75. Arthur, "Menhir"; Arthur, "Masseria Quattro Macine," 184–85.

76. Nucita and Bolognini, *Guida*, 53. The published height ranges from 4.7 to 5.2 m; regardless of the precise measurement, it is the most imposing specimen in the region. Studies of the "prehistoric" menhirs include Palumbo, "Inventario"; Palumbo, "Scoperte"; Masciullo, *Dolmen.*

77. A. Del Sordo in Lombardi Satriani, *Santi*, 224; Jurlaro, "Martyrium," 89–90; Rodotà, *Del origine, 1:360; Palumbo, "Pseudo-Pietrefitte."

78. The text mentions a cistern "iuxta Crux ubi annuatim pergimus cum ramis palmarum" (Poso, *Ostuni*, 91).

79. Calò Mariani, "Chiesa," 99, fig. 33.

80. Arnaud, "Exorcisme." Tryphon became the patron saint of Alessano only in 1701; Jacob, "Esorcismo," 26.

81. Jacob, "Esorcismo," esp. 28–36; p. 33: "Τί με ἐπερωτᾷς, ἀρχιστράτηγε; Τὸ ἄχος τῆς γῆς καὶ ὁ κτύπος τοῦ οὐρανοῦ αὐτό ἐστι νέφος καὶ ἐγένετο ἐπὶ τῆς γῆς καὶ ἐπετάσθη ἐν τῷ οὐρανῷ καὶ βαστάζει ὀργὴν κινουμένην καὶ ὑπάγει, ἵνα ἐξαλείψῃ χώρας καὶ χωρία, ἀμπελῶνας ἐκριζώσῃ, ποταμοὺς διαστρέψῃ, ῥύακας κινήσῃ καὶ πέτρας, ὄφεις ἐκβάλῃ, ὀρνέων κάρας συνθλάσῃ."

82. See, e.g., Barb, "St. Zacharias," 40.

83. Di Nola, *Arco*, 46; Montinaro, "S. Vito."

84. Such as, for instance, when pilgrims crawl under the Vatican obelisk ("St. Peter's Needle"), as recorded ca. 1200 in Master Gregorius's *Marvels of Rome*. I thank John Osborne for this reference.

85. Di Nola, *Arco*, 46; Rivera, *Mago*, 333.

86. Di Nola, *Arco*, 21, 39.

87. Hasluck, "Stone Cults"; Galdoz, *Vieux rite*. There are similar *tripimeni petri* in Cyprus at Lemesos and Dara.

88. Montinaro, "S. Vito." The painting, representing a single male figure who is probably Saint Vitus, does not predate the fifteenth century.

89. Imbriani, "Riflessione," 74: "in die sollemnitatis cingitur ecclesia et postea anno sequenti dividitur inter sacerdotes."

90. Ibid., 75.

91. A related ritual involving wax was performed by Ashkenazic Jewish women, who measured the circumference of individual graves or entire cemeteries by laying down candlewicks; the length of wick was then divided and made into individual wax candles. There are hints that this ritual began centuries before its eighteenth-century attestation, perhaps in the period when the Ashkenazic Jews were still in Italy; see Weissler, *Voices*, 133–38.

92. Weinberger, *Jewish Hymnography*, 147. Yehiel ben Abraham is the father of Nathan ben Yehiel, compiler of the *Arukh* dictionary; they were members of the learned family of the Anavim who would later produce the authors of *Shibolei ha-Leqet* and *Tanya Rabati*.

93. Harari, "Leadership."

94. Ta-Shma, "Acceptance."

95. Kieckhefer, *Magic*, 153–56.

96. Gentilcore, *From Bishop*. Cf. Machin, "St. George," 114, on "a total religious strategy" in a Cretan village.

97. At issue was whether the requirement was given in the Torah or was only handed down by the rabbis. See Schechter, "Notes," 99–100; Bowman, *Jews*, 123–24, 213–14.

98. Horowitz, "Towards a Social History"; Horowitz, "Religious Practices."

99. Bowman, *Jews*, 124, citing a tradition connected to a rabbi from Verona.

100. Horowitz, "Towards a Social History," 145. He cites a poem by Immanuel of Rome, a Dante imitator of ca. 1300, who places in his circle of hell Jewish men who loiter around the mikvah and comment on the women.

101. Bonfil, *History and Folklore*, 173.

102. Semeraro, "Fra Roberto Caracciolo," 54.

103. For many insights on the polemics of food, see Freidenreich, *Foreigners*.

104. Semeraro, "Fra Roberto Caracciolo," 58.

105. Cattle numbers declined between the Byzantine and Angevin eras while caprines increased; see Davis, "Some Animal Bones."

106. Albarella, "Faunal Remains," in Arthur, "Masseria Quattro Macine," 222–24. On hippophagy, see also Bonnassie, "Consommation," 1037.

107. De Venuto, "Zooarchaeology," esp. fig. 9; Davis, "Some Animal Bones."

108. Massaro, "Territorio," 287; for Jewish butchers in northern Italy see Toaff, "Vita," 252.

109. Hollender, *"Piyyut* italiano," 27: "the swimmers are permitted if they have two [things], scales and fins; the birds three: crop, gizzard, extra toe," as discussed in the Mishnah.

110. Isaiah ben Mali di Trani, *Teshuvot ha-Rid*, ed. Wertheimer, 510–11. Isaiah stressed that dreams are not authoritative on their own and that his ruling was based on law, although he did seek guidance from the prophet; see Kanarfogel, *Peering*, 228.

111. *Sefer ha-Makhria* 35; cited in Zimmer, "Baking," 146.

112. Bonfil, *History and Folklore*, 127–28.

113. Ibid., 128, distinguishes the more stringent Palestinian Talmud requirements for Jewish participation from the more lenient Babylonian Talmud.

114. Zidkiyahu Anav, *Shibolei ha-Leqet*, ed. Buber, sect. 151, deals with whether someone can join in communal prayer after eating bread with someone who is not careful about "gentile bread"; normally it would be a blessing to join such a prayer, but Zidkiyahu disagrees with another sage and avers that it is better not to do so because such bread is forbidden.

115. Cappellini et al., "Multidisciplinary Study"; for fourteenth-century evidence, see Acconcia Longo and Jacob, "Anthologie," 159, with a list of wine measures owed by one village. Wine amphorae have been studied by Arthur and Auriemma, "Search."

116. See Chapter 1, n. 29.

117. Horowitz, "Towards a Social History," 140, 142.

118. Ibid., 142; cf. Toaff, "Vita," 251: in cases of need, northern Italian Jews used the must and wine of their community.

119. Schechter, "Notes," 98: "Regarding the matter of the wine about which you wrote to me, if we have come to investigate the wines of our kingdom according to halakhic materials, I have a lot to say about them, and what is in my heart on this matter is the glory of God, the matter is hidden. If we were face to face I could tell you, but I do not want to write about it, because these matters are not given to writing—'don't investigate and don't scrutinize them'" (my trans.).

120. The type known as a *Grubenhaus*, found at Supersano, probably seventh century; see Arthur, "Edilizia," 27, 29–31; Arthur, *"Grubenhauser."*

121. Arthur, "Case, chiese," 43, 45; Arthur, "Edilizia," 31–34.

122. Arthur, "Edilizia," 35.

123. Arthur, "Ricostruire," 73; Arthur, "Edilizia," 18–20, 38.

124. Porter, "Origin," 214.

125. "Si debiano levari et non habitare più in mezzo li detti cristiani"; legislation cited in Romanello, "Affermazione," 14.

126. Horowitz, "Way We Were," 77.

127. Spagnoletto, *"Mezuzà,"* 244.

128. Colafemmina and Gramegna, *Sinagoga Museo*, 76–77. The "House of the Rabbi" (casa Ciardi) was demolished, but its arched window was reconstructed elsewhere.

129. This statement by Eliezer ben Nathan of Mainz was part of a larger trend among Ashkenazic sages that acknowledged that European Christians were no longer "idolaters," in contrast with Orthodox Christians. On this development, see the excellent article by Kogman-Appel, "Christianity, Idolatry" (quote on p. 91).

130. See Chapter 1, n. 107.

131. Horowitz, "Way We Were," 79; Trachtenberg, *Jewish Magic*, 146–52.

132. Jansson, "Magic," esp. 416–18.

133. Arthur, "Verso un modellamento," 224.

134. Steinschneider, *Donnolo*, 9.

135. E. Lieber, "Asaf's 'Book,' " 236. In *Sefer ha-Mirqahot* Donnolo mentions the honey of Otranto and Oria in connection with a medicinal potion of Hippocrates; see Falkenhausen, "Tra Occidente e Oriente," 45; Sharf, *Universe*, 95–96.

136. For the evil eye in Italy, see Moss and Cappannari, "*Mal'occhio*"; Appel, "Myth"; Ladiana, "Culla"; Di Segni, "Cultura folklorica"; Pitrè, "Jettatura"; Interesse, *Puglia*; Galt, "Evil Eye"; Galt, "Magical Misfortune." For the Byzantine world, see Koukoules, Βυζαντινῶν Βίος, 1:244–48.

137. Ecclus. 14:10. The Wisdom of Sirach (or Ecclesiasticus) did not become part of the Jewish scriptural canon, but it was still influential on the Jewish liturgy. It was preserved in the Septuagint and is part of the Orthodox and Roman canon. See Wazana, "Case," 693.

138. Foskolou, "Virgin," 251–52.

139. Callisen, "Evil Eye."

140. Maguire, Maguire, and Duncan-Flowers, *Art and Holy Powers*; also Vukosavović, ed., *Angels and Demons*, 54–55. Such "eyespots" (*ocelli*) are also common in the animal kingdom, where they seem to intimidate or deflect attackers; see Behrens, "Eyes Have It."

141. Kessler, "Evil Eye(ing)," 135.

142. Bohak, *Ancient Jewish Magic*, 364, 373.

143. Jehiel ben Yekutiel ben Binyamin Anav ha-Rofe, *Tanya Rabati*, 73 (sect. 19). On Jehiel, see Chapter 6, n. 87.

144. Tomb 8, which also contained bronze coins; see Cedro, "Abbigliamento," 43.

145. Bohak, *Ancient Jewish Magic*, 383.

146. Bruno, "Chiese e religione," 30.

147. L. C. Jones, "Evil Eye," 155. The "fig" was also a Jewish amulet: "the thumb thrust out between the first and second fingers will work to avert the evil eye," according to Isaacs, *Divination*, 144.

148. For examples of the *mano fica* made a century ago, see http://chnm.gmu.edu/ worldhistorysources/d/361/whm.html museum.org.uk/broughttolife/objects/display.asp x?id=4470. For the *hamsa*, see Sabar, "From Sacred Symbol."

149. Véronèse, "God's Names," 41–42: "pentalum quod est altissimum nomen" (n. 25).

150. Fratti, Sansoni, and Scotti, *Nodo di Salomone*. Additional knots in Caprara, "*Singularità*," 25–27, are interpreted as signs of inseparability or union.

151. Bohak, *Ancient Jewish Magic*, 322 with bibliography.

152. See Day, "Knots."

153. The tefillin originate in the biblical injunctions (Exod. 13:9, Deut. 6:6–8, 11:18) to take the commandments uttered by God and "bind them for a sign upon your hand and as frontlets between your eyes"; cf. Prov. 35. See Gandz, "Knot," 197–98.

154. Gandz, "Knot," 192–93.

155. Zidkiyahu Anav, *Shibolei ha-Leqet*, ed. Mirsky, sect. 107.

156. See, e.g., Greenfield, "Contribution."

157. Examples include Acquarica del Capo, where the date 1595 is near some circles; or the sixteenth-century painting in the vestibule of the Cathedral of Otranto that is incised with a circle in the lower-right corner.

158. Hachlili, *Menorah,* 204–9; L. Levine, "History."

159. Bruno, "Chiese e religione," 30; Bruno, ed., "Area cimiteriale," 233; Gravili, "Gioco."

160. Nuzzo, "Reperti," 38–39; the author considers these *tabulae lusoriae* Roman rather than medieval.

161. Although I was able to view them only from a distance, this unpublished Galatina church contains still-impressive figural paintings perhaps datable to ca. 1300.

162. I have also observed vertical game boards incised on walls at the monastery of Hosios Loukas (upper floor) in Greece and at the Royal Chapel at Pyrga on Cyprus.

163. In Cassiano, "Chiesa di San Giovanni Evangelista" (the only publication that mentioned them prior to Safran, "Scoperte salentine," 76–77), these are mistaken for "a fish [and] a labyrinth with icon" (56).

164. Milan, Biblioteca Ambrosiana, MS A 45 sup. (gr. 1); my translation. For the Greek, see Jacob, "Esorcismo," 24.

165. Barb, "St. Zacharias," esp. 40.

166. "Santu Nocila di menzu a mari / spacca l'àschia de stu rorsu / leva la màcula de 'st'occiu. / Sciuvidia santu, Venerdia santu, Sabatu santu, Pasca santu, via li vermi de 'sta panza"; Interesse, *Puglia*, 34. See also Gentilcore, *From Bishop*, 107–13, for early modern examples and the designation "extra-canonical."

167. Haines, "Music and Magic," 169.

168. Jacob, "Bibliothèque médiévale," 291–96. The manuscript was used in or near Aradeo in the late thirteenth to early fourteenth century, but additional texts and drawings were added up to the sixteenth century. For the SATOR-AREPO square, see now Sheldon, "Sator Rebus."

169. Angel, "Use," 789, cites Shaul Shaked.

170. Trachtenberg, *Jewish Magic*, 112–13.

171. Bonfil, *History and Folklore*, 266–68 (sect. 14).

172. Harari, "Scroll."

173. Bonfil, *History and Folklore*, 310–13 (sect. 42).

174. The *merkavah* is the divine chariot-throne of Ezekiel 1 and 10; see, e.g., Gruenwald, *Apocalyptic*; Elior, "Merkabah"; Dan, *Jewish Mysticism*; Boustan, "Study."

175. Véronèse, "God's Names," esp. 39–43.

176. Kanarfogel, *Peering*, 228. Isaiah's ruling is cited by several later authorities.

177. See Chapter 1 on supernatural names.

178. For "parabiblical" rather than "apocryphal" or "pseudepigraphical," see http://teo.au .dk/fileadmin/www.teo.au.dk/fakultetet/afdelinger_og_centre/gammel_og_ny_testamente/ forskning/MRPL.pdf.

179. The last clause is the beginning of a very common liturgical formula. "Δέσποτα Κύριε ὁ Θεὸς ἡμῶν, ὁ εὐλογήσας τοὺς τρεῖς βόας Ἥλιον καὶ Κορνήλιον καὶ Τρισκύλιον, καὶ ἀπὸ ἀσθενείας οὐκ ἐφοβήθησαν, ἀλλὰ γέγοναν μακρόβιοι. Ὁ εὐλογήσας τὸν βοῦν τὸν Ἱεροσαλυμίτην, ὁ τὰ τίμια ξύλα φέρας καὶ ποιήσας αὐτὸν μακρόβιον καὶ μακρο-χρόνιον, καὶ νόσον οὐκ ἐφοβήθησαν. Κατ᾽ἐκείνην τὴν εὐλογίαν εὐλόγησον τὰ βοήδια τοῦ δούλου τοῦ Θεοῦ ὁ δεῖνα διὰ τὸ ἅγιον ὄνομά σου καὶ διὰ πρεσβειῶν τῆς ἀχράντου δεσποίνης ἡμῶν Θεοτόκου καὶ ἀειπαρθένου Μαρίας, τῶν τιμίων ἀσωμάτων καὶ ἐπου-ρανίων δυνάμεων καὶ τοῦ ἁγίου ἐνδόξου ὁ δεῖνα καὶ πάντων τῶν ἁγίων, ἀμήν. Ὅτι πρέ-πει σοι." Jacob, "Rite du καμπανισμός," 236–37; I thank Vasileios Marinis and Stratis Papaioannou for help with this translation. It was the search for these mysterious names of cows that first spurred my interest in medieval magic.

180. Bohak, "Hebrew," 75–76.

181. Véronèse, "God's Names," 44 and n. 45.

182. Ibid., 49, 50 n. 69.

183. Tamburini, "Documenti pontifici," 28.

184. Haines, "Music and Magic," 172.

185. Miller, trans., "Kasoulon," 1327 (chap. 14). See also Gerstel, "Layperson," 106.

186. Colafammina, "Cultura nelle giudecche," 110–11; the Christians were allowed to buy the offending synagogue (in a neighborhood of Christian houses) from the Jews, who were permitted to build a new one in the Jewish part of town.

187. For the foregoing, see Elbogen, *Jewish Liturgy*, esp. 117–18, 173.

188. Bonfil, *History and Folklore*, 304–6 (sect. 39).

189. Zidkiyahu Anav, *Shibolei ha-Leqet*, ed. Buber, 295; Bonfil, "Mito, retorica," 115–18.

190. Bonfil, *History and Folklore*, 124–25.

191. Castaldo, "Immagini."

192. Judah Romano, *Chiarificazione*, ed. Debenedetti Stow, 2:129; De Donno, *Dizionario*, nos. 16663, 16665, *zzampogna, zzampognaru* (the musician).

193. Di Segni, "Cultura folklorica."

194. I. Adler, "Music Notations"; Golb, "Music of Ovadiah."

195. C. Levi, "Contributo"; Hilton, *Christian Effect*, 45.

196. Rivera, *Mago*, 185, 251–52.

197. Naselli, "Etimologia."

198. On various aspects of tarantism, medieval and modern, see De Martino, *Sud e Magia*; De Martino, *Terra del rimorso*; Di Mitri, "Mitografia"; Lapassade, *Intervista*; Mina, ed., *Morso*; Gentilcore, *From Bishop*, 149–56; Gentilcore, "Ritualized Illness"; Horden, "Commentary on Part IV"; Lüdtke, *Dances*; Lüdtke, "Tarantism"; Daboo, *Ritual, Rapture*.

199. Although San Foca, on the Adriatic coast near Lecce, was also considered to be protected from insect and snake bites by its homonymous patron saint, Phocas, it never became a site of veneration by the afflicted *tarantati*.

Chapter 8. Theorizing Salentine Identity

1. Díaz-Andreu and Lucy, "Introduction," 1.

2. Loud, "Laws," 175.

3. S. Jones, *Archaeology of Ethnicity*, 104.

4. See esp. Lucy, "Ethnic and Cultural Identities"; Bartlett, "Medieval and Modern," esp. 39–42; de Heusch, "*Ethnie*."

5. See, e.g., "Neanderthals, Humans Interbred—First Solid DNA Evidence," http://news.nationalgeographic.com/news/2010/05/100506-science-neanderthals-humans-mated-interbred-dna-gene/; and Billinger, "Another Look."

6. Jones, *Archaeology of Ethnicity*, xiii and 84.

7. Bentley, "Response," 169.

8. Jacob, "Vaste," 251–52; Berger and Jacob, "Nouveau monument," 217–18.

9. See Introduction, note 40. The village of Racale (for Herakleia?) near Gallipoli may bear witness to this population transfer.

10. Bentley, "Ethnicity," 25–26; Jones, *Archaeology of Ethnicity*, esp. 65–83.

11. Neilos of Rossano, *Vita*, 62–63 (sect. 8). Peters-Custot, *Grecs de l'Italie*, 33 n. 110, indicates that this is evidence for all these groups actually being present in Rossano, but surely the Greek-speaking children are simply naming all the "ethnic" groups they have heard of, regardless of their actual local presence.

12. Loud, "How 'Norman'"; Falkenhausen, "Gruppi etnici," 133; Peters-Custot, *Grecs de l'Italie*, 33. Many "Normans" came from elsewhere in France, particularly Brittany.

13. Falkenhausen, "Gruppi etnici," 138; Drell, "Cultural Syncretism," 196, quotes G. A. Loud: "people began to give their children the names of the conquerors in an attempt 'to fit into the accepted social structure and emphasise their links with the invaders.'"

14. Other reasons include, among many similar examples, men who are identified as "Grecus" but sign documents in Latin, or the eleventh-century Catholic bishop of Bari named Bizantius, recorded as being *terribilis et sine metu contra omnes Graecos* (Falkenhausen, *Dominazione*, 174), or the Orthodox abbot named Benedict at San Vito dei Normanni [**109.A**].

15. Peters-Custot, *Grecs de l'Italie*, 33 n. 113.

16. Kazhdan, "Latins and Franks," 89–90, 99; Kolbaba, "Byzantine Perceptions," 135.

17. Cited in Majeska, "Byzantines," 81.

18. Kolbaba, *Byzantine Lists*, 178, 180.

19. Kolbaba, "Byzantine Perceptions," 139 n. 104. In 1204, Constantine Stilbes expanded the already stereotypical critique with the longest such list, "The Faults of the Latin Church"; see Kolbaba, *Byzantine Lists*, 178.

20. Kazhdan, "Latins and Franks," 84–85, affirms the absence of the collective term "Latins" (*Latinoi*) in Byzantine texts before the twelfth century; on Anna Komnene's use of the term, ibid., 90.

21. Ibid., 86.

22. Hunger, *Graeculus perfidus*, 40.

23. George Pachymeres, in Laiou, "Italy and the Italians," 73.

24. Hunger, *Graeculus perfidus*, 38.

25. Kolbaba, "Meletios Homologetes." In the first and last lines Meletios claims to discuss the customs of the Italians.

26. P. Hoffmann, "Lettre," 277–81. The manuscripts are Mount Athos, Iviron Monastery, MS 199, copied in 1297/98 by a scribe from Galatina, and Rome, Biblioteca Vallicelliana, MS C 97² (gr. 47), executed in 1424 by the son of a *protopsalte* from Corigliano.

27. Hoffmann, "Lettre," 281 (lines 52–53). "Goths" usually appear in Byzantine discourse as "Scythians."

28. Darrouzès, "Faux acte"; Acconcia Longo and Jacob, "Anthologie," esp. 165, 220. The latter authors show that the codex was copied in the Grecìa salentina.

29. Minuto, "Trattato contra Greci."

30. Corsi, "Testimonianze," 95.

31. Loenertz, "Épitre de Théorien"; Magdalino, *Empire*, 387; Magdalino, "Prosopography," 53–55.

32. "καὶ ἀγαπᾶτε τοὺς Λατίνους αὐτοὺς <ὡς> συναδέλφους · ὀρθόδοξοι γάρ εἰσι καὶ τέκνα τῆς καθολικῆς καὶ ἀποστολικῆς ἐκκλησίας ὥσπερ ἡμεῖς" (Vatican City, Biblioteca Apostolica Vaticana, MS gr. 1481, fol. 151v).

33. This was suggested to me many years ago by Paul Magdalino, although he is not so specific in "Prosopography," 54, where he does associate Theorianos with southern Italy. The name was known in twelfth-century Gallipoli; see Trinchera, *Syllabus*, 520, 530.

34. See Kaldellis, *Hellenism*, 63.

35. Ibid., 115–16 and quote on 343; Page, *Being Byzantine*, 66. The identification of Michael VIII Palaiologos as "Altissimus Imperator Graecorum" on a silk textile in Genoa is evidence that the inscriptions were added to this Byzantine gift by "Westerners"; see Johnstone, "Byzantine 'Palio.'" The textile is explicated more fully in Hilsdale, "Imperial Image" (see p. 181 for the inscription).

36. Kaldellis, *Hellenism*, 345.

37. Acconcia Longo and Jacob, "Anthologie," 217 (Γραικῶν ἐκκλησίας); Hoeck and Loenertz, *Nikolaos-Nektarios*, 133, line 146; 134, lines 168 and 185.

38. Acconcia Longo, "Nuovo codice," 135.

39. Zeitler, "Urbs Felix," 128.

40. Jacob, "Vestiges d'un livret," 522–23.

41. Lelli, "Influenza," 201–205; Lelli, "Liturgia, lingue." *Qehillah* means community or congregation.

42. Lelli, "Influenza"; Lelli, "Liturgia, lingue."

43. Jacoby, "Jewish Community"; Jacoby, "Juifs de Byzance."

44. Shepkaru, *Jewish Martyrs*, esp. 128–32; Shepkaru, "To Die for God."

45. Geula, "Midrašim," 43 and nn. 2–3, reads "Salon[ti]" ("Salento") citing agreement with the *Dizionario storico dell'Accademia della Lingua Ebraica*'s "Salon[ty]" and divergence from Ginzberg's 1928 reading, "Salon[icco]." Cf. Bonfil, "La visione ebraica," 31, 52, 57, where Bonfil maintains the reading of the damaged word as "Salon[icco]," revising his own earlier reading ("Vision of Daniel") of the damaged word as "Salon[ti?]," which was accepted by Holo, *Byzantine Jewry*, 25 n. 7. Given that the sequence of places listed moves roughly from west to east—Rome, Salen[?], Sicily, Verria, Strongylon, and so on—it is hard to see why Thessalonike should appear between Rome and Sicily and not adjacent to Verria, which is, in fact, its geographical location.

46. Bowman, "Jewish Responses"; Lasker and Stroumsa, *Polemic*; Biale, "Counter-History"; J. Cohen, "Towards a Functional Classification"; D. Berger, "Mission"; Krauss, *Jewish-Christian*; Limor and Stroumsa, *Contra Iudaeos*; de Lange, "Fragment," describes one such text in a mix of Hebrew and Greek (twelfth century).

47. Holo, *Byzantine Jewry*; Elukin, *Living Together*, is probably too rosy.

48. Hollender, "*Piyyut* italiano," 28.

49. Bonfil, *History and Folklore*, 272 (sect. 19). These epithets make a rhyme in Hebrew: *malchut arelim, odey alelim, ovdim levalim*.

50. "Franga" was used by a member of the Kalonymos family, formerly from southern Italy; see Schirmann, "Beginning," 265.

51. Zimmels, "Scholars," 176; Holo, "Byzantine-Jewish," 942.

52. Bonfil, *History and Folklore*, 260; of Basil's son, Leo VI, who annulled his father's decree of Jewish persecution, the *Chronicle of Ahima'az* says "may his memory be blessed" (ibid., 270).

53. Shabbetai Donnolo uses the term "Romi," and also distinguishes "Greek" from "Macedonian" as referring, respectively, to ancient Greece and the Byzantine Macedonian dynasty; see Holo, "Byzantine-Jewish," 941.

54. Shepkaru, *Jewish Martyrs*, 115.

55. For example, Bonfil, *History and Folklore*, 319–21.

56. For this northern art, see Lipton, *Images*; Mellinkoff, *Outcasts*; Strickland, *Saracens*.

57. For Jews in Byzantine art, see Revel-Neher, *Image*; Maayan-Fanar, "Silenus."

58. See fig. 28 in Falla Castelfranchi, "Sul Bosforo," 321: Christ's blessing hand, with palm forward, has the thumb over the ring and little fingers while the two fingers extended in blessing have the nails visible. Fingernails were often associated with divination (onychomancy) or considered demonic (especially the thumb, in Jewish texts); their parings were supposed to be saved so that one would not be incomplete at the time of bodily resurrection.

59. An identical trio appears at San Mauro near Gallipoli, but without the knife.

60. In the Jephonias episode at Santa Maria di Cerrate [**Plate 15**], the Jew is now invisible even though the archangel is well preserved; it must have been effaced deliberately. At Acaya, Jephonias's severed hands drip blood.

61. Falla Castelfranchi, *Pittura monumentale*, 137.

62. S. A. Epstein, *Speaking*, 108–9.

63. See Chapter 3.

64. Barth, "Enduring," 12; Bartlett, "Medieval and Modern," 40; Hakenbeck, "Situational Ethnicity"; Geary, "Ethnic Identity."

65. E.g., Arthur, "Albania," 79–81.

66. Blumenkranz, "Conversion"; Rotman, "Converts," 914–16; Falkenhausen, "Jews in Byzantine Southern Italy," 287–88; Colafemmina, "Conversione al giudaismo"; Bonfil, "Ovadiah da Oppido"; Prawer, "Autobiography."

67. Jacobus of Verona, *Liber*, ed. Röhricht, 173; and ed. Khull, 49.

68. Hoeck and Loenertz, *Nikolaos-Nektarios*, 182–84; Falkenhausen, "In Search," 886.

69. Eleuteri and Rigo, *Eretici*, 42–50; Falkenhausen, "In Search," 886.

70. Starr, "Mass Conversion."

71. Zeldes, "Legal Status," 3–11; Scheller, "Materiality."

72. Colafemmina, *Ebrei e cristiani*; Ferorelli, *Ebrei*, chap. 2. In 1267, Manuforte, the former *archisynagogus* of Trani, was instrumental in indicting the Jewish holy books and accusing individual Jews.

73. Zeldes, "Legal Status," 8; Scheller, "Materiality," esp. 410–11.

74. Malkiel, "Jews and Apostates," 6.

75. Ibid., 9, 24. There were also serial apostates.

76. Ibid., 23–24 (quote on p. 24).

77. Ibn Hawqal; cited in Davis-Secord, "Medieval Sicily," 66.

78. Ankori, *Karaites*, 287, 297–98.

79. Barker, "Thoughts," with earlier bibliography.

80. Ibid., 56.

81. Loud, "How 'Norman,'" esp. 23–24.

82. Robinson, "Some Cave Chapels," 206.

83. McKee, *Uncommon Dominion*, 114–15.

84. Makris, "Gasmulen."

85. Canart and Lucà, eds., *Codici greci*, no. 60 (p. 132, by André Jacob), describes this manuscript (Grottaferrata, Biblioteca della Badia Greca, MS Crypt. Z.α XLIV). Vat. gr. 1276 (cited above, n. 28) contains an early fourteenth-century Salentine copy of Digenis Akritis.

86. McKee, *Uncommon Dominion*, 188.

87. McKee, "Households," 66.

88. Quave and Pieroni, "Ritual Healing," 58.

89. Nederveen Pieterse, "Hybridity," 234–35.

90. Barth, "Introduction."

91. Barth, "Enduring," 13.

92. Gardette, *Culture*, 34–37.

93. Falkenhausen, "In Search," 883; Bonfil, *History and Folklore*, 158, 284–85 (sect. 29).

94. See Chapter 7, n. 35.

95. Attested in a responsum of Isaiah of Trani (thirteenth century); see Bowman, *Jews*, 213–14.

96. For some examples from medieval Ashkenaz, see Malkiel, "Jews and Apostates," 32; and especially Baumgarten, *Mothers*. Joint businesses owned by a Jew and a non-Jew and other such interactions are mentioned in *Shibolei ha-Leqet* (with the author or his brother offering firsthand observations about thirteenth-century Rome) and by Isaiah of Trani; see, e.g., Zidkiyahu Anav, *Shibolei ha-Leqet*, ed. Mirsky, 112–13. The mendicant orders wanted to limit the activities of Jewish butchers and wine producers so that Christians would not be forced to come into contact with them (Toaff, "Vita," esp. 253); although this information pertains to northern Italy it was likely true in the south as well.

97. "In illa civitate cum cristianis morantur"; see Jacobus of Verona, *Liber*, ed. Röhricht, 173, and ed. Monneret de Villard, 14.

98. Calò Mariani, "Dal chiostro," 719, 722.

99. *Tanya Rabati*, an abridgment of *Shibolei ha-Leqet* that served as the basis of the later Italian prayer book, refers to a Roman authority, the author's uncle Benjamin, who permits Jews to wear clothing sewn by non-Jews that are delivered on the Sabbath. This is in opposition to Ashkenazic practice. Clearly, Jews in thirteenth-century Rome were using non-Jewish tailors (Jehiel ben Yekutiel ben Binyamin Anav ha-Rofe, *Tanya Rabati*, 77–78 (sect. 19).

100. Bruno, "Chiese medievali"; Limoncelli, "Dallo scavo." This was certainly the function of the comparable examples in fifteenth-century Crete; see Gratziou, "Evidenziare."

101. This compromise was mooted at the Second Council of Lyons in 1274, but there is no evidence that such a solution was actually implemented. See Vetere, "S. Maria de Nerito," 332.

102. Ercole Lamia, bishop of Alessano; cited in Rodotà, *Dell'origine,* 1:400. Cf. also the custom at Ruffano, in Lisi, "Per la storia."

103. Coco, "Cause," 258.

104. Lisi, *Fine del rito,* 117.

105. Paoli, *De Ritu*; complete rite, 212–52; Rodotà, *Dell'origine*, 1:392. Galatone (Galatena Oppidum Graecorum) had a population of 4,750 in 1412 (Vetere, "S. Maria de Nerito," 332). It became part of the diocese of Nardò only after 1413; apparently it was independent before that date, under the authority of a *protopapas* rather than a bishop, and had other privileges as a result; see Danieli, *Rito greco,* 24. Nardò's population in 1412 was over twenty thousand, and nearly twelve thousand of these were "Greek" ethnically or by rite (Vetere, "S. Maria de Nerito," 314).

106. "Interea alternante Choro Latino, & Graeco, cantatur alta voce Responsale" (Paoli, *De Ritu*, 117).

107. Zacchino, *Galatone*, 79, 100–1.

108. On the persistence of Orthodox customs in Galatone as late as 1637, see Megha, *Galatone*; Vetere, "S. Maria de Nerito," 336.

109. Milan, Biblioteca Ambrosiana, C7 sup.; see Jacob, "Annales d'une famille."

110. Ibid., 40.

111. Ungruh, *Bodenmosaik*, esp. 158–88.

112. Ibid., 144–47, 329–41 (Thalassa) and 87–96, 112–13, 278–81 (Kairos). These observations were made by Christine Ungruh at the 47th International Congress on Medieval Studies at Kalamazoo in May 2012, in a paper titled "Kairos: On the Efficacy of a Classical Motif in Medieval Italian Art."

113. "καὶ λέγων ὅτι Πεπλήρωται ὁ καιρὸς καὶ ἤγγικεν ἡ βασιλεία τοῦ θεοῦ · μετανοεῖτε." Mark 1:15 was read in the Orthodox church on the eve of Theophany and in the Roman church on the third Sunday after Epiphany and the first Sunday of Lent. Could the baptismal font originally have been near these images?

114. Galaktion's emendations to the Orthodox baptismal rite are discussed in Chapter 5.

115. Pasquini, "Interculturalità."

116. Cited in Ughelli, *Italia Sacra*, col. 53: "tres Græcorum erant Ecclesiae, in quibus Græci Sacerdotes, & Ministri, Græco more sacra faciebant." See also Rodotà, *Dell'origine,* 1:373.

117. Jacob, "Fondation d'hôpital." Cf. the twenty days' remission for attending the anniversary of the consecration at Santa Maria del Galeso [**144**].

118. Parenti, *Monastero,* 337; Canart and Lucà, eds., *Codici greci*, 109 (by André Jacob). A further note marks the death of Emperor Henry VII in 1313 and another names the last Orthodox archpriest of Galatina (second half of the fifteenth century). For the Castro bishop, see Jacob, "Vat. gr. 1238."

119. Papadakis, *Crisis*, 20.

120. Marino Sanudo Torsello, *Istoria del Regno*, 143–44 (ca. 1326–33): "Sonvi anco molti Greci in Calabria ed in Terra d'Otranto, che ubbidiscono alla Santa Chiesa Romana, ma forse non così devotamente, se l'imperator sior Michiel Paleologo detto e il Patriarca Costantinopolitano ed il figlio del detto imperatore Sior Andronicus fossero fermi e ubbidienti alla Chiesa romana e non in contumacia, onde segue danno immenso." Beginning right after the Normans' arrival, bishops who refused to recognize the primacy of the Roman pope had to relocate to a still-Orthodox bishopric, but few did so; they preferred to recognize papal authority and retain their episcopal seats; see Falkenhausen, "Popolamento," 41.

121. Lisi, *Fine del rito*; Coco, "Cause"; Coco, "Vestigi." Andrano is not included in the sixteenth-century catalog that lists towns according to which language is spoken and which rite is celebrated, but its neighbors are identified as belonging to the group that speaks Latin (actually Romance) and practices both rites; see Corsi, "Comunità bizantine."

122. The title of the scene and the texts on the scrolls held by Zechariah and John are transcribed and translated in Safran, "Betwixt or Beyond," 123.

123. Constas, *Proclus*, 173–75.

124. Ibid., 191.

125. Spatharakis, *Pictorial Cycles*, 150, 193; Pätzold, *Akathistos-Hymnos*.

126. See Leroy, *Homilétique*, 67–75; manuscript contents at "Pinakes: Textes et manuscrits grecs," http://pinakes.irht.cnrs.fr/rech_manusc/resultManuscrit/filter_ville/351/filter_depot/633/filter_cote/Vat.%2Bgr.%2B1633; *De Incarnatione* occupies fols. 52–55.

127. Grottaferrata, MS Crypt. Γα 1; see Parenti, *Monastero*, 367. I thank Stefano Parenti for his generous assistance.

128. Bourdieu, *Distinction*.

129. By Asterius of Amaseia, Gregory of Nyssa, and Proclus of Constantinople (fols. 56–66).

130. His Orthodox feast days occur in other months: May 8, June 30 (with all the apostles), and September 26.

131. Kogman-Appel, "Jewish Art," 19.

132. Mary Louise Pratt, *Under Imperial Eyes: Travel Writing and Transculturation* (New York: Routledge, 1992), 6, cited in Ashley and Plesch, "Cultural Processes," 4. See also Morrissey, "Cultural Geographies."

133. Rosser-Owen, "Mediterraneanism," 9.

134. But cf. Ambrose, "Influence."

135. Appropriation is "active, subjective, and motivated" (Nelson, "Appropriation," 118).

136. Many of these concepts are discussed in the excellent overview by Ashley and Plesch, "Cultural Processes."

137. Safran, "Betwixt or Beyond," esp. 119–22.

138. See Tronzo, "Regarding Norman Sicily," 109–10; Safran, "'Byzantine' Art."

139. Peters-Custot, *Grecs de l'Italie*; for the term, see esp. 28–29. Her focus is on language, law, and religion, "the least material forms of culture that define cultural particularity" (29).

140. Shaw and Stewart, "Introduction," 6.

141. Drell, "Cultural Syncretism," 201.

142. Peters-Custot, *Grecs de l'Italie*, 549–66; Jacob, "Culture grecque," 61–62; Jacob, "Gallipoli," 308; cf. Cavallo, "Libri greci." Peters-Custot, *Grecs de l'Italie*, notes that "latinization" is exclusively linguistic and a better term would be "occidentalization" (26) or "romanization" (265), especially given the papal effort to bring the region under its jurisdiction; but cf. p. 433, where all three terms are used. Mattingly, "Cultural Crossovers," 285–87, addresses "the -ization problem."

143. Marcus, *Rituals*; Kogman-Appel, "Jewish Art."

144. See Marcus, *Rituals*, 104; and the essays in Kessler and Nirenberg, eds., *Judaism and Christian Art.*

145. He argued that the Spaniards' contact with so-called New World peoples affected them as well as the dominated Amerindian groups; see Ortíz, *Cuban Counterpoint*, 102; see also Coronil, "Transcultural Anthropology."

146. See Rogers, "From Cultural Exchange"; Altschul, "Future of Postcolonial"; Burke, *History and Social Theory*, esp. 106.

147. Rogers, "From Cultural Exchange," 478.

148. Flood, *Objects of Translation*, 4.

149. Hutnyk, "Hybridity," 83. The author surveys what he calls the "uses and misuses" of the "usefully slippery" term and its synonyms.

150. Nederveen Pieterse, "Hybridity," 221. The French equivalent is *bricolage* (ibid., 237).

151. Ibid., 220; also 224–30.

152. Tronzo, "Regarding Norman Sicily," esp. 108–9; Tronzo, "Restoring Agency," 579–80.

153. Shaw and Stewart, "Introduction," esp. 1, 6, 10; Drell, "Cultural Syncretism."

154. Rosser-Owen, "Mediterraneanism," 10.

155. This is different from (though not unrelated to) Homi Bhabha's statement in *Location of Culture*, 228, that "translation is the performative nature of cultural communication," which refers mainly to the physical movement of individuals and takes cultural translation in a non-linguistic sense.

156. Burke, *History and Social Theory*, 107; see also Classen, "Translation."

157. Classen, "Translation," 73, 75.

158. Margit Mersch included these terms in a lecture titled "Transkulturalität, Verflechtung, Hybridisierung—'neue' epistomologische Modelle in der Mittelalter-forschung" at the conference on "Processes of Entanglement: Agents, Junctures, Interpretations and Conceptualizations of Mutual Interaction in the Premodern Period" at the Westfälische Wilhelms-Universität in Münster, April 3–5, 2013.

159. Flood, *Objects of Translation*, 5, citing Sheldon Pollock's ideas on "cosmopolitanism."

160. That this was already the case a millennium earlier is argued in Colivicchi, ed., *Local Cultures.*

161. Peters-Custot, *Grecs de l'Italie*, 435–566: "La rupture du XIIIᵉ siècle et ses conséquences; la latinisation des minorités."

162. Falkenhausen, "Popolamento," 40; Falkenhausen, "Babele di lingue," esp. 27.

163. Nederveen Pieterse, "Hybridity," 238.

164. Bhabha, *Location of Culture*, 2.

165. Michel Butor, quoted in Ashley and Plesch, "Cultural Processes," 11.

166. Peters-Custot, *Grecs de l'Italie*, 28, 50.

167. Safran, "'Byzantine' Art." "Italo-Byzantine" has occasionally been used to refer to artistic style or context, but the tendency among art historians in Italy is to call most postmedieval art in the Salento simply "Byzantine."

168. Peters-Custot is very aware of these sharp differences between the Byzantine themes of Longobardia and Calabria, but she nevertheless uses the same locution for both.

169. One scholar essentially threw up his hands and began an article on the Salentine "school" of Greek poets this way: "Call them 'Byzantines' or 'Greeks' or 'Italo-Byzantines' or 'Italo-Greeks' of the 'Salento' or 'Terra d'Otranto'; the only thing on which everyone can agree is the poetic chronology of three generations of thirteenth-century poets" (Cesaretti, "Da 'Marco d'Otranto,'" 183).

170. Beta thalassemia, an anemia that confers resistance to malaria; see McCormick, "Imperial Edge," 25–30.

Works Cited

Abbreviations

BMFD *Byzantine Monastic Foundation Documents*. Ed. John Philip Thomas and Angela Con-
 stantinides Hero, with Giles Constable. 5 vols. Washington, D.C.: Dumbarton Oaks
 Research Library and Collection, 2000. http://www.doaks.org/resources/publications/
 doaks-online-publications/byzantine-studies/typikapdf
BSTd'O *Bollettino storico di Terra d'Otranto*
BT Babylonian Talmud
DOP *Dumbarton Oaks Papers*
MEFRM *Mélanges de l'École française de Rome, Moyen âge, Temps modernes*
PT Palestinian (Yerushalmi) Talmud
RSBN *Rivista di Studi Bizantini e Neoellenici*

Primary Sources

Aetius Amidenus, *Libri medicinales V–VIII*. Ed. Alexander Olivieri. Corpus Medicorum Graeco-
 rum 8, no. 2. Berlin: Academiae Scientiarum, 1950. http://cmg.bbaw.de/epubl/online/
 cmg_08_02.html.
Alberti, F. Leandro. *Descrittione di tutta Italia di F. Leandro Alberti bolognese*. Riproduzione
 anastatica dell'edizione 1568. 2 vols. Bergamo: Leading Edizioni, 2003.
Anskar. *Anskar, the Apostle of the North, 801–865: Translated from the Vita Anskarii by Bishop
 Rimbert, His Fellow Missionary and Successor*. Trans. Charles H. Robinson. London: Society
 for the Propagation of the Gospel in Foreign Parts, 1921.
Brightman, F. E. *Eastern Liturgies, Being the Texts Original or Translated of the Principal Liturgies
 of the Church*. Piscataway, N.J.: Gorgias Press, 2002.
Codice diplomatico del regno di Carlo I e II d'Angio. 3 vols. Ed. Giuseppe del Giudice. Naples:
 Stamperia della R. Università, 1863–1902.
Corpus Inscriptionum Graecarum. Vol. 4, pt. 39. Ed. August Böckh et al. Berlin: Officina Acad-
 emica, 1877. http://www.mom.fr/digimom/Notice.php?id=1146&limit=0.
*Corpus Inscriptionum Hebraicarum: Enthaltend Grabschriften aus der Krim und andere Grab-
 und Inschriften in alter hebräischer Quadratschrift sowie auch Schriftproben aus Hand-
 schriften vom IX.–XV. Jahrhundert*. Ed. Daniil A. Khvol'son. St. Petersburg, 1882; repr.,
 Hildesheim: Olms, 1974.
Corpus Inscriptionum Iudaicarum. Vol. 1, *Europe*. Ed. Jean-Baptiste Frey. Sussidi allo studio
 delle antichità cristiane 1. Vatican City: Pontificio istituto di archeologia cristiana, 1936.
Eustathius of Thessaloniki. *The Capture of Thessaloniki*. Trans. John R. Melville Jones. Byzantina
 Australiensia 8. Canberra: Australian Association for Byzantine Studies, 1988.

Felix Fabri. *The Wanderings of Friar Felix Fabri*. Vol. 2, pt. 1. Trans. Aubrey Stewart. London: Palestine Pilgrims' Text Society, 1892.

Isaiah ben Mali di Trani. *Teshuvot ha-Rid: The Responsa of Rabbi Isaiah the Elder of Terrani, Italy (13th cent.)* [in Hebrew]. Ed. Abraham Joseph Wertheimer. Jerusalem: Yad ha-Rav Hertzog, 1967.

Jacobus of Verona. *Liber peregrinationis*. Ed. and trans. Ferdinand Khull. In *Zweier deutscher Ordensleute Pilgerfahrten nach Jerusalem in den Jahren 1333 und 1346*. Graz: Styria, 1895. http://resikom.adw-goettingen.gwdg.de/berichte/PDF/Khull_1895_Ordensleute.pdf.

———. Ed. Reinhold Röhricht. In "Le pèlerinage du moine augustin Jacques de Vérone (1335)." *Revue de l'Orient Latin* 3 (1895): 155–302.

———. Ed. U. Monneret de Villard. In *Il nuovo Ramusio* 1. Rome: Libreria dello Stato, 1950. In Archivio della Latinità italiana del Medioevo (ALIM). http://www.uan.it/alim/letteratura .nsf/(testiID)/367AC644ECB35B5BC1256D480034B4BC!opendocument.

Jacobus de Voragine. *The Golden Legend: Readings on the Saints*. Trans. William Granger Ryan. 2 vols. Princeton, N.J.: Princeton University Press, 1993.

Jehiel ben Yekutiel ben Binyamin Anav ha-Rofe. *Tanya Rabati: Piske halakhot, dinim u-minhagim* [in Hebrew]. Jerusalem: Mosad ha-Rav Kook, 2011.

Jerahmeel (pseud.). *The Chronicles of Jerahmeel; or, the Hebrew Bible Historiale* Ed. and trans. Moses Gaster. Prolegomenon by Haim Schwarzbaum. New York: Ktav Publishing House, 1971.

John Malalas. *The Chronicle of John Malalas*. Trans. Elizabeth Jeffreys, Michael Jeffreys, and Roger Scott, with Brian Croke. Byzantina Australiensia 4. Melbourne: Australian Association for Byzantine Studies, 1986.

Judah (ben Moshe) Romano. *La chiarificazione in volgare delle "espressioni difficili" ricorrenti nel Misnèh Toràh di Mosè Maimonide: Glossario inedito del XIV secolo*. Ed. Sandra Debenedetti Stow. 2 vols. Rome: Carucci Editore, 1990.

Marino Sanudo Torsello. *Istoria del Regno di Romania*. In *Chroniques gréco-romanes inédites ou peu connues publiées avec notes et tables généalogiques par Charles Hopf*, ed. Charles Hopf, 99–170. Berlin: Weidmann, 1873; repr., Brussels: Culture et Civilisation, 1966.

Midrash Tanhuma. Trans. John T. Townsend. Hoboken, N.J.: Ktav, 1989. Tractate Ha'azinu. http://www.sacred-texts.com/jud/mhl/mhl04.htm.

Neilos of Rossano. *Vita di San Nilo Abate, fondatore della Badia di Grottaferrata,* by Saint Bartholomew. Trans. D. Antonio Rocchi. Rome: Desclée, Lefebvre e C., 1904.

Patrologiae cursus completus, series Graeca [*Patrologia Graeca*]. Ed. J.-P. Migne. 166 vols. Paris: Migne, 1857–86.

Rerum italicarum scriptores. . . . Ed. Ludovico Antonio Muratori. 25 vols. Milan: ex-Typographia Societatis Palatinae, 1723–51.

Zidkiyahu (ben Abraham) Anav ha-Rofe. *Shibolei ha-Leqet*. Ed. Salomon Buber. In *Sefer Shibole ha-leqet ha-shalem* [in Hebrew]. Vilna, 1886; repr., Jerusalem: Alef makhon le-hotsa'at sefarim, 1969.

———. Ed. Samuel K. Mirsky. In *Shibolei Haleket Completum* [in Hebrew]. New York: Feldheim, 1966.

———. Ed. Simha Hasida. In *Il libro "Shibboley Hal-Leket" (Parte seconda)* [in Hebrew]. Jerusalem: Mekhon Yerushalayim, Or ha-mizrah, 1987.

Secondary Sources

Aar, Ermanno. "Gli studi storici in Terra d'Otranto." *Archivio Storico Italiano*, ser. 4, 9 (1882): 238.

Abatangelo, Luigi. *Chiese-cripte e affreschi italo-bizantini di Massafra*. 2 vols. Taranto: Cressati, 1966.

Abrahams, Israel. *Jewish Life in the Middle Ages*. Ed. Cecil Roth. London: E. Goldston, Ltd., 1932.

Abrahamse, Dorothy. "Rituals of Death in the Middle Byzantine Period." *Greek Orthodox Theological Review* 29 (1984): 125–34.

Abrams, Dominic, and Michael A. Hogg. *Social Identity Theory: Constructive and Critical Advances*. London: Harvester-Wheatsheaf, 1990.

Abulafia, David. "Bad Rulership in Angevin Italy: The Sicilian Vespers and Their Ramifications." *Haskins Society Journal* 8 (1996): 115–35.

Acconcia Longo, Augusta. "Un nuovo codice con poesie salentine (Laur. 58, 25) e l'assedio di Gallipoli." *RSBN* 20–21 (1983–84): 123–70.

Acconcia Longo, Augusta, and André Jacob. "Une anthologie salentine du XIVᵉ siècle: Le *Vaticanus gr.* 1276." *RSBN*, n.s., 17–19 (1980–82): 149–228.

Adelman, Howard Tzvi. "Religious Practice Among Italian Jewish Women." In *Judaism in Practice: From the Middle Ages Through the Early Modern Period*, ed. Lawrence Fine, 203–9. Princeton, N.J.: Princeton University Press, 2001.

Adler, Israel. "The Music Notations by Ovadiah the Norman Proselyte and Their Significance for the Study of Jewish Music." In *Giovanni-Ovadiah da Oppido, proselito, viaggiatore e musicista dell'età normanna: Atti del convegno internazionale, Oppido Lucano, 28–30 marzo 2004*, ed. Antonio De Rosa and Mauro Perani, 207–23. Florence: Giuntina, 2005.

Adler, Marcus Nathan. *The Itinerary of Benjamin of Tudela: Critical Text, Translation and Commentary*. London: Henry Frowde, 1907.

Alaggio, Rosanna. *Brindisi medievale: Natura, santi e sovrani in una città di frontiera*. Naples: Editoriale Scientifica, 2009.

Alessio, Giovanni. "Grecità e Romanità nell'Italia meridionale." In *Byzantino-Sicula II: Miscellanea di Scritti in memoria di Giuseppe Rossi Taibbi*, 11–44. Palermo: Istituto siciliano di studi bizantini e neoellenici, 1975.

———. "Nuovo contributo al problema della grecità dell'Italia meridionale." *Rendiconti del R. Istituto lombardo di Scienze e Lettere* 72, no. 2 (1938–39): 109–72; 74, no. 2 (1940–41): 631–706; 77, no. 2 (1943–44), 617–706; 79, no. 1 (1945–46): 65–92.

———. "Sul nome di Òtranto." *Archivio Storico Pugliese* 5 (1952): 216–36.

Alexandre-Bidon, Danièle. "Du drapeau à la cotte: Vêtir l'enfant à la fin du Moyen Âge (XIIIᵉ–XVᵉ s.)." In *Le vêtement: Histoire, archéologie, symbolique vestimentaire au Moyen Âge*, ed. Michel Pastoureau, 123–68. Paris: Léopard d'Or, 1989.

Alexandre-Bidon, Danièle, and Didier Lett. *Children in the Middle Ages: Fifth to Fifteenth Centuries*. Trans. Jody Gladding. South Bend, Ind.: University of Notre Dame Press, 1999.

Alexiou, Margaret. *The Ritual Lament in Greek Tradition*. 2nd ed. Revised by Dimitrios Yatromanolakis and Panagiotis Roilos. Lanham, Md.: Rowman & Littlefield, 2002.

Althaus, Klaus-Rainer. *Die Apsidenmalereien der Höhlenkirchen in Apulien und in der Basilikata, Ikonographische Untersuchungen*. Hamburg: Kovac, 1997.

Altschul, Nadia R. "The Future of Postcolonial Approaches to Medieval Iberian Studies." *Journal of Medieval Iberian Studies* 1 (2009): 5–17.

Ambrose, Kirk. "Influence." *Studies in Iconography* 33 (2012): 197–206.

Amelang, James S. "Mourning Becomes Eclectic: Ritual Lament and the Problem of Continuity." *Past & Present* 187 (May 2005): 3–31.

Amorosi, Vincenzo, Angelandrea Casale, and Felice Marciano. "Famiglie nobili del Regno di Napoli in uno stemmario seicentesco inedito." In *Atti della Società Italiana di Studi Araldici*, 24th Convivio Scientifico, Rome, 17–18–19 novembre 2006. http://centrostudiarc.altervista.org/pdf/ArticoloCasaleAmorosiMarciano.Stemmario.pdf.

Anderson, Trevor. "La popolazione." In *Da Apigliano a Martano: Tre anni di archeologia medioevale, 1997–1999*, ed. Paul Arthur, 48–50. Galatina: Congedo, 1999.

Anderson, Trevor, and Paul Arthur. "Informazioni dai casali di Quattro Macine." In *L'infanzia e le sue storie in Terra d'Otranto*, ed. Angelo Semeraro, 61–65. Lecce: Conte Editore, 1999.

Andreano, Manuela. "Tempietto di San Lorenzo a Mesagne: Nuovo studio." *Brundisii Res* 23 (2000): 131–63.

Angel, Joseph. "The Use of the Hebrew Bible in Early Jewish Magic." *Religion Compass* 3, no. 5 (2009): 785–98.

Angelov, Dimiter G. "Prosopography of the Byzantine World (1204–1261) in the Light of Bulgarian Sources." In *Identities and Allegiances in the Eastern Mediterranean After 1204*, ed. Judith Herrin and Guillaume Saint-Guillaume, 101–20. Burlington, Vt.: Ashgate, 2011.

Angusheva, Adelina, and Margaret Dimitrova. "Monks, Women, Herbs: Distribution of Ancient Greek and Byzantine Knowledge of Women's Health in South Slavonic Religious Centers." In *Proceedings of the 38th International Congress on the History of Medicine, 1–6 September 2002*, ed. Nil Sari et al., 469–79. Ankara: Türk Tarih Kurumu, 2005.

Angusheva-Tihanov, Adelina, and Margaret Dimitrova. "Medieval Slavonic Childbirth Prayers: Sources, Context and Functionality." *Scripta & e-Scripta* 2 (2004): 273–90. Central and Eastern European Online Library. http://www.ceeol.com.

Ankori, Zvi. *Karaites in Byzantium: The Formative Years, 970–1100*. New York: Columbia University Press, 1959.

Appel, Willa. "The Myth of the *Jettatura*." In *The Evil Eye,* ed. Clarence Maloney, 17–27. New York: Columbia University Press, 1976.

Aprile, Marcello. "Frammenti dell'antico pugliese." *Bollettino dell'Atlante lessicale degli antichi volgari italiani* 1 (2008): 96–147.

Arduini, David, and Chiara Grassi. *Graffiti di navi medievali sulle chiese di Pisa e di Lucca*. Pisa: Felici, 2002.

Argyrou, Vassos. *Tradition and Modernity in the Mediterranean: The Wedding as Symbolic Struggle.* Cambridge: Cambridge University Press, 1996.

Ariès, Philippe. *L'enfant et la vie familiale sous l'Ancien Régime*. Paris: Plon, 1960. English translation by Robert Baldick, *Centuries of Childhood: A Social History of Family Life*. New York: Vintage, 1962.

Arnaud, Louis. "L'exorcisme de Tryphon le Martyr." *Echos d'Orient* 12 (1909): 201–5.

Arranz, Miguel. *L'Eucologio constantinopolitano agli inizi del secolo XI: Hagiasmatarion & Archieratikon (Rituale & Pontificale) con l'aggiunta del Leitourgikon (Messale).* Rome: Editrice Pontificia Università Gregoriana, 1996.

———. "Les Sacrements de l'ancien Euchologe constantinopolitain (3)." *Orientalia Christiana Periodica* 49 (1983): 284–302.

Arthur, Paul. "L'Albania e la Terra d'Otranto nel Medioevo: Tre casi studio." In *Gli Illiri e l'Italia: Convegno internazionale di Studi, Treviso, 16 ottobre 2004*, 77–91. Treviso: Fondazione Cassamarca, 2005.

———. "Ampolle da pellegrino dal casale medioevale di Quattro Macine, Giuggianello (LE)." *Studi di Antichità* 8, no. 2 (1995): 381–84.

———. "L'archeologia del villaggio medievale in Puglia." In *Vita e morte dei villaggi rurali tra Medioevo ed età moderna: Dallo scavo della* Villa de Geriti *ad una pianificazione della tutela e della conoscenza dei villaggi abbandonati della Sardegna; Atti del Convegno, Sassari–Sorso, 28–29 maggio 2001*, ed. Marco Milanese, 97–121. Florence: All'Insegna del Giglio, 2001.

———. "Byzantine and Turkish Glazed Ceramics in Southern Apulia, Italy." *Byzas* 7 (2007): 239–54.

———. "Un casale medioevale tra Bisanzio e l'Occidente: Quattro Macine, Giuggianello (Lecce)." In *Scavi medievali in Italia, 1994–1995*, ed. Stella Patitucci Uggeri, 167–74. Rome: Herder, 1998.

———. "Case, chiese, contadini e la fisionomia del villaggio." In *Apigliano: Un villaggio bizantino e medioevale in Terra d'Otranto; L'ambiente, il villaggio, la popolazione*, ed. Paul Arthur and Brunella Bruno, 43–46. Galatina: Arti Grafiche Panico, 2009.

———. "Un *chôrion* bizantino?" In *Da Apigliano a Martano: Tre anni di archeologia medioevale, 1997–1999*, ed. Paul Arthur, 14–20. Galatina: Congedo, 1999.

———. "Il cimitero." In *Da Apigliano a Martano: Tre anni di archeologia medioevale, 1997–1999*, ed. Paul Arthur, 51–53. Galatina: Congedo, 1999.

———. "Economic Expansion in Byzantine Apulia." In *Histoire et culture dans l'Italie byzantine*, ed. André Jacob, Jean-Marie Martin, and Ghislaine Noyé, 389–405. Rome: École française, 2006.

———. "Edilizia residenziale di età medievale nell'Italia meridionale: Alcune evidenze archeologiche." In *Edilizia residenziale tra IX–X secolo: Storia e archeologia*, ed. Paola Galetti, 31–58. Florence: All'Insegna del Giglio, 2010.

———. "*Grubenhauser* nella Puglia bizantina: A proposito di recenti scavi a Supersano (LE)." *Archeologia Medievale* 26 (1999): 171–78.

———. "Islam and the Terra d'Otranto: Some Archaeological Evidence." In *Papers from the EAA Third Annual Meeting at Ravenna 1997*, vol. 2, *Classical and Medieval*, ed. Mark Pearce and Maurizio Tosi, 166–70. Oxford: Archaeopress, 1998.

———. "'Masseria Quattro Macine'—A Deserted Medieval Village and Its Territory in Southern Apulia: An Interim Report on Field Survey, Excavation and Document Analysis." With contributions by Umberto Albarella, Brunella Bruno, and Sarah King. *Papers of the British School at Rome* 64 (1996): 181–237.

———. "Medieval Fairs: An Archaeologist's Approach." In *Archeologia w teorii w praktyce*, ed. Andrzej Buko and Przemyslaw Urbańczyk, 419–36. Warsaw: Naukowa oficyna wydawnicza, 2000.

———. "I menhir nel Salento." In *Puglia preromanica dal V secolo agli inizi dell'XI*, ed. Gioia Bertelli, 289–91. Bari: Edipuglia–Jaca Book, 2004.

———. "Ricostruire una chiesa medievale." In *Apigliano: Un villaggio bizantino e medioevale in Terra d'Otranto; L'ambiente, il villaggio, la popolazione*, ed. Paul Arthur and Brunella Bruno, 73–76. Galatina: Arti Grafiche Panico, 2009.

———. "Riflessioni sulla popolazione del villaggio." In *Apigliano: Un villaggio bizantino e medioevale in Terra d'Otranto; L'ambiente, il villaggio, la popolazione*, ed. Paul Arthur and Brunella Bruno, 51–52. Galatina: Arti Grafiche Panico, 2009.

———. "Il Salento bizantino: Alcune osservazioni." In *L'Adriatico dalla tarda antichità all'età carolingia: Atti del Convegno di studio, Brescia, 11–13 ottobre 2001*, ed. Gian Pietro Brogiolo and Paolo Delogu, 183–94. Florence: All'Insegna del Giglio, 2005.

———. "Uno stampo eucaristico bizantino da Soleto (LE)." *Archeologia Medievale* 24 (1997): 525–30.

———. "Tra Giustiniano e Roberto il Guiscardo: Approcci all'archeologia del Salento in età bizantina." In *I Congresso nazionale di archeologia medievale* (Pisa, 1997), ed. Sauro Gelichi, 194–99. Florence: All'Insegna del Giglio 1997.

———. "Verso un modellamento del paesaggio rurale dopo il Mille nella Puglia meridionale." *Archeologia Medievale* 37 (2010): 215–28.

Arthur, Paul, and Rita Auriemma. "A Search for Italian Wine: Middle Byzantine and Later Amphoras from Southern Puglia," *INA Quarterly* 23, no. 4 (1996): 14–17.

Arthur, Paul, and Brunella Bruno, eds. *Apigliano: Un villaggio bizantino e medioevale in Terra d'Otranto; L'ambiente, il villaggio, la popolazione*. Galatina: Arti Grafiche Panico, 2009.

———. *Il complesso tardo-antico ed alto-medievale dei SS. Cosma e Damiano, detto Le Centoporte, Giurdignano (LE): Scavi, 1993–1996*. Galatina: Congedo, 2009.

Arthur, Paul, Brunella Bruno, and Massimo Limoncelli. "Notizie scavi Taurisano, S. Maria della Strada, 2004." *Archeologia Medievale* 31 (2004): 345–46.

Arthur, Paul, Lucio Calcagnile, Trevor Anderson, Brunella Bruno, Gianluca Quarta, and Marisa D'Elia. "Sepolture multiple e datazioni al radiocarbonio ad alta risoluzione di resti osteologici provenienti dal villaggio di Quattro Macine, Giuggianello (LE)." *Archeologia Medievale* 34 (2007): 297–301.

Arthur, Paul, Giuseppe Gravili, Massimo Limoncelli, Brunella Bruno, Marco Leo Imperiale, Claudia Portulano, Erminia Lapadula, and Giuseppe Sarcinelli. "La chiesa di Santa Maria della Strada, Taurisano (Lecce): Scavi, 2004." *Archeologia Medievale* 32 (2005): 173–205.

Arthur, Paul, and Luciano Piepoli. "L'archeologia del metallo in Terra d'Otranto nel Medioevo." In *Archeometallurgia: Dalla conoscenza alla fruizione*, ed. Claudio Giardino, 243–50. Bari: Edipuglia, 2011.

Ascoli, Graziadio Isaia. *Iscrizioni inedite o mal note, greche, latine, ebraiche, di antichi sepolcri giudei nel Napoletano*. Turin: Loescher, 1880.

Ashley, Kathleen, and Véronique Plesch. "The Cultural Processes of 'Appropriation.'" *Journal of Medieval and Early Modern Studies* 32, no. 1 (2001): 1–15.

Assaf, Simcha. "Family Life of Byzantine Jews" [in Hebrew]. In *Sefer ha-yovel li-profesor Shemu'el Krois: Li-melo't lo shiv'im shanah*, 169–77. Jerusalem: R. Mas, 1936.

Attolico, Angelofabio. "Cultura artistica bizantina in un territorio a nord est di Taranto: La decorazione pittorica della chiesa maggiore della Gravina di Riggio a Grottaglie." In *Le aree rupestri dell'Italia centro-meridionale nell'ambito delle civiltà italiche: Conoscenza, salvaguardia, tutela; Atti del IV Convegno internazionale sulla civiltà rupestre, Savelletri di Fasano (BR), 26–28 novembre 2009*, ed. Enrico Menestò, 381–93. Spoleto: Centro italiano di Studi sull'alto medioevo, 2011.

Attolico, Angelofabio, and Maristella Miceli. "Un edificio di culto di età bizantina in agro di Grottaglie (Ta): Alcune note sulla 'Chiesa Maggiore' della gravina di Riggio." In *L'Habitat rupestre nell'area mediterranea: Giornate Internazionali di studio in Terra Jonica, Massafra–Palagianello, 29–31 ottobre 2010*, 27–34. Crispiano, 2012.

Aykroyd, Robert G., David Lucy, A. Mark Pollard, and Charlotte A. Roberts. "Nasty, Brutish, But Not Necessarily Short: A Reconsideration of the Statistical Methods Used to Calculate Age at Death from Adult Human Skeletal and Dental Age Indicators." *American Antiquity* 64 (1999): 55–70.

Babić, Staša. "Status Identity and Archaeology." In *The Archaeology of Identity: Approaches to Gender, Age, Status, Ethnicity and Religion*, ed. Margarita Díaz-Andreu et al., 67–85. London: Routledge, 2005.

Bacci, Michele. "The Legacy of the Hodegetria: Holy Icons and Legends Between East and West." In *Images of the Mother of God: Perceptions of the Theotokos in Byzantium*, ed. Maria Vassilaki, 321–36. Aldershot: Ashgate, 2005.

Bahn, Paul G. "Art." In *The Oxford Companion to Archaeology*, ed. Brian M. Fagan, 48–49. New York: Oxford University Press, 1996.

Baldacci, Osvaldo. *Puglia*. 2nd rev. ed. Vol. 14 of *Le Regioni d'Italia*. Turin: UTET, 1962.

Baldassarre, Paola. "La civiltà rupestre dell'alto Salento nelle visite pastorali." In *Il popolamento rupestre dell'area mediterranea: La tipologia delle fonti; Gli insediamenti rupestri della Sardegna*, ed. Cosimo Damiano Fonseca, 103–24. Galatina: Congedo, 1988.

Baldini Lippolis, Isabella. "Half-Crescent Earrings in Sicily and Southern Italy." In *Byzanz—Das Römerreich im Mittelalter*, part 1, *Welt der Ideen, Welt der Dinge*, 235–55. Mainz: Römisch-Germanischen Zentralmuseum, 2010.

Ball, Jennifer. *Byzantine Dress: Representations of Secular Dress in Eighth- to Twelfth-Century Painting*. New York: Palgrave Macmillan, 2005.

Baltoyianni, Chrysanthe. "Christ the Lamb and the ἐνώτιον of the Law in a Wall Painting of Araka on Cyprus." *Deltion tēs Christianikēs Archaiologikēs Hetaireias* 17 (1993–94): 53–58.

Bandy, Anastasius, trans. "*Machairas: Rule* of Neilos, Bishop of Tamasia, for the Monastery of the Mother of God *Machairas* in Cyprus." In *BMFD* 3:1107–75.

———. "*Mamas: Typikon* of Athanasios Philanthropenos for the Monastery of St. Mamas in Constantinople." In *BMFD*, 3:973–1041.

Barb, A. A. "St. Zacharias the Prophet and Martyr: A Study in Charms and Incantations." *Journal of the Warburg and Courtauld Institutes* 11 (1948): 35–67.

Bar-Ilan, Meir. "Prayers of Jews to Angels and Other Mediators in the First Centuries CE." In *Saints and Role Models in Judaism and Christianity*, ed. Marcel Poortuis and Joshua Schwartz, 79–95. Leiden: Brill, 2004.

Barker, John. "Thoughts on Byzantine Dynastic Marriage Policies; or, Were the Palaiologoi Really Italians?" In *ΑΝΑΘΗΜΑΤΑ ΕΟΡΤΙΚΑ: Studies in Honor of Thomas F. Mathews*, ed. Joseph D. Alchermes with Helen C. Evans and Thelma K. Thomas, 47–56. Mainz: Philipp von Zabern, 2009.

Barth, Fredrik. "Enduring and Emerging Issues in the Analysis of Ethnicity." In *The Anthropology of Ethnicity: Beyond "Ethnic Groups and Boundaries,"* ed. Hans Vermeulen and Cora Govers, 11–32. Amsterdam: Spinhuis, 1994.

———. "Introduction." In *Ethnic Groups and Boundaries*, ed. Fredrik Barth, 9–38. Boston: Little, Brown, 1969.

Bartlett, Robert. "Medieval and Modern Concepts of Race and Ethnicity." *Journal of Medieval and Early Modern Studies* 31 (2001): 39–56.

———. "Symbolic Meanings of Hair in the Middle Ages." *Transactions of the Royal Historical Society*, 6, no. 4 (1994): 43–60.

Bascapè, Giacomo C., and Marcello del Piazzo. *Insegne e simboli: Araldica pubblica e privata medievale e moderna*. Rome: Ministero per i Beni culturali e ambientali, 1983.

Baumgarten, Elisheva. *Mothers and Children: Jewish Family Life in Medieval Europe*. Princeton, N.J.: Princeton University Press, 2004.

———. "'A Separate People'? Some Directions for Comparative Research on Medieval Women." *Journal of Medieval History* 34 (2008): 212–28.

Baun, Jane. "The Fate of Babies Dying Before Baptism in Byzantium." In *The Church and Childhood: Papers Read at the 1993 Summer Meeting and the 1994 Winter Meeting of the Ecclesiastical History Society*, Studies in Church History 31, ed. Diana Wood, 115–25. Oxford: Blackwell, 1994.

Behrens, Roy J. "The Eyes Have It." *Design* 75, no. 1 (1973): 2–6.

Bekakos, Sotirios. "*Panaiere* e *Pan(n)aiero* e i suoi riflessi in Puglia e Basilicata." *Thalassia Salentina* 32 (2009): 29–51.

Belli D'Elia, Pina. *Alle sorgenti del Romanico: Puglia XI secolo*. Bari: Edizioni Dedalo, 1987.

———, ed. *Bari, Pinacoteca Provinciale*. Bologna: Calderini, 1972.

———. "La cattedrale di Taranto: Aggiunte e precisazioni." In *La chiesa di Taranto: Studi storici in onore di mons. Guglielmo Motolese, arcivescovo di Taranto, nel XXV anniversario del suo episcopato*, vol. 1, *Dalle origini all'avvento dei Normanni*, ed. Cosimo Damiano Fonseca, 129–61. Galatina: Congedo, 1977.

———. "La cultura artistica." In *L'Ebraismo dell'Italia meridionale peninsulare dalle origini al 1541: Società, economia, cultura* [IX Congresso Internazionale dell'Associazione Italiana per lo studio del Giudaismo, Potenza, 1992], ed. Cosimo Damiano Fonseca et al., 203–15. Galatina: Congedo, 1996.

———, ed. *Icone di Puglia e Basilicata dal Medioevo al Settecento.* Milan: Mazzotta, 1988.

———. "Principi e mendicanti: Una questione d'immagine." In *Territorio e feudalità nel Mezzo-giorno rinascimentale: Il ruolo degli Acquaviva tra XV e XVI secolo; Atti del Primo Convegno Internazionale di studi su La Casa Acquaviva d'Atri e di Conversano, 13–16 settembre 1991*, 2 vols., ed. Caterina Lavarra, 2:261–94. Galatina: Congedo, 1996.

———. "Il Romanico." In *La Puglia fra Bisanzio e l'Occidente*, 117–53. Milan: Electa, 1980.

Belting, Hans. "Byzantine Art Among Greeks and Latins in Southern Italy." *DOP* 28 (1974): 1–29.

———. *Likeness and Presence: A History of the Image Before the Era of Art.* Chicago: University of Chicago Press, 1994.

Benjamin, Sandra. *The World of Benjamin of Tudela: A Medieval Mediterranean Travelogue.* London: Associated University Presses, 1995.

Bentley, G. Carter. "Ethnicity and Practice." *Comparative Studies in Society and History* 29, no. 1 (1987): 24–55.

———. "Response to Yelvington." *Comparative Studies in Society and History* 33, no. 1 (1991): 169–75.

Berger, David. "Mission to the Jews and Jewish-Christian Contacts in the Polemical Literature of the High Middle Ages." *American Historical Review* 91, no. 3 (1986): 576–91.

Berger, Michel. "L'église Mater Domini à Bagnolo del Salento: Essai de reconstitution du pro-gramme iconographique de l'abside et de ses annexes." In *Vaticana et Medievalia: Études en l'honneur de Louis Duval-Arnould*, ed. Jean-Marie Martin, Bernadette Martin-Hisard, and Agostino Paravicini Bagliani, 15–26. Florence: Sismel-Edizioni del Galluzzo, 2008.

———. "Les fresques du chevet de la chapelle Saint-Nicolas de Celsorizzo (an. 1283): Une image de la vision théophanique et l'illustration de la Divine Liturgie." In *Puer Apuliae: Mélanges offerts à Jean-Marie Martin*, ed. Errico Cuozzo et al., 39–50. Paris: Association des amis du centre d'histoire et civilisation de Byzance, 2008.

———. "Un inédit italo-grec de la Passion legendaire de Saint Étienne: Les peintures murales de l'église Santo Stefano a Soleto, en Terre d'Otrante." In *La Chiesa greca in Italia dall'VIII al XVI secolo: Atti del Convegno storico interecclesiale (Bari, 30 apr.–4 magg. 1969)*, 3:1377–88. Padua: Antenore, 1972–73.

———. "Les peintures de l'abside de S. Stefano à Soleto: Une illustration de l'anaphore en Terre d'Otrante à la fin du XIVᵉ siècle." *MEFRM* 94, no. 1 (1982): 121–70.

———. "La représentation byzantine de la 'Vision de Dieu' dans quelques églises du Salento médiévale." In *Histoire et culture dans l'Italie byzantine*, ed. André Jacob, Jean-Marie Martin, and Ghislaine Noyé, 179–203. Rome: École française, 2006.

———. "S. Stefano di Soleto e i suoi affreschi." In *Paesi e figure del vecchio Salento*, ed. Aldo de Bernart, 2:81–128. Galatina: Congedo, 1980.

Berger, Michel, and André Jacob. *La Chiesa di S. Stefano a Soleto: Tradizioni bizantine e cultura tardogotica.* Terra d'Otranto Bizantina 1. Lecce: Argo, 2007.

———. "Des peintures pré-iconoclastes in Terre d'Otrante: Les fresques de l'église San Pietro à Crepacore et leur dédicace." *MEFRM* 119, no. 1 (2007): 25–42.

———. "Un nouveau monument byzantin de Terre d'Otrante: La chapelle Saint-Nicolas de Celsorizzo, près d'Acquarica del Capo, et ses fresques (an. 1283)." *RSBN* 27 (1990): 211–57.

Bernardini, Lisa. "Les donateurs des églises de Cappadoce." *Byzantion* 62 (1992): 118–40.

Bertagnin, Mauro, Ilham Khuri-Makdisi, and Susan Gilson Miller. "A Mediterranean Jewish Quarter and Its Architectural Legacy: The *Giudecca* of Trani, Italy (1000–1550)." *Traditional Dwellings and Settlements Review* 14, no. 11 (2003): 33–46.

Bertaux, Émile. *L'art dans l'Italie méridionale.* Paris: A. Fontemoing, 1904.

Bertelli, Gioia. "Arte bizantina nel Salento: Architettura e scultura (secc. IX–XIII)." In *Ad ovest di Bisanzio, il Salento medioevale: Atti del seminario internazionale di studio (Martano, 29–30 aprile 1988),* ed. Benedetto Vetere, 215–40. Galatina: Congedo, 1990.

Bevere, Riccardo. "Vestimenti e gioielli in uso nelle Province Napoletane dal XII al XVI secolo." *Archivio storico per le province napoletane* 22 (1897): 312–41.

Bhabha, Homi K. *The Location of Culture.* New York: Routledge, 1994.

Biale, David. "Counter-History and Jewish Polemics Against Christianity: The *Sefer toldot yeshu* and the *Sefer zerubavel.*" *Jewish Social Studies* 6, no. 1 (1999): 130–45.

Billinger, Michael S. "Another Look at Ethnicity as a Biological Concept: Moving Anthropology Beyond the Race Concept." *Critique of Anthropology* 27, no. 5 (2007): 5–35.

Binski, Paul. *Medieval Death: Ritual and Representation.* London: British Museum Press, 1996.

Blair, Claude. *European Armour, Circa 1066 to Circa 1700.* London: B. T. Batsford, 1972.

Blanc, Odile. "Vêtement féminin, vêtement masculin à la fin du Moyen Âge: Le point de vue des moralistes." In *Le vêtement: Histoire, archéologie et symbolique vestimentaire au Moyen Âge,* ed. Michel Pastoureau, 243–53. Paris: Léopard d'Or, 1989.

Bland, Kalman. "Defending, Enjoying, and Regulating the Visual." In *Judaism in Practice: From the Middle Ages Through the Early Modern Period,* ed. Lawrence Fine, 281–97. Princeton, N.J.: Princeton University Press, 2001.

———. "Icons vs. Sculptures in Christian Practice and Jewish Law." *Jewish Studies Quarterly* 11 (2004): 201–14.

Blier, Suzanne Preston. "Ritual." In *Critical Terms for Art History*, ed. Robert Nelson and Richard Shiff, 187–96. Chicago: University of Chicago Press, 1996.

Bloch, Abraham P. *The Biblical and Historical Background of Jewish Customs and Ceremonies.* New York: Ktav, 1980.

Bloch, Maurice. "Deference." In *Theorizing Rituals: Issues, Topics, Approaches, Concepts*, ed. Jens Kreinath, Jan Snoek, and Michael Stausberg, 495–506. Leiden: Brill, 2006.

Bloch, Peter. "Seven-Branched Candelabra in Christian Churches." *Journal of Jewish Art* 1 (1974): 44–49.

———. "Siebenarmige Leuchter in christlichen Kirchen." *Wallraf-Richartz Jahrbuch* 23 (1961): 55–190.

Blumenkranz, Bernhard. "La conversion au Judaisme d'André, Archevêque de Bari." *Journal of Jewish Studies* 14 (1963): 33–36.

Bo, Vincenzo. *La religione sommersa.* Milan: Rizzoli, 1986.

Boccadamo, Vittorio. *Terra d'Otranto nel Cinquecento: La visita pastorale dell'archidiocesi di Otranto del 1522.* Società e religione 11. Galatina: Congedo, 1990.

Bohak, Gideon. *Ancient Jewish Magic: A History.* Cambridge: Cambridge University Press, 2008.

———. "Hebrew, Hebrew Everywhere? Notes on the Interpretation of the *Voces Magicae.*" In *Prayer, Magic, and the Stars in the Ancient and Late Antique World*, ed. Scott Noegel, Joel Walker, and Brannon Wheeler, 69–82. University Park: Pennsylvania State University Press, 2003.

Bonfil, Robert(o). "Cultura ebraica e cultura cristiana nell'Italia meridionale nell'epoca alto-medievale." In *L'Ebraismo dell'Italia meridionale peninsulare dalle origini al 1541: Società, economia, cultura* [IX Congresso Internazionale dell'Associazione Italiana per lo studio del Giudaismo, Potenza, 1992], ed. Cosimo Damiano Fonseca et al., 115–60. Galatina: Congedo, 1996.

———. *History and Folklore in a Medieval Jewish Chronicle: The Family Chronicle of Ahimaʻaz ben Paltiel.* Studies in Jewish History and Culture 22. Leiden: Brill, 2009.

———. *Jewish Life in Renaissance Italy.* Trans. Anthony Oldcorn. Berkeley: University of California Press, 1994.

———. "Mito, retorica, storia: Saggio sul 'Rotolo di Ahimaʻaz." In *Tra due mondi: Cultura ebraica e cultura cristiana nel Medioevo*, 93–133. Naples: Liguori, 1996.

———. "Ovadiah da Oppido: Riflessioni sul significato culturale di una conversione." In *Giovanni-Ovadiah da Oppido, proselito, viaggiatore e musicista dell'età normanna: Atti del convegno internazionale, Oppido Lucano, 28–30 marzo 2004*, ed. Antonio De Rosa and Mauro Perani, 45–65. Florence: Giuntina, 2005.

———. "Tra due mondi: Prospettive di ricerca sulla storia culturale degli Ebrei dell'Italia meridionale nell'alto Medioevo." In *Italia Judaica: Atti del I Convegno internazionale, Bari, 18–22 maggio 1981*, 135–58. Rome: Multigrafica, 1983.

———. "La visione ebraica di Daniele nel contesto bizantino del secolo X." *RSBN*, n.s., 40 (2003): 25–65.

———. "The Vision of Daniel as a Historical and Literary Document." In *Yitzhak F. Baer Memorial Volume = Zion* 44 (1979): 111–47.

Bonnassie, Pierre. "Consommation d'aliments immondes et cannibalisme de survie dans l'Occident du Haut Moyen Âge." *Annales: Économies, sociétés, civilisations* 44, no. 5 (1989): 1035–56.

Bouchard, Michel. "A Critical Reappraisal of the Concept of the 'Imagined Community' and the Presumed Sacred Languages of the Medieval Period." *National Identities* 6, no. 1 (2004): 3–24.

Bougard, François, Laurent Feller, and Régine Le Jan, eds. *Dots et douaires dans le haut Moyen Âge.* Rome: École française, 2002.

Boulton, D'Arcy J. D. "Insignia of Power: The Use of Heraldic and Paraheraldic Devices by Italian Princes, c. 1350–c. 1500." In *Art and Politics in Late Medieval and Early Renaissance Italy,* ed. Charles M. Rosenberg, 103–27. Notre Dame, Ind.: University of Notre Dame Press, 1990.

Bourbou, Chryssi, and Sandra J. Garvie-Lok. "Breastfeeding and Weaning Patterns in Byzantine Times: Evidence from Human Remains and Written Sources." In *Becoming Byzantine: Children and Childhood in Byzantium*, ed. Arietta Papaconstantinou and Alice-Mary Talbot, 65–83. Washington, D.C.: Dumbarton Oaks Research Library and Collection, 2009.

Bourdieu, Pierre. *Distinction: A Social Critique of the Judgment of Taste.* Trans. Richard Nice. London: Routledge & Kegan Paul, 1986.

Boustan, Raʻanan. "Rabbi Ishmael's Miraculous Conception: Jewish Redemption History in Anti-Christian Polemic." In *The Ways That Never Parted: Jews and Christians in Late Antiquity and the Early Middle Ages*, ed. Adam H. Becker and Annette Yoshiko Reed, 307–43. Tübingen: Mohr Siebeck, 2003; repr., Minneapolis: Fortress Press, 2007.

———. "The Study of Heikhalot Literature: Between Mystical Experience and Textual Artifact." *Currents in Biblical Research* 6, no. 1 (2007): 130–60.

Bowman, Alan K., and Greg Woolf, "Literacy and Power in the Ancient World." In *Literacy and Power in the Ancient World*, ed. Alan K. Bowman and Greg Woolf, 1–16. Cambridge: Cambridge University Press, 1994.

Bowman, Steven. "Jewish Responses to Byzantine Polemics from the Ninth Through the Eleventh Centuries." *Shofar* 28, no. 3 (2010): 103–15.

———. *The Jews of Byzantium (1204–1453).* Tuscaloosa: University of Alabama Press, 1985.

Breakwell, Glynis M., ed. *Social Psychology of Identity and the Self Concept.* London: Surrey University Press, 1992.

Bromberger, Christian. "Hair: From the West to the Middle East Through the Mediterranean." *Journal of American Folklore* 121, no. 482 (2008): 379–99.

Brown, Richard D. "Microhistory and the Post-Modern Challenge." *Journal of the Early Republic* 23 (2003): 1–20.

Browning, Robert. "Further Reflections on Literacy in Byzantium." In *To Hellenikon: Studies in Honor of Speros Vryonis, Jr.*, ed. John S. Langdon et al., 1:68–84. New Rochelle, N.Y.: Caratzas, 1993.

Broyde, Michael J. "Hair Covering and Jewish Law: Biblical and Objective (*Dat Moshe*) or Rabbinic and Subjective (*Dat Yehudit*)? *Tradition* 42, no. 3 (2009): 97–179.

Bruno, Brunella. "Archeologia medievale nei Sassi di Matera." In *Scavi medievali in Italia 1996–99: Atti della Seconda Conferenza Italiana di Archeologia Medievale (Cassino, 16–18 dicembre 1999)*, ed. Stella Patitucci Uggeri, 137–48. Rome: Herder, 2001.

———, ed. "L'area cimiteriale e il casale in località S. Giovanni Piscopìo, Cutrofiano (Lecce)." *Archeologia Medievale* 35 (2008): 199–239.

———. "Borgo Terra a Martano." In *Apigliano: Un villaggio bizantino e medioevale in Terra d'Otranto; L'ambiente, il villaggio, la popolazione*, ed. Paul Arthur and Brunella Bruno, 65–72. Galatina: Arti Grafiche Panico, 2009.

———. "La chiesa bizantina a Giuggianello, Casale Quattro Macine." In *Puglia preromanica dal V secolo agli inizi dell'XI*, ed. Gioia Bertelli, 278–79. Bari: Edipuglia–Jaca Book, 2004.

———. "La chiesa di S. Nicola?" In *Apigliano: Un villaggio bizantino e medioevale in Terra d'Otranto; L'ambiente, il villaggio, la popolazione*, ed. Paul Arthur and Brunella Bruno, 27–30. Galatina: Arti Grafiche Panico, 2009.

———. "Chiese e religione." In *Da Apigliano a Martano: Tre anni di archeologia medioevale, 1997–1999*, ed. Paul Arthur, 25–30. Galatina: Congedo, 1999.

———. "Le chiese medievali a due absidi nel Salento: Primi dati." In *III Congresso Nazionale di Archeologia Medievale, Salerno, 2–5 ottobre 2003*, ed. Rosa Fiorillo and Paolo Peduto, 446–50. Florence: All'Insegna del Giglio, 2003.

———. "I cimiteri e il rito funerario." In *Apigliano: Un villaggio bizantino e medioevale in Terra d'Otranto; L'ambiente, il villaggio, la popolazione*, ed. Paul Arthur and Brunella Bruno, 35–38. Galatina: Arti Grafiche Panico, 2009.

———. "Il triconco di San Lorenzo a Mesagne." In *Puglia preromanica dal V secolo agli inizi dell'XI,* ed. Gioia Bertelli, 248–50. Bari: Edipuglia–Jaca Book, 2004.

Bruno, Brunella, and Marisa Tinelli. "S. Maria delle Grazie, Campi Salentina (LE): Il rinvenimento di un butto sacro?" In *V Congresso Nazionale di Archeologia Medievale* [Foggia and Manfredonia, 30 settembre–3 ottobre 2009], ed. Giuliano Volpe and Pasquale Favia, 698–703. Florence: All'Insegna del Giglio, 2009.

———. "Testimonianze bizantine e medievali da Gallipoli (LE)." *Archeologia Medievale* 39 (2012): 215–27.

Burgarella, Filippo. "Lavoro, mestieri e professioni negli atti greci di Calabria." In *Mestieri, lavoro e professioni nella Calabria medievale: Tecniche, organizzazioni, linguaggi; Atti dell'VIII Congresso storico Calabrese, Palmi (RC), 19–22 novembre 1987*, 53–86. Soveria Mannelli: Rubbettino, 1993.

Burgers, G.-J. L. M. *Constructing Messapian Landscapes: Settlement Dynamics, Social Organization and Culture Contact in the Margins of Graeco-Roman Italy.* Amsterdam: J. C. Gieben, 1998.

Burke, Peter. *History and Social Theory.* 2nd ed. Cambridge: Polity Press, 2005.

———. "The Language of Gesture in Early Modern Italy." In *A Cultural History of Gesture: From Antiquity to the Present Day*, ed. Jan Bremmer and Herman Roodenberg, 71–83. Cambridge: Polity Press, 1991.

Caffarelli, Enzo. "Liste di frequenze onomastiche dagli indici delle *Rationes decimarum Italiae* dei secoli XIII–XIV." *Rivista italiana di onomastica* 1 (1995): 191–99.

Caillet, Jean-Pierre. "L'image cultuelle sur l'autel et le positionnement du célébrant (IXe–XIVe siècles)." *Hortus Artium Medievalium* 11 (2005): 139–47.

Calabuig, Ignazio M. "The Rite of Dedication of a Church." In *Handbook for Liturgical Studies, V: Liturgical Time and Space,* ed. Anscar J. Chupungco, 333–79. Collegeville, Minn.: Liturgical Press, 2000.

Callisen, S[terling] A. "The Evil Eye in Italian Art." *Art Bulletin* 19 (1937): 450–62.

Calò, Maria Stella. *La chiesa di S. Maria del Casale presso Brindisi.* Fasano: Lions Club di Brindisi, 1967.

Calò Mariani, Maria Stella. *L'arte del Duecento in Puglia.* Turin: Istituto Bancario San Paolo di Torino, 1984.

———. "La chiesa dal XII al XV secolo." In *Il Tempio di Tancredi: Il monastero dei Santi Niccolò e Cataldo in Lecce,* ed. Bruno Pellegrino and Benedetto Vetere, 82–110. Cinisello Balsamo: Silvana, 1996.

———. "Dal chiostro alle corti." In *Storia di Lecce dai Bizantini agli Aragonesi,* ed. Bruno Pellegrino, Maria Marcella Rizzo, and Benedetto Vetere, 661–734. Bari: Laterza, 1992.

———. "Echi d'Oltremare in Terra d'Otranto: Imprese pittoriche e committenza feudale fra XIII e XIV secolo." In *Il Cammino di Gerusalemme: Atti del II Convegno internazionale di studio, Bari–Brindisi–Trani, 18–22 maggio 1999,* ed. Maria Stella Calò Mariani, 235–74. Bari: Mario Adda, 2002.

———. "Note sulla pittura salentina del Quattrocento." *Archivio Storico Pugliese* 32 (1979): 139–64.

———. "Predicazione e narrazione dipinta nella chiesa di Santa Caterina d'Alessandria a Galatina (Terra d'Otranto)." In *Medioevo: Immagine e racconto; Atti del Convegno internazionale di studi, Parma, 27–30 settembre 2000,* ed. Arturo Carlo Quintavalle, 474–84. Milan: Electa, 2003.

———. "San Nicola nell'arte in Puglia tra XIII e XVIII secolo." In *San Nicola di Bari e la sua Basilica: Culto, arte, tradizione,* ed. Giorgio Otranto, 98–137. Milan: Electa, 1987.

Campana, Francesco. *Il Tempietto di S. Lorenzo Martire a Mesagne.* Latiano: Neografica, 2002.

Campbell, John R., and Alan Rew, eds. *Identity and Affect: Experiences of Identity in a Globalising World.* London: Pluto Press, 1999.

Canart, Paul. "Aspetti materiali e sociali della produzione libraria italo-greca tra Normanni e Svevi." In *Libri e lettori nel mondo bizantino: Guida storica e critica,* ed. Guglielmo Cavallo, 105–53. Rome: Laterza, 1982.

Canart, Paul, and Santo Lucà, eds. *Codici greci dell'Italia meridionale.* Rome: Retablo, 2000.

Canziani, Estella. "Abruzzese Folklore." *Folklore* 39, no. 3 (1928): 209–47.

Cappellini, Enrico, et al. "A Multidisciplinary Study of Archaeological Grape Seeds." *Naturwissenschaften* 97, no. 2 (2010): 205–17. http://www.ncbi.nlm.nih.gov/pubmed/20033124?dopt=Abstractplus.

Caprara, Roberto. *La chiesa rupestre di San Marco a Massafra.* Florence: Roberto Caprara, 1979.

———. *Le chiese rupestri del territorio di Taranto.* Taranto: Comune di Taranto, 1981.

———. *L'insediamento rupestre di Palagianello.* Vol. 1, *Le chiese.* Florence: Il Davide, 1980.

———. "Iscrizioni inedite, mal edite o poco note in chiese rupestri pugliesi." *Archivio Storico Pugliese* 62 (2009): 7–28.

———. "*Singularità* in graffiti di siti rupestri pugliesi." In *All'alba del terzo millennio: Miscellanea di studi in onore di Antonio Chionna,* ed. Vincenzo Carella and Ernesto Marinò, 7–52. Fasano: Schena Editore, 2004.

———. *Società ed economia nei villaggi rupestri: La vita quotidiana nelle gravine dell'arco Jonico Tarentino.* Fasano: Schena Editore, 2001.

Caprara, Roberto, Carmela Crescenzi, and Marcelo Scalzo. *Iconografia dei Santi: Le chiese rupestre di Taranto.* Taranto: Comune, 1990.

Caputo, Antonio. "San Teodoro d'Amasea patrono di Brindisi: È qui la festa popolare." http://www.brindisiweb.it/arcidiocesi/santi/santeodoro_festa_popolare.pdf.

Caroli, Elina. "Entre renaissance culturelle et persistance de la question méridionale: Le cas de l'essor touristique du Salento contemporain (Italie)." *Articulo: Journal of Urban Research* 4 (2008). http://articulo.revues.org/759.

Carr, Annemarie Weyl. "Byzantines and Italians on Cyprus: Images from Art." *DOP* 49 (1995): 339–57.

Carr, Carolyn Kinder. "Aspects of the Iconography of Saint Peter in Medieval Art of Western Europe to the Early Thirteenth Century." Ph.D. diss, Case Western Reserve University, 1978.

Carrieri, Miranda. "L'antica chiesa di San Nicola a Cisternino." In *La chiesa di San Nicola a Cisternino*, ed. Raffaele Semeraro, 48–78. Fasano: Schena Editore, 2003.

Carrino, Rachele. "Il mosaico pavimentale della cattedrale di Brindisi." In *XLIII Corso di cultura sull'arte ravennate e bizantina*, ed. Raffaella Farioli Campanati, 193–221. Ravenna: Edizioni di Girasole, 1998.

———. "Il mosaico pavimentale della cattedrale di Taranto." In *Atti del IV Colloquio dell'Associazione italiana per lo studio e la conservazione del mosaico, Palermo, 9–13 dicembre 1996*, ed. Rosa Maria Carra Bonacasa and Federico Guidobaldi, 491–512. Ravenna: Edizioni del Girasole, 1997.

Cartledge, Judith, Gillian Clark, and Valerie Higgins. "The Animal Bones: A Preliminary Assessment of the Stock Economy." In *Excavations at Otranto*, vol. 2, *The Finds*, ed. Francesco D'Andria and David Whitehouse, 317–36. Lecce: Congedo, 1992.

Cassandro, Giovanni. "Un inventario dei beni del principe di Taranto." In *Studi di storia pugliese in onore di Giuseppe Chiarelli*, ed. Michele Paone, 2:1–57. Galatina: Congedo, 1972.

Cassiano, Antonio. "L'arte al tempo dei principi." In *Dal Giglio all'Orso: I principi d'Angiò e Orsini del Balzo nel* Salento, ed. Antonio Cassiano and Benedetto Vetere, 262–305. Galatina: Congedo, 2006.

———. "Chiesa di San Giovanni Evangelista." In *San Cesario di Lecce: Storia, arte, architettura*, 55–68. Galatina: Congedo, 1981.

———, ed. *Iconostasi dalla Chiesa di San Niccolò dei Greci di Lecce.* Lecce: Museo Sigismondo Castromediano, 1990.

———. "Momenti di arte gotica nel Salento." *Ricerche e Studi in Terra d'Otranto* 3 (1988): 39–70.

Cassiano, Antonio, and Benedetto Vetere, eds. *Dal Giglio all'Orso: I principi d'Angiò e Orsini del Balzo nel Salento.* Galatina: Congedo, 2006.

Cassoni, Mauro. "Il tramonto del rito greco in Terra d'Otranto, II. Soleto." *Rinascenza Salentina* 3 (1935): 71–80.

Cassuto, David. "Costruzioni rituali ebraiche nell'Alto Medioevo." In *Gli Ebrei nell'Alto Medioevo*, Settimane di Studio del Centro italiano di studi sull'alto medioevo 26, 2:1017–57. Spoleto: Centro italiano di Studi sull'alto medioevo, 1980.

Cassuto, Milka. "La corrispondenza tra nomi ebraici e greci nell'onomastica giudaica." *Giornale della Società Asiatica Italiana*, n.s., 2–3 (1932): 209–30.

Cassuto, Umberto. "Un ignoto capitolo di storia ebraica." In *Judaica: Festschrift zu Hermann Cohens siebzigstem Geburtstage*, 389–404. New York: Arno, 1980. Originally published Berlin: Cassirer, 1912.

———. "Iscrizioni ebraiche a Bari." *Rivista degli Studi orientali* 15 (1935): 316–22.

———. "Iscrizioni ebraiche a Trani." *Rivista degli Studi orientali* 13 (1931): 172–80.

———. "Una lettera ebraica del secolo X." *Giornale della società asiatica italiana* 29 (1918–20): 97–110.

Castaldo, Daniela. "Immagini della musica al tempo dei del Balzo Orsini." In *Dal Giglio all'Orso: I principi d'Angiò e Orsini del Balzo nel Salento*, ed. Antonio Cassiano and Benedetto Vetere, 445–65. Galatina: Congedo, 2006.

Castronovi, Cosima. *Tracce di cultura longobarda nel territorio tarantino altomedievale: Il villaggio rupestre di Santa Marina in Massafra.* Massafra: Dellisanti, 2005.

Catalano, I. M., A. Genga, C. Laganara, R. Laviano, A. Mangone, D. Marano, and A. Traini. "Lapis Lazuli Usage for Blue Decoration of Polychrome Painted Glazed Pottery: A Recurrent Technology During the Middle Ages in Apulia (Southern Italy)." *Journal of Archaeological Science* 34 (2007): 503–11.

Catenacci, Carmine. "Il lamento funebre tra la Grecia antica e la *Grecìa* salentina: A proposito dei *Canti di pianto e d'amore dall'antico Salento* editi da B. Montinaro." *Quaderni Urbinati di Cultura Classica*, n.s., 53, no. 2 (1996): 139–64.

Cavallo, Guglielmo. "La cultura italo-greca nella produzione libraria." In *I Bizantini in Italia*, 495–612. Milan: Scheiwiller, 1982.

———. "Libri greci e resistenza etnica in Terra d'Otranto." In *Libri e lettori nel mondo bizantino: Guida storica e critica*, ed. Guglielmo Cavallo, 155–78. Rome-Bari: Biblioteca Universale Laterza, 1982.

———. "Manoscritti italo-greci e cultura benedettina (secoli X–XIII)." In *L'esperienza monastica benedettina e la Puglia*, Atti del Convegno di studio organizzato in occasione del XV centenario delle nascita di san Benedetto (Bari, Noci, Lecce, Picciano, 6–10 ottobre 1980), ed. Cosimo Damiano Fonseca, 1:169–95. Galatina: Congedo, 1983.

Cazzato, Mario. "Collepasso (Da '*Casale*' a '*Feudo Nobile*')." In *Paesi e figure del vecchio Salento*, ed. Aldo De Bernart, 3:137–84. Galatina: Congedo, 1989.

Cazzato, Mario, and Antonio Costantini. *Grecìa salentina: Arte cultura e territorio.* Ed. Luigi Orlando. Galatina: Congedo, 1996.

Cedro, Giovanna. "Abbigliamento." In *Da Apigliano a Martano: Tre anni di archeologia medioevale, 1997–1999*, ed. Paul Arthur, 40–44. Galatina: Congedo, 1999.

Centonze, Carmela G., Addolorata De Lorenzis, and Norma Caputo. *Visite pastorali in diocesi di Nardò (1452–1501)*, ed. Benedetto Vetere. Galatina: Congedo, 1988.

Cesaretti, Paolo. "Da 'Marco d'Otranto' a Demetrio: Alcune note di lettura su poeti bizantini del Salento." *RSBN*, n.s., 37 (2000): 183–208.

Ceschi, Carlo. "Il rosone della Chiesa di S. Domenico in Taranto." *Rinascenza Salentina* 4 (1936): 30–36.

Chartier, Roger. "Intellectual History or Social History?" In *Modern European Intellectual History: Reappraisals and New Perspectives*, ed. Dominick La Capra and Steven L. Kaplan, 13–46. Ithaca, N.Y.: Cornell University Press, 1981.

Cherubini, Giovanni. "Il contadino." In *Condizione umana e ruoli sociali nel Mezziogiorno normanno-svevo: Atti delle none giornate normanno-sveve, Bari, 17–20 ottobre 1989*, ed. Giosuè Musca, 131–52. Bari: Edizioni Dedalo, 1991.

Chionna, Antonio. *Beni culturali di San Vito dei Normanni.* Fasano: Schena Editore, 1988.

———. "La lunga storia della cripta di San Biagio." In *Miscellanea per i settant'anni di Roberto Caprara*, ed. Antonio Caprara, Francesca Galli, and Marcello Scalzo, 149–64. Massafra: Tecnografica, 2000.

Chronz, Michael. "Der Beitrag des Nikolaos von Otranto (Nektarios von Casole) zur Vermittlung zwischen den Kulturwelten des 13. Jahrhunderts." In *Geistesleben im 13. Jahrhundert*, Miscellanea Mediaevalia 27, ed. Jan A. Aertsen and Andreas Speer, 555–73. Berlin: De Gruyter, 2000.

Cioffari, Gerardo, et al., eds. *I codici liturgici in Puglia.* Bari: Edizioni Levante, 1986.

Cioffari, Gerardo, Anna Maria Tripputi, and Maria L. Scippa. *Agiografia in Puglia: I santi tra critica storica e devozione popolare.* Bari: Malagrinò, 1991.

Cirese, Alberto Maria. *Il pianto funebre nei sinodi diocesani: Saggio di una ricerca*. Rieti: La Lapa, 1953.

The City of Mystras: Mystras, August 2001–January 2002. Trans. David Hardy. Catalog for the exhibit "Byzantine Hours: Works and Days in Byzantium," Athens, Thessaloniki, Mystras, 2001. Athens: Hellenic Ministry of Culture, 2001.

Clark, Lucia. "On the Brink: Griko, a Language of Resistance and Celebration." *Cultural Survival* 25, no. 2 (Summer 2001). http://www.culturalsurvival.org/publications/cultural-survival -quarterly/italy/brink-griko-language-resistance-and-celebration.

Classen, Albrecht. "Translation as the Catalyst of Cultural Transfer." *Humanities* 1 (2012): 72–79.

Coco, Primaldo. "Le cause del tramonto del rito greco in Terra d'Otranto." *Rinascenza Salentina* 4 (1936): 255–64.

———. *Vestigi di grecismo in Terra d'Otranto*. Grottaferrata: Scuola tipografica Italo-orientale "S. Nilo," 1922.

Codrington, H. W. *The Liturgy of Saint Peter: With a Preface and Introduction by Dom Placid De Meester*. Münster: Aschendorff, 1936.

Cohen, Esther, and Elliott Horowitz. "In Search of the Sacred: Jews, Christians, and Rituals of Marriage in the Later Middle Ages." *Journal of Medieval and Renaissance Studies* 20 (1990): 225–49.

Cohen, Jeremy. "Towards a Functional Classification of Jewish Anti-Christian Polemic in the High Middle Ages." In *Religionsgespräche im Mittelalter*, ed. Bernard Lewis and Friedrich Niehwöhner, 93–114. Wiesbaden: Harrassowitz, 1992.

Cohen, Shaye J. D. "Epigraphical Rabbis." *Jewish Quarterly Review*, n.s., 72, no. 1 (1981): 1–17.

Cohen-Harris, Elisheva. "Where Did Medieval Jewish Women Stand? Visual Sources, Halakhic Writings and Architecture." *Conservative Judaism* 52, no. 4 (2000): 3–13.

Colafemmina, Cesare. "Archeologia ed epigrafia ebraica nell'Italia meridionale." In *Italia Judaica: Atti del I Convegno internazionale, Bari, 18–22 maggio 1981*, 199–210. Rome: Multigrafica, 1983.

———. "La conversione al giudaismo di Andrea arcivescovo di Bari." In *Giovanni-Ovadiah da Oppido, proselito, viaggiatore e musicista dell'età normanna: Atti del convegno internazionale, Oppido Lucano, 28–30 marzo 2004*, ed. Antonio De Rosa and Mauro Perani, 55–65. Florence: Giuntina, 2005.

———. "La cultura nelle giudecche e nelle sinagoghe." In *Centri di produzione della cultura nel Mezzogiorno normanno-svevo: Atti delle dodicesime giornate normanno-sveve, Bari, 17–20 ottobre 1995*, ed. Giosuè Musca, 89–118. Bari: Edizioni Dedalo, 1997.

———. "Di alcune iscrizioni ebraiche a Trani." *Rassegna mensile di Israel* 67 (2001): 305–12.

———. "Di alcune iscrizioni giudaiche di Taranto." In *Studi di storia pugliese in onore di Giuseppe Chiarelli*, ed. Michele Paone, 1:233–42. Galatina: Congedo, 1972.

———. "Di una iscrizione greca-ebraica di Otranto." *Vetera Christianorum* 12 (1975): 131–37.

———. *Documenti per la storia degli Ebrei in Puglia nell'Archivio di Stato di Napoli*. Bari: Messaggi, 1990.

———. "Due nuove iscrizioni sinagogali pugliesi." *Vetera Christianorum* 31 (1994): 383–95.

———. *Gli ebrei a Taranto: Fonti documentarie*. Bari: Società di storia patria per la Puglia, 2005.

———. "Gli ebrei a Taranto nella documentazione epigrafica (secc. IV–X)." In *La chiesa di Taranto: Studi storici in onore di mons. Guglielmo Motolese, arcivescovo di Taranto, nel XXV anniversario del suo episcopato*, vol. 1, *Dalle origini all'avvento dei Normanni*, ed. Cosimo Damiano Fonseca, 109–27. Galatina: Congedo, 1977.

———. "Gli ebrei di Bari e di Otranto in una lettera di Hasdai ibn Shaprut di Cordova." In *Bitonto e la Puglia tra tardoantico e regno normanno: Atti del Convegno (Bitonto, 15–17 ottobre 1998)*, ed. Custode Silvio Fioriello, 247–56. Bari: Edipuglia, 1999.

———. *Ebrei e cristiani novelli in Puglia: Le comunità minori.* Cassano del Murge: Regione Puglia, Assessorato alla cultura, Istituto ecumenico "S. Nicola," 1991.

———. "Gli ebrei, la Puglia e il mare." In *Andar per mare: Puglia e Mediterraneo tra mito e storia,* ed. Raffaella Cassano, Rosa Lorusso Romito, and Marisa Milella, 307–12. Bari: Consorzio Idria, 1998.

———. "Epigrafi e cimiteri ebraici nella Oria altomedioevale." In *Itinerari in Puglia: Il Medioevo,* ed. Mariapina Mascolo, 68–93 (=*LibrArte* 4 [2011]). Bari: CSSAM, 2012.

———. "Gli epitalami di Meiuchas e Shabbetai da Otranto." *Brundisii Res* 9 (1977): 45–67.

———. "Un epitalamio di Amittai da Oria." *Familiare '82: Studi offerti per le nozze d'argento a Rosario Jurlaro e Nunzia Ditonno,* 85–89. Brindisi: Edizione Amici della "A. de Leo," 1982.

———. "Un frammento di iscrizione ebraica sinagogale." In *Palazzo Adorno: Storia e restauri,* ed. Regina Poso, 25–29. Matera: R&R, 2000.

———. "Hebrew Inscriptions of the Early Medieval Period in Southern Italy." In *The Jews of Italy: Memory and Identity,* ed. Bernard Cooperman and Barbara Garvin, 65–81. Bethesda: University Press of Maryland, 2000.

———. "Insediamenti e condizione degli Ebrei nell'Italia meridionale e insulare." In *Gli Ebrei nell'Alto Medioevo,* Settimane di Studio del Centro italiano di Studi sull'alto medioevo 26, 1:197–227. Spoleto: Centro italiano di Studi sull'alto medioevo, 1980.

———. "L'insediamento ebraico: San Lorenzo." In *Archeologia di una città: Bari dalle origini al X secolo,* ed. Giuseppe Andreassi and Francesca Radina, 513–21. Bari: Edipuglia, 1988.

———. "L'iscrizione brindisina di Baruch ben Yonah e Amittai da Oria." *Brundisii Res* 7 (1975): 295–300.

———. "Un' iscrizione sinagogale di Gravina del XII secolo." *Archivio Storico Pugliese* 29 (1976): 177–81.

———. "Un' iscrizione venosina inedita dell'822." *Rassegna mensile di Israel* 43, nos. 5–6 (1977): 261–63.

———. "Iscrizioni ebraiche a Brindisi." *Brundisii Res* 5 (1973): 91–106.

———. "I mestieri degli ebrei nella Calabria medievale." *Mestieri, lavoro e professioni nella Calabria medievale: Tecniche, organizzazioni, linguaggi; Atti dell'VIII Congresso storico Calabrese, Palmi (RC), 19–22 novembre 1987,* 327–39. Soveria Mannelli: Rubbettino, 1993.

———. "Note su di una iscrizione ebraico-latina di Oria." *Vetera Christianorum* 25, no. 2 (1988): 641–51.

———. "San Nilo di Rossano e gli Ebrei." *Atti del Congresso internazionale su S. Nilo di Rossano, 28 settembre–1 ottobre 1986,* 119–30. Rossano, 1989.

———. *Sefer Yuhasin: Libro delle discendenze.* Cassano delle Murge: Messaggi, 2001.

———. "Le testimonianze epigrafiche e archeologiche come fonte storica." *Materia giudaica* 9 (2004): 37–52.

———. "Tre iscrizioni ebraiche altomedievali a Matera." In *Una manna buona per Mantova (Man Tov le-Man Tovah): Studi in onore di Vittore Colorno per il suo 92° compleanno,* ed. Mauro Perani, 103–16. Florence: Leo S. Olschki, 2004.

———. "Valenza sacrificale della circoncisione in un inno di Shabbatai da Otranto." In *Sangue e Antropologia: Riti e culto; Atti della V Settimana di Studi, Roma, 26 novembre–1 dicembre 1984,* ed. Francesco Vattioni, 925–31. Rome: Pia Unione Preziosissimo Sangue, 1987.

Colafemmina, Cesare, and Giorgio Gramegna. *Sinagoga Museo Sant'Anna: Guida al Museo.* Cassano delle Murge: Messaggi, 2009.

Colafemmina, Cesare, Pasquale Corsi, and Giuseppe Dibenedetto, eds. *La presenza ebraica in Puglia: Fonti documentarie e bibliografiche.* Bari: Luigi di Pascale, 1981.

Colella, Giovanni. *Toponomastica pugliese dalle origini alla fine del Medio Evo.* Trani: Vecchi, 1941.

Colivicchi, Fabio, ed. *Local Cultures of South Italy and Sicily in the Late Republican Period: Between Hellenism and Rome.* JRA Supp. 83. Portsmouth, R.I.: Journal of Roman Archaeology, 2011.

Colorni, Vittore. "La corrispondenza fra nomi ebraici e nomi locali nella prassi dell'ebraismo italiano." In *Italia Judaica: Atti del I Convegno internazionale, Bari, 18–22 maggio 1981,* 67–86. Rome: Multigrafica, 1983.

———. "La corrispondenza fra nomi ebraici e nomi locali nella prassi dell'ebraismo italiano." In *Judaica Minora: Saggi sulla storia dell'ebraismo italiano dall'antichità all'età moderna,* 661–825. Milan: Giuffrè, 1983.

Coluccia, Rosario. "Lingua e politica: Le corti del Salento nel Quattrocento." In *Letteratura, verità e vita: Studi in ricordo di Gorizio Viti,* ed. Paolo Viti, 129–72. Rome: Edizioni di Storia e Letteratura, 2005.

———. "La Puglia." In *L'Italiano nelle regioni: Lingua nazionale e identità regionali,* ed. Francesco Bruni, 685–719. Turin: UTET, 1992.

Compatangelo, Rita. *Un cadastre de pierre: Le Salento romain, paysage et structures agraires.* Paris: Les Belles Lettres, 1989.

Congedo, Lucia Lazari. "Una raccolta settecentesca di proverbi salentini." In *Studi di storia pugliese in onore di Giuseppe Chiarelli,* ed. Michele Paone, 5:5–66. Galatina: Congedo, 1980.

Constable, Giles. "Introduction to *Burchardi, ut videtur, Abbatis Bellevallis Apologia de Barbis.*" In *Apologiae Duae,* Corpus Christianorum, Continuatio Mediaevalis 62, ed. Robert B. C. Huygens, 46–130. Turnhout: Brepols, 1985.

———. "Preface." In *BMFD,* 1:xi–xxxvii.

Constantelos, Demetrios J. "Clerics and Secular Professions in the Byzantine Church." *Byzantina* 13, no. 1 (1985): 373–90.

———. "Liturgy and Liturgical Daily Life in the Medieval Greek World—the Byzantine Empire." In *The Liturgy of the Medieval Church,* ed. Thomas J. Heffernan and E. Ann Matter, 109–43. Kalamazoo, Mich.: Medieval Institute Publications, 2001.

Constas, Nicholas. *Proclus of Constantinople and the Cult of the Virgin in Late Antiquity: Homilies 1–5, Texts and Translations.* Leiden: Brill, 2003.

Corchia, Antonio, ed. *Iscrizioni latine del Salento: Otranto.* Galatina: Congedo, 1992.

Cordasco, Maria Cannataro. "Alfabetismo a Bari fra età sveva ed età angioina: Una prima indagine." In *Cultura e società in Puglia in età sveva e angioina: Atti del convegno di studi, Bitonto, 11–13 dicembre 1987,* ed. Felice Moretti, 131–47. Bitonto: Centro ricerche di storia e arte bitontina, 1989.

Coronil, Fernando. "Transcultural Anthropology in the Américas (with an Accent): The Uses of Fernando Ortíz." In *Cuban Counterpoints: The Legacy of Fernando Ortíz,* ed. Mauricio A. Font and Alfonso W. Quiroz, 139–56. Lanham, Md.: Lexington, 2005.

Corrain, Celto, and Pierluigi Zampini. *Documenti etnografici e folkloristici nei sinodi diocesani italiani.* Bologna: A. Forni, 1970.

Corsi, Pasquale. "Comunità bizantine in Terra d'Otranto." In *Ad ovest di Bisanzio, il Salento medioevale: Atti del seminario internazionale di studio (Martano, 29–30 aprile 1988),* ed. Benedetto Vetere, 31–55. Galatina: Congedo, 1990.

———. "Comunità d'Oriente in Puglia: Alcuni esempi." *Nicolaus* 14 (1987): 159–210.

———. "Il territorio a sud-est di Bari in epoca bizantina: Conversano tra il IX e l'XI secolo." In *Società, cultura, economia nella Puglia medievale: Atti del convegno di studi "Il territorio a sud-est di Bari in età medievale" (Conversano, 13–15 maggio 1983),* ed. Vito L'Abbate, 55–72. Bari: Edizioni Dedalo, 1985.

———. "Testimonianze sulla presenza bizantina in Puglia: I risultati di un sondaggio preliminare." *Lingua e storia in Puglia* 24 (1984): 89–108.

Coulet, Noël. *Les visites pastorales.* Turnhout: Brepols, 1977.

Cuffel, Alexandra. "From Practice to Polemic: Shared Saints and Festivals as 'Women's Religion' in the Medieval Mediterranean." *Bulletin of SOAS* 68, no. 3 (2005): 401–19.

Cuomo, Luisa Ferretti. "Antichissime glosse salentine nel codice ebraico di Parma, De Rossi, 138." *Medioevo Romanzo* 4 (1977): 185–271.

———. "*Italchiano* versus *giudeo-italiano* versus *0 (zero)*: Una questione metodologica." *Italia* 3 (1982): 7–32.

———. "Sintagmi e frasi ibride volgare-ebraico nelle glosse alachiche dei secoli XI–XII." In *Lingua, cultura e intercultura: L'italiano e le altre lingue; Atti del VIII convegno SILFI, Copenhagen, 22–26 giugno 2004*, ed. Iorn Korzen, 321–34. Fredriksberg: Samfundslitterature Press, 2005.

Curta, Florin. "Some Remarks on Ethnicity in Medieval Archaeology." *Early Medieval Europe* 15, no. 2 (2007): 159–85.

Curzi, Gaetano. "Segni e simboli nel soffitto dipinto della cripta del Crocefisso a Ugento (Lecce)." *Ikon* 2 (2009): 191–202.

Cutler, Anthony. "La 'questione bizantina' nella pittura italiana: Una visione alternativa della 'maniera greca.'" In *La pittura in Italia: L'Altomedioevo,* ed. Carlo Bertelli, 335–54. Milan: Electa, 1994.

Cutolo, Alessandro. *Maria d'Enghien.* 2nd ed. Galatina: Congedo, 1977.

Daboo, Jerri. *Ritual, Rapture and Remorse: A Study of Tarantism and* Pizzica *in Salento.* Bern: Peter Lang, 2010.

Dahan, Gilbert. *The Christian Polemic Against the Jews in the Middle Ages.* Trans. Jody Gladding. Notre Dame, Ind.: University of Notre Dame Press, 1998.

Dalena, Pietro. "Itinerari pugliesi dei pellegrini verso la Terra Santa." http://www.webalice.it/fporetti/Sintesi%20Convegno.htm.

———. *Strade e percorsi nel Mezzogiorno d'Italia (secc. VI–XIII).* Cosenza: Duemme, 1995.

Dal Pino, Franco Andrea. "Santi protettori di mestieri nella Calabria medievale." In *Mestieri, lavoro e professioni nella Calabria medievale: Tecniche, organizzazioni, linguaggi; Atti dell'VIII Congresso storico Calabrese, Palmi (RC), 19–22 novembre 1987*, 353–65. Soveria Mannelli: Rubbettino, 1993.

Da Molin, Giovanna. *La popolazione del regno di Napoli a metà Quattrocento.* Bari: Adriatica, 1979.

Dan, Joseph. "The Beginnings of Jewish Mysticism in Europe." In *The Dark Ages: Jews in Christian Europe,* ed. Cecil Roth, 282–90. New Brunswick, N.J.: Rutgers University Press, 1966.

———. "La cultura ebraica nell'Italia medievale: Filosofia, etica, misticismo." In *Gli ebrei in Italia*, Storia d'Italia, Annali 11, ed. Corrado Vivanti, 339–58. Turin: Einaudi, 1996.

———. *Jewish Mysticism.* Vol. 2, *The Middle Ages.* Northvale, N.J.: Jason Aronson, 1998–99.

D'Andria, Francesco. "La documentazione archeologica medioevale nella Puglia meridionale." In *Le aree omogenee della Civiltà Rupestre nell'ambito dell'Impero Bizantino—la Serbia: Atti del quarto convegno internazionale di studio sulla civiltà rupestre medioevale nel Mezzogiorno d'Italia (Taranto-Fasano, 19–23 settembre, 1977)*, ed. Cosimo Damiano Fonseca, 223–28. Galatina: Congedo, 1979.

———. "La documentazione archeologica negli insediamenti del Materano tra tardoantico e alto medioevo." In *Habitat, Strutture, Territorio: Atti del terzo convegno internazionale di studio sulla Civiltà Rupestre medioevale nel Mezzogiorno d'Italia (Taranto-Grottaglie, 24–27 settembre 1975)*, ed. Cosimo Damiano Fonseca, 157–162. Galatina: Congedo, 1978.

D'Andria, Francesco, Giovanni Mastronuzzi, and Valeria Melissano. "La chiesa e la necropoli paleocristiana di Vaste nel Salento." *Rivista di archeologia cristiana* 82 (2006): 231–321.

D'Angela, Cosimo. "Contesti tombali tardoantiche e altomedievali." *La parola del passato* 50 (1995): 319–26.

———, ed. *La cripta della Cattedrale di Taranto*. Taranto: Editrice Scorpione, 1986.

———. "La documentazione archeologica negli insediamenti rupestri medioevali dell'agro orientale di Taranto." In *Habitat, Strutture, Territorio: Atti del terzo convegno internazionale di studio sulla Civiltà Rupestre medioevale nel Mezzogiorno d'Italia (Taranto-Grottaglie, 24–27 settembre 1975)*, ed. Cosimo Damiano Fonseca, 165–79. Galatina: Congedo, 1978.

———. "Due stele bizantine nel Museo Nazionale di Taranto." *Byzantion* 48 (1978): 386–92.

———. "Nota sulla 'Cripta del Redentore' di Taranto." In *La civiltà rupestre medioevale nel Mezzogiorno d'Italia: Ricerche e problemi; Atti del primo convegno internazionale di studi (Mottola-Casalrotto, 1971)*, ed. Cosimo Damiano Fonseca, 221–29. Genoa: Istituto Grafico S. Basile, 1975.

———. *Ori bizantini del Museo Nazionale di Taranto*. Taranto: Editrice Scorpione, 1989.

———. "Le orificerie bizantine del Museo Nazionale di Taranto." *Vetera Christianorum* 21 (1984): 181–96.

———. "Le origini della chiesa di Taranto." In *La chiesa di Taranto: Studi storici in onore di mons. Guglielmo Motolese, arcivescovo di Taranto, nel XXV anniversario del suo episcopato*, vol. 1, *Dalle origini all'avvento dei Normanni*, ed. Cosimo Damiano Fonseca, 21–51. Galatina: Congedo, 1977.

———. "La ricerca archeologica negli insedimenti rupestri medievali." In *Il popolamento rupestre dell'area mediterranea: La tipologia delle fonti; Gli insediamenti rupestri della Sardegna (Atti del seminario di studio, Lecce, 19–20 ottobre 1984)*, ed. Cosimo Damiano Fonseca, 223–28. Galatina: Congedo, 1988.

———. "I rinvenimenti tardoantichi e medievali." In *Il Museo di Taranto, Cento Anni di Archeologia*, 113–22. Taranto: Mandese, 1988.

———. "Un saggio di scavo in località S. Pietro Mandurino (Taranto)." *Vetera Christianorum* 12 (1975): 139–54.

———. *Taranto medievale*. Taranto: Cressati Editore, 2002.

———. "Vestigia del culto dei 'SS. Trium Puerorum' nel Tarantino." *Nicolaus* 3 (1975): 423–28.

Danieli, Francesco. *Il rito greco a Galatone: S. Franceso d'Assisi in un codice bizantino del sec. XV*. Galatina: Congedo, 2005.

———. "San Francesco d'Assisi nel Salento bizantino." *Cultura Salentina: Rivista di pensiero e cultura meridionale*, October 5, 2009. http://culturasalentina.wordpress.com/2009/10/05/san-francesco-d'assisi-nel-salento-bizantino/

Daquino, Cesare. *Bizantini di Terra d'Otranto: San Nicola di Casole*. Lecce: Capone, 2000.

———. *I Messapi: Il Salento prima di Roma*. Cavallino: Capone, 1999.

Darrouzès, Jean. "Un faux acte attribué au Patriarche Nicolas (III)." *Revue des Études Byzantines* 28 (1970): 221–37.

Davis, Simon J. M. "Some Animal Bones from Five Medieval Sites in the Salento, Southern Italy." Unpublished paper, 1999.

Davis-Secord, Sarah C. "Medieval Sicily and Southern Italy in Recent Historiographical Perspective." *History Compass* 8, no. 1 (2010): 61–87.

Day, Cyrus L. "Knots and Knot Lore." *Western Folklore* 9, no. 3 (1950): 229–56; 16, no. 1 (1957): 8–26.

De Angelis, Alessandro. "Introduzione ai dialetti italiani meridionali estremi (salentino, calabrese meridionale, siciliano)." http://www.yumpu.com/it/document/view/8974028/Introduzione-ai-dialetti-italiani-meridionali-estremi-universita-per.

De Donno, Nicolo, ed. *Dizionario dei proverbi Salentini*. Galatina: Congedo, 1995.

De Felice, Emidio. *I cognomi italiani*. Bologna: Il Mulino, 1980.

Degasperi, Angelica. "Le monete." In *Da Apigliano a Martano: Tre anni di archeologia medioe-vale, 1997–1999*, ed. Paul Arthur, 37–39. Galatina: Congedo, 1999.

De Giorgi, Cosimo. *La Provincia di Lecce: Bozzetti di Viaggio*, 2 vols. Lecce: Spacciante, 1882–88; repr., Galatina: Congedo, 1975.

De Giorgi, Manuela. "La *Koimesis* bizantina di Miggiano (Lecce): Iconografia e fonti liturgiche." In *Medioevo mediterraneo: L'Occidente, Bisanzio, e l'Islam; Atti del VII Convegno inter-nazionale di Studi, Parma, 21–25 settembre 2004*, ed. Arturo Carlo Quintavalle, 332–40. Milan: Electa, 2007.

de Heusch, Luc. "L'*ethnie*: The Vicissitudes of a Concept." *Social Anthropology* 8, no. 2 (2000): 99–115.

de Lange, Nicholas. "A Fragment of Byzantine Anti-Christian Polemic." *Journal of Jewish Studies* 41 (1990): 92–100.

———. "Hebraism and Hellenism: The Case of Byzantine Jewry." *Poetics Today* 19, no. 1 (1998): 129–45.

———. "Jewish Sources." In *Byzantines and Crusaders in Non-Greek Sources, 1025–1204*, Pro-ceedings of the British Academy 132, ed. Mary Whitby, 361–82. Oxford: Oxford University Press/British Academy, 2007.

Delatte, Armand. *Anecdota Atheniensia*. Vol. 1, *Textes grecs inédits relatifs a l'histoire des religions*. Liège: H. Vaillant-Carmanne; Paris: É. Champion, 1927.

De Leo, Pietro. "Contributo per una nuova *Lecce Sacra*: I. La serie dei vescovi di Lecce di N. Fatalo," pt. 2, "Dalla conquista normanna al concilio tridentino." *La Zagaglia* 17, nos. 65–66 (1975): 3–34. http://www.culturaservizi.it/vrd/files/ZG1975_contributo_nuova_Lecce_sacra.pdf.

Del Giudice, Giuseppe. *Una legge suntuaria inedita del 1290: Memoria letta all'Accademia Pon-taniana nelle tornate del 16 marzo e 20 aprile 1884*. Atti del Accademia Pontaniana 16 (1886). Naples: Regia Università, 1887.

D'Elia, Michele. "Aggiunte alla pittura pugliese del tardo-medioevo (La cripta del Crocefisso a Ugento)." In *Scritti di storia dell'arte in onore di Ugo Procacci*, ed. Maria Grazia Ciardi Duprè Dal Poggetto and Paolo Dal Poggetto, 1:62–67. Milan: Electa, 1977.

Della Monaca, Andrea. *Memoria historica dell'antichissima, e fedelissima città di Brindisi*. Lecce: Pietro Micheli, 1674.

Dell'Aquila, Franco, and Aldo Messina. *Le chiese rupestri di Puglia e Basilicata*. Bari: M. Adda, 1998.

———. "Il *templon* nelle chiese rupestri dell'Italia meridionale." *Byzantion* 59 (1989): 20–47.

Delogu, Paul. "Patroni, donatori, committenti nell'Italia meridionale longobarda." In *Commit-tenti e produzione artistico-letteraria nell'alto medioevo occidentale*, Settimane di Studio del Centro italiano di studi sull'alto medioevo 39, 303–34. Spoleto: Centro italiano di Studi sul-l'alto medioevo, 1992.

Delouca, Katerina. "Les graffitis de navires de l'Occident médiéval dans les monuments byzan-tins: L'exemple du Théseion." In *Utilis est lapis in structura: Mélanges offerts à Léon Pres-souyre*, 373–77. Paris: Comité des travaux historiques et scientifiques, 2000.

Del Re, Niccolò. "Potito." In *Bibliotheca Sanctorum*, 10:1071–74. Rome: Istituto Giovanni XXIII nella Pontificia Università lateranense, 1968.

De Martino, Ernesto. *Sud e magia*. Milan: Feltrinelli, 1959; repr., 1996.

———. *La terra del rimorso: Contributo a una storia religiosa del sud*. Milan: Saggiatore, 1961.

De Meester, Placido. *Rituale-benedizionale bizantino*. Rome: Tipografia Leonina, 1930.

De Meo, Nicola. *La civiltà contadina in Calabria e nel Mezzogiorno*. Soveria Manelli: Calabria Letteraria Editrice, 1987.

De Sanctis, Brizio. "La chiesa di San Nicola e Cataldo in Lecce e le due iscrizioni relative alla sua fondazione." *Rivista di archeologia cristiana* 23–24 (1947–48): 353–65.

De Simone, Raffaele. "Dana." In *Bibliotheca Sanctorum*, 4:447. Rome: Istituto Giovanni XXIII nella Pontificia Università lateranense, 1964.

De Venuto, Giovanni. "Zooarchaeology in the South Italy: A Perspective of Study for the Economic Characters of the Consumption and Production During the Middle Ages." Medieval Europe, Paris 2007, 4th International Congress of Medieval and Modern Archaeology. http://medieval-europe-paris-2007.univ-paris1.fr/G.Devenuto.pdf.

Díaz-Andreu, Margarita. "Gender Identity." In *The Archaeology of Identity: Approaches to Gender, Age, Status, Ethnicity and Religion*, ed. Margarita Díaz-Andreu et al., 13–42. London: Routledge, 2005.

Díaz-Andreu, Margarita, and Sam Lucy. "Introduction." In *The Archaeology of Identity: Approaches to Gender, Age, Status, Ethnicity and Religion*, ed. Margarita Díaz-Andreu et al., 1–12. London: Routledge, 2005.

Di Dario Guida, Maria Pia. *Alla ricerca dell'arte perduta: Il Medioevo in Italia Meridionale*. Rome: Gangemi, 2006.

Didi-Huberman, Georges. "Ex-voto: Image, Organ, Time." *L'Esprit Créateur* 47, no. 3, (2007): 7–16.

Diehl, Charles. *L'art byzantin dans l'Italie méridionale*. Paris: Librairie de l'Art, 1894.

Di Gangi, Giorgio, and Chiara Maria Lebole. "Luoghi dei vivi, luoghi dei morti: Aspetti di ritualità e topografia nella Calabria medievale." In *Atti del III Convegno nazionale di Archeologia medievale, Salerno, 2–5 ottobre 2003*, ed. Rosa Fiorillo and Paolo Peduto, 3:747–52. Florence: All'Insegna del Giglio, 2003.

Di Mitri, Gino Leonardo. "Mitografia, danza e dramma sacramentale alle origini del Tarantismo." In *Quarant'anni dopo De Martino: Il Tarantismo; Atti del Convegno internazionale di studi sul tarantismo, Galatina, 24–25 ottobre 1998*, ed. Gino Leonardo De Mitri, 1:71–99. Nardò: Besa, 2000.

Di Nola, Alfonso M. *L'arco di rovo: Impotenza e aggressività in due rituali del Sud.* Turin: Boringhieri, 1983.

Di Segni, Riccardo. "La cultura folklorica degli Ebrei d'Italia." http://www.morasha.it/zehut/rds07_culturafolklorica.html.

Ditchfield, Philip. *La culture matérielle médiévale: L'Italie méridionale byzantine et normande.* Rome: École française, 2007.

Djurić, Vojislav J., and Anna Tsitouridou. *Namentragende Inschriften auf Fresken und Mosaiken auf der Balkanhalbinsel vom 7. bis zum 13. Jahrhundert.* Stuttgart: Steiner, 1986.

Doniger, Wendy, and Gregory Spinner. "Female Imaginations and Male Fantasies in Parental Imprinting." *Daedalus* 127, no. 1 (1998): 97–129.

D'Onofrio, Mario, ed. *I Normanni: popolo d'Europa, 1030–1200: Rome, 28 gennaio–30 aprile 1994.* Venice: Marsilio, 1994.

D'Oria, Filippo. "Il documento notarile italo-greco in età fridericiana: Appunti per una discussione." In *Per la storia del Mezzogiorno medievale e moderno: Studi in memoria di Jole Mazzoleni*, 1:93–106. Rome: Ufficio centrale per i beni archivistici, 1998.

Drell, Joanna H. "Cultural Syncretism and Ethnic Identity: The Norman 'Conquest' of Southern Italy and Sicily." *Journal of Medieval History* 25, no. 3 (1999): 187–202.

Durante, Daniele. *Spartito (io resto qui): Storie e canzoni della musica popolare salentina.* Lecce: Salento Altra Musica Edizioni, 2005.

Durante, Roberta. "Miniature e affreschi in Terra d'Otranto." *RSBN* 45 (2008): 225–56.

Efthymiadis, Stephanos. "D'Orient en Occident mais étranger aux deux mondes: Messages et renseignements tirés de la Vie de Saint Nicolas le Pèlerin (*BHL* 6223)." In *Puer Apuliae: Mélanges offerts à Jean-Marie Martin*, ed. Erricco Cuozzo et al., 207–23. Paris: Association des amis du centre d'histoire et civilisation de Byzance, 2008.

———. "L'enseignement secondaire à Constantinople pendant les XIe et XIIe siècles: Modèle éducatif pour la Terre d'Otrante au XIIIe siècle." *Nea Rhōmē* 2 (2005): 259–75.

Egidi, Pietro. "Ricerche sulla popolazione dell'Italia meridionale nei secoli XIII e XIV." In *Miscellanea di studi storici in onore di Giovanni Sforza*, ed. Paolo Boselli, 731–50. Turin: Baroni, 1923.

Ehrlich, Uri, and Ruth Langer. "The Earliest Texts of the Birkat Haminim." *Hebrew Union College Annual* 76 (2005): 63–112.

Eicher, Joanne B. "Introduction: Dress as Expression of Ethnic Identity." In *Dress and Ethnicity: Change Across Space and Time*, ed. Joanne B. Eicher, 1–5. Oxford: Berg, 1995.

Elbogen, Ismar. *Jewish Liturgy: A Comprehensive History.* Trans. Raymond P. Scheindlin. Philadelphia: Jewish Publication Society; New York: Jewish Theological Seminary of America, 1993.

Eleuteri, Paolo, and Antonio Rigo. *Eretici, dissidenti, Musulmani ed Ebrei a Bisanzio: Una raccolta eresiologica del XII secolo.* Venice: Cardo, 1993.

Elior, Rachel. "Merkabah Mysticism, a Critical Review." *Numen* 37, no. 2 (1990): 233–49.

———. "Mysticism, Magic, and Angelology: The Perception of Angels in Hekhalot Literature." *Jewish Studies Quarterly* 1 (1993/94): 3–53.

Elkins, James, and Robert Williams, eds. *Renaissance Theory.* New York: Routledge, 2008.

Elukin, Jonathan. *Living Together, Living Apart.* Princeton, N.J.: Princeton University Press, 2007.

Emmanuel, Melita. "Some Notes on the External Appearance of Ordinary Women in Byzantium: Hairstyles, Headdresses; Texts and Iconography." *Byzantinoslavica* 56 (1995): 769–78.

Epifani, Maria Antonietta. *Stregatura: Mentalità religiosa e stregoneria nel Mezzogiorno di antico regime.* Nardò: Beso, 2000.

Epstein, Marc Michael. *Dreams of Subversion in Medieval Jewish Art and Literature.* University Park: Pennsylvania State University Press, 1997.

Epstein, Steven A. *Speaking of Slavery: Color, Ethnicity, and Human Bondage in Italy.* Ithaca, N.Y.: Cornell University Press, 2001.

Erikson, Erik. *Identity and the Life Cycle.* New York: Norton, 1980.

Esposito, Marina. "Feste e tradizioni popolari: I luoghi, le date." In *Itinerari in Puglia: tra arte e spiritualità*, ed. Mimma Pasculli Ferrara, 199–203. Rome: De Luca, 2000.

Evans, Helen C., ed. *Byzantium: Faith and Power (1261–1557).* New York: Metropolitan Museum of Art, 2004.

Evans, Jessica, and Stuart Hall, eds. *Visual Culture: The Reader.* London: Sage, 1999.

Falkenhausen, Vera von. "Una babele di lingue: A chi l'ultima parola? Plurilinguismo sacro e profano nel regno Normanno-Svevo." *Archivio storico per la Calabria e la Lucania* 76 (2010): 13–35.

———. "Between Two Empires: Byzantine Italy in the Reign of Basil II." In *Byzantium in the Year 1000*, ed. Paul Magdalino, 135–59. Leiden: Brill, 2003.

———. *La dominazione bizantina nell'Italia meridionale dal IX all'XI secolo.* Bari: Ecumenica Editrice, 1978.

———. "L'ebraismo dell'Italia meridionale nell'età bizantina (secoli VI–XI)." In *L'Ebraismo dell'Italia meridionale peninsulare dalle origini al 1541: Società, economia, cultura* [IX Congresso Internazionale dell'Associazione Italiana per lo studio del Giudaismo, Potenza, 1992], ed. Cosimo Damiano Fonseca et al., 25–46. Galatina: Congedo, 1996.

———. "I gruppi etnici nel regno di Ruggero II e la loro partecipazione al potere." In *Società, potere e popolo nell'età di Ruggero II: Atti delle terze giornate normanno-sveve, Bari, 23–25 maggio 1977*, 133–56. Bari: Edizioni Dedalo, 1979.

———. "Un inedito documento greco del monastero di S. Vito del Pizzo (Taranto)." *Cenacolo*, n.s., 7 (1995): 7–20.

———. "In Search of the Jews in Byzantine Literature." In *Jews in Byzantium: Dialectics of Minority and Majority Cultures*, ed. Robert Bonfil et al., 871–91. Leiden: Brill, 2012.

———. "The Jews in Byzantine Southern Italy." In *Jews in Byzantium: Dialectics of Minority and Majority Cultures*, ed. Robert Bonfil et al., 271–96. Leiden: Brill, 2012.

———. "Il popolamento: Etnìe, fedi, insediamenti." In *Terra e uomini nel Mezzogiorno normanno-svevo: Atti delle settime giornate normanno-sveve, Bari, 15–17 ottobre 1985*, ed. Giosuè Musca, 39–73. Bari: Dedalo, 1987.

———. "Réseaux routiers et ports dans l'Italie méridionale byzantine (VIᵉ–IXᵉ siècle)." In *Hē kathēmerinē zōē sto Vyzantio: tomes kai synecheies stēn hellēnistikē kai rōmaïkē paradosē; praktika tou [1.] Diethnous Symposiou, 15–17 septemvriou 1988*, ed. Christina G. Angelidē, 711–31. Athens: Kentron Vyzantinōn Ereunōn, 1989.

———. "San Pietro nella religiosità bizantina." In *Bisanzio, Roma e l'Italia nell'alto medioevo*, Settimane di Studio del Centro italiano di studi sull'alto medioevo 34, 2:627–58. Spoleto: Centro italiano di Studi sull'alto medioevo, 1988.

———. "The South Italian Sources." *Proceedings of the British Academy* 132 (2006): 95–120.

———. "Taranto in epoca bizantina." *Studi medievali*, ser. 3, 9 (1968): 133–66.

———. "Tra Occidente e Oriente: Otranto in epoca bizantina." In *Otranto nel medioevo tra Bisanzio e l'Occidente*, ed. Hubert Houben, 13–60. Galatina: Congedo, 2007.

Falkenhausen, Vera von, and Mario Amelotti. "Notariato e documento nell'Italia meridionale greca (X–XV secolo)." In *Per una storia del notariato meridionale*, 9–69. Rome: Consiglio nazionale del notariato, 1982.

Falla Castelfranchi, Marina. "Anche i santi andavano a scuola." In *Scritti offerti a Raffaele Laporta*, ed. Università degli studi "G. D'Annunzio," 241–60. Chieti: Vecchio Faggio, 1990.

———. "La chiesa di San Barsanofrio, oggi S. Francesco di Paola, a Oria." In *Puglia preromanica dal V secolo agli inizi dell'XI*, ed. Gioia Bertelli, 251. Bari: Edipuglia–Jaca Book, 2004.

———. "La chiesa di San Pietro a Otranto." In *Puglia preromanica dal V secolo agli inizi dell'XI*, ed. Gioia Bertelli, 181–92. Bari: Edipuglia–Jaca Book, 2004.

———. "La chiesa di San Pietro di Crepacore nei pressi di Torre Santa Susanna." In *Puglia preromanica dal V secolo agli inizi dell'XI*, ed. Gioia Bertelli, 147–60. Bari: Edipuglia–Jaca Book, 2004.

———. "La chiesa di San Salvatore a Sanarica." In *Puglia preromanica dal V secolo agli inizi dell'XI*, ed. Gioia Bertelli, 283–88. Bari: Edipuglia–Jaca Book, 2004.

———. "La chiesa di San Salvatore e la sua decorazione pittorica." In *Sanarica*, ed. Antonio Cassiano, 59–85. Galatina: Congedo, 2001.

———. "La chiesa di Santa Maria della Croce a Casaranello." In *Puglia preromanica dal V secolo agli inizi dell'XI*, ed. Gioia Bertelli, 161–75. Bari: Edipuglia–Jaca Book, 2004.

———. "La chiesa di Santa Marina a Muro Leccese." In *Puglia preromanica dal V secolo agli inizi dell'XI*, ed. Gioia Bertelli, 193–205. Bari: Edipuglia–Jaca Book, 2004.

———. "La cripta anonima nella Gravina di Riggio presso Grottaglie." In *Puglia preromanica dal V secolo agli inizi dell'XI*, ed. Gioia Bertelli, 262–65. Bari: Edipuglia–Jaca Book, 2004.

———. "La cripta delle Sante Marina e Cristina a Carpignano Salentino." In *Puglia preromanica dal V secolo agli inizi dell'XI*, ed. Gioia Bertelli, 206–21. Bari: Edipuglia–Jaca Book, 2004.

———. "Culto e immagini dei Santi Medici nell'Italia meridionale bizantina e normanna." In *La cultura scientifica e tecnica nell'Italia meridionale bizantina: Atti della sesta Giornata di studi bizantini; Arcavacata di Rende, 8–9 febbraio 2000*, ed. Filippo Burgarella and Anna Maria Ieraci Bio, 59–96. Soveria Mannelli: Rubbettino, 2006.

———. "La cultura artistica bizantina in Puglia." In *Arte in Puglia dal Medioevo al Settecento: Il Medioevo*, ed. Francesco Abbate, 79–95. Rome: De Luca Editori d'Arte, 2010.

———. "La decorazione pittorica bizantina della Cripta della Celimanna." In *Supersano: Un paesaggio antico del basso Salento*, ed. Paul Arthur and Valeria Melissano, 67–80. Galatina: Congedo, 2004.

———. "La decorazione pittorica della cripta detta del Crocefisso ad Ugento." In *La Cripta del Crocefisso ad Ugento: La storia, gli studi, le nuove acquisizioni*, ed. Maria Consiglia De Matteis, 39–55. Ugento: Associazione Pro-Loco Ugento e Marine, 2006.

———. "La decorazione pittorica d'epoca macedone della chiesa presso Torre Santa Susanna (Br), e un'ipotesi sul committente." In *Medioevo: Arte e storia; Atti del Convegno internazionale di studi, Parma, 18–22 settembre 2007*, ed. Arturo Carlo Quintavalle, 157–64. Milan: Electa, 2008.

———. "Del ruolo dei programmi iconografici absidali nella pittura bizantina dell'Italia meridionale e di un'immagine desueta e colta nella cripta della Candelora a Massafra." In *Il popolamento rupestre dell'area mediterranea: La tipologia delle fonti; Gli insediamenti rupestri della Sardegna*, ed. Cosimo Damiano Fonseca, 193–217. Galatina: Congedo, 1987.

———. "Il *Mandylion* nel Mezzogiorno medioevale." In *Intorno al Sacro Volto: Genova, Bisanzio e il Mediterraneo (secoli XI–XIV)*, ed. Anna Rosa Calderoni Masetti, Colette Dufour Bozzo, and Gerhard Wolf, 187–208. Venice: Marsilio, 2007.

———. "I monumenti di Nardò dal XIII al XVIII secolo." In *Citta e monastero: I segni urbani di Nardò (secc. XI–XV)*, ed. Benedetto Vetere, 241–76. Galatina: Congedo, 1986.

———. "Note preliminari su Oria nel IX secolo." In *Atti del VI Congresso nazionale di Archeologia Cristiana, Pesaro-Ancona, 19–23 settembre 1983*, 1:113–25. Florence: Nuova Italia, 1986.

———. *Pittura monumentale bizantina in Puglia*. Milan: Electa, 1991.

———. "Sul Bosforo d'Occidente: La cultura artistica ad Otranto in epoca tardoantica e medioevale." In *Otranto nel medioevo tra Bisanzio e l'Occidente*, ed. Hubert Houben, 281–324. Galatina: Congedo, 2007.

Fanciullo, Franco. "Latino e greco nel Salento." In *Storia di Lecce dai Bizantini agli Aragonesi*, ed. Benedetto Vetere, 421–86. Bari: Laterza, 1993.

Farella, Vittorio. "La chiesa e la cripta rupestre dell'Annunziata a Lizzano (per una ipotesi di restauro)." In *Le aree omogenee della Civiltà Rupestre nell'ambito dell'Impero bizantino—la Cappadocia: Atti del quinto convegno internazionale di studio sulla Civiltà Rupestre medioevale nel Mezzogiorno d'Italia (Lecce-Nardò, 12–16 ottobre 1979)*, ed. Cosimo Damiano Fonseca, 351–401. Galatina: Congedo, 1981.

———. "Note sul monastero italo-greco di San Vito del Pizzo (Taranto)." *Cenacolo* 4 (1974): 31–44.

Favreau, Robert. "Les commanditaires dans les inscriptions du haut moyen âge occidentale." In *Committenti e produzione artistico-letteraria nell'alto medioevo occidentale*. Settimane di Studio del Centro italiano di Studi sull'alto medioevo 39, 681–722. Spoleto: Centro italiano di Studi sull'alto medioevo, 1992.

Felle, Antonio Enrico. "La documentazione epigrafica." In *Torre Santa Susanna: Chiesa di S. Pietro; Storia archeologia restauro*, ed. Grazia Angela Maruggi and Gaetano Lavermicocca, 13–18. Bari: Mario Adda, 2000.

Fenster, Thelma. "Preface: Why Men?" In *Medieval Masculinities: Regarding Men in the Middle Ages*, ed. Clare A. Lees, ix–xiii. Minneapolis: University of Minnesota Press, 1994.

Ferorelli, Nicola. *Gli ebrei nell'Italia meridionale dall'età romana al secolo XVIII*. Bologna: A. Forni, 1966.

Fibbi, Rosita, Bülent Kaya, and Étienne Piguet. *Nomen est omen: Quand s'appeler Pierre, Afrim ou Mehmet fait la différence*. Nationales Forschungsprogramm Bildung und Beschäftigung, n.s., PNR 43, Synthesis 3. Bern: Schweizerischer Nationalfonds, 2003. http://www.snf.ch/SiteCollectionDocuments/nfp/nfp43_piguet_synthesis3.pdf.

Fine, Lawrence. "The Arts of Calligraphy and Composition and the Love of Books." In *Judaism in Practice: From the Middle Ages Through the Early Modern Period*, ed. Lawrence Fine, 318–24. Princeton, N.J.: Princeton University Press, 2001.

Finkelstein, Louis. *Jewish Self-Government in the Middle Ages.* New York: Jewish Theological Seminary of America, 1924.

Fishman, Talya. "The Rhineland Pietists' Sacralization of Oral Torah." *Jewish Quarterly Review* 96, no. 1 (2006): 9–16.

Fleischer, Ezra. "Hebrew Liturgical Poetry in Italy." In *Italia Judaica: Atti del I Convegno internazionale, Bari, 18–22 maggio 1981*, 415–26. Rome: Multigrafia, 1983.

———. "Prayer and Piyyut in the Worms Mahzor." In "Introductory Volume" to *Worms Mahzor, MS Jewish National and University Library Heb. 4° 781/1*, facsimile edition, ed. Malachi Beit-Arié, 36–78. Jerusalem: Jewish National University Library of the Hebrew University, 1985.

Fleming, Robin. "Bones for Historians: Putting the Body Back into Biography." In *Writing Medieval Biography: Essays in Honour of Brank Barlow*, ed. David Bates, Julia Crick, and Sarah Hamilton, 29–48. Woodbridge: Boydell, 2006.

Flood, Finbarr B. *Objects of Translation: Material Culture and Medieval "Hindu-Muslim" Encounter.* Princeton, N.J.: Princeton University Press, 2009.

Folgerø, Per Olav. "The Vision in Daniel 7, 9–13 and the Ascension of Christ: On the Analepsis Scene in the Development of the Cupola-Pantocrator System." *Arte medievale*, n.s., 6, no. 2 (2007): 21–28.

Follieri, Enrica. "Il culto dei santi nell'Italia greca." In *La Chiesa greca in Italia dall'VIII al XVI secolo: Atti del Convegno storico interecclesiale (Bari, 30 apr.–4 magg. 1969)*, 2:553–77. Padua: Antenore, 1972–73.

Fonseca, Cosimo Damiano. "La civiltà rupestre in Puglia." In *La Puglia fra Bisanzio e l'Occidente*, 37–116. Milan: Electa, 1980.

———. *Civiltà rupestre in Terra Jonica.* Milan: Bestetti, 1970.

Fonseca, Cosimo Damiano, and Cosimo D'Angela, eds. *Casalrotto I: La Storia–Gli Scavi.* Galatina: Congedo, 1989.

Fonseca, Cosimo Damiano, and Valentino Pace, eds. *Federico II e l'Italia: Percorsi, luoghi e strumenti.* Catalog of exhibition held in Rome, Palazzo Venezia, December 22, 1995–April 30, 1996. Rome: De Luca Editalia, 1995.

Fonseca, Cosimo Damiano, et al. *Gli insediamenti rupestri medioevali nel Basso Salento.* Galatina: Congedo, 1979.

Fontana, Maria V. "Byzantine Mediation of Epigraphic Characters of Islamic Derivation in the Wall Paintings of Some Churches in Southern Italy." In *Islam and the Italian Renaissance*, Warburg Institute Colloquia 5, ed. Charles Burnett and Anna Contadini, 61–75. London: Warburg Institute, University of London, 1999.

———. "Riferimenti islamici negli affreschi di Santa Maria di Anglona e di Santa Maria di Cerrate a Squinzano." *Archivio storico per la Calabria e la Lucania* 76 (2010): 37–54.

Forbes, Thomas R. "Chalcedony and Childbirth: Precious and Semi-Precious Stones as Obstetrical Amulets." *Yale Journal of Biology and Medicine* 35, no. 5 (April 1963): 390–401.

Forte, F., R. O. Strobl, and L. Pennetta. "A Methodology Using GIS, Aerial Photos and Remote Sensing for Loss Estimation and Flood Vulnerability Analysis in the Supersano–Ruffano–Nociglia Graben, Southern Italy." *Environmental Geology* 50 (2006): 581–94.

Foscarini, Amilcare. *Armerista e notiziario delle famiglie nobili, notabili e feudatarie di Terra d'Otranto.* Lecce, 1927; repr., Bologna: Forni, 1971.

Foskolou, Vassiliki. "The Virgin, the Christ-child, and the Evil Eye." In *Images of the Mother of God: Perceptions of the Theotokos in Byzantium*, ed. Maria Vassilaki, 251–62. Aldershot: Ashgate, 2005.

Foti, Maria Bianca. *Cultura e scrittura nelle chiese e nei monasteri italo-greci.* Messina: Sicania, 1992.

Fraenkel, Avraham. "R. Amnon and the Penetration of 'ונתנה תוקף' into Italy, Ashkenaz and France." *Zion* 67, no. 2 (2002): 125–38.

Franses, Henri. "Symbols, Meaning, Belief: Donor Portraits in Byzantine Art." Ph.D. diss., Courtauld Institute of Art, 1992.

Fratti, Liliana, Umberto Sansoni, and Riccardo Scotti. *Il nodo di Salomone: Un simbolo nei millenni.* Turin: Ananke, 2010.

Freedberg, David. *The Power of Images: Studies in the History and Theory of Response.* Chicago: University of Chicago Press, 1989.

Freidenreich, David M. *Foreigners and Their Food: Constructing Otherness in Jewish, Christian, and Islamic Law.* Berkeley: University of California Press, 2011.

Freudenthal, Gad. "'Arav and Edom as Cultural Resources for Medieval Judaism: Contrasting Attitudes Toward Arabic and Latin Learning in the Midi and in Italy." *Late Medieval Jewish Identities: Iberia and Beyond,* ed. Carmen Caballero-Navas and Esperanza Alfonso, 123–56. New York: Palgrave Macmillan, 2010.

Friedman, Mordechai Akiva. *Jewish Marriage in Palestine: A Cairo Geniza Study.* 2 vols. Tel Aviv: TAU; New York: JTS, 1980.

Frolov, A. "La 'Podea': Un tissu décoratif de l'église byzantine." *Byzantion* 13 (1938): 461–504.

Frugoni, Chiara. "Il mosaico della cattedrale di Otranto." In *La Puglia fra Bisanzio e l'Occidente,* 197–204. Milan: Electa, 1980.

Gaballo, Marcello, ed. *Civitas Neritonensis: La storia di Nardò di Emanuele Pignatelli ed altri contributi.* Galatina: Congedo, 2001.

Gabellone, Francesco. "Virtual Cerrate: A DVR-Based Knowledge Platform for an Archaeological Complex of the Byzantine Age." *CAA 2008, Computer Applications and Quantitative Methods in Archaeology* (Budapest, 2008).

Galdoz, Henri. *Un vieux rite médical: Opuscule offert à Anatole de Barthélemy pour fêter le 50ᵉ anniversaire de son élection comme membre de la Société des Antiquaires de France, le 9 mai, 1842.* Paris: Librairie E. Rolland, 1892.

Galt, Anthony H. "The Evil Eye as Synthetic Image and Its Meanings on the Island of Pantelleria, Italy." *American Ethnologist* 9 (1982): 664–81.

———. "Magical Misfortune in Locorotondo." *American Ethnologist* 18, no. 4 (1991): 735–50.

Gambacorta, Antonio. "Culto e pelegrinaggi a S. Nicola di Bari fino alla prima Crociata." In *Pellegrinaggio e culto dei santi in Europa fino alla prima Crociata, 8–11 ottobre 1961,* 487–502. Todi: Accademia Tudertina, 1963.

Gandz, Solomon. "The Knot in Hebrew Literature, or From the Knot to the Alphabet." *Isis* 14, no. 1 (1930): 189–214.

Gardette, Philippe. *Une culture entre Renaissance italienne et Orient: Prolégomènes à la culture juive byzantine.* Istanbul: Éditions Isis, 2010.

Garnier, François. *Le langage de l'image au Moyen Age.* Vol. 1, *Signification et symbolique.* Tours: Léopard d'Or, 1982.

Gaspari, Anna. "Francesco d'Assisi: Un Santo venerato anche dalla chiesa bizantina? Il 'caso' del manoscritto Galat. 4." *Archivum Franciscanum Historicum* 101, no. 1 (2008): 155–80.

———. *Rico sposo della povertà: Ufficio liturgico italogreco per Francesco d'Assisi; Edizione critica, traduzione e commento.* Rome: Antonianum, 2010.

Geary, Patrick. "Ethnic Identity as a Situational Construct in the Early Middle Ages." *Mitteilungen der anthropologischen gesellschaft in Wien* 113 (1983): 15–26.

Geertz, Clifford. *The Interpretation of Cultures.* New York: Basic Books, 1973.

Gelao, Clara. *Un capitolo sconosciuto di arte decorativa: "Tecta depicta" di chiese medievale pugliesi.* Bari: Grafica Safra, [1981].

———. "Chiesa cattedrale (già Chiesa Abbaziale di S. Maria Assunta), Nardò." In *Insediamenti benedettini in Puglia*, ed. Maria Stella Calò Mariani, 2:433–40. Galatina: Congedo, 1985.

Gell, Alfred. *Art and Agency: An Anthropological Theory*. New York: Oxford University Press, 1998.

Gentilcore, David. *From Bishop to Witch: The System of the Sacred in Early Modern Terra d'Otranto*. Manchester: Manchester University Press, 1992.

———. "Ritualized Illness and Music Therapy: Views of Tarantism in the Kingdom of Naples." In *Music as Medicine: The History of Music Therapy Since Antiquity*, ed. Peregrine Horden, 255–72. Aldershot: Ashgate, 2000.

Gerstel, Sharon E. J. "An Alternate View of the Late Byzantine Sanctuary Screen." In *Thresholds of the Sacred: Architectural, Art Historical, Liturgical and Theological Perspectives on Religious Screens, East and West*, ed. Sharon E. J. Gerstel, 135–61. Washington, D.C.: Dumbarton Oaks, 2006.

———. *Beholding the Sacred Mysteries: Programs of the Byzantine Sanctuary*. Seattle: College Art Association, 1999.

———. "The Chora Parekklesion, the Hope for a Peaceful Afterlife, and Monastic Devotional Practices." In *The Kariye Camii Reconsidered*, ed. Holger A. Klein, Robert G. Ousterhout, and Brigitte Pitarakis, 129–45. Istanbul: Istanbul Research Institute Symposium Series, 2011.

———. "The Layperson in Church." In *Byzantine Christianity*, People's History of Christianity 3, ed. Derek Krueger, 103–23. Minneapolis: Fortress Press, 2006.

———. "Liturgical Scrolls in the Byzantine Sanctuary." *Greek, Roman and Byzantine Studies* 35, no. 2 (1994): 195–204.

———. "Painted Sources for Female Piety in Medieval Byzantium." *DOP* 52 (1998): 89–111.

———, ed. *Thresholds of the Sacred: Architectural, Art Historical, Liturgical and Theological Perspectives on Religious Screens, East and West*. Washington, D.C.: Dumbarton Oaks Research Library and Collection, 2006.

Gerstel, Sharon E. J., and Alice-Mary Talbot. "Nuns in the Byzantine Countryside." *Deltion tēs Christianikēs Archaiologikēs Hetaireias* 27 (2006): 481–90.

Gervers, Veronika. "Medieval Garments in the Mediterranean World." In *Cloth and Clothing in Medieval Europe: Essays in Memory of Professor E. M. Carus-Wilson*, ed. N. B. Harte and K. G. Ponting, 297–315. London: Heinemann Educational, 1983.

Geula, Amos. "Lost Aggadic Works Known Only from Ashkenaz: Midrash Abkir, Midrash Esfa and Devarim Zuta" [in Hebrew]. Ph.D. diss., Hebrew University of Jerusalem, 2006.

———. "Midrašim composti nell'Italia meridionale." In *Gli Ebrei nel Salento*, ed. Fabrizio Lelli, 43–74. Galatina: Congedo, 2012.

Gianfreda, Grazio. *Il mosaico di Otranto: Biblioteca medioevale in immagini*. Lecce: Grifo, 1998.

Giannelli, Ciro. "Un documento sconosciuto della polemica tra Greci e Latini intorno alla formula battesimale." *Orientalia Christiana Periodica* 10 (1944): 150–67.

Gibson, Gail McMurray. "Blessing from Sun and Moon: Churching as Women's Theater." In *Bodies and Disciplines: Intersections of Literature and History in Fifteenth-Century England*, Medieval Cultures 9, ed. Barbara A. Hanawalt and David Wallace, 139–54. Minneapolis: University of Minnesota Press, 1996.

Gies, Frances, and Joseph Gies. *Life in a Medieval Village*. New York: Harper & Row, 1990.

Gigante, Marcello. *Poeti bizantini di Terra d'Otranto nel secolo XIII*. Naples: Università di Napoli, Cattedra di Filologia Bizantina, 1979; repr., Galatina: Congedo, 1985.

Gilleard, Chris. "Old Age in Byzantine Society." *Ageing & Society* 27 (2007): 623–42.

Ginzberg, Louis. *The Legends of the Jews*. 7 vols. Philadelphia: Jewish Publication Society, 1967–69.

Ginzburg, Carlo. "Microhistory: Two or Three Things That I Know About It." *Critical Inquiry* 20 (1993): 10–35.

Goar, Jacobus. *Euchologion sive rituale graecorum.* Graz: Akademische Druck, 1960.

Goitein, Shelomo Dov. *A Mediterranean Society: The Jewish Communities of the Arab World as Portrayed in the Documents of the Cairo Geniza.* Vol. 4, *Daily Life.* Berkeley: University of California Press, 1983.

Golb, Norman. "The Music of Ovadiah the Proselyte and His Conversion." *Journal of Jewish Studies* 18 (1967): 43–63.

Gold, David L. "The Glottonym *Italkian.*" *Italia* 2 (1980): 98–102.

Golinkin, David. "Episodes in the History of the Timing for Naming Boys and Girls" [in Hebrew]. In *Zev Falk Memorial Volume (Sefer Zikaron li-Professor Zev Falk)*, ed. Rivka Horvitz et al., 27–38. Jerusalem: Makhon Schechter/Meisharim, 2005.

Goskar, Tehmina. "Material Worlds: The Shared Cultures of Southern Italy and Its Mediterranean Neighbours in the Tenth to Twelfth Centuries." *Al-Masaq* 23, no. 3 (2011): 189–204.

Gougaud, Louis. *Devotional and Ascetic Practices in the Middle Ages.* Trans. Gerald C. Batesman. London: Burns Oates & Washbourne, 1927.

Gould, Richard A. "Ethnoarchaeology." In *The Oxford Companion to Archaeology*, ed. Brian M. Fagan, 207–8. New York: Oxford University Press, 1996.

Gouldner, Alvin W. "Cosmopolitans and Locals: Toward an Analysis of Latent Social Roles, I." *Administrative Science Quarterly* 2, no. 3 (1957): 281–306.

Gratziou, Olga. "Evidenziare la diversità: Chiese doppie nella Creta veneziana." In *I Greci durante la venetocrazia: Uomini, spazio, idee (XIII–XVIII sec.); Atti del Convegno internazionale di Studi, Venezia, 3–7 dicembre 2007*, ed. Chryssa Maltezou, Angeliki Tzvara, and Despina Vlassi, 757–63. Venice: Istituto ellenico di studi bizantini e postbizantini di Venezia, 2009.

Gravili, Giuseppe. "Il gioco." In *Da Apigliano a Martano: Tre anni di archeologia medioevale, 1997–1999*, ed. Paul Arthur, 45–47. Galatina: Congedo, 1999.

Grayzel, Solomon. *The Church and the Jews in the XIIIth Century: A Study of Their Relations During the Years 1198–1254, Based on the Papal Letters and the Conciliar Decrees of the Period.* Philadelphia: Dropsie College, 1933.

Green, Monica H. "Conversing with the Minority: Relations Among Christian, Jewish, and Muslim Women in the High Middle Ages." *Journal of Medieval History* 34 (2008): 105–18.

Greenfield, Richard P. H. "A Contribution to the Study of Paleologan Magic." In *Byzantine Magic*, ed. Henry Maguire, 117–53. Washington, D.C.: Dumbarton Oaks Research Library and Collection, 1995.

Griffith, Sidney. "The Handwriting on the Wall: Graffiti in the Church of St. Antony." In *Monastic Visions: Wall Paintings in the Monastery of St. Antony at the Red Sea*, ed. Elizabeth S. Bolman, 185–93. Cairo: American Research Center in Egypt; New Haven, Conn.: Yale University Press, 2002.

Grimes, Ronald L. "Performance." In *Theorizing Rituals: Issues, Topics, Approaches, Concepts*, ed. Jens Kreinath, Jan Snoek, and Michael Stausberg, 379–94. Leiden: Brill, 2006.

Grohmann, Alberto. *Le fiere del Regno di Napoli in età aragonese.* Naples: Istituto Italiano per gli Studi Storici, 1969.

Gruenwald, Ithamar. *Apocalyptic and Merkavah Mysticism.* Arbeiten zur Geschichte des antiken Judentums und des Christentums 14. Leiden: Brill, 1980.

Guglielmi, Maria. "Appunti sulla pittura del due e trecento a Brindisi: Modelli di trasmissione dell'iconografia mariana." In *Virgo Beatissima: Interpretazione mariane a Brindisi*, ed. Massimo Guastella, 83–95. Brindisi: Alfeo, 1990.

———. *Gli affreschi del XIII e XIV secolo nelle chiese del centro storico di Brindisi.* Martina Franca: Lions Club, 1990.

Guillou, André. "L'art des 'moines basiliens' dans les pays grecs et latins de l'Italie méridionale." In *L'art dans l'Italie méridionale: Aggiornamento dell'opera di Émile Bertaux*, ed. Adriano Prandi, 4:293–301. Rome: École française, 1978.

———. "Arte e religione nell'Italia greca medioevale." In *Aspetti della civiltà bizantina in Italia: Società e cultura*, 367–98. Bari: Ecumenica, 1976. Trans. and reprinted from "Art et religion dans l'Italie grecque mediévale: Enquête," in *La Chiesa greca in Italia dall'VIII al XVI secolo: Atti del Convegno storico interecclesiale (Bari, 30 apr.–4 magg. 1969)*, 2:725–58 (Padua: Antenore, 1972–73).

———. "L'Italia bizantina dalla caduta di Ravenna all'arrivo dei Normanni." In *Il Mezzogiorno dai Bizantini a Federico II*, ed. André Guillou et al., 3–128. Turin: UTET, 1983.

———. "Noms, prénoms et surnoms dans la Calabre byzantine: Une enquête linguistique." In *Byzance: Hommage à André N. Stratos*, ed. Nia A. Stratos, 2:461–78. Athens: N. Stratos, 1986.

———. "Notes d'épigraphie byzantine." *Studi medievali*, ser. 3, 11 (1970): 403–8. Reprinted in *Culture et société en Italie byzantine (VIᵉ–XIᵉ s.)*, no. VIII. London: Variorum, 1978.

———. *Recueil des inscriptions grecques médiévales d'Italie*. Rome: Ecole française, 1996.

Gunderson, Erik. *Staging Masculinity: The Rhetoric of Performance in the Roman World*. Ann Arbor: University of Michigan, 2000.

Haarmann, Harald. *Language in Ethnicity: A View of Basic Ecological Relations*. Berlin: Mouton de Gruyter, 1986.

Hachlili, Rachel. *The Menorah, the Ancient Seven-Armed Candelabrum: Origin, Form and Significance*. Leiden: Brill, 2001.

Hahn, Thomas. "The Difference the Middle Ages Makes: Color and Race Before the Modern World." *Journal of Medieval and Early Modern Studies* 31 (2001): 1–37.

Haines, John. "Why Music and Magic in the Middle Ages?" *Magic, Ritual, and Witchcraft* 5, no. 2 (2010): 149–72.

Hakenbeck, Susanne E. "Situational Ethnicity and Nested Identities: Approaches to an Old Problem." In *Early Medieval Mortuary Practices,* Anglo-Saxon Studies in Archaeology and History 14, ed. Sarah Semple and Howard Williams, 19–27. Oxford: Oxford University School of Archaeology, 2007.

Hales, Shelley, and Tamar Hodos, eds. *Material Culture and Social Identities in the Ancient World*. Cambridge: Cambridge University Press, 2010.

Hall, Stuart. "Cultural Identity and Diaspora." In *Theorizing Diaspora: A Reader*, ed. Jana Evans Braziel and Anita Mannur, 233–46. Malden, Mass.: Blackwell, 2003. Originally published in *Identity: Community, Culture, Difference*, ed. Jonathan Rutherford, 222–37 (London: Lawrence and Wishart, 1990).

———. "Introduction: Who Needs 'Identity'?" In *Questions of Cultural Identity*, ed. Stuart Hall and Paul du Gay, 1–17. London: Sage, 1996.

Hallpike, C. R. "Social Hair." *MAN: Journal of the Royal Anthropological Institute of Great Britain and Ireland* 4, no. 2 (1969): 256–64.

Hamling, Tara, and Catherine Richardson, eds. *Everyday Objects: Medieval and Early Modern Material Culture and Its Meanings*. Farnham: Ashgate, 2010.

Hanawalt, Barbara A. "Medievalists and the Study of Childhood." *Speculum* 77, no. 2 (2002): 440–60.

Handaka, Sophia, ed. *Tokens of Worship* (Λατρείας Τάματα). Athens: Benaki Museum, 2006.

Harari, Yuval. "Leadership, Authority, and the 'Other' in the Debate over Magic from the Karaites to Maimonides." *Journal for the Study of Sephardic and Mizrahi Jewry* 1 (2007): 79–101.

———. "The Scroll of Ahima'az and Jewish Magical Culture: A Note on the Ordeal of the Adulteress" [in Hebrew]. *Tarbiz* 75, nos. 1–2 (2005–6): 185–202.

Harris, Jennifer. "Fact and Fiction: Some New Books on the History of Dress." *Art History* 6 (1983): 110–14.

Harris, W. V., ed. *Rethinking the Mediterranean*. Oxford: Oxford University Press, 2004.

Hartnup, Karen. *"On the Beliefs of the Greeks": Leo Allatios and Popular Orthodoxy*. Medieval Mediterranean 54. Leiden: Brill, 2004.

Hasluck, F. W. "Stone Cults and Venerated Stones in the Graeco-Turkish Area." *Annual of the British School at Athens* 21 (1914/15–1915/16): 62–83.

Hennessy, Cecily. *Images of Children in Byzantium.* Aldershot: Ashgate, 2008.

Herzfeld, Shmuel. "Searching for Sources of the Zohar: A Woman's Headcovering." http://www.rabbishmuel.com/files/jewish_customs20.haircovering. doc.

Hicks, Alison J., and Martin J. Hicks. "The Small Objects." In *Excavations at Otranto*, vol. 2, *The Finds*, ed. Francesco D'Andria and David Whitehouse, 279–313. Galatina: Congedo, 1992.

Hicks, Dan, and Mary C. Beaudry, eds. *The Oxford Handbook of Material Culture Studies.* Oxford: Oxford University Press, 2010.

Hilsdale, Cecily. "The Imperial Image at the End of Exile: The Byzantine Embroidered Silk in Genoa and the Treaty of Nymphaion (1261)." *DOP* 64 (2010): 151–99.

Hilton, Michael. *The Christian Effect on Jewish Life.* London: SCM Press, 1994.

Hoeck, Johannes, and Raimund J. Loenertz. *Nikolaos-Nektarios von Otranto, Abt von Casole: Beitrage zur Geschichte der ost-westlichen Beziehungen unter Innozenz III und Friedrich II.* Ettal: Buch-Kunstverlag, 1965.

Hoffman, Lawrence A. "The Role of Women at Rituals of Their Children." In *Judaism in Practice*, ed. Lawrence Fine, 99–114. Princeton, N.J.: Princeton University Press, 2001.

Hoffmann, Lars. "Nikolaos/Nektarios von Otranto, Gegen die Juden: Edition und Kommentar." In preparation.

Hoffmann, Philippe. "Aspetti della cultura bizantina in Aradeo dal XIII al XVII secolo." In *Paesi e figure del vecchio Salento,* ed. Aldo De Bernart, 3:65–88. Galatina: Congedo, 1989.

———. "Une lettre de Drosos d'Aradeo sur la fraction du pain." *RSBN* 22–23 (1985–86): 245–84.

Hollender, Elisabeth. "Il *piyyut* italiano—tradizione e innovazione." *Rassegna mensile di Israel* 60, nos. 1–2 (1994): 23–41.

Holo, Joshua. "Byzantine-Jewish Ethnography: A Consideration of the *Sefer Yosippon* in Light of Gerson Cohen's 'Esau as Symbol in Early Medieval Thought.'" In *Jews in Byzantium: Dialectics of Minority and Majority Cultures*, ed. Robert Bonfil et al., 923–49. Leiden: Brill, 2012.

———. *Byzantine Jewry in the Mediterranean Economy*. Cambridge: Cambridge University Press, 2009.

———. "Hebrew Astrology in Byzantine Southern Italy." In *The Occult Sciences in Byzantium*, ed. Paul Magdalino and Maria Mavroudi, 291–323. Geneva: Pomme d'Or, 2006.

Holweck, Frederick George. *A Biographical Dictionary of the Saints.* St. Louis, Mo.: Herder, 1924.

Hood, William. "Saint Dominic's Manners of Praying: Gestures in Fra Angelico's Cell Frescoes at S. Marco." *Art Bulletin* 68, no. 2 (1986): 195–206.

Horden, Peregrine. "Commentary on Part IV, with a Note on the Origins of Tarantism." In *Music as Medicine: The History of Music Therapy Since Antiquity*, ed. Peregine Horden, 249–54. Aldershot: Ashgate, 2000.

Horne, Charles F. *Sacred Books and Early Literature of the East: Medieval Hebrew; The Midrash; The Kabbalah.* New York: Purke, Austin, and Lipscomb, 1917. http://www.sacred-texts.com/jud/mhl/mhl08.htm.

Horowitz, Elliott. "The Eve of the Circumcision: A Chapter in the History of Jewish Nightlife." *Journal of Social History* 23, no. 1 (1989): 45–69.

———. *Reckless Rites: Purim and the Legacy of Jewish Violence.* Princeton, N.J.: Princeton University Press, 2006.

———. "Religious Practices Among the Jews in the Late Fifteenth Century According to Letters of R. Obadiah of Bertinoro" [in Hebrew]. *Pe'amim* 37 (1988): 31–40.

———. "Speaking to the Dead: Cemetery Prayer in Medieval and Early Modern Jewry." *Journal of Jewish Thought and Philosophy* 8 (1999): 303–17.

———. "Towards a Social History of Jewish Popular Religion: Obadiah of Bertinoro on the Jews of Palermo." *Journal of Religious History* 17, no. 2 (1992): 138–51.

———. "The Way We Were: *Jewish Life in the Middle Ages.*" *Jewish History* 1, no.1 (1986): 75–90.

Houben, Hubert. "Grotte di proprietà dell'ordine Teutonico in Puglia." In *Quando abitavamo in grotta: Atti del I Convegno internazionale sulla civiltà rupestre, Savelletri di Fasano (BR), 27–29 novembre 2003*, ed. Enrico Menestò, 259–69. Spoleto: Centro italiano di Studi sull'alto medioevo, 2004.

———. *Il "libro del capitolo" del monastero della SS. Trinità di Venosa (Cod. Casin. 334): Una testimonianza del Mezzogiorno normanno*. Galatina: Congedo, 1984.

———. "Nord e Sud: L'immagine di due città del Mezzogiorno d'Italia (Brindisi e Otranto) in resoconti di viaggiatori (secc. XIV–XVI)." In *Imago urbis: L'immagine della città nella storia d'Italia; Atti del Convegno internazionale, Bologna, 5–7 settembre 2001*, ed. Francesca Bocchi and Rosa Smurra, 309–21. Rome: Viella, 2003.

———. "L'Ordine Teutonico nel Salento: Bilancio storiografico e prospettive di ricerca." *L'Idomeneo: Rivista della sezione di Lecce* 1 (1998): 139–60.

———. "La tradizione commemorativa medioevale in Puglia e Basilicata: Bilancio storiografico e prospettive di ricerca." In *La tradizione commemorativa nel Mezzogiorno medioevale: ricerche e problemi; Atti del seminario internazionale di studio, Lecce, 31 marzo 1982*, ed. Cosimo Damiano Fonseca, 67–90. Galatina: Congedo, 1984.

Hughes, Diane Owen. "Distinguishing Signs: Ear-rings, Jews and Franciscan Rhetoric in the Italian Renaissance City." *Past & Present* 112 (1986): 3–59.

———. "Earrings for Circumcision: Distinction and Purification in the Italian Renaissance City." In *Persons in Groups: Social Behavior as Identity Formation in Medieval and Renaissance Europe*, ed. Richard C. Trexler, 155–77. Binghamton, N.Y.: Medieval & Renaissance Texts & Studies, 1985.

———. "From Brideprice to Dowry in Mediterranean Europe." *Journal of Family History* 3 (1978): 266–76.

Hunger, Herbert. *Graeculus perfidus, Ἰταλός ἰταμός: Il senso dell'alterità nei rapporti greco-romani ed italo-bizantini*. Rome: Unione Internazionale degli Istituti di Archeologia, Storia e Storia dell'Arte in Roma, 1987.

Hunt, Alan. *Governance of the Consuming Passions: A History of Sumptuary Law.* London: Macmillan, 1996.

Hutnyk, John. "Hybridity." *Ethnic and Racial Studies* 28 (2005): 79–102.

Iacovelli, Gianni. "Il senso della morte nel mondo contadino meridionale." In *All'alba del terzo millennio: Miscellanea di studi in onore di Antonio Chionna*, ed. Vincenzo Carella and Ernesto Marinò, 307–13. Fasano: Schena Editore, 2004.

Idel, Moshe. "Dall'Italia a ʿAškenaz e ritorno: La circolazione di alcuni temi ebraici in età medievale." In *Gli Ebrei nel Salento*, ed. Fabrizio Lelli, 105–44. Galatina: Congedo, 2012.

Imbriani, Eugenio. "Riflessioni sulle leggende di fondazione della chiesa e del culto di Santa Maria della Strada a Taurisano (Lecce)." In *Architettura medievale in Puglia: S. Maria della Strada a Taurisano,* ed. Mario Cazzato and Aldo De Bernart, 73–78. Galatina: Congedo, 1992.

Imbrighi, Gastone. "I santi nella toponomastica italiana." *Memorie geografiche* 4 (1958): 1–102.

Imperiale, Marco Leo, Massimo Limoncelli, and Manuela De Giorgi. "Due chiese bizantine nel basso Salento: Archeologia dell'architettura e decorazione pittorica." In *IV Congresso Nazionale di Archeologia Medievale, Scriptorium dell' Abbazia, Abbazia di San Galgano (Chiusdino, Siena), 26–30 settembre 2006*, ed. Riccardo Francovich and Marco Valenti, 613–20. Florence: All'Insegna del Giglio, 2006.

Interesse, Giuseppe. *Puglia mitica.* Fasano: Schena Editore, 1983.

Isaacs, Ronald H. *Divination, Magic, and Healing: The Book of Jewish Folklore*. Northvale, N.J.: Jason Aronson, 1998.

Izmirlieva, Valentina. *All the Names of the Lord: Lists, Mysticism, and Magic*. Chicago: University of Chicago Press, 2008.

Jacob, André. "Les annales du monastère de San Vito del Pizzo, près de Tarente, d'après les notes marginales du *Parisinus gr. 1624*." *RSBN*, n.s., 30 (1993): 123–53.

———. "Les annales d'une famille sacerdotale grecque de Galatina dans l'*Ambrosianus C7 sup.* et la peste en Terre d'Otrante à la fin du Moyen Age." *BSTd'O* 1 (1991): 23–51.

———. "L'anthroponymie grecque du Salento méridionale." *MEFRM* 107, no. 2 (1995): 361–79.

———. "Apigliano, 828/829: La più antica iscrizione datata di Terra d'Otranto?" *RSBN* 46 (2009): 127–39.

———. "Un arménien de trop dans le Salento: À propos d'une inscription funéraire de la *masseria* Quattro Macine à Giuggianello." *La parola del passato* 65 (2010): 362–71.

———. "Une bibliothèque médiévale de Terre d'Otrante (Parisinus gr. 549)." *RSBN* 22–23 (1985–86): 285–315.

———. "Le cadran solaire 'byzantin' de Taurisano en Terre d'Otrante." *MEFRM* 97, no. 1 (1985): 7–22. Italian translation, "L'orologio solare 'bizantino' di Taurisano." In *Architecture medievale in Puglia: Santa Maria della Strada a Taurisano*, ed. Mario Cazzato and Aldo De Bernart, 57–71. Galatina: Congedo, 1992.

———. "Cerrate en Terre d'Otrante ou Carrà en Calabre dans la souscription du *Vaticanus gr. 1221*?" *Helikon* 31–32 (1991–92): 427–39.

———. "Le chandelier a trois branches de l'évêque Pantoléon: À propos de l'inscription de Georges de Gallipoli." *Bollettino della Badia greca di Grottaferrata*, n.s., 53 [= Ὀπώρα: *Studi in onore di mgr Paul Canart per il LXX compleanno*, ed. Santo Lucà and Lidia Perria] (1999): 187–99.

———. "Le ciborium du prêtre Taphouros à Sainte-Marie de Cerrate et sa dédicace." In *Cavalieri alla conquista del Sud: Studi sull'Italia normanna in memoria di Léon-Robert Ménager*, ed. Errico Cuozzo and Jean-Marie Martin, 117–33. Bari: Laterza, 1998.

———. "La consecration de Santa Maria della Croce à Casaranello et l'ancien diocèse de Gallipoli." *RSBN* 25 (1988): 147–63.

———. "Un copiste du monastère de Casole: Le hiéromoine Thomas." *RSBN*, n.s., 26 (1989): 203–10.

———. "Le culte de Saint Martin de Tours dans la Terre d'Otrante hellénophone." In *Puer Apuliae: Mélanges offerts à Jean-Marie Martin*, ed. Errico Cuozzo et al., 345–56. Paris: Association des amis du centre d'histoire et civilisation de Byzance, 2008.

———. "Le culte de Saint Vincent de Saragosse dans la Terre d'Otrante byzantine et le sermon inédit du *Vaticanus Barberinianus Gr. 456 (BHG 1867e)*." In *Philomathestatos: Studies in Greek Patristic and Byzantine Texts Presented to Jacques Noret for His Sixty-Fifth Birthday*, ed. B. Janssens, B. Roosen, and P. Van Deun, 285–96. Leuven: Peeters, 2004.

———. "Culture grecque et manuscrits en Terre d'Otrante." In *Atti del III° Congresso internazionale di studi salentini e del 1° Congresso storico di Terra d'Otranto, Lecce, 22–25 ottobre 1976*, ed. Pier Fausto Palumbo, 51–77. Lecce: Centro di Studi Salentini, 1980.

———. "Une dédicace de sanctuaire inédite à la Masseria Li Monaci, près de Copertino en Terre d'Otrante." *MEFRM* 94, no. 2 (1982): 703–10.

———. "Deux épitaphes byzantines inédites de Terre d'Otrante." In *Studi in onore di Michele D'Elia: Archeologia, arte, restauro e tutela, archivistica*, ed. Clara Gelao, 166–72. Matera: R&R, 1996.

———. "Deux formules d'immixtion syro-palestiniennes et leur utilisation dans le rite byzantin d'Italie méridionale." *Vetera Christianorum* 13 (1976): 29–64.

————. "'Ecclesia Alexanensis alias Leucadensis': A la récherche du siège primitif d'un diocèse salentin." *Rivista di storia della chiesa in Italia* 33 (1979): 490–99.

————. "Épidémies et liturgie en Terre d'Otrante dans la seconde moitié du XIVᵉ siècle." *Helikon* 31–32 (1991–92): 93–126.

————. "Épigraphie et poésie dans l'Italie méridionale hellénophone." In *L'épistolographie et la poésie épigrammatique: Projets actuels et questions de méthodologie; Actes de la 16ᵉ Table ronde organisée par Wolfram Hörandner et Michael Grünbart dans le cadre du XXᵉ Congrès international des Études byzantines, Collège de France, Sorbonne, Paris, 19–25 Août 2001*, 161–70. Paris: Centre d'études byzantines, néo-helléniques et sud-est européennes, EHESS, 2003.

————. "Un esorcismo inedito contro la grandine tràdito da due codici salentini." In *Segni del tempo: Studi di storia e cultura salentina in onore di Antonio Caloro*, ed. Mario Spedicato, 23–39. Galatina: Panico, 2008.

————. "L'euchologe de Sainte-Marie du Patir et ses sources." In *Atti del Congresso internazionale su S. Nilo di Rossano, 28 settembre–1 ottobre 1986*, 75–118. Rossano, 1989.

————. "L'evoluzione dei libri liturgici bizantini in Calabrie e in Sicilia dall'VIII al XVI secolo, con particolare riguardo ai riti eucaristici." In *Calabria bizantina: Vita religiosa e strutture amministrative; Atti del primo e secondo incontro di Studi Bizantini*, 47–69. Reggio Calabria: Parallelo, 1974.

————. "Une fondation de chapelle par l'évêque Dieudonné de Castro en 1383." *BSTd'O* 2 (1992): 85–89.

————. "Une fondation d'hôpital à Andrano en Terre d'Otrante (inscription byzantine du Musée provincial de Lecce)." *MEFRM* 93, no. 2 (1981): 683–93.

————. "La fondation du monastère de Cerrate à la lumière d'une inscription inédite." *Rendiconti della Classe di scienze morali, storiche e filologiche dell'Accademia nazionale dei Lincei*, ser. 9, 7 (1996): 211–23.

————. "La formazione del clero greco nel Salento medievale." In *Ricerche e Studi in Terra d'Otranto* 2 (1987): 21–36.

————. "Fragments liturgiques byzantins de Terre d'Otrante." *Bulletin de l'Institut Historique Belge de Rome* 43 (1973): 345–76.

————. "Fragments peu connues d'eucologes otrantais." *Bulletin de l'Institut Historique Belge de Rome* 42 (1972): 99–108.

————. "Gallipoli bizantina." In *Paesi e figure del Vecchio Salento*, ed. Aldo De Bernart, 3:281–312. Galatina: Congedo, 1989.

————. "L'inscription métrique de l'ènfeu de Carpignano." *RSBN* 20–21 (1983–84): 103–22.

————. "Inscriptions byzantines datées de la Province de Lecce (Carpignano, Cavallino, San Cesario)." *Accademia Nazionale dei Lincei, Rendiconti della Classe di Scienze morali, storiche e filologiche*, ser. 8, 37 (1982): 41–62.

————. "Iscrizioni bizantine di Cavallino." In *Caballino*, ed. Fernando De Dominicis, 241–46. Cavallino di Lecce: Capone, 1984.

————. "La lettre patriarcale du typikon de Casole et l'évêque Paul de Gallipoli." *RSBN* 24 (1987–88): 143–63.

————. "Une mention d'Ugento dans la Chronique de Skylitzès." *Revue des Études Byzantines* 35 (1977): 229–35.

————. "Le nom de famille du dernier copiste grec de Gallipoli: A propos du colophon du *Laurentianus* 86, 15 (An. 1347)." *BSTd'O* 2 (1992): 77–83.

————. "Notes sur quelques inscriptions byzantines du Salento méridional (Soleto, Alessano, Vaste, Apigliano)." *MEFRM* 95, no. 1 (1983): 65–88.

————. "Nouveaux documents italo-grecs pour servir à l'histoire du texte des prières de l'ambon." *Bulletin de l'Institut Historique Belge de Rome* 38 (1967): 109–44.

———. "Un nouvelle Amen isopséphique en Terre d'Otrante (Nociglie, Chapelle de la Madonna dell'Itri)." *RSBN* 26 (1989): 187–95.

———. "Un opuscule didactique otrantais sur la Liturgie eucharistique: L'adaptation en vers, faussement attribuée à Psellos, de la *Protheoria* de Nicolas d'Andida." *RSBN* 14–16 (1977–79): 161–78.

———. "La reconstruction de Tarente par les Byzantins aux IXe et Xe siècles: À propos de deux inscriptions perdues." *Quellen und Forschungen aus italienischen Archiven und Bibliotheken* 68 (1988): 1–19.

———. "Le rite du καμπανισμός dans les euchologes italo-grecs." In *Mélanges liturgiques offerts au R.P. dom Bernard Botte à l'occasion du cinquantième anniversaire de son ordination sacerdotale (4 juin 1972),* 223–44. Louvain: Abbaye du Mont César, 1972.

———. "Rouleaux grecs et latines dans l'Italie méridionale." In *Recherches de codicologie comparée: La composition du codex au Moyen Âge,* ed. Philippe Hoffmann and Christine Hunzinger, 69–97. Paris: École Normale Supérieure, 1998.

———. "Testimonianze bizantine nel Basso Salento." In *Il Basso Salento: Ricerche di storia sociale e religiosa,* ed. Salvatore Palese, 49–69. Galatina: Congedo, 1982.

———. "La traduction de la Liturgie de saint Basile par Nicolas d'Otrante." *Bulletin de l'Institut Historique Belge de Rome* 38 (1967): 49–107.

———. "La traduction de la Liturgie de saint Jean Chrysostome par Léon Toscan: Edition critique." *Orientalia Christiana Periodica* 32 (1966): 111–62.

———. "Vaste en Terre d'Otrante et ses inscriptions." *Aevum: Rassegna di scienze storiche linguistiche e filologiche* 71, no. 2 (1997): 243–71.

———. "Le Vat. gr. 1238 et le diocèse de Paléocastro." *Rivista di storia della chiesa in Italia* 25 (1971): 516–23.

———. "Vestiges d'un livret italo-grec d'exorcismes (Cryptenses Γ.β. XXXVII et B.α. XXIII)." *Memoriam sanctorum venerantes: Miscellanea in onore di Monsignor Victor Saxer,* 515–24. Vatican City: Pontificio Istituto di archeologia cristiana, 1992.

Jacob, André, and Antonio Caloro, eds. *Luoghi, chiese e chierici del Salento meridionale in età moderna: La visita apostolica della città e della diocesi di Alessano nel 1628.* Galatina: Congedo, 1999.

Jacobs, Janet Liebman. *Hidden Heritage: The Legacy of the Crypto-Jews.* Berkeley: University of California Press, 2002.

Jacobs, Joseph. "Names (Personal)." In *The Jewish Encyclopedia,* ed. Isidore Singer et al., 9:152–60. New York: Funk & Wagnalls, 1916.

Jacoby, David. "The Jewish Community of Constantinople from the Komnenian to the Palaiologan Period." *Vizantijskij Vremennik* 55, no. 2 (80) (1988): 31–40.

———. "The Jews and the Silk Industry of Constantinople." In *Byzantium, Latin Romania and the Mediterranean,* no. XI. Aldershot: Ashgate Variorum, 2001.

———. "Les Juifs de Byzance: Une communauté marginalisée." In *Praktika Hēmeridas hoi Perithōriakoi sto Vyzantio, 9 Maiou 1992,* 103–54. Athens: Hidryma Goulandrē-Chorn, 1993.

———. "Silk in Western Byzantium Before the Fourth Crusade." *Byzantinische Zeitschrift* 84–85 (1991–92): 452–500.

Jacovelli, Espedito. "Discussion." In *I laici nella 'Societas Christiana' dei secoli XI e XII: Atti della terza settimane internazionale di studio, Mendola 1965,* 523–27. Milan: Vita e Pensiero, 1968.

———, ed. *Gli affreschi bizantini di Massafra: Guida per la visita al complesso criptologico.* Massafra: Pro Loco, 1960.

Jamison, Evelyn. "La carriera del logotheta Riccardo di Taranto e l'ufficio del 'logotheta sacri palatii' nel regno normanno di Sicilia e d'Italia meridionale." *Archivio Storico Pugliese* 5 (1952): 169–91.

Jansson, Eva-Maria. "The Magic of the Mezuzah in Rabbinic Literature." In *Jewish Studies in a New Europe: Proceedings of the Fifth Congress of Jewish Studies in Copenhagen 1994 Under the Auspices of the European Association for Jewish Studies*, ed. Ulf Haxen, Hanne Trautner-Kromann, and Karen Lisa Goldschmidt Salamon, 415–25. Copenhagen: C. A. Reitzel A/S International Publishers, Det Kongelige Bibliotek, 1998.

Johnstone, Pauline. "The Byzantine 'Pallio' in the Palazzo Bianco at Genoa." *Gazette des Beaux-Arts* 87 (1976): 99–108.

Jolivet-Lévy, Catherine. *Les églises byzantines de Cappadoce, le programme iconographique de l'abside et de ses abords*. Paris: Éditions du Centre national de la recherche scientifique, 1991.

———. "Images des pratiques eucharistiques dans les monuments byzantins du Moyen Âge." In *Pratiques de l'eucharistie dans les Églises d'Orient et d'Occident (Antiquité et Moyen Âge)*, vol. 1, *L'institution*, Actes du séminaire tenu à Paris, Institut catholique (1997–2004), ed. Nicole Bériou, Béatrice Caseau, and Dominique Rigaux, 161–200. Turnhout: Brepols, 2009.

———. "Note sur la représentation du *Mandylion* dans les églises byzantines de Cappadoce." In *Intorno al Sacro Volto: Genova, Bisanzio e il Mediterraneo (secoli XI–XIV)*, ed. Anna Rosa Calderoni Masetti, Colette Dufour Bozzo, and Gerhard Wolf, 137–44. Venice: Marsilio, 2007.

Jones, Lars Raymond. "*Visio Divina*, Exegesis, and Beholder-Image Relationships in the Middle Ages and the Renaissance: Indications from Donor Figure Representations." Ph.D. diss., Harvard University, 1999.

Jones, Louis C. "The Evil Eye Among European-Americans." In *The Evil Eye: A Casebook*, ed. Alan Dundes, 150–68. Madison: University of Wisconsin Press, 1981. Originally printed in *Western Folklore* 10 (1951): 11–25.

Jones, Siân. *The Archaeology of Ethnicity: Constructing Identities in the Past and Present*. London: Routledge, 1997.

Jordan, Robert, trans. "*Evergetis: Typikon* of Timothy for the Monastery of the Mother of God Evergetis." In *BMFD* 2:454–506.

———. "*Pantokrator: Typikon* of Emperor John II Komnenos for the Monastery of Christ *Pantokrator* in Constantinople." In *BMFD* 2:725–81.

Jurlaro, Rosario. "Commento." In Annibale De Leo, *Dell'origine del rito greco nella chiesa di Brindisi*, ed. Rosario Jurlaro, 124–72. Galatina: Congedo, 1974.

———. "Epigrafi medievali brindisine." *Studi Salentini* 31 (1968): 231–77.

———. "Il 'martyrium' su cui sorse la basilica di S. Leucio in Brindisi." *Rivista di archeologia cristiana* 45 (1969): 89–95.

———. "Nuovi stampi eucaristici dal Salento (Contributo per la storia della liturgia eucaristica e greca in Italia)." *Bollettino della Badia greca di Grottaferrata* 17 (1963): 147–56.

———. *Storia e cultura dei monumenti brindisini*. Fasano: Rotary Club of Brindisi, 1976.

Kahane, Henry, and Renée Kahane. "Greek in Southern Italy." *Romance Philology* 20, no. 4 (1967): 404–38.

Kalamara, Paraskévé. *Le système vestimentaire à Byzance du IV^e jusqu'à la fin du XI^e siècle*. 2 vols. Ph.D. diss, École des Hautes Études en Sciences Sociales, 1995. Villeneuve d'Ascq: Presses Universitaires du Septentrion, 1995.

Kaldellis, Anthony. *Hellenism in Byzantium: The Transformations of Greek Identity and the Reception of the Classical Tradition*. Cambridge: Cambridge University Press, 2007.

Kalopissi-Verti, Sophia. "Church Foundations by Entire Villages (13th–16th C.): A Short Note." *Recueil des travaux de l'Institut d'études byzantines* 44 (2007): 333–40.

———. *Dedicatory Inscriptions and Donor Portraits in Thirteenth-Century Churches of Greece*. Vienna: Österreichischen Akademie der Wissenschaften, 1992.

———. "Painters in Late Byzantine Society: The Evidence of Church Inscriptions." *Cahiers Archéologiques* 42 (1994): 139–58.

———. "The Proskynetaria of the Templon and Narthex: Form, Imagery, Spatial Connections, and Reception." In *Thresholds of the Sacred: Architectural, Art Historical, Liturgical and Theological Perspectives on Religious Screens, East and West*, ed. Sharon E. J. Gerstel, 107–32. Washington, D.C.: Dumbarton Oaks Research Library and Collection, 2006.

Kanarfogel, Ephraim. "Attitudes Toward Childhood and Children in Medieval Jewish Society." *Approaches to Judaism in Medieval Times* 2 (1985): 1–34.

———. *"Peering Through the Lattices": Mystical, Magical, and Pietistic Dimensions in the Tosafist Period*. Detroit, Mich.: Wayne State University Press, 2000.

Kant, Laurence H. "Jewish Inscriptions in Greek and Latin." *Aufstieg und Niedergang der römischen Welt* 2.20.2 (1987): 671–713.

Kaplan, Aryeh. *Sefer Yetzirah: The Book of Creation*. York Beach, Maine: Samuel Weiser, 1990.

Karasu, Tufan. *Alanya Ships: Ship Graffiti in the Medieval Castle*. Alanya: Dogu Akdeniz Kültür ve Tarih Araştirmalari Vakfı, 2005.

Karsenty, Eric. "La Mishmarà degli ebrei romani: Fonti e usi analoghi in altre comunità ebraiche." *Rassegna mensile di Israel* 67 (2001): 419–30.

Kazhdan, Alexander. "Latins and Franks in Byzantium: Perception and Reality from the Eleventh to the Twelfth Century." In *The Crusades from the Perspective of Byzantium and the Muslim World*, ed. Angeliki E. Laiou and Roy Parviz Mottahedeh, 83–100. Washington, D.C.: Dumbarton Oaks Research Library and Collection, 2001.

———. "Michael." In *The Oxford Dictionary of Byzantium*, ed. Alexander Kazhdan et al., 2:1360. Oxford: Oxford University Press, 1991.

———. "Names, Personal." In *The Oxford Dictionary of Byzantium*, ed. Alexander Kazhdan et al., 2:1435–36. Oxford: Oxford University Press, 1991.

———. "The Peasantry." In *The Byzantines*, ed. Guglielmo Cavallo, trans. Thomas Dunlap, Teresa Lavender Fagan, and Charles Lambert, 43–73. Chicago: University of Chicago Press, 1997.

Keck, David. *Angels and Angelology in the Middle Ages*. Oxford: Oxford University Press, 1998.

Keil, Matthias S. "'I Look in Your Eyes, Honey': Internal Face Features Induce Spatial Frequency Preference for Human Face Processing." *PLoS Computational Biology*, March 27, 2009. http://www.ploscompbiol.org/article/info%3Adoi%2F10.1371%2Fjournal.pcbi.1000329.

Kemper, Dorothée. "Una iscrizione greca inedita a S. Maria di Cerrate." *Archivio Storico Pugliese* 45 (1992): 309–13.

Kessler, Herbert L. "Evil Eye(ing): Romanesque Art as a Shield of Faith." In *Romanesque Art and Thought in the Twelfth Century: Essays in Honor of Walter Cahn*, ed. Colum Hourihane, 107–35. Princeton, N.J.: Index of Christian Art, 2008.

Kessler, Herbert L., and David Nirenberg, eds. *Judaism and Christian Art: Aesthetic Anxieties from the Catacombs to Colonialism*. Philadelphia: University of Pennsylvania Press, 2011.

Kieckhefer, Richard. *Magic in the Middle Ages*. Cambridge: Cambridge University Press, 1989.

Kiesewetter, Andreas. "I Principi di Taranto e la Grecia (1294–1373/83)." *Archivio Storico Pugliese* 54 (2001): 53–100.

———. "Ricerche e documenti per la signoria di Raimondo del Balzo-Orsini sulla contea di Lecce e sul principato di Taranto (1385–1399/1406)." *BSTd'O* 11 (2001): 17–30.

Klapisch-Zuber, Christiane. "The Medieval Italian Mattinata." *Journal of Family History* 5 (1980): 2–27.

Klar, Benjamin. *Mehkarim ve-ʿiyunim ba-lashon, ba-shirah uva-sifrut, ha-mevi le-vet ha-defus A. M. Haberman* [in Hebrew]. Tel Aviv: Mahbarot le-Sifrut, 1953/54.

Knappett, Carl. *Thinking Through Material Culture: An Interdisciplinary Perspective*. Philadelphia: University of Pennsylvania Press, 2005.

Kogman-Appel, Katrin. "Christianity, Idolatry, and the Question of Jewish Figural Painting in the Middle Ages." *Speculum* 84, no. 1 (2009): 73–107.

———. "Jewish Art and Cultural Exchange: Theoretical Perspectives." *Medieval Encounters* 17 (2011): 1–26.

Kokko, Hanna, and Rufus A. Johnstone. "Social Queuing in Animal Societies: A Dynamic Model of Reproductive Skew." *Proceedings of the Royal Society of London, Series B*, 266 (March 22, 1999), 571–78.

Kolbaba, Tia M. *The Byzantine Lists: Errors of the Latins.* Urbana: University of Illinois Press, 2000.

———. "Byzantine Perceptions of Latin Religious 'Errors': Themes and Changes from 850 to 1350." In *The Crusades from the Perspective of Byzantium and the Muslim World*, ed. Angeliki E. Laiou and Roy Parviz Mottahedeh, 117–43. Washington, D.C.: Dumbarton Oaks Research Library and Collection, 2001.

———. "Meletios Homologetes *On the Customs of the Italians.*" *Revue des Études Byzantines* 55 (1997): 137–68.

Kölzer, Theo. "Zur Geschichte des Klosters S. Nicola di Casole." *Quellen und Forschungen aus italienischen Archiven und Bibliotheken* 65 (1985): 418–26.

Kostova, Rossina. "Lust and Piety: Graffiti from Bulgarian Medieval Monasteries." In *Disziplinierung im Alltag des Mittelalters und der frühen Neuzeit: Internationaler Kongress, Krems an der Donau, 8. bis 11. Oktober 1996*, ed. Gerhard Jaritz, 233–54. Vienna: Österreichische Akademie der Wissenschaften, 1999.

Koukoules, Phaidon. *Βυζαντινῶν Βίος καὶ Πολιτισμός [Life and Civilization of the Byzantines].* 6 vols. Athens: Institut français d'Athènes, 1948–57.

Kraack, Detlev. *Monumentale Zeugnisse der spätmittelalterlichen Adelsreise: Inschriften und Graffiti des 14.–16. Jahrhunderts.* Abhandlungen der Akademie der Wissenschaften in Göttingen, Philologisch-Historische Klasse, 3. Folge, Nr. 224. Göttingen: Vandenhoeck & Ruprecht, 1997.

Krauss, Samuel. *The Jewish-Christian Controversy from the Earliest Times to 1789.* Ed. and rev. William Horbury. Tübingen: Mohr, 1996.

Kriss, Rudolf, and Hubert Kriss-Heinrich. *Peregrinatio neohellenika: Wallfahrtswanderungen im heutigen Griechenland und in Unteritalien.* Vienna: Verlag des Österreichischen Museums für Volkskunde, 1955.

Kroesen, Justin E. A., and Victor M. Schmidt, eds. *The Altar and Its Environment, 1150–1400.* Studies in the Visual Cultures of the Middle Ages 4. Turnhout: Brepols, 2009.

Krohn, Paysach. "Names and Their Significance." http://www.torah.org/features/spirfocus/names.html.

Külzer, Andreas. *Disputationes Graecae Contra Iudaeos: Untersuchungen zur byzantinischen antijüdischen Dialogliteratur und ihrem Judenbild.* Byzantinisches Archiv 18. Stuttgart: B. G. Teubner, 1999.

Ladiana, Fernando. "La culla di paese: Massafra/ritualità popolare della nascita." In *Puglia e Basilicata tra medioevo ed età moderna: Uomini, spazio e territorio; Miscellanea di studi in onore di Cosimo D. Fonseca*, ed. Fernando Ladiana, 357–80. Galatina: Congedo, 1988.

Ladner, Gerhart B. "The Gestures of Prayer in Papal Iconography of the Thirteenth and Early Fourteenth Centuries." In *Images and Ideas in the Middle Ages: Selected Studies in History and Art*, 2:209–37. Rome: Edizioni di storia e letteratura, 1983. Reprinted from *Didascaliae, Studies in Honor of Anselm M. Albareda*, ed. Sesto Prete, 245–75 (New York: B. M. Rosenthal, 1961).

Laidlaw, James, and Caroline Humphrey. "Action." In *Theorizing Rituals: Issues, Topics, Approaches, Concepts*, ed. Jens Kreinath, Jan Snoek, and Michael Stausberg, 265–83. Leiden: Brill, 2006.

Laiou, Angeliki E. "Italy and the Italians in the Political Geography of the Byzantines (14th Century)." *DOP* 49 (1995): 73–98.

Lane, Barbara Greenhouse. "The Development of the Medieval Devotional Figure." Ph.D. diss., University of Pennsylvania, 1970.

Langer, Ruth. "The *Birkat Betulim*: A Study of the Jewish Celebration of Bridal Virginity." *Proceedings of the American Academy for Jewish Research* 61 (1995): 53–94.

Lapadula, Erminia. "Accessori dell'abbigliamento e oggetti di ornamento di età bassomedievale dal cimitero di Torre di Mare (MT)." In *IV Congresso Nazionale di Archeologia Medievale, Scriptorium dell'Abbazia, Abbazia di San Galgano (Chiusdino, Siena), 26–30 settembre 2006*, ed. Riccardo Francovich and Marco Valenti, 436–39. Florence: All'Insegna del Giglio, 2006.

———. "Oggetti accessori dell'abbigliamento di età bassomedievale in Terra d'Otranto." In *III Congresso Nazionale di Archeologia Medievale, Salerno, 2–5 ottobre 2003*, ed. Rosa Fiorillo and Paolo Peduto, 147–52. Florence: All'Insegna del Giglio, 2003.

Lapassade, Georges. *Intervista sul tarantismo*. Maglie: Madona Oriente, 1994.

Laporta, Alessandro. "Surbo." In *Paesi e figure del vecchio Salento*, ed. Aldo De Bernart, 3:313–60. Galatina: Congedo, 1989.

Lasker, Daniel J., and Sarah Stroumsa. *The Polemic of Nestor the Priest: Introduction, Annotated Translations, and Commentary*. 2 vols. Jerusalem: Ben-Zvi Institute, 1996.

Lavermicocca, Nino. "Memorie paleocristiane di Puglia." In *Studi di storia pugliese in onore di Giuseppe Chiarelli*, ed. Michele Paone, 1:243–317. Galatina: Congedo, 1972.

———. "Il programma decorativo del Santuario rupestre di S. Nicola di Mottola." In *Il Passaggio dal dominio bizantino allo Stato normanno nell'Italia meridionale: Atti del secondo convegno internazionale di studi (Taranto-Mottola, 31 ottobre–4 novembre, 1973)*, ed. Cosimo Damiano Fonseca, 291–337. Taranto: Amministrazione provinciale di Taranto, 1977.

Layton, Robert. "Art and Agency: A Reassessment." *Journal of the Royal Anthropological Institute* 9, no. 3 (2003): 447–63.

Leach, Edmund R. "Magical Hair." *MAN: Journal of the Royal Anthropological Institute of Great Britain and Ireland* 88, no. 2 (1958): 147–64.

Lebbe, Christophe. "The Shadow Realm Between Life and Death." In *The Pagan Middle Ages*, ed. Ludo J. R. Milis, trans. Tanis Guest, 65–82. Woodbridge: Boydell Press, 1988.

Lefort, Jacques, and Jean-Marie Martin. "L'organisation de l'espace rural: Macédoine et Italie du sud (Xe–XIIIe siècle)." In *Hommes et richesses dans l'Empire byzantin*, vol. 2, *VIIIe–XVe siècle*, ed. Vassiliki Kravari, Jacques Lefort, and Cécile Morrisson, 11–26. Paris: Lethielleux, 1991.

Le Goff, Jacques. "Les gestes symboliques dans la vie sociale: Les gestes de la vassalité." In *Simboli e simbologia nell'alto Medioevo*, Settimane di Studio del Centro italiano di Studi sull'alto medioevo 23, 679–788. Spoleto: Centro italiano di Studi sull'alto medioevo, 1976.

Le Grand, Léon. "Relation du pèlerinage à Jérusalem de Nicolas de Martoni, notaire italien (1394–1395)." *Revue de l'Orient Latin* 3 (1895): 566–669.

Lehnardt, Peter Sh. "Studies in the Emergence of the Tradition of Hebrew Liturgical Poetry in Italy" [in Hebrew]. Ph.D. diss., Ben Gurion University of the Negev, 2006.

Lelli, Fabrizio. "Gli ebrei nel Salento: Primi risultati delle ricerche in corso." In *Gli Ebrei nel Salento*, ed. Fabrizio Lelli, 9–41. Galatina: Congedo, 2012.

———. "L'influenza dell'ebraismo italiano meridionale sul culto e sulle tradizioni linguistico-letterarie delle comunità greche." *Materia giudaica* 11, nos. 1–2 (2006): 201–15.

———. "Liturgia, lingue e manifestazioni letterarie e artistiche degli ebrei di Corfù." In *Evraikì: Una diaspora mediterranea da Corfù a Trieste*, ed. Tullia Catalan, Annalisa Di Fant, and Fabrizio Lelli, 33–60. Trieste: La Mongolfiera, forthcoming.

———. "L'*Odissea* di Moshe Ron e le testimonianze letterarie dei profughi ebrei nei campi di transito del Salento." In *Moshe Ron, Un'odissea dei nostri giorni*, ed. Fabrizio Lelli, 7–28. Galatina: Congedo, 2004.

Lemaître, Jean Loup, ed. *Prieurs et prieurés dans l'Occident médiéval: Actes du colloque organisé à Paris le 12 novembre 1984 par la IV^e Section de l'École pratique des Hautes Études et l'Institut de Recherche et d'Histoire des Textes*. Geneva: Librairie Droz, 1987.

Leone de Castris, Pierluigi. *Arte di corte nella Napoli Angioina*. Florence: Cantini, 1986.

———. "La pittura del Duecento e del Trecento a Napoli e nel Meridione." In *La pittura in Italia: Le Origini*, 395–446. Milan: Electa, 1985.

Lepore, Giorgia. "La chiesa dei Santi Crisante e Daria a Oria." In *Puglia preromanica dal V secolo agli inizi dell'XI*, ed. Gioia Bertelli, 139–45. Bari: Edipuglia–Jaca Book, 2004.

Leroy, François Joseph. *L'homilétique de Proclus de Constantinople: Tradition manuscrite, inédits, études connexes*. Studi e testi 247. Vatican City: Biblioteca Apostolica Vaticana, 1967.

Lesses, Rebecca M. *Ritual Practices to Gain Power: Angels, Incantations, and Revelation in Early Jewish Mysticism*. Harvard Theological Studies 44. Harrisburg, Pa.: Morehouse Group, 1998.

Levi, Clara. "Contributo allo studio delle 'XII parole della verità.'" *Lares* 4 (1933): 15–27.

Levi, Giovanni. "On Microhistory." In *New Perspectives on Historical Writing*, ed. Peter Burke, 93–113. University Park: Pennsylvania State University Press, 1991.

Levi Pisetzki, Rosita. *Storia del costume in Italia*. 5 vols. Milan: Istituto Editoriale Italiano, 1964–69.

Levine, Lee I. "The History and Significance of the Menorah in Antiquity." In *From Dura to Sepphoris: Studies in Jewish Art and Society in Late Antiquity*, ed. Lee I. Levine and Zeev Weiss, 131–53. JRA Supp. 40. Portsmouth, R.I.: Journal of Roman Archaeology, 2000.

Levine, Molly Myerowitz. "The Gendered Grammar of Ancient Mediterranean Hair." In *Off With Her Head!: The Denial of Women's Identity in Myth, Religion, and Culture*, ed. Howard Eilberg-Schwartz and Wendy Doniger, 76–130. Berkeley: University of California Press, 1995.

Licata, Delfina. "La 'festa' del Perdono: La Settimana Santa a Taranto." *Religioni e società* 40–41 (2001): 120–32.

Licinio, Raffaele. *Masserie medievali: Masserie, massari e carestie da Federico II alla Dogana delle pecore*. Bari: Mario Adda, 1998.

Lickel, Brian, David L. Hamilton, Grazyna Wieczorkowska, Amy Lewis, Steven J. Sherman, and A. Neville Uhles. "Varieties of Groups and the Perception of Group Entitativity." *Journal of Personality and Social Psychology* 78, no. 2 (2000): 223–46.

Lieber, Elinor. "Asaf's 'Book of Medicines': A Hebrew Encyclopedia of Greek and Jewish Medicine, Possibly Compiled in Byzantium on an Indian Model." *DOP* 38 (1984): 233–49.

Lieber, Laura S. "The Piyyutim le-Hatan of Qallir and Amittai: Jewish Marriage Customs in Early Byzantium." In *Talmuda de-Eretz Israel: Archaeology and the Rabbis in Late Ancient Palestine*, ed. Steven Fine and Aaron Koller. Studia Judaica 73. Berlin: De Gruyter, forthcoming.

———. "The Poetry of Creation: Zevadiah and Amittai's *Yotzerot le-Hatan* ('Groom's Yotzers')." Paper delivered at the Society for Biblical Literature conference, Atlanta, 2010.

Lightbown, Ronald W. *Mediaeval European Jewellery, with a Catalogue of the Collection in the Victoria & Albert Museum*. London: Victoria and Albert Museum, 1992.

Lillich, Meredith Parsons. "Early Heraldry: How to Crack the Code." *Gesta* 30, no. 1 (1991): 41–47.

Limoncelli, Massimo. "Dallo scavo archeologica alla riprogettazione virtuale di un edificio: La chiesa a doppia abside del casale di Quattro Macine, Giuggianello (LE)." In *III Congresso Nazionale di Archeologia Medievale, Salerno, 2–5 ottobre 2003*, ed. Rosa Fiorillo and Paolo Peduto, 458–63. Florence: All'Insegna del Giglio, 2003.

Limone, Oronzo. *Santi monaci e santi eremiti: Alla ricerca di un modello di perfezione nella letteratura agiografica dell'Apulia normanna*. Galatina: Congedo, 1988.

Limor, Ora, and Guy Stroumsa. *Contra Iudaeos: Ancient and Medieval Polemics Between Christians and Jews.* Tübingen: Mohr, 1996.

Lipton, Sara. *Images of Intolerance: The Representation of Jews and Judaism in the* Bible moralisée. Berkeley: University of California Press, 1999.

Lisi, Giuseppe. *La fine del rito greco in Terra d'Otranto.* Brindisi: Edizione Amici della "A. de Leo," 1988.

———. "Per la storia del rito greco in Terra d'Otranto: Una lettera inedita dell'Arcivescovo di Otranto del 1580." *Brundisii Res* 13 (1981): 167–75.

Loenertz, Raymond Joseph. "L'épitre de Théorien le Philosophe aux prêtres d'Oria." In *Byzantina et Franco-Graeca,* 45–70. Rome: Edizioni di Storia e letteratura, 1970.

Lombardi Satriani, Luigi M. "La moneta dei morti." *La parola del passato* 50 (1995): 327–39.

———. *Santi, streghe e diavoli.* Florence: Sansoni, 1971.

Loud, G. A. "How 'Norman' Was the Norman Conquest of Southern Italy?" *Nottingham Medieval Studies* 25 (1981): 13–34.

———. "The Laws of King Roger II (ca. 1140s)." In *Medieval Italy: Texts in Translation*, ed. Katherine L. Jansen, Joanna Drell, and Frances Andrews, 175–86. Philadelphia: University of Pennsylvania Press, 2009.

Lowden, John. *Illuminated Prophet Books: A Study of Byzantine Manuscripts of the Major and Minor Prophets.* University Park: Pennsylvania State University Press, 1988.

Lucy, Sam. "The Archaeology of Age." In *The Archaeology of Identity: Approaches to Gender, Age, Status, Ethnicity and Religion*, ed. Margarita Díaz-Andreu et al., 43–66. London: Routledge, 2005.

———. "Ethnic and Cultural Identities." In *The Archaeology of Identity: Approaches to Gender, Age, Status, Ethnicity and Religion*, ed. Margarita Díaz-Andreu et al., 86–109. London: Routledge, 2005.

Lüdtke, Karen. *Dances with Spiders: Crisis, Celebrity and Celebration in Southern Italy.* New York: Berghahn, 2009.

———. "Tarantism in Contemporary Italy: The Tarantula's Dance Reviewed and Revived." In *Music as Medicine: The History of Music Therapy Since Antiquity*, ed. Peregrine Horden, 293–312. Aldershot: Ashgate, 2000.

Lunardi, Giovanni, Hubert Houben, and Giovanni Spinelli, eds. *Monasticon Italiae 3: Puglia e Basilicata.* Repertorio topo-bibliografico dei monasteri italiani. Cesena: Badia di Santa Maria del Monte, 1986.

Maayan-Fanar, Emma. "Silenus Among the Jews? Anti-Jewish Polemics in Ninth-Century Byzantine Marginal Psalters." In *Between Judaism and Christianity: Art Historical Essays in Honor of Elisheva (Elisabeth) Revel-Neher*, ed. Katrin Kogman-Appel and Mati Meyer, 259–78. Leiden: Brill, 2009.

MacMullen, Ramsay. "The Epigraphic Habit in the Roman Empire." *American Journal of Philology* 103 (1982): 233–46.

Machin, Barrie. "St. George and the Virgin: Cultural Codes, Religion and Attitudes to the Body in a Cretan Mountain Village." *Social Analysis* 14 (1983): 107–26.

Maddalena, Giuseppe. "Maria tra i cavalieri: Contributo allo studio dell'antica araldica medioevale brindisina." In *Virgo Beatissima: Interpretazione mariane a Brindisi*, ed. Massimo Guastella, 97–105. Brindisi: Editrice Alfeo, 1990.

Magdalino, Paul. *The Empire of Manuel I Komnenos, 1143–1180.* Cambridge: Cambridge University Press, 1993.

———. "The Evergetis Fountain in the Early Thirteenth Century: An *Ekphrasis* of the Paintings in the Cupola." With Lyn Rodley. In *Studies on the History and Topography of Byzantine Constantinople*, no. VII. Variorum Collected Studies 855. Aldershot: Ashgate, 2007.

———. "Prosopography and Byzantine Identity." In *Fifty Years of Prosopography: The Later Roman Empire*, ed. Averil Cameron, 41–56. Oxford: Oxford University Press for the British Academy, 2003.

Magdalino, Paul, and Maria Mavroudi, eds. *The Occult Sciences in Byzantium*. Geneva: Pomme d'Or, 2006.

Magee, Joe C., and Adam D. Galinsky. "Social Hierarchy: The Self-Reinforcing Nature of Power and Status." *Academy of Management Annals* 2 (2008). http://www.psinetwork.org/uploads/83Magee%20and%20Galinsky%20Hierarchy%20for%20PSI.pdf.

Maguire, Henry P., Eunice Dauterman Maguire, and Maggie J. Duncan-Flowers. *Art and Holy Powers in the Early Christian House*. Urbana: Krannert Art Museum; University of Illinois Press, 1989.

Majeska, George P. "The Byzantines on the Slavs: On the Problem of Ethnic Stereotyping." *Acta Byzantina Fennica* 9 (1997–98): 70–86.

Makris, Giorgios. "Die Gasmulen." *Θησαυρίσματα* 22 (1992): 44–96.

Malachi, Zvi. "A Hebrew Poem from Italy on the Slave Trade." *Israel Oriental Studies* 2 (1972): 288–89.

Malecore, Irene M. *Magie di Japigia: Etnografia e folklore del Salento*. Naples: A. Guida, 1997.

Malkiel, David. "Between Worldliness and Traditionalism: Eighteenth-Century Jews Debate Intercessory Prayer." *Jewish Studies, an Internet Journal* 2 (2003): 169–98.

———. "Jews and Apostates in Medieval Europe—Boundaries Real and Imagined." *Past & Present* 194 (2007): 3–34.

Manarese, Cesare. "Araldica." In *Enciclopedia Italiana di scienze, lettere ed arti*, 3:924–47. Milan: Istituto Giovanni Treccani, 1929.

Mancarella, Giovanni Battista. *Salento: Monografia regionale della "Carta dei Dialetti Italiani."* Lecce: Edizioni del Grifo, 1998.

Manchia, G[ianfranco], and D[onatella] Serini. "Comunità ebraiche e giudecche nella Puglia medievale." *Studi salentini* 68 (1991): 128–75.

Mancuso, Piergabriele. "Manuscript Production in Southern Italy: New Information from a[n] 11th–12th Century Manuscript from the Cairo Genizah." *Materia giudaica* 14, nos. 1–2 (2009): 419–30.

Mann, Jacob. *Texts and Studies in Jewish History and Literature*, vol. 1. Cincinnati: Hebrew Press of the Jewish Publication Society of America, 1931.

Manni, Luigi. *Dalla guglia di Raimondello alla magia di messer Matteo*. Galatina: Congedo, 1994.

Maraspini, A. L. *The Study of an Italian Village*. Paris: Mouton, 1968.

Marcus, Ivan G. *The Jewish Life Cycle: Rites of Passage from Biblical to Modern Times*. Seattle: University of Washington Press, 2004.

———. "Prayer Gestures in German Hasidism." In *Mysticism, Magic and Kabbalah in Ashkenazi Judaism*, ed. Karl Erich Grözinger and Joseph Dan, 44–59. Berlin: Walter de Gruyter, 1995.

———. *Rituals of Childhood: Jewish Acculturation in Medieval Europe*. New Haven, Conn.: Yale University Press, 1996.

Marella, Giuseppe. "Brindisi: Modelli urbanistici e manifesti ideologici nella prima età normanna." *Kronos*, supp. 2 (2006): 123–47.

Marinis, Vasileios. "The Byzantine Church Beyond the Liturgy." In *Cambridge World History of Religious Architecture*, ed. Richard Etlin. Cambridge: Cambridge University Press, forthcoming.

Marjanović-Vujović, Gordana. "Finds of Earrings in Men's Graves in the Medieval Necropolis at Trnjane." *Archaeologia Iugoslavica* 20–21 (1980–81): 162–66.

Marsh, Peter. "Identity: An Ethogenic Perspective." In *Persons in Groups: Social Behavior as Identity Formation in Medieval and Renaissance Europe*, ed. Richard C. Trexler, 17–30. Binghamton, N.Y.: Medieval & Renaissance Texts & Studies, 1985.

Martin, Jean-Marie. "Le devenir du *cognomen* et le début de l'émergence du nom de famille: Bari, 1266–1343." *MEFRM* 110, no. 1 (1998): 83–92.

———. "L'empreinte de Byzance dans l'Italie normande: Occupation du sol et institutions." *Annales: Histoire, Sciences sociales* 60 (2005): 733–65.

———. "Hellénisme et présence byzantine en Italie méridionale." In *L'ellenismo italiota dal VII al XII secolo: Alla memoria di Nikos Panagiotakis*, ed. Nikos Oikonomides, 181–202. Athens: Ethniko Hidryma Ereunōn, 2001.

———. "L'Italie méridionale." In *L'anthroponymie: Document de l'histoire sociale des mondes méditerranéens médiévaux*, ed. Monique Bourin, Jean-Marie Martin, and François Menant, 29–39. Rome: École française, 1996.

———. "La naissance de la province de Terre d'Otrante au XIIᵉ siècle." *Scritti di storia pugliese in onore di Mons. Carmine Maci*, ed. Michele Paone, 23–33. Galatina: Congedo, 1994.

. "Une origine calabraise pour la Grecìa Salentine?" *RSBN*, n.s., 22–23 (1985–86): 52–63.

———. *La Pouille du VIᵉ au XIIᵉ siècle*. Rome: École française, 1993.

———. "Quelques remarques sur le culte des images en Italie meridionale pendant le haut M.A." In *Cristianità ed Europa: Miscellanea di studi in onore di Luigi Prosdocimi*, ed. Cesare Alzati, 1:223–36. Rome: Herder, 1994.

Martin, Jean-Marie, and Ghislaine Noyé. "Les campagnes de l'Italie méridionale byzantine (Xᵉ–XIᵉ siècles)." *MEFRM* 101, no. 2 (1989): 559–96.

———. "Les villes de l'Italie byzantine (IXᵉ–XIᵉ siècles)." In *Hommes et richesses dans l'Empire byzantin*, vol. 2, *VIIIᵉ–XVᵉ siècle*, ed. Vassiliki Kravari, Jaques Lefort, and Cecile Morrisson, 27–62. Paris: Lethielleux, 1991.

Martin-Hisard, Bernadette. "Le culte de l'archange Michel dans l'empire byzantin (VIIIᵉ–XIᵉ siècles)." In *Culto e insediamenti micaelici nell'Italia meridionale fra tarda antichità e medioevo: Atti del Convegno internazionale, Monte Sant'Angelo, 18–21 novembre 1992*, ed. Carlo Carletti and Giorgio Otranto, 351–73. Bari: Edipuglia, 1994.

Masciullo, Salvatore. *Dolmen e menhir della Provincia di Lecce*. Castrignano dei Greci: Almatea, 1999.

Massaro, Carmela. "La città e i casali." In *Storia di Lecce dai Bizantini agli Aragonesi*, ed. Maria Marcella Rizzo, Bruno Pellegrino, and Benedetto Vetere, 345–92. Bari: Laterza, 1993.

———. "Economia e società in una 'quasi città' del Mezzogiorno tardomedievale: San Pietro in Galatina." In *Dal Giglio all'Orso: I principi d'Angiò e Orsini del Balzo nel Salento*, ed. Antonio Cassiano and Benedetto Vetere, 147–93. Galatina: Congedo, 2006.

———. *Società e istituzioni nel mezzogiorno tardomedievale: Aspetti e problemi*. Galatina: Congedo, 2000.

———. "Territorio, società e potere." In *Storia di Lecce dai Bizantini agli Aragonesi*, ed. Benedetto Vetere, 251–343. Bari: Laterza, 1993.

Mathews, Thomas. "'Private' Liturgy in Byzantine Architecture: Toward a Re-appraisal." *Cahiers archéologiques* 30 (1982): 125–38.

Mattingly, David. "Cultural Crossovers: Global and Local Identities in the Classical World." In *Material Culture and Social Identities in the Ancient World*, ed. Shelley Hales and Tamar Hodos, 283–95. Cambridge: Cambridge University Press, 2010.

Mayer Modena, Maria. "The Spoken Language of the Jews of Italy: How Far Back?" In *The Jews of Italy: Memory and Identity*, ed. Bernard Cooperman and Barbara Garvin, 307–16. Bethesda: University Press of Maryland, 2000.

Mazzarella, Emilio. *La Cattedrale di Nardò*. Galatina: Congedo, 1982.

Mazzotta, Oronzo. *Monaci e libri greci nel Salento medievale.* Novoli: Bibliotheca Minima, 1989.

McCormick, Michael. "The Imperial Edge: Italo-Byzantine Identity, Movement and Integration, A.D. 650–950." In *Studies on the Internal Diaspora of the Byzantine Empire*, ed. Hélène Ahrweiler and Angeliki E. Laiou, 17–52. Washington, D.C.: Dumbarton Oaks Research Library and Collection, 1997.

McCracken, Grant. *Culture and Consumption: New Approaches to the Symbolic Character of Consumer Goods and Activities.* Bloomington: Indiana University Press, 1988.

McGuire, Brian Patrick. *The Birth of Identities: Denmark and Europe in the Middle Ages.* Copenhagen: Reitzel Medieval Centre, Copenhagen University, 1996.

McKee, Sally. "Households in Fourteenth-Century Venetian Crete." *Speculum* 70, no. 1 (1995): 27–67.

———. "Sailing from Byzantium: Byzantines and Greeks in the Venetian World." In *Identities and Allegiances in the Eastern Mediterranean After 1204*, ed. Judith Herrin, 291–300. Burlington, Vt.: Ashgate, 2011.

———. *Uncommon Dominion: Venetian Crete and the Myth of Ethnic Purity.* Philadelphia: University of Pennsylvania Press, 2000.

McLaughlin, Megan. *Consorting with Saints: Prayer for the Dead in Early Medieval France.* Ithaca, N.Y.: Cornell University Press, 1994.

Medea, Alba. *Gli affreschi delle cripte eremitiche pugliesi.* 2 vols. Rome: Collezione Meridionale Editrice, 1939.

———. "Mural Paintings in Some Cave Chapels of Southern Italy." *American Journal of Archaeology* 42, no. 1 (1938): 17–29.

Megha, Cosimo. *Galatone Sacra: Relazione sullo stato della chiesa di Galatone, 1637.* Ed. Francesco Potenza. Galatina: Congedo, 1989.

Meinardus, Otto. "Mediaeval Navigation According to Akidographemata in Byzantine Churches and Monasteries." *Deltion tēs Christianikēs Archaiologikēs Hetaireias* 4–6 (1970–72): 29–52.

Mellinkoff, Ruth. *Outcasts: Signs of Otherness in Northern European Art of the Late Middle Ages.* Berkeley: University of California Press, 1993.

Menna, Maria Raffaella. "L'iconografia di Pietro a Bisanzio." In *La figura di San Pietro nelle fonti del medioevo: Atti del convegno tenutosi in occasione dello "Studiorum universitatum docentium congressus" (Viterbo e Roma, 5–8 settembre 2000)*, ed. Loredana Lazzari and Anna Maria Valente Bacci, 442–56. Louvain-la-Neuve: Fédération Internationale des Instituts d'Études Médiévales, 2001.

Mennonna, Mario, ed. *Nardò Sparita: Storia e iconografia (secc. XI–XVIII).* Galatina: Congedo, 1997.

Mercati, Giovanni. "Non Russia, ma Rossano nell'Antirretico di Teodoro Cursiota." In *Opere minori IV,* Studi e Testi 79, 169–71. Vatican City: Biblioteca Apostolica Vaticana, 1937.

Mérindol, Christian de. "Signes de hiérarchie sociale à la fin du Moyen Âge d'après le vêtement: Méthodes et recherches." In *Le vêtement: Histoire, archéologie et symbolique vestimentaire au moyen âge*, ed. Michel Pastoureau, 181–223. Paris: Léopard d'Or, 1989.

Mersch, Margit, and Ulrike Ritzerfeld. "'Lateinisch-griechische' Begegnungen in Apulien: Zur Kunstpraxis der Mendikanten im Kontaktbereich zum orthodoxen Christentum." In *Lateinisch-griechisch-arabische Begegnungen: Kulturelle Diversität im Mittelmeerraum des Spätmittelalters*, ed. Margit Mersch and Ulrike Ritzerfeld, 219–84. Berlin: Akademie Verlag, 2009.

Metzger, Marcel. "Peintures 'placées haut' et images 'placées bas.'" *Revue des sciences réligieuses* 68 (1994): 453–64.

Metzger, Thérèse, and Mendel Metzger. *Jewish Life in the Middle Ages: Illuminated Hebrew Manuscripts of the Thirteenth to Sixteenth Centuries.* New York: Alpine Fine Arts Collection, 1982.

Meyer, Elizabeth A. "Explaining the Epigraphic Habit in the Roman Empire: The Evidence of Epitaphs." *Journal of Roman Studies* 80 (1990): 74–96.

Micali, Salvador. "La fabbrica del Duomo: Interventi e restauri nei resoconti delle visite pastorali." In *Città e monastero: I segni urbani di Nardò (secc. XI–XV)*, ed. Benedetto Vetere, 195–239. Galatina: Congedo, 1986.

———. "S. Maria di Nardò: Note sul corredo pittorico." In *Insediamenti benedettini in Puglia: Per una storia dell'arte dall'XI al XVII secolo; Catalogo della Mostra*, ed. Maria Stella Calò Mariani, 441–46. Galatina: Congedo, 1985.

Michael, Michael. "The Privilege of 'Proximity': Towards a Re-Definition of the Function of Armorials." *Journal of Medieval History* 23 (1997): 55–74.

Michaels, Alex. "Ritual and Meaning." In *Theorizing Rituals: Issues, Topics, Approaches, Concepts*, ed. Jens Kreinath, Jan Snoek, and Michael Stausberg, 247–61. Leiden: Brill, 2006.

Michalsky, Tanja. "Sponsoren der Armut: Bildkonzepte franziskanisch orientierter Herrschaft." In *Medien der Macht: Kunst zur Zeit der Anjous in Italien*, ed. Tanja Michalsky, 121–48. Berlin: Dietrich Reimer, 2001.

Miele, Michele. *I concili provinciali del Mezzogiorno in età moderna*. Naples: Editoriale Scientifica, 2001.

Milella, Marisa. "I cavalieri di Dio: Iconografia dei santi cavalieri negli affreschi pugliesi." In *Le crociate: L'Oriente e l'Occidente da Urbano II a San Luigi 1096–1270, Palazzo Venezia, Rome, 14 febbraio–30 aprile 1997*, ed. Monique Rey-Delqué, 214–17. Milan: Electa, 1997.

———. "La raffigurazione dell'uomo." In *La Parola si fa immagine: Storia e restauro della basilica orsiniana di Santa Caterina a Galatina*, ed. Fernando Russo, 163–88. Venice: Marsilio Editore, 2005.

Milella Lovecchio, Marisa. "Alcune note di iconografia nicolaiana in Puglia: Un incontro tra oriente e occidente." *Continuità: Rassegna tecnica Pugliese* 3/4 (1986): 50–56.

Miller, Timothy, trans. "*Kasoulon*: *Rule* of Nicholas for the Monastery of St. Nicholas of Kasoulon near Otrantro." In *BMFD*, 4:1319–30.

Mina, Gabriele, ed. *Il morso della differenza: Antologia del dibattito sul tarantismo fra il XIV e XVI secolo*. Nardò: Besa, 2000.

Minervini, Laura. "Il contributo di Giuseppe Sermoneta alla storia linguistica degli ebrei siciliani." In *Italia* 13–15 [special issue in memory of Giuseppe Sermoneta, ed. Robert Bonfil] (2001): 125–36.

Minuto, Domenico. "Il 'Trattato contra Greci' di Antonio Castronovo (1579)." In *La Chiesa greca in Italia dall'VIII al XVI secolo: Atti del Convegno storico interecclesiale (Bari, 30 apr.–4 magg. 1969)*, 3:1001–73. Padua: Antenore, 1972–73.

Mirsky, Samuel K. "R. Isaiah of Trani and the Author of Shibolei ha-Leqet" [in Hebrew]. *Talpiot* 9 (1964): 49–109.

Mirzoeff, Nicholas. *An Introduction to Visual Culture*. 2nd ed. London: Routledge, 2009.

Montefrancesco, Angelo. "Nuove ricerche intorno alla cripta di S. Michele Arcangelo alla Masseria 'Li Monaci.'" *Il Castello: Quaderno di storia, arte e cultura* 3, no. 1 (1992): 4–11.

Monti, James. *The Week of Salvation: History and Traditions During Holy Week*. Huntington, Ind.: Our Sunday Visitor, 1993.

Montinaro, Brizio. *Canti di pianto e d'amore dall'antico Salento: Testo a fronte*. Milan: Bompiani, 1994.

———. "S. Vito ha una pietra forata: Appunti per un rito arcaico." *Apulia* (June 1979). Repub. with photos in http://www.fondazioneterradotranto.it/2012/10/29/s-vito-ha-una-pietra-forata-appunti-per-un-rito-arcaico/.

Montinaro, Maria, and Franco Carliano. "Il Campanilismo." In *Grecìa salentina*, Problemi e documenti 1, ed. Rocco Aprile, Gustavo Buratti, Gerhard Rohlfs, and Lina Colella, 2:159. Cavallino di Lecce: Capone Editore, 1980.

Mørch, Henning. "Location of Rural Settlements and Geology—A Case Study of the Salento Peninsula (S. Italia)." *Geografisk Tidsskrift* 87 (1987): 42–49.

Morosi, Giuseppe. *Studi sui dialetti greci della terra d'Otranto*. Lecce, 1870; repr., Sala Bolognese: A. Forni, 1994.

Morrissey, John. "Cultural Geographies of the Contact Zone: Gaels, Galls and Overlapping Territories in Late Medieval Ireland." *Social & Cultural Geography* 6, no. 4 (2005): 551–66.

Moss, Leonard W., and Stephen C. Cappannari. "*Mal'occhio, Ayin ha ra, Oculus Fascinus, Judenblick*: The Evil Eye Hovers Above." In *The Evil Eye*, ed. Clarence Maloney, 1–15. New York: Columbia University Press, 1976.

Mrozowski, Przemyslaw. "Genuflection in Medieval Western Culture: The Gesture of Expiation—The Praying Posture." *Acta Poloniae Historica* 68 (1993): 5–26.

Muir, Edward. *Ritual in Early Modern Europe*. Cambridge: Cambridge University Press, 1997.

Munro, John H. "The Medieval Scarlet and the Economics of Sartorial Splendor." In *Cloth and Clothing in Medieval Europe: Essays in Memory of Professor E. M. Carus-Wilson*, ed. N. B. Harte and Kenneth G. Ponting, 13–70. London: Heinemann Educational, 1983.

Murphy, Conn. "An Early Irish Visitor to the Island of Crete: The Journey of Symon Semeonis from Ireland to the Holy Land." *Classics Ireland* 10 (2003). http://www.ucd.ie/cai/classics-ireland/2003/murphy.html.

Musella Guida, Silvana. "Il Regno del lusso: Leggi suntuarie e società; Un percorso di lungo periodo nella Napoli medievale e moderna (1290–1784). "Papiers" présentés lors de la rencontre AFHE-SISE de mai 2007 sur l'économie du luxe. http://lodel.ehess.fr/afhe/docannexe.php?id=446.

Naselli, Carmelina. "L'etimologia di 'Tarantella.'" *Archivio Storico Pugliese* 4 (1951): 218–27.

Neale, John Mason, trans. *Hymns of the Eastern Church*. London: Spottiswoode and Co., 1862. http://ccel.org/ccel/neale/easternhymns.txt.

Nederveen Pieterse, Jan. "Hybridity, So What? The Anti-Hybridity Backlash and the Riddles of Recognition." *Theory, Culture & Society* 18, nos. 2–3 (2001): 219–45.

Negro, Massimo. "Miggiano: Gli archi di Santa Marina." Dec. 6, 2011. http://massimonegro.wordpress.com/2011/12/06/miggiano-gli-archi-di-santa-marina/.

Nelson, Robert. "Appropriation." In *Critical Terms for Art History*, 2nd ed., ed. Robert Nelson and Richard Shiff, 116–28. Chicago: University of Chicago Press, 2003.

Newman, Hillel I. "*Sandak* and Godparent in Midrash and Medieval Practice." *Jewish Quarterly Review* 97, no. 1 (2007): 1–32.

Nicolle, David C. *Arms and Armour of the Crusading Era, 1050–1350*. 2 vols. White Plains, N.Y.: Kraus International, 1988.

Niehoff-Panagiotidis, Johannes, and Elisabeth Hollender. "ἔχομε ראש חדש: The Announcement of the New Moon in Romaniote Synagogues." *Byzantinische Zeitschrift* 103, no. 1 (2010): 99–127.

Nocent, Adrien. "Christian Initiation in the Roman Church from the Fifth Century Until Vatican II." In *Handbook for Liturgical Studies, IV: Sacraments and Sacramentals*, ed. Anscar J. Chupungco, 49–90. Collegeville, Minn.: Liturgical Press, 2000.

Nolé, Maria Anna. "Rituali terapeutici in area meridionale e nella cultura tradizionale lucana." Thesis, Università degli studi della Basilicata, Potenza, 2005–6.

Norman, Diana. "Politics and Piety: Locating Simone Martini's *Saint Louis of Toulouse* Altarpiece." *Art History* 33, no. 4 (2010): 597–619.

Novembre, Domenico. "Per una geografia del Salento medioevale." In *Salento Porta d'Italia: Atti del Convegno internazionale, Lecce 1986*, 235–65. Galatina: Congedo, 1989.

Noy, David. *Jewish Inscriptions of Western Europe*. Vol. 1, *Italy (Excluding the City of Rome), Spain and Gaul.* Cambridge: Cambridge University Press, 1993.

Nucita, Ada, and Pierluigi Bolognini. *Guida della Grecìa Salentina: Itinerario storico artistico.* Lecce: Capone, 1996.

Nuzzo, Donatella. "I reperti epigrafici." In *Torre Santa Susanna: Chiesa di S. Pietro; Storia archeologia restauro*, ed. Grazia Angela Maruggi and Gaetano Lavermicocca, 37–40. Bari: Mario Adda, 2000.

Oikonomides, Nikos. "Literacy in Thirteenth-Century Byzantium: An Example from Western Asia Minor." *To Hellenikon: Studies in Honor of Speros Vryonis, Jr.*, ed. John S. Langdon et al., 253–65. New Rochelle, N.Y.: Caratzas, 1993.

Orlando, Roberto. *Taurisano: Guida alla storia, all'arte, al folklore.* Galatina: Congedo, 1996.

Orlando, Vito. *Feste devozione e religiosità: Ricerca socio-religiosa in alcuni Santuari del Salento.* Galatina: Congedo, 1981.

Ortese, Sergio. "La chiesa di Santa Maria de Itri a Nociglia: La decorazione tardogotica." In *Segni del tempo: Studi di storia e cultura salentina in onore di Antonio Caloro*, ed. Mario Spedicato, 41–48. Galatina: Panico, 2008.

———. "Il ciclo della Maddalena nel castello di Copertino." In *Percorsi di conoscenza e tutela: Studi in onore di Michele D'Elia*, ed. Francesco Abbate, 95–109. Pozzuoli: Paparo, 2008.

———. "Una committenza Del Balzo Orsini Chiaromonte nella cappella della Maddelena a Copertino: Note sulla pittura tardogotica del Salento." In *Un principato territoriale nel Regno di Napoli? Gli Orsini del Balzo principi di Taranto (1399–1463): Atti del convegno internazionale di studi, Lecce 20–22 ottobre 2009*, ed. Benedetto Vetere, 577–88. Rome: Istituto Storico Italiano per il Medioevo, 2013.

———. "Una committenza Maremonti nella chiesa di Santa Caterina d'Alessandria in Galatina." In *Dal Giglio all'Orso: I principi d'Angiò e Orsini del Balzo nel Salento*, ed. Antonio Cassiano and Benedetto Vetere, 402–15. Galatina: Congedo, 2006.

———. "Un enigma iconografico nella chiesa rupestre di Santa Maria della Grotta a Ortelle." *Kronos* 8 (2005): 99–108.

———, ed. *Nociglia, Chiesa di Santa Maria de Itri: Un palinsesto pittorico sulle rotte Leucane.* Copertino: Lupo Editore, 2011.

———. "Per il ciclo pittorico della chiesa di Santa Croce a Minervino di Lecce." In *Territorio, culture e poteri nel Medioevo e oltre: Scritti in onore di Benedetto Vetere*, ed. Carmela Massaro and Luciana Petracca, 1:415–34. Galatina: Congedo, 2011.

———. "La pittura tardogotica nel Salento leccese: I cantieri "minori." Tesi di dottorato di ricerca, Università del Salento, 2008.

———. "Una rilettura della cripta dopo il restauro." In *La cripta di Santa Maria della Grotta a Ortelle: Storia e restauri*, ed. Sergio Ortese, 3–22. Lecce: Lupo Editore, 2009.

———. "Sequenza del lavoro in *Santo Stefano* a Soleto." In *Dal Giglio all'Orso: I principi d'Angiò e Orsini del Balzo nel Salento*, ed. Antonio Cassiano and Benedetto Vetere, 336–96. Galatina: Congedo, 2006.

———. "Sulla chiesa di Santa Maria d'Aurìo presso Lecce e le sue pitture murali." *Kronos* 5/6 (2003): 203–8.

Ortíz, Fernando. *Cuban Counterpoint: Tobacco and Sugar.* New York: Knopf, 1947.

Ousterhout, Robert. "Byzantium Between East and West and the Origins of Heraldry." In *Byzantine Art: Recent Studies; Essays in Honor of Lois Drewer*, ed. Colum Hourihane, 153–70. Tempe: Arizona Center for Medieval and Renaissance Studies, 2009.

——. "Symbole der Macht: Mittelalterliche Heraldik zwischen Ost und West." In *Lateinisch-griechisch-arabische Begegnungen: Kulturelle Diversität im Mittelmeerraum des Spätmittelalters*, ed. Margit Mersch and Ulrike Ritzerfeld, 91–109. Berlin: Akademie Verlag, 2009.

——. "Temporal Structuring in the Chora Parekklesion." *Gesta* 34, no. 1 (1995): 63–76.

Owusu, Vincent. "Funeral Rites in Rome and the Non-Roman West." In *Handbook for Liturgical Studies, IV: Sacraments and Sacramentals,* ed. Anscar J. Chupungco, 355–80. Collegeville, Minn.: Liturgical Press, 2000.

Pace, Valentino. "Arte di età angioina nel regno: Vicinanza e distanza dalle corte." In *Medien der Macht: Kunst zur Zeit der Anjous in Italien*, ed. Tanja Michalsky, 241–60. Berlin: Dietrich Reimer, 2001.

——. "La chiesa di Santa Maria delle Cerrate e i suoi affreschi." In *Obraz Vizantii: Sbornik statei v cest' O. S. Popovoi* [L'immagine di Bisanzio: Raccolta di studi in onore di O. S. Popova], ed. Anna Vladimirova Zakharova, 377–98. Moscow: Severnyi Palomnik, 2008.

——. "Pittura bizantina nell'Italia meridionale (secoli XI–XIV)." In *I Bizantini in Italia*, ed. Guglielmo Cavallo, 429–94. Milan: Libri Scheiwiller, 1982.

——. "La pittura delle origini in Puglia: Secoli IX–XIV." In *La Puglia fra Bisanzio e l'Occidente*, 317–400. Milan: Electa, 1980.

——. "San Mauro nell'agro di Gallipoli: Un monumento della transperiferia bizantina del XIII secolo." In *Sannicola, Abbazia di San Mauro: Gli affreschi italo-greci sulla Serra d'Altolido presso Gallipoli*, ed. Sergio Ortese, 23–35. Copertino: Lupo Editore, 2012.

Page, Gill. *Being Byzantine: Greek Identity Before the Ottomans*. Cambridge: Cambridge University Press, 2008.

Palma, Pantaleo. "Le antiche registrazioni degli atti di battesimo della parrocchia dei SS. Pietro e Paolo in Galatina nella problematica della ricostruzione dei caratteri originari della popolazione della Grecìa Salentina." *BSTd'O* 3 (1993): 145–60.

——. "Istituzioni e società nella Grecìa Salentina: Evoluzione e trasformazione di una minoranza etnica." In *Civiltà della Magna Grecia: Problematica dei paesi ellenofoni; Convegno internazionale, 24–27 settembre 1992*, ed. Accademia Tiberina, sezione di Napoli, 125–39. Naples, 1993. http://grecia-salentina.it/MELPIGNANO/a/a.html.

Palumbo, Giuseppe. "Inventario delle pietrefitte salentine." *Rivista di scienze preistoriche* 10 (1959): 86–146.

——. "Pseudo-Pietrefitte in Terra d'Otranto e l'evoluzione degli 'Osanna' o 'Sannà.'" *Studi salentini* 6 (1958): 169–77.

——. "Scoperte di pietrefitte in Terra d'Otranto." *Archivio Storico Pugliese* 5 (1952): 45–57.

Palumbo, Lorenzo, and Filippo Marra. "Presicce e dintorni." *BSTd'O* 4 (1994): 179–200.

Panzanelli, Roberta, ed. *Ephemeral Bodies: Wax Sculpture and the Human Figure.* Los Angeles: Getty Research Institute, 2008.

Paoli, Sebastiano. *De Ritu Ecclesiae Neritinae: Exorcizandi Aquam in Epiphania; Dissertatio.* Naples: Felix Mosca, 1719.

Papaconstantinou, Arietta, and Alice-Mary Talbot, eds. *Becoming Byzantine: Children and Childhood in Byzantium*. Washington, D.C.: Dumbarton Oaks Research Library and Collection, 2009.

Papadakis, Aristeides. *Crisis in Byzantium: The Filioque Controversy in the Patriarchate of Gregory II of Cyprus (1283–1289)*. Rev. ed. Crestwood, N.Y.: St. Vladimir's Seminary Press, 1996.

Papadia, Baldassar. *Memorie storiche della città di Galatina nella Japigia*. Naples: Vincenzo Orsini, 1792.

Papanikola-Bakirtzi, Demetra, ed. *Everyday Life in Byzantium: Thessaloniki, White Tower, October 2001–January 2002*. Catalog for the exhibit "Byzantine Hours: Works and Days in Byzantium." Athens: Hellenic Ministry of Culture, 2002.

Parani, Maria G. *Reconstructing the Reality of Images: Byzantine Material Culture and Religious Iconography (11th–15th Centuries)*. Leiden: Brill, 2003.

Parenti, Stefano. "Christian Initiation in the East." In *Handbook for Liturgical Studies, IV: Sacraments and Sacramentals*, ed. Anscar J. Chupungco, 29–48. Collegeville, Minn.: Liturgical Press, 2000.

———. "The Christian Rite of Marriage in the East." In *Handbook for Liturgical Studies, IV: Sacraments and Sacramentals*, ed. Anscar J. Chupungco, 255–74. Collegeville, Minn.: Liturgical Press, 2000.

———. "La frazione in tre parti del pane eucaristico nella liturgia italo-bizantina." *Ecclesia Orans* 17 (2000): 203–27.

———. *Il Monastero di Grottaferrata nel Medioevo (1004–1462)*. Rome: Pontificio Istituto Orientale, 2005.

Parenti, Stefano, and Elena Velkovska, eds. *L'Eucologio Barberini gr. 336*. Rome: CLV–Edizioni Liturgiche, 1995.

Parlangeli, Oronzo. *Sui dialetti romanzi e romaici del Salento*. Milan: Hoepli, 1953; repr., Galatina: Congedo, 1989.

Pasculli Ferrara, Mimma. "I dipinti murali." In *La cripta della Cattedrale di Taranto*, ed. Cosimo D'Angela, 37–46. Taranto: Editrice Scorpione, 1986.

Pasquini, Laura. "Interculturalità letteraria e commistione iconografica fra cultura ebraica, araba e cristiana nel mosaico pavimentale della Cattedrale di Otranto." In *L'interculturalità dell'ebraismo: Atti del Convegno internazionale Bertinoro, Ravenna, 26–28 maggio 2003*, ed. Mauro Perani, 193–221. Ravenna: Longo, 2004.

Passarelli, G. "Le epigrafi bizantine del Museo Castromediano di Lecce." *Archivio e Cultura* 14 (1980): 33–55.

———. "Stato della ricerca sul formulario dei riti matrimoniali." In *Studi bizantini e neogreci: Atti del IV Congresso nazionale di studi bizantini*, ed. Pietro L. Leone, 241–48. Galatina: Congedo, 1983.

Pastore, Michela. "Fonti per la storia di Puglia: Regesti dei Libri Rossi e delle pergamene di Gallipoli, Taranto, Lecce, Castellaneta e Laterza." In *Studi di storia pugliese in onore di Giuseppe Chiarelli*, ed. Michele Paone, 2:153–295. Galatina: Congedo, 1973.

Patera, Maria. "Exorcismes et phylactères byzantins: Écrire, énoncer les noms du démon." *Cahiers "Mondes anciens"* 1 (2009). http://mondesanciens.revues.org/139.html.

Patlagean, Evelyne. "La 'Dispute avec les Juifs' de Nicolas d'Otrante (vers 1220) et la question du Messie." In *La storia degli ebrei nell'Italia medievale: Tra filologia e metodologia*, ed. Maria Giuseppina Muzzarelli and Giacomo Todeschini, 19–27. Bologna: Grafiche Zanini, 1989.

Patterson, Helen, L. "Contatti commerciali e culturali ad Otranto dall'IX al XV secolo: L'evidenza della ceramica." In *La ceramica nel mondo bizantino tra XI e XV secolo e i suoi rapporti con l'Italia: Atti del seminario, Certosa di Pontignano (Siena), 11–13 marzo 1991*, ed. Sauro Gelichi, 101–23. Florence: All'Insegna del Giglio, 1993.

Pätzold, Alexandra. *Der Akathistos-Hymnos: Die Bilderzyklen in der byzantinische Wandmalereien des 14. Jahrhunderts*. Stuttgart: Franz Steiner, 1989.

Paxton, Frederick S. *Christianizing Death: The Creation of a Ritual Process in Early Medieval Europe*. Ithaca, N.Y.: Cornell University Press, 1990.

Peduto, Paolo. "Osservazioni sul rito in epoca medievale." *La parola del passato* 50 (1995): 311–18.

Pellegrini, Giovanni Battista. *Toponomastica italiana*. Milan: Hoepli, 1990.

Pellegrino, Bruno, ed. *Terra d'Otranto in età moderna*. Galatina: Congedo, 1984.

Pellegrino, Bruno, and Benedetto Vetere, eds. *Il Tempio di Tancredi: Il monastero dei Santi Niccolò e Cataldo in Lecce*. Cinisello Balsamo: Silvana, 1996.

Peltonen, Matti. "Clues, Margins, and Monads: The Micro-Macro Link in Historical Research." *History and Theory Studies in the Philosophy of History* 40, no. 3 (2002): 347–59.

Peluso, Maria, and Pietro Pierri. *Cripte e affreschi nell'agro di Grottaglie.* Manduria: Centro Ricerche Storiche, 1981.

Peluso, Vincenzo. "Iscrizioni latine del Salento leccese." *BSTd'O* 8 (1998): 113–78.

The Penguin Book of Hebrew Verse. Trans. T. Carmi. Harmondsworth: Penguin, 1981; repr., London: Penguin, 2006.

Pentcheva, Bissera V. *Icons and Power: The Mother of God in Byzantium.* University Park: Pennsylvania State University Press, 2006.

Perani, Mauro. "Nuovo inventario dei frammenti di manoscritti medievali della *Mishna,* della *Tosefta* e del *Talmud* rinvenuti nella 'Geniza Italiana.'" In *Una manna buona per Mantova (Man Tov le-Man Tovah): Studi in onore di Vittore Colorno per il suo 92ᵒ compleanno,* ed. Mauro Perani, 333–63. Florence: Olschki, 2004.

Perani, Mauro, and Alessandro Grazi. "La 'scuola' dei copisti ebrei pugliesi (Otranto?) del secolo XI: Nuove scoperte." *Materia giudaica* 11, nos. 1–2 (2006): 13–41.

Peri, Vittorio. "La Congregazione dei Greci (1573) e i suoi primi documenti." *Studia Gratiana* 13 (1967): 129–256.

Pertusi, Agostino. "Sopravvivenze pagane e pietà religiosa nella società bizantina dell'Italia meridionale." In *Calabria bizantina: Tradizione di pietà e tradizione scrittoria nella Calabria greca medievale,* 17–46. Reggio Calabria: Casa del Libro, 1983.

Peters-Custot, Annick. "Le barbare et l'étranger dans l'Italie méridionale pré-normande (IXᵉ–Xᵉ siècles): L'Empire à l'épreuve de l'altérité." In *Le barbare, l'étranger: Images de l'autre; Actes du colloque organisé par le CERHI, Saint-Étienne, 14 et 15 mai 2004,* ed. Didier Nourrisson and Yves Perrin, 147–63. Saint-Étienne: Publications de l'Université de Saint-Étienne, 2005.

———. *Les grecs de l'Italie méridionale post-byzantine (IXᵉ–XIVᵉ siècle): Une acculturation en douceur.* Rome: École française, 2009.

Petersen, Lauren Hackworth. "The Baker, His Tomb, His Wife, and Her Breadbasket." *Art Bulletin* 85, no. 2 (2003): 230–57.

Petta, Marco. "Codici greci del Salento posseduti da biblioteche italiane ed estere." *Brundisii Res* 4 (1973): 59–121.

———. "Manoscritti liturgici greci nelle chiese di Galatone." In *Studi di storia pugliese in onore di Giuseppe Chiarelli,* ed. Michele Paone, 2:685–706. Galatina: Congedo, 1973.

———. "Tre manoscritti greci della chiesa parrocchiale di Galatone." *Bollettino della Badia greca di Grottaferrata* 24 (1970): 3–26.

———. "Ufficiatura del fidanzimento e del matrimonio in alcuni eucologi otrantini." In *Familiare '82: Studi offerti per le nozze d'argento a Rosario Jurlaro e Nunzia Ditonno,* 95–104. Brindisi: Edizione Amici della "A. de Leo," 1982.

Philippidis-Braat, Anne. "Inscriptions du IXᵉ au XVᵉ siècle." In Denis Feissel and Anne Philippidis-Braat, "Inventaires en vue d'un recueil des inscriptions historiques de Byzance, III: Inscriptions du Péloponnèse (à l'exception de Mistra)." *Travaux et Mémoires* 9 (1985): 299–395.

Pierce, Joanne M. "'Green Women' and Blood Pollution: Some Medieval Rituals for the Churching of Women After Childbirth." *Studia Liturgica* 29, no. 2 (1999): 191–215.

Piliego, Paola. "Un'iscrizione bizantina inedita dal casale medioevale di Quattro Macine in Terra d'Otranto." *Taras* 24/25 (2004): 147–56.

———. "Le iscrizioni bizantine degli insediamenti di Quattro Macine e Apigliano in Terra d'Otranto." *Vetera Christianorum* 46, no. 1 (2009): 87–111.

Piltz, Elisabeth. *Kamelaukion et Mitra: Insignes byzantins impériaux et ecclésiastiques.* Stockholm: Almqvist & Wiksell, 1977.

Piponnier, Françoise. "Une révolution dans le costume masculin au XIVᵉ siècle." In *Le vêtement: Histoire, archéologie et symbolique vestimentaire au Moyen Âge*, ed. Michel Pastoureau, 225–42. Paris: Léopard d'Or, 1989.

Pitrè, Giuseppe. "The Jettatura and the Evil Eye." In *The Evil Eye: A Casebook*, ed. Alan Dundes, 130–42. Madison: University of Wisconsin Press, 1981.

Plesch, Véronique. "Memory on the Wall: Graffiti on Religious Wall Paintings." *Journal of Medieval and Early Modern Studies* 32 (2002): 167–97.

Podskalsky, Gerhard, Rainer Stichel, and Apostolos Karpozilos. "Death." In *The Oxford Dictionary of Byzantium*, ed. Alexander Kazhdan, 1:593–94. New York: Oxford University Press, 1991.

Pohl, Walter. "Introduction: Strategies of Distinction." In *Strategies of Distinction: The Construction of Ethnic Communities, 300–800*, ed. Walter Pohl, 1–16. Leiden: Brill, 1998.

———. "Telling the Difference: Signs of Ethnic Identity." In *Strategies of Distinction: The Construction of Ethnic Communities, 300–800*, ed. Walter Pohl, 17–69. Leiden: Brill, 1998.

Polito, Emanuele. "Del rito e delle chiese greche a Mesagne." *Studi Salentini* 70 (1993): 88–125.

Porsia, Franco, and Mauro Scionti. *Taranto*. Bari: Laterza, 1989.

Porter, H. B. "The Origin of the Medieval Rite for Anointing the Sick or Dying." *Journal of Theological Studies* 8, no. 2 (1956): 211–25.

Poso, Cosimo Damiano. *Ostuni nel medioevo: Lo sviluppo urbano dall'XI alla metà del XIII secolo*. Galatina: Congedo, 1997.

———. *Il Salento Normanno: Territorio, istituzioni, società*. Galatina: Congedo, 1988.

Pössel, Christina. "The Magic of Early Medieval Ritual." *Early Medieval Europe* 17, no. 2 (2009): 111–25.

Prandi, Adriano. "Elementi bizantini e non bizantini nei santuari rupestri della Puglia e della Basilicata." In *La Chiesa greca in Italia dall'VIII al XVI secolo: Atti del Convegno storico interecclesiale (Bari, 30 apr.–4 magg. 1969)*, 3:1363–75. Padua: Antenore, 1972–73.

———. "Pitture inedite di Casaranello." *Rivista dell'Istituto d'archeologia e storia dell'arte*, n.s., 10 (1961): 227–92.

Prawer, Joshua. "The Autobiography of Obadyah the Norman, a Convert to Judaism at the Time of the First Crusade." In *Studies in Medieval Jewish History and Literature*, ed. Isadore Twersky, 110–34. Cambridge, Mass.: Harvard University Press, 1979.

Presta, Teodoro. *La basilica degli Orsini: Santa Caterina d'Alessandria in Galatina*. Galatina: Grafiche Panico, 1991.

Presta, Teodoro, and Clemente Marsicola. *La basilica orsiniana, Santa Caterina in Galatina*. Genoa: Stringa, 1984.

Price, Frederick K. C. "Name It and Claim It! What Saith the WORD? . . ." *Ever Increasing Faith Messenger* 2 (Summer 1989).

"Il Principato di Taranto e l'Apulia crocevia del Mediterraneo tra le Crociate e il sacco di Otranto (1089–1480)." Associazione italiana di cultura classica, delegazione di Taranto. Convegno 2000. http://www.webalice.it/fporetti/Sintesi%20Convegno.htm.

Prinzing, Günter. "Observations on the Legal Status of Children and the Stages of Childhood in Byzantium." In *Becoming Byzantine: Children and Childhood in Byzantium*, ed. Arietta Papaconstantinou and Alice-Mary Talbot, 15–34. Washington, D.C.: Dumbarton Oaks Research Library and Collection, 2009.

Puce, Adriano. "Il male di S. Donato nel Salento: Contributo psicologico-sociale." *La ricerca folklorica* 17 (1988): 43–59.

Pugliese Carratelli, Giovanni. *Magna Grecia: Il Mediterraneo, le metropoleis e la fondazione delle colonie*. Milan: Electa, 1985.

Quaranta, Francesco. "In difesa dei matrimoni greci e del mattutino pasquale: Un testo pugliese inedito del XIII secolo." *Studi sull'Oriente cristiano* 5, no. 2 (2001): 91–117. http://www.ktistes.altervista.org/taranto.html.

Quave, Cassandra Leah, and Andrea Pieroni. "Ritual Healing in Arbëreshë Albanian and Italian Communities of Lucania, Southern Italy." *Journal of Folklore Research* 42, no. 1 (2005): 57–97.

Rao, Ursula. "Ritual in Society." In *Theorizing Rituals: Issues, Topics, Approaches, Concepts*, ed. Jens Kreinath, Jan Snoek, and Michael Stausberg, 143–60. Leiden: Brill, 2006.

Reif, Stefan. "Some Changing Trends in the Jewish Literary Expression in the Byzantine World." In *Literacy, Education, and Manuscript Transmission in Byzantium and Beyond*, ed. Catherine Holmes and Judith Waring, 81–110. Leiden: Brill, 2002.

Resnick, Irwin M., and Kenneth F. Kitchell Jr. "'The Sweepings of Lamia': Transformations of the Myths of Lilith and Lamia." In *Religion, Gender, and Culture in the Pre-Modern World*, ed. Alexandra Cuffel and Brian Britt, 77–104. New York: Palgrave Macmillan, 2007.

Revel-Neher, Elisabeth. *The Image of the Jew in Byzantine Art*. Oxford: Pergamon Press, 1992.

Rhoby, Andreas. *Byzantinische Epigramme auf Fresken und Mosaiken*. Byzantinische Epigramme in inschriftlicher Überlieferung 1. Vienna: Verlag der Österreichischen Akademie der Wissenschaften, 2009.

———. *Byzantinische Epigramme auf Stein*. Byzantinische Epigramme in inschriftlicher Überlieferung 3. Vienna: Verlag der Österreichischen Akademie der Wissenschaften, forthcoming 2014.

Ribezzi Petrosillo, Vincenzo. *Guida di Brindisi*. Ed. Mario Cazzato. Galatina: Congedo, 1993.

Richler, Benjamin. *Hebrew Manuscripts in the Vatican Library: Catalogue*. Vatican City: Biblioteca Apostolica Vaticana, 2008.

Richler, Benjamin, and Malachi Beit-Arié. *Hebrew Manuscripts in the Biblioteca Palatina in Parma: Catalogue*. Jerusalem: Jewish National and University Library, 2001.

Rivera, Annamaria. *Il mago, il santo, la morte, la festa*. Bari: Edizioni Dedalo, 1988.

Roach-Higgins, Mary Ellen, and Joanne B. Eicher. "Dress and Identity." *Clothing and Textiles Research Journal* 10, no. 4 (1992): 1–8.

———. "The Language of Personal Adornment." In *The Fabrics of Culture: The Anthropology of Clothing and Adornment*, ed. Justine M. Cordwell and Ronald A. Schwartz, 7–21. New York: Mouton, 1979.

Robinson, Gertrude. "Some Cave Chapels of Southern Italy." *Journal of Hellenic Studies* 50 (1930): 186–209.

Roccas, Sonia, and Marilynn B. Brewer. "Social Identity Complexity." *Personality and Social Psychology Review* 6, no. 2 (2002): 88–106.

Rodley, Lyn. "Patron Imagery from the Fringes of the Empire." In *Strangers to Themselves: The Byzantine Outsider*, ed. Dion C. Smythe, 163–73. Aldershot: Ashgate, 2000.

Rodotà, Pietro Pompilio. *Dell'origine, progresso, e stato presente del rito greco in Italia*. 3 vols. Rome: Salomoni, 1758–63.

Rogers, Richard A. "From Cultural Exchange to Transculturation: A Review and Reconceptualization of Cultural Appropriation." *Communication Theory* 16 (2006): 474–503.

Rohlfs, Gerhard. "Autochthone Griechen oder byzantinische Gräzität?" *Revue de linguistique romane* 4 (1928): 118–200.

———. *Calabria e Salento: Saggi di storia linguistica (Studi e ricerche)*. Ravenna: Longo, 1980.

———. *Dizionario storico dei cognomi salentini (Terra d'Otranto)*. Galatina: Congedo, 1982.

———. *Etymologisches Wörterbuch der unteritalienischen Gräzität*. Halle: M. Niemeyer, 1930.

———. *Grammatica storica dei dialetti italogreci (Calabria, Salento)*. Rev. ed. Munich: C. H. Beck, 1977.

———. *Latinità ed ellenismo nel Mezzogiorno d'Italia: Studi e ricerche*. Chiaravalle Centrale: Frama Sud, 1985.

———. "Linguaggio greco." In *Grecìa salentina*, Problemi e documenti 1, ed. Rocco Aprile, Gustavo Buratti, Gerhard Rohlfs, and Lina Colella, 1:31–33. Cavallino di Lecce: Capone, 1978.

———. *Scavi linguistici nella Magna Grecia*. Galatina: Congedo, 1974.

———. *Toponomastica greca nel Salento*. Fasano: Schena Editore, 1970.

Roll, Susan. "The Churching of Women After Childbirth: An Old Rite Raising New Issues." *Questions Liturgiques/Studies in Liturgy* 76, nos. 3–4 (1995): 206–29.

Rolleston, J. D. "Laryngology and Folk-Lore." *Journal of Laryngology and Otology* 57 (1942): 527–32.

Romaine, Suzanne. *Language in Society: An Introduction to Sociolinguistics*. 2nd ed. Oxford: Oxford University Press, 2000.

Romanello, Maria Teresa. "L'affermazione del volgare nel Salento medievale." *Archivio storico per le province napoletane* 96 (1978): 9–65.

Rosser-Owen, Mariam. "Mediterraneanism: How to Incorporate Islamic Art into an Emerging Field." *Journal of Art Historiography* 6 (2012): 1–33.

Roth, Cecil. "Italy." In *The Dark Ages: Jews in Christian Europe*, ed. Cecil Roth, 100–121, 402–6. New Brunswick, N.J.: Rutgers University Press, 1966.

Rotman, Youval. "Converts in Byzantine Italy: Local Representations of Jewish-Christian Rivalry." In *Jews in Byzantium: Dialectics of Minority and Majority Cultures*, ed. Robert Bonfil et al., 893–921. Leiden: Brill, 2012.

Rousseau, Vanessa. "Emblem of an Empire: The Development of the Byzantine Empress's Crown." *Al-Masaq* 16 (2004): 5–15.

Rubin, Miri. *Corpus Christi: The Eucharist in Late Medieval Culture*. Cambridge: Cambridge University Press, 1991.

Rubin, Nissan. *Life's End: Ceremonies of Burial and Mourning in the Writings of the Sages* [in Hebrew]. Tel Aviv: Hakibbutz Hameuhad, 1997.

Rugo, Pietro. *Le iscrizioni dei sec. VI–VII–VIII esistenti in Italia*. Vol. 4, *I ducati di Spoleto e Benevento*. Cittadella: Bertoncello, 1978.

Russo, Fernando, ed. *La Parola si fa immagine: Storia e restauro della basilica orsiniana di Santa Caterina a Galatina*. Venice: Marsilio Editore, 2005.

Sabar, Shalom. "Childbirth and Magic: Jewish Folklore and Material Culture." In *Cultures of the Jews: A New History*, ed. David Biale, 671–722. New York: Schocken, 2002.

———. "From Sacred Symbol to Key Ring: The *Hamsa* in Jewish and Israeli Societies." In *Jews at Home: The Domestication of Identity*, Jewish Cultural Studies 2, ed. Simon J. Bronner, 140–62. Oxford: Littman Library of Jewish Civilization, 2010.

Safran, Linda. "The Art of Veneration: Saints and Villages in the Salento and the Mani." In *Les villages dans l'empire byzantin Ve–XVe siècle*, ed. Cécile Morrisson and Jean-Pierre Sodini, 179–92. Paris: Lethielleux, 2003.

———. "Betwixt or Beyond? The Salento in the Fourteenth and Fifteenth Centuries." In *Renaissance Encounters: Greek East and Latin West*, ed. Marina S. Brownlee and Dimitri Gondicas, 115–44. Leiden: Brill, 2012.

———. "A Bilingual Jewish Tombstone Inscription in Oria." In *Medieval Italy: Texts in Translation*, ed. Katherine L. Jansen, Joanna Drell, and Frances Andrews, 487–89. Philadelphia: University of Pennsylvania Press, 2009.

———. "'Byzantine' Art in Post-Byzantine Southern Italy? Notes on a Fuzzy Concept." In "Fuzzy Studies: A Symposium on the Consequence of Blur (Part 3)," special issue of *Common Knowledge* 18, no. 3 (2012): 487–504.

———. "Byzantine South Italy: New Light on the Oldest Wall Paintings." In *Byzantinische Malerei: Bildprogramme, Ikonographie, Stil; Symposium in Marburg vom 25.–29.6.1997*, ed. Guntram Koch, 257–74. Wiesbaden: Reichert, 2000.

———. "Cultures textuelles publiques: Une étude de cas dans le sud de l'Italie." *Cahiers de civilisation médiévale* 52, no. 3 (2009): 245–63.

———. "Deconstructing 'Donors' in Medieval Southern Italy." In *Female Founders in Byzantium and Beyond*, ed. Lioba Theis, Margaret Mullett, and Michael Grünbart, 133–49, *Wiener Jahrbuch für Kunstgeschichte* 60–61 (2011–12). Vienna: Böhlau, 2013.

———. "Greek in the Salento: Byzantine and Post-Byzantine Public Texts." In *Inscriptions in Byzantium and Beyond: New Methods, Current and Future Projects*, Veröffentlichungen zur Byzanzforschung, ed. Andreas Rhoby. Vienna: Austrian Academy of Sciences, forthcoming 2013.

———. "Jewish and Greek Patronage in Apulia: Two Texts (1313/14, 1372/73)." In *Medieval Italy: Texts in Translation*, ed. Katherine L. Jansen, Joanna Drell, and Frances Andrews, 258–60. Philadelphia: University of Pennsylvania Press, 2009.

———. "Language Choice in the Medieval Salento: A Sociolinguistic Approach to Greek and Latin Inscriptions." In *Zwischen Polis, Provinz und Peripherie: Beiträge zur byzantinischen Geschichte und Kultur*, Mainzer Veröffentlichungen zur Byzantinistik 7, ed. Lars Hoffmann, 853–82. Wiesbaden: Harrassowitz, 2005.

———. "A Medieval Ekphrasis from Otranto." *Byzantische Zeitschrift* 83, no. 2 (1990): 425–27.

———. "Public Textual Cultures: A Case Study in Southern Italy." In *Textual Cultures of Medieval Italy*, ed. William Robins, 115–44. Toronto: University of Toronto Press, 2011.

———. "Raffigurar(si) gli Ebrei nel Salento medievale." In *Gli Ebrei nel Salento*, ed. Fabrizio Lelli, 241–55. Galatina: Congedo, 2013.

———. "Redating Some South Italian Frescoes: The First Layer at S. Pietro, Otranto, and the Earliest Paintings at S. Maria della Croce, Casaranello." *Byzantion* 60 (1990): 307–33.

———. *San Pietro at Otranto: Byzantine Art in South Italy*. Rome: Edizioni Rari Nantes, 1992.

———. "Scoperte salentine." *Arte medievale* 8, no. 2 (2010): 61–86.

Sakellariou, Eleni. *Southern Italy in the Late Middle Ages: Demographic, Institutional and Economic Change in the Kingdom of Naples, c. 1440–c. 1530*. Leiden: Brill, 2012.

Salerno, Franco. "L'epilessia nelle tradizioni popolari campane: Alla ricerca dell'equilibrio perduto." http://www.cefaleecampania.it/salerno-franco.html.

Salerno, Maria Rosaria. "*Domus* degli Ospedalieri di S. Giovanni di Gerusalemme e vie di pellegrinaggio nel Mezzogiorno d'Italia." In *Viaggi di monaci e pellegrini*, ed. Pietro De Leo, 77–131. Soveria Mannelli: Rubbettino, 2001.

Salzman, Marcus, ed. and trans. *The Chronicle of Ahimaaz*. New York: Columbia University Press, 1924; repr., New York: AMS Press, 1966.

Sanders, Guy D. R. "Three Peloponnesian Churches and Their Importance for the Chronology of Late 13th and Early 14th Century Pottery in the Eastern Mediterranean." In *Recherches sur la céramique byzantine: Actes du colloque organisé par l'École française d'Athènes et l'université de Strasbourg II, Athènes, 8–10 avril 1987*, ed. Vincent Déroche and Jean-Michel Spieser, 189–99. Athens: École française, 1989.

Schapiro, Meyer. *Words and Pictures: On the Literal and the Symbolic in the Illustration of a Text*. The Hague: Mouton, 1973.

Schechter, S[olomon]. "The Child in Jewish Literature." *Jewish Quarterly Review* 2, no. 1 (1889): 1–24.

———. "Notes on Hebrew MSS in the University Library at Cambridge." *Jewish Quarterly Review* 4, no. 1 (1891): 90–101.

Scheller, Benjamin. "The Materiality of Difference: Converted Jews and Their Descendants in the Late Medieval Kingdom of Naples." *Medieval History Journal* 12, no. 2 (2009): 405–30.

Schipa, Michelangelo. "La migrazione del nome 'Calabria.'" *Rinascenza Salentina* 8 (1940): 111–37.

Schirmann, Jefim. "The Beginning of Hebrew Poetry in Italy and Northern Europe." In *The Dark Ages: Jews in Christian Europe,* ed. Cecil Roth, 249–66, 429–32. New Brunswick, N.J.: Rutgers University Press, 1966.

Schirone, Giovanna Rossella. *Giudei e giudaismo in Terra d'Otranto.* Cassano Murge: Messaggi, 2001.

Schmelzer, Menahem H. "A Fifteenth Century Hebrew Book List." In *Studies in Jewish Bibliography and Medieval Hebrew Poetry: Collected Essays,* 83–95. New York: Jewish Theological Seminary of America, 2006.

Schmitt, Jean-Claude. "Entre le texte et l'image: Les gestes de la prière de Saint Dominique." In *Persons in Groups: Social Behavior as Identity Formation in Medieval and Renaissance Europe,* ed. Richard C. Trexler, 195–220. Binghamton, N.Y.: Medieval & Renaissance Texts & Studies, 1985.

Scholem, Gershom Gerhard. *Jewish Gnosticism, Merkabah Mysticism, and Talmudic Tradition.* New York: Jewish Theological Seminary of America, 1960.

Schottmüller, Konrad. *Der Untergang des Templer-Ordens: Mit urkundlichen und kritischen Beiträgen.* Berlin, 1887; repr., New York: Johnson Reprint, 1970. http://archive.org/stream/deruntergangdes00schogoog/.

Sciarra, Benita. "Gli affreschi della chiesa superiore di S. Lucia in Brindisi." *Studi Salentini* 41–42 (1972): 112–16.

Sciarra Bardaro, Benita. "S. Anna (Parrocchia di S. Anna) Brindisi." In *Insediamenti benedettini in Puglia,* ed. Maria Stella Calò Mariani, 429–32. Galatina: Congedo, 1985.

Segal, Eliezer. "Dressing for Success." *Jewish Free Press,* March 22, 2001. http://ucalgary.ca/~elsegal/Shokel/010322_ChangeClothes.html.

Semeraro, Marcello. "Fra Roberto Caracciolo e gli Ebrei." In *Studi storici,* ed. Cesare Colafemmina, 43–60. Molfetta: Ecumenica Editrice, 1974.

Semeraro-Herrmann, Marialuisa. *Il santuario rupestre di San Biagio a San Vito dei Normanni.* Fasano: Grafischena, 1982.

Semeraro-Herrmann, Marialuisa, and Raffaele Semeraro. *Arte medioevale nelle lame di Fasano.* Fasano: Schena Editore, 1998.

Sermoneta, Giuseppe. "Considerazioni frammentarie sul giudeo-italiano." *Italia* 1 (1976): 1–29.

Ševčenko, Nancy Patterson. "Close Encounters: Contact Between Holy Figures and the Faithful as Represented in Byzantine Works of Art." In *Byzance et les images: Cycle de conférences organisées au musée du Louvre du 5 octobre au 7 décembre 1992,* ed. André Guillou and Jannic Durand, 256–85. Paris: Louvre conférences et colloques, 1994.

———. "The Representation of Donors and Holy Figures on Four Byzantine Icons." *Deltion tēs Christianikēs Archaiologikēs Hetaireias,* ser. 4, 17 (1993–94): 157–65.

Sharf, Andrew. *The Universe of Shabbetai Donnolo.* New York: Aris & Phillips, 1976.

Shatzmiller, Joseph. "Les angevins et les juifs de leurs états: Anjou, Naples et Provence." In *L'État angevin: Pouvoir, culture et société entre XIIIᵉ et XIVᵉ siècle,* 289–300. Rome: Ecole française, 1998.

Shaw, Rosalind, and Charles Stewart. "Introduction: Problematizing Syncretism." In *Syncretism/Anti-syncretism: The Politics of Religious Synthesis,* ed. Charles Stewart and Rosalind Shaw, 1–26. London: Routledge, 1994.

Sheldon, Rose Mary. "The Sator Rebus: An Unsolved Cryptogram." *Cryptologia* 27, no. 3 (2003): 233–87.

Shepkaru, Shmuel. *Jewish Martyrs in the Pagan and Christian Worlds.* Cambridge: Cambridge University Press, 2006.

———. "To Die for God: Martyrs' Heaven in Hebrew and Latin Crusade Narratives." *Speculum* 77 (2002): 311–41.

Shohat, Ella. "The Struggle over Representation: Casting, Coalitions, and the Politics of Identification." In *Late Imperial Culture*, ed. Román de la Campa, E. Ann Kaplan, and Michael Sprinkler, 166–78. London: Verso, 1995.

Sigal, Pierre André. "L'ex-voto au Moyen Âge dans les régions du Nord-Ouest de la Méditerranée (XIIᵉ–XVᵉ siècles)." *Provence historique* 33, no. 131 (1983): 13–31.

Sinkewicz, Robert E. *Theoleptos of Philadelpheia: The Monastic Discourses; A Critical Edition, Translation and Study.* Toronto: Pontifical Institute of Mediaeval Studies, 1992.

Sirat, Colette. *Hebrew Manuscripts of the Middle Ages.* Ed. and trans. Nicholas de Lange. Cambridge: Cambridge University Press, 2002.

Skeates, Robin. *Visual Culture and Archaeology: Art and Social Life in Prehistoric South-East Italy.* London: Duckworth, 2005.

Skinner, Patricia. "Gender, Memory and Jewish Identity: Reading a Family History from Medieval Southern Italy." *Early Medieval Europe* 13, no. 3 (2005): 277–96.

Smith, Jonathan Z. *Relating Religion: Essays in the Study of Religion.* Chicago: University of Chicago Press, 2004.

Snoek, Jan A. M. "Defining 'Rituals.'" In *Theorizing Rituals: Issues, Topics, Approaches, Concepts*, ed. Jens Kreinath, Jan Snoek, and Michael Stausberg, 3–14. Leiden: Brill, 2006.

Snyder, Lynn M., and Charles K. Williams II. "Frankish Corinth: 1996." *Hesperia* 66, no. 1 (1997): 7–47.

Sonne, Isaiah. "Alcune osservazioni sulla poesia religiosa ebraica in Puglia." *Rivista degli studi orientali* 14 (1933): 68–82.

Sorlin, Irène. "Striges et géloudes: Histoire d'une croyance et d'une tradition." *Travaux et Mémoires* 11 (1991): 412–36.

Spagnoletto, Amedeo. "La *mezuzà* di Trani: Prime indagini conoscitive." In *Arte in Puglia dal Medioevo al Settecento: Il Medioevo*, ed. Francesco Abbate, 241–45. Rome: De Luca Editori d'Arte, 2010.

Spano, Benito. *La grecità bizantina e i suoi riflessi geografici nell'Italia meridionale e insulare.* Pisa: Libreria Goliardica, 1965.

Spatharakis, Ioannis. *The Pictorial Cycles of the* Akathistos *Hymn for the Virgin.* Leiden: Alexandros Press, 2005.

Spedicato, Giuseppe A. "Testimonianze sul monastero italo-greco di Santa Maria di Cerrate (presso Lecce)." *Studi bizantini e neogreci: Atti del IV Congresso nazionale di studi bizantini*, ed. Pietro L. Leone, 249–61. Galatina: Congedo, 1983.

Sperber, Daniel. *The Jewish Life Cycle: Custom, Lore and Iconography; Jewish Customs from the Cradle to the Grave.* Trans. Ed Levin. Oxford: Oxford University Press; Ramat Gan: Bar Ilan University Press, 2008.

Spinosa, Giorgio. "S. Maria della Croce di Casaranello: Analisi delle strutture architettoniche." *Arte medievale*, n.s., 1, no. 2 (2002): 149–63.

Starkey, Kathryn, and Horst Wenzel, eds. *Visual Culture and the German High Middle Ages.* New York: Palgrave Macmillan, 2005.

Starr, Joshua. *The Jews in the Byzantine Empire, 641–1204.* Athens, 1939; repr., New York: Burt Franklin, 1970.

———. "The Mass Conversion of Jews in Southern Italy (1290–1293)." *Speculum* 21 (1946): 203–11.

Steimann, Ilona, and, Michal Sternthal. "Dawid and 'Eliyyà Nezer Zahav the Physician: Scribes and Illuminators in Salento." In *Gli ebrei nel Salento*, ed. Fabrizio Lelli, 273–84. Galatina: Congedo, 2012.

Steinschneider, Moritz. *Donnolo: Pharmakologische Fragmente aus dem X. Jahrhundert, nebst Beiträgen zur Literatur der Salernitaner hauptsächlich nach handschriftlichen hebräischen Quellen.* Berlin: Julius Benzian, 1868.

Stemberger, Günter. *Introduction to the Talmud and Midrash.* Trans. Markus Bockmuehl. Edinburgh: Clark, 1996.

Stern, Sacha. *Calendar and Community: A History of the Jewish Calendar, Second Century BCE–Tenth Century CE.* Oxford: Oxford University Press, 2001.

Stern, Sacha, and Piergabriele Mancuso. "An Astronomical Table by Shabbetai Donnolo and the Jewish Calendar in Tenth-Century Italy." *Aleph* 7 (2007): 13–41.

———. "Corrigenda." *Aleph* 8 (2008): 343–44.

Stewart, Charles. *Demons and the Devil: Moral Imagination in Modern Greek Culture.* Princeton, N.J.: Princeton University Press, 1991.

Stranieri, Giovanni. "Un *limes* bizantino nel Salento? La frontiera bizantino-longobarda nella Puglia meridionale: Realtà e mito del 'limitone dei greci,'" *Archeologia Medievale* 27 (2000): 333–55.

Strickland, Debra Higgs. *Saracens, Demons & Jews: Making Monsters in Medieval Art.* Princeton, N.J.: Princeton University Press, 2003.

Strittmatter, Anselm. "Liturgical Latinisms in a Twelfth-Century Greek Euchology." In *Miscellanea Giovanni Mercati*, 3:41–64. Studi e testi 123. Vatican City, 1946.

———. "'Missa Grecorum,' 'Missa Sancti Iohannis Crisostomi': The Oldest Latin Version Known of the Byzantine Liturgies of St. Basil and St. John Chrysostom." *Traditio* 1 (1943): 79–137.

Stylianou, Andreas, and Judith A. Stylianou. "Donors and Dedicatory Inscriptions, Supplicants and Supplications in the Painted Churches of Cyprus." *Jahrbuch der Österreichischen Byzantinistik Gesellschaft* 9 (1960): 97–128.

Susini, Giancarlo. *Fonti per la storia greca e romana del Salento: Ricerche condotte col contributo dell'Amministrazione provinciale di Lecce.* Bologna: Accademia delle scienze dell'Istituto di Bologna, 1962.

Taft, Robert F. "Byzantine Communion Spoons: A Review of the Evidence." *DOP* 50 (1996): 209–38.

———. *The Byzantine Rite: A Short History.* Collegeville, Minn.: Liturgical Press, 1992.

Taft, Robert F., and Alexander Kazhdan. "Kollyba." In *The Oxford Dictionary of Byzantium*, ed. Alexander Kazhdan, 2:1137–38. New York: Oxford University Press, 1991.

Tagliente, Paola. "La ceramica del casale." In *Da Apigliano a Martano: Tre anni di archeologia medioevale, 1997–1999*, ed. Paul Arthur, 31–36. Galatina: Congedo, 1999.

Talbot, Alice-Mary. "The Death and Commemoration of Byzantine Children." In *Becoming Byzantine: Children and Childhood in Byzantium*, ed. Arietta Papaconstantinou and Alice-Mary Talbot, 283–308. Washington, D.C.: Dumbarton Oaks Research Library and Collection, 2009.

Tamblé, Maria Rosaria. "Antisemitismo e infanzia abbandonata: Un singolare connubio nella Lecce tardomedievale." *Sefer Yuhasin* 16–17 (2000–2001): 31–45.

Tamburini, Filippo. "Documenti pontifici della Terra di Puglia (sec. XIV–XVI)." *BSTd'O* 5 (1995): 23–40.

Tanga, Ivana. "Dolci per l'oltretomba." http://www.taccuinistorici.it/ita/news/medioevale/usi -curiosita/Dolce-dei-morti.html.

Ta-Shma, Israel M. "The Acceptance of Maimonides' *Mishneh Torah* in Italy." *Italia* 13–15 (2001): 79–90.

———. "Rabbi Jesaiah di Trani the Elder and His Connections with Byzantium and Palestine." *Shalem* 4 (1984): 409–16.

Tautu, Luigi. "La badia di San Niceta presso Melendugno (Lecce)." In *La Chiesa greca in Italia dall'VIII al XVI secolo: Atti del Convegno storico interecclesiale (Bari, 30 apr.–4 magg. 1969)*, 3:1187–99. Padua: Antenore, 1972–73.

Teteriatnikov, Natalia B. "The New Image of Byzantine Noblemen in Paleologan Art." *Quaderni Utinensi* 8, no. 15–16 (1990): 309–19.

Thomas, John Philip. *Private Religious Foundations in the Byzantine Empire*. Dumbarton Oaks Studies 25. Washington, D.C.: Dumbarton Oaks Research Library and Collection, 1987.

Thümmel, Hans Georg. "Die bilderfeindlichen Schriften des Epiphanios von Salamis." *Byzantinoslavica* 47 (1986): 169–88.

Thurston, Herbert. "Chapelet." In *Dictionnaire d'archéologie chrétienne et de liturgie*, vol. 3, pt. 1, cols. 399–406. Paris: Letouzey et Ané, 1913.

Toaff, Ariel. "La vita materiale." In *Gli ebrei in Italia*, Storia d'Italia, Annali 11, ed. Corrado Vivanti, 237–63. Turin: Einaudi, 1996.

Tortorelli, Raffaela. "Aree cultuali e cicli agiografici della civiltà rupestre: I casi di Santa Margherita e San Nicola di Mottola." Tesi di dottorato di ricerca, Università degli studi di Roma "Tor Vergata," 2008. http://hdl.handle.net/2108/527.

Trachtenberg, Joshua. *Jewish Magic and Superstition*. New York: Jewish Publication Society of America, 1961.

Tragni, Bianca. "San Pietro in Bevagna tra religiosità popolare e folklore." In *San Pietro in Bevagna nella storia e nella tradizione*, ed. Giovanni Lunardi and Bianca Tragni, 61–94. Manduria: Regione Puglia, Centro regionale servizi educativi e culturali, 1993.

Travaglini, Adriana. *Inventario dei rinvenimenti monetali del Salento: Problemi di circolazione*. Rome: Bretschneider, 1982.

Travaini, Lucia. "Saints and Sinners: Coins in Medieval Italian Graves." *Numismatic Chronicle* 164 (2004): 159–81.

Treves, Marco. "I termini italiani di Donnolo e di Asaf (secolo X)." *Lingua Nostra* 22 (1962): 64–66.

Trexler, Richard C. "Introduction." In *Persons in Groups: Social Behavior as Identity Formation in Medieval and Renaissance Europe*, ed. Richard C. Trexler, 3–16. Binghamton, N.Y.: Medieval & Renaissance Texts & Studies, 1985.

Tridente, Corrado. "Un santo pellegrino in Puglia: San Nicola di Trani." In *Il Cammino di Gerusalemme: Atti del II Convegno internazionale di studio, Bari–Brindisi–Trani, 18–22 maggio 1999*, ed. Maria Stella Calò Mariani, 363–72. Bari: Mario Adda, 2002.

Trinchera, Francesco. *Syllabus Graecarum Membranarum*. Naples: Cataneo, 1865.

Tritsaroli, Paraskevi, and Eleni Gini-Tsophopoulou. "Who, Where and How Dead Were Buried in Byzantine Times? Bioarchaeological Analysis of Two Cemeteries of Middle Byzantine Period from Attica and Boeotia, Greece (XIth–XIVth Centuries AD)." Paper delivered at 21st International Congress of Byzantine Studies, London, August 2006.

Tritsaroli, Paraskevi, and Frédérique Valentin. "Byzantine Burials [sic] Practices for Children; Case Studies Based on a Bioarchaeological Approach to Cemeteries from Greece." In *Nasciturus, infans, puerulus vobis mater terra: La muerte en la infancia*, ed. Francesc Gusi Jener, Susanna Muriel, and Carme Olària, 93–113. Castello: SIAP, 2008. http://dialnet.unirioja.es/descarga/articulo/2794985.pdf.

Trivellato, Francesca. "Is There a Future for Italian Microhistory in the Age of Global History?" *California Italian Studies* 2, no. 1 (2011). http://escholarship.org/uc/item/0z94n9hq.

Tronzo, William. "Regarding Norman Sicily: Art, Identity and Court Culture in the Later Middle Ages." In *Art and Form in Norman Sicily: Proceedings of an International Conference, Rome*,

6–7 December 2002, Römisches Jahrbuch der Biblioteca Hertziana 35, ed. David Knipp, 101–14. Munich: Hirmer, 2005.

———. "Restoring Agency to the Discourse on Hybridity: The Cappella Palatina from a Different Point of View." In *Die Cappella Palatina in Palermo: Geschichte, Kunst, Funktionen*, ed. Thomas Dittelbach, 579–85. Künzelsau: Swiridoff, 2011.

Twersky, Isadore. "The Contribution of Italian Sages to Rabbinic Literature." In *Italia Judaica: Atti del I Convegno internazionale, Bari, 18–22 maggio 1981*, 383–400. Rome: Multigrafica, 1983.

Uggeri, Giovanni. *La viabilità romana nel Salento.* Fasano: Grafischena, 1983.

———. "La Via Traiana 'Calabra.'" *Ricerche e Studi* 12 (1979): 115–30.

Ughelli, Ferdinando. *Italia Sacra, sive de episcopis Italiae* Vol. 9, *Complectens metropolitanas, earumque suffraganeas ecclesias, quae in Salentinae, ac Calabriae Regni Neapolitani clarissimis provinciis continentur.* Venice: Sebastian Coleti, 1722.

Ungruh, Christine. *Das Bodenmosaik der Kathedrale von Otranto (1163–1165): Normannische Herrscherideologie als Endzeitvision.* Affalterbach: Didymos, 2013.

Vacca, Nicola. "Sui primordi della tipografia nel Salento (con un breve excursus)." *Archivio Storico Pugliese* 18 (1965): 200–208.

Valchera, Adriana, and Serena Zampolino Faustini. "Documenti per una carta archeologica della Puglia meridionale." In *Metodologie di catalogazione dei beni archeologici*, vol. 2, ed. Francesco D'Andria, 2:103–58. Bari: Edipuglia, 1997.

Vallone, Giancarlo. "Galatina tra storia e leggenda: Problemi demografici e formazione del territorio (sec. XII–XV)." *BSTd'O* 3 (1993): 19–40.

Van Gennep, Arnold. *The Rites of Passage.* Chicago: University of Chicago Press, 1961.

Van Heurck, Emile H. "Le contrepoisage et le rite des offrandes substitutives et votives." *Bulletin de la Société française d'histoire de la médecine* 17 (1923): 97–113.

Vasco Rocca, Sandro, ed. *Mosaici medievali in Puglia.* Bari: Mario Adda; Rome: Istituto Centrale per il Catalogo e la Documentazione, 2007.

Vassilaki, Maria, ed. *Mother of God: Representations of the Virgin in Byzantine Art.* Milan: Skira, 2000.

Velkovska, Elena. "Funeral Rites According to the Byzantine Liturgical Sources." *DOP* 55 (2001): 21–51.

———. "Funeral Rites in the East." In *Handbook for Liturgical Studies, IV: Sacraments and Sacramentals*, ed. Anscar J. Chupungco, 345–54. Collegeville, Minn.: Liturgical Press, 2000.

Vendola, Domenico. "Le decime ecclesiastiche in Puglia nel sec. XIV." *Iapygia* 8 (1937): 137–66.

———. *Rationes decimarum Italiae nei secoli XIII e XIV: Apulia–Lucania–Calabria.* Vatican City: Biblioteca Apostolica Vaticana, 1939.

Vergara, Pasquale, and Gianfranco Fiaccadori. "Un cippo iscritto da Gallipoli e un nuovo epigramma di Giorgio Cartofilace." *La parola del passato* 38 (1983): 303–16.

Véronèse, Julien. "God's Names and Their Uses in the Books of Magic Attributed to King Solomon." *Magic, Ritual and Witchcraft* 5, no. 1 (2010): 30–50.

Vetere, Benedetto. "'Civitas' e 'urbs' dalla rifondazione normanna al primato del Quattrocento." In *Storia di Lecce dai Bizantini agli Aragonesi,* ed. Benedetto Vetere, 55–195. Bari: Laterza, 1993.

———. "S. Maria de Nerito tra greci e latini." In *Le aree omogenee della Civiltà Rupestre nell'ambito dell'Impero bizantino—la Cappadocia: Atti del quinto convegno internazionale di studio sulla Civiltà Rupestre medioevale nel Mezzogiorno d'Italia (Lecce-Nardò, 12–16 ottobre 1979),* ed. Cosimo Damiano Fonseca, 297–350. Galatina: Congedo, 1981.

———. "Visite pastorali neritine di epoca medioevale (sec. XV)." In *Il popolamento rupestre dell'area mediterranea: La tipologia delle fonti; Gli insediamenti rupestri della Sardegna,* ed. Cosimo Damiano Fonseca, 91–101. Galatina: Congedo, 1988.

Vetere, Benedetto, and Salvatore Micali. *Nardò*. Galatina: Congedo, 1979.

Vetrugno, B[arbara], and E[lisa] Vetrugno. "Scoperte eccezionali sotto il pavimento della chiesa di S. Nicola vescovo." *Nuova Messapia*, December 2002–March 2003, 4.

Villani, Matteo. "Il contributo dell'onomastica e della toponomastica alla storia delle devozioni." In *Pellegrinaggi e itinerari dei santi nel Mezzogiorno medievale*, ed. Giovanni Vitolo, 249–66. Naples: Liguori, 1999.

Viscardi, Giuseppe Maria. *Tra Europa e "Indie di Quaggiù": Chiesa, religiosità e cultura popolare nel Mezzogiorno (secoli XV–XIX)*. Rome: Edizioni di storia e letteratura, 2005.

Visceglia, Maria Antonietta. *Territorio, feudo e potere locale: Terra d'Otranto tra Medioevo ed età moderna*. Naples: Guida, 1988.

Vogel, Cyrille. *Medieval Liturgy: An Introduction to the Sources*. Rev. and trans. William G. Storey and Niels Krogh Rasmussen. Washington, D.C.: Pastoral Press, 1986.

Vukosavović, Filip, ed. *Angels and Demons: Jewish Magic Through the Ages*. Jerusalem: Bible Lands Museum, 2010.

Walsham, Alexandra. "Review Article: The Dangers of Ritual." *Past & Present* 180, no. 1 (2003): 277–87.

Ware, R. Dean. "Medieval Chronology: Theory and Practice." In *Medieval Studies: An Introduction,* ed. James Powell, 252–77. Syracuse, N.Y.: Syracuse University Press, 1992.

Waugh, Christina Frieder. "'Well-Cut Through the Body:' Fitted Clothing in Twelfth-Century Europe." *Dress* 26 (1999): 3–16.

Wazana, Nili. "A Case of the Evil Eye: Qohelet 4:4–8." *Journal of Biblical Literature* 126, no. 4 (2007): 685–702.

Weber, Christoph F. "Heraldry." In *Medieval Italy: An Encyclopedia*, ed. Christopher Kleinhenz, 1:495–98. New York: Routledge, 2004.

Weinberger, Leon J. *Jewish Hymnography: A Literary History*. London: Vallentine Mitchell, 1998.

———. "A Note on Jewish Scholars and Scholarship in Byzantium." *Journal of the American Oriental Society* 91, no. 1 (1971): 142–44.

Weinstein, Roni. *Marriage Rituals Italian Style: A Historical Anthropological Perspective on Early Modern Italian Jews*. Leiden: Brill, 2004.

Weissler, Chava. *Voices of the Matriarchs*. Boston: Beacon, 1998.

Weitzmann, Kurt. *The St. Peter Icon of Dumbarton Oaks*. Washington, D.C.: Dumbarton Oaks, 1983.

Whaley, Joachim, ed. *Mirrors of Mortality: Studies in the Social History of Death*. New York: St. Martin's Press, 1980.

Wieseltier, Leon. *Kaddish*. New York: Alfred A. Knopf, 1998.

Williams, Margaret H. "Jewish Festal Names in Antiquity—A Neglected Area of Onomastic Research." *Journal for the Study of Judaism* 36, no. 1 (2005): 21–40.

Wilson, Stephen. *The Means of Naming: A Social and Cultural History of Personal Naming in Western Europe*. London: UCL Press, 1998.

Winkelmann, Friedhelm. "'Über die körperlichen Merkmale der gottbeseelten Väter': Zu einem Malerbuch aus der Zeit zwischen 836 und 913." In *Fest und Alltag in Byzanz*, ed. Günter Prinzing and Dieter Simon, 107–27. Munich: Beck, 1990.

Wolffsohn, Michael, and Thomas Brechenmacher. "Nomen est Omen: The Selection of First Names as an Indicator for Public Opinion in the Past." *International Journal of Public Opinion Research* 13, no. 2 (2001): 116–39.

Wolfson, Eliot R. "The Theosophy of Shabbetai Donnolo, with Special Emphasis on the Doctrine of *Sefirot* in His *Sefer Hakhmoni*." *Jewish History* 6 (1992): 281–316.

Woodfin, Warren. "Clothing the Icon: The *Podea* and Analogous Liturgical Textiles." http://www.bsana.net/conference/archives/2001/abstracts_2001.pdf.

———. "A *Maiestas Domini* in Middle-Byzantine Constantinople." *Cahiers archéologiques* 51 (2003–4): 45–53.

Woolfenden, Graham. "Eastern Christian Liturgical Traditions, Eastern Orthodox." In *Blackwell Companion to Eastern Christianity*, ed. Ken Parry, 319–38. Malden, Mass.: Blackwell, 2007.

Wulf, Christoph. "Praxis." In *Theorizing Rituals: Issues, Topics, Approaches, Concepts*, ed. Jens Kreinath, Jan Snoek, and Michael Stausberg, 395–411. Leiden: Brill, 2006.

Zacchino, Vittorio. *Galatone antica medioevale moderna: Origine e sviluppo di una comunità meridionale.* Galatina: Congedo, 1990.

Zeitler, Barbara. "'Urbs Felix Dotata Populo Trilingui': Some Thoughts About a Twelfth-Century Funerary Memorial from Palermo." *Medieval Encounters* 2, no. 2 (1996): 114–39.

Zeldes, Nadia. "Legal Status of Jewish Converts to Christianity in Southern Italy and Provence." *California Italian Studies* 1, no. 1 (2010): 1–17. http://escholarship.org/uc/item/91z342hv.

Zimmels, Hirsch J. "Scholars and Scholarship in Byzantium and Italy." In *The Dark Ages: Jews in Christian Europe*, ed. Cecil Roth, 175–88, 415–18. New Brunswick, N.J.: Rutgers University Press, 1966.

———. "Science." In *The Dark Ages: Jews in Christian Europe*, ed. Cecil Roth, 297–301. New Brunswick, N.J.: Rutgers University Press, 1966.

Zimmer, Eric. "Baking Practices and Bakeries in Medieval Ashkenaz" [in Hebrew]. *Zion* 65, no. 2 (2000): 141–62.

Zunz, Leopold. *Die Ritus des synagogalen Gottesdienstes, geschichtlich entwickelt.* Berlin: Louis Lamm, 1919.

Index

References to the Database entries appear in **bold**. References to the color plates appear in ***bold italics***.

Acknowledgments

Isaiah of Trani the Elder (the RID), a Jewish sage who lived north of the Salento whose name appears often in this book, referred to his contemporary thirteenth-century Talmudists as "standing on the shoulders of giants" who had interpreted the text before them. This is the first time that this metaphor, attributed to Bernard of Chartres, was used in Hebrew literature. I, too, have benefited from the broad shoulders of scholarly giants without whom my own multidisciplinary work would not have been possible. Paul Arthur's excavations of medieval villages in the Salento have been fundamental; without them I would have had little to say about the physical characteristics, funerary practices, and physical settings of Salentine individuals. André Jacob's meticulous analyses of so many Greek inscriptions and manuscript texts not only relieved me of a considerable amount of work but also provided outstanding models of interpretive rigor. Cesare Colafemmina has published almost the entire epigraphic record of the lost southern Italian Jewish communities, rescuing them single-handedly from historical darkness. (He passed away on September 12, 2012, and will be sorely missed.) Finally, art historians Marina Falla Castelfranchi and Valentino Pace have done more to make the "Byzantine" wall paintings of the Salento available than any other scholars; although I have not always agreed with them, and I move quite far from their interests in this book, they have stimulated my work enormously over the past quarter century. I am proud to know such giants, and I am forever in their debt.

This work has been taking shape in my mind ever since I first visited the Salento, but it became less amorphous only in the past decade or so. Research trips to assemble the Database were made possible by generous fellowships from the J. William Fulbright Foundation and the Social Sciences and Humanities Research Council of Canada. Dumbarton Oaks, the incomparable Byzantine research center, supported my work with a year-long sabbatical fellowship in 2002–3 and a month-long research stipend in 2012. A generous subvention from the Millard Meiss publication fund of the College Art Association has helped finance the book's photographic corpus. I have also profited greatly from the support of colleagues and institutions where I have taught or been a visiting scholar—the Catholic

University of America, the University of Toronto, the Hebrew University of Jerusalem, and the University of Cyprus at Nicosia—and in all the universities and conferences where I have presented parts of the work in progress. I am grateful, too, for my current home at the Pontifical Institute of Mediaeval Studies in Toronto.

The author of any book with a lengthy gestation has many individuals to thank for advice, assistance, and support at various stages of its completion. I am especially grateful to Mariagrazia Ammirabile, Tzvika Aviv, Doron Bar, Elisheva Baumgarten (who encouraged me at a crucial juncture), Robert Bonfil, Michele Bonfrate (my guide, driver, and companion through several photographic campaigns), Benedetta Braccio, Susannah Brower, Brunella Bruno, Domenico Caragnano, Jill Caskey (always a perceptive and gracious reader), Mina Castronovi, James Cleeman, Jonathan Conant, Alan D. Corre, Vincent Debiais, Nicholas de Lange, Maria De Mola, Antonella Di Marzo (my first and closest friend at the Bari Soprintendenza), Rabbi Ed Elkin, Vera von Falkenhausen, Vito Fumarola (one of my first spelunking companions and, with his wife, Nina, the epitome of southern hospitality), Sharon Gerstel, Amos Geula, Giovanni Giangreco, Carrie Gluck, Ari and Adina Goldberg, Lars Hoffmann, Elliott Horowitz, Herbert Kessler, Fabrizio Lelli, Laura Lieber, Erika Loic, Adi Louria, Karen Lüdtke (whose work on contemporary Salentine anthropology was a major inspiration), Margaret Mullett, Leonora Neville, Sergio Ortese (whose knowledge of painting in the late medieval Salento is unparalleled), Stratis Papaioannou, Maria Parani, Alison Locke Perchuk, Herbert and Lillian Safran, Alisa Schreier and Judah Rose, Alon Shalev, Paola Tagliente, Alice-Mary Talbot, Lioba Theis, and Christine Ungruh.

Vasileios Marinis and Michèle Mulchahey have saved me from countless errors in medieval Greek and Latin, respectively; they bear no responsibility for any that remain. A series of student assistants in Toronto performed critical tasks that moved the book forward: Adam Awad, Ady Gruner, Dana Katz, Alma Mikulinsky, Emanuel Nicolescu, Dianna Roberts, and especially Romney David Smith. Paul Arthur, Antonio Cassiano, Antonella Di Marzo, Roberta Durante, Louis Duval-Arnould, Adrian Fletcher, André Jacob, Cosimo Mottolese, and Valentino Pace generously shared photographs or provided other visual assistance. Margretta de Vries ably drew the map despite my inability to provide proper GIS coordinates for abandoned villages and the Via Appia. At the University of Pennsylvania Press, Jerry Singerman has graciously accommodated faulty word counts and other blunders while Caroline Winschel and Noreen O'Connor-Abel have patiently fielded countless questions. Jennifer Shenk's expert eye caught more inconsistencies than I would care to admit. I warmly and sincerely thank them all, and I apologize to anyone whose name I may have omitted.

My greatest thanks are reserved for my family, who have supported this work for a very long time. My son, Josiah, has never known a time when I was not thinking about the Salento. I am completing this book as he begins high school, so it is time for both of us to broaden our horizons and begin new projects. My husband, Adam S. Cohen, has patiently endured my repeated trips to Italy, which left him a single parent for weeks at a time; he has rarely complained about my frenetic work habits; and he has been the best possible partner in raising our son and keeping me sane. This book is dedicated to Adam and Josiah, with all my love.